Introduction to Cinematography

Introduction to Cinematography offers a practical, stage-by-stage guide to the creative and technical foundations of cinematography. Building from a skills-based approach focused on professional practice, cinematographer and author Tania Hoser provides a step-by-step introduction for both cinematographers and camera assistants to the techniques, processes, and procedures of working with cameras, lenses, and light. She provides hands-on insight into negotiating with production constraints and understanding the essentials of the image workflow from shot to distribution, on projects of any scope and budget.

Richly illustrated, the book incorporates exercises and sample scripts throughout, exploring light, color, movement 'blocking' and, pacing scenes. The principles and techniques of shaping and controlling light are applied to working with natural light, film lamps, and, as with all areas of cinematography, to low budget alternatives. This makes *Introduction to Cinematography* the perfect newcomer's guide to learning the skills of cinematography that enables seamless progression from exercises through to full feature shoots. Assessment rubrics provide a framework to measure progress as the reader's ability to visually interpret scripts and enhance the director's vision develops.

The book also teaches readers:

- To understand and develop the combination of skills and creativity involved in cinematography;
- Photographic principles and how they are applied to control focus exposure, motion blur, and image sharpness;
- To identify the roles and skills of each member of the camera department, and how and when each are required during a shoot;
- The order and process of lighting on all scales of productions and the use and application of the four main types of lamps;
- How to use waveforms, false color, and zebras for monitoring light levels, and meters for guiding exposure choices;
- The principles of the color wheel, color palettes, and the psychological effects of color choices;
- How to shoot for different types of fiction and nonfiction/documentary films and how to apply these skills to other genres of TV and film production;
- Strategies for both starting and progressing your career within cinematography and the camera department.

Tania Hoser started her career as a union apprentice and later worked her way up through the camera grades on feature films and commercials. Tania completed her training at the Royal College of Art, where she won the Kodak and Metz cinematography prizes and shot six award-winning films. During this time, she also had several television commissions as a writer/director. She has taught film, photography, and cinematography at universities including the University of the West Indies, Barbados, and Abu Dhabi Women's College, United Arab Emirates.

Introduction to Cinematography

Learning Through Practice

Tania Hoser

NEW YORK AND LONDON

First published 2018
by Routledge
711 Third Avenue, New York, NY 10017

and by Routledge
2 Park Square, Milton Park, Abingdon, Oxon OX14 4RN

Routledge is an imprint of the Taylor & Francis Group, an informa business

© 2018 Taylor & Francis

The right of Tania Hoser to be identified as the author of this work has been asserted by her in accordance with sections 77 and 78 of the Copyright, Designs and Patents Act 1988.

All rights reserved. No part of this book may be reprinted or reproduced or utilised in any form or by any electronic, mechanical, or other means, now known or hereafter invented, including photocopying and recording, or in any information storage or retrieval system, without permission in writing from the publishers.

Knowledge and best practice in this field are constantly changing. As new research, technology and experience broaden our understanding, changes in professional practices, techniques or approaches may become necessary.

Techniques and approaches suggested herein have been beneficial in the experience of the author. They are neither the only nor necessarily the optimal approach to any aspect of cinematography. Practitioners and researchers must always rely on their own experience and knowledge in evaluating and using any information, methods, approaches, techniques and exercises described herein. In using such information or methods they should be mindful of their own safety and the safety of others, including parties for whom they have a professional responsibility.

Any and all guidance on health and safety and best practice has been included based on the author's sole experience and does not constitute any form of insurance or medical advice.

To the fullest extent of the law, neither the Publisher nor the authors, contributors, or editors, assume any liability for any injury and/or damage to persons or property as a matter of products liability, negligence or otherwise, or from any use or operation of any methods, products, instructions, or ideas contained in the material herein.

Trademark notice: Product or corporate names may be trademarks or registered trademarks, and are used only for identification and explanation without intent to infringe.

Library of Congress Cataloging-in-Publication Data
Names: Hoser, Tania, author.
Title: Introduction to cinematography : learning through practice / Tania Hoser.
Description: New York : Routledge, Taylor & Francis Group, 2018. | Includes index.
Identifiers: LCCN 2018006732| ISBN 9781138235137 (hardback) |
ISBN 9781138235144 (pbk.) | ISBN 9781315305318 (e-book)
Subjects: LCSH: Cinematography.
Classification: LCC TR850 .H67 2018 | DDC 777—dc23
LC record available at https://lccn.loc.gov/2018006732

ISBN: 978-1-138-23513-7 (hbk)
ISBN: 978-1-138-23514-4 (pbk)
ISBN: 978-1-315-30531-8 (ebk)

Typeset in Syntax
by Florence Production Ltd, Stoodleigh, Devon, UK

Printed and bound in Great Britain
by Bell and Bain Ltd, Glasgow

Contents

Acknowledgments *xvii*
Preface *xix*

Section A: The Bigger Picture 1

1 Cinematography: The Bigger Picture 3

Learning Outcomes 4
The Cinematography Triangle: Technology, Technique and Taste 4
Developing Your Visual Language 5
How and Where to Learn Cinematography 6
 Learning in Education *6*
 Learning in a Professional Environment *8*
 Learning Independently *9*
Techniques for Developing Creativity and Imagination 10
 Working Creatively Within the Limits of a Production *11*
The Creative Workflow 14
 Collaboration Techniques *15*
 Progress and the Learning Cycle *16*
Assessing Your Work 17

Section B: Essential Working Knowledge for Cinematographers and Camera Assistants 19

2a Working on Set: Professional Practice 21

Learning Outcomes 21
The Role of the Production Department 21
The Role of the Camera Assistant in Pre-Production 22
The Role of the Cinematographer in Pre-Production 23
The Camera Crew 24
 The Camera Department Hierarchy *24*
 The Role of the 2nd AC and Trainee *26*
 The Role of the 1st AC *26*
 The Role of the Camera Operator *27*
 The Role of the DP *27*
 The Role of the Digital Imaging Technician (DIT) *27*
 The Role of the Dolly Grip *28*

CONTENTS

	Shoot Procedure Step-by-Step	29
	How to Survive the Shoot	32
	Protecting the Camera Equipment	34

2b Camera Assistant Skills 37

Learning Outcomes	37
Focus and Focus Pulling	37
Best Practice for Putting on the Clapper Board	43
Record Keeping: Notes and Camera Sheets	45
Managing Batteries and Power Supply	45
Setting Up and Calibrating the Monitor	46
Data Management and Rushes Delivery	48
To Backup Data 50	
Directory Structure and Folders Layout 50	

3 Fundamental Photographic Knowledge for Cinematography 53

Learning Outcomes	53
Understanding Exposure	54
The Camera and the Camera Sensor	56
Image Noise	58
ISO and How the Sensor Responds to Light	59
Clipping and Avoiding Clipping	59
Recording Color and Bit Depth	60
Recording Formats	60
RAW 60	
Log 61	
LUT 61	
Moiré	62
Exposure	62
Zebras 64	
Histograms 64	
Monitors and IRE Levels 65	
Exposure Problems and Solutions	66
Controling the Look of the Image with Aperture and Shutter Speed	67
Aperture and Depth of Field 67	
Shutter Speed and Motion Blur 71	
Aperture Shutter Speed and ISO: Ideals and Compromises 72	
White Balance	74
Black Balance/Shading	75
Flare	75
Polarization	76
Summary	76

4a Assembling the Camera and Preparing to Shoot 77

Learning Outcomes	77
Selecting an Appropriate Camera	77
Assembling the Camera	77
Mounting the Lens 80	

CONTENTS

Camera Supports	81
Tripod 82	
Camera Heads 82	
Leveling the Camera Head 84	
Hand-Held Supports and Apparatus	84
Securely Connecting the Camera	88
Assembling Camera Accessories	91
Follow Focus 91	
Matte Box and Eyebrow 93	
Filters 95	
Balancing the Camera	95
Camera Menu Set-Ups	96
Cleaning the Camera and Equipment	97
The Cinematographer's Toolbag	98
The Camera Assistant's Kit	98

4b Camera Preparation and Testing 101

Learning Outcomes	101
Checking and Prepping the Equipment	102
Dead Pixel Test	104
Lens Performance Tests	104
Lens Sharpness and Color Fringing Test 105	
Focus Tests 105	
Zoom Lens and Drift Test 106	
Bokeh Test 107	
Anamorphic Lens Tests 107	
Lens Flare Test 107	
Filter Tests	107
IR Pollution Tests For ND Filters 108	
Variable ND Tests 108	
Color Tests	109
Dynamic Range Test	109
The Low Light Test	110

5 Understanding and Managing the Digital Workflow from Camera to Screen 113

Learning Outcomes	113
Workflow Step-by-Step	115
Choosing the Camera	116
Resolution 116	
Dynamic Range 117	
The Impact of High Dynamic Range on Camera Choice 117	
Bit Depth 118	
Recording Choices and Compression	118
Recording In RAW 120	
Recording in Log 121	
DSLR Log Equivalents 122	
Recording in LUT 122	

CONTENTS

 Choice of Codec and Bit Rate 124
 The Importance of Bit Rate 127
 The Post-Production Workflow 128
 Editing 128
 Preparation Files for Grading: Display and Scene Referred Transforms 128
 ACES 128
 Conversion LUTs 129
 The Master Grade 130
 Choosing a Color Space 130
 Color Correcting 131
 Color Grade 132
 VFX 134
 Final Grade and Conforming for Display 134
 Archiving 135
 Exporting for Delivery 135
 Supporting Concepts and Theories 136
 Methods of Compression 136
 Pixels, Photosites and Screens 137
 Shape Squeeze and Crop 137

Section C: Storytelling: Shots, Scenes and Time 139

6 Storytelling in Shots: Lenses and Composition 141

 Learning Outcomes 141
 Focal Length and Composition 143
 The Two Effects of Focal Length 143
 Wide-Angle Lenses 143
 Standard/Normal Lenses 145
 Long Lenses 146
 Focal Length and Aspect Ratio 148
 The Z-Axis 148
 How Sensor Sizes Affect the Angle of View 149
 How Sensor Size Affects Depth of Field 152
 Lens Choices 152
 Specialist and Macro Lenses 152
 T-Stops or F-Stops 153
 Lens Manufacturers and Lens Mounts 154
 Composition and Storytelling 155
 Choosing Shot Sizes 156
 Using Depth of Field and Focus Pulling for Storytelling 158
 Screen Direction: Right to Left and Left to Right 158
 Headroom 159
 Leadroom 159
 Aspect Ratio, Genre and Composition 160
 Frame Height Power and Perspective 162
 Photographic Composition Guidelines 162
 Arrangement of Objects Within the Frame 163

7 Storytelling in Scenes: Constructing the Scene and Working with the Director — 165

- Learning Outcomes — 165
- Genre and Stereotype — 166
 - *Genre* — 166
 - *Stereotypes and Theories of Representation* — 168
- The Gap Between Intentions and Reality — 169
- Working with the Director — 170
- Blocking and Shooting the Scene — 171
 - *Shooting Order and Shooting Efficiently* — 172
 - *The Shooting Ratio* — 173
 - *The Master Shot* — 173
 - *Handles* — 173
- Continuity Coverage — 174
 - *The Line* — 174
- Recurring or Developing Elements in Scenes throughout the Film — 175
 - *Recurring Metaphors and Motifs* — 175
 - *Developing and Changing the Positioning of People* — 176
- Positioning and Movement of Background Elements and Action — 177
- Viewer's Perspective and Eyeline — 177
- The Flow of Time and Pacing the Scene — 178
- Developing Shots and Oners — 179
- Camera Movement — 179
 - *Where the Camera Moves* — 179
 - *How the Camera Moves* — 180
 - *Speed of Movement* — 180
 - *Choosing When to Start or Stop Movement* — 180
 - *Camera Movement Exercises* — 180
- Production Constraints — 181
 - *Stylizing* — 182
- The Magic Bullet — 182

8 Speed and Time — 185

- Learning Outcomes — 185
- Story Time, Film Time and Screen Time — 186
 - *Real Time* — 186
 - *Linear Story Structure* — 187
 - *Non-Linear Story Structure* — 188
- Controling the Flow of Time — 188
- Speeding Up Time — 189
 - *Montage* — 189
 - *Fast Motion* — 189
- Expanding or Slowing Down Time — 190
 - *Simultaneous Time* — 190
 - *Noticing What Would Otherwise Go Unnoticed* — 191
 - *High Speed/Slow Motion Shots* — 191
- The Effect of Shutter Speed, Shutter Angle and Frame Rate on the Look of a Film — 193
- Interlaced or Progressive Frames — 195

CONTENTS

Flicker Flicker Flicker: Lamp Choices, Shutter Speeds Hz, Flicker and Phasing — 196
 Flicker and High Speed Cinematography 196
 Removing Flicker or Rolling Bars When Shooting Monitors 199
Understanding and Avoiding the Rolling Shutter Effect — 199
Exercises — 200

Section D: Shooting Creatively and Efficiently When Working Alone — 203

9 Solo Shooting: Documentary and Television — 205

Learning Outcomes — 205
The Freedom and Scope of Working Alone — 206
Types and Modes of Documentary — 206
 Expository or Traditional Documentary 207
 Observational Documentary 208
 The Participatory Mode 208
 The Performative Mode 208
 The Reflexive Mode 209
 The Poetic Mode 209
Preparation — 210
 Story 210
 Style 210
 Content 211
Permissions — 211
Workflow and Recording Settings — 211
Lens Choice and Camera Settings — 212
Equipment Choices, Safety and Preparation — 213
Shoot Procedure — 214
Covering a Scene and Shooting for the Edit — 214
Creating Scenes When Shooting Observational Documentary — 217
Solo Shooting Techniques — 218
 Operating 218
 Focus 218
 Exposure 219
Lighting and Lighting Equipment — 220
 Safety 220
 Lighting and Color Temperature in Observational Documentary 221
Lighting and Shooting Interviews — 221
Cinematographer's Guide to Recording Sound — 224
Documentary Filming Assessment Rubric — 228

Section E: Camera Operating and Methods of Moving the Camera — 231

10 Camera Operating — 233

Learning Outcomes — 233
Benefits of Having a Dedicated Camera Operator — 234

CONTENTS

The Effect of Camera Movement on the Viewer	234
Devising Shots	235
Working with Others	235
Working with the Grip 235	
Working with the AC 235	
Positioning Artists 236	
Positioning Props 236	
Framing	236
Leadroom 237	
Headroom 237	
Scanning the Frame 238	
Eyelines	239
Crossing the Line	239
Selecting Equipment	239
What Type of Camera Head for Which Type of Movement 240	
Which Camera Supports for What Type of Movement 240	
Sliders 243	
Techniques and Tools for Shooting Hand-Held	245
Choosing the Optimal Focal Length 245	
How to Operate Smoothly and Steadily While Moving 246	
Learning to Move Safely Within a Space 247	
Working with Actors 248	
Key Points, for Self-Assessment	250

Section F: Light and Lighting — 251

11a Lighting: The Fundamentals of Lighting, Light Metering and Exposure — 253

Learning Outcomes	253
Key Light	254
Hard Key Light 254	
Soft Key Light 254	
Fill Light and Lighting Ratios	255
Flat Light	256
Monitoring and Measuring Light	256
IRE 257	
False Color 258	
Waveform Monitor 259	
Vectorscope 259	
Light Metering and Measurement	260
Light Measurements 260	
Stops 261	
Exposure Values 261	
Setting a Meter 261	
Incident Meters 262	
Spot Meters 262	
Exposure	263
High Dynamic Range and Standard Dynamic Range 263	
Understanding and Using the Sensitometric/Response Curve 264	
Dynamic Range, Latitude and Exposure 266	

Three Techniques for Exposure 266
Changing the Aperture in Shot 267

11b Lighting: Natural and Available Light — 269

Learning Outcomes — 269
Natural Light — 270
Available Light — 270
Assessing Locations for Natural Light — 271
Assessing Locations for Available Light — 272
Assessing Locations for Lighting by Contrast — 273
Working with the Weather — 273
 Shooting in the Rain 274
Shooting Day Exteriors — 274
 Using Butterfly Frames and Five-in-One Kits and Reflectors 274
 Shooting Exteriors Without a Reflector or Diffusion Kit 276
 Reverses 277
Magic Hour, Evening and Night Shoots — 277
 Magic Hour 277
 Blue Hour 278
 When to Shoot Moonlit Scenes 279
 Shooting in Firelight 280
Day Interiors in Available Light — 281
Lighting Interviews — 282
Available Light Night Interiors — 282
Day for night — 283
 Exteriors 283
 Interiors 283

12 Shaping and Controling Light — 285

Learning Outcomes — 285
Creating Motivated Light and Emulating Light Sources — 286
Controling Shape with Light — 288
 Direction 288
 3/4 Front Lighting 288
 3/4 Back Lighting 288
 Light and Texture 289
Motivated Key Light — 289
Intensity, Distance, Drop-Off and the Inverse-Square Law — 290
Techniques for Creating Fill Light — 291
 Bounce Fill 292
 Lit Fill 292
 Negative Fill 292
Rim Lighting with Back Light — 293
Controling and Modifying Light — 293
 Shade and Shadows 294
 How and When to Use Flags and Barn Doors 294
 Creating Shadows of Blinds and Windows 295
 Breaking Up Light 296

Reducing Softening or Sharpening Light	296
Reducing Light Levels 296	
Diffusing Light to Soften It 297	
Bouncing Light to Soften It 297	
Making Light Harder 298	
Reflection	298
Refraction	299
Lamp Choices, Personal Preferences and Lighting Styles	299
Lighting Control	301
How to Select Appropriate Lamps	301
Bulb Types 302	
Lamp Housings 306	

13 Lighting Locations and Studio Sets 311

Learning Outcomes	311
Differences Between Lighting Studio Sets and Locations	312
Timing Priorities and Planning	313
Production Design and Planning	314
Lighting Plans 315	
Color Temperature Planning 315	
The Order and Process of Lighting	316
Lighting for Wide Shots 319	
Lighting Medium Shots 319	
Lighting Close-Ups 319	
Setting Lamps	320
Key Light 320	
Balancing Set Lighting and Key Light 321	
Fill Light 322	
Back Light 323	
Drawing Attention to Different Parts of the Frame	323
Practical Lamps 323	
Flags, Nets and Cookies 324	
Creating Slivers and Accents 324	
Color Temperature Tweaks	324
Diffusing with Smoke – Fog	324
Day Exteriors	325
Day Interiors	325
Night Interiors	326
Night Exteriors	327
Wet Downs	329
Light Changes During a Shot	329
Lighting Green-Screen	330
Car Interiors	330
Stairs and Halls	330
Lighting with Very Little Time	331
Working with the Lighting Department	331
Shooting and Managing the Power Supply Without a Gaffer 332	
Working with a Gaffer 332	

Section G: Color, Image Control and Creating the 'Look' of the Film: Combining and Using All Aspects of Cinematography Creatively — 335

14 Color, Image Control and the 'Look' of the Film — 337

Learning Outcomes — 337
Imagination and Visualization — 338
Controling the Look: From Outside to Inside — 339
What to Create During the Shoot and What to Leave to Post — 340
Color — 341
 Color and Meaning 342
 The Color Wheel and Color Choices 343
 Colored Light, Color Temperature and Creative White Balance 340
Using Charts and Communicating with the Colorist — 348
Black-and-White Cinematography — 349
Sharpening or Softening the Image — 351
 Controling Image Sharpness 351
 Controling Image Softness 351
 Camera Diffusion Filters 352
 Lamp Diffusion Filters 352
 Smoke, Fog, Mist and Haze 353
 Flare 354
 Halation or Blooming 354
 Saturation and Glow 355
Polarization — 355
Choice of Lenses — 356
Camera Choice — 357
Shooting on Film — 358
Image Control and Grading — 358

Section H: Working in the Film and Television Industries — 361

15 Starting and Developing a Career in Cinematography — 363

Learning Outcomes — 363
The Personal Picture — 363
The Bigger Picture — 364
 Getting a Foot in the Door 364
 CVs and Online Presence 365
 Mentors and Support 365
 Personality and General Approach 366
 Fitting in With the Camera Department 366
 Self-Assessment: The Learning Cycle 367
 Getting Established in the Industry 367
Factors That Affect How Well You Fit In — 368
 What Happens When You Are One of Them, Not One of Us 369
 Solutions 371
Living Where the Industry Is Small — 372
Specialist Routes — 373

Becoming a Cinematographer ... 373
 The Director's Perspective 374
 The Producer and Production Department's Perspective 374
 Confidence, Charisma and Control 375
Starting as a DP ... 376
Moving Up from AC to DP ... 377
Developing Your Career As a DP ... 379

Appendices 1 Camera Department Roles and Relationships Overview ... 385
 2 Assessment Rubric ... 387
 3 What's the Problem? ... 389
 4 Don't Do That, Kevin ... 391

Index ... 393

Acknowledgments

I would like to thank the following for kindly giving their insights, information, advice and support:

Sean Bobbitt BSC; Andrew Boulter; Lucy Bristow ACO; Julian Bucknall; Georgina Burrell; Paul Curtis; Martyn Culpan; Charlie England; Matthew Hicks; Petra Korner AAC; Dana Kupper; Paul Mackay; Kellie Madison; Andy Maltz; Kim Plowright; Steven Poster ASC ICG; Larry Prinz; Roberto Schaefer ASC AIC; Kevin Shaw ICM; Jonathan Smiles; Oliver Stapleton BSC; Tomas Tomasson; Josh White; David Wright.

Companies

ARRI: Karolin Sallge and Marion Schuller; The Camera Division: Rufus Burnham; Dedo: Roman Hoffmann; DSC Labs: Tatiana Manukyan; Easyrig: Johan Hellsten; Focus 24: Sam Falla, Laura Radford Photography: Laura Radford; Litegear; Paul Royalty; Liquid Productions: Oliver Hall; Panalux: Ole Mienert; Panavision: George Rumsey and Chapman Dollies Los Angeles and Video Link Romania.

And to the following for their help with producing and preparing the manuscript and images: Alice Angel, Chris Bourton; Mina Bryant; Helen Charlottes; Paul Crampton; Leon Davies; Stuart Dodd, Sarah Lewis; Adrian Pircalabu; Feena Quinn; Leah Quinn; Eva Sbaraini; Silvia Sbaraini; Suzie Greene-Tedesco; Raymond Yeung; Samuel Scott; Bill Taitt; Chris Tait.

Diagrams and illustrations by Lucy Cresser, Stuart Dodd and the author.

Any photos not credited are by the author.

Preface

This book is a 'letter to my younger self'. It contains the information, advice and guidance that would have made my, and I hope will make your, journey from camera trainee to director of photography smoother, faster and more enjoyable.

I have looked at the technical and creative areas of cinematography and what, in the long run, becomes the most important of all: the development and use of visual language. The book is based around practical advice and guidance for camera assisting, shooting, lighting and managing the digital work flow. This is supported with a level of theory that will allow you to use the techniques described.

The combination of information, links, exercises and insights reflects the way many of us currently learn, but in this text, they have been curated to lead and support you through your learning experience. Conversely, the exercises included are unlike most people's experience of learning cinematography, which is trying to apply a whole range of unfamiliar skills all at once. Here I suggest exercises you can practice in much the same way a musician practices scales before trying to play a concerto. The aim is for you to understand the concepts and be confident about many important cinematographic skills before shooting a film.

Feature films are arguably the highest form of cinematographic art and many discussions with, and examples from, leading directors of photography are shown. However, I have also included discussions with, and looked at the output of, a broad range of people working in all areas of the film and TV industries. The advice and open and honest insights they give provide a taste of the realities and scope of this fascinating industry, whichever area you aim to work in.

Enjoy the journey.

SECTION A

The Bigger Picture

1
Cinematography: The Bigger Picture

We are writing stories with light and darkness, motion and colors. It is a language with its own vocabulary and unlimited possibilities for expressing our inner thoughts and feelings.
Vittorio Storaro[1]

Hero DP Christopher Doyle.

Minority Report DP Janusz Kamiński.

If you don't understand the technical needs of the scene then you are in trouble before you start.
Nick Knowland[2]

In still photography, lens choice, frame selection, composition and lighting are used to capture the essence of a single moment. In a film, many moments must work together to tell a story. Cinematography requires the ability to create a series of images that have the creative development and appropriate technical consistency to produce a meaningful film.

This chapter explores the heart of the art of cinematography, and shows tried and tested steps for learning technical skills and developing creativity that will stand you in good stead throughout your career. It starts by looking at the scope of cinematography, and compares what can be gained by learning within education to learning on set or independently. It then looks at how visual language is acquired and how it can be expanded. Exercises and guidance are given for learning the essential but intangible areas of creativity and teamwork. These are followed with exercises to help you understand story structure and how to use light in storytelling, that can be applied to shoots of any budget. The chapter finishes by detailing how to assess your own work as it progresses.

A: THE BIGGER PICTURE

> **LEARNING OUTCOMES**
>
> *This chapter will help you:*
>
> 1. Understand the range and combination of skills and creativity involved in cinematography
> 2. Make a realistic assessment about what the different routes to becoming a cinematographer offer
> 3. Apply creative thinking to both technical and creative problems
> 4. Understand what influences your visual language and how to broaden it
> 5. Work effectively in teams, in both learning and professional environments
> 6. Work creatively with limited resources
> 7. Use Kolb's Learning Cycle for evaluating and improving your process of skills acquisition and creative development
> 8. Assess and evaluate your own work and the work of others

The principles and practice in this book apply to all types of productions, from documentary, music videos, short, corporate or web films, to art, commercials, TV and feature films. The larger and more complex the production, the larger the crew. Although the titles Director of Photography (DP) or cinematographer can be used interchangeably on dramas, generally speaking, DP is used for larger films. Cameraperson or shooter are terms used on smaller projects. A sound knowledge of assistant camera (AC) skills is needed, not only by ACs (camera assistants) and cinematographers who shoot alone, but also by cinematographers to understand the time, equipment and practical requirements of the ACs. Here, the roles and duties of camera assistants are shown separately, to give guidance for cinematographers and a thorough grounding for those working as ACs.

THE CINEMATOGRAPHY TRIANGLE: TECHNOLOGY, TECHNIQUE AND TASTE

I joke around sometimes and say that the DP is like a shrink for the director, but there's some truth in there.
Reed Morano[3]

Controling the camera and being able to use photographic techniques and image technology to produce the most appropriate images for a film are essential skills for a cinematographer. However, these skills are only part of what a cinematographer offers to a film. It is the ability to creatively use film language to help the director interpret a script, story or idea and turn it into images that marks out a cinematographer from someone who knows how to use a camera.

The three bodies of knowledge combined in cinematography are:

Technology: Knowing how camera equipment works, can be put together to do what you need, and how to apply photographic principles effectively when using it.

Technique: Not only knowing the procedures and your role in the processes of making a film but also being able to collaborate with others to ensure the best work possible is achieved within the time, budget and other constraints of the project.

Taste: The ability to choose how and what to shoot for a project, to bring the director's (or your own) vision to the audience.

1: CINEMATOGRAPHY: THE BIGGER PICTURE

The more confident with technology you are, the more you can create shots that appear as you want. The more confident with technique you are, the quicker you can shoot and the more shots you can squeeze into the time available. The more you develop your taste and understanding of visual language, the more easily and effectively you can translate stories into shots. Now there is widespread access to cameras and editing programs, creative and technical skills can be practiced so there is an expectation that if you have an interest in cinematography you are active in taking pictures and working with moving images.

When learning, there is a lot of talk about which cameras and equipment will improve your cinematography. It's important to remember that, although you need to know the equipment you are working with, you don't need to know about every item on the market. Having technical knowledge or vocabulary that outstrips your technique and creativity will not benefit you or anyone else when you are shooting. This tech talk can make those who are less technically adept or knowledgeable think they can't be cinematographers. However, if you learn more slowly, being spot on with your professional technique (see C2) will make you a very useful member of a camera crew, while you build your knowledge of equipment.

You don't have to be a boffin, you just need to be up to speed with the equipment and techniques you are using on set.
Lucy Bristow ACO[4]

DEVELOPING YOUR VISUAL LANGUAGE

Whatever your technical starting point, because we live in a rich visual world, you already have a visual language and ability to 'read' an image and understand its meaning. Your visual language and understanding develop as a result of every image and motion picture you've ever seen, alongside the environments, designs and visual culture that surrounded you. You don't have to like or use all influences, but they do become part of your visual dictionary.

Your choice of viewing affects the continuing development of your visual language and the breadth of your visual reference.

> The word genre is used in several ways:
>
> For the type of film: Horror, Sci Fi, Western
> For the format of the film: High Definition, 3D, 35mm
> For the budget: big, low, micro
> For the form: Documentary, Drama etc.
> For the effect of the film: Feel good, weepy
> Or the audience: Teen, Family
> Or a combination of any of the above: feel-good teen docudrama

Shot choices, composition, lighting and color are elements of the visual language of each film – (left) Drama Thriller: *Babadook* DP Radoslaw Ładczuk has high-contrast 'hard lighting' and blue tones; (center) Drama Fantasy: *About Time* DP John Guleserian uses softer lighting and 'warmer' tones; (right) Western Rom Com: *A Million Ways to Die in the West* DP Michael Barrett includes wide vistas and desert locations.

EXERCISE: As a starting point for understanding the use and development of visual language, search for a list of the best movie remakes in a genre (such as horror, action or romance) that you find interesting. Watch the original and remake. Note how different directors working at different times have handled similar subjects. Choose three similar scenes to unpick. Look at what shots are included and how they differ in each film.

You broaden your visual language by expanding your reference points. This makes as much difference to your development as a cinematographer as improving your techniques and technical abilities. Watch broadly, look at full-length and short films in various genres. Watch films made by the same director to see what makes them distinctive. Watch films from different countries and explore

A: THE BIGGER PICTURE

(top) *Snapseed* DP Tomas Tomasson, Iceland (bottom) *Veer Zara* DP Anil Mehta, India.

the visual threads of identity (subject, location, look and filmmaking styles) that make up a 'national cinema'. Watch films made at different budget levels. Note, above all, how 'story is king'. Each time you set up a shot, you should connect what you're framing to the story you're telling. Even if you don't get to shoot films as frequently as you would like, and have no access to camera equipment, you still have the opportunity to develop your visual language. This depth and breadth of knowledge is highly valued by directors, is an important part of what you offer and a key part of your learning.

> National cinema refers not only to the look of the film and the favored subject matter, but also to the people and places within which films are made.

HOW AND WHERE TO LEARN CINEMATOGRAPHY

Training and education are different. Training teaches you how and when to do specific tasks. Education develops your ability to analyse so you can see the bigger picture, assess what needs to be done and problem-solve so that you can tackle any task. To become a cinematographer, most people need a combination of both.

Learning in Education

Film courses are not all the same; it is important to understand the the aims of a course to find one that suits you. Despite the wide variety of names, courses usually fall into the following categories:

Film studies courses

You will analyse film, its constituent parts, its sociohistorical and political context. Any practical components of the course are primarily to help you understand the process, rather than to teach professional filmmaking skills.

Film art or Multimedia courses

These usually have a central aim of exploring film and what you can do with it to push creative boundaries.

Film production courses

These are primarily intended to develop your ability to make films and choose what films to make. Although film production courses often include film studies, these analytical classes are intended to enhance your practical work and understanding of the implications of your choices.

Cinematography courses

Some, but not all, film production courses include cinematography modules or specializations. Few programmes below Masters level are devoted to cinematography.

Views about how useful film courses are for learning to work professionally range considerably and often stem from unrealistic expectations, and not differentiating the course types above.

> *There are lots of courses promising you will end up working in Hollywood but you end up either under- or unemployed. You are sold a glossy idea but are given very little practical training . . . Courses don't ever produce people who know what to do on set. They may understand how films are put together but have no idea how to do it.*
> **Julian Bucknall**[5]

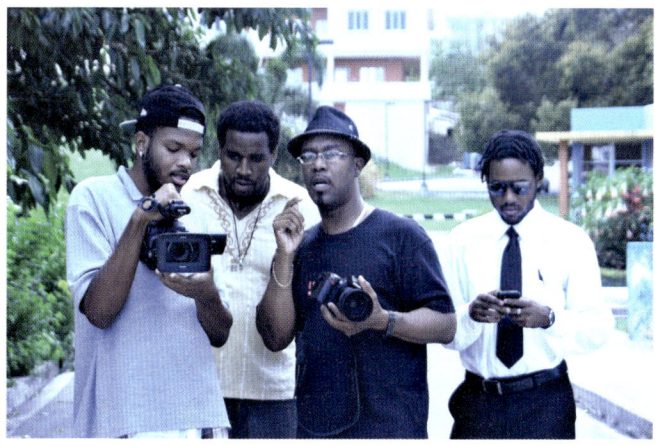

University of the West Indies EBCCI Cinematography class shoot. From left to right, Vonley Smith, Damien Pinder, George Cox and Elton Wharton.

Even those courses that focus on film production and cinematography can leave students frustrated because they don't end up being able to shoot at the professional level of the films they study. The blame is frequently laid on inadequate equipment or training on how to use it. There are several reasons why courses can't offer extensive training in using equipment:

- It's impossible to cover all the skills and equipment in the teaching hours available.
- Each individual skill isn't complex enough to meet courses' graduate outcome requirements, which are about producing people who can think and work independently.
- The higher the academic level of the course, the more it is geared towards knowing how, why and when to combine the many skills used in cinematography, rather than assessing each of them.

To get the most out of studying in an academic institution, it helps hugely to accept that you are largely responsible for learning technical skills yourself and making the most of the time that can usually be booked to practice with equipment. In music schools, for example, it is accepted that the majority of the technical skills needed to play an instrument are acquired through private practice. The reality is the same in cinematography. Most courses offer brief introductions to technical skills, and good ones often offer guidance on learning to teach yourself.

What you usually get on a film production or cinematography course is:

- A guided programme of activities exploring what film is; and the opportunity to learn both the potential and the problems of film production by making films yourself.
- Lectures, readings, discussion and screenings of films you probably wouldn't otherwise encounter, that examine elements including lighting, composition and color, and how these support the meaning and purpose of the film.
- Constructive feedback to help you develop and progress.

It would be very difficult to put yourself through the same programme of activities without being in an academic environment. If you make a conscious effort to apply what you learn on the analytical parts of your program to the shots you choose, this will greatly help your development as a cinematographer.

> *I tell my students that the role of the cinematographic image is not simply to be beautiful, the image must be just, it must be the ideal one for the moment at hand. Knowing the difference between ideal and beautiful requires more than technical know-how.*
> **Michael Yaroshevsky**[8]

It is both legitimate and common for the study of cinematography to be the study of the film drama which is (arguably) the 'highest' form of the art.
Will Howe[6]

The new breed of DPs come out of film school can leapfrog those who have been working their way up for years, which is not necessarily a good thing, you need to learn your craft.
Andrew Boulter[7]

Nobody comes in (to college) thinking about what to put in the frame. I try to get them to hold up a frame to the world and think about what choosing that particular frame does and to see how aesthetics can drive the narrative.
Will Howe

A: THE BIGGER PICTURE

When choosing which college or university to study at, consider:

- Whether the course focuses on film studies, film art or film production
- The balance between practice and theory
- How many contact hours, i.e. face-to-face teaching time, there are each week
- What proportion of marks are allocated to practical work; this reflects how much time should be spent on it
- The criteria for selecting students, and if they're likely to be on a level with you

Learning in a Professional Environment

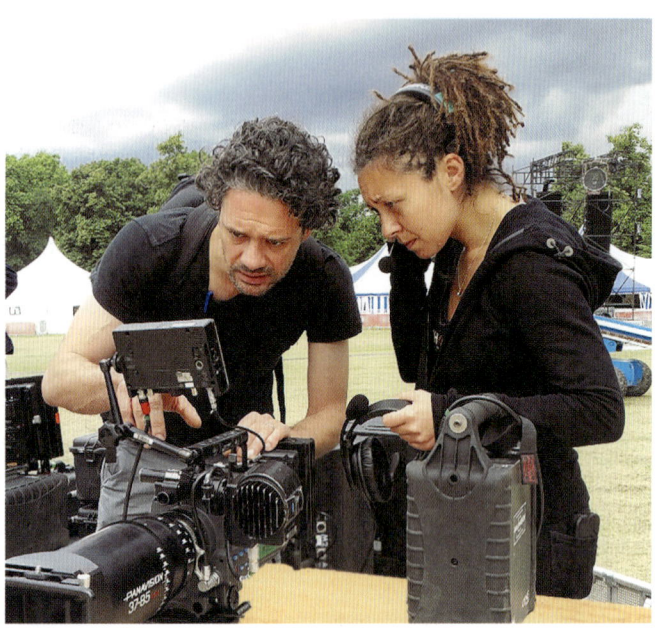

Charlie England 1st AC (assistant camera) and Alexandra Voikou (then 2nd AC, now 1st AC). Photo by Tom Case.

Working on set on professional shoots you gain a body of knowledge about the process and practice of making films. You will build up your practical and technical skills and learn to collaborate with co-workers effectively and efficiently.

Starting as a camera trainee, then working up through the grades of 2nd AC, 1st AC and Camera Operator used to be the main route to becoming a cinematographer. Now, because there are other on-set jobs where you can learn important aspects of the DP's job, combined with increased access to cameras, this isn't the only route.

As a Camera Assistant

In addition to learning to use and assemble the camera equipment, you will see the myriad of tiny adjustments to camera angles, props and cast positions that make shots work. You will learn to anticipate problems, avoid them and work efficiently, effectively and fast. It is an excellent opportunity to see and learn from the lighting being used, although as shoots become more ambitious and tightly budgeted there is less time to observe what the DP is doing. If you work on shoots with one or two assistants, you will acquire the full range of camera assisting skills. The larger the production, the more specialized knowledge is, the narrower the range of tasks that you learn and the more pigeonholed you become. Many people aspire to work on large productions but moving up grades is very tricky on big films.

Finding your first jobs on set and building up enough work to sustain you is difficult, without either considerable good luck and persistence or good connections (see C15 for strategies for finding work). Although keenness and reliability are very important, at the beginning you have few specific skills to offer. One way to gain knowledge and skills is to work in the kit room of a camera house.

Not only does it give you more knowledge about kit (especially at the higher end) it's also a great opportunity to network with ACs when they are in testing . . . We quite frequently have people apply for jobs who have been freelancing for a while already.
Sam Falla (Focus 24)[9]

Working in Camera Rental Houses

You may start by collecting and delivering kit to shoots, then checking equipment and camera packages in and out. You will gain a more thorough knowledge of a wide range of camera equipment than camera assistants do on set, and you may have the chance to test and use the equipment after work. You are very likely to meet camera assistants who come to the equipment house to test kit; if they can rely on your help and knowledge in a camera house, they may give you an opportunity when a trainee is needed on set.

If you take the camera assistant route after studying at film school, you will use little of the film analysis you learned, as you will be employed only for your practical and technical skills. What your education should give you is the ability to see how what you're doing on set fits into the bigger picture of what the cinematographer is aiming at. It is this understanding and overview, combined with the professional technique and technical skills you will acquire as an assistant, that can help you move up to become a cinematographer. The ideal is to spend two or three years as an assistant, absorb all you can, then focus your efforts on becoming a DP. Conversely, if you start as a camera assistant, you might find, after a few years' experience, that going to film school helps you make the move to become a DP.

The other on-set jobs that are also routes to becoming a DP are DIT (Digital Imaging Technician) or in the lighting department as a Gaffer. If you work in either of these areas, you start at the same position or grade, regardless of whether you have studied film or not.

You should be aware that when looking for work as a camera assistant, people aren't buying into your shooting skills or aspirations. They are interested in your knowledge of cameras, ability to anticipate what is needed and how easy you are to be around.
Julian Bucknall

As a Gaffer

You have the opportunity to learn about different types of lamps and how they are set (positioned), changed and modified to affect how or where the light falls and what it looks like. For men, it's currently considered easier to get into the lighting department than the camera department (far less so for women). Lighting is one of the key recognisable and prized skills of a cinematographer and, although gaffers who become DPs are likely to be heavily dependent on good ACs and DITs, strong lighting abilities can help you move across to work as a cinematographer.

As a Digital Image Technician

You will look after several of the technical aspects of image acquisition and play an important role in making sure the image is technically as it should be for post-production (see C5). A DIT may be involved in the DP's choice of camera settings and often sets them on the camera. The DIT currently has a better opportunity than anyone else on set to see and learn from the DP's photographic, lens, lighting and composition choices, which serve as a very good grounding for several aspects of cinematography.

Lamp refers to the lamp housing.

Light refers to the light coming from the lamp.

The terms are used interchangeably in daily life but not in cinematography.

At its best, learning by working on set offers the chance to absorb skills and practice from experts, to travel, to work with wonderful people, in great places, and to earn good money. At its worst, you can spend more time trying to get work than working and feel you never get established enough to be sure to make a living. In any event, each time you move up a grade, you take a big risk and are likely to have a considerable reduction in income, until you become established in your new role. There's always the possibility that you will not successfully establish yourself in the higher grade and it is very difficult to go back down (see C15 for starting and developing your career).

Whatever your role, on set you don't have the chance to see and analyse why any shot does or doesn't work in the cutting-room or discuss alternative shots. Analytical skills are important to using visual language purposefully and effectively in cinematography. As a cinematographer, when you suggest a shot or changes you may not think you are engaged in analytical discussion, but you are. Ironically, the busier you become as a technician, with the long hours this entails, the more difficult it is to build up this body of knowledge.

Learning Independently

Although cinematography is usually a collaborative art, there are many shooters, including documentary makers, YouTubers and vloggers, who teach themselves to create polished films with little or no outside assistance. It is more difficult to tackle drama and music videos because unless you keep your shoots very simple, you can spend more time drumming up equipment, help and money than shooting. However, it does make you resourceful and knowledgeable about the whole process of filmmaking.

A: THE BIGGER PICTURE

If you can produce a good body of work, get it out to people, and convince them to trust you to shoot for them, you can start working as a cinematographer from the outset.

If working independently, your success depends as much on finding reliable people to collaborate with as your own skill and creativity. If you are lucky enough to find a group to work with that are passionate about film, and reliable, it can be a great way to explore and learn. Chatting with people isn't a reliable way to find out how well they'll work as part of a team. Working for a day or two with them will give you a far better idea of who to collaborate with on a longer project.

There are almost as many routes to becoming a cinematographer as there are cinematographers and none of them are guaranteed paths to success. For example, working in still photography is another route and can provide a solid grounding before moving into cinematography. The industry is continually changing and what was a good route five years ago may not be now. Whichever route you choose, genuine interest, enjoyment of the filmmaking process, a love of film, determination and chance all play a part. Once you are working, it is your adaptability, creativity and teamwork that help your progress. Developing these skills from the outset will give you a huge advantage.

TECHNIQUES FOR DEVELOPING CREATIVITY AND IMAGINATION

Creative thinking is not only used in shot choices and lighting, but in the practical skills of configuring and reconfiguring equipment. The four factors affecting your ability to be creative are:

- Technical knowledge
- Adaptability, flexibility and imagination
- Motivation
- Cognitive skills

As well as technical knowledge, your cognitive skills, adaptability, flexibility and imagination can all be developed and improved. It has been demonstrated that creative thinking, which is one of the highest forms of intelligence, relies on physical connections in the brain.[10] Whatever your age and IQ, you can continue to forge new connections and increase your ability to see things differently and so become 'smarter' and more creative.[11]

Experience **Knowledge** **Creative Thinking**

I think the point of cinematography, of what we do, is intimacy. It is the balance between the familiar and the dream, it is being subjective and objective, it is being engaged and yet standing back and noticing something that perhaps other people didn't notice before, or celebrating something that you feel is beautiful or valid, or true or engaging in some way.
Christopher Doyle[12]

1: CINEMATOGRAPHY: THE BIGGER PICTURE

Creative thinking in cinematography requires letting go of prejudgements about what you are assessing and looking at it in new ways. Engage with what you are portraying on an emotional level. Exploring any subject in depth can bring new, creative and inspired ways to show it.

EXERCISE: Select a vegetable and shoot a series of shots exploring shape, texture and the ability to transform your subject with light.

Photo by Debbie Sutton.

Canterbury Christ Church University class project photos by Debbie Sutton. The exercise was to visually explore, shape form, light and meaning using one type of vegetable.

For some people, new skills come quickly and automatically; for others, they require more thought and practice. For those who learn more slowly, it is good to know that once you have learned something, not only your ability to carry out a process or procedure, but your ability to see how it can be applied, is as good as someone's who learned it quickly.

Working Creatively Within the Limits of a Production

Each shot has a purpose within the story; the options for how to visually express that purpose are open-ended. A close-up shot evoking the act of looking may say more than a fully focused one. A shot of the sky, a wall or the ground will say different things about a person's response to a situation and may reveal more than just a shot of their face.

The composition and the shape of the glasses evokes the act of looking. Photo courtesy of Georgina Burrell, GeorgieB TV.

11

A: THE BIGGER PICTURE

When I get a project, I look at the script and work out what they (the commissioners) are trying to get out of it and how I would do it in a perfect world. I know there will be a compromise on that view down the line, due to budget, but this gives me the best starting point.
Tomas Tomasson[13]

Creativity and Imagination

- Imagination is used to expand your options irrespective of your resources.
- Creative thinking is used to get the most from the resources and options you have.

Limited choices but endless possibilities

Having a limitless imagination can be a wonderful way to start, but it can also leave you floundering in a sea of possibilities. You are rarely able to shoot everything you can imagine with the time, money and equipment available. Develop your ability to use limits to help, rather than curb, your imagination. Start with as few parameters as possible and explore the visual potential of each of them.

EXERCISE: 'Light in the Dark'

- Shoot a short film (between 1 and 2 minutes). Two people are stuck in a pitch-black room with one prop, e.g. a chair or book.
- Use either one practical lamp (a practical lamp is one that could ordinarily be found in the room, as opposed to a film lamp) or one source of light from outside the room.
- The light must only be on for between 40% and 60% of the time in the finished film.
- Create a story that both incorporates and is enhanced by the lighting used.
- Include at least 7 shots.

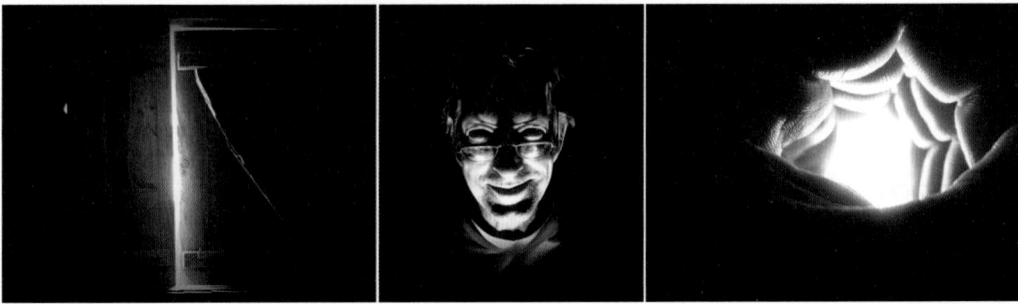

Examples showing the creative potential of a single source of light. (left) Photo by Okan Caliskan, (center) Photo uncredited pxhere.com, (right) Photo by Harald Funken.

To ensure the story has a strong start, is driven forward, and has turning points and an 'end', you may find the following suggestions, based on Aristotelian story structure, useful.

- Start by thinking of characters who are in a heightened state or who want something to change while they are in the room. They could be prisoners, robbers, lovers, refugees, children, a parent and child who are hiding, or an attacker and victim, or an interrogator and suspect.
- Make the audience aware of something either inside or outside the room that becomes a threat or an opportunity for one or both characters.
- Let the light reveal or signify something that one or both characters have a reaction to.
- This action should then change the behavior or emotional response of one or both characters.

Brainstorm ways the light can be used that will help when developing both the story and shot ideas. For example, the light could:

Be swinging on a cable; perhaps the characters move in response to it.

Be used by one to 'break' the other into submission or insanity.

Be coming from outside the room, or could be an uncontrollable light from inside, that makes them more vulnerable to being found.

Be modified by the character(s) during the scene; it could be covered with something that affects its quality and so the mood of the scene.

Be used to try and help them escape.

Be used to tell stories and create shadows.

Reveal things about the characters that the audience wouldn't have expected from their behavior in the dark.

Imagine a small child on a chair, reaching up to a light bulb with hope and anticipation on their face, but by reaching up to grasp it they inadvertently destroy it. Could this idea be used here? Or could the idea be flipped, so that for half the film the characters try to reach the light to turn it on, but, once they succeed, it changes their relationship, revealing things or emotions the darkness covered?

The visual possibilities and the impact of the light on the story are huge in this exercise because there are few other factors. Light often has an impact on story and many of the questions you may ask about the quality and function of the light in this exercise can be asked about the light in almost any scene. Is it daytime or night-time? Is the light cold/bluish or warm/orangey? Is it hard and causing dark shadows or is it soft, gently wrapping around the characters? What is the effect of this light on the characters and story? What does it reveal about the characters? Does it change during the scene?

As cinematographers, we create atmospheres with light, or when working on location, select or adapt the available light, to tell and enhance stories. There is no single best solution for each situation and as Freddie Francis said, "there is no such thing as good cinematography or bad cinematography, there is just cinematography that is right for the film."[14]

Less is more

Expanding your cinematic language and using creativity allows you to achieve more within your practical limits. As the opening sequence in Satya Collymore's *Diaries of an Immigrant*[15] shows, not all shots have to show exactly what is happening. The brain sees more than the eye does. Silhouettes, shadows, traces of movement and the result of action, rather than the action itself, often tell more of the story than seeing the whole of the action.

Diaries of an Immigrant DP Jason A. Russell.

EXERCISE: Create a scene of someone walking down a road, but only include one shot of their face.

Cinematographic storytelling relies on the viewer's imagination to infer the meaning of shots, so that abstract shots can be used as part of storytelling. Likewise, the viewer's mind fills in the gaps between shots. If, for example, you want to show a character running through traffic, you could take a shot of

A: THE BIGGER PICTURE

them running towards a busy road, then take close-ups in a car park, where you can safely and inexpensively work with a limited number of moving cars and people. The more you learn more about lenses, apertures and other cinematographic techniques, the more you will be able to control what the audience does or doesn't see and influence how they connect what they see with what they feel or believe.

THE CREATIVE WORKFLOW

It is very unlikely that anyone has ever visualized what is 'right' for each shot of a film in an instant. Like any processes, cinematographic creativity can be broken down into manageable chunks. On a simple level, if a shot isn't working, you assess why not and adjust one thing at a time until it does. This can be done in terms of composition or lighting, etc. so that it follows photographic rules but whilst the shot may look 'better' on the screen that won't necessarily make it right for the film.

The creative workflow in film requires being on the same page as the director and ideally all those with creative input. Read the script, or if it is a documentary or other type of production, read the 'treatment'; which outlines the ideas and concepts. Then discuss the project. Consider when and where it's set, what it wants to show about the world and if and how this reflects the director's world view, i.e. their attitude to, and philosophy of, life. Ask what the film is meant to reveal, and what the audience should ideally feel or do after they see it. A good director should either know the answer to these questions or be happy to discuss them and the answers usually reveal the reason the film is being made.

The next step is to get on the same page visually. It is important to look at, rather than just talk about, examples and references of films and image ideas that you think are relevant to the project and discuss if and how they might influence your film. You may use specific elements or ideas from the references you look at or adopt or adapt ideas in a number of ways:

- Follow a model by using similar visual elements in similar ways to other films in the same genre.

- Combine existing ideas from different sources in new ways.

- 'Swap systems' by identifying visual systems that have been used in a particular way in one film and using them to do something completely different in yours; such as:

(top) Western shootout visual conventions from *Once Upon a Time in the West* DP Tonino Delli Colli and the same visual conventions used in a shoplifting scene (bottom) in *Three Way Split* DP Simon Reeves.

Visual reference adapted from *Samurai Fiction* DP Yujiro Yajima, fight scene (top) to dance scene in *Kill Bill* DP Robert Richardson (bottom).

Once you understand the director's aims and have agreed on guiding visual concepts, they will inform your choices throughout the production. Being on the same page but each doing your separate jobs means that you can tap into your body of cinematographic knowledge (which is more specialized than the director's) in a way that tells the story, works for the film and achieves more than the director could without you. This is key to avoiding a not uncommon source of conflict which is the director feeling the DP is more interested in 'pretty' shots than the story.

Collaboration Techniques

Films are rarely solo exercises. The larger and more complex the project, the harder it is to do everything yourself. Learning to create, think and work collaboratively is a huge part of becoming either an effective cinematographer or camera assistant. When working in the camera department, under pressure and as part of what are often quite large teams, there can be fallouts, misunderstandings and mistakes in any production, from student projects to major feature films. Whatever your natural abilities, interpersonal and management skills can be developed.

On a professional set, all crew members are expected to know how to work collaboratively. In an educational environment, you are expected to discuss how you will work together at the start of a project.

Professional teamwork

- Presume that other people know what they are doing. Don't try to 'help' everyone else do their job; this will make you do yours less well.

- Do your job in the order and way that makes it easier for others to do theirs.

- Presume that everyone in the group has positive intentions, but be aware that if people blame you for something, their primary aim is usually to protect themselves.

- Ask specific questions if something isn't happening or isn't as you expected. Is there anything I can do so that this can be achieved? What is the difficulty?

- Listen well; look at the person speaking and give them your attention.

- Explain what you understand the other person has said (there is often a mismatch between what is said and what is meant).

- Highlight areas of agreement and then give helpful information rather than criticism if someone isn't aware of something they should be.

- Be open to alternative approaches.

A leader should additionally be able to:

- Unpick the information needed from unclear explanations.

- Handle lots of different sets of information without losing concentration.

- Know the processes of your department well enough to prioritize and know what needs to be done when.

- Be flexible and instantly re-plan if the shot has to change.

In Student Groups you should:

- Agree how often you will meet, how you will communicate and what happens if someone can't meet or do their allocated tasks.

Stay calm, listen, observe and lead by example.
Jonathan Taylor, ASC[16]

A: THE BIGGER PICTURE

- Listen before speaking, and agree that one person should talk at a time.
- Think about what others have said, rather than pushing your point.
- Explain what you understand the other person means by what they have said.
- Give respect and consideration to each other's ideas; give specific reasons if you think an idea won't work. (This also helps you clarify your own thoughts and spot any of your own errors.)
- Share tasks out so they involve equal amounts of work, but ensure that each member plays a creative part and the 'prestige' jobs are distributed fairly.
- Agree that once on a shoot, group discussion should stop and people should focus on their own task.
- If you need help from others, identify exactly which part of your job you're struggling with, get help with that, then resume your role.

Distributing tasks in Student Groups

It can be challenging working in groups where some students are more motivated than others, but be aware that the most demotivating factor is to be allocated jobs that don't seem interesting and relevant. On student shoots, rather than sticking to the specific split of tasks on a professional shoot, and having nobody specifically responsible for visually important tasks such as location finding, consider allocating people to the following tasks that would even up the creative input and require collaboration:

1. Location finding and specifying specific times of day for shooting and the direction of the shots to make use of the visual potential of the location.
2. Composing the frame, operating the camera and being responsible for maintaining consistency between shots so they can cut together.
3. Lighting and exposure.
4. Checking technical issues, backing up data and grading (see C5).
5. Assembling the camera and leading on all technical factors such as focus, depth of field, shutter speed and flare, and using these creatively to enhance shots and help tell the story.

Irrespective of how tasks are allocated, students who are serious about learning cinematography should remember three key points:

- You will learn a lot from doing the less 'glamorous' roles of location scouting, props and casting.
- Pre-production work pays off when you are shooting.
- Finding effective creative solutions, whatever the circumstances, will stand you in great stead as a cinematographer.

An inherent difficulty with student groups is that, once formed, they must usually work together until the end of a project. In 'real life', individuals who do not deliver will be fired. It helps if there is a mechanism whereby if any student isn't able, for whatever reason, to contribute adequately, they are opted out of the group or of the mark.

I hear and I forget, I see and I remember, I do and I understand.
Confucius[17]

Progress and the Learning Cycle

Whether you study in college, learn on set or independently, your approach to learning plays a large part in how your skills and, ultimately, your career progresses, and is a key part of professional working practice.

1: CINEMATOGRAPHY: THE BIGGER PICTURE

It has been shown that learning through practice helps embed knowledge.[18]
The most effective way of doing this is through Kolb's Learning Cycle,[19] as follows:

- Break down what you need to learn into specific skills or areas of knowledge. For example. when making a documentary about snails, you need to learn about macro photography, shooting at ground level, how snails behave, etc.

- Explore and understand the governing principles of macro photography.

- Define one or more specific learning aims, e.g. focusing for macro photography.

- Test the principles in practical situations by shooting either a snail or a similar object.

- Review your work; check the outcome is as expected. Can you see it clearly? Is the shape defined? Is the focus on the most interesting part of the snail? Is enough of it in focus?

- Show and discuss your work with others to gain an outside perspective.

- If your test shots weren't looking as good as you would like, learn how to solve any technical focus problems but also expand your options. Try shooting again but, say, in a different environment, wetting the floor, or adding a light to the background so there is more contrast between it and the snail. *It is at this stage where the 'magic' happens and you see your cinematography improve.*

- Review again.

- Make notes about what you learned and any points to watch out for.

- When you need to incorporate different factors or learn new skills, start the cycle again.

It's been shown that writing notes helps you clarify and retain what you have been reading, watching or listening to. It is the process of selection of what to take notes of that helps with memorisation and understanding.[21] Making notes also creates an invaluable personalized resource you can draw on at any time.

Extensive testing is common in professional practice and is part of the standard preparation for films (see C4b). It is rarely done on student shoots, and can result in the whole group's work being wasted because something that could have been easily checked for has been missed.
Will Howe

At the end of the shoot I had to write up all the camera issues and solutions we found in the series bible so future directors and DPs know the problems and how to avoid them. It is common practice on long-running series.
Georgina Burrell[20]

ASSESSING YOUR WORK

You reflect on your work to learn from it, but, by its nature, film is intended for an audience. In film festival competitions or on some types of film courses,---- there may be a consideration about whether you are pushing the boundaries of cinematic language, but, for the general viewer, the effectiveness of how cinematic language is used to tell a story is most important. In neither case is the equipment used usually relevant.

Whatever your stage of learning, the rubric in Appendix 2 is helpful for assessing both your own work and for comparing it to films you admire. You can use it to check how effectively you are at controlling the technical sides of cinematography, such as good focus and exposure, and how well these are being used to support your creative, visual interpretation of the story or script.

As you progress through this book and shoot the exercises, you should move from the lower to the higher levels of achievement.

> **The aim of learning through practice is not just to be able to achieve an optimal balance of technical expertise and creativity in single shots. It is to be capable and confident enough so that you won't fail to achieve it throughout a film, whatever the demands of the shoot.**

NOTES

1. Vittorio Storaro ASC AIC, oft quoted, original source not found.
2. Nick Knowland BSC, speaking at Cinefest, Arnolfini Centre, Bristol, 2016.
3. Morano, Reed. "Making it as a Cinematographer Regardless of the 'Female Thing'". *IndieWire,* February 24, 2015. http://www.indiewire.com/2015/02/dp-reed-morano-on-making-it-as-a-cinematographer-regardless-of-the-femalething-64771/
4. Lucy Bristow ACO (camera operator) in discussion with the author (September 2016)
5. Julian Bucknall (1st AC) in discussion with the author (September 2016)
6. Will Howe (senior lecturer, Canterbury Christ Church University) in discussion with the author (October 2016)
7. Andrew Boulter (DP) in discussion with the author (September 2016)
8. Michael Yaroshevsky (DP and faculty, Concordia University) in communication with the author (August 2017)
9. Sam Falla (operations manager, Focus 24) in discussion with the author (August 2017)
10. Sternberg, Robert J. *Handbook of Creativity.* Cambridge, England: Cambridge University Press, 2002.
11. Pritchard, Alan. *Ways of Learning: Learning Theories and Learning Styles in the Classroom.* London, England: David Fulton Publishers, 2005.
12. Christopher Doyle HKSC, oft quoted, original source not found.
13. Tomas Tomasson (DP) in discussion with the author (November 2016)
14. Freddie Francis BSC, oft quoted, original source not found.
15. *Diaries of an Immigrant*, directed by Satya Collymore, (Barbados, 2013), film.
16. Taylor, Jonathan. "ASC Close-Up." *The American Society of Cinematographers*, March 2012. https://theasc.com/ac_magazine/March2012/ASCClose-Up/page1.html
17. Confucius, oft quoted, original source not found.
18. Bosch, Françoise and Piolat, Annie. Note Taking and Learning: A Summary of Research. *WAC Journal*, Vol. 16, September 2005.
19. Kolb, David A. Experiential Learning: *Experience as the Source of Learning and Development.* New Jersey, USA: Prentice Hall, 1983.
20. Georgina Burrell (DP/shooting PD, georgieb.tv) in discussion with the author (May 2017)
21. Bosch, Françoise and Piolat, Annie. Ibid.

SECTION B

Essential Working Knowledge for Cinematographers and Camera Assistants

2a
Working on Set: Professional Practice

The aim of learning good professional practice is to enable you to work in the most efficient way possible, adapt effectively to different filming situations and be recognized as a professional. Knowing the procedure of a shoot and the scope and boundaries of your job will help you gain confidence, prioritize your tasks and know what you should be doing at any given time.

There are only minor differences in working practice internationally, which makes it easy to adapt to working with new crews in your home country and overseas. This chapter guides you through professional working practice in pre-production and on a shoot and details the roles of each member of the camera department. It goes on to show how to protect yourself and your equipment, to survive the many and varied filming situations you will find yourself in.

> **LEARNING OUTCOMES**
>
> *This chapter will help you:*
>
> 1. Use pre-production effectively to streamline both the creative and practical work on a shoot
> 2. Identify and understand the roles and skills required by each member of the camera department
> 3. Know what you should be doing at each stage of a shoot
> 4. Take steps to prevent harming yourself or others on a shoot
> 5. Protect the camera equipment in a wide variety of weather and shooting conditions

The filmmaking process starts long before the shoot and usually continues long after it. Pre-production is when all the practical plans for the shoot are made but this is not the first stage of a film project. Whatever the genre, most films go through prolonged and often painful development and financing stages. When a film is eventually green-lit, the crew is entrusted to realize the full potential of the project and it is this responsibility that should always underlie your professional practice.

THE ROLE OF THE PRODUCTION DEPARTMENT

The production department co-ordinates all aspects of the filmmaking from casting to location finding, production design and catering. Production controls the budget, schedule and hiring of personnel. Understanding the purpose of the three key documents produced by the production department before the shoot will help you work together effectively.

The Budget: Includes all costs for every department. Being sensible with equipment requests is the key to working with production on the budget. Make sure you have enough to do what you need and some backup kit but don't, for example, order equipment needed for a few specific days for the whole shoot. Production would prefer that they coordinate deliveries and collections so you have what you need when you need it.

The Schedule: Specifies which scenes are going to be shot each day. It is very carefully calculated so that all the personnel, cast and equipment are in the required locations for the right length of time to get the shots needed. The schedule is like a house of cards. If one scene isn't shot or completed on the given day, it can cause a great deal of time-consuming and expensive re-arranging of the rest of the shoot days. To help the production department produce a viable schedule, flag up and discuss any scenes you envisage being complex or time-consuming to set up or light.

The Call Sheet: Based on the schedule, a Call Sheet is produced for each shoot day and usually issued at some point (often the evening) before the shoot. The call sheet gives the address and directions for the shoot. It lists which scenes are being shot, where, when, with what equipment and personnel and what is happening to the rushes (footage that has been shot) at the end of the day. It also provides information about hospitals and emergency contacts and the weather.

Everyone on set has the same call sheet and is expected to read and follow any instructions on it. If the call sheet has been shared with you online, at least one paper copy is very handy so that you have it to hand at all times.

Call sheet example.

THE ROLE OF THE CAMERA ASSISTANT IN PRE-PRODUCTION

In pre-production the objective of the camera assistant is to reduce the risk of delays or equipment failure on the shoot by:

- Ensuring you have everything the camera department needs; and as little as possible that you won't need.

- Checking that all the equipment you have works as it should and can be assembled and reconfigured quickly (see C4a and 4b).

> Accurately anticipating the kit to bring comes with experience and requires knowing which accessories are needed when, the preferences of the DP and understanding the needs of each shoot.

THE ROLE OF THE CINEMATOGRAPHER IN PRE-PRODUCTION

In pre-production the cinematographer's objectives are:

- To research and discuss with the director to decide on the look or looks that will be shot.

- To check, by testing, that the looks can be achieved with the combination of equipment, lighting and post production facilities you have.

- Make as many decisions about shots, locations, equipment, facilities and people needed as you can, prior to the shoot to reduce set-up and discussion time once shooting.

This process starts, as per C1, by discussing concepts and approaches with the director and looking at references together. The steps involved in pre-production vary primarily based on the time available but, where time allows, will is more important than the budget. It is both possible and useful to go through all the steps below, whatever your budget.

Step-by-step

1. Read the script or brief before you meet with the director.

2. Make ideas a priority at the first meeting, don't just talk about how you would shoot the film. Find out the director's thoughts on visualizing the story before discussing yours. Engage with the story rather than try to second-guess what the director wants to hear.

 > *Have conviction and get your fingers into the story. Your visual concepts are what you are being hired for. At the first meeting, I only talk about concepts and broad ideas for the visuals.*
 > David Wright[1]

3. Based on what you have discussed or found out during the meeting, do lots of visual research, (like watching films, scenes of films, looking at photos, art, or going to places or spaces, or reading further about the concepts in the film) to help you develop ideas.

4. Use your references at a second meeting to narrow down ideas about the look (lights, locations, etc.) and language (shot choices, shot durations, movement) you think would work. Don't lock these off until you have the location scouted and tested, but do have these discussions as early as you can on a project. This is because on a big shoot, the director may well become very busy with other departments in the run-up to a shoot. Or on a low budget project, you may all be busy scrambling around in the time-consuming process of getting the equipment, facilities and personnel in place for as little money as possible.

5. Go with the director and the designer (if there is one) to look at enough potential locations until you find places that work for your scenes in terms of both the look of the place and the shots you can get there. Pay particular attention to the position of the sun and if and when direct sunlight will shine into the location and when it will be obscured. Look at how the light falls naturally and is reflected back by the colors and textures of the environment and what, if any lighting is already available there. (See C11 and C12.)

6. Start working on a storyboard of what will be in frame for either the key shots in each scene or every shot in the film (these can be done with apps or drawn very simply; stick figures are fine).

7. Go on a scout with the other heads of department, production design, sound, gaffer and, if possible, camera assistant and grip, to look at the practicalities of shooting in the locations. Assess access to the location, interference of extraneous sound, availability of electricity, and safety of equipment and personnel, etc.

When I read the script, I really just try to be moved by the story in a multi-sensory way. Images and music come to mind, not just ideas from other films . . . I also bring what I have been experiencing in life, like an art exhibition or an image of something I've seen that's stayed with me.
Roberto Schaefer

You never know if having the same ideas as the director or having something new to add is more likely to get you hired.
Roberto Schaefer[2]

B: ESSENTIAL WORKING KNOWLEDGE

ASPECT RATIO

4:3 = 1.33.1

16:9 = 1.77.1

A good storyboard artist doesn't just illustrate your ideas, they can convey the tone of the film and help develop shot ideas. Storyboards courtesy of Don Seed.

8. Produce a shot list and photo/video or storyboard, ideally shot at the location with people standing in for your cast. These should be at the same or a similar aspect ratio/shape that you are planning to shoot, because your shots will look very different depending on the shape of the frame. This is a good time to test out aspect ratios (see C6) if you aren't sure. The lower the budget the more important this is because you will have less equipment and fewer people with enough experience to make optimal decisions on the spot while you are shooting. This shot list will get refined later but it is important to produce it early to help you prepare your equipment list, and for production to work out how long each scene will take to shoot. Use a director's viewfinder app on your Smartphone (from around $10) that allows you to program in the camera you will be using, and see exactly the same framing you will get.

9. As per C5, find out if VFX will be used and as much detail as you can about the post-production workflow, i.e. what will happen to the footage between when you shoot it and when it is shown.

10. Bearing this in mind, choose and test equipment to find the camera and lenses that will help you create the look you want and the image quality you need at the budget you have.

11. When you have found a suitable camera and lenses, create camera and lighting equipment lists or, if you have sufficiently experienced AC and gaffer, ask them to complete the lists to include all accessories to make everything work as needed. Try to leave what can often be difficult and lengthy price negotiations to the production department. If you are renting equipment and the budget is tight, liaise with the rental house to adjust the package of equipment to fit the budget you have. The more information the rental manager has about what you need to do, the better they will be able to advise on the best package of equipment.

12. Decide on what crew is needed and who would be the right crew, considering your budget and their availability.

13. As per C5, test the post-production workflow and work with the DIT (digital imaging technician) to create a LUT (lookup table) that, without altering the original footage, allows the director and others to see roughly what the finished film will look like.

14. Work with the gaffer pre-rigging lighting, if possible and needed.

THE CAMERA CREW

The Camera Department Hierarchy

(See also Appendix 2)

In the camera department, the roles and hierarchy are quite clearly defined with each member reporting to the next in line but all being overseen and ultimately answerable to the director of photography. The director of photography has many areas to oversee, so the camera assistants take full responsibility for setting up and preparing the camera.

I let others do their job so I can keep control of the image choices and lighting . . . Be clear about what you want and let them help you to find the best way to achieve it.
Roberto Schaefer

24

```
                    ┌──────────────┐
                    │ DIRECTOR OF  │        ⟨· · ·⟩   OFTEN THE SAME
                    │ PHOTOGRAPHY  │                     PERSON
                    └──────────────┘
```

```
┌──────────┐  ┌──────────┐  ┌──────────┐            ┌──────────┐  ┌──────────┐
│ COLORIST │  │   DIT    │  │  CAMERA  │            │ KEY GRIP │  │  GAFFER  │
│          │  │ Digital  │  │ OPERATOR │            │          │  │          │
│          │  │ Imaging  │  │  or eg   │            │          │  │          │
│          │  │Technician│  │Steadicam │            │          │  │          │
│          │  │          │  │ operator │            │          │  │          │
└──────────┘  └──────────┘  └──────────┘            └──────────┘  └──────────┘
                            ┌──────────┐  ┌──────────┐            ┌──────────┐
                            │  FIRST   │  │  DOLLY   │            │ BEST BOY │
                            │ASSISTANT │  │   GRIP   │            │          │
                            │  CAMERA  │  │          │            │          │
                            └──────────┘  └──────────┘            └──────────┘
              ┌──────────┐  ┌──────────┐  ┌──────────┐            ┌──────────┐
              │   DATA   │  │  SECOND  │  │  GRIPS   │            │ELECTRIC- │
              │ WRANGLER │  │ASSISTANT │  │          │            │  IANS    │
              │          │  │  CAMERA  │  │          │            │          │
              └──────────┘  └──────────┘  └──────────┘            └──────────┘
                            ┌──────────┐
                            │  CAMERA  │
                            │ TRAINEE  │
                            └──────────┘
```

Whatever your role, you are expected to know the skills involved in your own job and how to multi-task and prioritize so you carry them out in a way that makes the life of the rest of your department as straightforward as possible, particularly your immediate superior.

One of the primary things that defines work on a film shoot is that each shot requires a different set-up and that there are frequent changes and adjustments to the plan. Very often you will find that lenses and filters are changed after a shot has been set up. As a camera assistant, or even a trainee, your ears, eyes, and your ability to anticipate changes, are at least as important as your technical skill. Whilst carrying out your own tasks, you should be listening and watching to see how shots are changing and have equipment ready before it is asked for by the DP.

The aim of learning good professional practice and having a thorough knowledge of your job is so that as a crew you can work safely, quickly and efficiently. Think of how a Formula 1 crew practices skills and teamwork so they can shave a few seconds off a tire change. This applies equally to film, where the unit cost (camera hire, wages, cast etc.) is high for every minute you are shooting.

It takes time and confidence to be able to carry out your own tasks, anticipate what is needed next and have the co-ordination skills to be a fast and efficient crew member. It helps to practice any skills that require multi-tasking, learn what you can technically so you know when and why changes are made, look after yourself so you can stay alert and not stress too much.

Camera crew sizes differ wildly depending on the scale of the production and the complexity of the shoot. There may be several cameras in a unit (a unit usually includes at least one member from every department) and there may be several units on the film. On a very large production there may be a dedicated crew member for setting up monitors or data wrangling or working with specific pieces of equipment; on a very small crew there may be one cameraperson and one assistant. The following job descriptions are for mid-sized drama shoots.

To become a professional, know your stuff, listen out and be prepared for anything, but don't stress.
Danna Rogers[3]

The Role of the 2nd AC and Trainee

> The trainee should be anticipating the needs of the second AC – and filling time efficiently. Being friendly and confident – learning quickly – reading the room socially and technically and knowing when to talk and when not to.
> Danna Rogers

– Helping the 1st AC by: managing the camera cart and equipment so that everything they need is available as soon as it is required.

– Anticipating when lenses or other equipment should be brought to the camera. Helping with equipment set-ups and lens changes by handing the right kit to the 1st AC when needed and putting away what isn't needed.

– Setting up and moving the monitor as required and making sure it is adequately shaded.

– Managing battery charging and keeping an eye on battery level, anticipating battery changes so it never runs out during a shot. Likewise, managing data mags or cards (for recording onto) and ensuring no run-outs during a shot.

> There are an awful lot of things to think about when you are a clapper loader (2nd AC). You have to be methodical but flexible and not forget anything. It helps if you have a trainee.
> Simon Reeves[4]

– Placing marks for the actors during rehearsals and standing in the actors' positions so the 1st AC can find focus if needed.

– Having the correct color or gray charts ready to put on when requested by the 1st AC.

The 2nd AC also:

– Slates shots, keeps notes of the technical set-ups and writes them up onto report sheets if required.

– Looks after playback and data recording if required.

– Anticipates and brings rain cover or protective gear if needed.

– Brings tea to the camera department, director, key grip and script supervisor whenever possible and before being asked.

– Delivers the data mags as per production department's instructions, and if required backs up data. Data wrangles on small shoots.

– In the UK, the 2nd AC also often helps the grips build tracks for the dolly (see C10).

The Role of the 1st AC

The 1st AC helps the DP and/or Camera Operator by making sure the camera is:

> On a fast-moving shoot, do your best to run with the flow and keep ahead of the game if you possibly can. Smile and make it work if you are running behind, but do what needs to be done as quickly as possible.
> Julian Bucknall[5]

– Set up with the lenses and accessories required (such as zoom focus or motion controls) as soon as needed, is working as it should be, is as ergonomic (easy to use) as possible, is placed where it is wanted and is balanced and level on the camera head each time it is moved (see C4a).

This usually means the 1st AC knows more about the camera kit than anyone else on set.

The 1st AC also:

– Ensures that the camera is protected from rain, sun or other environmental factors.

– Checks with the DP what settings should be put on the camera, such as ISO, color temperature, shutter speed, angle and frame rate (see C3) and sets, additional settings such as codecs in the menu if there is no DIT (see C5).

- Makes sure the 2nd AC lays marks for the actors, calculates the depth of field to know how far apart actors can move without going out of focus and pulls focus using the techniques outlined below to keep the focus where needed.

- Makes sure there is no light hitting the camera lens which could cause flare.

- Calculates how much light will be lost if any additional filters are added to the camera and informs the DP.

Most importantly, the 1st AC lets the operator or DP know if and where any of the shot goes out of focus and if there are any other problems with the equipment that have affected the shot or will delay the shoot.

The Role of the Camera Operator

(See also C10)

The camera operator (whether there is a separate operator or when the DP is also operating) helps the rest of the camera crew by:

- Consistently framing the shot the same way even when moving, so nothing unexpected is in or out of frame.

- Communicating with the grip about what position the camera should be in.

- Letting the 1st AC know at which point to pull focus or change the zoom or other settings during a shot.

- Letting the 1st AC know at which points any of the focus or zoom pulls haven't worked.

- Letting the DP or director know if a shot hasn't gone to plan.

The Role of the DP

On set the DP helps:

- The 1st AD (the first assistant director, who manages the set) by being clear on how long lighting will take.

- The gaffer by giving them information that will let them set/position the power supplies and cables as far ahead of time as possible.

- The director and operator by collaborating on producing effective and realizable shots.

- The 1st AC by letting them know the technical specifications needed and if a difficult focus pull is required, changing the lens or increasing the lighting levels if needed to make sure the focus pull isn't impossible (see C3).

The Role of the Digital Imaging Technician (DIT)

The DIT is the link between production and post-production. The role of the DIT on set is to:

- Thoroughly know the technical capabilities and settings of the camera (often better than the DP or the 1st AC does).

- Check that the requirements for the digital workflow are adhered to (see C5).

- Set up the file formats, file naming conventions to be used for every camera throughout the film.

Many of the calculations can be made using phone apps. The 1st AC needs to know how to get the required information quickly and efficiently from the apps without disrupting the workflow on set and not being distracted by messages or calls coming and make sure their phone is on silent.
Michael Mayer[6]

Always be ready to change – don't stick hard and fast to the plans. If the director changes their mind or says they prefer it another way, think on your feet. Make it happen or say if you can't do it. If what the director wants isn't possible, offer them something in between.
Roberto Schaefer

B: ESSENTIAL WORKING KNOWLEDGE

Digital Report sheet.

A good DIT looks at it (the image) like a cinematographer and learns your way of looking at things.
Roberto Schaefer

- Monitor the image during recording for technical issues including exposure and flicker.

- Check the image after it has been shot for problems such as highlight clipping and color discrepancies, and that it is technically as it should be for delivery.

- Produce digital report sheets, including default project settings such as resolution, aspect ratio and frame rate (see C3 and C5) and the settings used for each shot.

- Liaise with post-production re rushes delivery and back up data and specify which drives they have been backed up to and the total amount of data used.

- Additionally, the DIT works with the DP to create a customized look for the images that are viewed on the monitor and this is also sent to post-production for a guide to how the finished film should look.

Not all DITs have the same level of experience and expertise, although all are called DITs. It is important to be clear about what can be offered by whom and what equipment is required.

- Data wranglers/Junior DIT – set up the camera frame rate, reel names and recording codecs (see C5) and back up the data and deliver it to post-production.

 This requires a laptop and bus-powered drives (that pull their power from the computer).

- DIT – as above and are also able to identify errors, such as flicker and artifacts (image disturbances) not noticeable to the untrained eye both on the monitor and within the files. Should also be able to transcode footage to the required format for post-production, which saves time in post, if required.

 This requires more computing power, such as a Mac Pro tower or fast, powerful current equivalent, grade 1 monitor and suitable shade for the monitor.

- Experienced/more highly trained DIT – as above and also able to create a customized look, and adjust and apply it via a live feed during the shoot. They will liaise with all departments to help guarantee the workflow is as it should be throughout the production.

 This requires on-set color management tools such as ACES (see C5), which should be used in conjunction with a 10-bit calibrated monitor and a closed tent or dark viewing space.

The Role of the Dolly Grip

The dolly grip is responsible for anything associated with the camera's operation and movement, advises on what equipment (from the very wide range available) is most suited for a particular job, assembles, maintains, operates it and makes sure it is safe. They may be assisted by additional grips. Usually anything other than tripods are set up by the grips. A good dolly grip will enable complex shots to be achieved quickly and safely. In North America, grips are also responsible for anything that cuts or diffuses light.

> The key grip has overall responsibility for the dolly grips and grips and for finding a safe way to shoot. An experienced key grip may know, for example, that removing fuses doesn't stop airbags from going off if a car is jolted, which can happen and smash a camera into the operator even if the car is on a trailer.

SHOOT PROCEDURE STEP-BY-STEP

The camera department may be one of the largest departments who have a presence on set, but other departments such as production design or costume may well have many more members working elsewhere. Each department will have at least one representative on set to ensure the work of that department is presented at its best in each shot.

This results in a lot of people working together, which can make the set a very busy and distracting place to work in. The objective of the processes and procedures followed on set is that your work integrates smoothly within your department and interweaves seamlessly with the work of other departments for the benefit of the film. Although all departments are working together as a unit, avoid getting involved in solving other departments' problems. You don't know the parameters they are working in, may not come up with the best solutions, will reduce the efficiency of your own department and will add to the distractions. Whatever role you have been hired to do, focus on your own job and do it in a way that helps others do theirs.

The working environment on a film set may not appear formally structured, but there is a clear hierarchy, protocol and procedure which is efficient and understood by crews all over the world. Chat should be kept to a low volume and shouldn't distract from your, or others', tasks. Once the actors and director are on set, there should be no talking other than what is needed to do your job. Most directors prefer to be the only one who talks to the cast – other than, for example, when setting marks (see C2b).

Organization: The 1st AD is part of the production department, manages the set, co-ordinates the rehearsals and shots. The 1st AD's role is to make sure that all the shots planned for the day are completed so the shoot stays on schedule. Interestingly, the aim of the 1st AD is, on one level, at odds with the aim of the camera department – and almost everyone else on set – who all want each shot to be the best it can be, rather than the quickest it can be.

Many things delay progress on a shoot and, when schedules slip, from the camera department's perspective it seems that some 1st ADs just shout at people to make them speed up. Others take the far more useful approach of establishing what is holding things up and finding how problems can be solved or worked around. You will notice the difference.

Procedure: On-set procedures vary depending on how much lighting takes place, the needs of the shoot and the size of the crew, but other than on-the-fly documentaries, the following steps are (or should) be taken. Skipping steps increases the ratio of shots that don't work, so although this happens for a variety of reasons don't adopt a chaotic way of working because it will result in a higher proportion of unusable shots for which the DP or camera department will almost always be blamed. The key to knowing what to prioritize at any point is knowing shoot procedure well enough and being attentive enough to what is happening on set to be able to anticipate what is needed next. If you

> On the face of it, learning about shooting procedure seems a world away from the creative thinking discussed in the previous chapter. However, every aspect of preparing for a shot – from adjusting the position of the camera or props, so objects and people appear in the right place in the frame, to angling a glass surface so it isn't creating a flare, or pulling focus at a specific point – involves creativity assessing and adjusting the options you have to tell the story in the best way for the film. The procedure can be scaled down according to the scope, type and timescales of the project you are shooting.

Photo courtesy of Laura Radford Photography.

> Divide the number of shots planned by the hours available to find shots expected per hour. Unrealistic schedules don't benefit anyone. Work with the director to cover several shots in one, reduce the list or make some of the shots simpler.

follow the same process for each shot, what seems chaotic will become routine and you will find you have more time to make sure all your tasks fit into the time available.

- **Arrival**: The camera assistants are **never** late. Arrival time is as per call sheet in the USA and call time minus 30 minutes in the UK or as specified by the 1st AC.

 The camera assistants build the camera (see C4a), get the equipment required for the day's shoot ready and put it on a camera cart or organize it into as few boxes as is practicable. The cinematographer arrives at the call time and confirms which lens should be on the camera and any other specific requirements. If it is the first day of a shoot, the DP re-confirms the frame rate, aspect ratio, resolution, etc. (see C3) and these are set on the camera by the DIT or the 1st AC if there is no DIT. During the shoot day, it is the 1st AC who makes any subsequent changes unless the DIT has remote access to the camera settings.

- **Blocking**: The camera assistants bring the camera and monitor to the set and get any necessary rain or sun protection set-up. The scene is 'blocked'. Blocking is the decisions about which shots will be in the scene, where the camera will be placed for each, how high it will be, which lens will be used and what, if any, movement of the camera or actors will be included.

 > Sometimes just the actors, director, DP and 1st AD are present for blocking. If so, the information is then relayed to the ACs, grip and sound department by the 1st AD. Otherwise. these crew members watch quietly. If the 1st AC is on set, they mark the actor's positions during the blocking.

- **Lighting**: The Cinematographer tells the AD how long lighting will take. The AD clears the set so the DP, Gaffer, sparks and grips can light. The camera stays on set during this time so the DP can use the monitor as part of their assessment of the lighting.

- **Setting up the shot, the walk through and marking rehearsals**: The AD calls the Operator, grips, ACs, sound and art departments back to set. The camera operator (or DP) oversees the placement of the camera for the first (usually master) shot. The dolly grip and grips set up track if required. If not the ACs set up the tripod. The ACs put the correct lens and any additional equipment onto the camera required for the shot.

- When the camera is ready and able to move as it should, either stand-ins or the actors are called for a 'walk through' of the shot so the DP can see how the light falls on them and focus marks can be laid before rehearsals start. Any improvement tweaks are made to the lighting, shot or actors' positions and marks are adjusted. The operator checks the shot works throughout and nothing unwanted is in frame and, unless substantial changes are needed, guides the props or art department to adjust them (the art director will usually be watching the monitor to check the new positions work well from their perspective).

 > On union films, camera assistants can't touch props. On non-union films, there are usually props people on hand but camera assistants may have to help out with making minor adjustments including raising objects slightly so they appear in a better place in a frame, tilting reflective surfaces like picture frames, etc. so they don't show unwanted reflections or highlights, and putting anti-flare on objects that are catching the light in an unsuitable way.

 The cinematographer tells the 1st AC what camera settings, filters, color temperature, etc. (see C3) are wanted. The 1st AC sets these and checks for flare. The 2nd AC notes the camera settings in a notebook, and prepares the ident (identification), i.e. the clapper board.

2A: WORKING ON SET: PROFESSIONAL PRACTICE

- **Rehearsal:** The director, actors and all departments, including hair and makeup are called to rehearse the shot (performance rehearsals occur prior to the shoot). When everyone is in place, the AD calls 'quiet on set'. All calls connected with the shots are relayed by the additional assistant directors and runners positioned outside the set so that everyone knows when to be still and silent and when they can work and when, for example, to stop passers-by or traffic. During the rehearsal, the camera department has the chance to make sure that any lighting changes, operating, focus pulls, zooms or other adjustments happen at the right time during shot.

 In reality, it is often decided that a shot needs to be tweaked or changed at this stage. The necessary changes, re-marks and focuses are done as quickly as possible.

- Unfortunately, but not infrequently, **'Let's shoot the rehearsal'** is called just before rehearsals start, which means that any issues you were hoping to check or resolve in rehearsal will be recorded. There should be a roughly correct aperture already set to enable you to see the image on the monitor, but if you aren't happy with it or any key cinematographic element such as exposure or focus, these need to be noted and the director alerted; particularly if they decide they don't need another take.

- **The Shot and Calling the Roll**: When rehearsals are complete, the AD calls for final checks/last looks. For makeup, hair and wardrobe. The DP makes any final adjustment to the aperture (especially if working in natural light which may be changing frequently). The AD calls the roll:

 > 'Quiet on Set.'
 > 'Stand by to shoot.'
 > 'Run sound.' The sound recordist confirms 'Sound running' when it is.
 > The AD calls 'Roll camera', The 1st AC switches it on and calls 'Camera Speed' when it is running correctly and the initial framing is correct. If there are additional cameras, the A camera says 'A speed', followed by 'B speed', etc.
 > The 1st AC or operator says 'mark it'.
 > The second AC is already in place and lifts the slate in position (see C2b), announces the slate and quickly moves away.
 > If and when the camera has to be slightly refocused or panned to see the slate, the 1st AC lets the 1st AD know beforehand and says 'Set' when the camera is in the position to start the shot.
 > The AD calls 'background action' if needed.
 > The director calls 'action' when they are ready.
 > The actors and camera movements start as required, the shot continues until the director calls 'Cut'.
 > The operator continues rolling for a few seconds before cutting, to complete any actions or let actors clear the frame.

Problems in Shot: Any problems that affect part of the shot, such as moments that went out of focus or something dropped into shot, etc., are usually flagged up at the end. Anything that makes the whole shot unusable is often flagged up by the operator during the shot so that the director can either hear it or see it (by, for example, slightly raising their hand). It will then either be the director or AD who call 'cut'. This process can vary, so you should clarify what the director would like to happen before the shoot.

> Standard working practice is that assistants do not chip into on-set discussions, so say nothing unless you have seen something that nobody else has spotted. In that case, mention it to your direct superior or quietly to the DP, rather than call out on set, as too many voices are distracting.

> The reason why tweaks or changes are made at this late stage is because this is the first time all parameters are in place, so it may be possible to see something better than planned shots. (This doesn't make pre-production shot lists unnecessary. They are a solid foundation from which to improve on and ensure you will get a set of shots that work when edited.)

B: ESSENTIAL WORKING KNOWLEDGE

One way or another there is usually some form of playback, Sometimes I look at playback at the end of a shot to check anything I'm not sure of – if there is a VTR person or DIT, they automatically check back at the end of the scene, especially on high-speed shots to check for flicker.
Roberto Schaefer

- **Further takes and pick-ups**: After each take, there is discussion between the operator, DP and director about if and how to tweak the shot for additional takes. When the tweaks are finalized, the director continues with as many takes as needed until they have the performance they want. If only part of the shot is repeated, it is called a pick-up and marked as such on the clapper board.

- Shots are often, but not always, checked back at the end of the scene so any technical errors should be flagged up after the take they occurred in.

Subsequent shots: All shots in the same direction are shot, usually from the widest to the tightest, so that lights are set for the wide shot, then brought closer as needed for the tight shots. When all shots in one direction are complete, reverses are shot and any equipment moves and lighting changes required take place.

- **Food, drinks and breaks**: Drinks are brought to set by camera assistants whenever possible during the day, when it won't interfere with shooting. Meal breaks should be called by the 1st AD but if time is short, food is taken 'on the run' or sometimes not at all.

- **End of day procedure after Wrap is called**: After the AD calls 'wrap', the DP specifies any notes for the ACs or DIT to pass on to post-production. The DP discusses the following day's work with the gaffer, and likewise with the AC if necessary. When possible, the DP then works with the DIT to make sure rushes are close enough to the desired look to give a starting point in post-production. The ACs take care of equipment cleaning (see C4a), first line maintenance, and delivering rushes or backing up in whatever way has been agreed by production. ACs also need to charge batteries, store the equipment in protective boxes and make sure it is put in the agreed safe place overnight.

HOW TO SURVIVE THE SHOOT

Protocols and situations vary, but in my experience most freelance assistants come into work when feeling ill until told to go home by their department, whereas full-time staff call in sick when necessary.

A film can't be made without a crew. The safety of people always comes before the safety of equipment. People get killed or seriously injured on film sets (my former fellow trainee, Mark Milsome, was killed on set whilst I have been writing this book). Crew also get killed when driving home (see Haskell Wexler documentary *Who Needs Sleep?*[7]). Keep a healthy perspective on the importance of your life and health over the needs of the shoot. There are many things you can do to look after yourself and many ways production can help ensure the crew's health and safety whilst maximizing the smooth running of the shoot.

> *Production should be offering hotels if it's a long shoot, rather than extra overtime. You might have heat or sun sickness and then have to drive a couple of hours after a long shoot. You are probably still feeling the adrenalin for 30–40 minutes, so an hour into your drive you may be in trouble.*
> Danna Rogers

Bring bars if there is no time to eat meals. I have frequently found myself on a 10h continuous day and having then done 2 hours' overtime with no meal breaks or sandwiches brought to set.
Julian Bucknall

Energy: There are reportedly three ways the body gains energy; by eating, sleeping or releasing adrenaline. Film work can be physically hard. Bring small high-energy snacks with you because, when your energy is drained and your adrenalin runs out, it is easier to get ill and make mistakes. It is not only working hard that uses energy but, likewise, so does being too hot or cold.

In the Heat: A wet cloth on the back of your neck absorbs body heat quickly and isn't obtrusive. Wear or bring larger shoes, as most people's feet swell to some degree in the heat. See the American Society of Cinematographers' discussion[8] on the topic!

2A: WORKING ON SET: PROFESSIONAL PRACTICE

To avoid getting hot, it can help to wear either a floppy hat, or any hat that covers the back of your neck. Stay in the shade when possible, cover your skin, choose light layers, use sunscreen and drink plenty of fluids.

In the Wet: Invest in breathable waterproof jacket and trousers and boots so you don't sweat too much.

In the Cold: You will probably get hot when you work and cold when you are static. Wear layers, again with breathable fabrics, but make sure you can still move comfortably in them. If you get hot when setting up a shot, put your coat back on **before** the first take, so you don't freeze while you are standing still.

Respiratory health: Environmental hazards can have an effect on your short- and long-term health. Wear masks when working in sandy, dusty or smoky environments. Masks vary, check if you have been given the right mask for the hazard.

Eye health: If shooting with your eye to the eye-piece, the eye-piece will get sweaty and dirty and be the perfect breeding ground for germs. Use an eye-piece cover and change it daily. Don't share eye-piece covers, and take extra care if you have any contagious or potentially contagious issue with your eyes, such as a sty, conjunctivitis or a cold.

Photo courtesy of Georgina Burrell, GeorgieB TV.

Working with equipment

Don't take shortcuts with anything that could compromise safety, however tired or rushed you are. If you don't think a shot is safe, put in adequate safety measures or as a department, insist that the shot should be changed to a something similar but safer. The DP, Key Grip, Dolly Grip or Gaffer should be the ones to suggest any changes for safety reasons or declare that a shot is too unsafe to carry out.

- Use gloves if handling warm or hot lamps.
- Use a camera cart or trolley when possible, and always organize your kit so you don't have to move it too often. Carry heavy objects with other people. Make sure the route is already clear when you are carrying heavy objects. Learn and use a safe manual handling technique (see below).[9]

Photo by David Condrey.

Start in a good posture. At the start of the lift, slightly bending the back, hips and knees is preferable to bending over from the waist (stooping) or squatting.

Straighten your legs and back as you begin to lift the load, not before.

Keep the load close to the waist. Keep the load close to the body for as long as possible while lifting. Keep the heaviest side of the load next to the body. It may be better to lift the item, and hold it with both hands or arms close to your waist, than to carry it by the handle with the weight near your feet.

Avoid twisting the back or leaning sideways, especially while the back is bent. Shoulders should be kept level and facing in the same direction as the hips. Turning by moving the feet is better than twisting and lifting at the same time.

Keep the head up when handling. Look ahead, not down at the load, once it has been held securely.

Move smoothly. The load should not be jerked or snatched, as this can make it harder to keep control and can increase the risk of injury.

Put down, then adjust. If precise positioning of the load is necessary, put it down first, then slide it into the desired position.
The Health and Safety Executive

B: ESSENTIAL WORKING KNOWLEDGE

PROTECTING THE CAMERA EQUIPMENT

It is the camera assistants' collective responsibility to protect the camera equipment against the elements and anything else that might cause it harm. Equipment loss or failure can delay the shoot. Whilst equipment can be very expensive, the combined location, crew, cast and catering costs, etc. often cost far more than the price of the equipment.

Loss or theft: The dangers of loss or theft of equipment are high because there are many different pieces of equipment getting moved around frequently, and bits and pieces can be put in different places when they are taken on and off the camera in a rush. It is easy to mislay or leave behind equipment, particularly batteries, because they are usually charged away from the main set and quick-release plates because they get left on the bottom of cameras.

Photo courtesy of Laura Radford Photography.

There is an illusion of safety when you are working in a film unit, but if you are on location, even if there is a safety officer on set, keep everything close by or it will disappear.
Danna Rogers

Solution: During pre-production, make a list of the equipment that should be in each box. Stick them to the inside lids of the boxes and also take photographs of what should be in there.

Keep organized and have only three places for equipment: either in a safe and secure camera car/truck or room, in a safe place on or near the set (ideally on a camera cart), or right next to the camera. Always remember that equipment is not safe if there is nobody watching it.

At the end of each shot, make sure all equipment is in one of the three places. Each time the direction of the shot is changed, make sure your equipment is all together and out of shot. If possible, have the battery charging station in the same place as the equipment. Have only one person responsible for charging the batteries, so there is no confusion about who needs to collect the batteries and battery chargers when you change location.

Do a 'dummy check'/'nervous', which is a thorough look around of everywhere you have shot or stored equipment after you have packed up and are ready to leave at the end of the day, or when you leave a location. You will be surprised at how often this practice keeps you out of trouble. Follow focus rods, filters, cogs, connectors and bits and pieces are often kept in the assistant's bag. Check and empty your bag to ensure that even the smallest items get returned.

Damage to Equipment: It is easy to damage equipment, either when assembling it, when using it if it isn't secured or, more frequently, when pieces of kit are being passed from one person to another.

Solution: Check equipment is secure every time something is attached. Hold onto it with one hand but try to move it with the other to see if it will come loose or has too much play in it.

When building and reconfiguring cameras, particularly during lens changes, if you don't feel you have something securely in your hands, say so. 'Yours' and 'Mine' are often called to let each other know who has the piece of equipment but if in doubt say 'I haven't got it', or 'Got it'.

Symon Mynk 1st AC and Eusebio A. Cabrera Jr 2nd AC with the fully prepared camera cart. (bottom) Martyn Culpan keeping camera boxes organized.

2A: WORKING ON SET: PROFESSIONAL PRACTICE

Equipment also gets damaged by dirt and dust getting inside it. Clean lenses and camera equipment as per cleaning guidance (C4a).

Dangers during shooting
The three key areas of danger are:

Environmental, Weather and Water damage: Remember that these come from both natural sources, such as rain, sun, sand, dust and humidity, and from sources such as water from bowsers being used to create 'rain' during shot.
Solution: To protect from sand dust, light debris or light rain, use a bespoke camera cover or more usually, a 4' × 4' polythene bags (or, for a low-budget option, adapt a transparent shower curtain).

> When the manufacturers' waterproof camera covers aren't flexible enough to fit around the lenses and accessories you are using, prepare different bags to cover the camera when it has a zoom lens and when it has a prime on. Cut a hole for the lens and protect the edges, then stick them to the matte box. Cut flaps so you can access the parts of the camera you need. The camera mustn't get too hot though, or it will shut down, so create a vent in the bag, possibly with corrugated piping to let the heat escape.
> Charlie England[10]

In the rain, use large 6-foot diameter 'golf' umbrellas to protect the camera equipment and crew, tarps or plastic sheets supported by lighting stands, or pop-up 10' × 10' tents (called Easy ups). If using an umbrella, make sure the drips don't fall in front of the lens. Don't forget to use groundsheets under the equipment and to protect cables if it is very cold, and cable junctions in particular if it is wet.

Roland Phillips 2nd AC. Rain cover with black air vent and green access port. Photo by Martyn Culpan.

Photo courtesy of Liquid Productions.

> **Adequate shade should be provided for the film unit, not just so the monitor and viewfinder can be seen, but importantly to help protect people and equipment from the heat. Use umbrellas or flags or request additional shade to be provided.**

Impact Damage: This can be from explosions, breaking glass (including sugar glass), or more frequently from objects being thrown in the direction of the camera as part of the action. The camera can be covered, but the lens front is usually vulnerable.
Solution: Optical flats are strong glass filters that don't affect the image but protect the lens. They can be screwed on or placed in front of the lens. Large screens can also be put up in front of the camera to stop debris hitting the camera and crew.

Photo courtesy of Laura Radford Photography.

B: ESSENTIAL WORKING KNOWLEDGE

The 1st AC can call it (call cut) if the camera is getting damaged or going to get damaged.
Danna Rogers

Cameras or camera equipment coming loose: Pieces of equipment or whole cameras can (and have been known to) fall off, particularly when the camera is being flipped, spun, swung, suspended or attached to vehicles during the shot. Damage to people and the camera can be severe.

Solution: Check the call sheet, or ideally read the script, and arrange to have additional ties and security chains if there is any possibility you will need them. Use more, rather than fewer, additional securing techniques and have the fixings and safety checked by the key grip.

For extreme environments or underwater: Environmental housings are sealed plastic covers for the camera. They seal and protect cameras from water or anything else, but are not for deep water use. Underwater housings are heavier and stronger and can be used underwater up to the depth specified. Both of these options are costly and make it far more difficult to access the camera and controls, so are only used when essential.

NOTES

1. David Wright (DP) in discussion with the author (September 2016)
2. Roberto Schaefer ASC AIC (DP) in discussion with the author (September 2016)
3. Danna Rogers (1st AC) in discussion with the author (March 2017)
4. Simon Reeves (DP, was 1st AC) in discussion with the author (August 1993)
5. Julian Bucknall (1st AC) in discussion with the author (September 2016)
6. Mayer, Michael. "8 Must-Have Cinematography Apps." *The Beat*, October 28, 2016. https://www.premiumbeat.com/blog/8-must-have-cinematography-apps/
7. *Who Needs Sleep?* directed by Haskell Wexler (USA, 2006), film.
8. CML. Cinematography Mailing List. "Work Shoes and Boots." August 23, 2003. http://cinematography.net/edited-pages/WorkShoesBoots.htm
9. "MSD – Manual handling," Health and Safety Executive. http://www.hse.gov.uk/msd/manualhandling.htm
10. Charlie England (1st AC) in discussion with the author (September 2016)

2b
Camera Assistant Skills

This chapter looks at best practice for focus pulling, slating, record keeping, setting up monitors, and battery and data management. An in-depth knowledge of these skills is required by camera assistants on larger shoots. The same principles apply when shooting alone.

> **LEARNING OUTCOMES**
>
> *This chapter will help you:*
>
> 1. Use best practice to carry out: slating, focus pulling, record keeping and battery management
> 2. Set up and manage monitors
> 3. Use safe and consistent professional data management and delivery procedures

FOCUS AND FOCUS PULLING

Focus pulling is both an art and a precise technical skill. The objective of focus pulling is to keep the subject in focus even if it is moving and, when appropriate for the story, move the focus to a different subject.

1st AC/focus puller (right) assessing the constantly changing distance between the camera sensor and subject while adjusting the wireless remote focus control to maintain focus. Photo courtesy of Easyrig.

B: ESSENTIAL WORKING KNOWLEDGE

A focus puller needs to know:

- How to quickly and accurately get the subject in focus.
- How to use the tools available to move the focus either when standing next to the camera or when working remotely.
- Techniques to move the point of focus as the subject of interest moves or changes, without the viewer being aware (unless a visible focus shift is wanted).
- Which optical and photographic factors affect the depth of field or focus.
- When to alert the DP if it isn't possible to pull focus effectively on the lens or aperture that has been given.

There should be books about focus pulling . . . you feed each other ideas, they focus your frame, they need to be in tune with your work. It's about understanding the film that is being made as much as knowing how to use the tools.
Petra Korner[1]

Focus pulling is part of storytelling. In the frame on the left Mina looks at Feena and is slightly out of focus, whereas in the frame on the right she is in focus and smiling.

However deep or shallow the depth of field, from the point of focus approximately 1/3 of the depth of field is in front of that point and 2/3 behind. Photo by José Manuel de Láa.

The depth of field is the distance between the point closest to the camera that will be in focus and the point furthest away from the camera that will be in focus. In the shot of a tape measure (left), the depth of field is shallow.

There are three factors that affect the depth of field: focal length, aperture and distance.

- A short focal length (usually used for a wide shot), gives a wider angle of view and a deeper depth of field.
- A longer focal length (usually used for a tight shot), gives a narrower angle of view and a shallower depth of field.
- A wider aperture gives a shallower depth of field and likewise so does a closer distance between the camera sensor and

The aperture is an adjustable ring of (usually metal) blades that controls how much light passes through the lens to the sensor. A large aperture is often called a wide aperture. Shooting wide open refers to using the largest aperture a given lens can shoot at. Reducing the amount of light coming through is called closing down the aperture.

Large Aperture
f/2

Small Aperture
f/22

38

2B: CAMERA ASSISTANT SKILLS

Short focal length. *Longer focal length.*

Two shots from *The Shining* DP John Alcott (left) showing that when a short (wide angle) focal length lens is used, all other things being equal the background will be more in focus than it will be when using a long focal length lens (right).

the subject. These three factors (distance, aperture and focal length) are decided by the DP. The focus puller isn't usually in control of them but uses the distance, aperture and focal length in calculations to find out how much depth of field they have in each shot. The theory behind these and the use of charts or apps to calculate depth of field are explored further in Chapter 3.

OTHER OPTICAL AND PHOTOGRAPHIC FACTORS

- Each lens has a Minimum Focus, which is the closest distance it can focus at.

- Shorter focal length lenses can usually focus closer than long lenses.

- 'Prime' (single focal length) lenses can usually focus closer than zoom lenses and macro lenses can focus very close (a few inches) from the lens.

- To focus closer than minimum focus, you can use a diopter, which is a filter that attaches to the front of the lens. Diopters come in different strengths and can be stacked if needed to focus on something very close. Split field diopters are also available. These allow you to focus close in one area and at a distance in another.

- Tilt shift lenses can be used, to allow different parts of the frame to be focused at different places. Tilt shift lenses have better optical quality but are far more expensive than split field diopters.

- When pulling focus, the size of the frame may change. Check for this if you have a large focus pull. This may be less noticeable if the shot is moving.

- Even if not pulling focus on a shot, if you are zooming using a lens primarily designed for still photography, it may go out of focus during the shot. As a focus puller you are responsible for making sure the shot is in focus, whatever the cause.

The minimum distance a lens can focus is shown on the side of the lens, although sometimes it can focus a little closer. This image also shows that on the focus ring the distance between 4′ and 4′2″ is far further than the distance between 60′ and 120′.

Right: A split field diopter allows close and distant objects to be in focus. In the bottom half of the diopter you can see that the edge of a bar very close to the diopter is in focus but the background isn't. In the top half, the box in the distance is in focus. To use a split field diopter, make sure the transition line between the bottom and the top is positioned along a horizontal line such as the edge of a table in frame so it isn't noticeable.

39

B: ESSENTIAL WORKING KNOWLEDGE

FINDING FOCUS ON A ZOOM LENS

1. Open the aperture so the image is bright and the depth of field is shallower.
2. Take a note of the focal length (zoom position you are starting at).
3. Zoom in as far as you can and move the focus ring until the focus is at its sharpest. If focusing on a person, focus on their eye unless told otherwise. If focusing on something that isn't very detailed or is dark, have the 2nd AC hold up a clapper board or torch in exactly the same place, so that you can focus on that.
4. Mark the position of the focus on either the barrel of the lens or on a 'follow focus' which is a cog-based system that allows you to see and pull focus more easily when either next to the camera or working remotely. Put the focus mark against the static datum line on either the lens or the follow focus.
5. Zoom back out to your original focal length.
6. Ideally, also measure the distance from the sensor line (usually marked as a circle with a line through it) on the camera to the subjects, to check they correlate.

HOW TO FOCUS WHEN USING A PRIME LENS

1. If you are on a prime lens, you can zoom in on the monitor to help you see when the shot comes into focus.
2. Alternatively, someone can hold a torch up for you where you need to focus which helps you see when you are in focus or not, because the ring of light produced by the torch will be blurred unless it is fully in focus.

Whether focusing on the barrel of the lens or on a follow focus, making arrows out of camera tape makes it far easier to see when the focus is at the correct distance for a particular shot or part of a shot. The arrow goes on the moving ring or barrel and lines up with a static datum line.

PREPARING TO PULL FOCUS

To prepare to pull focus, mark the position of the focus at the start of the shot and any further positions you need to pull the focus to when the camera or the subject moves during the shot. To do this, repeat the process of finding focus at the different positions and mark the follow focus with a triangle at each point. You may want to number the triangles for each focus position. Alternatively, when preparing to pull focus for several actors that are moving, put on a different-colored triangle for each of them, one at their nearest point to the camera and one at their farthest or most important point.

To find out how precisely you need to pull focus and how much leeway there is if the camera or the actors don't stay precisely at the distance from the camera they were supposed to, use an app or chart to check the depth of field. If you put in the focal length, aperture and distance from the subject, the app will tell you how far forward or backward the camera or person can move without going out of focus (see C3 for the theory of depth of field).

Focus is measured between the sensor and the subject. This mark shows you the sensor line and the hook can be used to hook on a tape measure to check distance.

AUTOFOCUS

Some cameras, particularly those designed primarily for television and documentary work and some DSLRs, have an autofocus feature. Autofocus mechanisms find focus based on either contrast or phase detection which compares light levels, or both. This means the subject must have a degree of contrast and be well enough lit for the camera to find focus. Many cameras use an infra-red beam to detect the distance, but the subject still needs to be distinguishable from the surroundings. Autofocus finds focus on the center of the frame or the dominant feature in the frame, unless the focus position has been adjusted.

On cameras or lenses that don't have autofocus, a CineTape can be attached to provide autofocus. CineTape can be very useful if your subject stays dominant in the frame or at the center of shot, and you don't have such a shallow depth of field that it is critical for the focus to be on the eye (because the CineTape isn't precise enough to do this). CineTape is often useful for Steadicam shots. You can set up a CineTape with a Preston (or other) wireless remote focus control that allows you to instantly override the automatic focus to follow focus manually, which is very useful.

(left) CineTape distance sensors also known as bull horns (right) Martyn Culpan setting up the CineTape sensor: his left hand is on the wireless transmission and his right on the remote control used to adjust distances.

FOLLOWING FOCUS

To follow focus when people are moving or pull focus between different people or subjects, requires knowing the distance between what you are focusing on and the sensor of the camera. It requires a combination of planning, knowledge and judgement. If there is more than one actor in shot, you need to know who to focus on, and if and when to switch the focus to the other actor. As above, the viewer's attention switches as the focus shifts, so this switching of the attention is part of the storytelling. Switches or shifts of focus can be made as seamless as possible or deliberately noticeable, meaning both how and when the focus shifts are important.

On some fast action films, I'm thinking 'OMG what is the operator going to do next!'
Julian Bucknall

> *So many little things that we (focus pullers) do make a difference (to the story). How you pull from one person to another as the head turns to or away from you. Everything snaps, or it moves slowly, so the audience knows who has the power. I hate pulling with dialogue unless there is a specific reason. You can leave the focus on the person in the foreground even when the other person is talking, if their reaction is more important.*
> Julian Bucknall[2]

If the distance between the actors or objects you want to keep in focus remains within the depth of field you have there is no need to pull focus.

To avoid pulling focus, it is sometimes possible to move the point at which you focus so that everything you need in focus stays within the depth of field you have. See C3 for splitting the focus. If you don't have enough depth of field and can't split the focus, there are two primary techniques for pulling focus. The first is to have marks laid for the actor's positions during rehearsal, then checking the distances and marking up the focus ring precisely before you shoot. If the actors' positions change, you try to put down new marks. The second technique is to not put down physical marks, but to measure out the distances between the camera and different parts of the set. You then need to judge the distance between the camera and subject, even if the camera moves and the artists don't hit their marks.

In both cases, you need to know the depth of field you are working with so you can judge how much preparation is required and how much leeway there is for error. Precise focus pulling is more

B: ESSENTIAL WORKING KNOWLEDGE

Focus peaking creates lines (in this case, red lines) around the areas of the frame that are in focus: (top) focus on the phone cover in the background, (bottom) focus on the foreground cables.

difficult if both camera and subject are moving, if you are on a longer lens, and if the camera is hand-held or on a rig.

Many people set up a monitor to show focus peaking. Focus peaking creates red lines around the parts of the shot that are in focus. The red lines disappear as focus is lost, so if you carefully watch the part that needs to stay sharp, you know whether it is in focus. The difficulty can be simultaneously watching the monitor to check your subject isn't out of focus and watching the actor so you know where they are and can pull focus with them to keep them in focus. Some of the top focus pullers argue that you can do a better job if you watch the subject, not the monitor, and that you should be learning to always keep what you want in focus rather than just relying on focus peaking to show when it has gone wrong. About 50 percent of focus pullers use focus peaking and/or CineTape, but the others prefer not to.

> On many cameras you can zoom in on the EVF or monitor while recording to check you are in focus, but for practical reasons this isn't always possible when shooting.

I'm an old-school focus puller, I don't use focus peaking, some people rely on it, but I just watch the actors. You anticipate movement better by watching the artists rather than the monitor. On a long lens shot, if you're watching the monitor, you won't see the movement much because of the foreshortening (see C6). When you are looking upstairs or downstairs, distances look different to the eye than on a monitor, so it's better to learn to judge by eye . . . Imagine how far front of matte box is away from film plane (where the film or sensor is) and be aware of the height at the start of the shot. Plot out distances on set and make judgements about the distances in between. Imagine an arc that the camera may move in and what the distances will be at any point. When the camera moves, the speed of your mental maths makes a difference for judging how far away the camera is from its predicted path. You can work it out in a mathematical/mechanical way or be intuitive. After a few films, you get to know what (distances of) 5 foot or 10 foot looks like . . . When you can't be in a location or if you don't know where the actor is, or if you (the camera) spin round before you see them, you have to do it on the monitor.
Julian Bucknall

FOCUS PULLING TIPS

There is no doubt that focus pulling can be challenging and requires skill, aptitude and spatial awareness, all of which can only be improved with practice. The following are tips that may help with pulling focus and ensuring the whole of each shot is usable.

- The distance between focus points on the lens is bigger the closer you are to your subject. So, when you are focusing between 3 and 6 feet, you will be turning the focus ring far more than between 20 feet and 25 feet.

- Try to ease the pull-in at the beginning of the shot and ease it out at the end, so there are no abrupt changes – unless a visible focus pull is desired.

- If your subject clears frame at the end of the shot, pull the focus to the background as they clear focus.

- Particularly if you are using a zoom lens, you usually can't do rapid focus pulls without the size of the frame changing. You can conceal this change in the size of the frame by doing your focus pull while the camera is moving, panning or tilting during the shot.

Precision focus pulling can require, for example, pulling focus to follow a mascara brush from the root to the tip of an eyelash. When you are working with very precise and shallow depths of field you must be allowed time for proper focus preparation. The hardest part of a focus puller's job is often the decision about if and when to ask for time for preparation and if and when to let people know the shot is unusable. If you are repeatedly pushed into situations that are impossible to focus, a word with the DP is often the best route to having your life made easier.

> *It is more and more common for directors to want to turn over all the time. People shoot from whenever the 1st AD calls rehearsals. This can mean you are shooting rehearsals without the information you need for focus pulling. In the worst cases, the camera continues to roll for 6 or 7 minutes while the director tells the actors what they want them to do; so there are a lot of takes all shot without cutting the camera and any technical tweaking has to be done on the fly. Getting as far as possible with focus marks, etc. before rehearsals is essential, as is remembering which were the good takes for focus and camera so that notes can be made at the end of the shot. In these kinds of shoots there is no time to check technical details on playback before moving on, so if you have made an error you must flag it up immediately.*
> Charlie England

For guidance on setting up the follow focus, see C4a.

BEST PRACTICE FOR PUTTING ON THE CLAPPER BOARD

Slates/clapper boards are put on (usually) at the beginning of shot. They show information to identify each shot and also focus the attention of the unit. The information on the board should include:

- The title of the film
- The name of the Director and the Director of Photography
- The scene number as per the script (found on the call sheet)
- The slate number, starting from 1 at the beginning of the shoot
- The take number, starting at 1 for each slate

B: ESSENTIAL WORKING KNOWLEDGE

- P/U if it is part of a take: a pick-up
- M or MOS if it is recorded without sound
- The frame rate, e.g. 23.97fps (see C3 and C8)
- EXT or INT for exterior or interior
- The roll number if shooting on film

And ideally:

- A white, gray and color reference chart as shown here.
- Any filters used (other than NDs)
- Which LUT has been used or should be used (see C3 and C5)

> A digital slate shows the time code for the shot being recorded. Digital slates are often used in conjunction with a Lockit sync box (or equivalent) which is attached to the camera and used by the sound department for precise sound and picture syncing.

> Mobile phone slate apps are available, often as part of inexpensive filmmaker toolkits that include a collection of cinematography tools such as depth of field calculators.

Eusebio A. Cabrera Jr, 2nd AC with the clapper board on the set of *This Too Shall Pass*.

Here the clapper board is correctly positioned close to actor, angled towards camera and clearly visible. P/U is written on the board to let the editor know that the current take will be shorter than a full take of this shot.

Slates can be put on poorly or superbly and are one of the ways a 2nd AC or trainee gets noticed and judged.

- Make sure you have changed the slate to the right number and any other information before the shot is ready.

- Hold the board still in shot, then clap it. After that, move it and yourself quickly out of shot. If the board isn't still, the image will be blurred and unreadable.

- Gauge where to place the slate so that the information is clearly visible, doesn't disturb the artists and is in a place where you can quickly get out of shot or hide without disturbing the artists or shot.

- If the slate is close to an artist's face, the clap should be clear but quiet.

- If you are shooting a close-up, a smaller slate is better. If you can't fit all the information on the slate in shot, move the slate through the shot so the camera sees the information, and make sure you position the board so that the clap is in frame when

you clap it. There are also tiny slates for pack shots (which are always mute) or you could write the information on a small piece of card.

- If you are shooting a wide shot, you would benefit from a larger slate.
- If you can't place a slate near the action, the focus puller can pull focus to the slate but this must be pre-arranged before the roll is called.
- If shooting in low light, you may need an additional light or a torch attached to your board.

The correct procedure for slating is: when the 1st AD calls 'Run camera', the slate is quickly lifted into place by the second AC. The 1st AD calls 'Mark it', the 2nd AC announces the scene and take number only (unless the shot is a pick-up, i.e. a shorter part of the same shot that is being re-taken, in which case the loader also calls 'Pick up').

On some shoots, the slate is filmed and shot number announced before the shot happens and only the clap is done when the 1st AD calls 'Mark it'.

If it hasn't been possible to put the slate at the front of the shot, when the director calls 'Cut', the loader then calls 'Slate' or 'End Board', holds the board upside down for the camera, announces the slate number, take number (pick-up if necessary) and adds the words 'On the end'.

For a useful video showing slating see techniques, see Rocket Jump's 'How to Slate'.[3]

Acrylic board with a light attached: useful for night shoots. The board is held upside down to indicate to the editor that the information refers to the shot that has just finished, not the one that is about to start (some assistants also write E/B on the board).

RECORD KEEPING: NOTES AND CAMERA SHEETS

Different productions and DPs have their own requirements about which notes accompany the footage you have shot. The metadata on the camera stores some information but, irrespective of whether or not the production department requires camera report sheets to be submitted, notes about the camera settings are usually kept by the 2nd AC in a notebook. The lens, filters, ISO, fps and shutter angle and, ideally, the camera height used on each slate are all noted. If there is a DIT, they keep notes of how much data (or film) has been used on each shot; if there isn't a DIT, the 2nd AC also records this. If camera sheets are required, the notes must be transferred to camera sheets during quieter moments in the day so they can be quickly finalized and handed to production shortly after the wrap. The second AC's notebook is useful for the camera department if shots need to be repeated or set up in similar ways. Camera sheets are a more permanent record, as they help production keep track of footage and how many takes each shot is requiring. Camera sheets also provide essential information to post-production long after the camera crew has finished on the project.

MANAGING BATTERIES AND POWER SUPPLY

Equipment reliant on batteries includes but isn't limited to: cameras, monitors, wireless controls, grip equipment and light meters, along with the phones, tablets and laptops of crew members (which, when working in remote locations, you may not be able to charge elsewhere). Some equipment (e.g. a small monitor) doesn't draw much power, so batteries last all or most of the day. Others, particularly

Camera assistant's notebooks may read clearly to the assistant but the information is far more legible when transferred neatly to camera sheets.

B: ESSENTIAL WORKING KNOWLEDGE

on-board camera batteries, may need to be changed frequently. It is the AC's responsibility to order enough batteries and keep track of how much power is left to ensure that there will be no battery run-outs during shots. You must also arrange enough power sockets so that charging can be carried out during the day.

It helps to:

- Keep an organized battery management routine and charge batteries as soon as you can after they run down.

- Order and use block batteries, which are large off-camera batteries that last far longer than on-board batteries when the camera or monitor is static.

- Label all chargers and batteries, so you and others can easily see which battery should be charged by which charger.

- For any equipment that has more than two batteries, number the batteries and use them in sequence so you can keep tabs on which are empty and which are full.

Be aware that all batteries lose power more quickly in the cold, so keep them warm, particularly if you are running low on battery power and not able to recharge them. A handy tip is that a 'dead' battery can often be given a little extra charge by warming it up with body heat. So, if you just need a couple of extra shots, putting the battery under your clothes for 5 or 10 minutes might be enough to get you out of trouble.

SETTING UP AND CALIBRATING THE MONITOR

Director Raymond Yeung watching a shot being played back on the set of *Front Cover*. Photo courtesy of Laura Radford Photography.

When assembling the camera, a 5- or 7-inch monitor should be attached to the camera for the operator and 1st AC. It is connected to the camera with a BNC or LCD/EVF (electronic viewfinder) cable. If the AC or camera operator is pulling focus by looking at the monitor, set it for focus peaking. If the AC is using the monitor during shot and is standing away from the camera, make sure it is brighter than usual, so they can see it from a distance.

When possible, also set up a larger monitor on a stand or a table about 7 feet from the camera (usually on camera left which is the left side when looking through the camera), so it is close to the camera but not disrupting the work around it.

Make sure the monitor is shaded so it can be seen clearly. Either use purpose-made shades or have flags put in place to shade the monitor. Connect the monitor by cable or wirelessly.

Wireless transmission systems, such as the Teradek Bolt, can transmit a video feed from the camera to more than one monitor, so they can also be set up for remote monitors used for focus pulling or by DITs or the director. When working alone with a director, particularly on documentaries, set up and give them a small (approx. 7-inch) monitor and a neck strap, so they can keep it with them (and not lose it).

High-definition wireless video transmitters and receivers in many countries use the same technology and frequencies as mobile phones and may, depending on their quality and antennae, be subject to interference. This means you should know how to switch channels if necessary, or quickly set up or switch to a wired monitor if needed.

Monitor images can be overlaid with frame lines to show the aspect ratio (shape of the frame being shot) or any other guidelines or information needed. Make sure you know how to set the overlays, and switch between the options available on the monitor, including false color and waveforms for the

DP (see C3) and any playback options, such as side-by-side comparisons to previous shots, if the monitor will be used for playback. Don't get too wrapped up in playback, though, or you will never keep up with your work. If there is no playback operator, teach a production assistant or runner how to use playback.

If you are shooting in UHD you should be using a high-end monitor that can display the full UHD color space. Calibrating a UHD monitor requires specialist software and should be done by the DIT, not the camera assistant. Likewise, it is complicated to set up the colors on a computer monitor, to be a useful reflection of what is being shot, and if this is required it should also be done by a DIT.

If you aren't shooting in UHD and there is no DIT on set, camera assistants should know how to calibrate a video monitor with SMPTE bars. The following is summarized from Odin Lindblom's guide.[4]

(top of frame) Wireless video transmission systems are often used (particularly when the camera is hand-held or moving) to avoid running cables from the camera to monitors.

- Stop as much light as possible from reaching the monitor screen by using shades or flags and positioning it away from any direct light. Keep an eye out if anything changes, making light fall on the screen or reflections show.

- Clean any dust off the monitor.

- Connect a cable between the BNC (or SDI) connections on the camera and the monitor.

- Send color bars from the camera to the monitor. Monitors can accept signal from a variety of different inputs, so switch the monitor to the camera input if you aren't seeing them.

- Adjust the brightness, contrast, chroma and phase to their midpoints. If you're working with a consumer monitor, brightness may be called picture, chroma may be called color, and the phase may be called hue or tint.

Set up the luma by:

1. Turning the chroma all the way down, so the image is black and white. Look at the three PLUGE (Picture Lineup Generating Equipment bars), which are the short black bars on the lower right side of the screen below the red bar (see figure on page 48 for the instructions below).

2. Adjust the brightness so that the left PLUGE bar and the middle PLUGE bar are the same as the larger black square next to them. The right PLUGE bar should just barely be brighter than the middle and left PLUGE bars. Stand back a few feet so you see them properly and use the same distance when assessing all the settings.

To set the contrast:

1. Turn the contrast up all the way until the righthand PLUGE bar is very bright. Turn down the contrast until you can just barely see where the bar is again. If the contrast is too high, the white square at the bottom left will start to bleed over onto the adjacent colors. This is more common on old CRT monitors but should still be checked. Turn the contrast down until the white square is well defined again.

Set up the chroma by:

1. Turning the chroma up to its middle position. Turn the "blue only" button on. If you are using a consumer monitor, you won't have this option, so you will have to do your best to make the following adjustment by eye. With a little experience you can adjust it so the yellow should be a lemon yellow without orange or green. And the magenta should not be red or purple.

> SMPTE bars have an arrangement of colors and brightness that allow you to check if the monitor has been adjusted correctly. There were previously different regional viewing systems – NTSC, primarily North American TV color systems and PAL, primarily for UK and EU systems – but in virtually all cases we now we all use the same HD SMPTE bars.

B: ESSENTIAL WORKING KNOWLEDGE

2. Now at the top of the screen, you'll see alternating blue and black bars. SDI-HD and the prosumer HDMI are component signals with three separate video channels. For these adjust the chroma so that the tops and bottoms of the blue bars match. When using a BNC you are sending a single composite system. For this adjust the outside blue bars and the phase for the inside blue bars until the tops and bottoms match. It is preferable to use component signals whenever possible, because they have more color information and definition than composite.

3. Turn your bars input off and switch back to camera input as needed.

4. When your monitor is calibrated, don't change the settings unless you have to start again because there is a change in the light in the environment. Even if working in the same place recheck the monitor weekly.

(top) Adjust the brightness so that the left PLUGE bar and the middle PLUGE bar are the same as the black rectangle below them. The right PLUGE bar should just barely be brighter than the middle and left PLUGE bars. (bottom) Adjust the brightness so that the left PLUGE bar and the middle PLUGE bar are the same as the larger black square next to them.

DATA MANAGEMENT AND RUSHES DELIVERY

There can be a problem at some point with data transfer from the original camera media. When data is gone it is gone. In my experience loss of data happens at about the same frequency when using digital as it does when using film.
Jonathan Smiles[5]

The process of managing data and data backups must always be consistent and reliable. The production insurance company may have specific requirements about either the process or the number and type of backups to be made. If none have been specified, it is the production department's responsibility to decide how many redundancies (backups) should be made and what the handover procedure should be.

2B: CAMERA ASSISTANT SKILLS

There is a large amount of data produced when shooting video and, as resolution and/or speed increases, the data rate increases substantially. Whatever resolution you are shooting at, the data required is multiplied when you shoot formats such as 3D and Virtual Reality that require several images to make up one shot.

Whilst an app can help you calculate the amount of data being produced per minute of footage, if you input the camera, resolution, bit depth, frame rate and bit rate (see C5), it will tell you nothing about how long the takes will be, whether the director will want to keep rolling between takes, and how many shots there will be on any given day.

If there is no data wrangler, the camera assistants make sure there are enough cards or hard drives to shoot on and that data is passed to production for backing up, or do the backups themselves.

To manage the data on a shoot, you need to ensure you have enough cards (often generically referred to as 'mags') and make sure they are large if you will be shooting long takes. If the camera will be static, you can use larger and faster external recording drives to record onto. This is essential for some forms of high-speed shooting. Cameras such as the Phantom can shoot up to 5000fps and require an external hard drive, because they can record more quickly and in a less compressed format than the camera's internal recorder.

Always overestimate the amount you think you will need and ensure you will have enough hard drives to backup onto.

It is essential that the procedure for data management is known by all the camera crew and stuck to even when busy. It is also essential that any data backup or transfer mistakes are owned up to immediately while there is a chance to re-shoot. The footage must also be checked before cards or external hard drives are re-formatted. Some useful guidelines are as follows:

1. Number your cards or drives with a permanent marker or label, so that if an error appears you can quickly identify the one that has produced the error. If possible, set the card or drive number in the metadata stored by the camera, and on any idents or clapper boards.

2. Have separate storage folders for used and unused cards or mags. Never store them together. If your system involves an overnight wait to get clearance from post-production before you can re-format cards, have a third folder or case to store the ones that have been downloaded but are waiting to be re-formatted.

3. On some larger cards or mags you will be able to mark the cards with a piece colored tape to indicate they are ready for recording. (N.B. don't use camera tape – the sticky residue will damage the camera. Paper tape is better.)

4. When the full cards are taken out of the camera, if there is a protect tab, the 1st AC should pull the protect tab across as soon as it is taken out.

5. The 2nd AC pulls off the tape that indicated that it was ready to use, tears it in half and sticks it back on the drive, in a cross to indicate that it is dead. Alternatively, use an equivalent visual system.

6. The designated person takes the data/mags, to the person responsible for transferring it, and only leaves it with them if they are present and have accepted the data. If they are not there, take it back to the set and try again later. Don't just leave it for them.

7. If you are responsible for making the data backups, use the system on page 50.

8. The speed at which the data is backed up depends on the bit rate of the hardware, so backing up onto a laptop may take longer than it would onto a databank in a post-production house and prevent the camera assistant carrying out their other duties. If this is the case, alert production to the issue and try to get a member of production to be assigned to backing up the data.

> Any cable going between a camera and a recorder is usually referred to as an umbilical cord, which, like its namesake, should not be detached until its job is complete, or data can be lost.

> If you are able to use both an external and internal recorder at the same time, you will have an instant backup.

9. After the data has been backed up, find out from production who is to decide when the cards can be re-formatted. This is based on when production or post-production have also checked the footage for content.

10. Have only one person who does the re-formatting, and stick to this system. If it is the 1st AC re-formatting the cards, the 2nd AC should give verbal and/or visual confirmation, such as a colored tape and, when they hand the card or mag to the 1st AC, confirm that it is ready to be formatted.

To Backup Data

You need high-capacity drives and fast connections between your external drives or card reader and your computer, *not* USB2. Use Thunderbolt, USB3 or equivalent and have spare cables for your drives, and a battery backup system in case the power goes out.

Your data should be dumped to two hard drives. You should ideally aim to have three copies of your data, but an absolute minimum of two. Use a system that has CRC (Cycle Redundancy Checking) which checks for copying errors and incomplete copies. These systems are different to dragging and dropping (which shows that a folder or file has been moved, but not that all the contents have gone with it). A CRC system such as TurboCopy or SuperCopier will show a tick when the data is fully and successfully copied.

Directory structure and folders layout

As advised by Evan Luzi,[6] it is important to be organized and consistent with the structure of your folders and the naming system for the files you download.

- Name each hard drive, e.g. Production Name 01.

- Have a folder for each day: Day 1, Day 2, etc.

- Within each day's folder, make folders for A Cam, B Cam and Sound.

- Name the first roll for A Camera A-001, and the first roll for B camera as B-001. Save everything. Don't get rid of the thumbnails or anything, because this can mess things up, especially with RED cameras.

- Continue the numbers throughout the shoot so, if the end of day 1 is file A-008, start day 2 with A-009.

- Dump the sound at lunch or the end of the day, so all the sound from Day 1 goes in the Day 1 folder, in the file marked sound. Name the sound files SND001 and so on.

- Create a text file to put in log notes for each day.

- If leaving your own notes for the editor, create a 'please read me' document. Don't rely on the producer or anyone else to relay info about corrupt files, etc. Do it yourself. Most post-production people will actually read it.

- Use Apple I or Windows properties to check each folder. Check that the size of the original and the new folder is exactly the same on each drive.

- Watch clips from the copied data, NOT the original footage, so there is no chance of damaging the original footage when viewing it. Watch a clip at the beginning, at the middle and at the end of the folder. If the folder contains a lot of clips, do five to eight spot checks by opening the clip, watching a bit at normal speed, then scrubbing through quickly and watching at the end.

- Do this for both copies you have created.

- If you are being pressured to turn over cards quickly, reduce the amount of checks, but don't scrap them. Explain the importance of checking the footage to production if needed.

- When you hand over a mag to a camera assistant or cameraperson to be formatted, say 'this is okay to format'. Don't just say 'this is good' or 'okay' because you could just mean the work looks nice. Be clear and direct.

- Have a pre-arranged plan for how the hard drives are taken to post-production at the end of the day:

NOTES

1 Petra Korner (DP) in discussion with the author (September 2016)
2 Julian Bucknall (Ist AC) in discussion with the author (September 2016)
3 Jacobsen, Tomm. "How To Slate", *RocketJump Film School*, May 13, 2015. https://www.youtube.com/watch?v=bd7BPX8oEeE
4 Lindblom, Odin. "How to Calibrate a Monitor". *Videomaker Magazine*, March 30, 2015. https://www.videomaker.com/article/c10/17816-how-to-calibrate-a-monitor
5 Jonathan Smiles (post-production workflow consultant) in discussion with the author (October 2016)
6 Luzi, Evan. "Digital Cinema Media Management 101: Basics of Data Wrangling", *The Black and Blue*, August 28, 2011. https://www.youtube.com/watch?time_continue=12&v=Uh95S99DwVo

3
Fundamental Photographic Knowledge for Cinematography

Creating the optimal look and exposure for your shots requires sound photographic knowledge. Wherever you are shooting a scene you would rarely achieve the effect you want by leaving the camera on automatic. This chapter takes you through the photographic factors that affect how the image is recorded, starting by looking at the dynamic range of the camera sensor, which affects how many dark and light tones can be recorded, and the bit depth, which affects how much color detail can be created. It then looks at how the recording choices, RAW, Log and LUT affect the data that is recorded, moving on to aperture, shutter speed, ISO and metering, which all affect your exposure decisions, depth of field and the movement blur in an image. This is followed by a look at the basics of lenses and focal length, and how flare, polarization, white balance and black balance all affect the image. The chapter finishes by looking at the sets of decisions you would make in ideal situations and how, when and which photographic compromises to make, to allow you to shoot in almost any situation.

LEARNING OUTCOMES

This chapter will help you understand:

1. What automatic exposure does and the limitations of using it
2. What dynamic range and bit depth are, how they are related to the camera sensor and processor and what effect they have on the image
3. What native ISO is and the implication of raising ISO on image noise and dynamic range
4. How IRE levels can help you monitor a scene and choose optimal exposure
5. How to use waveforms, false color and zebras for monitoring metering and guiding exposure choices
6. The relationship between light levels, exposure, image noise and over-exposure or 'clipping'
7. What depth of field and movement blur are
8. How to create a deep depth of field or a shallow depth of field using the aperture
9. What shutter speed is and the relationship between shutter speed and frame rate
10. How to increase or decrease movement blur with shutter speed and shutter angle
11. How to approach compromising on aperture shutter speed or ISO appropriately for your shooting situation
12. What the Kelvin color temperature scale is and how to white balance correctly
13. What flare is and how to avoid it or use it

B: ESSENTIAL WORKING KNOWLEDGE

UNDERSTANDING EXPOSURE

The following simple exercise provides a useful starting point for understanding exposure and the use of camera meters in both still and motion picture photography.

EXERCISE: Put your camera onto automatic or if using a stills camera, set it to P, which is programmable automatic. Take shots of three pieces of fabric in even lighting (no shadows or bright spots) without anything else in the frame. You will see that all three appear a roughly similar mid-gray. This is because the camera is doing what it has been set up to do, which is to average out the brightness of what is in shot to mid/18% gray. The camera doesn't know what you are photographing, it has just been set up to create an 18% gray average brightness for what is in frame. This is not connected with the color but with the average brightness of the shot.

To shoot the black fabric you will need to tell the camera to make the shot darker than gray. If using a stills camera, press your exposure compensation button and at the same time roll the dial to push the meter to the minus side, to allow the image to be darker, until it appears as dark as (but no darker than) the fabric does and you can still see some detail in the black areas. In a digital motion picture camera, do the same by decreasing the exposure with the lens, iris or exposure control. Now, for the white fabric use the exposure compensation or iris to the + side, which will allow the image to be brighter. Do this as far as you need to with the white fabric, until it looks as white but you can still see the details of the texture of the fabric within it.

This exercise demonstrates that the optimal exposure for a shot is not necessarily achieved by having the meter at the mid (18% gray) point. If you want the average to be darker than gray the meter will need to be towards the minus side. This doesn't mean the shot is under-exposed, it just means that you intend for it to have an average brightness which is darker than mid gray. In practice this means that if you were shooting, for example, a black spider crawling across a black leather sofa in the moonlight, you would need to tell the camera that the exposure should be darker than gray by having the meter to the minus side.

The exposure has been adjusted to make black, gray and white cards appear as they do to the eye. (bottom) Using the camera's auto exposure, black, white and gray cards all look roughly the same mid/18% gray.

Using automatic exposure is not advisable because, although it may work when the average of the shot is mid gray (e.g. the shot of the egg on the left below), it will only remain OK if the shot stays in the same place and nothing changes in the background. If the egg is moved to the edge of frame or further back, the average of the shot will change and so will the exposure.

Most brown skin tones read around 18% gray. Black, a little lower. White, a little higher. However, the overall reading of the frame depends on what else is in shot.

3: FUNDAMENTAL PHOTOGRAPHIC KNOWLEDGE

Shots where the subject and background are both intended to be brighter than mid gray are called 'high key' and are not suitable for automatic exposure. Shots where the subject and background are intended to be darker than mid gray are called 'low key' and not suitable for automatic exposure. Shots where the foreground and background are around the brightness of mid gray will be less problematic on automatic exposure so long as nothing changes (left) high key shot from *Harry Potter and the Deathly Hallows Part 2* DP Eduardo Serra, (center) low key shot from *Django Unchained* DP Robert Richardson, (right) *The New World* DP Emmanuel Lubezki – the average brightness of this shot is mid-gray (the term mid/middle gray refers to how bright an image or part of an image is, irrespective of its color).

When appropriate creatively, there is a lot of latitude for bringing what would be a mid-gray shot down (left) or up (right). *The New World* DP Emmanuel Lubetzki.

Although automatic exposure has many limitations, in practice, particularly in documentary and fast shooting situations, automatic exposure is used as a starting point. If you do this, use automatic exposure, then switch to manual and adjust from there as needed.

In situations where automatic exposure works for what you are shooting but everything could do with being a little bit brighter, you can push the exposure compensation up a little to the + side, to make the whole picture a little brighter or to the – side, to make it all a little darker.

Don't rely on automatic exposure, because:

1. There are so few shooting situations where nothing changes in shot or between shots.

. The camera's light meter averages out the brightness of the frame but will usually be set to give more priority to what is in the center of frame. So, if your subject is at the edge of frame, the camera won't prioritize giving it the correct exposure.

3. In low-light situations, fully automatic may also adjust the ISO/Gain, which is what controls the sensitivity of the camera to light, but produces more noise. Noise is avoided when possible (see C3), but if unavoidable it is far better if you, rather than the camera, decide if and when you need to increase the gain. For any cameras (usually DSLRs) that have auto ISO as an option, remember to go into the ISO settings and switch to a fixed ISO, because using auto ISO can result in noise levels going up and down within and between shots.

(top) High ISO creating visible image noise (bottom) low ISO: no visible image noise.

55

B: ESSENTIAL WORKING KNOWLEDGE

THE CAMERA AND THE CAMERA SENSOR

In digital cinematography, light enters the lens and is shaped and focused by it to form an image on the camera sensor. How the sensor turns the light and color information about that image into data is the foundation of digital cinematography.

The vast majority of cameras in use now have CMOS sensors. CMOS sensors don't run as hot as CCD sensors, use less power and, arguably, produce a more cinematic look. (see C5 for other sensors).

A CMOS complementary metal oxide semiconductor sensor has two main layers. The first is made up of wafers of silicon, with light-capturing wells, called 'photosites', etched into them. This layer collects photons (light) and converts it into an electrical signal.

The second layer is made up of a series of filters that affect how the image is created and how color information is recorded.

The performance and look created by cameras depends on:

HOW MUCH LIGHT THE SENSOR CAN CAPTURE

Resolution does not dictate how much light a sensor can capture, The sensor's resolution is just a description of how many photosites the sensor has. The higher the resolution, the larger or higher-resolution screen your film can be shown on without seeing the individual pixels.

Showing photosites (light-capturing wells) in a camera sensor and Bayer pattern filter (above), which enables the camera to record color rather than just light levels.

> The term pixel used to be used for the recording points on the sensor and display points on the screen. They aren't the same thing, so to avoid confusion this book uses photosites for the sensor and pixels for the screen. A pixel is just a box of light on a screen and can be any size. A large low-resolution screen has fewer pixels spread out over a large area. A small high-resolution screen has many pixels squeezed into a small area.

Lots of photosites can be crammed onto a small sensor (many phones have high resolution cameras) but high resolution is not essential for cinematography, even 4k cinematography only requires 9 megapixels. Bigger sensors allow the photosites to be larger and spread out more. The advantage of bigger photosites is that they capture more light, and the more light captured by each photosite, the better the cameras performance in low light and the greater the dynamic range that can be recorded. The dynamic range is how bright or dark an image can be and still be recorded with visible detail. The greater the dynamic range, the more the camera can record of what the eye can see. The eye can see at least 20 stops of dynamic range, whereas currently most cameras can only record between 8 and 14 stops.

Dynamic range is important for showing detail in shots that have a wide range between the bright and dark areas. It is also increasingly important to shoot on a sensor that can produce a wide dynamic range, now high dynamic range screens are becoming increasingly prevalent. Another advantage of shooting with a camera that has a wide dynamic range is the rendition of detail in the shaded areas. This is because the sense of how three-dimensional an object appears when shown on a two-dimensional screen depends on being able to see the transition between dark and light, and the finer those transitions are, the more three-dimensional it looks.

The higher the resolution of the screen/display format, the higher resolution the image must be recorded at to avoid pixilation. (top) The resolution is high enough, (bottom) the image is pixelated because the resolution is too low for the display format.

3: FUNDAMENTAL PHOTOGRAPHIC KNOWLEDGE

(top) 20 stops of dynamic range is usually considered the dynamic range the human eye can see, (center) a camera that can only record 8 stops of dynamic range will record everything below as solid black and everything above as solid white, (bottom) 14 stops dynamic range is currently the dynamic range of many of the better digital cinema cameras.

High dynamic range. *Low dynamic range.*

(left) *The Homesman* DP Rodrigo Prieto, shows a high dynamic range shot including very bright and very dark areas, (right) *Brokeback Mountain* DP Rodrigo Prieto shows a low dynamic range shot. (N.B A low key shot may have a high/wide dynamic range if it also contains bright areas or may low/narrow dynamic range if it only contains dark areas.)

THE FILTER USED TO CREATE COLOR

The sensor itself doesn't recognize colors, so a Bayer filter is placed over it to enable color information to be recorded. It filters light into what are the primary colors (for light): red, green and blue, from which all other colors can be calculated.

Each small section of the Bayer filter has two green filters, one red and one blue. It was designed this way because our eyes are more sensitive to green. This means you can shoot more green-based colors, in lower levels of light, than reds, without getting noise.

57

B: ESSENTIAL WORKING KNOWLEDGE

The sensors different camera manufacturers use have many similarities but the filters over them vary considerably. For example, if a manufacturer makes their filters thinner, more light will go through and, as below, the sensor will be 'faster' and require less light to create an image, but if they choose to prioritize having truer colors, the filters must be thicker but the sensor will be 'slower' and require more light to create the same image. There are several layers of filters over the sensor performing different functions and the difference in decisions about how and why they are constructed is part of the reason different cameras produce images with a different look.

HOW EFFICIENTLY LIGHT AND COLOR ARE PROCESSED

The camera processor decodes the color information created by the Bayer filter in a process called debayering. The debayering process, and all aspects of processing, i.e. converting light captured by the sensor into data, varies greatly between manufacturers and may also vary between models of cameras. It is the design of both sensors and processors that result in the differences between the point at which noise is created, and the ISO performance of cameras.

IMAGE NOISE

Image noise looks like dots at a random variation of brightness or color in images (the digital equivalent of film grain) that can be seen moving around in moving pictures. In still pictures, grain can look charming, but in motion pictures, because each frame is moving, the noise appears to jump about in a distracting way.

Noise is created due to the camera's electronic processing, debayering and reading and writing data. It is also created by electrical interference from lens motors, etc., and from wind, solar and magnetic interference. Noise isn't usually visible when there is a lot of light because the signal level of the light is far higher than the signal level of the noise, i.e. it has a higher signal to noise ratio. Noise is usually more visible in the darker areas of the image because the signal (light) level is lower and so the signal to noise ratio is lower.

The more efficiently the camera's processor turns light information into data, the less light it needs to make black without noise. The noise floor is the lowest light level at which the camera can record and still produce detailed images without noise. Below the noise floor, noise will be clearly visible in the image.

There are editing plug-ins which reduce noise in post-production, but these don't work as well as producing an image with no perceptible noise.

3: FUNDAMENTAL PHOTOGRAPHIC KNOWLEDGE

ISO AND HOW THE SENSOR RESPONDS TO LIGHT

Exactly how much light is needed to produce an image is measured by agreed standards. Any camera set to 100 ISO needs the same amount of light to create an image of the same brightness and any light meter set to 100 ISO will read light in the same way. This is because "the *International Organization for Standardization*, known as 'ISO' has created a set of criteria for the manufacturers to use to determine the sensitivity of a digital sensor to light. ASA is the American Standard but is exactly the same as ISO so the terms can be used interchangeably."[1]

The higher the ISO number, the less light is needed to record the same image. When there is little light available, you may need to raise the ISO. If you double the ISO (raising it from 800 to 1600), you need half the light to get the same shot. If you half the ISO (lowering it from 800 to 400), you need double the light.

What happens when you raise the ISO is that the charge created when light that hits the sensor is amplified to produce a higher signal level than it would have. Unfortunately, the noise is also amplified, and if you double the ISO twice or more the noise is usually visible.

The ISO at which the sensor records an image without any amplification is called the camera's native ISO and depends, as do most aspects of sensors, on the size of the photosites, the design of the filters and the cameras processing abilities.

Native ISOs in current digital cinema cameras range from 400 to 5000. Most cameras have one native ISO. The optimal native ISO for a shoot depends on where you will be filming. In low light a higher native ISO is better whereas in bright sunlight a lower one would be preferable. The needs of the whole shoot should be taken into consideration when selecting a camera. 800 is currently the most widely used native ISO.

Raising the ISO also reduces the dynamic range the camera can record. Photosites are little wells that capture photons of light and turn them into electrical signals. Amplifying the signal effectively raises the level of the bottom of the well, but doesn't increase the height of the well, so fewer photons are captured and the dynamic range is smaller. Raising the ISO therefore results in recording with less dynamic range and with more noise, so should only be done when absolutely necessary.

Increasing the *Gain* does exactly the same thing as raising the ISO. Gain control is usually found in older cameras. Each 6db the gain doubles the speed of sensitivity, so makes 800 ISO become 1600 ISO, which is the equivalent to doubling the light.

Raising the ISO allows fewer photons (particles of light) to be captured, which reduces the dynamic range.

CLIPPING AND AVOIDING CLIPPING

Noise is visible when light levels are too low. When they are too high, clipping occurs. When the photosites are full the whites 'clips out' and become pure undetailed white, so the white areas look like blank screen rather than part of a picture. If there is excessive light the photons that would have

In *Diaries of an Immigrant* DP Jason A Russell (left) the whites in this shot are clipping (they contain no details) but do not bleed into the face and aren't distracting, (middle) the whites of the flower are clipping/blooming, which takes away from the shape of the flower and is somewhat distracting, (right) the clipping works here because it makes the background foliage work very well graphically.

gone into one photosite spread to others and blooming occurs. In film this can create an interesting and aesthetically pleasing effect when used creatively, but in digital imaging it is usually unpleasant because of the harsh transition between areas of the image that are and aren't clipped.

If the dynamic range of a shot is too wide for the sensor to record, the highlights will clip/burn out. Increasing the lighting in the darker areas will reduce the range. Another way to reduce the range is to use a graduated filter to darken part of the image. Try this because it is a situation you may face often.

(left) The dynamic range of the shot is too wide to see details in both the bright and dark areas. Bringing up the exposure to see the face makes the over-exposed background worse, (center) Using a graduated filter on the window helps, but Paul's face is still a little too dark, (right) Using graduated filter and lighting Paul's face creates a better balance.

RECORDING COLOR AND BIT DEPTH

Bit depth refers to how many distinct colors can be produced (from which many more combined colors can be created). For cameras this depends not only on the sensor but on how finely the camera's processor can slice up the color information from the light that is captured. The more finely sliced the color information, the more distinct colors are available in the image and the higher the bit depth. Higher bit depths make subtle transitions of color smoother on the screen, color manipulation easier and color matching in VFX possible (see C5).

8-bit 256 colors
10-bit 1024 colors
12-bit 4096 colors

What this means in practice is that it is inadvisable to use 8-bit cameras when doing any significant color grading and it is very unwise for VFX. If you are using an 8-bit camera, set the white balance (see pages 74–5) as accurately as possible to avoid the need for color grading.

RECORDING FORMATS

When light hits the camera sensor, data is produced. This happens for each frame the camera records – usually 24 or more a second. How that data is stored affects not only how much data is created per second of film shot, but also how it can be used. The recording format and options you choose dictate how data is stored.

RAW

RAW is a recording option on many, but not all, cameras. When recording in a RAW file format, all the information produced by the sensor is recorded as data rather than as an image. The color information and light information are stored separately and have to be re-combined/processed before an image can be seen. The benefit of recording in RAW is that the full dynamic range and bit depth the camera can record in are retained for use in post-production. Because the entire range of information about the light levels is stored, there is very good scope for adjusting the image to see detail in the dark and light areas and for adjusting brightness levels where required. Because the full color information

is also retained (subject to the camera being 10-bit or above), this allows for manipulation of colors and VFX. Because light and color information are stored separately, a completely different set of color information could be applied to the image without degrading it, so the color of the scene can be dramatically changed if desired.

RAW files are large because a great deal of information is produced to record all the information created about every stop of dynamic range and RAW doesn't use processing or lossy compression to reduce it. Camera manufacturers create their own version of RAW designed to store these large files as efficiently as possible. Some give alternative RAW options that losslessly make the file slightly smaller, but shooting RAW always produces a lot of data. Shooting in RAW doesn't give a better-quality image per se; it only gives more potential for recording a wider dynamic range and for the image to be manipulated later. If neither of these is needed, there is no benefit to shooting RAW.

LOG

When recording in Log, you are recording image files not just data. Light and color information are stored together as an image (unlike in RAW) but are put through an algorithm that makes the image very low contrast and spreads out the image data in a way that is very efficient and (all other things being equal) creates far smaller files. The advantage of Log is that virtually the same amount of detail can be recorded in the bright and dark parts of the image as in RAW but with smaller file sizes, which means it has almost as much flexibility to adjust and change the look in post-production as RAW does. However, although you can see a Log shot on a monitor, it will always look very low contrast and de-saturated; nothing like how you intend it to when screened. When working in Log you must overlay a LUT on the monitor which adjusts the color and contrast so you can assess the shot.

One of the main reasons Log files are smaller is that, when not recording in Log, starting from the darkest part of an image, to create an area that is one 'stop' (see below) brighter, double the light is needed and so double the information is recorded. In an image with a dynamic range of 12 stops the quantity of information recorded about the brightest area is exponentially larger than that in the darkest area. RAW files record all the information, so they are very big, whereas the algorithm used to store information in Log files reduces the file sizes substantially. In post-production (which is always required when shooting Log images), the full dynamic range can be re-created from the Log files due to several aspects of the algorithm that affect both what information is stored and how it is stored.

Log recording dictates how the image information is stored but not what size the files are. That is decided by the codec or compression options selected (see C5). Log can offer a good balance between retaining information and manageable file sizes. When shooting in Log, you need to white balance (see pages 74–5) but not as precisely as you do when shooting LUT.

LUT

A LUT is a look up table that dictates how every aspect of an image should be displayed. Think of it like a photo filter used on a smart phone app that can change the look of an image.

A burnt in LUT is embedded into the image and can't be removed and unlike RAW and Log, it reduces your post production

Different LUTs applied to the same image; both are believable representations of the scene but create very different looks, which would affect the mood and tone of the film. Photo courtesy of Arri (www.arri.com).

options. You must therefore choose a LUT and shoot so that little or no post production work is required to adjust the image before it is screened.

Alternatively a LUT can be laid over RAW or Log footage so that it shows what might be done to the footage in post production but because it isn't embedded it can be removed without affecting the footage and swapped or changed to something completely different later.

As with Log, shooting with a burnt in LUT isn't in itself a recording format decision and a suitable codec and compression must be selected. It is the codec and associated compression used to record your footage that dictates the file sizes. When recording with a burnt in LUT, files are virtually always smaller than Log files, though, because the additional information required for the Log encoding and decoding doesn't have to be stored. The key point to remember when shooting with a burnt in LUT is that all your photographic decisions and choices affect the finished image and are difficult to alter, so you must expose and color balance with great care.

When starting off you might not have the opportunity to shoot RAW because of the storage space and computing power required. However, it is well worth shooting the same test shots in Log and LUT and comparing how far you can manipulate the image afterwards. When shooting test shots, if possible choose one low dynamic range shot, one high dynamic range shot, one with lots of strong colors and one with a range of muted colors.

MOIRÉ

Moiré is the unwanted random movement of lines on surfaces with close stripes or grid patterns. It is caused when the pattern of what you are filming doesn't match up well with the grid of the photosites on the sensor. On digital cinema cameras moiré is less of a problem than it was, because the increased resolution and corresponding pixel density means that the grid of pixels on the sensor is usually narrow enough not to create moiré. Having said that, you are more likely to work with lower-resolution or older cameras when you first start out, so you should watch for it on playback. To avoid moiré, avoid the narrow patterns and stripes that cause it and/or reduce the sharpening in the menu of your camera.

Moiré can also occur on DSLRs because, although they are often far higher resolution than digital cinema cameras, when they are used for recording video some of the pixel lines are skipped and this can cause the grid mismatches that result in moiré.

Moiré.

EXPOSURE

As shown in the exercise with black, gray and white fabric on page 54, the correct exposure for a shot is one that conveys the scene the way you want it. This does not mean, as per the shots of Paul on page 63, that any shot can be under- or over-exposed, nor does it mean that you should use extremes of under- or over-exposure for high or low key shots. There is more information recorded in the mid-range of the dynamic range than at either end, so if you can shoot closer to the mid-range and grade the shots (make them brighter or darker) in post-production, you will retain the most detail. If you have a shot with very bright and very dark areas (i.e. with a wide dynamic range), it is not usually possible to position the darker areas near to the midpoint of the exposure, or the brighter parts of the shot will be way too bright. If the dynamic range is too great to record detail in everything you want to see, the solution is usually either to add light to the dark areas or to avoid or reduce the brightness of the light areas.

3: FUNDAMENTAL PHOTOGRAPHIC KNOWLEDGE

(left) Under-exposed, (center) correctly exposed, (right) over-exposed.

Low key shot with fine tonal details *Samsara* Director/DP Ron Fricke.

(top) Correctly exposed high key shot Photo from Pixaby.com, (bottom) correctly exposed low key shot Photo by Vishwanatha Srinivasan.

Learning to expose an image is about making the optimal choice for the technical and creative needs of your shot. In addition to your camera meter, there are several other useful tools that can be found in most cameras or monitors (see C11a).

Before looking at the tools, it is useful to clarify the two different sets of terminology used in exposure, which can cause confusion:

- **Stops**: Stops measure the amount of light being let through a lens and into the camera. These stop numbers correspond with levels of light read (in stops) with a light meter. Dynamic range is how many stops a camera can record information in before losing detail in the shadows or highlights.

- **IRE**: Irrespective of how many stops of dynamic range your camera has, the IRE level is effectively the percentage of the total voltage of your video signal.

B: ESSENTIAL WORKING KNOWLEDGE

Zebras

Most cameras allow you to set zebra stripes that can be seen either on a monitor or in the viewfinder. If you set the zebras to 100% (of the video signal), you will see striped lines on the part of the image that has been clipped. If you don't see any stripes, then you know you don't have anything clipped in frame.

If you set the zebras to 70% for interviews or standard day interiors, you should usually expose so that you see stripes on the brighter part of a white face or on the highlights of a brown face. Some people set the zebras to 75%, so they just show on the highlights. Irrespective of the skin tone of the people in the frame, any parts of the shot above the brightness level the zebras have been set to will have stripes on them. Having zebras set to 70% or 75% can be very helpful for keeping skin tones exposed consistently, but be aware that you still have to watch out for clipped areas. Darker skin tones are less problematic in terms of overexposure, but should be kept consistent from shot to shot. For dark skin tones, watch for highlights.

Zebras set to 75% showing zebras on the highlights of Mina's face, the rim of Feena's face and the window. (If your camera allows you to flip between 75% and 100% zebras, you can also check which parts of the shot are clipped.)

Histograms

Zebras are not available on all cameras, but histograms virtually always are. A histogram displays the combined light level for the whole of the frame in a graph. A histogram shows how your image is exposed. The darker parts of your image are shown on the left side and the lighter parts on the right-hand side. The higher the top at any point, the more has been recorded at that brightness.

There is no correct histogram, but a histogram will show you how much of your image is in the brighter or darker areas and warn you that details have been lost in any points that reach the edge.

A histogram for a low key shot should ideally show mainly at the left end, but not too far or it will show little detail or be below the noise floor. A high key shot should ideally show mainly at the right, but not too far or it will have little detail or will be clipped.

If the histogram has narrow spikes, there is a lot of information in the shot at exactly the same brightness level. If it is more rounded, there is a gentler gradation of light and shade within the shot.

Check the histogram to see if you have any information in the far right or far left areas and to see where the rest of the information is. If the histogram spreads from the far right to the far left, your shot has a high dynamic range. If it is mainly in one area, you have a low dynamic range shot. If your dynamic range is low, you can choose whether to expose the whole shot a little brighter or darker to retain maximum detail (which is recorded in the central areas) and have the most potential for adjustments later.

Try displaying the histogram on a camera and adjusting the aperture. You will see that the histogram moves as you open up or close down the aperture, and you may see that the steps it moves in are wider in the middle of the histogram than at the ends of it.

There is no such thing as a 'correct' histogram, but the histogram should be appropriate for your subject: (top) this histogram for this correctly exposed shot from *The Master* DP Mihai Malaimare Jr is mainly in the darker end, (bottom) this histogram for this correctly exposed shot from *Bruce Almighty* DP Dean Semler is mainly in the lighter end.

Monitors and IRE Levels

IRE (Institute of Radio Engineers) levels effectively show you the percentage of the video signal you are recording. They can be shown on a waveform monitor or false color monitor. Either can usually be displayed on your viewfinder or monitor.

The reason to use waveform or false color monitors, which are alternative ways to read IRE levels rather than relying on the image shown on the monitor, is that the monitor image isn't a full representation of what is being recorded on the sensor. Most monitors display only around 7 stops of dynamic range, which is far less than most cameras record. Using a waveform or false color monitor ensures that you won't be misled about the relative strengths of the bright, dark or midtones of an image. Monitors, particularly any kind of OLED (organic light emitting diode), emit light to make the image displayed look punchier, and turn off the pixels in any part of the image that is black so they look richer; whereas on your recorded shot they may look dingy.

Waveform monitor: The height of the wave represents the IRE levels at that point in the image. You can corner display or overlay a waveform to give an instant reading of the whole picture.

> Irrespective of the dynamic range, all cameras will produce an image with IRE levels of 0% to 100%. However, on a camera with a low dynamic range, e.g. 8 stops, something the eye would see as gray would appear black and have no detail, and something cream might be pure white with no detail. A camera with a higher dynamic range can record more shades of gray and show more detail, and variation in the dark, and the light areas.

False color and waveform meter showing IRE levels on test charts.

The shots above show false color and waveform being used to show light levels on a lens chart. The red level shows the IRE level is at 100% and correspondingly the waveform is at the top. The blue shows it is between 2% and 10% and the line is at the bottom. The yellow and green are as per the IRE key on page 66, and in between. The concept of waveforms is simple because the waveform level is in exactly the same position as the image on the screen, but it can take a little practice to immediately read it.

False Color Monitor: A false color monitor responds to the brightness of the different areas of the image. There is a key for which colors represent which IRE level (see below). Any areas that are red are clipped and are pure white with no detail. False color is probably the most straightforward and easily accessible exposure tool.

> Davinci Resolve is currently a freely available, and very good, editing and post-production software that includes waveform monitors.

B: ESSENTIAL WORKING KNOWLEDGE

- Learn to put on a false color monitor
- Memorize the color key
- For regular daylight scenes, depending on the complexion and the balance of brightnesses you want in the shot, aim to have light skin tones around 65–70% IRE, brown skin tones around 50% and darker skin tones between 35 and 50%. (The optimal IRE level for exposures varies if you are shooting in Log – see C11a.)

The key shows which IRE level each color represents when monitoring with false color.

(top) Without false color, (bottom) with false color.

EXPOSURE PROBLEMS AND SOLUTIONS

Too little light

If you don't have enough light to get the exposure you want, do any or all of the following:

- Open up the aperture/iris
- Find a place to shoot where the light is brighter
- Add additional lighting
- Raise the ISO to push the IRE level up, but remember that (as shown above) raising the ISO increases noise and reduces the dynamic range of the image, so avoid raising it more than one or two stops, unless there is no other way to get your shot.

Too much light

If you have more light than you want, you must reduce the level of light reaching the sensor by doing any or all of the following:

- Close down the aperture/iris
- Reduce the light level or find somewhere darker to shoot
- Lower the ISO
- Use an ND (Neutral Density) filter

> Reducing the ISO below the native ISO will also reduce the dynamic range, but is unlikely to increase the noise levels, because if you need to reduce the ISO your light (and so signal level) will be high.

3: FUNDAMENTAL PHOTOGRAPHIC KNOWLEDGE

Neutral density filters act like sunglasses and reduce the amount of light coming into the camera and bring down the IRE level of your shot without altering the ISO or adjusting the aperture. If using an ND to reduce the light level by 3 stops or more, you must use an IR or hot mirror (see C4a).

CONTROLING THE LOOK OF THE IMAGE WITH APERTURE AND SHUTTER SPEED

You can control how much light reaches the sensor with the shutter speed, aperture and ISO. The reason for controlling how much light reaches the sensor is not just to get a suitable exposure level. The combination of aperture and the shutter speed you use affects the look of the shot.

Aperture and Depth of Field

If you need to let all the available light in to get an exposure, you have to open up the aperture as wide as you can. If you have more light than you need, you can select your aperture to give you the depth of field that is optimal for your shot.

The smallest aperture number on a lens represents the widest open aperture it can go to, and the largest is the most closed. A wide-open aperture gives a shallow depth of field. A closed-down aperture gives a deep depth of field.

For each of the full stop numbers, which are 1.4, 2, 2.8, 4, 5.6, 8, 11, 16, 22, half the amount of light is stopped from coming through the lens compared to the previous number. If you think about the word stop as literally meaning stopping light, it is easy to remember that small numbers stop less light than larger ones. The stop numbers may seem like an illogical sequence, but because they simply halve the light coming in at the previous stop. Learning them keeps photography maths straightforward because changing one stop is equivalent to doubling or halving the shutter speed or ISO.

Photography maths: This is the ability to make quick mental maths calculations about how much to adjust one or more of the key photographic elements, ISO, aperture and shutter speed to either maintain the same exposure or change it as required. To maintain the same exposure, you could, for example, halve the amount of light coming through the aperture by closing the stop from 2.8 to 4 to get a slightly deeper depth of field, but double the effect of the light on the sensor by raising your ISO from 400 to 800.

Large Aperture
f/2

Small Aperture
f/22

The same shot of flowers: (left) a wide-open aperture creates a shallow depth of field, making the background out of focus, (right) a small aperture creates a deep depth of field, which keeps the background in focus.

Manufacturers construct lenses so that they have the widest aperture that can be included for the price they are selling the lens at. It is easier and cheaper to make short focal length lenses open up wider than long focal length lenses; consequently, zoom lenses often (but not always) open up wider at the short end than the long end.

67

B: ESSENTIAL WORKING KNOWLEDGE

| F1.4 | F2 | F2.8 | F4 | F5.6 | F8 | F11 | F16 | F22 | F32 |

These aperture numbers represent full 'stops'. From left to right, each stop the aperture is closed down by reduces the amount of light passing through the lens by half.

Lenses are usually marked with full stops, other than the numbers at the beginning or end of the aperture ring, which indicate the maximum or minimum aperture.

When you close down the aperture, exactly how much of the background is in focus depends on:

- The aperture
- The focal length of the lens
- The distance from the subject in focus to the position of the sensor in the camera
- The distance from the subject to the background

(left) a shorter focal length gives a wider angle of view, (right) a longer focal length gives a narrower angle of view.

3: FUNDAMENTAL PHOTOGRAPHIC KNOWLEDGE

Apps or online calculators can be used to calculate the depth of field.

> The circle of confusion is the size of the point of focus that is truly sharp. It can vary from sensor to sensor (or film stock to film stock), so if you have the option of specifying which camera you are using in a depth of field calculator, do so in order to get the most precise depth of field.

Using this RED depth of field calculator, the type of camera used, aperture, focal length of the lens being used and the distance focused at are put into the calculator, and it calculates the nearest point in focus, the furthest and the total depth of field. (N.B. Many but not all depth of field calculators allow you to put in the type of camera; others just ask for the sensor size.) Screenshot red.com depth-of-field calculator.

If you want to open up your aperture to have a shallower depth of field and have more light than you need, as above you can put an ND filter on to reduce the light level to allow the aperture to be opened up without ending up with too bright a shot. If you need a deeper depth of field, you have to either close down the aperture and (if necessary) find more light, or raise the ISO or adjust the shutter speed or angle (see page 71).

The following exercise allows you to see the effect of aperture on depth of field whilst also learning about the effect of focal length of lenses.

EXERCISE: This essential exercise can be done on a still or a movie camera, using the following standard focal lengths: 18mm, 25mm, 50mm, 85mm, 105mm and 200mm (if you have it). *Use these same focal lengths even if you have a zoom lens.* Shoot the following series of shots outside on a fairly bright day, but in an area where there are no harsh shadows or bright spots in the frame. The person should stay in the same position but you will move for each shot. Frame the first shot, and every other shot, to show the face from the bottom of the chin but no lower to the top of the head but no higher. In each shot, also make sure you include part of a wall with visible details on it approximately 8ft behind the person you are photographing. Focus on the person's eyes. Shoot each shot with a wide-open aperture (the smallest aperture number your camera can go to), then repeat the 85mm shot on an aperture of 8 then at 11, 16 and 22.

Looking back at the shots from this exercise, you should see:

- The longer the focal length, the shallower the depth of field.

- The wider open the aperture, the shallower the deeper the depth of field.

- To get a sharp background, you need to choose either a shorter focal length or a more closed-down aperture, or both.

The other very significant aspect of what you can see from this exercise is the effect of focal length on the look of the person or subject you are photographing. The difference is quite dramatic:

- When you get very close to your subject on a short focal length lens, you very much exaggerate the volume of whatever is closest to camera and make what is further away seem far further than it really is. This technique exaggerates distances, noses and features close to camera – this is a wide-angle effect.

- When you use a 'standard' focal length, the features and distance to the background look normal.

- When you use a long focal length lens, the nose is slightly flattened and the distance to the background seems less. This is called foreshortening.

> You may find that your first shot, which is very close and wide, is too close for the minimum focus of your lens. Use the closest focus you can, but still shoot the shot so you can see the results of the overall exercise.

B: ESSENTIAL WORKING KNOWLEDGE

Examples of these shots have been purposefully omitted here, so you shoot your own.

From this exercise you can see that it is relatively easy to get a shallow depth of field by opening up the aperture and, if that doesn't give you a shallow enough depth of field, then move back and use a longer focal length lens.

If you need a deep depth of field to keep several parts of the shot in focus or to allow for people to move without pulling focus or going out of focus, you can do one of three things: stop down (if you have enough light); select a wider lens, because it will give you a deeper depth of field; make a photographic compromise (see below).

One of the many uses of this knowledge is that when shooting hand-held, particularly if you are shooting without a focus puller, the usual option is to use a wideish lens and calculate the depth of field with an app or calculator (as below) to check you have enough depth of field to allow your subjects to move around and stay in focus.

The maximum depth of field can be found at the hyperfocal distance, which is usually also shown when you look up a depth of field on an app. The hyperfocal distance is the distance you can set the focus to, and have everything from half the distance you are focused at right up to infinity in focus. In practice, unless you are on a wide lens (14mm or wider) or at a very closed-down aperture, the near point is usually too far away from who you are filming to be useful.

What is used far more often is 'splitting' the depth of field. Splitting focus relies on the fact that the depth of field is approximately 1/3 in front of the subject you have focused on and 2/3 behind. It may benefit you not to put the focus exactly on your subject, but, for example, if you move your focus forward, the person will be able to move further forward without going out of focus than they could if you put the point of focus exactly on them. Likewise, if they are likely to move backwards, you could position the point of focus a little further back to make better use of the depth of field you have.

Depth of field is approximately 1/3 in front of focus point and 2/3 behind. Photo by José Manuel de Láa.

Provided that you have enough depth of field to keep your subject in focus, if you move the point of focus forward you can make the background out of focus. Alternatively, you could move the person and the point of focus forward to ensure an out of focus background.

In this example, the person has been moved back so the flowers are in focus, because it is more important that the flowers are in focus than the person's back arm.

Experiment with putting in 18, 35 and 85mm focal lengths into a depth of field calculator, then adjusting the focus distance and aperture to see how much the depth of field changes. This will help you have an idea about how your lens and aperture choices will affect your depth of field.

> N.B. However shallow or deep your depth of field, everything at the same distance from the camera will be in focus.

Shutter Speed and Motion Blur

In still photography, if you want to close down the aperture to get a deep depth of field, you can open the shutter for longer to let enough light in. It is different for moving pictures. The shutter can't be open for longer than the frame rate. Films are made by shooting a number of frames per second and then playing them back at the same rate to create a moving picture. How many frames per second you shoot is called the frame rate. Most films are shot at one of the following frame rates: 23.97, 24, 25, 29.8 or 30.

Unless otherwise specified, the shutter should be open for half the frame rate, so for 25fps the shutter speed would be 1/50th and, for 30fps, 1/60th.

The frame rate selected for your production depends on the electricity, and historically on the TV systems used in the country you are shooting, but may vary by approximately 0.03 of a second, particularly if you are shooting sound.

- 24fps is widely used for film.
- 30fps is widely used when shooting for TV in countries with the NTSC system (including North America, parts of South America and Japan).
- 29.98 is used in the same countries when sound is being recorded.
- 25fps is widely used for TV and film in PAL countries (most of Africa, Asia, Europe and parts of South America).

Always check with production what your frame rate should be and ensure that you and the sound recordist are recording at the same frame rate.

A shutter speed of half the frame rate is described as having a shutter angle of 180 degrees. This harks back to film cameras, which had a rotating shutter that was closed for half the time while the film was moved up ready to take the next frame. While initially learning cinematography, most people stick with a 180-degree shutter angle, but film cameras, digital cinema cameras and some DSLRs can be adjusted from this. Some cameras allow you to adjust the shutter speed up to virtually the duration of the frame, some have a shutter angle setting. The result of having a shutter angle larger than 180 degrees is that the sensor is exposed for longer than half the frame rate, and the result of a shutter angle of less than 180 degrees is that the sensor is exposed for less than half the frame rate.

Photo by Alexander Stein.

> *Fast Motion*
>
> If more frames are played back than you shot in one second, you will see more than a second of activity in the playback and so see fast motion. This is called under-cranking.
>
> If the time base of your film is 24fps and you shoot 12fps, your shots will be twice as fast.
>
> *Slow Motion*
>
> If fewer frames are played back than you shot in one second, they will be spread over more than one second in the playback so you will see slow motion. This is called over-cranking.
>
> If the time base for your film is 25fps and you shoot 50fps, your shots will play at half-speed.
>
> It is better to shoot at a higher frame rate than just slowing down your footage in post-production. When footage is slowed down, frames are duplicated, the slow motion isn't as smooth and the movement may be stuttered.

> A reduction of 0.03fps was brought in shortly after color was introduced, because the color carrier signal was phasing with the sound carrier signal and distorted the picture.
>
> It is essential that your sound recordist knows whether you are shooting 24 or 23.97 or 30 or 29.97, or there will be substantial syncing problems later. In the USA, it is recommended to use the 0.97 options.

Shutter speed calculations require understanding the concept that shutter speed is measured in fractions of a second, so a shorter shutter speed has a higher number: (left) a 180-degree shutter allows light in for half the frame time, so at 25fps the shutter is open for half of 1/25 of a second, i.e. 1/50 of a second, (center) a 270-degree shutter allows light in for 3/4 of the frame time, so at 25fps the shutter speed is open for 3/4 of 1/25 of a second, so the shutter speed is 1/37 of a second, (right) a 90-degree shutter allows light in for 1/4 of the frame time, so the shutter speed is 1/100 of a second.

Whilst the shutter on a digital cinema camera can be adjusted to be open for any duration up to 0.1 seconds less than the frame rate, only the specific adjustments below are usually made. This is to keep a simplicity about the calculations for exposure and flicker when the shutter is adjusted. (If the shutter speed and Hz frequency used for electric lighting are out of sync, visible flicker can be produced – see C12.)

- A 90-degree shutter angle reduces the light reaching the sensor by 1 stop (because half the light is let in).

- A 270-degree shutter angle increases the light reaching the sensor by 1/2 a stop

- A 364-degree shutter angle increases the light reaching the sensor effectively by 1 stop (because virtually double the light is let in).

The other effect of changing the shutter angle is on the motion blur created during a shot. Motion blur is the slight drag of any part of an image that moves while the shutter is open. Audiences are accustomed to seeing the motion blur created when a 180-degree shutter angle is used on standard frame rates (between 24 and 30fps). The motion blur doesn't make the film look out of focus; it is just part of what has become accepted as cinematic naturalness, and the blur produced at 24 or 25fps is considered slightly more cinematic than the 30fps used in TV in North America.

If a shutter angle of less than 180 degrees is used less motion blur is created and the shot looks crisper and sharper but slightly less 'natural'. A shot using a narrow angle may, depending on the speed of the action and any camera movement, also look stuttered, because the shutter is only open for 1/4 of the frame rate, so there may be jumps in action between each frame shot. There are times when this effect is wanted visually to subliminally affect the audience. Films such as *Gladiator* and *Saving Private Ryan* use this disconcerting effect as part of their storytelling. At other times a shutter speed of more than 180 degrees is used to show more motion blur for the effect it has on the viewer's perception of the image (see C8).

Adjusting the shutter angle can be done either for the subliminal effect on the viewer or to increase or decrease the amount of light reaching the sensor when needed. It is rarely the first option for adjusting the amount of light but is a handy option if there is no other way to get the stop required for a shot or scene.

If shooting at high speed, e.g. 50fps, the shutter will again only be open for half the frame rate, i.e. 1/100 of a second, unless the shutter angle is also adjusted. This means that you may need more light to shoot the same shot at 50fps than at 25. Alternatively, you could open up the aperture or increase the ISO or adjust the shutter angle.

Aperture Shutter Speed and ISO: Ideals and Compromises

There are many ways to approach choosing the best combination of aperture shutter speed and ISO in cinematography.

The concept of the **exposure triangle** reminds us that to maintain the same exposure, if you change, e.g. shutter speed you need to adjust either the aperture or ISO.

Exposure values convert the resulting stop achieved by the combination of aperture, shutter speed and ISO that you have chosen into a single figure that you can view on a meter and refer back to when you adjust any of the settings to check you have maintained the same exposure.

I find it more useful to find the optimal camera settings and balance between aperture, shutter and ISO by thinking of the ideal settings and then where best to make compromises.

Ideally, choose:

- The most suitable frame rate for the country you are shooting in and the platform(s) your film will be screened on.
- The shutter speed that will let you achieve the motion blur or sharpness you want, without causing a stuttered look (unless you want it).
- The aperture for the depth of field you want.
- The native ISO of the camera.
- To expose the most important parts of your frame well within the dynamic range of your camera and have nothing outside the dynamic range.

In order to do this, you would need to be completely in control of the amount of light you have available and have time to change the light levels every time you needed to. This is only feasibly possible on a studio shoot, with large crews and plenty of time and lamps for lighting. Most of us don't have that degree of control.

Compromise: Welcome to the world of cinematography! It's all about making the best decisions about which photographic settings to prioritise and which element or combination of elements you can compromise on in order to get the look you want at the exposure you need.

Photography mathematics is easy – all you have to do is learn which numbers equate to doubling or halving the amount of light reaching the sensor. If you change one, balance out with the other, unless you want the exposure to go down or up.

Decide what is fixed or essential and work around that. For example, if you need a certain depth of field that requires an aperture of 8 (this is often when there is a short distance apart from both subjects, as per this shot of goats) but this would make you 2 stops under your ideal exposure, you can bring in additional lighting or find somewhere bright enough to give you those 2 extra stops, or you could adjust any of the following:

- You could raise the ISO by 2 stops (by doubling the ISO number and then doubling it again).
- Or double the ISO (to achieve one additional stop) and open the shutter angle to 364 degrees to let the light in for virtually twice as long to get yourself the other stop.
- You could double the ISO and open the shutter angle to 270 degrees to get an extra half a stop. This would mean the exposure would be half a stop less than ideal, but this would be easily correctable in post.
- If working with people, rather than goats!, you could ask the person behind to move a little closer to the person in front so that you can open up a stop and shoot on 5.6 and then add a half a stop with ISO and half a stop with shutter angle.
- You could use a wider-angle lens and go a bit closer to your subject, which will give you a slightly deeper depth of field. You may find that you then only need an extra half a stop to get the depth of field you need.

Photo by Filinecek.

These options show that there are many ways to achieve the same thing, and they all rely on knowing how many stops or fractions of stop difference all of your choices produce and knowing practical work-arounds of adjusting people's positions or lens choices as needed. The more experience you have in practical situations, and the more you look at the effects of your decisions, the easier you will find it to decide what compromises to make in practice.

B: ESSENTIAL WORKING KNOWLEDGE

WHITE BALANCE

The color of artificial light varies depending on what type of bulb or light source is creating it. The color of natural light varies depending on the time of day. The Kelvin scale measures the color of light from infrared to ultraviolet, as below. Tungsten film lamps produce light at 3200 degrees Kelvin and HMI film lamps or other light sources balanced for daylight produce light at 5600 degrees Kelvin. Noon sunlight is approximately 5600K, but the color temperature of daylight varies depending on the time of day, and at sunset or sunrise it is closer to 3500K.

In daily life we don't usually notice the color temperature of the light, but we do pick up on the mood it creates. Cameras don't adjust for different-colored light in the way our eyes do. Cameras can be set to daylight, tungsten or to any other color temperature. By setting the white balance on the camera, you tell it what to read as white.

The Kelvin scale from infrared at the left to ultraviolet at the right, showing the position in degrees of Kelvin of film lamps, equipment and natural light sources.

There are three ways to do this:

1. Use a pre-set white balance in the camera, which will be shown either as sun and bulb symbols or as numbers.
2. Dial in the specific degrees Kelvin you want.
3. Set your own white balance manually.

Wherever you set your color temperature, any light produced from a source that is further towards the infrared end on the chart to the left (and anything it illuminates) will read as 'warmer', i.e. more orange. Any light produced form a source that is further to the right will read as 'cooler', i.e. bluer.

If you set the camera to a white balance of, for example, 8000K (or as close as your camera can go), anything lit by the midday sun would look very warm and orangey. Likewise, if you set it to 2000K, even interior tungsten lamps would look blue. These are not color temperatures for shooting at; they are just exercises to see how you can control it.

(left) Icon for daylight (right) icon for tungsten (usually interior) light.

When working quickly, in non-color-critical situations, the color temperature is set by choosing the sunlight or tungsten options on the camera and a gray, white and color chart is included on the clapper board to give the color grader a reference point for how the colors should look. In any other situation, the decision of where to set the white balance is made by the DP. The DP also decides when and which color reference charts to shoot (see C4b and C5) for more precise communication with post-production about color.

Photo from Pixaby.com.

74

If shooting in unusual situations, where there is (for example) strong neon light or sodium/orange street lighting, or where there is a mixture of color temperatures from, e.g. street light and interior light, you should set your white balance manually under the lighting that you want to appear neutral. Then ideally also shoot a gray card for 10 seconds in the same place. A professional gray card is exactly 18% gray and so can be made to appear exactly the same color in post-production. To set a white balance manually:

- Hold a white card in an unshaded area in the light you will be shooting in, and push the white balance button to tell the camera to read this color as white.

- Next push the shading/black balance button so that, from its white reading, the camera will then calculate the black reading and so be able to assess any colors in between.

- Re-balance for each scene unless the color temperature of the lighting remains the same.

Do not use auto white balance, particularly if there are differences in the color temperature of the light within the area you are shooting in – for example, if some areas are lit by daylight and some by interior lamps. This is because the camera will keep adjusting what it reads as white whenever the camera moves either during a shot or from one shot to the next, making it very difficult to match shots when editing them together. See C14 for using color and mixed color temperatures creatively and for adjusting the color temperature of your gray card to make shots look warmer or cooler.

BLACK BALANCE/SHADING

Black balancing is not only to provide a color reference for the camera. Black balancing also minimizes noise in the blacks and avoids any color cast in the shadows. This balancing or 'shading' should to be done at the beginning of a shoot and then redone if the working temperature changes more than 5 to 10 degrees. To shade the camera, there is usually a black balance button on the camera, which should be pressed when the port cap is on the lens (see C4a).

FLARE

When a bright light source is shining on the lens, particularly if it goes straight down the middle of it, light can be internally reflected by the glass elements of the lens. The effect of this is that, when the light reaches the sensor, it adds light to both the bright and dark parts of the image, causing the light to disperse and diffuse, creating lower contrast, haze or sometimes rings, the shape of which depends on the optics and iris of the lens. Flare results in an inconsistency in the saturation and definition of a shot, which can make it look washed out and very difficult to match or cut together with other shots. It is the camera assistant's job to make sure there is no flare on the lens unless it is specifically requested. This is done by keeping the lens fully in the shade (see C2). Flare can also be used creatively (see C14).

(top) No flare (bottom) flare.

B: ESSENTIAL WORKING KNOWLEDGE

POLARIZATION

Polarizing light with a polarizing filter cuts out light from one direction, which reduces reflections, allowing you, for example, to see into a river rather than just the reflections on the surface. Polarization also makes the colors more saturated and increases contrast. Other filters affect the look but can be mimicked (to varying degrees of success) in post-production, but it is very difficult to achieve the same reduction in reflections and effect that a correctly positioned polarizer has on an image. When using a polarizing filter, you need to rotate the filter until the polarizing effect is visible. (See C14 for more information about using polarizing filters and their effect on the look of the film.)

(top) Polarizer will always reduce level of light and cut some glare, (bottom) when rotated to correct position will increase contrast, reduce reflections and saturate colors.

SUMMARY

- How much detail you record depends on the resolution and bit depth of the sensor, and how close to the middle of the dynamic range you are recording.

- How much noise you have depends on your signal to noise ratio. Noise increases at the lower end of the dynamic range. It is also increased by the electrical amplification needed to raise the ISO, and by external factors such as heat.

- The further away from the native ISO of the camera, the more the dynamic range is reduced and the more electrical noise is created.

- A wide-open aperture such as 1.4, 2, or 2.8 gives a shallow depth of field, whereas a small aperture such as 16 or 22 gives a deep depth of field.

- If you need to close down your aperture to get a deeper depth of field and do not have enough light to maintain a good exposure, you can raise the ISO or adjust the shutter angle, or a combination of both. .

- Shooting a frame rate higher than the playback frame rate creates slow motion. Shooting a frame rate lower than the playback frame rate creates fast motion.

- Shutter angle is usually 180 degrees, and results in the shutter speed being half the frame rate. A smaller, e.g. 90-degree, shutter angle results in a shutter speed of 1/4 of the frame rate and (compared to a standard 180-degree shutter) you lose 1 stop of light. A larger shutter angle of 270 degrees results in a shutter speed of 3/4 of the frame rate and you gain 1/2 stop. A shutter speed of 259 degrees results in a shutter speed virtually the same as the frame rate, and you gain 1 stop.

- A smaller shutter angle will give crisp motion and usually a sharper but slightly less 'real' look to the image. A larger shutter angle results in increased motion blur.

- Light hitting the lens can cause flare, so keep the lens in shade unless you want that as part of the look.

- Polarization cuts the light from one direction, so creates a more saturated look with fewer reflections.

NOTE

1 Hannemyr, Gisle. "How ISO is Determined for Digital Cameras". *DPAnswers.com*, August 24, 2010. http://dpanswers.com/content/tech_iso.php

4a
Assembling the Camera and Preparing to Shoot

This chapter guides you through camera choices, camera assembly and camera care. The principles and practices described, along with the pointers and guidelines provided, will help you be prepared to work with any of the vast array of cameras and accessories available.

> **LEARNING OUTCOMES**
>
> *This chapter will help you:*
>
> 1. Select an appropriate camera for your shoot
> 2. Assemble the camera and accessories so that everything can be used easily and reconfigured quickly
> 3. Understand the principles applied when setting up hand-held rigs, gimbals and Steadicams
> 4. Change lenses and filters safely
> 5. Set key functions on the camera
> 6. Clean lenses and the camera without damaging them
> 7. Know what should be included in a camera assistant's or DP's kit

SELECTING AN APPROPRIATE CAMERA

There are two main ways to group cameras: those made by the same manufacturer and those made for the same type of cinematography or area of the market.

Cameras made by the same manufacturer: These will often share sensor design and processing systems, and will therefore produce a similar 'look'. They will also often share the same accessory systems, with many accessories being interchangeable between models. Many of the accessories, particularly those that connect the camera to the head, the supports for accessories and everything at the back of the camera are brand-specific and not interchangeable, because they have been designed and tested so that they are not too heavy to be supported, and if used and connected properly will not fall off or apart.

Most cameras can be used to shoot virtually any project but are optimized for specific areas of the market. Many manufacturers are designing cameras to cover each area of the market, so understanding the different options will help you choose the best camera for the job.

Cameras designed primarily for drama offer the most flexibility for customizing shots. They have a wide variety of accessories and are modular rather than ready to shoot out of the box. This would make shooting alone very difficult and ACs are virtually always needed.

I go to the NAB show in Las Vegas and try to go into rental places to test and try new cameras, but keeping up with the equipment is what camera assistants have to do.
Roberto Schaefer[1]

B: ESSENTIAL WORKING KNOWLEDGE

If people talk to us about what they need the camera to do, we can guide them on the best option for their budget.
Grahame Wood[2]

On the xxxx the on/off function was right by my shoulder and it wasn't possible to disable it. It was very annoying.
Georgina Burrell[3]

High-end: Flagship cameras offer the most flexibility, the most advanced sensors and are designed to make shooting life easier, e.g. allowing you to remotely control the focus and zoom without any additional accessories.

Mid-market: When a new model is launched, the previous models immediately lose value and rental rates drop. For example, the ARRI Amira has the same sensor as the newer ARRI Alexa, but doesn't go to such high speeds and doesn't have anamorphic or RAW options. If your shoot doesn't require what the newer camera has to offer, this would be a good option.

Documentary- or TV-oriented: Documentary-oriented cameras have fewer accessories and are primarily designed for one person to use. They often have built-in focus and zoom controls and a place for an on-board mic. It is important to check that the weight and the position of the functions suit you. Many options, such as the Canon C300, have Super 35 sensors, but when necessary opting for a camera with a smaller sensor will give you a deeper depth of field for an equivalent shot size. Some of the Blackmagic (and other) cameras offer smaller Micro Four Thirds sensors that can be far easier to keep in focus.

DSLRs: These span all areas of the market for low budget shoots, but be aware that the full-frame sensor makes the depth of field shallower for an equivalent angle of view, so they are far more difficult to keep in focus. Also, be aware that to use a DSLR for a drama you will need accessories that may add substantially to your costs and, as with many small cameras, you may need to put them in a cage, which can make them bulkier and more awkward but are necessary for use with drones, etc.

ASSEMBLING THE CAMERA

Both solo shooters and camera assistants need to be able to assemble and reconfigure the camera and accessories quickly and safely.

Many current cameras are modular, so they can be reconfigured to be small and light, when needed for a drone or car rig, or with the full capacity for in-shot adjustments in complex drama shoots. Modular cameras have a wide range of accessories; even the viewfinder and monitor are accessories that need to be attached. Modular cameras usually require plates or brackets to attach accessories. Often a magic arm is attached to the bracket and then, for example, a monitor is attached to that. A magic arm is flexible and lockable and enables you to position accessories where you need them.

It can be daunting to learn to set up cameras if you don't have the opportunity to see it being done on set. Start by watching build and set-up videos online. They are available for most cameras, but be sure to select ones that are made by people who know what they are doing. Try camera manufacturers, rental houses and film schools, who are usually reputable sources. There are also camera menu simulators available as apps or online for most cameras, provided by the manufacturers, so you can learn to navigate around the settings menus. Both the set-up videos and the menu simulators provide valuable introductions and speed up your learning, but don't show you all the possible combinations of accessories or replace hands-on experience. The guidance below may help by giving you practical tips that aren't included in the videos.

Photo courtesy of Liquid Productions.

Bracket attached to the top of the camera with two different-sized screw threads for mounting accessories..

4A: ASSEMBLING THE CAMERA AND PREPARING TO SHOOT

On-camera LCD monitor on a magic arm with power cable connected (a video cable – usually SDI – will also need to be attached between the monitor and camera).

Photo by David Condrey.

If you are completely new to setting up equipment, think about what the function of the item you are assembling is. To work out how pieces connect, look at both sides of what you are trying to assemble, to see what sort of joining mechanism there is and whether you need a screwdriver, hex/Allen key, whether they clip, slot into a dovetail or v-lock, or have gears that need to mesh together. You will feel, or hear a click, when most pieces of equipment have located together correctly. Importantly, always check if there is an additional locking mechanism such as a lever or rings, to tighten and provide additional security for locking two pieces of kit together. Secondary locking mechanisms are always used when putting a camera on a sliding base plate. Also, look to see if there are buttons you need to press to allow one piece of kit to slide onto another and, likewise, if a lever or a button needs to be pressed to allow you to dismantle that piece of equipment.

When assembling cables, there are often locating lugs and/or marks, which means they can only fit together in a certain way, so look at both the male end and female socket to find them.

(top) 'QRP' quick release plate is being positioned so that it can be attached to the bottom of the sliding base plate (which is upside down), (middle) the angled lip of the QRP is slid into the angled groove so it can be attached to the camera head, (bottom) brass-colored lugs are lined up so the battery can be attached to the back of the camera.

79

It can be very helpful to work with another person, to learn how to assemble kit and find the functions; two heads are usually better than one. For students there may be opportunities to practice setting up equipment outside class time. Alternatively, camera rental houses will also often let you go in to learn and practice if and when they are quiet. Do your online viewing and research first to ensure you make the most of any hands-on time you get.

Whether or not you are new to equipment, when putting two pieces of camera kit together, particularly when you put a camera onto a head or base plate, **always** check it is secured and fully in place, and not wobbly at all, before you take your hands off. Do this by holding it firmly with one hand and shaking it gently with the other to check there is no wobble.

Hand-tighten screws but don't over-tighten them and, when taking out, cables pull on the connector, not the cable. Learn which cables are for which piece of equipment, and attach labels or color-coded tape if you need or want instant reminders.

Build the camera on a flat surface or a tripod. Do not assemble a camera while holding it in your hands or on your lap. Make sure you don't set the tripod so high when setting up the equipment that you can't see all of the camera, including the top. Once the camera body has been built and the viewfinder attached, the lens can be mounted.

Mounting the Lens

Lens ready to be attached to the (PL/Panavision) lens mount; when the lens is in place, the silver-colored bar is rotated up to lock it in place.

There are a range of different types of lens mounts for both cameras and lenses. The lens mount and camera mount must match. Not all lenses are available with every mount, but the camera's mount can sometimes be changed if required. This must be done before the lens tests are carried out (or the tests will be invalid) and not changed until after the shoot. This is so that the distance between the sensor and the rear of the lens mount (known as the flange focal distance) remains exactly the same, because it is critical for focus.

If the distance changes, or is not correct, this will result in the lenses either not being in focus at all or the distances specified on the lens not being off, making focus pulling impossible.

Alternatively, in many cases, lens mount adaptors can be used so that a lens with an incompatible mount can be put onto a camera and maintain the correct flange focal (back focus) distance so can be used without further testing.

The ARRI PL mount is used for the majority of professional lenses, but Canon EF and, to a lesser extent, Nikon F mounts are now increasingly used (see C6 for a fuller account of lens mount options).

When attaching the lens, you expose the sensor to the environment you are in, so make sure you are in a dust-free and dry environment, where nothing can blow into the lens. If you are outside and the wind is blowing, make sure you turn the camera so the wind is not blowing anything into the camera body when you take the lens port cap from the camera body.

> **Panavision have a wide range of lenses, but their lenses cannot be used with lens adaptors and the mounts on the cameras can't be changed.**

4A: ASSEMBLING THE CAMERA AND PREPARING TO SHOOT

Take the cap off the rear element, i.e. the back of the lens (or have an assistant who has already done this hand it to you). Line up the dots on the lens port and the lens, and twist until you hear a reassuring click so you know the lens is correctly located. Look on the camera body to see if there is an additional locking mechanism at the back of the lens onto the camera body and twist that to secure the lens. The standard practice is to put the aperture to wide open when attaching a lens, so the operator or DP can see as much as possible without relying on the set lighting. Most professional lenses have aperture numbers marked on both sides, but, if your lens only has them marked on one side, make sure the numbers appear on the operator's side of the camera.

Make sure you can see the datum line(s), which are the fixed lines on the body of the lens against which you read the aperture or focus position, and that they aren't obstructed by the follow focus or any other mechanism attached to the camera. Check and remember what the minimum aperture is for the lens you have put on the camera, and the minimum focus if there is any likelihood you will be needing to focus close. You are expected to have this information to hand instantly without having to look anything up.

Often, some or all of the information you need to know about a lens is written on it: for example, the manufacturer, focal length or zoom range and the minimum aperture (which is written as, say, 1:2.8, because all apertures are a ratio of how the aperture compares to 1). Particularly if you are using still lenses, there may be additional information, including the filter thread size and sensor size covered, and whether or not it has image stabilization.

Focus and aperture are read against the static white datum line/mark. Photo courtesy of Arri (www.arri.com).

CAMERA SUPPORTS

Camera supports allow the camera to be held securely and operated safely and steadily at the required height or heights or hand-held. All camera supports have maximum weight limits, over which they will become unstable or unsafe and un-insured. Camera assistants set up tripods and hand-held/shoulder rigs and sliders. Dollies, Steadicams and gimbals, etc. should be set up by the dolly grip or grips, because set-up time is longer, but on low budget shoots this can fall to the ACs.

> A dolly allows the camera to be moved either on tracks or on a level surface and may allow the camera to be raised or lowered during shot. If the space is large enough, it can be quick and easy to leave the camera on a dolly so it can be moved and used for both static and moving shots. A hand-held rig allows the camera to be held steadily on the operator's shoulder. A bazooka is a very strong camera support that can be used in tight spaces that are too small for a tripod. A high hat supports the camera on the ground but still allows for a camera head (see below) to be used, so the camera can be operated.

(left) Chapman hybrid Dolly Photo courtesy of Chapman/Leonard, (center left) hand-held/shoulder rig. Photo courtesy of Arri (www.arri.com), (center right) a bazooka which has a smaller footprint than a tripod, so can support the camera head and camera in smaller spaces (at the top it has a Euro Mount (right) high hat for a flat/Moy head. A high hat is used for low level shots and can be placed on the ground (or any flat surface).

B: ESSENTIAL WORKING KNOWLEDGE

Tripod

The weight and robustness of the tripod you need depends on the weight of your camera and the likelihood of it being blown or knocked over. The wider the base and the heavier the tripod, the more stable it will be, and vice versa.

If your tripod is a little light or there is a lot of wind or something that might knock it over, widen the legs and weigh down the tripod by putting sandbags or a weight on the legs, or attach something heavy to a hook under the tripod head if it has one. Using a spreader to stand the tripod on also helps keep the tripod stable. The tripod legs slot into the holes in the spreader and integrated elastic bands connect the spreader to the legs. Some video tripods have middle spreaders halfway up the tripod.

If your tripod has spikes at the bottom (that are great for gripping surfaces such as grass, etc.), be sure to place them in a spreader or put rubber caps on when using it inside.

Raise the bottom sections of the tripod before you put the camera on, and then adjust the height, using the top section or sections when you are shooting, because this makes adjusting the height easier, avoids you having to bend down and keeps the tripod more stable.

Tripods either incorporate a camera head or are designed to accept either a head with a flat base or a bowl fitting. For bowl tripods there are several standard sizes; 75mm, 100mm and 150mm. Make sure your tripod bowl is the same size as the bowl for your camera head or you have an adaptor. An adaptor (often called a world cup or Moy to bowl adaptor) will allow a bowl head to be attached to a Mitchell/flat-based tripod.

Camera Heads

The job of the camera head is to hold the camera steady and allow you to move it as slowly or quickly as needed, in whatever direction your shot requires.

(top) Tripod with spreader, (middle) when using a spreader place the inner spike into the spreader. The outer one is pushed into the ground (where appropriate) for exteriors. (bottom) secure with band (tighten band if it becomes loose).

(top left) Flat Moy/Mitchell base head (bottom left) Moy head being attached to Moy tripod (top right) 150mm bowl head (bottom right) Euromount to bowl adaptor. Not all flat-bottom heads are made by Moy: equipment is sometimes known by the name of the original manufacturer, even though it is now produced by others.

4A: ASSEMBLING THE CAMERA AND PREPARING TO SHOOT

Friction heads

Relies on two, usually nylon, disks being pushed together to create more or less friction. These are often difficult to operate smoothly and aren't seen as suitable for video.

Fluid heads

Fluid heads come with either bowl or flat bases, and work by allowing fluid to be forced through an opening inside the head as it is moved. You adjust the tension of the fluid settings separately for pan and tilt. Adjust the tension so that you have to push with a moderate but gentle, consistent force to achieve a smooth movement. When changing the fluid tension, an air bubble may be created, so fully pan or tilt as far as it can go several times to release this airlock, or it may well cause a bump when shooting.

When setting up the camera, set the tension adjustment to the middle setting, and then the operator will adjust it from there. Attach a pan bar at an angle of about 45 degrees, as per the picture (center right) for ease of operating. If working with the camera in a tight space, use a shorter pan bar. There is usually a release halfway up the pan bar which allows the bottom section to retract, so the bar is shorter. Sometimes the bottom half of the pan bar is removable to make it shorter. (Don't lose the bit you remove.)

Most camera heads have a spirit level (often called a bubble), adjust the head or legs until the bubble is in the center.

Geared heads

Geared heads have flat bases. They are controlled by separate circular handles for the pan and the tilt. The gear ratio and the handle sizes can be changed for pan and tilt separately, making the same turn of the handle result in greater movement of the head if required. The benefit to the operator of a geared head is that it can be easier to move it precisely and replicate movement, easier to change speed during shot, and can be smoother than a fluid head when working on fast pans or tilts. Another advantage of a geared head is that it usually has a tilt plate built in, so you don't have to lower a camera leg to create a high tilt as you often have to when using a fluid head. When setting up a camera with a geared head, make sure the gears for both pan and tilt are set to a moderate

On a fluid head, a single pan bar is used to control the pan and tilt; however, either the pan or tilt can be locked if needed, so it only controls one.

(left) Geared head handles (right) tilt plate being engaged.

B: ESSENTIAL WORKING KNOWLEDGE

gearing ratio (so the head doesn't move too quickly or slowly when the handles are turned) and that the medium-sized wheels are on unless the operator has specified otherwise, and that the pan and tilt locks are on when you bring it to the set. If the geared head has slots for an AC tool box at the front, also attach that.

Leveling the Camera Head

Virtually all camera heads have a spirit level bubble incorporated in them. To level up a bowl head, undo the bottom screw and adjust until the bubble is level.

To adjust a flat-based head, you need to either adjust the tripod legs or use a three-way leveler underneath the head. Each time you move the camera to set up a shot, you should re-'bubble' it.

HAND-HELD SUPPORTS AND APPARATUS

Hand-held or stabilized camera supports are designed to allow different degrees of camera stability, and to distribute the weight of the camera in different ways. The optimal rig depends on the weight of the camera, the style of movement being aimed at (see C10) and the budget.

In most cases, when configuring the camera to use in any kind of hand-held rig, make the camera as small and light as possible. In all cases, the camera needs to be balanced when it is set up, to avoid the camera operator having to fight to keep it level and upright, and the camera must be positioned so the operator can comfortably look through the viewfinder. When changing lenses or filters, many rigs have an offset mechanism that can be adjusted rather than requiring a full re-balancing. When setting up any type of rig, see if it can be put down on the floor or a table as it is and not fall over. If not, set up a box or something appropriate so that it can be put down safely (see picture below). Broadly speaking, the following are in the order of how long they take to set up.

(top) A three-way leveler is often used for a flat/Moy head and has three screws that can adjusted to level the camera; it can be placed on top of a Euro Mount, on a bozooka or on a dolly to enable leveling, and it can also (with an additional adaptor) be used on a tripod under a flat/Moy head to avoid having to level the camera by adjusting the height of the tripod legs. (bottom) bowl heads are leveled by loosening the holding screw underneath, adjusting the bowl and tightening up the holding screw.

4A: ASSEMBLING THE CAMERA AND PREPARING TO SHOOT

Hand-held camera with curved shoulder support. Photo by Andi Graf.

Hand-held: If the camera is to be kept at its smallest and lightest, just attach a hand grip to the camera, use prime lenses rather than zooms and a small or clip-on matte box, that attaches to the lens rather than being supported by bars. Most manufacturers have a curved-shaped shoulder plate that can be attached under the camera for hand-held work to make it steadier on the shoulder and more comfortable.

Hand-held with a shoulder rig: Shoulder rigs are designed so the camera can be sat on, or forward of the shoulder, and a matte box, filters and follow focus and small monitor can be attached if needed. Shoulder rigs have slots for either 15mm or 19mm bars, which affects the size of the matte box required and some of the accessories attached to them. Safety, comfort and balance are key to assembling a shoulder rig. If it is set forward, put extra weight or use a heavier battery on the back to keep it balanced, and likewise balance it with weights or by re-arranging the accessories if there is a pull to the side. A camera on a shoulder rig should stay balanced with only a light touch of one hand on one of the hand grips.

Easyrig

The Easyrig or equivalent allows you the flexibility of hand-holding, so you can pan and tilt the camera and raise and lower it, but the weight is carried across your hips rather than your back. This makes it far easier to hand-hold for a long time. To set up an Easyrig, put on the vest and adjust the tensions, so it is secure across the hips. Adjust or select the arm height and how far forward it should be for the operator to look through the viewfinder without having to extend or compress their neck. The further forward the arm, the further in front of the operator the camera will sit. Adjust the tensions and attach the camera to the hook that hangs down from the arm. The camera must have a top handle, so you may need to attach one or

DP Ian McGlocklin, using a shoulder rig, is able to adjust the 'eyebrow' to keep the lens shaded because the camera setup is well balanced and only requires one hand to keep it steady.

Photo courtesy of Easyrig.

B: ESSENTIAL WORKING KNOWLEDGE

Steadicam at mid-height. Photo courtesy of Adrian Pircalabu.

Steadicam with central pole used to operate it at eye height. Photo courtesy of Laura Radford Photography.

use a cage if necessary. The camera is held in place by the hook and cable but should not be left dangling from it. The camera should be balanced after it is attached to the hook. To balance the camera, add weight to it or adjust the attachment position between the camera and the Easyrig.

Steadicam

A Steadicam distributes the weight of the camera onto the operator's body. The camera is kept level by a system of weights and balancing springs.

A Steadicam can be set up so that it is in high, low or central mode (as pictured, left). If set in high or low mode, a sled/platform supports weights to keep the camera level. The weight needed on the sled depends on the weight of the camera and the distance between camera and sled, so make sure the camera has all the necessary accessories on it when you set it up. Start with one weight on each side of the sled and then add more where needed. To test if the camera is balanced, hold the camera and Steadicam horizontal. It should take approximately 2.5 seconds to drop down to become vertical. If it goes faster than this, there is too much weight on the sled.[4]

Momentum Productions show some good tips for AC's balancing a Steadicam.[5]

Gimbals

Steadicams use physics and moving parts to keep the camera level, whereas gimbals use sensors that detect camera movement and motors that position the camera, to keep it level and steady while you move. Gimbal stabilizers can take a while to set up and learn to control. There are some top-end gimbals that are self-leveling, so are quicker.

> Gimbals are essential to getting steady footage from a drone. In some cases, you can remove the gimbal from a drone to use as a lightweight hand-held gimbal.

Gimbals are held out in front of the operator so, for all but the smallest gimbals and cameras, carrying one puts a lot of strain on the upper arm and back. Gimbals are often combined with Easyrigs or equivalents.

Gimbals are classified by the number of movements that they correct for: 2-axis correct for 'tilt', i.e. the lens of the camera tilting down or up and for side-to-side movement, which is called 'pan'; 3-axis gimbals (including the widely used Ronin) also correct for 'roll'.

2- or 3-axis gimbals are used for drones. For a gimbal to be used hand-held, a minimum of 3-axis correction is recommended.

4A: ASSEMBLING THE CAMERA AND PREPARING TO SHOOT

Practice moving your hand as per these shots to understand which movements gimbals correct for: 2-axis correct for pan and tilt, 3-axis also correct for roll, and 5-axis also correct for horizontal and vertical movement.

Hand-held gimbals have a frame built around them, which the camera operator holds while the gimbal functions to keep the camera level inside the frame. If the camera operator is walking, they need to compensate for any up-and-down movement as they walk by keeping their arms level.

4- or 5-axis correction requires a combination of 3-axis gimbal correction and correction for up-and-down/vertical movement and side-to-side/horizontal movement, which is usually a spring-based correction similar to what is used in a Steadicam.

Gimbals must be balanced properly or the motor will be working overtime. This may result in the stabilization not being as effective, the battery draining faster and the lifespan of the gimbal being shortened. A gimbal is balanced based by weight, so make sure all the accessories are attached to the camera before you start, and use a quick-release plate so you can attach and detach the camera without re-setting the weights. To balance a gimbal, turn the motor off, lock all the axes, then unlock one and adjust the position of the camera until it stays balanced when not held, then lock that axis and repeat for each axis.

To make the process easier for the next time you set the gimbal up, mark the position with tape or a marker. If you will use several lenses, color-code the markings to speed up the adjustments after lens changes.

In the control app, there are settings that adjust how much the gimbal responds to correct for movements. It can be set for anything from a slight to a very responsive movement correction. To find the optimal degree of correction for the camera, the operator and shooting conditions usually take a little trial and error, so allow extra time when first setting up a gimbal.

Aperture's '7 Essential Gimbal Movements'[6] shows the kind of shots that can be achieved with a gimbal (http://www.camcorder-hq.com/articles/what-is-a-gimbal).

Hand-held gimbal. Photo courtesy of Arri (www.arri.com)

B: ESSENTIAL WORKING KNOWLEDGE

Photo by Pixaby member 350543.

The ARRI Trinity. Photo courtesy of Arri (www.arri.com).

Combination Rig

A gimbal can be used in conjunction with an Easyrig, Steadicam or equivalent. It will take additional time to balance the gimbal and then set it up to be balanced on a rig, but because the operator needs to counteract any up-and-down movement of the gimbal with their arms, for anything other than a very light camera or a quick shot a combination rig is advisable.

The ARRI Trinity rig combines the benefits of a Steadicam and gimbal. As a high-end system, the gimbal is self-leveling and, because it is an integrated system designed specifically for the Steadicam and the gimbal to work together, the set-up is more streamlined and should be quicker than when using two separate systems. However, as with all systems, you will still need to allow time to balance it properly.

SECURELY CONNECTING THE CAMERA

Whatever type of support is being used, when connecting the camera to the support, it must be securely attached. If the camera is being connected directly to the support, there is usually a plate that comes off the tripod or other camera support that is screwed into the bottom of the camera to enable the camera to be connected and locked securely in place. In virtually all cases there will be two mechanisms to lock the camera into place – often a locating dove tail and an additional lever to secure it into place.

Very often the camera is not connected directly to the support. It is first attached to a base plate that allows bars to be inserted, onto which camera accessories such as the follow focus and matte box can be attached. A sliding base plate is often used so that the position of the camera can be adjusted without removing the camera from the support.

When using any form of base plate, the attachment of the camera to the base plate and the base plate to the support are both vital, and both will have double locking mechanisms. Whichever system is used, always check the camera is secure and stable before you remove your hands.

> When attaching plates to cameras and supports, if there is a choice between using 1/4-inch screws and 3/8 ones, choose the larger, and if possible use both.

4A: ASSEMBLING THE CAMERA AND PREPARING TO SHOOT

(left) Locking mechanism (right) measuring scale, so if a camera set-up with a particular lens and set of accessories is balanced at a specific distance on one occasion, it will be quick to balance it by positioning it in the same place the next time the same set-up is used.

Various types of plates are available, including:

ENG plate ENG (Electronic News Gathering) plates are now fairly widely used. The plate has locating lugs. Attach the plate to the bottom of the camera, then place the camera, down onto the lugs and push it forward until it clicks into place, and check it is solidly connected. To remove the camera, pull the lever (usually red) and slide the camera backwards so it clears the lugs, then lift it off.

Dovetail plate: A dovetail plate is often part of a tripod. Attach the dovetail plate to the bottom of the camera, slide it in and lock it in place with a lever.

Quick-release plate: Some tripods have a QRP built into them. Or a QRP can be attached to the top of a camera head. A QRP is often used to connect the sliding base plate so it (and the camera) can be quickly attached or removed. QRPs are also used frequently when attaching cameras to Steadicams and other rigs. If you use the same system of quick-release plates (see below) for all your equipment, it is easy to quickly move the camera from one place to another.

When using a QRP, attach the plate to the bottom of the camera. Tilt it forward so the front fits under the triangular section, then put the back of the camera down until it clicks into place. There will be a second security button or lever at the back of the plate, which needs to be released for removal.

Sliding Base Plate: This allows the whole camera set-up to be slid forward or backward on the tripod for balancing or re-balancing, when different lenses are put on, or to slide the camera forward to make the attachment and removal of accessories easier.

Push button and pull lever across to release the quick-release plate.

The bottom half of the sliding base plate is a standard size, but the top half (known as the bridge plate) that connects to the camera is specific to the camera being used. If the wrong bridge plate is used, the camera won't line up correctly on the sliding base plate and it won't be possible to attach accessories.

Once the bridge plate has been attached to the bottom of the camera, to put it onto the sliding base plate, position the camera so it pushes the button down on the back left as you slide it on and

B: ESSENTIAL WORKING KNOWLEDGE

Make sure the camera and base plate/dovetail are at the same angle, so it will slide onto the base plate easily (this can be surprisingly tricky with a heavy camera setup). This is shown at an angle for demonstration purposes here, but the base plate should be on a flat surface or camera head.

push it forward. At the front of the sliding base plate is a lug that will stop it sliding too far forward. When you set up the camera, make sure you put this at the front.

Both the button and the lug are fail safe mechanisms, because the camera should always be locked into position with the lever at the side of the sliding base plate. It can take practice to quickly and smoothly slide a camera onto a base plate. The knack is getting the camera and bridge plate level, rather than tilted forward, as you slide it onto the base plate. Sometimes, lowering the height of the tripod can help, particularly if the camera is heavy.

Bridge Plate: As above, the bridge plate is specific to the camera you are using, and is designed so that the camera sits at exactly the right height and position to accept the bars, and any standard-size matte box and accessories. In drama-oriented camera kits, there are usually two bridge plates as part of a camera kit: one that will allow the bars to be set wider for larger 6-inch matte boxes, and one that is for bars set at a narrower distance to allow for the smaller (more widely used) 4-inch matte boxes. Some systems use even smaller matte boxes.

Here the ARRI Amira camera has two separate bridge plates attached, the top one is for narrower 15mm bars/rods, which are used to support lightweight accessories and a small matte box. The bottom wider bridge plate is for 19mm bars/rods, which will support heavier accessories and larger (usually 6-inch matte boxes).

If there is a mismatch and it is necessary to adjust the height of the camera, a riser or a 'cheese plate' which is a flat riser with lots of holes in can be added to the bottom of the camera to raise the height.

In this shot the camera is upside down so the bridge plate can be attached. This can only be done if there are no protruding accessories and the camera is stable and strong. More often the camera is held up by another assistant for the base plate to be attached, or placed upright while the attachment is made.

4A: ASSEMBLING THE CAMERA AND PREPARING TO SHOOT

Rods/Bars: Support the follow focus, matte box and any additional accessories. Rods are either 15mm or 19mm in diameter. It is important that the rods match the size of the inserts in the bridge plate and that the bars are long enough, so there is room to attach the matte box in front of the lens, but not so long that there is any possibility of them being in shot in a wider shot. Check by setting everything up during testing that the bridge plates, bars and matte boxes are all compatible. If you are using prime lenses and zooms, you usually need short and long bars with you. If you are using more than one set of bars, bridge plate and matte boxes, make sure you know which lenses require which and you mark up the boxes or put color-coded tape on them if necessary.

ASSEMBLING CAMERA ACCESSORIES

Once the bars are connected, slide or clip on the iris, focus and zoom controllers as required, starting with whichever one will be nearest the camera body, i.e. at the back of the lens. The guiding principle for positioning accessories is placing them so that they are easy to use, don't obstruct anything else and allow the aperture, zoom and focus to be used freely and lens and filter changes to happen quickly. Many of the accessories used have cables that connect them to the camera. Both the cables and the accessories should also look as neat and tidy as possible and not be protruding unnecessarily.

Both 15mm and 19mm bars/rods come in short and long versions. Here a lens support (which comes with the lens) is being clipped onto 19mm-long bars.

> *The camera should be low profile, without accessories or cables unnecessarily protruding and look clean, organized and professional. People notice.*
> Julian Bucknall[7]

Follow Focus

The follow focus is a device that uses cogs to turn the focus ring of a lens. (If you are using a lens that doesn't have gears, you can attach a gear strap, which is like a belt with gear notches around the lens.)

Put the follow focus on the 'dummy' side of the camera (not the operator's side, unless the situation requires you both to be on the same side).

Connect the cogs of the follow focus to the cogs of the lens. Many people connect them at the top of the lens, but if there is space connect them underneath so you retain a clear view of the lens and the follow focus doesn't obstruct anything else. Then engage the clutch at the back of the follow focus, which locks it in position, so the movement of the follow focus and lens correspond. Mark the minimum focus distance, and then specific distances (including infinity) on the ring, with a permanent marker. Temporary marks are added, usually with triangles, as needed for each shot.

(left) The follow focus cog is engaged at the bottom of the lens so it doesn't obscure the lens markings. (center) ideally in permanent marker put first mark at the minimum focus distance (right) then mark additional distances in permanent marker.

B: ESSENTIAL WORKING KNOWLEDGE

Different lenses have different spaces between focus distances, so you need to go through the same process and have separate rings for each lens.

Each time you change a lens, also change the focus ring, which pushes on and clips into place, then turn the lens to minimum focus, line up your focus ring at the same point and re-engage the clutch.

If the follow focus isn't set up correctly, or if it comes loose, it won't be possible to pull focus accurately. It is the focus puller's job to make sure that the marks on the lens and the marks on the follow focus correspond. Any play in the cogs must be tightened up using the screw at the back of the cogs. This may need tightening a couple of times a day to stay precise.

A speed crank, sometimes known as a toffee hammer, is useful if you need to pull focus quickly and you can stand next to the camera. If you need to operate the follow focus away from the camera and don't have access to a remote controller, you can use an extension whip (shown in C10). If you are far away or can't stay by the camera, a wireless follow focus system allows you to see the same focus information and pull focus. There are a variety of remote controllers including Preston, cmotion and Scorpio. They all need an electronic motor to turn the focus ring, a wireless transmitter from the camera and a remote unit that can be operated by the focus puller. When you assemble the motorized controllers, ensure that they don't obstruct your view of the lens markings, that they don't get jammed up with any other mechanisms, and that the gears mesh smoothly but firmly, so they don't jump out when being used, particularly if the camera is moving around vigorously.

Arrows are used to mark focus distances for a particular shot or part of a shot. The speed crank/handle shown can be used to pull focus quickly between focus marks.

(left and center) Separate motorized controls are attached to the zoom, iris and focus rings on the lens and connected to the wireless transmitter, (right) points corresponding to focal length, aperture and focus are programmed in and then controlled on the remote handset.

Setting up a remote controller uses the same principles as setting up a standard follow focus. Position the focus distance to infinity (∞), register that on the remote unit, then set a new point on the remote controller for each distance on the lens unless your system can calibrate the distances automatically for you (although you will always have to actively start the callibration). Some wireless models can remember the focus points for more than one lens, and can also control the focus, iris and zoom. These are called **FIZ**. They may also be able to turn the camera on and off. When remotely controlling the zoom, focus and aperture, a separate motorized system is connected to each of them, but the information is passed through a single wireless transmitter to the remote control unit.

CineTape

CineTape or equivalents create an autofocus system that can be instantly overridden and used as a standard wireless remote when needed. Set the 'bull horns', which are the distance sensors at the top of the camera (on a securely positioned magic arm or accessory plate), then set lens and focus distances on the remote controller, as above.

CineTape Bull horns on top of the camera and connected to the CineTape wireless transmitter.

The size of the matte depends on the focal length (and corresponding angle of view) of the lens. Always make sure the correct-size matte is on, to avoid seeing parts of the matte in shot. N.B. Because the matte is black, you may not immediately notice it.

Matte Box and Eyebrow

Matte boxes help keep the sun off the lens to protect it from flare. This protection is increased if a matte is clipped onto the front. Different-size mattes are available for different focal length lenses.

If you aren't using mattes or for additional flare protection, an eyebrow is attached to the top of the matte box, to help keep light off the lens. Check by looking into the lens from the front of the camera (without blocking the light yourself), to see if any stray light is hitting it before the shot is taken. Do this again after any changes to lighting or camera position.

B: ESSENTIAL WORKING KNOWLEDGE

Matte boxes also hold filters and are described by the size of the filters they hold, and how many filter trays they have, e.g. 6-inch 3-tray matte box. Some matte boxes also have additional rotating filter trays, which can allow polarizing filters to be turned to the best position for the polarizing filter to do its job of reducing reflections.

Most lenses become physically longer when the focus distance increases, and zoom lenses also become longer when the focal length is increased. For this reason, the matte box shouldn't be positioned right up to the front of the lens if there is a chance the lens will then extend forward. Find out the longest focal length and the maximum distance you will be focusing at. Set the lens to that position, which will be where it is protruding furthest, and then position the matte box so it is very close to it. To avoid a gap between the lens and the matte box, which could let in light and so create flare, there is usually a rubber connecting section called a donut, which slots into the back ring of the matte box and sits around the outside of the lens and allows for a little movement as the focus or zoom changes. There are different sizes of donuts that can be used with different lenses. When this system doesn't work, an even more flexible fabric version is available, which looks like a hair scrunchy but is broader. The objective is to not let light come through to the lens, so if these aren't available you can use a cloth and clips.

Matte box with eyebrow/French flag at top and sides to stop light hitting the lens, and filter number written on tape stuck to the matte box. The matte box is slid onto the camera bars and then swung out or slid off again to change lenses when needed. Most drama crews write the filters that are currently being used on the side of the matte box for quick reference, because filters may affect exposure and color balance.

The eyebrow/French flag is attached onto screws at the top of the matte box.

Lens donut to stop light from behind the camera bouncing back off the filter and causing flare.

Filters

Filters are put into filter trays to fit into the matte box. Filter trays are square for all filters, other than graduated filters, 'grads'. The rectangular filters used for grads allow you to move the filter up and down, so the light can be cut from the desired part of the frame and the transition (which can be soft or hard) hidden along a suitable point.

> **If you have several filters on the camera, the usual best practice is to put the diffusion filter at the back (closest to the lens), the ND filter in the middle and any color or color temperature filter at the front.**

If there are not enough filter trays, you can tape two filters together and slot them into the matte box without the filter tray. However, take care they are properly taped in from underneath and are taped around the edges so they don't directly touch the slots and get scratched. It is also possible to create a 'petal', which is a circle of tape attached to the front of the lens and cut to create sticky supports to attach the filter to a lens if necessary.

Some cameras have internal filter modules (IFMs) that are part of the lens mount. If a camera has an IFM, there must always be either a filter or a dummy filter in it to keep the distance between the lens and the sensor correct.

BALANCING THE CAMERA

The camera should be positioned so it is balanced and doesn't tilt forward or backwards when the locks of the camera head are off. It should be balanced when it goes onto the head, and then again when all the accessories have been put on. The balancing mechanism available on some tripods may be sufficient to adjust it when swapping between prime lenses, but will not be adequate when heavy zoom lenses are put on.

Some heads include measuring guides so you know and can record exactly where the head has been positioned.

Having a camera properly balanced is not only safer but it also makes operating easier and more consistent.

(top) Filter being placed in a filter tray. (bottom) The filter being slid into the filter slot. Here each slot has a (silver) locking mechanism at the side of the matte box to hold it in position, and a (black) release mechanism.

Well-balanced camera set-up. Photo by Jason Youngman.

B: ESSENTIAL WORKING KNOWLEDGE

(left) Key camera settings are displayed around the monitor or viewfinder image, (center) menus are set up on the cameras flip-out LCD screen if it has one or (right) on the camera body.

CAMERA MENU SET-UPS

Online simulators, such as the ARRI,[8] simulator or the Canon equivalent, can be used to learn the settings on most cameras. A summary of the settings can usually be seen around the monitor image.

Many camera crews also write or display this information on the back of the camera so it is visible to all when shooting.

Certain settings usually remain the same for the whole shoot, such as aspect ratio, resolution and recording format (although sometimes these change, particularly if you go high speed). Others, such as shutter speed, white balance and shutter angle, may change from shot to shot or scene to scene as per the DP's directions.

The functions of the following settings within workflow are explained in C5. You should use online simulators to practice using and setting the following:

- Resolution
- Recording format and Aspect Ratio if set separately
- Codec
- Bit rate if available
- Frame rate
- Shutter angle
- ISO
- White balance/Degrees Kelvin
- Black balance/Shading
- Time code
- Camera number

Also make sure you can adjust:

- Overlays for action-safe areas in the viewfinder
- Focus peaking
- False color
- Audio channel levels and whether to have audio recording on or not

Black balance/shading is also part of the camera set-up and preparation. (See C3 and 4b.)

CLEANING THE CAMERA AND EQUIPMENT

The camera body, matte boxes and accessories can be cleaned with a cloth or brush. Separate brushes are kept (covered) for cleaning the lens and the camera body. Some people use compressed air, but it is essential that no dust is blown into the fan or grill of the camera, so a cloth or brush is preferable.

You should avoid letting media drives or media slots get dirty, but, if they do, use a brush or cloth to clean them. Do not attempt to clean media drives if there is data that hasn't been backed up on them. Pass this to production for the post house to attempt, and alert production that there may be an issue transferring. This is particularly important if there is dirt on the contacts. For a media drive that doesn't have data on, you can use a dry lens cloth to gently clean the metal contacts, but be sure to test it before it is used, because the soft metal the contacts are made of can easily be damaged.

Lenses and filters: Keep lenses covered when not in use, and away from dusty, humid or polluted environments. Avoid touching both the front and rear elements, to avoid leaving fingerprints on lenses.

1. For any light dust or dirt on the lens, use a blower brush, a camel hair lens brush or a lipstick-style camera brush that retracts and has a cover that keeps it clean.

2. A dry lens tissue can be used as an alternative to a lens brush, but don't apply pressure, because you may grind in dirt and scratch the lens coating. Only use a tissue once.

3. If this doesn't clean it, put a drop of cleaner on the cloth first (not on the lens first); only a drop, because too much lens cleaner leaves a residue. Wipe the lens or filter gently in a circular motion, working outward from the center, which will remove or move debris to the edges of the image circle, where it will be less intrusive. When wiping, apply only enough pressure to remove the smudge. Keep lens cloths clean in a bag and wash regularly.

Eusebio A. Cabrera Jr, cleaning the camera filter between hand-held takes.

4. If you get residue smears from over-cleaning, these can be reduced with a lens pen, but ask the camera house to clean it off if possible.

5. Clean the rear element in the same way, but clean rear elements as infrequently as possible, to reduce the risk of lens cleaner residue smudges or damaging the lenses.

6. Clean the lens caps, too, so you aren't immediately re-introducing dirt to the lens.

7. Don't use eyeglass cleaner or tissues or rubbing alcohol.

8. Keep your lens cloths or tissues in a sealed bag, so they don't get dirty.

9. A dirty lens barrel will not degrade image quality, but keeping the lens barrel clean helps avoid issues with dirt getting into the mechanics of the focus and zoom mechanisms. Use a brush, lens cloth or tissue and, if necessary, lens-cleaning solution to keep it clean.

10. Keep your camera bag clean, to avoid dirt getting in when items are inside.

> **Glass is relatively hard and durable. but lens coatings are far less so. They can be damaged by scratches and chemicals, including non-specialist lens cleaners, and pollution or anything else suspended in the air from hairspray to smoke.**

> **Any dirt or marks on the rear element are most likely to cause a problem because of the way that the light is focused narrowly through the back of the lens. Dirt on the front element of a lens is more likely to show in the shot on a wide lens than a longer one.**

B: ESSENTIAL WORKING KNOWLEDGE

Sensor cleaning

Stop down lens to f22, point camera to a flat light source such as a light box or cloudy sky, run the camera at 24/25fps or slower, and look through the viewfinder to see if you have any specks of dirt on your sensor; which will appear as marks on the frame.

- Don't clean the sensor unless there is visible dust or marks on your images.
- Remove the lens (in a dust-free environment), open the shutter and shine a light onto the sensor.
- Use a specialist tool such as the arctic butterfly charged sensor brush, which spins to create an electric charge that will hold after you turn the brush off and put it near the sensor. The charge creates static electricity so it will attract the dust. If that doesn't do the trick, clean the sensor very gently with a specialist sensor cleaning lint-free swab. If needed, use two drops of sensor cleaning solution, not lens cleaner, which is more likely to leave residue.[9]

Sensor cleaning swab – always keep sealed until needed.

THE CINEMATOGRAPHER'S TOOLBAG

- Pan/Gaffer Glass (to look at lamps and particularly the sun without hurting your eyes)
- Laser pointer (to show where you want lamps and light to be)
- Sun seeker/flight logistics type app (to see what direction the sun will be coming from at any time of day in any location)
- Director's viewfinder/Artemis or similar phone app (to block/devise shots without the camera)
- Food bars, hot/cold/rainy weather kit and comfortable shoes

THE CAMERA ASSISTANT'S KIT

Assistants carry a range of equipment used for the following purposes:

- **Focus:** laser or traditional measuring tapes or tools. Sausages for marks that actors feel rather than see, chalk, colored tape (each actor has different color). Apps for distance and depth of field calculations. Additional focus rings for follow focus if needed.

- **Helping position things:** Wedges, gaffer tape plus 246s, (which are blocks of different heights that can be used to raise objects so they are in a better position in the frame), but only if there is no props or art department (who would normally have them) on the shoot.

- **Shot marking or idents:** Clapper board or digital slate or apps for marking.

- **Reconfiguring equipment:** Allen keys, screwdriver, Swiss army knife, Stanley/utility knife.

- **Holding things together:** gaffer tape, crock clips, elastic bands, cable ties.

- **Cleaning:** Dust air, lens brushes, equipment brushes, lens cleaner, lens tissues, lens cloths.

(top left) Various tools for creating marks, (top right) measuring tools, (bottom) dust air, croc clips, camera tape and assistant's pouch in camera assistant's bag.

- **Protecting:** Rain covers, ground sheet, cloths for drying off kit.
- **Apps or tools for calculations:** Speed, frame rate shutter angle, filter factors, etc.
- **Record keeping:** pens, notebook, camera report sheets or apps.
- **For preventing flare reaching the camera:** Mattes for the matte box, French flag, Anti flare (black wrap, used to block light, can also be handy).
- **Calibration:** Charts, gray scale.
- **Other:** Marker pens, torch, WD-40, scissors, mirror (allowing you to see things you can't reach), food bars, hot/cold/rainy weather kit and comfortable shoes.

N.B. Focus rings, mattes and 246s are not usually owned by the ACs.

EXERCISES: Practice setting up, configuring and reconfiguring cameras. Compare your speed with others and help each other to improve your efficiency. Make sure you can assemble:

- Tripod, head
- Base plate and/or sliding base plate and a quick-release plate
- The camera body, viewfinder and monitor
- Magic arms
- Batteries
- Recording mags or external recorders
- Follow focus, zoom control, including remote options and changing focus rings
- Matte box, filters and eyebrow/French flag
- Bars/lens rods
- Prime and zoom lenses, change them quickly and select and use the correct follow focus rings or adjust the wireless calibration for them
- External recorder
- Lockit box for wireless sync lock to other devices and sound or another device
- Run stop cable

NOTE

1. Roberto Schaefer ASC AIC (DP) in discussion with the author (September 2016)
2. Grahame Wood (executive coordinator, The Camera House, LA) in discussion with the author (March 2017)
3. Georgina Burrell (DOP/shooting PD georgieb.tv) in discussion with the author (May 2017)
4. Luzi, Evan. "A Beginner's Guide to Basic Steadicam Positions". *The Black and Blue*, 2017. http://www.theblackandblue.com/2014/01/09/basic-steadicam-positions/
5. Momentum Productions. "How to Balance a Glidecam (Steadicam, Flycam, Laing, Wieldy)". *YouTube*, May 29, 2016. https://www.youtube.com/watch?v=63u1ucCydVM
6. Aperture. "7 Essential GIMBAL MOVEMENTS in 4 Minutes". *YouTube*, July 12, 2016. https://www.youtube.com/watch?v=wv9mTkE_xTA
7. Julian Bucknall (1st AC) in discussion with the author (September 2016)

8 Arri. "The ARRI ALEXA Camera Simulator, SUP 11.1". Arri, 2017. http://www.arri.com/camera/alexa/tools/alexa_camera_simulator/alexa/

9 Radev, Vlady. "Some Simple Tips On How to Clean Your Camera Sensor". *4K Shooters*, March 5, 2015. http://www.4kshooters.net/2015/03/05/some-simple-tips-on-how-to-clean-your-camera-sensor_right_away/

4b
Camera Preparation and Testing

Camera preparation is essential to check that you have all the equipment you need, it works as it should and that the many and various accessories are compatible. Testing allows you to see what type of image a camera or lens produces and whether it is appropriate for the look you want and the situations you will be shooting in. This chapter guides you through camera preparation and testing, as carried out by the camera assistant or the cinematographer.

> **LEARNING OUTCOMES**
>
> *This chapter will help you:*
>
> 1. Prepare an appropriate camera kit for a shoot
> 2. Understand what each type of lens or camera test will tell you
> 3. Shoot lens tests
> 4. Shoot camera tests
> 5. Shoot low light and dynamic range tests

How much testing you do depends on the type of shoot you are undertaking. You may spend anything from 15 minutes checking your lenses and equipment before a day's run and gun shoot, to a week or more before a feature. Testing can be carried out either in 'ideal' test conditions or in the situation you will be shooting in.

Testing equipment prior to a shoot is to ensure that:

- The equipment is working as it should.
- Everything you need is in the kit.
- You know how to put it together quickly and efficiently.
- All moving parts are working smoothly.
- You know what the limitations of your equipment are.

> *Today [testing] is not just about how your camera will perform in ideal conditions but in the conditions you will be using it, and all the way through the post-production pipeline.*
> Petra Korner[2]

The more you know about the shoot, the more relevant you can make your tests.

Don't go by anything written on the lens. Calibrate your own aperture and focus. Ignore the dynamic range in the sales literature . . . trust what you find when you test.
Oliver Stapleton[1]

101

B: ESSENTIAL WORKING KNOWLEDGE

Test lenses for: the look they create, their resolving power (see page 104), contrast and flare behavior, focus accuracy and how well they match to create a set. Test cameras for: dead pixels, dynamic range, low-light performance, high speed performance and flicker if needed.

Also test: The workflow, by shooting and grading test shots, putting them through all the key stages they will go through in post-production. Also test for the specific looks you want to achieve, which may involve shooting skin tones, and being on location and creating a LUT (see C5 and C14).

> Many DPs often just specify the lenses and camera they want and the 1st AC orders the rest.

CHECKING AND PREPPING THE EQUIPMENT

Even if you are familiar with all or most of the kit you are using, and even if you own it, check it before each shoot starts.

- Check that everything you are expecting is in the kit, and that all the accessories for every type of shot you anticipate possibly needing are there.

- Add any rain, heat and safety protection required and extra cables (usually one spare for each) and as many batteries and other equipment as needed to ensure you don't run out of power.

- Check that the lenses and camera, legs sliders, base plates and everything you are using are fitting together as easily and securely and smoothly as they should. Put WD-40 on legs and rails/bars if not smooth, or swap them for different ones.

- Check that no cable connections are loose or failing.

- Make sure you can configure the equipment as needed for all the situations you can envisage in your upcoming shoot.

- Label all the boxes and on lens boxes, specifying which lenses are in which box. Color-code (usually with electrical tape) the equipment for A Camera, B Camera, etc.

- Make a list and/or take photographs of what is in each box, so you know what should be where when it is returned after the shoot.

- Mark up focus rings for the follow focus and calibrate the wireless/remote focus.

- Check the sensor is clean and clean if necessary (see C4a).

- Practice using the menu system.

- Check you know what the primary settings for the shoot (recording format, resolution, frame rate, etc.) will be and that you can set them. Touch base with the sound department to check that you are both expecting to work at the same frame rate, to avoid difficulties in syncing up and post-production.

> *There are so many third-party accessories. Even an experienced AC can often find themselves working with new pieces of kit. They all fit together in different ways, you can be surprised. They are not always the most logical.*
> Charlie England[3]

> When testing, you have a chance to play and learn about the kit in a less pressured environment. You also get to know the people working in equipment hire houses.

(left) A small LCD monitor is either part of the camera or attached as an accessory to display the shot, settings information and frame lines, (center and right) frame lines, title and action safe areas. Photo courtesy of Liquid Productions.

Charlie England 1st AC: One-day test for a four-day commercial

- I arrive (at the camera hire house), call up my email with the DP's equipment list, check if everything on the list is there and follow up with rental house about anything that is missing or due to be added later. I order any extra bits I think are needed and double check with the DP if there is anything else that they want to add to the list.

- Open up the first camera body box and test all cables. I make sure there are 2 power cables and 2 cables for the block battery, 2 eyepiece cables for digital eyepiece and that there is a right-angle connector for the eyepiece to make camera profile smaller.

- Check the on-board batteries and battery plate.

- Put all accessories on camera – the wireless controls, CineTape, HD wireless video transmitter, etc. – and check they all work properly.

- Put a card in camera and check it is recording okay.

- Go through all menu settings in camera and set them up as per the DP's instructions: fps (frames per second), shutter angle, Kelvin (degrees/white balance), ISO and Resolution.

- Go through all menus and assign the user buttons I think we will want during the shoot (user buttons allow you to assign a menu function to a button on the outside of the camera to make it immediately accessible during the shoot without going into the menu and through the pages).

- Set up digital frame lines as above for aspect ratio and find out if the DP likes a cross or dot in the center of the image or needs any title or action safe lines.

- I copy the info onto an SD card so it can be pasted onto a second camera.

- Set the camera up at 6 feet from the lens chart to check the lenses are focusing at where they say on the barrel. If not, I ask the camera house to collimate (adjust the back focus) of the camera or identify any other lens problem.

- Make sure there is a set of plastic rings for the remote focus, and mark up a ring for each lens.

- Check all the matte box options for each lens (i.e. that the correct rails and filter trays and mattes are included and that the mattes don't show in frame on the lenses they are meant for) and that I have all the bars' base plates, risers and all the relevant reduction rings. Check there are also clip-on matte boxes.

- Make sure there are 2 battery chargers and all the batteries are charged.

- I always make sure there are block batteries and a battery belt as well as on-board batteries.

- I like to leave the camera built, so request a 'coffin' and have foam put around it so it doesn't have to be broken down when we move.

B: ESSENTIAL WORKING KNOWLEDGE

DEAD PIXEL TEST

Dead pixels can be sorted out in post-production, but it is far less complicated to do it before the shoot. Shoot and view back a black card. Dead pixels usually show up as white spots.

During black balance procedure (which is usually pressing and holding the black balance button for 3 seconds when the port cap is on), there is an auto pixel check which can usually, but not always, clear dead pixels. You may need to repeat several times. Even if there are no dead pixels, you should black balance the camera.

LENS PERFORMANCE TESTS

Lens tests sound complex but the more familiar you become with the process, the easier they are and the quicker you will be. It can vary, but usually camera assistants shoot tests for lens consistency, resolution, color fringing and focus. Cinematographers shoot tests for color rendition, dynamic range, low-light performance and flare and bokeh effects.

The aim of lens performance tests is to find lenses that:

– Have good resolving power to define details throughout the frame and match the other lenses you will be using well enough to create a set.

– Focus at the distance marks on the barrel.

– Match each other in terms of brightness and resolution.

To test lenses, compare how they perform in the same conditions by shooting charts or subjects that challenge the lens to show fine details, separate colors evenly and render skin tones accurately. A low budget option is to do this with objects such as a dollar bill and paint charts, but it should ideally be done using specialist charts

- Set up charts in a controlled environment, light the parts of them that will be in your test frame evenly, shoot at the same aperture on each lens and shoot 10 or 15 seconds of footage, then compare the results on the best monitor you can access.

- Put an ident board on each test stating what lens, focal length, aperture, distance and filters you are using so you know what you are comparing when you view the tests.

The specific tests depend on the need of the shoot. Unless the DP requests additional tests, ACs usually use the one chart lens sharpness, color aberration and focus test (as below). Other tests have specific purposes and, if desired, you can test for several things at once by putting up several charts.

The port/body cap must be on when dead pixel test or black balance is carried out. It should also be on at all times there is no lens on the camera.

Test charts should have fine details both in the central areas and at the edge of frame. The fine details allow you to compare performance of lenses. This chart is also suitable for the finer comparisons needed for back focus testing by engineers, but can be equally used by camera assistants. Chart courtesy of DSC Labs.

Lens Sharpness and Color Fringing Test

This shot shows the lens is sharp at the center but not at the edges of frame so is not suitable for shooting. There will be some softening at the edge of frame on most lenses but the amount varies depending on the quality, manufacturing and condition of the lens which is why tests are carried out. (The softening has been exaggerated here for demonstration purposes.)

Color fringing appearing at the edge of frame, making the blocks at the edge appear bluer than those at the center. Lenses with color fringing should be avoided, particularly for color-sensitive and VFX work.

Using a Siemens star chart or equivalent shoot tests to assess the 'sharpness' or 'resolving power' of a lens: its ability to separate lines that are close together.

- Compare the images produced on playback by looking at the center and at the edges of the frame to find out if the lens is sharp and how far out from the center it remains sharp. You will see how far out from the center the lens remains sharp.

- Look closely at the fine-detailed areas towards the edges of the frame to see if any colors (usually blue) appear. This is called color fringing.

- Check for differences between the brightness of different lenses when set to the same aperture, ideally by looking at a waveform monitor when shooting, to see where the IRE level is for each lens. Note down the differences in brightnesses and either adjust accordingly when shooting or, ideally, find lenses that match.

Focus Tests

- Put a chart, ideally including a Siemens star pattern or equivalent with a black border, on a flat wall.

- Position the camera so the distance between the focal plane/sensor marker on the camera and the chart is exactly the same as the closest distance marked on the lens. The chart should fill all or most of the frame.

- Open up the aperture as wide as possible (to minimize depth of field). Shoot 15 seconds.

Focal plane marker on camera.

B: ESSENTIAL WORKING KNOWLEDGE

- Now eye-focus and check if the position you place the focus ring when you eye-focus is the same as the distance on the lens. Whether it is or not, shoot another 15-second test where it is in sharpest focus by eye.

- View back (ideally on a large and sharp monitor) so you can see if the lens focuses properly at the distance as marked on it, or if it is better where you eye-focused if that distance was different.

- Check at three further distances between 4 feet and 12 feet.

- Repeat on different lenses.

If the eye focus and the distance don't match, you shouldn't use the lens. It should be sent back to the hire company for re-calibrating to correct any discrepancies.

Zoom Lens and Drift Test

- This is the same test as the focus test but, when testing with a zoom lens, test focus at several focal lengths: the longest, the shortest, and at least two others.

- Additionally, shoot test shots while you are zooming, to check that your lens remains focused at the same point throughout the zoom.

> Some faulty cinema lenses won't hold focus, and many still lenses are not parfocal, i.e. they will lose focus during a zoom.

- Also check if the lens focuses at infinity (which, depending on the lens, is where you focus for anything over approximately 30 feet). You will usually need to take the camera outside to do this.

The closer to the center you can distinguish the lines the sharper the lens. The softening has been exaggerated in the bottom frame for demonstration purposes.

> It is crucial to also check the lens focuses at infinity because, whilst you might be able to work around barrel distances not matching actual distances, you can't work around a lens that won't focus at infinity.

- When playing back, also look closely at the black border or lines at the edge and see if there are tiny lines of different colors at either side of the border, which show color fringing.

If the lens distances are out and/or the lens doesn't focus at infinity, it is because the distance between the lens and the sensor is not correct. This is known as the back focus. This may be because it is not properly seated on the lens mount. On some lenses, even tiny pieces of dirt on the mount can throw off focus. Check this first.

If the focus remains out, then the distance between the lens and the sensor is out due to either the fitting of the lens mount or other reasons. Back focus is usually adjusted by camera house staff not by ACs.

4B: CAMERA PREPARATION AND TESTING

Bokeh Test

Bokeh is the circles that appear around lights when they are out of focus. The more out of focus, the larger the bokeh.

- To test the look of the lens bokeh (which can vary between lens ranges and individual lenses), include fairy lights, a practical lamp and ideally a lens chart in a test shot.

- Shoot the same shot on different lenses and at different apertures.

- Place a practical lamp near the camera and pull focus to it, so that the charts and fairy lights are out of focus. View the shots from each lens at each aperture to compare the bokeh on the fairy lights and check that the practical lamp remains sharp and bokeh-free.

Bokeh. Photo by StockSnap.

Anamorphic Lens Tests

Anamorphic lenses often vary considerably from lens to lens and are almost invariably less sharp than spherical lenses.

- Compare test shots of a face on different lenses.

- Look to see if the, almost inevitable, loss of sharpness from top to bottom and side to side are acceptable and consistent across the lenses in a set.

- Test for flare and bokeh on anamorphic lenses, both of which are usually more pronounced than on spherical lenses and vary considerably from lens to lens. Test until you find a set that matches well together.

Lens Flare Test

Particularly if you want flare, as a creative effect, in some shots in your film you should test to find the effect of this technique, because the combination of the sensor, the lens and the coatings on the lens makes a great deal of difference to the resulting flare.

- Shine a flashlight into the lens from different angles and down the middle of the lens.

- Shining the light straight down the middle/barrel of the lens also tests for 'black sun' effects. This happens when a bright highlight (like the sun) inverts and turns black on screen. This mostly happens on lower-grade cameras and is somewhat fixable in post, but best avoided if possible.

(top) Shining light into the lens creates flare, (bottom) flare diffuses the image and reduces the contrast in all or part of the frame and can create rings or spots (artefacts) as shown here.

FILTER TESTS

The effect and look of any filters you are thinking of using can be tested with comparison tests. Shoot the same shot, ideally including a lens chart, but more importantly including a person, so you can see the effect on skin tones. Shoot tests on all the lenses you may be using to see what effect they have on each, because the effect can vary depending on the lens construction and coatings.

B: ESSENTIAL WORKING KNOWLEDGE

IR Pollution Tests For ND Filters

Infra-Red (IR) pollution can occur when a standard ND.9 or more is used to reduce the light reaching the camera (each .3 ND reduces the light by 1 stop, so a .9 ND will reduce it by 3 stops). The ND filter blocks the visible light but there is light that is outside the visible spectrum (including infrared light) that standard ND filters are not designed to block. This can result in distortions of the colors in an image, blacks look brown, the overall image may look oddly orange and there may be a lowering of contrast. It is often impossible to get rid of these effects of infrared light in post-production, so IR pollution should be checked for. IR or IRND filters are designed to counteract infrared pollution. Some cameras have IR filters built into their chips and in due course more cameras will do so, but in the meantime you should still test to check that they are as effective as they should be.

Hot mirrors are an alternative to IR filters. They reflect IR away rather than absorb it, but reportedly *may* cause issues on reflective surfaces. This would be difficult to test for, so an IR or IRND filter may be safer if you have many reflective surfaces where you are shooting.

> In addition to IR contamination, there can be problems of color bleeding with cheap filters.

- It is easiest to spot IR pollution on black, so put together a selection of black materials that reflect light differently.
- Shoot a control test with no filter.
- Increase the light level so you can shoot at the same aperture with your heaviest ND filter on.
- Shoot with ND .6, .9, 1.2 and 1.5 or higher if you know you will be using very strong filters.
- Compare the results side by side.
- Test different brands or combinations of filters to find the option that doesn't distort the look or colors.

Variable ND Tests

Variable NDs are screw-in filters. They are a circular polarizer and a linear polarizer that each remove light coming from one direction. Because each removes light from one direction, they can be aligned to block most, or even all, the light reaching the lens. This can allow you to open up your aperture to shoot wide open for a shallow depth of field, when working in very bright light levels. Unfortunately, variable filters can cause an X-pattern and vignetting, when used at wide angles or at the minimum and maximum ND densities. The degree to which this occurs varies between filters and, in general, the cheaper ones can cause more problems. Be aware that, unless the variable ND is an IR variable ND, there can also be IR problems. It is essential to test variable NDs before shooting.

An X-pattern is often created when working at high light levels and/or wide angles with a variable ND filter.

- Attach the variable ND to the lens.
- Find or create a scene with a range of light levels, so each time you adjust the ND level a different area of the frame will be 'correctly' exposed.
- Dial in the ND effect, stopping at different strenghts.
- Watch back to see if X-pattern occurs.
- Check at different apertures.
- Check at different focal lengths.

4B: CAMERA PREPARATION AND TESTING

Many of the tests above can be carried out by camera assistants' but cinematographers should test the elements that go together to create the look or looks of a film. However much experience you have as a DP, it is important to test before each film, because the look you get is the result of the interrelationship between the camera, the subject, location, and the combination of camera, lenses, filters and lights you use. Tests are particularly important for skin tones and colors, and to test any techniques or effects that you have not previously used.

Cinematographers usually perform tests to:

- Find the dynamic range of the camera at various ISOs.
- Test the color rendition of different lenses, particularly on skin tones.
- Test how lenses flare.
- Find how much bokeh they produce around lights and what it looks like.
- Test anamorphic lenses for distortion.
- Test for flicker if using unusual light sources or lamps or working at high speed (see C8).

COLOR TESTS

Using a color or skin-tone chart.

- Check color rendition, i.e. the lens's ability to produce the same colors by shooting color and skin-tone charts on different lenses and at different apertures.

- When reviewing the tests, pay particular attention to the rendition of any colors or skin tones that will be important in your shoot. Check color tests on a color-calibrated monitor that can simultaneously display a vectorscope that will help you see exactly what colors are being produced and if they match (see C14).

DYNAMIC RANGE TEST

Knowing the dynamic range of your camera allows you to know how bright and dark the areas in your frame can be and still retain detail. This test is a great help when you will be working in situations where you will see both bright (usually sunlight) and darker areas, e.g. indoors.

There are two ways to test dynamic range:

1. Using a gray scale chart.
2. Using a high contrast environment.

Checking dynamic range on gray, black and white charts

To test the dynamic range of your camera, David Mullen ASC[4] advises:

- Make sure you shoot at whatever is the widest dynamic range recording format the camera offers, usually RAW or Log.

- But also perform the same test in Rec.709 display gamma range, just for comparison, so you can judge how much extra you are recording than what you see on the monitor (C11a).

(top) Macbeth Color Checker, (bottom) Camera Belles chart. Courtesy of DSC Labs.

B: ESSENTIAL WORKING KNOWLEDGE

- Put a white card and a black card on each side of an 18% gray card.
- Make the black card as dark as possible (some people use non-reflective black velvet in a shadow box).
- Under-expose in 1-stop increments, and shoot 10 seconds at each stop.
- View your footage to find out how many stops you have under-exposed by, until you can't see any difference between the gray and black card. This tells you how many stops' dynamic range you have below 18% gray.
- Then over-expose in 1-stop increments until you can't see the difference between the white and gray card. This tells you how many stops' dynamic range above 18% gray.

Checking the dynamic range in the field

Dynamic range, low light and flare, summarized from MovieMaker:[5]

- Set up a shot in which you can see a person, either the wall or a curtain inside the room, and something with a lot of detail outside it. Make sure you also include some bright sky, so there is a huge range between the brightest and darkest parts of your frame.
- Use a spot meter, or zoom into the exterior to get a meter reading on the bright sky, or a bright part of the wall outside the window (see C11a for metering techniques).
- Take a reading on the person's face inside, with no lights on.
- Compare the readings to find out how many stops apart they are. There may be 16 or more stops' difference between the person's face and a very bright sky, or less if you are reading the wall of a building.
- Adjust your exposure so the bright sky or the bright wall is acceptably bright and not blown out. If you can't see the face, then the dynamic range is outside the range of the camera.
- Add 1 additional stop of light by using a reflector or shining a light on the person. Check it is exactly 1 stop, using your meter. See how many additional stops you need to add to get back in range, so the exposure of both the person and the outside wall or sky are acceptable, i.e. remain appropriately bright or dark but retain detail.
- The number of stops' difference between your person and your wall or sky is the dynamic range.

This is a quick and easy method of calculating dynamic range and whilst it would be more technically accurate if the inside and outside surfaces were the same color it remains a very useful test.

(top) Exterior and interior are both outside the dynamic range, (center) exterior brought into dynamic range, (bottom) interior brought into dynamic range.

LOW LIGHT TEST

This is particularly important if you are shooting low key scenes, where a large portion of the frame will be dark, particularly if you don't have enough light to allow you to expose a little higher and bring the level back down in post or you have to keep the light levels low so you can see candlelight. Find a small space with plenty of objects and detail in. Place a dimmed practical lamp or small torch, to create light equivalent to a couple of candles, to create a lit area which doesn't light up the whole room.

- Take a meter reading of the objects away from the light sources and the objects near the light sources.

- Have someone walk through in dark clothing with a flashlight on. Have them occasionally shine the flashlight onto certain objects, then shine it right into the lens as if searching for something.

- Repeat at different ISOs, starting from 100 and raising it until you are sure you can see the detail in the objects in the room.

- When viewing the footage, what you're looking for is not whether you can see the person clearly in the dark, but how much video noise you have to be willing to accept in order to see detail in the room.

- Note which ISO gives you an acceptable noise level. If you are going to also include bright areas in your low light shots, re-test the dynamic range of the camera at this ISO level, because the dynamic range is reduced when you raise the ISO.

- Look at how the objects react to being lit by the flashlight, and how the flashlight appears when it is in frame. Spectral highlights/reflections and the flashlight itself may well be clipping, i.e. being exposed at a higher level than your camera can record. See how the clipping appears in your finished image and whether you need to reduce the level of the flashlight or other light source you are using to get acceptable results.

SPEED AND FLICKER TESTS

As well testing for flicker, you may wish to test for the effect of different frame rates for slow or fast motion and for the effect of shutter angle on the look of the film (see C8).

GRADE TESTS AND CREATING A LUT

After you have selected your camera and lenses, you should find or create a LUT, to test how your in-camera choices will combine with post-production options, to create the look you want for your film (see C5b and C14).

NOTES

1 Oliver Stapleton BSC (DP) in discussion with the author (July 2017)
2 Petra Korner (DP) in discussion with the author (September 2016)
3 Charlie England (1st AC) in discussion with the author (September 2016)
4 Mullen, David ASC. "How to test the dynamic range of a camera." *Cinematography.com*, June 12, 2017. http://www.cinematography.com/index.php?showtopic=74722
5 Behar, Suny. "How to Perform a Camera Test: Narrow Your Focus to Three Simple Things". *MovieMaker*, February 17, 2016. https://www.moviemaker.com/archives/mm_guide_2016/how-to-perform-a-camera-test/

5

Understanding and Managing the Digital Workflow from Camera to Screen

Workflow is the plan for what happens to your footage at every stage, from shot to screen. It is the series of interrelated choices, from recording resolution, frame rate and recording format used in the camera, to how the footage is prepared for editing, VFX and display. Decisions made when filming affect what can or can't be done with the film during post-production, as well as where and how it can be screened. Choosing the optimal workflow is important for every type of production from major feature to web video. This chapter will help you create a plan that can be followed and checked against, so you can identify if and where problems arise. It will also help you understand the terminology and meaning of any specifications given by the production. Not all workflow decisions are technical; some practical factors can make the difference between a smooth or difficult post-production process. The decisions a DP needs to make at each stage of the production and in post-production are detailed. The chapter finishes by looking closely at how to work with a colorist to make the most of the huge creative toolbox now available to adjust and enhance the image after you have shot it.

LEARNING OUTCOMES

This chapter will help you:

1. Know which technical decisions made in pre-production and practical decisions made when shooting will affect what can be done with the image in post-production

2. Understand what the DP's role is at all stages of the post-production

3. Identify the difference between Log, LUT and RAW recording, how to assess which is right for your production and how to shoot for each

4. Select the most appropriate resolution and compression for your shoot and workflow

5. Be clear on how and where image 'quality' is created and maintained

6. Understand the principles of log encoding, compression, bit rate, bit depth, and how image files are transformed at the different stages of post-production and when preparing for display on different viewing platforms

7. Understand what a color gamut it, how display devices vary and the role of the colorist in ensuring that the optimal range and balance of colors are shown when the film is screened

8. Understand the role of the colorist, how to work together effectively and the scope of what can be achieved in grading

9. Understand the importance of viewing each format that the film will be screened in and what issues may arise

B: ESSENTIAL WORKING KNOWLEDGE

You find out what is happening to the images after you have shot them; what the commissioners have in mind, in terms of post-production. If working in a fast turnaround environment, with little post-production requirements, you produce images that are closest to being ready for display. If working with post-production, especially if that includes VFX, you work with the most flexible and highest-resolution format you are able to, and work in conjunction with a post house supervisor. You will need to work together on this.
Andrew Boulter[1]

To create the optimal workflow for your production, you need to know how the images you create will be used and where the finished film will be screened. Films are usually screened in multiple formats, from cinema to TV to web and mobile phone. Each viewing platform will probably display different dynamic ranges so brightnesses may have to be altered. They also display different ranges of colors known as color gamuts. If you find out the maximum display requirements for your project, and what needs to happen to the footage during post-production, e.g. grading and VFX, you can shoot accordingly, ensuring the files can do the required job, but you don't create huge amounts of unnecessary data.

The DP should decide on the workflow in conjunction with the production and post-production departments. Production input varies greatly. In television, there may be a 'production bible' that specifies the workflow pipeline for a particular series or show. On a very large production, sometimes you may have to produce a copy of your workflow diagram for insurance purposes.

> A 'color gamut' is the entire range of colors that can be shown on a viewing device (some are only visible at low or high brightness levels).
>
> A 'color space' is how the color gamut should be displayed on a viewing device. The prescribed color arrangement for HDTV is called Rec.709, for UHDTV it is called Rec.2020, and for cinema it is called P3. Professional grade monitors adhere to these standards, so you can see how the colors will look when screened. Consumer ones don't.

If something isn't right, there can end up being a blame game . . . if you don't understand the process, you risk getting the blame.
Andrew Boulter

At the opposite end of the spectrum, on a low budget shoot, or when working with inexperienced people, you may find you know more than people working in production. Particularly if the post-production team are not yet on board, you may take the lead in recommending the workflow pipeline. On some productions the workflow may seem to be organized but errors and omissions can come to light later.

As a DP you should have input into the creation and modification of the image at each stage from shoot to screen and should certainly attend the color grade, which is where the final look of the image is created. Many DPs on high-end films insist that, as part of their contract, they attend both the master grade and check the finished version of any other format the film will be displayed in.

Whatever level you are working at, once the recording formats and other settings have been decided on, you must make sure the same settings are used on all cameras involved in the shoot.

> Color grading is when a set of color, saturation, brightness, diffusion and other adjustments are made for each shot and scene and applied to the finished film.
>
> In the same way that image processing is now a standard part of still photography, grading is an integral part of making films.

5: THE DIGITAL WORKFLOW FROM CAMERA TO SCREEN

WORKFLOW STEP-BY-STEP

The following chart introduces the what and why of each stage and step that affects the workflow, and the role of the DP at each. This chapter will detail when and how to carry out each step.

WHAT TO DO	WHY
*Check image display and post-production requirements and choose a suitable camera or cameras	Camera/sensor choice dictates the maximum resolution, bit depth and dynamic range that can be recorded and must meet your needs
*Check aspect Ratio and widest and narrowest display format	So you compose for your aspect ratio and ensure no important action is in an area that will be cropped in other display formats
*Choose recording format: RAW, Log or LUT	For the optimal balance of the amount of data created and flexibility in post-production
*Choose recording codec and bit rate	If not shooting RAW, codec and bit rate choices compress the image data. The footage must not be compressed so much that the required post-production can't be carried out, but file sizes shouldn't be larger than necessary
Expose correctly for your recording format and workflow	Optimal exposure levels differ for Log, LUT and RAW (see C11a)
Read waveforms and scopes which are monitors that help you check your exposure (see C11a)	To ensure the light and color levels being recorded are not too high or low. N.B. This point is included at the request of Kevin Shaw CSI, who finds new DPs are often surprised by the levels they see on the same scopes in post-production and that they haven't checked them during production
Color balance correctly for your workflow	The degree of accuracy required differs depending on whether you are shooting RAW, Log or LUT and if there will be VFX
Shoot gray or color charts (see C14) and forward them to the colorist before the grade, or ask the editors to do so	The colorist often only gets the edited footage with the charts removed. Charts are important for color referencing during post-production
When shooting you can view the footage on an appropriate monitor, HD, UHD or HDR (high dynamic range) if the film will be screened in HDR	To enable you to see how much detail will be visible
Apply either standard Rec.709 or Rec.2020 color space to the main monitor used on set	So colors can be seen in approximately the same way they will show on either an HD or UHD screen in the finished film
Or apply a LUT (the LUT will still be designed to work with a specific color space but the color rendition and other factors will be adjusted)	To show a closer version of how the finished film will look. The more distinct the look you are creating, the more important it is to do this
Check the image after it has been recorded. This is done by the DIT or DP (see C2)	For any recording failures or image issues such as flicker, phasing, moiré – that will require re-shoots
*Use consistent and clear file numbering (see C2)	To avoid loss and confusion about which files are from which camera and shoot day
*Create and make sure that a robust data management system is being carried out in the agreed way (see C2)	To avoid data loss, have a clear line of responsibility and meet any requirements specified by the insurance company
If possible, work on a dailies grade, i.e. adjusting each shot or scene so that it is close to how you would like it look in the finished film, and making any adjustments to the LUT being used when you shoot	To ensure that you shoot optimally to achieve the look on subsequent shoot days, and to give the grader a good idea about the look you want to achieve for the finished film
*Make sure editing is done with a viewing LUT	Because seeing a low contrast or desaturated Log version of the film may well make the editors make different choices about shots than they would if it looked as it should
**Choose a file format for the master grade	Suitable for the equipment being used and integrating with VFX, etc.
KEY: * Check with production or post-production ** Not usually decided by the DP	

continued

115

B: ESSENTIAL WORKING KNOWLEDGE

WHAT TO DO	WHY
Select what viewing platform you will create your master grade for. Try to insist on the widest 'color space' possible (color space being how colors are arranged and appear on a specific class of viewing system such as cinema or HDTV)	If the widest color space will be cinema, try to insist the master grade is done for that even if the primary market in which the film will be sold is for HDTV. This is because it is easier to downscale the colors than to upscale them to a wider space. If this isn't allowed, always insist on what is called a color managed workflow (i.e. ACES – see below.)
Discuss the look of the film and any key shots with the colorist well before the grade and send images and examples of the look you would like to achieve. This is particularly important if you haven't been able to produce a daily grade	So the grader knows what you are trying to achieve. This step often makes everything go far more smoothly and saves time and money in the grade
Attend the grade and ensure you know which color space you are viewing in and that the monitor is appropriate	To work with the colorist to get the look you want with what you have shot, and the additional creative tools available in grading (see below)
** Select suitable codecs for all other formats the film will be screened in and for broadcasting	So it plays smoothly when screened
* Attend or remotely view the versions made for other viewing platforms on a monitor that is calibrated to match the grader's one	To check the look is maintained, the colors work, nothing unwanted shows and if radical changes in dynamic range are made, they work for the story
** Select an archiving codec	To allow the film to be safely stored and reformatted or reproduced later

KEY: * Check with production or post-production
 ** Not usually decided by the DP

CHOOSING THE CAMERA

Resolution

One of the first factors in camera choice is resolution. The higher the resolution of the sensor, the more detail you record, and the higher-resolution screen the film can be displayed on. Resolution of a camera sensor depends on the number of photosites rather than the size.

Screen resolution is measured in pixels. Pixels can be spread over a smaller or larger screen. The resolution you record in must be at least the same resolution as required for specified viewing format or larger.

There are advantages to choosing a camera with a higher resolution than you need for the display it will be screened on because if you shoot on the full sensor (which would give you a higher resolution than you need) but only frame for a smaller part of it:

- You will be able to see what the full sensor 'sees' in the viewfinder or on the monitor, i.e. you can see a little extra around the edge of the frame so you can see if a microphone or anything unwanted is about to come into frame.
- You are able to 'pan and scan', i.e. re-frame a little during editing.
- Image stabilization will work more effectively.
- It helps to future-proof your work so that, if needed, a higher resolution version or one at a different aspect ratio can be produced at a later date.

If a low-resolution film is shown on, for example, a 4k TV, the pixels will be visible as blocks and the edges of objects won't be smooth.

(center) Standard definition 720 x 480 pixels, (middle) high definition 1920 x 1080 pixels, (outer) 4k 4096 x 2160.

There is a good compromise, which is shoot at the highest resolution but post-produce at something more appropriate to the finishing. This gets the best of both worlds.
Kevin Shaw[2]

If a higher resolution than is required is used, it will usually look better than a standard version but will take more computing space and power to post-produce and more bandwidth to supply. If your production can afford the data storage, computer power and processing time, the ideal is to record in as high a resolution as possible, create a high-resolution master and appropriately lower-resolution versions for each viewing platform when required.

> Norms change for both aspect ratio and resolution, due to changes in the shape and specifications of viewing platforms. 4k UHD is on the way to becoming the new norm for TV and theatres, whilst 2k 16:9 is the new norm for Web. HDR High Dynamic Range is also becoming part of the mix.

Dynamic Range

Dynamic range is the steps (in F-stops) from dark to light that the camera can capture without loss of detail. The dynamic range of the camera depends on its sensor and the ISO being used. Choosing a camera with a high dynamic range is important when you need to record situations with both bright and dark areas that need to retain detail. These occur both in documentary, when you can't control light, and in drama, when you want to create substantially different lighting levels in parts of your shot. It is therefore clear to see why you would always choose a camera with a high dynamic range, although steps can be taken to (using lighting and filters) to reduce the dynamic range if your camera doesn't have sufficient range for what you are shooting.

The Impact of High Dynamic Range on Camera Choice

Until the introduction of HDR screens, the dynamic range that a camera records has virtually always been broader than the dynamic range the finished film has been screened on; with standard TV screens being as low as six to seven stops and HD TV and cinema screens ranging up to three or so stops higher. For HDR screens, the dynamic range is also variable but can be far higher, i.e. up to twenty stops. It is therefore important to understand a little about HDR and to always ensure you use a camera with as high a dynamic range as possible if your film may be screened in HDR.

For monitors and televisions, dynamic range is the difference between the peak brightness and black level that can be shown whilst still retaining detail. The dynamic range is described as a contrast ratio, which is calculated by dividing the peak brightness by the black level. Therefore, black level is an important factor because a screen with a black level of 0.5 nits (see below) will have twice the dynamic range of one with a black level of 1.0.

HDR (high dynamic range) is different to HD (high definition – which refers to resolution). High-definition images can be shown in standard dynamic range or high dynamic range.

Both the brightness and the black level of a monitor are measured in 'nits', which are candela/m^2. Standard definition TVs start at around 100 nits; HDR TVs, from around 500. The UHD target specification for consumer HDR TVs is 1000 nits.

> The human eye is sensitive to small changes in the dark areas of an image but only sees substantial changes in the bright areas. HDR displays increase definition in the brighter areas, so more detail is visible.

B: ESSENTIAL WORKING KNOWLEDGE

> To see the equivalent of 8-bit color on and HDTV, you would need 10-bit color on an HDR TV.
>
> If displaying on a top-end 4000 nits HDR screen, you would need 12-bit color.

HDR is different to just turning up the contrast on an SDR (standard dynamic range) TV. On HDR you will see detail in all of the bright and dark areas, whereas if you turn up the contrast on an SDR screen, all the detail would be lost.

There are three key technical aspects to HDR TVs:[3] The dynamic range, a minimum of 10-bit color and the 'color gamut' which is the range of colors they can show that is close to that of the P3 cinema specification.

- When shooting for HDR, choose a camera with a wide dynamic range – a minimum of 10-bit color – and avoid any color sub-sampling (see below).

HDR shows more detail than standard range television or cinema irrespective of the resolution. HDR 4k will show more detail than standard range 4k, so cinematographers need to watch out for details showing, where you thought they would be blown out, as well as paying more attention to makeup etc. HDR impacts the way attention is drawn to different parts of the screen, so your attention doesn't always carry through the cut in the same way as in the SDR grade. In a traditional Hollywood style of filmmaking, the edits are meant to be invisible. An HDR finish ideally doesn't change that, but your eye may be drawn to an unexpected part of the frame as the scene dynamics change. You should account for HDR through every part of the process.[4]

Bit Depth

Bit depth relates to the number of distinct colors that can be recorded by the camera and is also an important factor in camera choice. *Bit depth should not be confused with bit rate* (see page 124), *which is the rate per second that data is recorded.* The higher the bit depth, the smoother the gradations between colors within an image. This is most noticeable on images with fine gradations of color. Higher bit depths are also needed to finely match colors, to key out one image and insert another when using VFX. VFX aren't just used for action scenes; they are used frequently in film for changing backgrounds, adding elements to the shot and, for example, adding a rain effect. This technology is not restricted to big budget films and is used frequently and effectively on low budget films.

> 8-bit 256 colors
> 10-bit 1024 colors
> 12-bit 4096 colors

8-bit is okay if you aren't doing much grading and the image doesn't have a very gradual change of color such as a sunset. The more gradual the color change the higher bit depth required to show it smoothly. Likewise, the higher the resolution of the display the more likely it is to show colors as bands. With the increasing adoption of UHDT there is more likelihood of colors banding unless footage is recorded with at least 10 or ideally 12-bit color.

If you're going to be doing heavy color-grading work or compositing work, then you'll want a camera that offers at least 10-bit recording, ideally 12-bits or 16-bit (usually only in RAW) footage which gives the smoothest gradation and tonal feeling.[5]

RECORDING CHOICES AND COMPRESSION

The resolution, dynamic range and bit depth a camera records in is usually specified by the manufacturer, but it is important to remember that these specifications refer to RAW recordings in optimal conditions. Maximum resolution is usually reduced if you shoot high speed. Dynamic range is reduced if you raise the ISO and, as below, bit depth is reduced when certain codecs are used.

5: THE DIGITAL WORKFLOW FROM CAMERA TO SCREEN

The lower the bit depth, the harder it is to achieve smooth color gradations and precise color matching. Color gradations and blocks shown are not to scale.

(left) A RAW file without processing doesn't look like an image, (center) a Log file prior to post-production looks like a desaturated low contrast image, (right) a LUT file looks like an image but is difficult to adjust in post-production (not all LUTs are designed to show 'true' colors as per this example; they can be used to create a subtle or highly stylized look).

Recording in RAW

RAW is uncompressed (or occasionally a losslessly compressed) recording format. When you record in RAW (as per C3) all the information from the sensor is stored, color information is recorded separately and large uncompressed RAW files are created.

In post-production, RAW offers the most flexibility for (a) the image to be enhanced, (b) different grades to be applied, (c) backgrounds to be keyed out precisely, (d) VFX to be added seamlessly.

- Choose image resolution.

- If there are options of RAW formats (some cameras offer slightly smaller RAW recording) there is usually no disadvantage to choosing the smaller option, as the compression should be lossless (see supporting theories and concepts below, which detail the types and nature of compression).

- Use a camera pre-set white balance, because even though color information is recorded separately brightness levels of certain parts of the image can be slightly distorted if the white balance is way off.

- Keep the exposures within the scene fairly consistent but expose up a little, so the dark areas aren't in the bottom end of the dynamic range, as long as you don't clip the highlights. If you are not sure if the highlights will be clipped, err on the side of under-exposure rather than over-exposure.

Because RAW files can't be viewed without debayering, usually a Rec.709 or Rec.2020 (the UHD ultra high definition equivalent) or display LUT is used to view the images on a monitor. To see what the RAW image is recording, you should learn to read scopes. Be aware that, if recording in RAW and viewing in Rec.709, what you see in the monitor will have less dynamic range than you are recording. This can be a good thing because you will have more information, not less, available in post-production, but if your film will be screened in UHD or HDR you must have a UHD or HDR monitor and view in Rec.2020 or with a suitable LUT to be sure you can see what you are getting.

RAW provides the most flexible files possible, but if you are shooting a comedy sketch that will only end up on YouTube, too much data is overkill. Also, think about how much footage you are shooting. If you are shooting a documentary, you may shoot 3–5 hours of footage a day for many days.

Whichever format you record in, the more data you produce, the more hard drive space needed, the longer transcoding takes, and more powerful computer processors will be required in post-production. This can add to the cost of post-production and make it take longer. Another negative aspect of shooting at high resolution or RAW, and so producing high data rates, is that it can limit the length of your takes. Underwater photography, natural history, aerial shots, etc. often need as long as possible before having to change the recording mag and download the data. Also, for many productions a fast turnaround is important. News footage is often streamed live, the footage can't be processed or graded and data affects the bandwidth, so, for news too, data rates cannot be too high.

A lot of it comes down to being practical. If either you aren't going to be able to work with those files in post-production or you don't need to do much work with your images, then it is better not to work in RAW, and choose a codec and compression (see page 124) that provides the right balance of speed cost and quality.

- If filming a once-in-a-generation event, you will want to future-proof as far as finances will allow, and reduce resolution for outputting to current display devices.

- If filming an advertising spot for a local business, to show at a local sports event, that will by definition be out of date next year, you want to be as cost-effective as possible.

Another aspect to consider, particularly for inexperienced DPs or when working with a new company, is how far you trust the post-production in the project you are working on, to grade the footage as they should.

5: THE DIGITAL WORKFLOW FROM CAMERA TO SCREEN

Recording in Log

The Log format is designed to have many of the benefits of a RAW image, but without creating such large files. Log images are usually smaller than RAW images for two main reasons. First, as Art Adams[6] shows, the logarithmic algorithm reduces the amount of information recorded at the higher end of the dynamic range, by continually halving it, whereas RAW records it all.

Second, the color information is embedded into the file rather than being stored separately, so some of the color information you aren't using is discarded. *This means that when shooting you need to set the white balance.*

Shooting in Log is very popular and is suitable for most productions unless they are very post-heavy and require sophisticated color work and VFX. So long as it hasn't been highly compressed and sub-sampled (see below), Log retains all the information needed to produce a wide dynamic range and sufficient color information for most purposes.

You select Log under Color and Gamma (contrast) options in the camera, not under resolution, because Log is only dictating how the recording of the brightness and contrast levels are spread out, *not* the recording codec and how much it is compressed. After selecting Log, you then choose the codec you will record in (see page 124). It is important to remember that if you choose Log for its combination of flexibility and manageable file sizes, which is what makes post-production easier, you shouldn't choose a highly compressed codec that will get rid of the information (and flexibility) that Log is intended to retain. Also bear in mind that Log always requires post-production, so if the production you are working on doesn't have the time or money for it, Log is not appropriate.

Camera manufacturers have their own version of Log (e.g. LogC for ARRI, and S-Log for Sony), designed for what they consider optimum performance, and most manufacturers have different versions of Log optimized for different uses. There is a lot of discussion about Log choice; testing and experimenting is far more reliable than relying only on what you read.

> *On fast turnaround TV there is no time to go in to the grade. I found that with the workflow pipeline I was working in I was getting far closer to the look I wanted with one particular version of Log so stayed with that one.*
> Georgina Burrell[7]

> *Canon Log 1 is great for mixing footage with C100, C300 original or DSLRs, while Canon Log 2 is for bigger-budget productions, destined for cinema release or high-end commercials, which will require heavy grading in post. And, of course, the new Canon Log 3, being a more versatile and quicker tool, is ideal for more streamlined corporate work or the slick broadcast documentary.*[8]

(top) RAW files store all the information created by the light in each stop of dynamic range. For each stop brighter, twice the light is required than for the previous stop so twice the information is produced. This is one of the reasons why RAW files are so large. (bottom) Log recording is designed to allow equal amounts of information to be stored about each stop of the dynamic range.

(right) Low contrast and Log images retain detail allowing contrast to be increased or reduced in grading, (left) detail cannot be recovered in grading from images with a burnt-in LUT that have been recorded with high contrast.

> In Sony Log versions, the higher the number, the lower the contrast, and therefore the more flexibility in post production. This allows you to choose a Log version according to your needs on a shoot, although do check with the grader if possible – they should have a preference. If there won't be much time for post or you don't trust the grader, shoot in S-Log 2 which gives least flexibility (or shoot in LUT which has virtually no flexibility). If you want more scope later, shoot in S-Log 3.

121

B: ESSENTIAL WORKING KNOWLEDGE

When shooting in Log:

- Select Log under Color and Gamma options in camera.
- Choose a suitable recording codec.
- Make sure you color balance your footage or input a reasonably close Kelvin into the settings.
- Find out the manufacturer's recommendations for the IRE level to expose mid-gray, raise the brightness of the darkest areas if possible without clipping the highlights, but (as per C11a) without being inconsistent, i.e. making some shots far brighter than others, which will make them difficult to grade and cut together.
- Check the Log recording on a histogram or waveform monitor, to make sure that the Log image you are recording has a manageable dynamic range and isn't clipped.
- Make sure that when it is displayed on a monitor you apply a suitable Log LUT (see below), so what is seen is closer to how you want the finished film to look.
- That post-production knows it is log-encoded and which manufacturer's version of Log has been used.
- That a LUT is applied to the footage used during editing; this is particularly important when shooting in Log, to avoid the editing decisions being based on how images look when they are with the (story wise) very misleading desaturated and low contrast look that ungraded Log footage has.

> Any LUTs used with Log footage must be designed for the specific Log you are using, to avoid misleading colors and contrasts being shown. Likewise, any post-production LUTs must be for the Log you are using. Log footage may be edited in Log, but at some point, before final viewing (and usually before the master grade and VFX), it has to be converted back to a Linear file.

DSLR Log Equivalents

Some DSLR cameras can shoot RAW, but if this isn't an option, either in the camera menu or by upgrading the firmware with Magic Lantern or an equivalent, you will gain access to a range of video tools not available in the camera menus. If using Magic Lantern, select a picture style called Technicolor Cinestyle, which is the closest equivalent to Log. If this isn't possible, choose the flattest picture style in the camera to keep the contrast and saturation low, so you retain dynamic range and flexibility in post-production. Only use this if you will be grading your film, and always test first to check that these reductions are reversible in post-production.

Recording in LUT

A LUT is a lookup table which uses an algorithm to alter or convert one or more aspects of an image into something else. There are several different types of LUTs and each can be used in several different ways.

1D LUTs are suitable for viewing and in some circumstances for recording, whereas 3D LUTs can be used for viewing, grading or recording. Broadly speaking, if you were to try to grade with a 1D LUT, changing one color would affect all the other colors, whereas with a 3D LUT all the colors and other elements of the image can be changed independently.

The same shot using different LUTs, which create different looks. Which look you choose as the normal or 'correct' for your film is a creative decision.

VIEWING

When a LUT is used for viewing, it is applied over the top of an image file, so it can be viewed on a monitor or viewfinder but doesn't affect what is being recorded in any way. A viewing LUT (or Rec.709 or Rec.2020, the UHD equivalent – see below) must be used when shooting RAW (because it isn't possible to view a RAW file, which is just data, not an image) and is usually used when shooting Log, to give an idea about how the finished image will look.

GRADING

The same LUT can be used as the starting point for the grade (provided that it is a 3D LUT). Alternatively, it can be used as a guide for the grader to recreate the same look so that it can be modified with the more flexible tools available in the grading suite.

RECORDING

Alternatively, the same LUT can be 'burnt in' to the image during recording (see below).

An off-the-shelf LUT: Is designed to create either a general image look or a specific style such as a 70s look or a sci-fi look. As above, if these are 3D LUTs they can be used for viewing, grading or burning in when recording. They may also be used as the starting point of a grade. Lutify.me[9] and other sources offer some free LUTS. There are a great variety of LUTs, and there are many versions of the same LUTS that have been tailored for use with specific camera and recording options.

A bespoke 'Show' LUT: Is either a modification of an off-the-shelf LUT or generated from scratch. The DP guides either a DIT or a grader to create a LUT, that will be close to the look wanted for the finished film. The LUT must be created within the parameters of a specific color space, to avoid difficulties when viewing or grading with it.

Any set of image decisions that has been made in camera or in a grading suite can be exported as a LUT and loaded into one or more cameras and monitors. A TV series or show may have a Show LUT that is applied to all cameras.

Rec.709 or Rec.2020 can be used for both viewing and recording (although Rec.709 is available in most cameras but Rec.2020 is rarely available as a recording option). They aren't strictly speaking LUTs, although they are sometimes described as such. Rec.709 is a viewing profile that converts what you are recording into an HD color space for monitoring, and Rec.2020 is the UHD equivalent. Many DPs routinely view in Rec.709 or Rec.2020 on monitors on-set. This gives a standardized view, optimized for the color space to assess the image. Some DPs view on Rec.709 or Rec.2020 and have a separate monitor to show the LUT, particularly if the LUT is being tweaked live by the DIT.

RECORDING WITH A BURNT IN LUT

Shooting with a burnt in LUT can't be done in RAW or Log. When any LUT is '**burnt in**' during recording, it has a completely different role to when it is being used for viewing or grading. All the color, brightness and sharpness decisions are embedded into the footage and the dynamic range is often dramatically reduced in some LUTS (to around 6 or 7 stops – which is roughly equivalent of a standard dynamic range television or monitor); other LUTs may retain more dynamic range so it is important to find out and understand what changes a particular LUT will make. Once a LUT is burnt in, it makes it extremely difficult to reverse decisions or alter the look later. Once the color and contrast decisions, etc. are burnt in, the rest of the information is effectively discarded. This is why, irrespective of any further compression, an image with a burnt-in LUT will always be smaller than a RAW or a Log image.

If you are shooting with a burnt in LUT, for something that will have no post-production and must be ready for display, apply the LUT and adjust anything needed to get the look exactly as you want it in camera. If there will be any kind of post-production image adjustments done later, going halfway to creating the look you want with the LUT, but keeping the contrast down, allows you to store more detail in the brighter and darker areas, and gives a little more room for adjustment later.

If there is no time or money (for post-production) or I don't trust the production (to grade the footage) I use a codec that isn't too large and a burnt-in LUT.
Josh White[10]

When shooting with a burnt in LUT, keep things (exposure and color) consistent. You can still tweak it a little in the grade.
Josh White

Burnt in LUT is also the term used for creating the look within the camera. Many cameras have a Rec.709 recording option, but if you don't use this and create a look/LUT by adjusting the camera's own internal detail, color and contrast settings, you will not be creating a look optimized for a specific color space, so this is less advisable. Some cameras have a setting that locks out camera adjustments, so the look will stay in a specific color space. However, the rule of thumb when you are starting out is to use Rec.709 or an imported LUT, and only tweak it slightly in camera if necessary. The same applies to DSLRs: you may be able to import a LUT directly or through a third-party application such as Magic Lantern, but if this isn't possible, avoid using excessive changes within the camera settings other than (as above) reducing contrast to create a Log equivalent.

DPs have very differing views on if, when and how to use burnt in LUTs, much of which come from knowledge and experience, but these can be very different to the views of the colorist, who may have to help when things don't go to plan.

> *Most of the time I make my own LUTs, and when I shoot on the Alexa I shoot in Log C. In post[-production], they apply my LUT, and it's almost color graded.*
> *Sometimes I work with directors who like me to do it all in camera, though. I create the look with a combination of a LUT and color filters. If I am confident of how I am working creatively with the director, and sure we will both remain happy with the image, I will shoot [with a burnt in] LUT, but don't let production know how risky it is.*
> *If I am not confident in the director, or with the director's authority over final image, then I play it safer and shoot in Log or RAW.*
> *If I can shoot with a [burnt in] LUT, it saves a lot of time during shooting because I don't have to light for safety, and it saves a lot of time in post too. When I shoot with a LUT, I don't put a reference for the grader; there is nothing the grader has to do or could do.*
> Tomas Tomasson[11]

When shooting with a burnt in LUT:

- Select any picture settings, such as contrast, and detail that affect the look in camera, or preferably use a pre-defined LUT.

- Check that the director and producer are happy with the look you are using.

- Expose as you want it to look when shown.

- Choose an appropriate codec and bit rate.

It is important to remember that when applying a LUT, either in camera or in the grade, that the effect of the LUT depends on the image it is applied to. A LUT may make some areas darker and others lighter and will affect an over-exposed image differently to an under-exposed image. This is why monitoring the image with a LUT laid over the top helps you check for any under- or over-exposed areas and ensure the image is correctly exposed (see C11a).

Conversion LUTS are another type of LUT which are used in post-production (see page 129).

Choice of Codec and Bit Rate

RAW files retain all information and are always large. However, when shooting Log or with a burnt in LUT, your choice of codec is what dictates how big the files recorded will be and can also affect how much color information they retain.

A codec is the system by which a file is compressed and decompressed. The codec dictates both the file type created and how much of what type of compression is applied. A codec can be 'Lossless', which means that all the information can be retrieved when the file is decompressed, or 'Lossy' when it can't.

5: THE DIGITAL WORKFLOW FROM CAMERA TO SCREEN

> Capture codecs – are used in camera for recording.
>
> Transcoding codecs – turn your footage into something better suited to the editing and post-production software being used.
>
> Delivery codecs – are for screening.
>
> Archival codecs – are for storing.

The balance of how much the file can be compressed to make storage smaller and the amount of data that can be retrieved depends on what purpose the codec has been designed for. When used in digital filmmaking, a codec that greatly compresses information, or discards a lot of it, is used only when the viewing platform will be relatively low resolution, and/or when it is essential to have a low data rate. The various processes by which data is compressed and decompressed are detailed at the end of the chapter.

On documentaries I need a codec that doesn't fill up terabytes of hard drives, especially when I am doing the transfers myself at night and backing up to two hard drives.
Dana Kupper[12]

The codec dictates the file type that the data is recorded in. For the files to be used on any other device such as for editing, grading and/or displaying, the file types must be compatible. As per the diagrams of boxes on the right, to be compatible, both the file container and the way the data is arranged within the file must be readable by the particular viewing or editing systems.

The file extension, e.g. .MOV, shows the container or 'wrapper' the codec is stored in. Containers are associated with particular recording, viewing or editing systems. Most versions of files with a particular type of container are compatible with particular sorts of viewing or recording device. If a file with a .Mov extension isn't readable on a device or in a program you thought could read it, it is almost always because the way the information is arranged inside it isn't compatible.

It is possible to losslessly change the container from one file type to another. However, that won't ensure the contents are readable. Readability depends on both the container and the codec.

Each camera offers different codecs in the menu and supplies specifications about them, including how much data they produce at different resolutions and frame rates.

Not all files with the same containers are interchangeable, because the interior file structure may be different. The file extension, e.g. .mov, only refers to the container, which is why one .mov may be compatible with your editing software but another may not.

When designing cameras, manufacturers consider the needs of the users in their primary market and what they need, in terms of codecs and recording options. Whilst any camera can be used to film anything, not all the options shown in this chapter will be available on every camera. Some offer adjustable bit rate, others offer different versions of Prores, and some give a broader choice of color spaces, resolutions and codecs.

Sometimes the video file contents will sort of fit into a container and you can play the video, but it may judder or not work properly or may cause problems when creating transitions and other effects in post-production because the contents don't fit fully into the structure.

125

B: ESSENTIAL WORKING KNOWLEDGE

On features, I try to shoot RAW whenever I can, but I usually shoot the highest quality Prores on commercials, unless they are very post-heavy.
Petra Korner

Prores is a popular and useful codec for recording and post-production. There are a lot of versions of Prores that have different degrees of compression. Prores codecs need to be transcoded before display, because the Prores codecs aren't suitable for most display devices, even though they have a .Mov container that is a wrapper that has the same file ending as many codecs that can be read by display devices. One of the immediately distinguishing features of Prores codecs is whether they are described as, for example 4:4:4, 4:4:2 or 4:1:1. This indicates the degree of color/chroma sub-sampling within the codec; which is of key importance.

> If you use the ACES – Academy Color Encoding System – which is a color managed workflow, you can look at ACES central to find the suggested codec for your camera that should be selected to optimize your workflow. ACES give guidance on all the codec choices throughout the workflow, which can be very reassuring and beneficial. ACES relies on large files, so if shooting a quick turnaround project that doesn't require much post-production, it is not appropriate to use an ACES or any other color managed workflow.

Chroma sub-sampling

Chroma sub-sampling is a form of compression that reduces the amount of color information held about each individual frame. This type of compression is known as intra-frame compression.

When Chroma (color) is sub-sampled, instead of each pixel having separate color information assigned to it, the same information is assigned to one or more of its neighbors, which reduces the amount of information that has to be stored.

If using a codec that has color sub-sampling, particularly if it is heavily compressed, such as 4:2:0, problems can arise if you need to finely define the edges in post-production. You may see jagged lines around the edges because the picture is formed of bigger blocks of color than single pixels. Doing fine color work, chroma key or VFX without finely defined edges is very difficult and less successful.

Display devices are increasingly being designed to show more detail than older models and so, whilst 4:2:2 used to be the professional broadcast standard in Standard Definition, now in the more critical HD and UHD color spaces 4:2:2 can be problematic for finely detailed work, so 4:4:4 should be used.

4:4:4 records color information for each pixel and there is no color sub-sampling.

Sub-sampling involves storing one set of color information for more than one pixel. This makes colors less reliable and edge definition less precise.

Color sub-sampling results in a 'blocky' image. This image has been somewhat exaggerated to show that color gradations and transitions aren't smooth in a heavily sub-sampled image and that it would be very difficult to use for VFX where fine colors must be matched or to make a smooth line around the edge for chroma key work.

Codec and resolution	Color bit depth	Bit rate	Frame rate (fps)	Minutes recorded per 64GB card
MPEG-2 HD (1080 x 1920)	8-bit 4:2:2	50Mbps	23.98/25/29.97/ 50/59.97	120
XAVC HD (1080 x 1920)	10-bit 4:2:2	200Mbps	60	30

Camera data available online will show you the containers, codecs, bit rates and bit depths and any color sub-sampling for any recording format you are thinking of selecting.

Digital images are created in RGB, which is an additive system starting from a transparent background. If all three channels are recorded equally, the image is white.

444 codecs are not sub-sampled, and are described as RGB.

422 or 400 codecs are sub-sampled, and are described as YCbCr or YUV. In these codecs, the RGB values are calculated based on a formula.

Most color grading is RGB, and all displays are RGB. RGB is always 444.

Print starts with a white page, and CMYK values are used in a subtractive system to say how much of which part of the white should be removed to create the desired color.

The Importance of Bit Rate

Personally, I feel that bit rate is an excellent number to judge quality of the recording. You can make a judgement about the compression you are using by looking at one number, instead of having to think about your bit depth and color sub-sampling.

> *5–20Mbps consumer quality*
> *25–50Mbps lower prosumer/student*
> *50–100Mbps broadcast/higher prosumer*

It also helps you because it relates directly to file size and allows you to calculate how many cards you will need.

If you have a 16GB card and record it at 35Mbps (16000 divided by 35), it will fill up after 457 minutes, i.e. 7.6 hours.

If you record it at 125Mbps it will fill up in 128 minutes.
Dana Kupper

In most Sony cameras' menus, bit rate is the key method of controling the 'quality' of the data being recorded.

Bit rate can be either dictated by the codec you choose (the bit rates associated with particular codecs can be found in the camera specifications online), or it is set as a recording option within the camera menu. Bit rate is the amount of data created when recording a single second of video.

Bit rate does not tell you how the information is being compressed, but tells you how much it is being compressed. Knowing the bit rate of the codec you are recording gives you a broad-brush knowledge of how compressed the footage you are recording is.

It is hugely important to understand how bit rate can compress your footage over and above the codec you choose.

If you change the bit rate in camera, it dictates how much data will be recorded per second and, if necessary, compresses the footage more than the codec would normally do.

If you shoot at high resolution, it should create 50Mbps, but at a low bit rate of 10Mbps your footage will end up very compressed. Likewise, if you are shooting at 30fps, then increase your frame rate to 60fps but don't double your bit rate, as each frame will be twice as compressed.

For shoots with lots of VFX or heavy color grading, to maintain quality, shoot RAW, if not Log at the highest quality and bit rate. Test to make sure your workflow is correct, then don't change things. If it has to be changed, re-test to make sure no issues have been introduced.
Jonathan Smiles[13]

THE POST-PRODUCTION WORKFLOW

Editing

After the footage has been shot, it is checked for any faults or flaws, backed up (see C2b) and delivered to post-production for editing. If editing takes place far away from the shoot location, large data rate transfers, or delivery of the hard drives, needs to have been organized.

The footage is transcoded so it can be edited. There are Prores codecs that have been designed for editing which are popular. You may be able to use the files you shot in without transcoding them in an editing program, but this may make transitions, effects or speed changes far more time-consuming and more likely to need rendering. This slows down the editing or requires huge processing capacity that you are unlikely to have, especially if you are editing yourself. This is why files are transcoded into an editing codec and editing is often carried out using lower resolution (proxy) files. Files can often be transcoded from within the editing program, but specialist transcoding software is relatively inexpensive and makes this much (sometimes several days) quicker.

It isn't only the image that needs to reach post-production but also the LUTs used and information about the shots. Some is on the metadata of the files, and some on the camera and digital negative sheets (see C2).

It is important to make sure that the LUT is applied to the footage used in editing for two reasons. First, because the look of the film is part of the storytelling, and the story may come across differently if that look isn't visible. Second, because during the lengthy editing process the director and often the producer look at the film many times and get used to the way it looks. This can mean that when you come to grading the film, they have grown to love the look and you end up having to compromise on the look so it is closer to what was used in the edit.

Preparing Files for Grading: Display and Scene Referred Transforms

After editing, the project file that contains information about not just the cuts, but also about any size or speed changes, etc., is applied to the original full resolution footage, rather than the smaller proxy files used during the picture edit. In this process, the original footage for the selected cuts is transcoded losslessly into a file format that has single images rather than video files, which works best with grading software. This conversion is part of the ongoing workflow for the whole of the post-production pipeline, because the files used for the master grade become the basis from which all other versions of the film are made.

> In Avid, the project file is called an AAF. In Final Cut and Premiere, it is an XML.

> ACES specifies what is needed for an ACES color managed workflow. In other workflows, the DP may need to know more color science to make sure it is all okay or be reliant on others.

> Netflix now insists on an ACES workflow.

ACES

The Academy for Motion Picture Arts and Sciences has created ACES, the Academy Color Encoding System. ACES specifies the file type and options that can be used at all stages of the workflow to make color management and format transformations consistent and reliable from the shoot through to the final color correction and distribution on output devices with different color gamuts and viewing environments. It is also an excellent archive format.

ACES was created to solve the recurrent problems of incompatibilities caused when films are transferred from one format to another. It was originally intended to be just a file interchange system that would increase the color accuracy when transferring files/films between display formats, but to solve the problem it had to go deep into image and color science. This resulted in the development of a file format that can encode the entire visible spectrum of color within 30 possible stops of dynamic range. The CIE chromaticity diagram opposite represents human vision and shows that ACES (when used with a camera that records 12-bit color) can create and store more color information than the human eye can see. Therefore, unless the human eye evolves, there would never be a point at which you would require additional color information, whatever format is developed in the future.

ACES was created for the benefit of the motion picture industry and the viewing public. It is free to use and available from ACES central. It is an open source project and supported by over 60 industry companies.

What this means in practice is that ACES specifies what file formats you should record in; which should be RAW or an uncompressed 4:4:4 Log codec. They then provide scene referred IDTs (input device transforms) that are easy

> With ACES color and dynamic range are limited by what the camera can record, not by the display.

> The Academy has worked with the camera manufacturers to ensure that there are IDTs freely available for most cameras that are currently available. These are available from ACES central and are also built into virtually all color grading systems as standard.[14]

to use but involve a complex process that transforms original camera files into large master files suitable for grading, but which also serve as the widest possible source file for all future versions of the film.

The benefits of an ACES color managed workflow are not obvious until after the master grade and VFX are finished and the film is complete. The benefits are apparent at the point at which versions of the film are prepared for different color spaces, such as cinema and TV (when it is too late to go back and start again). The following comparison of methods of transferring films from one color space to another demonstrates why.

The colored areas show the color spectrum visible to the human eye; the lines show how much of the spectrum each color space can record.

> If you are shooting a low bit depth or resolution or fast turnaround project which will only be displayed in one format, a color managed workflow is not appropriate for your project.

Conversion LUTs

The LUTs used for viewing, recording and grading as discussed previously are each designed to work with a specific color space. What are often called Conversion LUTs, but are more correctly (although rarely) called an OETF (optical electro transfer function), are designed to convert an image for use in one color space into another, e.g. to convert a film that has, for example, been mastered to be shown on HDTV to one that can be shown on UHDTV.

Display referred

A conversion LUT or OETF is **not** based on the ACES system and is display referred. It doesn't link back to the original data that was recorded about the image, it just looks at how that film appears in the, e.g. HDTV, version and adjusts the colors so it will look as good as it can make it look on UHDTV.

A display referred conversion cannot access the extra color information that was recorded on the camera but discarded when the film was prepared for HDTV. The OETF makes calculations of how the colors should be 'upscaled' and arranged, but the colorist usually has to make substantial further judgements by eye to ensure they will display correctly.

> One of the difficulties with display referred transforms is that the accuracy of how the color has been arranged in the current color space depends on how well the monitor was set up when it was first graded. If the monitor wasn't accurate for the first grade, it will give odd results when the film is transferred into a different color space.

It can help to master your film in the widest color space that it may be viewed in. However, transforming from a larger to a smaller color space requires a larger gamut of colors being squeezed into a smaller space and, likewise, doesn't always result in either accurate or aesthetically appropriate colors being produced.

Whenever a display referred conversion is used, rather than linking back to the information from the original footage, a color chart and/or gray card (recorded at the start of the film in the first color space it was created for) is essential and forms the basis of how colors and brightness are matched between the old and new color space. This is highly dependent on both the skill of the colorist and the monitor being used to display the color and gray cards.

Scene referred

Display referred conversion OETFs or LUTs are not the only way to convert films for different display formats. In a color managed workflow such as ACES, 'scene referred' ODT (output display transforms) are used for conversion whenever the master film is converted for a different viewing format. These link back to the information from the original image files before they were put into a color space and so are not distorted by either what the project was mastered on or any previous versions that have been made. A scene referred transform doesn't physically refer back to the original camera files but, if the ACES IDTs have been used, the ODTs are able to remove the color space information from the master files before adapting them for the new color space. Scene referred transforms are far more accurate, reliable and quicker than display referred ones and the film that is created using an ACES ODT virtually invariably needs fewer color tweaks and adjustments.

> The ACES system has IDTs for transforming original footage so that it is ready for grading, and ODTs for each color space which accurately transform the graded footage so that (other than some limited tweaking known as 'trimming') it is ready for screening.
>
> The ACES IDTs and ODTs are far more reliable than anything available previously, because they have been very well designed and because the ACES color space is so large.

ACES takes a lot of the hard work out of grading but, however consistently the ODTs use their algorithms to translate colors from one color space to another, they can't guarantee the translation will work creatively, so there remains a subjective grading job to do between the colorist and the DP.
Paul Curtis[15]

THE MASTER GRADE

Choosing a Color Space

ACES files have the file extension .ACE and, as above, can hold more color information than the eye can see. However, you can't use an ACES file as a movie, because there are no displays that can show the full range of colors in an ACES master. A graded master is made in the full ACES space, but a version of it is viewed on the monitor you are grading to via an ODT. This means that, simultaneously, an ACES master which will be used as the basis for all further transforms is being made alongside a trimmed (tweaked) master in the specific color space you are monitoring on.

Whether you are using an ACES workflow or not, the first decision to be made about the master grade is which color space it is going to be graded to.

> The colorist can see the position of the full ACES color space on the vectorscopes, even though what is being viewed on the monitor is limited to the color space of the monitor.

> Manufacturers of professional grade monitors and displays adhere to industry standards so that (in theory) colors look the same when shown on different screens.

The master grade is when the most time and attention is given to each shot. It is advisable to grade to the widest color space possible and always to the highest dynamic range that the film will be screened in, so that any details will be visible and nothing will suddenly 'appear from nowhere' in a different version, i.e. don't master in SDR if your film will be shown in HDR. There may be much debate about this, though, as the producers may, with some justification, prioritize how it looks for their biggest market – which is currently rarely HDR.

When the decision has been made about which color space to master to, it is essential that the monitor is professional grade to accurately show the color space and dynamic range and calibrated precisely for that space.

The quality and suitability of the monitor and its calibration is even more crucial if you are using a display referred workflow, because all future versions of the film will be based on the master version as seen on the monitor.

When viewing your film in post-production, to enable you to grade in the best conditions for your color space, you are usually watching on a good-quality, calibrated monitor in near perfect conditions in a darkened room, but your viewers won't be. What may seem too saturated to you in these situations may not seem the same in an ordinary viewing situation. The colorist may be able to guide you as to how it will look in different viewing situations. If not, ask for a scene to be exported so you can view it in different conditions. You should also view your film in the grade at the appropriate size, e.g. projected if it is for cinema and on a suitable monitor if it is for TV, because screen size and distance change visual perception considerably.

> **There are systems which calibrate monitors at the operating system level, for matching displays throughout a VFX facility.**
>
> **For HDR grading, the monitor should ideally be 4000 nits.**

Color Correcting

When working with lower end cameras with less bit depth, dynamic range and resolution, or with highly compressed codecs, it can make it harder to prepare the footage to be worked on in post. It can also take more time to make it consistent from shot to shot and to do the color work.
Paul Curtis

It is in the grade that the limitations of the footage you shot may come to light.

The first stage of the grade is known as color correction, but before the color correcting (also known as the technical grade) is carried out, the footage is scene detected so that full scenes can be graded together.

Color correcting involves:

- Evening out exposures and pulling the dark tones down to make them look dark, and the light tones up to make them look bright, thereby maximizing the dynamic range that has been recorded.

- Adjusting the sharpness and contrast so it is closer to how the finished film will look.

- Evening out the color temperature of the footage (color charts are hugely useful for this).

- Managing noise and other artifacts (noticeable distortions of the image quality).

- Applying the look as closely as possible, based on the information given. This is often done by re-creating the LUT in the grading suite. (They are re-created because most LUTs have inherent limitations that effect how far they can be modified.)

> **Grading is essential if you shoot in Log or RAW and, although not absolutely necessary, if there is time, it is still usually done if you shoot with a LUT.**

On smaller projects I'm often not offered a fee for the grade, but will attend whenever possible. As well as the opportunity to push your ideas through to the final image, being present at a grade is also a good chance to expand your knowledge about the process and your network.
Dave Wright

B: ESSENTIAL WORKING KNOWLEDGE

I advise that these frames are exchanged and discussed with the colorist as early as possible, ideally during the test shoot or early days of shooting, so that the show look can be established and used throughout post. This saves a lot of time, money and debate in post!
Kevin Shaw

The color correction is usually carried out with the DP, but occasionally this stage is carried out before they arrive. Attending the technical grade is always advisable for new cinematographers so you can see how well decisions turned out, and it can be more time-efficient to combine the technical and the color grade as below.

To establish the starting point for the look you want, you should either have a LUT that has been used or created by the DIT, or reference examples or have prepared some frames in software such as Photoshop or (the now freely available) Da Vinci Resolve, to create a guide for the colorist. You shouldn't be wedded to this look, as there will be plenty of ways it can be enhanced in the grading suite, and in most cases your grading skills will be less advanced than the colorist's.

> After the film has been shot, there are voices other than the DP's that can influence the look. The director, producer and colorist will have a view but may not know how the looks are intended to be nuanced and woven throughout the film in the way you intend. By communicating with the colorist prior to the grade, the look can be kept as close to your intentions as possible, from the start of the post-production and grading process.

The Colorist Society International accredits colorists, and the ICA (International Colorist Academy) is an advanced training organization in which top end colorists offer training. Kevin Shaw from ICA has been of considerable assistance in preparing this chapter.

Color Grade

[Grading offers] a massive creative toolbox. It is a totally underrated job that can change the emotional connection with the viewer. If the balance of light isn't right or is distracting in shot, you can adjust it. If the highlights are clipped, you can soften them. You can adjust colors across the contrast curve; I often push the reds up a bit or mimic film by popping blue into shadows.

You can sharpen the eyes (but never skin) if needed.

Grading involves qualifying and isolating colors, tones, shapes or areas so you can treat them differently.

Hollywood has an obsession with teal and orange: to achieve that look you isolate the skin and change the color of the skin tone across the whole frame.

You can re-shadow and re-shade using tracking to follow a face and reduce exposure and vignette parts of the background.
Paul Curtis

The color grade is where the definitive master of the film, from which all other versions are derived, is carried out. The role of the colorist is not purely to make the look you want work within the color space being used, but to master your film and remove any blemishes, artefacts or problems that may have crept in. A good colorist will read the script and play a significant role in telling the story. Grading can enhance the mood and influence the audience's perception by selectively using an array of creative tools that aren't available on set. It is not a service, it is a creative collaboration. Colorists are trained and highly skilled. The machines used in the color suite are only as good as the operator, in the same way that the camera and lights are only as good as the DP.

The DP and colorist go through the film scene by scene together to finalize the look of each scene, and then shot by shot to make any adjustments to individual shots or parts of shots that will enhance them. You may create a particular look on a single character each time they are shown or create a specific look for certain types of scenes. Once the adjustments have been finalized, they can be applied and fine-tuned for all the scenes where the same look is wanted throughout the film.

A grading session is just a set of decisions stored in a sequence, it isn't embedded into the footage until it is exported. You can create multiple sessions/versions of different scenes of a film with alternate grades or styles.

Most colorists care passionately about their job, but interpretations can vary and there may be several voices guiding the grade, who may not understand the details of the story and which looks should weave through it as you do. Despite the best of intentions, mistakes can happen. You should always attend the grading if at all possible.

> *I shot different looks for the film within the film but, in editorial, it was evened out. Another time, I used a sodium light for an orange look, but it was graded out.*
> Roberto Schaefer

> You can create a LUT or several LUTs from the look you produce in the grading suite. These can be loaded into the camera or monitor, this is very useful if you are working on a lengthy shoot or a series.

It is not just coloring that happens during the grade.

- Highlights, midtones and shadows can be adjusted separately.

(left) The shirt has been made brighter and the background behind Feena's hair is now darker. In the original shot (right) contrasts are lower. The next step would be to brighten Feena's face to make her stand out more on the shot on the left.

- Contrasts can be increased or decreased to alter lighting ratios and increase or decrease shadows, but this does not override the need to light well, because the grader can only modify what has already been shot.

- You can use mattes to apply changes to parts of the frame, and the mattes can be tracked across the frame as something moves, so you can isolate a coat, for example, and change the color and track it as it moves across the shots.

- Noise can be reduced, film grain added for a specific look or to make elements shot on film or digital or created in VFX match.

(left) The skin tones are softened (right) the eyes have been sharpened. A skilled and experienced colorist will be able to combine the two effects and help guide you as to how much of each effect is enough and what may be too much.

- Edge sharpness can be altered, which has a considerable effect on how sharp the image seems to be. Non-sharpened 4k footage can seem to have less definition, even though it has more real resolution. A specific sharpness is not better or worse, but it does have a considerable effect on the look. Edge sharpness can be applied to a specific part of a frame, such as the eyes with mattes to make them stand out.

- You can introduce grads to change the brightness of areas of the picture.

- Whites can be de-focused to create a softer image.

B: ESSENTIAL WORKING KNOWLEDGE

VFX

VFX are often worked on early in the project, before editing and grading, so some decisions about the look of the film may not be certain at the time the VFX are prepared. However, VFX should always be carried out on footage that has already been at least partly color graded, even though further grading will be required when it is assembled with the background footage.

There are many different processes involved in VFX. To make sure files can be worked on precisely, and maintain a consistency of look across these processes, VFX is usually carried out with DPX files or open EXR, depending on your footage. These are single-shot bitmap files which have a high dynamic range.

If you aren't able to produce DPX files, you should supply the highest-quality files you have, e.g. Prores 4:4:4 with a CDL. The stages in VFX are:

> Compositing layers of VFX with the original footage requires finely detailed color work, so if you are going to need VFX in your project, ideally shoot in RAW. If that isn't possible, shoot with as high a bit depth and dynamic range as possible.

> It is easier for VFX artists to work with linear files, so even if you hand them over as Log versions, they are transformed before VFX work is carried out to avoid all the different processes happening in VFX all having to be log-encoded.

- The VFX team need a well-exposed, high-resolution, high bit depth shot to work with, which forms the background for the VFX.

- VFX and titles that are compatible with the background footage are produced. There are many elements of VFX which may be made by different people. Keeping everything compatible and looking similar is one of the tasks of the post-production supervisor or edit producer.

- The background and VFX are brought back to the grading suite. The VFX are fully graded to match the main footage, before they are blended smoothly in compositing. Ideally the DP attends to this to check the intended look is maintained.

Final Grade and Conforming for Display

After the footage, VFX sound and music are all conformed, i.e. put together with the footage you have graded in the master grade (as above), a final grade is then carried out to iron out any issues that have come up. Then a very high-resolution master is exported, again using ACES if that is the color management system being used for the project, and all versions for the various distribution formats are made from that.

> This is often a very rushed stage of the workflow because, despite everyone's best efforts, some elements may be delivered very shortly before the film needs to be delivered for distribution.

It is important to view each version and adjust if necessary, because when the versions are made for different platforms the dynamic range may be reduced or increased (for HDR), so some things that weren't visible previously become visible.

Also, if there are any aspect ratio changes for a display device, adjustment to image framing may need to be made, to make sure everything that needs to be seen in a shot is still included. The DP should attend if possible to ensure the shots also work for framing and lighting.

Archiving

The trimmed original footage (i.e. the parts of the shots that have been included in the film) should be retained with the master grade project files, to retain all the information about the project.

ACES is ideal for archiving, because the color gamut is so wide that you can go back and re-master for anything later.

If not archiving in ACES, use the widest color gamut master you have. Apple Prores HQ4:4:4 is popular and practical, not too large but high quality if written at 50Mbps. Beware that if the digital

archives insist on a format higher than you have produced, performing an up-conversion to that format may negatively impact the quality of your film.

EXPORTING FOR DELIVERY

When preparing video for display or download, it must be encoded, to reduce it to a size needed for the display device and so it is manageable for the download speed of delivery. The frame rate should be kept the same as you edited in. The resolution can be reduced but not up-sampled. The most popular current delivery codec for HD is currently H.264 and the most popular delivery container is currently .MOV or, for UHD, H.265. This has been adopted because there is a good balance between compression and retaining quality.

Bit rate: This is usually something that you select, and is hugely important because it affects image definition, file size and, therefore, the bandwidths you need to view it and how much it costs to deliver it. Too low bit rate may result in blocky web videos, but if you set it too large it will be reliant on higher bandwidth for delivery or it will buffer (pause) when played online.

Know what platform you are delivering to and check their current best practice and recommended settings, as this will change every six months.
Kim Plowright[16]

Photo from Pexels.com.

Constant Bit Rate: This maintains a set bit rate over the entire video clip, but this limits the image quality in segments with a lot of detail or movement. Constant bit rate intra-frame compression looks at every individual frame and compresses them the same amount.

> *When exporting for Vimeo or YouTube, I export at 50Mbps for a 1080p H.264 upload, even though when it appears it will be more like 5 or 10. Once you have uploaded your source file, they will transcode it, smartly serving the right size file for the viewer's bandwidth. However, providing a higher initial bit rate means that their system has to down-sample, which always provides a better-quality final result. This is a general truism for both acquisition and distribution. Although there is interpolation going on in the output, their systems are effective at keeping chroma detail on everything.*
> *Matthew Hicks[17]*

Variable Bit Rate allocates a higher bit rate to the more complex segments of media files (where there is a lot of movement or changes in light or color) and lower bit rates to the simple segments. You can set minimum and maximum bit rates within the VBR.

VBR is inter-frame and looks at each frame, and if a static doesn't need to pass as much information over from one frame to the next. VBR encoding requires more processing time. For most content, adding up the bit rates and dividing by the duration (in seconds) gives the average bit rate for the file. VBR produces significantly higher quality than CBR at similar overall average bit rate, so is usually preferable.

2 pass VBR: This is usually best because it does one pass to assess what is needed, and a second to do it. This may take more time when preparing the film, but is better quality.

A good place to start with bit rate is 40–50Mbps for 3840 x 2160 UHD, 10–20Mbps for 1920 x 1080 HD, and 5–10Mbps for 1280 x 720 HD. The optimal bit rate for each resolution may be higher, and depends on how much camera movement or fine detail are in the film. Online platforms will have their own specifications for resolution, frame rate, codec, wrapper and bit rate.

SUPPORTING CONCEPTS AND THEORIES

Methods of Compression

> Computers used to find it harder to work with interframe compression, but it is less of a problem now. If you are using any domestic computing equipment, you should test a small amount of footage and check it can cope with editing, layering images on top of each other during editing speed changes and transitions before you transcode all your footage.

The fundamentals of compression apply whether it is done in camera, during post-production or prior to display. Compression is used to reduce file size.

Compression involves interpolation, which is replacing something with something else.

Intra-frame compression: This reduces the amount of information recorded about a single frame. Prores and Cinema DNG are examples of inter-frame compression.

Inter-frame compression: This records a frame, then skips a frame, or couple of frames, and uses predictive codecs to calculate what has changed between the two, and just records the changes. The more changes there are in a frame and the less frequently the codec records a frame, the harder it is for it to be accurately reproduced. Inter-frame compression reduces file sizes to half or less of the original size. MPEG-4 and XDCam are examples of inter-frame compression.

When inter-frame and intra-frame compression are combined in codecs – such as H.264, which is used by most DSLRs for recording and for many web applications for display (but isn't useful for post-production) – file sizes can be reduced substantially.

Lossy compression: This does not allow the exact original data to be reconstructed from the compressed data. Both inter-frame and intra-frame compression, as described above, are lossy. Compressing information can often mean that, on high-resolution displays, the edges might not look so sharp and that color couldn't be refined precisely, but if only low-resolution displays are used this would save time and money.

If you are going to be working with finely detailed, color-critical or fast-moving subjects but have no other choice than to use a lossy codec, you should test that:

- It will display correctly on the most critical screen it is intended to be shown on.
- The image doesn't jump or break up when there is fast movement.
- It retains enough information to do any work you need to do later (you will need to check this with post-production).

5: THE DIGITAL WORKFLOW FROM CAMERA TO SCREEN

Lossless compression uses algorithms that allow the exact original data to be reconstructed from the compressed data. One of the ways this is done is by recording less information about pixel 2 if it is exactly the same as pixel 1, but retaining a code that will put the full amount of information back later. Most cameras that offer a compressed RAW format compress the information losslessly.

Pixels, Photosites and Screens

Screens: A pixel has luma and chroma information that dictates how bright and what color a box should be on a screen.

How many boxes/pixels there are on the horizontal y-axis is what is called the resolution of the image. What is called 2k has 2048 horizontal pixels, but the total number of pixels will vary depending on the shape/aspect ratio of the screen, so may be slightly more or slightly less than 2k.

A pixel isn't a set size, it can be any size depending on what screen it is being shown on. The viewing device spreads out the available pixels over whatever size screen it is being displayed on. If the pixels in an image are squeezed onto a smaller screen, the image gets smaller and the perceived sharpness increases, depending on the distance the viewer is from the screen. If the pixels are enlarged, to spread an image over a larger area, its perceived sharpness falls. There are interesting, although surprisingly variable, charts showing up to which viewing distance increased resolution can be perceived.

In order not to see the screen's individual pixels, the closer you sit, the higher resolution you need, particularly if the screen is large. If you sit far away from a high-resolution screen, say 4k, you won't be able to distinguish the extra pixels, compared to the more affordable 1080p resolution. You can use a screen size calculator to help assess the optimum screen size for a given distance. Likewise, a reverse 'angular resolution' calculation will help you work out the optimal resolution to shoot at for a given screen size, when viewed at a particular distance.

Sensors: A pixel is the unit of information created from photosites (see C3). Theoretically, if you have a camera sensor with 4 million photosites, you can then have that data translated to a 4-mega-pixel image (known as 4k). The difficulty with this is that photosites don't record color information, so a 4k image from 4 million photosites would only be truly possible in black and white. To create color information, a filter, usually a Bayer pattern filter, with two green, one red and one blue filter is put over 4 photosites to create 1 pixel, that has both light and color information. So, if a manufacturer uses the number of photosites as the resolution (and some do), this doesn't truly equate to the number of usable pixels being produced.

Shape Squeeze and Crop

Aspect ratios are a creative choice (see C6). If shooting a film that will be screened with a different aspect ratio to the sensor, you will shoot at less than the maximum resolution, unless the image is squeezed onto it to fill up the whole sensor, then un-squeezed in post-production.

The Bayer pattern filters the light hitting the sensor so that 50% of the sensor's photosites are used to represent green, 25% of the photosites represent red and the remaining 25% represent blue.

Some cameras (including ARRI) have a lens squeeze factor that allows you to adjust how much the image is squeezed. Make sure that post-production knows if they need to un-squeeze an image, and give them the lens squeeze factor so they know by how much.

Anamorphic lenses squeeze a wider image onto a sensor, rather than just recording on a small part of it, so always need un-squeezing in post-production.

Wonder Woman DP Matthew Jensen (left) the image is squeezed onto the sensor so that the whole of the sensor is used. (right) The image is un-squeezed for projection.

NOTES

1 Andrew Boulter (DP) in discussion with the author (September 2016)
2 Kevin Shaw (colorist, instructor and consultant, Colorist Society International) in discussion with the author (November 2017)
3 Roberts, Joe. "What is HDR TV? High dynamic range and HDR10+ explained". *Trusted Reviews*, September 28, 2017. http://www.trustedreviews.com/opinion/hdr-tv-high-dynamic-television-explained-2927035
4 Kaufman, Deborah. "Higher Ground – A Producer's Guide to High Dynamic Range (HDR)". *Light Iron*, July 26, 2017. http://lightiron.com/higher-ground-producers-guide-high-dynamic-range-hdr-2/
5 Gladstone, Steven. "Cinema Cameras: What Filmmakers Need to Know". *bhphotovideo.com*, 2016. https://www.bhphotovideo.com/explora/video/buying-guide/cinema-cameras-what-filmmakers-need-know
6 Adams, Art. "Log vs. Raw: The Simple Version". *ProVideo Coalition*, February 7, 2013. https://www.provideocoalition.com/log-vs-raw-the-simple-version/
7 Georgina Burrell (DOP/shooting PD, georgieb.tv) in discussion with the author (May 2017)
8 Stoilov, Ogy. "Canon Log 3 vs. Canon Log 2 Side by Side 4K Comparison". *4K Shooters*, August 3, 2016. http://www.4kshooters.net/2016/08/03/canon-log-3-vs-canon-log-2-side-by-side-4k-comparison/
9 Lutify Me. "Introducing LUTs For Lightroom". 2016. https://lutify.me/
10 Josh White (DP) in discussion with the author (September 2016)
11 Tomas Tomasson (DP) in discussion with the author (September 2017)
12 Dana Kupper (documentary cinematographer) in communication with the author (August 2017)
13 Jonathan Smiles (post-production workflow specialist) in discussion with the author (October 2016)
14 Andy Maltz (managing director Science and Technology Council of the Academy of Motion Picture Arts and Sciences) in discussion with the author (November 2017)
15 Paul Curtis (colorist and VFX, Inventome) in discussion with the author (December 2016)
16 Kim Plowright (freelance producer and product manager, and a senior lecturer at the National Film and Television School) in discussion with the author (September 2016)
17 Matthew Hicks (DIT) in discussion with the author (September 2016)

SECTION C

Storytelling: Shots, Scenes and Time

6
Storytelling in Shots: Lenses and Composition

Lenses are the tools of the trade of a cinematographer. Composing shots involves selecting which lens to use, where to position the camera and what to have in frame. A good understanding of lenses will help you select the optimal lens not only to include what you need in the frame but to emphasize what you want to draw the viewer's attention to. The chapter starts by looking at how wide, normal and long lenses can be used to control the relative size of people as they move within the frame, and how this can be used in storytelling. It then looks at the practical considerations of how sensor size and crop factors affect depth of field, and how lens mounts, compatibilities and size affect your lens choices. This is followed by examining how composition varies when using different aspect ratios and how headroom, eyelines and leadroom all affect viewer perception. The chapter continues by detailing the photographic composition techniques that help lead the viewer's eye. It finishes by looking at how the practical factors of re-arranging elements in your shots allows wide and close shots to match.

LEARNING OUTCOMES

This chapter will help you:

1. Understand what focal length is and how it affects the angle of view and perception of distance within a frame
2. Know what the z-axis is and how to use it to emphasize depth within the frame
3. Use the effect of wide, normal and long lenses for different storytelling purposes in close-up, mid- and wide shots
4. Use focal length and camera position to convey the perspective of the viewer
5. Evaluate the implications on meaning of movement from right to left or left to right
6. Use story concepts to decide how and where to draw the viewer's eye in the frame
7. Apply visual and photographic concepts including focus and composition 'rules' or guides for drawing the viewer's eye to part of the frame
8. Use appropriate positioning of people and consistent headroom and leadroom within the frame
9. Understand the implications of using and breaking the rule of thirds and traditional guides for composition of headroom and leadroom in the frame
10. Adjust compositions for different aspect ratios
11. Understand the practical and creative criteria for selecting lenses and the difference between lenses calibrated in T-stops and F-stops
12. Calculate equivalent focal lengths for cameras with different sensor sizes

C: SHOTS AND STORYTELLING

Composition is instinctive but it is an instinct based on a complex body of knowledge which can be expanded and developed. Watch and pause films to assess the composition of shots. Look at what is in the frame, how it is arranged, how your eye is led to what is important and how the rest of the frame works to support or inform what you are seeing. The most effective way to learn is a combination of looking at how other cinematographers compose their shots, and practicing techniques in order to develop your own style. The more quickly you are able to assess composition in the work of others, the more quickly and easily you will be able to assess what is and isn't working when you frame shots yourself.

You don't need expensive equipment to learn composition. Any stills or movie camera can be used, but ideally a DSLR with an APS-C sensor. All focal lengths referred to in this chapter are for a Super 35 sensor size which is the most common standard used in cinematography and a very close equivalent to APS-C. For adjustments (crop factors) to find equivalent focal lengths for cameras with full-frame or other sensor sizes see the guidance below. When practicing any of the examples in this chapter, it is useful to stick to the most widely used focal lengths (16, 18, 25, 35, 50, 80, 105 and 135mm) and move your camera position to get the frame you like, rather than adjusting the zoom. This will allow you to become familiar with the use and effect of different focal length lenses, so you can visualize how they will work in a space and know which ones to request for a particular shot. You will also be able to adapt easily when you have the opportunity to work with prime lenses and communicate professionally with directors.

(left) 18mm Wide shot. (right) 135mm Tight shot.

In most cases, the shorter the focal length, the physically shorter the lens is and the wider the angle of view. This is also known as wide, lose or zoomed out. The longer the focal length, the narrower the angle of view; also known as tighter or zoomed in.

6: STORYTELLING IN SHOTS: LENSES AND COMPOSITION

Focal length is the distance in mm from the point where the light rays coming into the lens converge to where the image is created on the sensor (measured when the lens is focused at infinity). A lens's focal length affects what the viewer can see from side to side, i.e. the angle of view.

In most cases, the shorter the focal length, the physically shorter the lens is and the wider the angle of view. This is also known as wide, loose or zoomed out. The physical size of a lens isn't always exactly the same as the focal length, because the glass elements inside a lens, that create the image and sharpen it, can be grouped in a way that reduces the length of a lens. Telephoto lenses, for example, are long lenses that have the elements grouped to make them slightly shorter than their effective focal length.

'Doublers' can be attached to the rear of a lens to increase the focal length. Doublers can be 1x (which double the focal length) or 2x (which quadruple it), etc. Each time the focal length is doubled in this way, 1 stop of light is lost.

Not all extenders are doublers – ARRI Focal length extenders (left) double the focal length of the lens, (right) multiply the focal length by 1.4. Photo courtesy of Arri (www.arri.com).

FOCAL LENGTH AND COMPOSITION

Look up from what you are reading and look at the space you are in. Place an object about 6 feet away from you, then hold your hand out in front of you. As you move your eye from your hand to the object at 6 feet, you understand the relationship of the distance between your hand and the object. Your eyes sense distances in a consistent way. You can draw your attention to different areas but, wherever you are, the same size object at 6 feet away will look the same size and so will the background.

When you are shooting a film, you are not locked into this perception of distance; the focal length of the lens you choose can alter it substantially.

The Two Effects of Focal Length

Focal length dictates how much can be seen from side to side, but also dictates how distances appear from front to back. Irrespective of the size of the person in frame, the perception of space, distance, and how close the viewer feels to the action, depends on the combination of what focal length lens is used and how far the lens (and camera) are from the subject. In the top frame from *Jaws* (to the right), more can be seen from side to side but the viewer feels closer to the character because a wider lens is used at a closer position and because the beach tent has come into frame. The bottom frame has been zoomed in to a longer focal length and the camera is positioned further back so less of the background can be seen, but the size of the character in the frame remains virtually the same. When a lens with a longer focal length is used in this way, the viewer feels further away from the action.

Two shots taken from a contra-zoom/zolly shot in *Jaws* DP Bill Butler. The camera tracks forward whilst the lens is zoomed out to keep Chief Brody the same size in frame from the bottom shot (which is the start of frame) to the top. This is done for storytelling reasons, so the intensity of Brody's reaction to the shark attack is maximized.

143

C: SHOTS AND STORYTELLING

Choice of lenses affects the shape of the face. Very wide-angle lenses (left) will both exaggerate volumes and distort shapes, particularly at the edge of frame. Wide lenses (center) make features more pronounced without noticeably distorting them. Normal lenses (right) will render face shapes and proportions roughly as the eye sees them.

Wide-angle lens.

Normal lens.

Long lens.

> At the NFTS (UK National Film and Television School) we look at what focal lengths do for different senses of perception and for the shape of the face. A lot of directors don't understand the effect of focal length on audience perception.
> Oliver Stapleton[1]

The aperture and depth of field exercises in Chapter 3 also demonstrated the effect of focal length on the appearance of the face and the perception of distance. Look back at those shots or repeat them by positioning a person 8 feet from a wall and shooting a shot from just their chin to the top of the head, but include part of the background in the shot on an 18mm lens. Then move back just as far as it takes to get exactly the same amount of their face in shot on a 50mm lens and then repeat by moving back and shooting on an 85mm lens and on the longest lens you have. Be sure to include only chin to the top of the head and to include some of the wall in each shot you take. When you view your shots you will see the following:

- **Wide-angle lenses:** up to 35mm – give a broader angle of view than our eyes do. If used close to any object, they enhance the volume of what is closer to you. A person's nose, for example, appears larger than it really is. It also makes what is further away from you (i.e. the background) seem further away than it really is. N.B. This wide angle effect is not apparent if there is nothing close to the lens, so wide-angle lenses (up to a point) can be used for wide shots without appearing to distort anything.

- **Normal lenses:** 35–70mm – represent distances in roughly the same way as your eyes do and give an angle of view that is similar to our eyes. Distances from camera to subject and subject to background appear normal.

- **Long/Telephoto lenses:** 75mm upwards – give a narrow angle of view and also flatten the image so the nose, for example, appears smaller than it really is and what is far away seems closer to the subject than it really is. The longer the lens is, the shallower the depth of field, so the subject is visibly distinct and the eye is drawn to them rather than the background.

Focal length affects what is in the frame and how it appears but it also has a substantial effect on the perspective of the viewer and importantly, what happens when people move within the frame. The use of focal length is an important part of storytelling and affects the viewer's perspective (their sense of how or where they are

6: STORYTELLING IN SHOTS: LENSES AND COMPOSITION

viewing from). Different focal lengths can be interspersed, to bring the viewer closer or further from the action, but this should always be done for a reason, as it is part of the visual voice of the film.

Wide-Angle Lenses

24–32mm OR SUPER-WIDE 16–24mm

Using a short focal length/wide-angle lens, close to the action, makes the viewer feel they are close to the subject and experiencing it close-up and in the character's personal space, or (depending on the angle of the camera) even first hand. They are commonly used in wide or super-wide shots, to see a wide angle of view, but although distances appear to be further than they would in real life on a wide-angle lens this is not immediately obvious if there is nothing in frame that is close to the camera.

When used in closer shots the increased perception of distance is more obvious. Wide-angle lenses are used in close shots to exaggerate the size and importance of people or objects close to camera. When there is movement forwards or backwards in the frame, using a wide-angle lens exaggerates it and makes people appear perceptibly larger as they come forward and smaller as they move back.

Watch out for:

- Using wide-angle lenses for over-the-shoulder shots because the shoulder may look very big. You often have to position the person whose shoulder you are seeing closer to the person they are talking to than would be natural in real life, to avoid this effect. Try it.

- If you place people too close to one side of the frame, they will appear stretched to the side and the arm nearest the edge of the frame will appear bigger. If you are very close to a person's face, you will enlarge and distort their face, particularly the nose.

For examples of using wide-angle lenses close to the subject, see the work of the Coen Brothers, *The Revenant*,[3] *The Shining*[4] and *A Clockwork Orange*.[5]

Wide-angle lenses used for over-the-shoulder shots allow a lot of the background to be seen, which keeps the context of the shot. They exaggerate the distances between people but allow slight differences in positioning to affect the size of people in frame. These shots from *No Country for Old Men* DP Roger Deakins appears to be a matching and reverse shot but to retain his power, in the bottom shot Anton Chigurh is placed slightly closer to the shopkeeper so he takes up more screen space than the shopkeeper did in the top frame.

There are always creative uses for so-called 'wrong' lens choices, e.g. the Central Park scene in *Serpico*,[2] but these are relatively rare and in no way diminish the need to learn and become confident with how focal lengths are usually used.

Standard/Normal Lenses

35–70mm

Using 'normal' or 'standard' lenses gives the viewer a perspective that is much the same as human vision and doesn't distort the size or distance between the characters.

Rarely used for wide shots, normal lenses are used most often for medium or MCU (medium close-up) dialogue shots, and are often the go-to choice for shot/reverse shots (showing both sides of a conversation), because they don't distort sizes or distances.

Likewise, in moving shots normal lenses don't change the relative size of people, as they move forward and backwards, so are good for scenes in which there are a number of people moving.

50mm is considered standard, although focal lengths from 35–70mm are used in similar ways.

Normal lenses are often used for dialogue scenes and allow the viewer to experience the film close enough to be able to empathize with the characters, but without feeling like they are participating.

145

C: SHOTS AND STORYTELLING

A 'clean' shot – reverse shot just shows each person in the conversation.

A 'dirty' shot reverse or OTS (over-the-shoulder) shots show the shoulder or head of one and the face of the other.

(left two shots) *Revolutionary Road* DP Roger Deakins, (right two shots) *The New World* DP Emmanuel Lubezki.

EXERCISE: Try shooting an over-the-shoulder shot with one person close to the camera and another moving forward and backwards on a wide-angle lens and then on a normal lens. Then shoot shot reverse shots, i.e. both sides of a conversation, on wide, normal and tight lenses.

Most camera manufacturers make a 50mm standard, prime (single focal length) lens that has a wide aperture and is relatively cheap. If you are learning to shoot with a DSLR and only have a zoom lens, a 50mm prime should usually be your first choice for an additional lens.

During daylight, you will be able to open up the aperture to make the most of the shallow depth of field it can offer. At night, the wide aperture will allow you to shoot with lower levels of light. An additional benefit is that a prime lens will be smaller and lighter than a zoom.

For examples of films using mainly normal lenses, see the work of Francis Ford Coppola and Alfred Hitchcock.

Long Lenses

ABOVE 75mm

The longer the focal length you use, the further away the viewer feels. On very long lenses the viewer may feel voyeuristic, i.e. as if they are seeing something they shouldn't.

You can enhance the feeling of observing from afar by having something slightly out of focus obscuring part of the shot. It usually looks better to have only a small amount of the shot obscured and for that part of the frame to be out of focus.

Long lenses don't have the angle of view to be used for wide shots and, when used for medium shots, the camera has to be at quite a distance from the subject. Long lenses are useful when you want to reduce the angle of view and decrease the depth of field to pick someone or something out from the background. This also makes them useful for when there is something in the background that you need out of frame (but can't change your camera position). Likewise, they are useful for cheating reverses, i.e. shooting one side of the dialogue or action in one place and the reverse somewhere completely different.

If you include something in the foreground of the frame, it must be done subtly (and is often out of focus), to avoid it dominating the frame.

6: STORYTELLING IN SHOTS: LENSES AND COMPOSITION

Tinker Tailor Soldier Spy (2011) DP Hoyte van Hoytema.

Long lenses are also used when you want a shallow depth of field or to see a focus rack, to dramatically shift focus from one part of the frame to another. They can also be used for their foreshortening effect, which reduces the apparent distance between the background and foreground. In an extreme 2000mm focal length example, in *Tinker Tailor Soldier Spy*,[6] this allows a plane to appear to be dangerously close as it approaches the characters for an entire scene.

Equally importantly, long lenses are used when the camera needs to be at a distance from who or what is being filmed to reduce the intrusiveness of the camera. This can be helpful in documentary situations but is difficult when hand-held because the longer the lens the shallower the depth of field and the more visible camera shake is.

> **Cathy Come Home**[7] *was an important story and marvelous to photograph, but the way we shot that was not at all the right way to photograph* Kes.[8] *On* Kes, *we hung back and were on longer lenses. Being on long lenses, we were always outside the circle of the performers [so the audience feel like observers]. Also, the narrower field of view behind them meant that we could see the real world, but our attention was drawn to what is happening. Ken [Loach] liked that. We found the rhythm and authenticity of the film, it was magical.*
> **Chris Menges**[9]

For other examples, see the work of directors Ridley Scott and Michael Bay, who often use long lenses.

EXERCISE: Use a long lens at a distance to make the viewer feel they are seeing something without the characters being aware of it. Try putting something close to the camera to enhance this effect. Compare the same shot from the same position on a wide and normal lens.

In this shot in *Kes*, DP Chris Menges, being on a longer lens, allows the camera to be further away from the action and allows the boy in the foreground to be clearly visible without dominating the shot (as he would on a wide lens).

C: SHOTS AND STORYTELLING

> Aspect ratio is the relationship between the longest side and the shortest side of a frame. In a 2.35:1 aspect ratio, for each 2.35cm or 2.35 inches (or whatever length you are measuring in) along the horizontal axis there will be one cm or inch on the vertical axis.

Focal Length and Aspect Ratio

In addition to the angle of view and distance of the camera to the subject, the aspect ratio also affects how much of the background can be seen. You will frame differently for a 2.35:1 aspect ratio than for a 1.33:1 because the wider the screen, the more of the background will be visible and so the elements of the frame can be arranged so it is balanced from side to side, weighted one side to the other or the eye is led across and through the frame. If the film is to be shown at the cinema but also shown on a squarer mobile phone or airline seat screen, each shot can be panned and scanned so the action can still be seen in the frame. If your film will be shown in multiple formats, what you must avoid is having action at both sides of a wide aspect ratio frame that will be impossible to contain in a narrower aspect ratio. Also, beware that if you don't have the option to pan and scan, you may lose important action altogether (see below). To avoid this, use frame guides marked on the EVF and the monitor and keep the action within the part of the frame that will be visible in all formats.

1.33:1 1.78:1 2.35:1

1.33:1 1.78:1 2.35:1

(top) You frame differently for different aspect ratios. (bottom) If a film shot for 2.35:1 (widescreen) is converted to a narrower aspect ratio, you can lose the action completely unless you 'pan and scan' so that the subject remains in shot.

THE Z-AXIS

The width of the screen is the x-axis, the height is the y-axis, and the depth is the z-axis. Shooting at angles which maximize what you can see in the z-axis, and particularly having action where there is movement back to front (particularly in 3D), makes the audience feel that something is coming at them.

6: STORYTELLING IN SHOTS: LENSES AND COMPOSITION

Shots using the z-axis exaggerate the effect of how different focal length lenses render space, when characters move towards or away from the camera. Try this by having two people repeat the same move on wide, standard and long lenses.

A character's move towards the camera can be used to increase power, domination and aggression, and a move away may be used to show weakness. Similarly, looking down on characters can make them appear weak, whereas looking up to them can make them appear more dominant, particularly if they are close.[10]

Finding locations that have leading lines, or allow for movement front to back, or angling the camera so the corner of the room is in the background (although not necessarily central), can help frame for the z-axis. Try it.

HOW SENSOR SIZES AFFECT THE ANGLE OF VIEW

Focal lengths crop factors and angles of view

The angle of view of a lens depends on its focal length and the size of the sensor. The focal lengths used in this book are for Super 35 sensors, which are currently the most frequently used in cinematography. Super 35 is the same size as 35mm motion picture film but confusingly is not the same size as 35mm still photography film or the digital equivalent, which is called full-frame. This is because in still photography 35mm is measured horizontally whilst for motion picture it is measured vertically.

Although both types of framing clearly have their place, these shots from *Mad Max: Fury Road* DP John Seale show that x-/y-movement (top) usually feels less dynamic than z-axis (bottom).

Super 35mm sensor size (top) is smaller than full-frame sensor size (bottom). These shots show that the larger the sensor, the wider the shot you get for the same focal length.

149

C: SHOTS AND STORYTELLING

> A crop factor is the number you need to multiply the focal length by to get a shot size equivalent to full-frame.

Full-frame sensors or their digital equivalent have a crop factor of 1. Super 35 sensors have a crop factor of approximately 1.4. For crop factors of other sensors, see below.

In practice:

- Learn which angle of view the focal lengths cover for one size sensor (usually Super 35 as used in this book).

- Find out the size of the sensor you are working on. If it isn't Super 35 (or very close), then either use an app or calculator to find the equivalents or learn them for your project.

N.B. The effective sensor size of most RED cameras and some others changes depending on the resolution you are shooting at, so always put the resolution as well as the camera model into the app to be sure of getting the correct equivalent focal length.

The guiding principle, which becomes a very handy rule of thumb, is as per the shots of Russian dolls on page 149: the smaller the sensor you are using, the shorter the focal length you need to get an equivalent shot, and the bigger the sensor, the longer the focal length you need to get the same shot.

> There are a range of sensor sizes. Confusingly, some are described by their size, some by their ratio and some by the number of pixels/photosites they contain.

Go-Pro Hero
CROP FACTOR - 5.5

Blackmagic Pocket
CROP FACTOR - 2.88

Canon C100, C300, C500
CROP FACTOR - 1.6

All manufacturers produce cameras with a variety of crop factors.

All sizes are approximate

ARRI ALEXA AMIRA 16.9 mode

Panasonic VariCam 35 / LT

RED SCARLET-W

All of the above have an approximate
CROP FACTOR - 1.4

These are S-35mm

Sony A7 Series, Nikon D810, Canon 5D Series
CROP FACTOR - 1

RED MONSTRO
CROP FACTOR - 0.9

ARRI ALEXA 65
CROP FACTOR - 0.69

Relative sizes and shapes of sensors.

Importantly, not all lenses can be used on all sensor sizes. If you use a lens that is designed for a smaller sensor on a camera with a larger sensor, it is very likely that the image circle the lens produces will not cover the whole sensor and will create vignetting.

> Vignetting may be a clearly visible dark circle or may just be dark corners. When testing, look at the edges of the frames to check for vignetting.

6: STORYTELLING IN SHOTS: LENSES AND COMPOSITION

There are additional glass and other costs to producing a lens with a larger image circle, so they are only made large enough for use on cameras up to a given sensor size. Any lens that covers, for example, a Super 35 sensor will cover the sensor on any other Super 35 camera or any smaller sensor.

It is expected that you should be familiar enough with the focal lengths used in Super 35 cinematography to be able to select a wide, normal or telephoto lens without referring to any app or chart. It is now very useful to know know full-frame lens sizes because some (but by no means all) 4k cameras have sensor sizes that are the same or closely equivalent to the size of a full-frame DSLR sensor. Learning about crop factors and being able to use apps or charts will enable you to choose which focal length lenses will produce wide, normal or tight shots when shooting with cameras with different sensor sizes.

> The simple rule of thumb is that if you are using a camera with a larger sensor than Super 35, such as a RED Dragon, ARRI 65, you use will use a longer focal length to get the same angle of view. If you are using a camera with a smaller sensor than Super 35, such as GoPro or Blackmagic Cinema Camera, you will shoot on shorter focal lengths to get the same angle of view.

Fortunately, although this is often seen as a confusing subject, the following should keep you safe:

- Make sure the lenses you have cover the sensor size you are using, by testing them.

- Calculate a rough percentage increase or decrease, to work out how much shorter or longer the lens you need will be than on a Super 35 sensor for the same-size shot.

- Adjust your camera framing and position to get the shot sizes you want.

	1.5 crop/Super 35	Full-frame	Angle of View
Fish eye lens	8–10mm	12–16mm	115–180 degrees or more
Ultra-Wide	14–24mm	20–35mm	85–115 degrees
Wide	24–32mm	35–50mm	65–85 degrees
Normal	35–60mm	50–90mm	40–65 degrees
Medium Telephoto	85–135mm	135–200mm	30–10 degrees
Telephoto	135–300mm	200–400mm	8–35 degrees
Super Telephoto	300mm plus	450mm	1–8 degrees

It is very easy to get confused about sensor sizes for two main reasons.

First, because, as above, the number used to describe the sensor size, in some cases, is the vertical length and in other cases the horizontal, and because, in some cases, such as Micro Four Thirds, it doesn't represent either measurement, and in other cases the sensor is commonly described by the pixel count (such as 8k) rather than the size.

Second, because the full-frame sensor used in full-frame stills cameras is described as having a crop factor of 1, whilst the Super 35 cinema cameras are described as having a crop factor of 1.4 or 1.5, depending on the exact sensor size of the camera you are using.

The recommendation to use APS-C DSLR cameras for practice in this book has been made because these also have a crop factor of around 1.5 and are a similar size sensor to Super 35.

Other points to note are that 65mm or 70mm sensors used in, e.g. the ARRI Alexa 65, are measured horizontally and the sensors used for 70mm Imax are measured vertically which means their crop factor is considerably different. Additionally, it is important to note that on some cameras (including many RED models), when you select to shoot at a lower resolution, you shoot on a smaller part of the sensor, so the crop factor changes. On other cameras, you shoot on the whole sensor, and the image size resolution is reduced. This essential information should be researched when you are preparing.

C: SHOTS AND STORYTELLING

HOW SENSOR SIZE AFFECTS DEPTH OF FIELD

It is a common misconception that a larger sensor size will produce a shallower depth of field. Depth of field itself is not affected by the size of the sensor. What happens is that, if you use a larger sensor, you either use a longer focal length to get the same size shot, which gives a shallower depth of field, or you move forward to get the same-size shot, which also gives a shallower depth of field.

LENS CHOICES

The construction, glass and coatings used on lenses affect how they look and what they can be used for. See Chapter 14 for comparing the look of different lenses. (*American Cinematographer*, or an online search for which films were shot with which cameras and lenses, will help you find out which lenses are currently being widely used.)

The practical factors that should be considered when choosing lenses are:

- If the focal length and/or zoom range will allow you to take the shots you want in the situation you will be shooting.

- If the lenses will cover the sensor of the camera.

- If the lens mount and camera mount are compatible or if one or other can be adapted (see below).

- The size and weight of the lens (lenses, even of the same focal length can vary hugely). You will need smaller lighter lenses for hand-held or drone work. If using long or heavy lenses, they will need additional supports underneath to stop them pulling on the lens mount and going out of alignment.

- Maximum aperture, i.e. how wide the aperture can open up and whether they are marked in T-stops or F-stops (see below).

- Minimum focus distance.

- If using a stills lens, whether it has cogs for a follow focus, if it is parfocal (retains focus as you zoom) and if the distance markings are spread out enough to allow you to focus pull.

- Quality of the glass and cost.

The size and weight of a lens may mean it requires an additional support underneath to avoid it pulling the lens mount out of alignment or, in the worst case scenario, falling off.

Specialist and Macro Lenses

Not infrequently, additional or specialist lenses are required so you can get all the shots you need. The most frequently used of these include:

- **Fish Eye** for a wide but distorted look.

- **Tilt Shift** which allow for changes in perspective and for different parts of the frame to be in focus as the same time.

- **Periscope lenses** (or adaptors), which are designed with a periscope tube and mirrors to allow the lens to be further way from the camera than regular lenses.

Fisheye shot. Photo by Robert Nathan Gralington.

6: STORYTELLING IN SHOTS: LENSES AND COMPOSITION

- **Macro lenses**. Macro lenses allow you to focus very close and/or film small subjects. A 1:1 macro lens produces an image on the sensor that is the same size as the object. Macro ratios can be higher than 1:1 but any lower isn't true macro. It isn't essential to have a camera with a large sensor for macro shots because lenses for smaller sensors magnify the image.

> Most normal camera lenses focus by moving an entire assembly of optical elements, which can prevent them focusing at close distances. Macro lenses use a 'floating' optical element, which constantly adjusts the lens's internal geometry, to give pin-sharp focusing, better contrast, and consistently high picture quality at all focus distances. The flip-side to this is that depth of field is very narrow, particularly for lenses with a long focal length.[11]

Tilt-shift lens. Photo by Charles Lanteigne (creative commons) CC BY-SA 3.0, https:www.commons.wikimedia.org/w/index.phpwcurid=17608571.

ANAMORPHIC LENSES

Whilst more of a production and aesthetic choice than a specialist lens, anamorphic lenses squeeze the image onto the sensor, to make full use of the sensor when shooting for widescreen and cinemascope formats. They tend to be softer, less consistent, have more flare, and create oval-shape bokeh (see C14).

T-STOPS OR F-STOPS

Light meters measure light in F-stops, which you would think tells you where to set your aperture to get a specific exposure. However, because of internal diffraction, a certain amount of light is lost going through a lens, so you may get a darker image than you expect.

Lenses marked in T-stops (you will see the T or F at the wide end of the aperture ring) have been tested and adjusted to compensate for any light loss, which allows you to set the stop as you read it on the meter. Lenses with F-stops haven't been adjusted, so you need to test to find out how much light they lose so you can adjust your stop. Many but not all lenses designed for film or digital cinema have T-stops. Virtually all stills lenses have F-stops. However, even with lenses that have T-stops you should still test and compare the brightness of each lens you are using and you may have to adjust your exposure to compensate for any differences.

Macro shot. Photo by Petra Pitsch at Pixaby.

Shot from ARRI Master Anamorphics Flare Sets Showreel showing oval anamorphic bokeh (light circles). Courtesy Arri (www.arri.com).

> *Never trust anything written on a lens. Test the focus distances and the apertures and (if necessary) put your own marks to the lens before you shoot.*
> Oliver Stapleton

LENS MANUFACTURERS AND LENS MOUNTS

Cameras with interchangeable lenses have a lens mount. For a lens to fit onto the mount, it must have a compatible mount. On some cameras the mount can be changed. On some lenses the mount can be changed or it can be used with an adaptor.

Lenses are mounted on the camera to hold them steady and secure, but also so that the distance between the lens and the sensor remains exactly the same. If it isn't, the lens will not focus. This is the reason you test focus and have the back focus (the rear flange focal distance) adjusted if necessary (see C4b). Lens mount adaptors are designed not to change this distance and allow the lens to sit deeply in them, so the lens remains the correct distance from the sensor.

> Lens manufacturers, like camera manufacturers, are sticking less to their traditional niches and making ranges of lenses for high, mid- and lower ends of the market. However, paying more may mean you get increased compatibility and functionality, but doesn't necessarily mean you get better glass – the look a lens gives should always be tested. Some of the better-known manufacturers' brands and mounts are:
>
> **Zeiss:** Particularly renowned for their sets of sharp primes, from the mid-range superspeeds to the higher-end ultraprimes and master primes. They have ARRI PL (positive lock), known as PL mounts. PL is the traditional motion picture standard. Most lenses with PL mount are mid- to high-end.
>
> **Angénieux:** Angénieux lenses were developed by ARRI and Zeiss together. They are mainly high-end with PL mounts, but have now also released some for the mid-market, with EF mounts.
>
> **Primo:** Primo lenses are made by Panavision, and are mid- to high-end primes and zooms. Primos have the PV mount, which is exclusive to Panavision lenses, and ensures that Panavision kit isn't mixable with other lenses or equipment.
>
> **EF mount:** Is the Canon-designed mount, but tends to be used by most manufacturers making lighter lenses for the lower end of the video lens market. EF mount lenses are often used in documentary and low budget shoots. EF mounts are also used in still photography, so zooms may not be parfocal.
>
> **E mount:** Is one of Sony's mounts, built originally for their smaller cameras like the F55, and now for most of their lenses that are built for motion picture work. E mount lenses are used for a lot of run-and-gun shooting. The very popular and flexible Sony FS7II, which in many ways is on a par with the Alexa mini but is less expensive, has an E mount. The E mount can be adapted for EF lenses with an adaptor.

COMPOSITION AND STORYTELLING

Composition involves both creativity and visual necessity.
The director relies on the DP to:

1. Devise shots that will tell the story and use the space to its best advantage, in the chosen aspect ratio.

2. Be familiar with the type and composition of shots used in the genre you are working in.

3. Select lenses that will create the desired perspective of the viewer.

4. Make the composition work to draw the viewer's eye to the desired part of the frame.

5. Use lighting and photographic techniques to enhance the composition, to draw the viewer's attention to specific areas in the frame.

6. Notice and re-position or avoid any unwanted elements in the frame.

7. Make the composition work precisely for any VFX and post-production when needed.

8. Ensure the viewer doesn't see the lighting, staging or anything that shouldn't be in the film.

There are many concepts that can be used to select your frame and a set of enduring and effective photographic composition guidelines (below). Not all can be applied in every shot. In practice the composition for the wide or master shot is considered first and the framing conventions or concepts used in the wide are continued where possible in the tighter shots.

The tendency is to start studying composition by looking at the photographic composition guidelines, but the process of framing a shot doesn't usually start with how it can fit into a formal composition. It is often most useful to start by considering the story, the characters, their relationship to each other, and the space they are in.

> *It's about how you can express this story within this space.*
> **Christopher Doyle**[12]

- Is one person more dominant than the other in the story at that time? Having one person larger is a frequent and effective way to show power relationships.

- Can you use composition to reflect the emotions of the characters? If, for instance, one of your main characters is feeling trapped, could your composition in each shot make sure they are surrounded by things or people which show they can't move freely?

- If there is an emotional distance between your characters, can you compose them so they will always appear separate?

- Can the background action or arrangement of people or objects in the frame emphasize the emotion or mood of the shot?

> *Once we started we couldn't move the camera, so I spent a lot of time before each shot making sure the frame would work for everyone. I got everything nicely in frame, and working with the CGI background, which I could see being keyed live in the studio and made sure it continued to work throughout the shot as the actors moved.*
> **Tomas Tomasson**[13]

Frames within frames reinforce the feeling of being constrained, as Kanji Watanabe paces from side to side in *Ikiru* DP Asakazu Nakai.

C: SHOTS AND STORYTELLING

- Could you layer your compositions, so interiors and exteriors are both seen to emphasize either the difference or connections between what is happening inside and out for the viewer, while the characters are only aware of one space? (This could be an emotionally wrought dialogue scene inside contrasted with busy happy people moving outside or someone equally suffering but for a different reason in the world beyond the window.)

- Could you use frames (either door frames or window frames or spaces between objects) to emphasize parts of a frame and hide other parts of it?

When creating your composition, you should also consider:

- How will you stimulate the viewer's eye? When the camera isn't moving, will the frame be static or move slightly or erratically to create 'frame energy'?

- If, for example, someone is pacing up and down in frame, will the frame be static so the person reaches the edge of frame and is confined by it, or will the frame move with them?

- Can you use elements which reveal or hide your characters as they move, if you position your camera carefully?

- Could light be used as a key part of your compositions? Could/should one character always be in a particular light source? If so, your framing and composition will have to work around where that source appears to come from.

It would take many projects to use and explore the framing concepts above, but when shooting documentary footage, particularly exercise footage where you are free to experiment as you wish, it is possible to look for and practice many of them.

EXERCISE: Choose no more than two of the concepts above and shoot an activity such as a game of catch or a conversation in a park or equivalent area where you can move around your subjects. The people you are filming should know you, be comfortable with you filming them and be prepared to move to a different part of the park so you can frame in different ways or with different elements in the foreground. Shoot the same project on a different occasion using two different framing concepts, and compare the results.

As your compositional abilities develop, you will be able to ensure that all parts of the frame are working towards telling the story. However, there are many occasions and several framing concepts that rely on different parts of the frame telling different stories. A conversation between two people with smiling faces but that shows their twitching feet or a broken bottle on the floor will provide two sets of information. The meaning of every aspect of the composition contributes to making the meaning of the whole shot. There is a compositional concept called Quadrant Framing that explores the use of different parts of the frame to tell different aspects of a story.[14]

Whichever composition concepts you use in a project, they form part of the visual language of the film and should usually be used in a consistent or developing way throughout it.

CHOOSING SHOT SIZES

Good rules of thumb to guide you in selecting how wide a shot should be are:

- If body language is helping tell the story about what a person is feeling, it should be included.

- The extent (width) of the background shown (other than in establishing shots) should be based on how much needs to appear to show where the action is happening and, generally speaking, only wider than that if the space they are in affects their action or emotion.

6: STORYTELLING IN SHOTS: LENSES AND COMPOSITION

- If someone is exerting power on someone else, favor shots that show them both. Let the powerful person take up more of the screen and/or appear larger, than the other person.

In the MWS shot below, the framing and composition is used so that limbs are not cut off just before joints: this is because cutting off at joints looks inconclusive. Likewise, for buildings and objects, avoid cutting them just before the top or edge if possible.

Shot sizes are referred to by acronyms:

ECU: Extreme close-up
BCU: Big close-up
CU: Close-up
MCU: Medium close-up
MS: Mid shot
MWS: Medium wide shot
WS: Wide shot
EWS: Extreme wide shot.

When framing, remember that cutting of limbs at the joints (ankles, knees, wrists or elbows) usually looks odd. Avoiding this often also helps with headroom because, as per this example, tilting down to include the hands rather than cutting at the wrists would reduce the excessive headroom.

157

C: SHOTS AND STORYTELLING

USING DEPTH OF FIELD AND FOCUS PULLING FOR STORYTELLING

Even if the focus isn't desperately shallow, the viewer's eye is still drawn to the sharpest point. When the focus shifts from one part of the frame to the other, the viewer's eye shifts, and effectively this means that the composition changes.

Shallow depth of field is very popular with new filmmakers because it looks cinematic and very different to camcorder or mobile phone video. Very shallow depth of field will result in obvious racks/pulls of focus, though. These should only be used when the intention is to make the viewer aware of a sudden change.

In this scene from *The Host* DP Kim Hyeong-gu, shallow depth of field and focus pulls help pick out the characters and tell the story within a crowded environment.

The same process of choosing the angle of view depending on how much background should be seen to tell the story applies to choosing the depth of field. The viewer should usually be able to see the background so they can see how the action is unfolding within the space (if it isn't necessary to see the space, there would be no point in choosing good locations). The background doesn't have to be as sharp as the foreground, though. The rule of thumb for very shallow depth shots is that they should only be used when the audience needs to focus purely on the subjects, and when their action relates only to each other and isn't influenced by where they are. Using this rule of thumb, you will find that extreme shallow depth is not used so frequently.

For other examples of creative and sophisticated use of depth of field, look at the work of Stanley Kubrick and Orson Welles,

SCREEN DIRECTION: RIGHT TO LEFT AND LEFT TO RIGHT

> The implications of right-to-left movement was originally believed to relate to the reading direction of Western audiences, but the research reveals it applies universally.

Although not often a consciously considered, screen direction has an effect. A team at Cleveland State University have researched into the effect of screen direction and found that the position of people and the direction of their movement has a significant effect on how most viewers interpret their characters and intentions. In summary:

Shots showing (left) walking left to right and (right) walking right to left from *Strangers on a Train* DP Robert Burks.

6: STORYTELLING IN SHOTS: LENSES AND COMPOSITION

- Movement of characters from left to right implies arriving, and actions that are positive and progressive.
- Movement from right to left implies leaving, or actions that are negative or less powerful.

In static shots, it shows that:

- The power and positive intentions of protagonists or positive characters is reinforced if they are placed on the right.
- The bad intentions of an antagonist or weaker character are reinforced if they are placed on the left.

It is interesting to look at the reference video and the Cleveland State University research (titled "Which Way Did He Go? Lateral Character Movement in Film").

HEADROOM

Headroom was traditionally, and is still often, gauged by having the eyes approximately 1/3 of the way down the frame or slightly higher in wide shots. This rule of thumb stems from the 'rule of thirds' (see below), but although still widely used, it is not as rigid as it used to be. When there are other major compositional elements in the frame, this 'rule' changes.

Mr. Robot was a turning point in framing conventions. It consistently broke the 'rules' of headroom and long siding [see below]. By consistently using low headroom and positioning people in the bottom section or third, a strong and distinct visual language was created.
Semih Ökmen[15]

In the shot on the left from *Mr Robot* DP Tod Campbell, the eyes are approximately 1/3 down the frame, while in the shot on the right they are approximately 2/3 down the frame.

Having eye height lower than 1/3 of the way down the frame changes the balance between the subject and their environment, and the standard positioning of eye height throughout a film has now become one of the compositional decisions made between the director and the DP in pre-production. Wherever you decide to position the eye height, this should be a guiding principle throughout the film. Even if there is a change in the headroom for a specific scene, make sure it remains consistent within a scene or the heads will appear to be bobbing up and down in the frame from shot to shot.

LEADROOM

Leadroom (sometimes known as noseroom) is the amount of distance from the person or subject of the shot to the edge of the frame. Traditionally there has always been more leadroom in the direction the person is looking, to give the viewer the sense that the action is happening in the film space. This helped create a sense of balance and was often used with the person positioned approximately one third of the way into the frame and facing towards the remaining two thirds. This is still widely used, particularly in shot reverse shots of conversation. However, 'short siding' where there is little or no leadroom is

Dr. Foster season 2 DP Ben Wheeler.

159

C: SHOTS AND STORYTELLING

In these scenes from *Dr Foster* season 2 DP Ben Wheeler, the framing in the top shots show the characters are comfortable with each other, whereas the short-sided framing in the bottom shots shows an uncomfortable relationship.

now also an option used in dialogue scenes. Leadroom can be used as part of how relationships are shown and to disrupt the sense of balance within the frame and within the film space. This doesn't negate photographic composition principles. What often happens is that the frame is perfectly balanced in all other respects than the position of the characters who are talking.

The above examples from *Dr Foster* season 2[16] show how the positioning of the characters within the frame is one of the ways their relationships are conveyed. In this case, long siding is used to convey a more comfortable relationship, and short siding is used to convey discomfort.

ASPECT RATIO, GENRE AND COMPOSITION

Aspect ratio, along with shot size and focal length, affects how much the viewer is seeing from side to side. Where the environment is far-reaching and/or the space plays a role in the storytelling, such as in westerns, war or epic films or any sub-genre of them, a wider aspect ratio is often beneficial.

(left) *Ben Hur* (2016) DP Oliver Wood, (right) *Das Tagebuch der Anne Frank* DP Bella Halben.

Interestingly, a wide aspect ratio was also used for *The Diary of Anne Frank*,[17] in both the recent 2016 film and the original 1959 version. In 1959, this was partly for commercial reasons, with widescreen becoming popular at the time it was made. In both films, uprights such as pillars are included in the design of the space so they could be included in the frame to create more cramped compositions. In other scenes in this film, having little headroom at the top of the frame helps create the feeling that the family are living in a cramped space.

6: STORYTELLING IN SHOTS: LENSES AND COMPOSITION

Rule of Thirds: The wider your frame, the more benefit you get from using the rule of thirds, which recommends putting your key focal point on one of the intersecting thirds lines.

Das Tagebuch der Anne Frank DP Bella Halben.

Placing your main subject on a thirds line allows the viewer's eye to settle on the subject, but also to gain information from the rest of the frame, and helps it become part of the storytelling, adding complexity to the world of the film. There should usually be something about the background, or within the background, that balances, complements or contrasts both the composition and the other visual messages in the shot. The background should only be empty if a void/negative space is part of the meaning.

Aspect ratio also affects the viewer's expectations about what is on screen. 1.77:1 (often described as 16:9 and sometimes 16x9) or 1.85:1 are currently the most frequently used aspect ratios. The theory is that these aspect ratios are the most similar to our eyes' angle of view. In practice, it is as much about what we are used to seeing. We only usually see wider aspect ratios on a larger screen at the cinema, so we associate wide aspect ratios with the more immersive 'broader' cinema experience.

A narrower aspect ratio such as 1.33:1 (which is the old 4x3 TV format) or 1.37:1 (the Academy format which was used for Hollywood studio films from the 1930s to 1950s) are squarer and narrower than the field of view we are currently used to seeing. The use of a narrower aspect ratio makes the viewer feel the world is crammed and limited, not only for us but also for the characters.

Choosing to compose with a narrower aspect ratio harks back to both older TV formats and a more restricted world. If this sense of restriction is appropriate for your subject, it is worth considering choosing a narrower aspect ratio. In *The Grand Budapest Hotel*,[18] three different aspect ratios were used to reflect the different time periods within film.

This same narrowing of the world of the subject can be achieved in a shot or scene by blocking part of the frame to achieve the same effect. If you see a couple through a window, or if much of the

Days of Heaven DP Néstor Almendros.

1.37:1 is one of three aspect ratios used in *The Grand Budapest Hotel* DP Robert Yeoman.

1.85:1 aspect ratio used in *Big Fish* DP Philippe Rousselot.

frame is filled by a wall, the viewer will feel that narrowing of the character's world. Aspect ratios depend on the viewing platform, though, and as platforms change, so do expectations. It is not unusual now to see video being presented in square formats online or on mobile phones. Central compositions are often better for these, particularly when subjects are moving, because movement is exaggerated at the edge of the frame.

FRAME HEIGHT POWER AND PERSPECTIVE

> Hitchcock created 'rules' that included: The size of the subject in frame should be relative to its importance and if something isn't important to the story it shouldn't be shown in close-up.

Frame height can be used to convey power relationships. Looking up at someone makes them seem more powerful, as does having them occupy a larger amount of screen space. Likewise, looking down at someone and/or showing them as smaller in the frame, diminishes them.

Other than for conveying power relationships, camera height is often overlooked when framing shots, particularly when shooting on the fly, without having thought about or prepared a storyboard or shot list. There are often opportunities for shooting from above or raising the height of the camera substantially enough to give the viewer a very different perspective. A high-angle shot gives an overview that is usually associated with letting the viewer feel that they can see the big picture, know everything, and have more information than a single character does. A low camera position changes the viewpoint, so we are seeing the world from whoever is temporarily or permanently at that level. Looking up from a low camera position can turn the subjects into powerful blocks within the frame, and places them in the environment in a completely different way.

No 'rule' holds true in all instances. In this shot from *Blood Simple* DP Barry Sonnenfeld, the camera angle is the key compositional factor in showing who is dominating the frame.

PHOTOGRAPHIC COMPOSITION GUIDELINES

All shots should serve the story, but the aim is that they should tell the story visually and also work compositionally. It is this combination that distinguishes the great frames in a film. The classic photographic compositions or organizations of elements, such as those based on or arranged around the rule of thirds, make the viewer feel a sense of balance and calm and allow the eye to focus on the main subject but also read the rest of the frame. There are other times when working against these is used to make the viewer feel uncomfortable and on edge. Working against classic guidelines doesn't mean a random arrangement of elements. It involves the use of carefully thought-out concepts of how to arrange shots that are used, where appropriate, throughout your film.

Pulp Fiction DP Andrzej Sekula.

> 'Movie Geometry – Shaping the Way You Think'[19] offers an interesting and convincing view of the psychological impact of shapes used within shot composition. It offers an additional layer of significance to some of the shapes created by traditional photographic compositions.

6: STORYTELLING IN SHOTS: LENSES AND COMPOSITION

Classic photographic composition guidelines include:

Leading Lines **Frames within Frames** **Balanced Composition**

Triangular Composition **Repeating Patterns** **Symmetrical Composition**

(top left) *Oh Brother Where Art Thou* DP Roger Deakins, (center top) *Bakara* Director/DP Ron Fricke, (top right) *Days of Heaven* DP Nestor Amendros (bottom left) *Wolf of Wall Street* DP Rodrigo Prieto (bottom center) *Bakara* Director/DP Ron Fricke, (bottom right) *Samsara* Director/DP Ron Fricke.

ARRANGEMENT OF OBJECTS WITHIN THE FRAME

Last but not least, once the shot is composed, the props or other elements in the frame should be adjusted for the best composition, to show what is needed and to support the action and overall composition of the shot, rather than distract from it. Having little bits of things in the edge of frame can be distracting, as can having something that is of no relevance to the shot taking up screen space. If your film is intended for a big screen, more of the elements in the frame will play a part in how your composition affects the viewer, and you should consciously read the screen before shooting to see what everything you are looking at will mean in terms of the story, mood, and aesthetics of the shot. This initially requires focused thought but will become instinctive over time.

Practically, it is very difficult to be adjusting the position of objects and checking how they fit in the frame at the same time. Ideally, you will be working with an art and/or props department who will move them while you look through camera or on the monitor. On a smaller shoot it may be your camera assistants or a runner that help you. Sometimes, a combination of moving some of the props and moving the camera a relatively small amount makes many of the compositional elements slot into place, without needing to call the director back to formally change the shot.

You will find that the best arrangement for a wide shot is not usually the best arrangement for a closer shot. Props, people, and furniture need to be moved closer together in a tight shot to maintain what appears to be the same distance between them, as in a wide shot. If an object appears on the edge of frame, either move it in so it still reads and doesn't distract, or remove it completely. Pay particular attention to the positioning of practical props (that are used in shot) and those that have a lot of visual significance.

NOTES

1 Oliver Stapleton BSC (DP) in discussion with the author (July 2017)
2 *Serpico*, directed by Sidney Lumet (UK, 1973), film.

3 *The Revenant*, directed by Alejandro G. Iñárritu (USA, 2015), film.
4 *The Shining*, directed by Stanley Kubrick (UK, 1980), film.
5 *A Clockwork Orange*, directed by Stanley Kubrick (USA, 1971), film.
6 *Tinker Tailor Soldier Spy*, directed by Tomas Alfredson (USA, 2011), film.
7 *Cathy Come Home*, created by Jeremy Sandford (UK, 1964–1970), drama series.
8 *Kes*, directed by Ken Loach (UK, 1969), film.
9 Chris Menges BSC ASC (DP) speaking at Cinefest, Arnolfini Centre, Bristol, September 2016.
10 Now You See It. "Which Way Did He Go? Lateral Character Movement in Film". *YouTube*, February 15, 2016. https://www.youtube.com/watch?v=Ys8-a0yD-MM
11 Photography Mad. "Macro Lenses". No date. http://www.photographymad.com/pages/view/macro-lenses
12 De Souza, Marcelo Paulo. "Christopher Doyle Masterclass in Cinematography". *YouTube*, May 7, 2008. https://www.youtube.com/watch?v=iDMRB5cCrzY
13 Tomas Tomasson (DP) in discussion with the author (September 2016).
14 Heyes, Justin. "The Quadrant System: A Simple Composition Technique Explained". *SLR Lounge*, February 7, 2015. https://www.slrlounge.com/the-quadrant-system-a-simple-composition-technique-explained/
15 Ökmen, Semih. "No Rules for Composition – (Mr. Robot)". *Vimeo*, 2015. https://vimeo.com/137119034
16 *Doctor Foster*, season 2, directed by Jeremy Lovering (UK, 2017), TV series.
17 *Das Tagebuch der Anne Frank*, directed by Hans Steinbichler (Germany, 2016), film.
18 *The Grand Budapest Hotel*, directed by Wes Anderson (USA, 2014), film.
19 Now You See It. "Movie Geometry – Shaping the Way You Think". *YouTube,* January 25, 2018. https://www.youtube.com/channel/UCWTFGPpNQ0Ms6afXhaWDiRw

7
Storytelling in Scenes: Constructing the Scene and Working with the Director

Having explored the use of lenses to compose single shots in the previous chapter, this chapter looks at how they are combined in scenes. Learning to construct a scene is often given less priority than the technical side of cinematography, but there is little more important than choosing the shots to create a story. The chapter starts by looking at how genre storytelling can be used to either create or break stereotypes, and how concepts from film analysis and theory can be used to inform film production. The chapter then looks at how choosing shots is the core of the collaboration between the director and the DP, and how to make the most of what you each bring to the project. There is an in-depth exploration of 'blocking the scene', which is choosing which shots to shoot from which position and in what order. This includes considering ensuring everything remains on the same side of the frame from shot to shot by not 'crossing the line'. The chapter goes on to look at shot choices for pacing the scene and the use and meaning of different types of movement. The chapter concludes by looking at choreographing movement so that it develops within a shot to cover part or all of a scene and techniques for constructing scenes when time is tight.

LEARNING OUTCOMES

This chapter will help you:

1. Create a sequence of shots to tell a story
2. 'Block' a scene by choosing the position of the camera for each shot
3. Shoot in genres without relying on clichés or stereotypes
4. Work effectively and collaboratively with the director
5. Create developing shots as a part or the whole of a scene
6. Analyze the effect of different types of movement and assess which is most appropriate for your scene
7. Construct a scene to maintain the constant direction of looks, eyeline, headroom and screen position, so that characters appear to stay on the same side of the frame and the geography of the film space remains consistent
8. Shoot efficiently within the constraints of your production

C: SHOTS AND STORYTELLING

GENRE AND STEREOTYPE

Blocking a scene is usually the first thing done by the director and the DP on set. It is when shot choices are worked out or finalized, so everyone knows where the camera will be placed for each shot, the details of the actor's moves in relation to the camera, how many shots there will be and how much of the scene will be 'covered' in each shot. The editor needs enough 'coverage' (different shots) of the same action so they have the creative scope to create mood and pace and balance what they show of the 'narrative development' (what is happening) and the emotional development (what it means to the characters) when they cut the scene. This requires having shots of both action and reactions, and usually involves repeating the same part of the scene in different shots.

The old TV standard of scene coverage was one wide shot, then a shot and a reverse shot of the dialogue in MCU and CU (or mid shot if there is also action in the shot) and a couple of cut-aways.

This is still functional but not often the best or most creative solution. There isn't one best method to cover any single scene. However, trial and error is not a reliable way to ensure you bring in the best footage for a production, so preparation and having a body of knowledge about how and why combinations of shots work is essential.

Two useful theories are:

The *Kuleshov Effect*, which explores how the meaning of a shot is perceived to alter depending on what shot we are shown before it. Seeing an expressionless child after a shot of a flower is likely to make the audience think they are content. Seeing the same shot of a child after a shot of a man with no shirt on will give the audience a completely different idea. This concept doesn't only affect editing, it should also inform what you choose to show as part of your shot as it develops.

Structuralist film theory, which explores the meaning the viewer infers from what they see. An enjoyable way to learn about Structuralist theory and how meaning can be manipulated and altered is to watch John Smith's short films such as *Om* and *Gargantuan*.

View *Om*, followed by the *Guardian 1986 Points of View* commercial, and then practice changing the meanings of an image by adding or subtracting information from it.

Om Director/DP John Smith

Look at scenes from films to see how they are constructed. If you are preparing a project in a particular genre, whether a niche sub-genre such as quirky art dramas set in coffee shops or a wider genre such as horror or sci-fi, compare how scenes are constructed in a variety of films. Look at scenes that have been constructed in similar ways, e.g. for a fight scene, look at Robert Downey Jr's *Sherlock Holmes*[1] and the boxing scene in Martin Scorsese's *Raging Bull*,[2] which are very similar. Then, look more widely at how fights are handled by different directors and by filmmakers of different nationalities.

Look at which shots have been included and think about the meaning and the impact of the shots for the viewer. Reading and viewing film analysis that explores the meaning and impact of shots can show you points of view you haven't considered. There are also online sources such as 'Every Frame a Painting' series[3] which includes Jackie Chan's 'How to Do Action Comedy',[4] which could be useful if preparing to shoot a fight scene.

Analysis and theory become interesting to cinematographers when you see how consistently many of the greatest filmmakers apply their own language of light, color, camera angle, lens choices and shot choices in a film, and how much these reflect both about the culture they are portraying and the filmmaker's own culture. This consistency is usually lacking with new filmmakers and is always lacking in those who randomly borrow shots and elements from other films without thinking about what a particular reference shot will mean in a film when it is used.

Film analysis usually involves exploring a mixture of sociohistorical, cultural and technical issues, which can make it feel less relevant to a cinematographer. However, having a broader understanding of the film you are making takes you half the way to knowing how to shoot it.

Genre

The viewers' expectations and understanding of composition and scene construction are based on both 'natural' psychological responses to the framing and sequencing of shots, and how they have been used in previous films of the same or similar genres. Knowledge of the genre you are working in is a pre-requisite. Many (or probably most) directors, particularly early in their career, want to work with DPs who have a good knowledge and ideally some experience in the genre of the film they are shooting.

> *The DP should know that setting shots is a language in itself; it's not just about the lighting. It's important for the DP to have experience in that particular genre. Even a quirky drama is its own genre. If it's a thriller, you need to hit the thriller beats. Camera movement is such an integral part of storytelling. In the martial arts piece I shot, our fighters were very talented and experienced. They knew exactly how to cover [the scene], breaking it down in 30-second increments. A great action DP will be able to offer a couple of different ways to make the scene work without relying on building the fight sequence in the cut.*
> Kellie Madison[5]

Shots from *The Gate* DP George Billinger showing simple and effective coverage of a fight scene: (left and center) shots from each side, and (right) a wider shot from a higher angle at the front.

C: SHOTS AND STORYTELLING

Growing up in Shanghai I didn't think of the environment as especially cinematic in the way people from the US do . . . Exotic isn't a static concept. Everyone sees everything differently – there is no set truth and no true objectivity – we all interpret.
DP Anon

In Chapter 1, we looked at how visual language and genre conventions develop continually for filmmakers and audiences, and how visual norms depend on the body of visual language you choose to surround yourself with and encounter where you live and travel.

I don't want to stick people in a box as only shooting horror or only action but they need to show me they have good knowledge about placing the camera. Know a genre but don't be tied to it, take elements from other films and put them together in a creative way taking a new spin on it.
Kellie Madison

Be aware that everyone consciously or unconsciously borrows genre and shot ideas, but be wary of copying and pasting shots or whole scenes. They won't mean the same to your audience as they did to the audience of the original film.

Always favor what is right for the film over shooting something that is replicating another film, or in a current style you would like to have on your showreel. Styles go out of date. The fast-cut sequences of *Requiem for a Dream*[6] were copied by many young filmmakers eager to show that they could use the technique, but it wasn't always appropriate and, being so stylized, soon made the films look outdated.

If you don't think about what you are doing and don't keep critically informed, you are not aware that you are unconsciously mimicking what you have already seen.
Sarah Turner[9]

The genre you are working in will give you a palette to paint from, but it must be adapted for the story you are telling about the characters in your film. Whichever genre you are working in, look at films that have aged well, such as *Blade Runner*[7] and *One Day in September*.[8] Don't just look at ones that have been made on a big budget. See how others have interpreted films in the same genre on lower budgets, and look for what has worked and what hasn't.

Stereotypes and Theories of Representation

Genre and stereotype can easily go hand in hand, but don't have to.

Representation is embedded in image and, as a cinematographer, you should be aware of what you are saying about groups of people by the way you create your shots. Film language and construction can be used as a means of either reinforcing or challenging dominant or oppressed groups.

Three shots depicting the changing portrayal of African Americans in North American films: (left) *Birth of a Nation* DP G. W. Btizer (center) *The Help* DP Stephen Goldblatt, (right) *Anita: Speaking Truth to Power* Dir Freida Lee Mock.

Laura Mulvey discusses the 'male gaze theory',[10] which references Stuart Hall[11] and shows how the framing of shots can be used to direct the viewer's eye ostensibly for the pleasure of the male character, but that this then becomes the lens through which both male and female viewers see the woman. In the example from *Transformers* (see opposite), the female audience may identify with Michaela but, because of the angles and shot choices, they are guided to identify with Michaela as a woman who is being watched, and so also see her as an object of desire.

7: STORYTELLING IN SCENES: CONSTRUCTING THE SCENE AND WORKING WITH THE DIRECTOR

In this scene from *Transformers* DP Mitchell Amundsen, the eye is drawn to Michaela's waist (left) and Michaela's lips are emphasized (center) to make the audience share Sam's response (right).

EXERCISE: You are standing in line in the supermarket (or somewhere that has a slow-moving queue). Think of a 5 or 7 shot scene. Which shots would you choose if the people in the line were:

a) Gradually becoming aware of the intimate details of the lives of two members of the queue who are having an increasingly intense discussion.

b) One of them is about to become a victim of murder.

How would your shot choices change if:

a) The main character is the cashier or the third person in the queue.

b) One of the people suddenly dies of natural causes.

Having chosen a scenario and a main character, decide on your shots but then consider how your shot choices would change if you were to shoot it in the style of a western, or a horror or a romance? The likelihood is that, even if you have come up with some very cool shots, they will be based on what you consider the expectations of your genre to be.

Now think about the psychological wellspring, that is, the characters within the film, to help you create a scene that extends beyond genre cliché. Think about what it is you want to say about these people in this moment in this place before you think about the genre you are working in. Then start to consider the genre conventions. Could you position the camera so someone's head would appear between two shelves which would create a classic western shot, but then move towards the shelves, changing the shot and revealing information or an emotion that is current, character-specific and relevant to the environment they are in?

Draw on the pool of visual resources from your viewing and visual knowledge, to help you find unique combinations of shots for the stories you are telling. The more you explore different ways to make stories, whether you do this type of exercise in your head, with your phone, or with a camera, the quicker you will be able to put ideas for scenes together.

THE GAP BETWEEN INTENTIONS AND REALITY

Genre relies on a body of pre-existing knowledge which helps create meaning. Because the viewer and the filmmaker don't share exactly the same body of knowledge, there is often a mismatch between what filmmakers think their story will mean to a viewer and what it does. This is a frequent frustration for new filmmakers.

If the film is viewed only by people the filmmaker knows, or people who have the same niche knowledge or references, they will usually understand what it means. This is why, when groups of friends or classmates make a movie, they might find it funny but nobody else does.

C: SHOTS AND STORYTELLING

For your film to reach a larger audience, something about the story or the experience of the characters must resonate widely by drawing on more broadly shared emotions or experiences. The shared interests may be about the particular subject, such as horse racing or office work or the school run, or on shared fears or desires, or ideally on both. Think of the ubiquitous *Blair Witch Project*[12] and how a story about shooting a film project wouldn't interest many people but how the fear of the unknown that they faced in the woods resonated with a very wide audience.

Your work as a DP is to help the director create the film that they intend. As per Chapter 1, you should find out: what the film means to the director, why they have chosen to make it and who they are 'speaking' to. When selecting the shots to be included in each scene, this should guide you so you are clear about:

- What you should be showing in each shot and what it reveals about the character(s) at this point in a story.

- What the tone of the scene is and how the shot will contribute to it.

It is more than a meme to say that if each shot isn't revealing something new, then it shouldn't be in the film.

> *The cinematographer often has a larger role in devising scenes in documentary, particularly in observational documentary. It is a great opportunity to learn how to construct scenes and quickly spot opportunities for powerful shots.*
> Georgina Burrell[13]

WORKING WITH THE DIRECTOR

> *With Wes Craven, our collaboration on shots came from movie history and understood language . . . he sat me down and showed me the shots he had in mind for certain places and then expected me and the AD to shot-list it . . . that doesn't happen with the younger directors.*
> Petra Korner[14]

No two directors have the same body of knowledge about film. Directors come from many different backgrounds. Some have learned about film through directing music videos, others from film school. Some started out as writers, actors, editors or even DPs. However experienced you are as a DP, you will often find yourself working with inexperienced directors. This doesn't in any way undermine what they have to offer. If the director can get a fantastic performance from the actors, or can access amazing contributors but doesn't know much about the language of lenses and shots, you can make a better film than working with someone who knows much the same as you do but can't get a good performance. As above, a director may need you to bring a knowledge of genre options and conventions. When you meet with the director, try and find out what it is they have to offer and what they need from you.

Director Raymond Yeung on the set of *Cut Sleeve Boys* with Steadicam operator Dominic Jackson. Photo courtesy of Cut Sleeve Boys.

> *In pre-production, assess the director's knowledge of lenses and of what focal lengths do and how involved they want to be in constructing scenes. Go through with them what they need to know but don't have film school on set.*
> DP and teacher Anon

It isn't unusual for experienced directors to work without storyboards and work out the scene once on set. I have never seen this work out well for new directors. It requires a body of knowledge and experience. When new directors don't storyboard, in my experience, it has always been a sign of over-confidence or under-preparation.
Camera Operator Anon

If I disagree with the director about a shot, sometimes I tell them I will give them what they want but give them what I think they need. It's high risk but nobody complains if the shot is good and works well in the film. It can be better than having an argument.
DP Anon

Irrespective of experience, directors give different levels of input into selecting shots depending to some extent on the genre you are working in but mainly on their way of working. Even if you are working with a very experienced director, who has precise ideas, if you think a shot needs additional coverage or could be tweaked, changed or substituted to better tell the story (bearing in mind what you have found out about the way the director wants to tell it), then tell them. Even an experienced director needs and wants you to both collaborate and cover their backs. Try not to make it sound like you think your ideas are always better, though, and always listen to the director and accept with grace if they don't take up your ideas or rein in any of your ambitious shots.

My biggest mistakes were of a political nature.
Petra Korner

Be clear when working with an inexperienced director that there are issues when covering a scene with a single shot because there is no way to change the pace of the scene; the editor can't play around with pacing and timing. Mention how important or useful cutaways might be – ask if they need a shot of this or that as an insert.
Lucy Bristow

If you suggest a different shot, be specific about why you think the change will work. Alternatively, just show them the shot in a rough form, and let them make up their own mind.

Some directors find it very hard to let go of the reins and let others do their jobs, but maintaining a professional and productive atmosphere is important.

Ultimately, it is only the director who knows the shots that will be shown before or after the one you are shooting, or the music or other elements that will be added, and can completely change or flip the meaning. Storytelling can be poignantly counter intuitive. In this shot from *One Day in September*, Andre Spitzer's vulnerability is enhanced by being counterpoised with a voice-over about hope and positivity in the film.

One Day in September cinematography by Neve Cunningham and Alwin H. Küchler.

If the director is sure that a shot or combination of shots will work, make sure the footage will cut together, but otherwise it is their call.

Whatever has happened when you wrap for the day, have a chat and be positive about the next day's shoot. Each day's work is a clean slate.

BLOCKING AND SHOOTING THE SCENE

A **scene** is a series of shots in one location. If the action continues in a different setting, the two scenes are described as a **sequence.** This is for production reasons, because the second area will require additional time to light, prepare and decorate and may not be anywhere near the first location.

A good scene has a narrative arc and usually a most significant moment. To start planning your scene, look at it being rehearsed and think about what the scene is trying to achieve in the film narratively and emotionally, what the most significant moment of the scene is and how you can help lead up to it by controling what the viewer sees and when.

- Walk round the set or location to find a wide shot.

- See if the shot you find gets better from a higher or lower or different angle.

- Then move in to see how and where you can get closer shots that pick up the moments and moods that tell the story. What is in the background and how can you angle the camera to make it work compositionally?

- Then assess if you can choreograph the action, so that several parts of the action are covered during one shot.

Shooting Order and Shooting Efficiently

- Shoot all shots in one direction first, starting from wide to tight. This allows the lighting and props to be set for the wide, and then just tweaked for the closer shots. When all the shots in one direction are completed, the lighting is adjusted and props, etc. moved to prepare for the shots in the opposite direction. Not all shots have to have reverses, and there is very rarely a wide in both directions. To save time, particularly if you only have one or two reverses to do, you can make it appear that you are shooting reverse shots by swapping the position of the actors so they continue to appear on the same side of the screen and shooting on a tighter lens, and/or open up the aperture for a shallower depth of field so you obscure the background.

- Shooting some shots with a smaller crew can also be time- and cost-efficient. Ideally in pre-production, work out which shots can be shot by a smaller or separate unit. Shots like a single sunrise shot don't need the whole crew, and B roll that doesn't involve cast can be shot separately or sometimes after most of the unit and cast have been stood down.

- Avoiding getting bogged down in solving problems that are stopping a shot working or causing a delay is very important. Always try to take an overview and assess if the shot can be adjusted to remove the problem, or if you can shoot something else while waiting for whatever is holding you up.

- Using two or more cameras can speed things up. You can often usefully use two cameras side by side for wider and closer shots in dialogue, or several cameras for action shoots. A second camera (or more) is often used, although, particularly for scenes that have sophisticated lighting, this often involves a compromise with the framing or lighting for the second camera. You have to evaluate the tradeoff and be aware that when using additional cameras, although shoot time goes down, the shooting ratio goes up.

> *You are responsible for every shot that is taken. If the B camera shots don't work so well it shows in the scene and reflects badly on you. Sometimes I get the B camera monitor image sent through to my camera so I can check but it is very difficult to operate the 'A' camera and be sure the 'B' camera shot is also working. You can be pushed into having two or more cameras on every shot but at a certain point you need to be the gatekeeper of the image.*
> DP Anon

The Shooting Ratio

The shooting ratio is the number of minutes shot compared to the finished length of the film. It is well worth thinking about when you construct the scene, because the higher your shooting ratio, the larger the proportion of your time and effort lies on the cutting-room floor. It is less unusual and less problematic to shoot a lot of footage for an action scene, but if you spend a lot of time setting up a shot and there is little or no chance of any of it being used, you are wasting time and money. Divide the cost of the cast, crew, equipment, locations and catering, etc. by the hours of shooting to get the unit cost per hour; it is usually surprisingly high. Lowering your shooting ratio is beneficial because, if your planning and forethought allows you to cut the number of shots or takes by half, you have twice as long to work on each shot and can be more thorough or shoot in a more sophisticated way.

> Different genres of program have different shooting ratios. A tightly controlled and rehearsed drama may have a very small ratio of around 6:1. Natural History, documentary and multi camera shoots have a much higher shooting ratio, often in excess of 20:1. The highest shooting ratios occur in big budget action features and observational documentary, where a great deal of footage is recorded to show how the story unfolds.
>
> Other factors affecting your shooting ratio are:
> - How many takes you do of each shot.
> - How long the script is compared to the running time of your film.
> - If further cuts are made in the edit to the planned run time of your film.

The Master Shot

The amount of time spent lighting and shooting the master shot can feel disproportionate because it may well be on screen for less time than an emotionally charged close-up. Wide shots are important, though, because wide shots set the scene, and give information about the geography of the space and how your characters interact with the wider world. In the wide shot all the details of your set or location can be seen and these have to stand up to the largest screen it will be displayed on.

To shoot a wide shot efficiently and make sure you don't run out of time for the close-ups, avoid spending excessive time making it work throughout one take, unless you know it will be used in full in the film, or importantly, if it will form the base for VFX. If not,

> VFX are usually applied to the master shot and then lighting effects are used to simulate the VFX in close-ups.

discuss with the director how to make sure you shoot until you get suitable sections of the master in different takes, to give the editor enough options of when to cut in and out of it. Masters are often, but not always, used at the beginning of a scene. If a master of the whole scene isn't needed, just shoot an establishing shot, which is the same thing but doesn't go through the whole scene. Make sure it works well, up until at least the point the dialogue becomes more significant than the action.

Handles

When a part of a scene is shot on more than one lens or from different angles, the editor has options of which part to include in the finished film. Whichever type of coverage you use, give the editor 'handles', which are a few seconds extra at the beginning and end of each shot, to let them add pauses when needed, to change the emphasis and allow for overlapping 'L' cuts, where picture or sound continues after the cut. For overlapping editing, which is where some of the action is repeated to expand the time, shoot even longer 'handles' at the start and finish of each shot.

To prepare your shot list you need to have some idea of how the director intends the shots to be cut together. If you have not been given other information, ALWAYS make sure you deliver shots that work for continuity editing.

C: SHOTS AND STORYTELLING

CONTINUITY COVERAGE

You need to become very familiar with not just the concept of continuity coverage, but also the practice. Practice until you are able to shoot in a way that will allow the editor to cut in and out, or between wide and closer shots, of the same action at any point in a scene, without the audiences feeling there has been a break in the action. This requires:

- The consistent timing of actions in masters and other shots, so actions occur at the same time and place in different-size shots. If a turn of a head happens at the same time in the wide and tight shot, the editor can cut either on the turn or any time before or after. If the head turns too early or late, the editor is usually substantially restricted because the head turn must be shown once but can't be shown twice. There should be a script supervisor/continuity person to check for this (and all other types of continuity, such as costume, hair and prop positioning) but when there isn't one it is the DP and director who watch out for it.

- Maintaining the constant direction of looks, so people always appear to be on the same side of frame, unless we see them move to the other side in shot.

- Cohesiveness of head height, so people don't appear to be bobbing up and down in the frame.

- Changing angles sufficiently (usually 20 or 30 degrees or more) between wider and tighter shots, to avoid them being tricky to cut together.

These two shots from *Revolutionary Road* DP Roger Deakins show that in the wider shot (top) the camera is at a sufficiently different angle to the tighter shot (bottom), to allow the shots to cut together without appearing to jump.

Traditional full continuity coverage involves shooting the following in one direction and then reverses on all or most of the shots:

A master shot – showing all of the action and the environment

MS – mid shot showing action and characters' movement

MCU – medium-close shots

CU – close-ups to emphasize the psychological impact of the action or conversation

Cutaways/B roll – to show details of what is driving the story forward.

Other shot terminology:

Two-shot, three-shot, etc. refers to how many people are in the shot. Glass shot, hat shot, etc. are just referring to what is in the frame. Likewise, the terms for the camera angle are mostly self-explanatory – low-angle, high-angle – but Dutch is often the term used for a shot that is tilted.

Full continuity coverage is still sometimes used for long scenes but is rare. There are many ways to vary and streamline traditional coverage that can be used systematically in a film or TV series and help create a distinctive style. For example, *The West Wing*[15] often used a Master, MS, Reverse and Steadicam. Triangle coverage is the simplest form of traditional coverage, and consists of a basic Master shot and two singles, plus the occasional additional close-up or cut-away to emphasize important parts of the scene.

The Line

Understanding and being able to avoid crossing 'the line' is essential for continuity coverage, so that people stay on the same side of the screen and look in the same direction consistently. The easiest way to understand this is by shooting an exercise.

7: STORYTELLING IN SCENES: CONSTRUCTING THE SCENE AND WORKING WITH THE DIRECTOR

EXERCISE: Put two people in a room and find a piece of string or tape. Put it between them (see right, the green ticked example). Shoot an over-the-shoulder shot of one person talking to the other, then a reverse shot over the other person's shoulder. View back to see that Actor 1 has remained on one side and Actor 2 on the other. (See Appendices 3 and 4 for short sample scripts to work with.)

Now shoot one shot from the other side of the line, and you will see they swap to the other side of the frame.

Next, try the same exercise with widescreen framing and you will see that crossing the line becomes more of an issue with a wider aspect ratio.

For continuity, editing people should not cross the line. However, it is now not uncommon for the director to use line cutting, which is when they choose to cross the line, to break continuity. This can have the effect of jolting the viewer out of being absorbed in the world they are watching and making them aware that they are viewing a film

Line cutting to cover up continuity mistakes will look out of place and wrong. When line cutting is used it should be as a device that has a reason and a consistency in the story, rather than as an excuse for camera errors.

> *If there are several people in a group, you can get away with crossing the line occasionally because people are looking in different directions depending on who they are talking to. It still throws the audience; most people wouldn't be able to pin it down but it is disorientating.*
> Lucy Bristow[16]

(See C10 for tips on shooting a three-way conversation.)

The line should connect the actors

When positioning the camera, think of a line physically connecting the actors and extending beyond them. Wherever you position the camera, so long as you stay on the same side of the line connecting them, the actors will stay on the same side of the screen.

RECURRING OR DEVELOPING ELEMENTS IN SCENES THROUGHOUT THE FILM

Recurring Metaphors and Motifs

Visual metaphors are visual elements that help tell a story. In *Diaries of an Immigrant*[17] an ant is used to show status of the protagonist. Where appropriate, shots that allow for the use of visual metaphors should be added to your shot list in pre-production, because these sorts of shots rarely come to mind in the middle of a shoot. The better you know your story or subject, the more intuitively you will think of or find visual metaphors. If a metaphor is used several times in your film, it becomes a motif (although a motif doesn't have to be a metaphor).

Motifs provide a visual thread through your film, which can develop and change. Motifs can be an object, a color, the way a person stands, or a particular kind of lighting or framing.

Psychological motifs or queues might include that, when one character looks out of the window what they see always includes the sky but when another does they never look high enough to see it.

Likewise, camera angles can provide psychological queues. As a character's status or power changes during a film or scene, the camera angle could change from looking up at them to looking down, or vice versa.

C: SHOTS AND STORYTELLING

These types of concepts are often discussed in pre-production but can easily be forgotten in the middle of a shoot, particularly when you are rushed, which is unfortunate (and avoidable) because it usually doesn't take any more time to shoot a shot in a conceptually richer way.

Emotional motifs might include rain or water. Shooting the same scene in the rain, or even next to the sea or a river, will create a different meaning than if that shot is filmed in a shopping mall. You may choose to place all the scenes with a particular character in a certain type of location or, as the story progresses, the locations may change from wide open to closed in or crowded.

Metaphors and motifs add layers of meaning and can initially seem insignificant, such as the wasp in Andrea Arnold's low budget but brilliant short film *Wasp*,[18] or instantly emotive, like the girl in the red coat in *Schindler's List*.[19]

In this scene from *Schindler's List* DP Janusz Kamiński uses a strong back light as a visual motif for Oskar Schindler; no back lighting is used for any of the other characters.

The physical and psychological motif of a wasp in *Wasp* DP Robbie Ryan creates a visceral turning point in the story as it crawls into the baby's mouth.

Developing and Changing the Positioning of People

The space between people is often used as an emotional metaphor, to show their relationship and how it changes. It relies not only on where the people are positioned in the frame but where the camera is. You need to learn the practicalities of making people appear to stay the same distance from each other and the emotional effect of making them move closer or further apart.

As per this example of flowers, practice positioning people having a conversation in a wide shot and see how far you have to move them so they appear in the same place in a closer shot.

EXERCISE: In this exercise the camera should be static, but you can pan and tilt if you wish. Place two people in a room and, as you circle around them to find your shots, you will see that the closer you are to the actors, the closer together they appear.

Shoot a 5 shot scene where the distance increases between them. Then shoot a 5 shot scene where it decreases. See Appendices 3 and 4 for short sample scripts to work with.

Try a wide lens and a tight lens, to see how you can increase or decrease the relative positions, sizes and distances of the people. Once you have done this, also experiment with choosing a slightly wider lens for one than the other.

The flowers and vases are in exactly the same position in these two shots. In the close-up (top) the distance appears natural. In the wider shot (bottom) they appear too close. Both people and props often need to be re-positioned to appear to be the same distance apart in wide and close shots.

7: STORYTELLING IN SCENES: CONSTRUCTING THE SCENE AND WORKING WITH THE DIRECTOR

POSITIONING AND MOVEMENT OF BACKGROUND ELEMENTS AND ACTION

The changing relationship between the environment and the action can considerably help the storytelling in a scene. This adds a layer of meaning and metaphor, but also dynamism, to the shot or scene. What is important is that you think about what changes during the scene and why.

At the start of a scene, the character could be surrounded by people but, by the end, they may be alone. Or the change may be subtler at the start, the background actors could be randomly looking in different directions but end up all looking towards or away from the subject. This would change the emotional effect of the composition or scene. See Cinefix's '3 Brilliant Moments in the Visuals of Emotion'.[20]

Whether or not it changes, movement behind the action, like traffic or people walking past or the sea or rain seen through a window, can add an additional layer of meaning to the scene. In almost every Kurosawa film, movement in the background of the frame that supports the story is used.

Spielberg places a pivotal scene in *Jaws*[21] on a moving ferry, which allows the background to move and impact the scene. On a low budget film, you could shoot on a bus or in a car, and choreograph what is seen behind as the bus or car turns to impact the meaning of the scene.

VIEWER'S PERSPECTIVE AND EYELINE

When constructing scenes, you choose whether the viewer's perspective (as explored in C6) is predominantly close to the action or is viewed as if from afar. When constructing the scene, you should consider if and when you want to vary this predominant perspective. If the viewer feels close to the action, you can allow the perspective to pop out to give an overview and then come back into the circle of the characters. Modern audiences are usually comfortable with changes in perspective, and the use of this kind of visual grammar, to emotionally see all sides of a story. The break in intensity itself can make the audience feel differently about what is happening to the characters and, like all aspects of controling the viewer's perspective, it is integral to storytelling.

Raging Bull DP Michael Chapman.

Eyeline

The position of the character's eyeline to camera also affects the perspective of the viewer. If the eyeline is directly towards the lens, it makes the viewer feel they are being addressed directly by a character. If it is just to the side of the lens but within the matte box, the viewer feels like they are involved in the story. If it is outside the matte box, the viewer feels as if they are observing the story from the outside. Eyeline is usually finalized on set but can be an element considered when creating scenes, particularly if characters are to look into the lens or address the viewer through the camera. The script supervisor will write down if characters are looking camera left to camera right or vice versa, but won't note down how close to the lens they are looking. It is important for the operator to notice and make sure eyelines work consistently.

C: SHOTS AND STORYTELLING

THE FLOW OF TIME AND PACING THE SCENE

Fast paced action films may have approximately 3000 shots, making the ASL Average shot length about 2 seconds. Slower dramas and romances are more likely to have around 850.
Stephen Follows[22]

A scene can be covered in a single shot or in hundreds of brief clips.

Not every scene needs shots to cover every aspect of the action. You may just shoot one shot of a brother getting his sister's lunch ready for school, and then see one shot of her on the bus. If the real story happens at school, that is where the scenes must be shot more fully. Keep an eye out for scenes that can be covered with a single shot, select the framing carefully to convey as much about the characters as possible, then move on. See C8 for how shots are put together to convey the flow of time.

Scenes where many shots are used are usually fast-paced scenes. It is important to be aware that pace is not the same as narrative or emotional development. In this example from *Schindler's List* (below),[23] the shot is static but, as each new element is added to it, the narrative develops.

In these three frames from Schindler's List DP Janusz Kamiński, elements change within a static frame in order to tell the story.

In a fast-paced scene, the events or objects that are coming at the characters may all mean the same thing. Many Hollywood blockbuster scenes can get boring because, whilst the action continues for what can be many minutes, nothing is happening that really changes what the character or audience is feeling. The 'Battle of the Bastards'[24] episode of *Game of Thrones* works well because of the underlying tensions of the characters, not the big action and effects. Likewise, with the dramatic tension in the action scenes in *Baby Driver*.[25]

If you are working on a film with a lot of coverage as a style option, think up simple ways to shoot each shot. One hard back or 3/4 back light as a stylistic convention, for example, will allow you to create shape but shoot quickly.

Either a multi-shot action scene or a single-shot scene can feel fast-paced if a lot changes in it. If, as a character walks or runs, they see different people and objects that keep making their situation worse or unexpected things happen, particularly if that makes them react differently, the pace of the storytelling can be very fast. Emotions may also unfold rapidly even in a slow shot, if it is designed well. A pan across a set of photos may reveal a whole range of emotions for a character and may reveal information that is new to both them and the viewer. How quickly things change, whether in short shots or within single shots, is like the emotional heartbeat of your film: you can make it slow or fast, and this emotional pace often marks the difference between a boring movie and an absorbing and gripping film.

When devising fast-cut scenes, you need to be aware of the viewer's eye trace. In theory, you could frame a series of shots so the eye trace moves smoothly across the frame as the shots progress, but because you don't know which shots will be edited in, it is usually best to frame all shots centrally to avoid the viewer's eye jumping all over the place. Fast-paced scenes can be exciting, but studies of cuts and camera movement show there are limits to what audiences can absorb. Pacing a scene too fast can leave the audience confused, irritated and feeling sick.

DEVELOPING SHOTS AND ONERS

A single static shot may cover the whole scene, but may also often involve either the movement of the actors within the frame, or the movement of the camera. Movement during the shot can allow the shot size to change so, for example, what starts as a wide shot may become a close shot or vice versa. There may be several moves or changes that occur in a shot and working out how and when these movements and changes happen is called choreography. One well-choreographed shot can be used to cover a whole of a scene but it is still always good to give the editor some options of B roll so that they can cut between takes to change the pace or action if needed.

EXERCISE: Try choreographing a shot where, at the start of the shot, one person walks towards the camera until they are in close shot and, e.g. looks at their phone or watch or a more significant object. What they are holding or the way they are holding it should reveal something about them – perhaps they are nervous. Then have them move backwards and reveal another person who is not aware of what the viewer has just seen in close-up (the shot will have become a wider two shot). There is some discussion or action between the two and then the second person moves and you pan with them to follow them. The first person follows them until they are both in a medium-close two shot.

If you use a longer lens from further away, the background is compressed due to foreshortening, which speeds up how quickly people appear to move towards or away from the camera. If you use a wider lens, it slows it down.

This kind of choreography is important to learn because it provides the foundation for composing shots that include moving actors and/or moving cameras, and enables you to control what information the viewer receives irrespective of what else is in shot.

> When shots are choreographed to combine several shots in one, you usually shoot most of the scene in one direction and just do reverses for the dialogue.

> John Huston used to talk about 3 in 1 shots: starting on a single, turning into a close shot, then becoming a 2 shot when the actors turn around.

> This type of practice allows you to start to build up a body of knowledge for converting stories into shots rather than starting from scratch with every shot in every film you shoot. I highly recommend that you create a visual collection of options of how to shoot dialogue scenes – both clips from films and exercises you shoot. You will soon see that there are many inventive ways to shoot and position people when talking and these will stand you in good stead as dialogue scenes are the mainstay of drama. *Revolutionary Road*,[26] which relies primarily on two-way dialogue, is an ideal starting point for options of how to cover dialogue scenes.

CAMERA MOVEMENT

Camera movement is not a separate subject to shots and storytelling, because if the move isn't helping to tell the story it is superfluous. The camera should move to either show an action, capture an emotion or give the viewer additional information. Where, how, at what speed and when movement starts or stops all affect the meaning of the shot.

Where the Camera Moves

Movement may be triggered by action but the camera doesn't have to move consistently in one direction at the same pace. It may slow down or you may pan, for example, to see one character catch up with the other or fall behind. To decide where the camera should move and what or who should be favored in the frame at any moment, think about where both the action and the emotion are in the frame.

> Moving shots are called by the name of what is supporting the camera, e.g. a crane, a dolly or a jib (which may, but doesn't have to, be part of a dolly, and moves the camera up or down).

> Strictly speaking, a track is a move side to side, and a dolly is a move forward and back, but either or both are commonly referred to as tracking or dolly shots. The currently unfashionable zolly is where the camera is zoomed out and tracked in at the same time, to keep the subject the same size but give a disconcerting change to the background.

C: SHOTS AND STORYTELLING

EXERCISE: Practice filming two people running, first favoring the one in the lead as they escape from the other and second favoring the one behind as they try to catch the first one. A significant impact on who appears to be 'good' or 'bad' is made by where they are positioned within the frame, i.e how much leadroom they do or don't have.

Learning to use movement to help the story unfold as the viewer watches applies equally in drama and documentary, see *City of God*[27] and *Titicut Follies*.[28]

> If the pacing of the scene reflects its heartbeat and what we are shown provides our emotional triggers, then the way the camera moves could be described as reflecting how far our nerves are jangling. As cinematographers, we are converting ideas and emotions into a visual language.

How the Camera Moves

How the camera moves is an important visual element and plays a significant part in guiding the viewer about how to feel about what they are viewing. The experience is different if the viewer is visually gliding seamlessly through the film space to if they are seeing what is happening in a frenzy of shots with an unsteady camera creating a lot of frame energy.

Speed of Movement

The speed of a camera move can completely change its meaning. Depending on the context a slow track in can be beautiful or ominous. The exercises below allow you to experiment with fast and slow moves, and allow you to see the impact of speeding up or slowing down a shot.

Choosing When to Start or Stop Movement

It is not just the speed that affects the meaning of a move; the point at which movement starts and stops can flip or reinforce what you want to say. Often, shots move to convey excitement (tracking with people) and cut the movement to convey surprise, when what is seen is unexpected. By starting or stopping movement, you can break or change the flow of a scene (see C10 for how to start and stop smoothly and synchronize the start of a move with the start of the action).

Camera Movement Exercises

The following exercises will help you use movement to combine shots as a part or the whole of a scene.

CAMERA PANS AND TILTS AND ACTORS STATIC

Panning and tilting are very obvious to the viewer but are useful for exposition, i.e. showing rather than telling what is relevant to the story (often at the beginning of a film).

1. Pan onto or off something relevant to what the people in shot are talking about.

2. Pan between two people talking, to reflect the dynamic of their conversation. Anticipate when to pan and when the reaction is more important than what is being said.

3. Add in occasional very fast 'whip' pans to let the viewer see moments when the conversation is being thrown back and forth.

CAMERA PANS AND/OR TILTS AND ZOOMS AS ACTORS MOVE

This allows for shot size changes to be concealed relatively seamlessly when working with just a tripod.

Have a small item on a table, e.g. a hairpin in an MCU on a table. As someone picks it up and walks away with it, pan with them until they are in a wide shot by a mirror (which doesn't have to be seen), as they put the hairpin in. Try the same shot, but zoom as you pan to maintain a medium shot as they move. This type of shot is easier on a tripod than hand-held.

7: STORYTELLING IN SCENES: CONSTRUCTING THE SCENE AND WORKING WITH THE DIRECTOR

CAMERA MOVES AND ACTORS STAY STILL

Moving the camera allows the viewer to feel they are moving to take a closer look at what is happening.

Set up two people having a conversation and use a slider (or a smooth hand-held movement) to move from a loose over-the-shoulder two shot into a single shot (i.e. from outside the conversation to inside it and vice versa).

CAMERA MOVES AND CHARACTERS MOVE

Try a 'Lateral Oner' to cover the whole action, whilst moving in one direction. See examples by Wes Craven or Jean-Luc Godard and create simple equivalents to practice with.

For more complex oners, experiment using a hand-held camera so you can move freely with the action. You may not be able to achieve the steadiness of a track or Steadicam, but will be able to learn how to combine shots. Oners can be simple or complex. Start simply.

If you find a way to tell a whole scene in one, you use the space differently than when splitting it up with close-ups.
Chris Menges[29]

In this scene from *A.I. Artificial Intelligence* DP Janusz Kamiński, the camera tracks from left to right whilst Henry moves, which allows a wide shot, then a medium shot favoring him, and a close shot favoring Monica to be created, as the shot develops.

There are many good examples of oners online. There are several good Spielberg examples easily available. Make sure that shot sizes change and pan the camera when necessary, to favor the action. Oners rely on timing and co-ordination, so whilst there are benefits of shooting a scene in one, because there are no issues with eyelines and additional coverage, they can take a long time to co-ordinate, and if a part of the shot goes wrong, you may have to re-shoot. Even the most experienced directors allow for a couple of cut-aways, to give the editor options to tighten and change pace if needed.

PRODUCTION CONSTRAINTS

You don't become a better filmmaker by having more time, money or equipment. You just have more options and more potential to get into trouble. People want to work with DPs for their creativity. One of the key ways you show this is by creating interesting shots and films, despite production constraints. Let restrictions of time, money, equipment or space help you narrow down your options and work creatively with them.

Start with idealistic thinking, then work backwards to achieving the spirit of that with what you have.
Tomas Tomasson[30]

Black Swan DP Matthew Libatique.

Put time into choosing locations that bring something extra to your shots and have light sources that work well for your scenes. If your locations are small, you can incorporate shooting through doors or windows, as part of your storytelling, or shoot into mirrors, to enable you to get shots in small spaces without having the camera take up too much space. If working with mirrors (particularly curved ones), always keep a careful look out for reflections of unwanted things, including the camera crew. If you want to think big but can't afford it, use the off-screen space to let characters react to something that isn't seen.

C: SHOTS AND STORYTELLING

Stylizing

Stylizing is finding a particular way to tell your story from an unusual perspective or with a very different look. This can be built into the story, such as Vonley Smith's film[31] about a man with HIV all shot from the person's POV with a GoPro on their head.

Alternatively, you could have a film in which there is only a small gap in a curtain, through which the world is seen most of the time.

Another way to stylize a film is to limit yourself to a couple of types of shots, all hand-held perhaps, like a Dogme film, or all on Steadicam. If you need to use a particular camera, for budget space or accessibility reasons, work with the look the camera can create and integrate that into the style you are creating, even if it is a GoPro or a cell phone.

Choosing 'limiting factors' that are right for your story, both visually and psychologically, will help rather than hinder your filmmaking. In any event, the more you become skilled in specific types of shots or movement, the more proficiently you will be able to use them. Using one slider well on a production can help you control your visual language, and give the film far more production value than using lots of grip equipment badly.

In *Through the Eyes of a Man With HIV* Director/DP Vonley W. Smith, uses a GoPro strapped to his head as a visual device to convey the perspective of the man for the whole film. This means that all the shots are wide angle and his hands can be used as a motif to tell the story.

THE MAGIC BULLET

Tell a story in the most authentic way possible that does the story justice, that tells it without unnecessary embellishment, and taps into the raw emotion of the story.
Petra Korner

It is not the number of shots, degree of complexity, your camera or your budget that gives your film its voice. It is:

- How you use and choose your lenses.

- How genuinely your visual language and shot choices emerge from the characters, stories and locations, rather than just the action being covered.

- How consistently and effectively your visual concepts are applied to your shot choices.

- Your ability to choreograph movement within a shot, so that one well-framed shot, which tells part of the story, develops and smoothly morphs into another.

- Applying what you have discussed in pre-production, rather than reverting to simply covering the action at eye height, once under stress on set.

NOTES

1 *Sherlock Holmes*, directed by Guy Ritchie (USA, 2009), film.
2 *Raging Bull*, directed by Martin Scorsese (USA, 1980), film.
3 "Every Frame a Painting". *YouTube*. https://www.youtube.com/channel/UCjFqcJQXGZ6T6sxyFB-5i6A
4 Chan, Jackie. "How to Do Action Comedy". *Every Frame a Painting*, December 2, 2014. https://www.youtube.com/watch?v=Z1PCtIaM_GQ

5. Kellie Madison (director) in discussion with the author (March 2017)
6. *Requiem for a Dream*, directed by Darren Aronofsky (USA, 2000), film.
7. *Blade Runner*, directed by Ridley Scott (USA, 1982), film.
8. *One Day in September*, directed by Kevin Macdonald (Australia, 1999), film.
9. Sarah Turner (reader in fine art, University of Kent) in discussion with the author (October 2016)
10. Mulvey, Laura. "The Male Gaze Theory". *Vimeo*, 2013. https://vimeo.com/77935410
11. Hall, Stuart. *Representation: Cultural Representations and Signifying Practices*. Thousand Oaks, CA: Sage Publications. 1997.
12. *The Blair Witch Project*, directed by Daniel Myrick and Eduardo Sanchez (USA,1999), film.
13. Georgina Burrell (DOP/shooting PD, georgieb.tv) in discussion with the author (May 2017)
14. Petra Korner AAC (DP) in discussion with the author (September 2016)
15. *The West Wing*, created by Aaron Sorkin (USA, 1999–2006), drama series.
16. Lucy Bristow ACO (camera operator) in discussion with the author (September 2016)
17. *Diaries of an Immigrant*, directed by Satya Collymore (Barbados, 2013), film.
18. *Wasp*, directed by Andrea Arnold (USA, 2003), film.
19. *Schindler's List*, directed by Steven Spielberg (USA, 1993), film.
20. Cinefix. "3 Brilliant Moments in the Visuals of Emotion". *YouTube*, October 25, 2016. https://www.youtube.com/watch?v=NDFTFFA0LtE
21. *Jaws*, directed by Steven Spielberg (USA, 1975), film.
22. Follows, Stephen. "How Many Shots Are in the Average Movie?" Stephen Follows Film Data and Education, July 3, 2017. https://stephenfollows.com/many-shots-average-movie/
23. *Schindler's List*, directed by Steven Spielberg (USA, 1993), film.
24. *Game of Thrones*. "Battle of the Bastards", episode 9, season 6. Directed by Miguel Sapochnik. Written by David Benioff and D. B. Weiss. TV-MA, June 19, 2016.
25. *Baby Driver*, directed by Edgar Wright (USA, 2017), film.
26. *Revolutionary Road*, directed by Sam Mendes (USA, 2008), film.
27. *City of God*, directed by Fernando Meirelles and Kátia Lund (USA, 2002), film.
28. *Titicut Follies*, directed by Frederick Wiseman (USA, 1967), film.
29. Chris Menges BSC ASC (DP) speaking at Cinefest, Arnolfini Centre, Bristol, September 2016.
30. Tomas Tomasson (DP) in discussion with the author (September 2016)
31. *Walking in the Shoes of a Man with HIV*, directed by Vonley Smith (Barbados, 2013), film.

8
Speed and Time

The body of knowledge in this chapter allows you to control a key aspect of the look and language of a film and avoid errors that will make the footage unusable. The chapter starts by looking at how time is conveyed within a film and the powerful impact it has on the viewer. The use of linear and non-linear storytelling to affect the direction and flow of time is considered in terms of how the cinematographer creates a look or looks for the film. It shows how distinct looks may be created for different time zones if time moves forward and backwards or how one look may develop and change if time just flows forward in a film.

The chapter then looks at the techniques and effects of expanding and contracting time with slow and fast motion and how and when to use or combine these within a scene.

The effect of shutter speed on the look of the film and how this subliminally impacts the viewer is considered and the use of shutter angle and frame rate to control this is explored. The chapter then goes on to look at the technical aspects of controling shutter speed, angle and frame rates in order to avoid the flicker caused by conflicts between power supplies, monitors and lamps. Finally, the pros and cons of interlaced and progressive frames, and global or rolling shutters, are explored.

LEARNING OUTCOMES

This chapter will help you:

1. Understand the impact of how time is conveyed in film
2. Know how to control the flow of time in linear storytelling
3. Shoot appropriately for linear and non-linear narratives
4. Use either shot choices or high speed, low speed and time-lapse cinematography for expanding or contracting time
5. Understand the implication of shutter speed on motion
6. Adjust the shutter angle to see more or less motion blur and understand the impact of this on the viewer
7. Avoid flicker due to incompatible frame rates/shutter speeds and electrical sources or monitor phasing
8. Avoid distortions due to the rolling shutter effect

C: SHOTS AND STORYTELLING

Unlike all the other art forms, film is able to seize and render the passage of time, to stop it, almost to possess it in infinity. I'd say that film is the sculpting of time.
Andrei Tarkovsky[1]

The Master DP Mihai Mălaimare, Jr.

Film by its nature involves manipulating time. It requires taking a series of pictures that, when played back appear to be moving. 16fps are needed for the 'persistence of vision' which makes shots look like a movie rather than a series of photographs.

One of the first things that makes an impact when we watch a film is how time is handled: how the story unfolds, the order we are shown events and when the viewer finds out information compared to when the characters do.

STORY TIME, FILM TIME AND SCREEN TIME

Screen time is the length of time the film takes to watch. Story time is the period of time the story spans. This can be anything from a day in Michael Haneke's *Funny Games*[2] to more than a decade in *Boyhood*,[3] most of a lifetime in *Forrest Gump*[4] or centuries in *Orlando*.[5]

Real Time

Having central framing and shut eyes in both these shots from *Forrest Gump* DP Don Burgess allows the audience to understand the jump in time between boy and adulthood.

If the story time and the film time are exactly the same, the film is set in 'real time'.

Live events such as sports are shot in what is known as 'real time' and are usually recorded by several cameras from different angles and cut together live.

Drama and documentary can also be recorded live, but more often real time is simulated by cutting the camera and then continuing the action from the same point in another shot.

In Alfred Hitchcock's *Rope*[6] the story time is exactly the same as the film time, so the film is set in real time, but, because the rolls of film weren't long enough to shoot the whole film in one go, the camera had to stop and start, so it would have taken longer to shoot.

- When shooting live real time, go with the flow of the action, anticipate the important moments and adjust the frame while you are shooting so they are featured. The art of looking with one eye and anticipating with the other is crucial (see C10).

- When shooting simulated real time, be sure that your shots match exactly, so there is no visible change of position action or extreme lighting changes between shots.

While some films are actual or simulated real time, in most films time is compressed so only the important moments and points are shown. Therefore, the 'screen time' is usually far shorter than the 'story time'.

Linear Story Structure

In real time, stories unfold in the order they occur. When time is compressed, many film stories are still told in the order events occur. This is called a linear structure.

- When shooting a film with a linear story structure, you may want the look or operating style to change as the film progresses. Most films aren't shot in the order they will be shown, though, so you must carefully note what look is required for which scene of the film.

Sometimes scenes are re-ordered in an edit and end up nowhere near where they were in the script. This could have the result that a scene you created in a style for the end of the film might be used at the beginning and can look all wrong. To avoid this, don't push the look as far as you want it to be when you shoot it (e.g. by using extreme color filters or hugely high contrasts) and allow for some of the look to be created in the grade.

Non-linear Story Structure

In life, we often experience stories in a non-linear structure. We find out different aspects of a story at different times and we piece together what has happened to whom by seeing things and receiving information sporadically. How, where, when and from whom we find things out makes a difference to what we understand about what we are being shown or told. Non-linear films expand on this experience and use the current time, the past and sometimes the future to better convey the inner journey and outer story of the characters.

- It helps to differentiate the different times in non-linear films by creating different looks and/or styles for the various time 'zones' or 'strands' within the film to help the viewer distinguish between them.
- Work closely with the director to understand what the different times mean to the characters and the viewers, in order to create appropriate looks.

> In 'The Sweet Hereafter' the flows of time forwards and backwards are handled superbly. DP Paul Sarossy creates different looks for the time zones in the film that also serve to visually differentiate between the calm outer world the characters inhabit and their tortured inner selves.

(left top and bottom) In *Eternal Sunshine of the Spotless Mind* DP Ellen Kuras, the different realities are shown with different looks. In *Memento* DP Wally Pfister (right top and bottom), different looks are created for the different location and story strands.

C: SHOTS AND STORYTELLING

- The position of scenes in a non-linear film may move many times, but should stay in the same time zone or story strand. This way, you can create clearly differentiated looks, but don't change that look too much within the time zone and make sure you attend the grade.

In Memento *(2000) [see previous page], the black-and-white scenes are shown in chronological order, while the color scenes work backward in time, and at the end of the movie create a circular completion, meeting at the end and piecing everything together.*

Why was the movie done like this? Because it's about a man who has short-term memory loss and whose sense of time is radically constricted . . . Since he can only recall short passages of time, aside from his long-term memories, the scenes are choppy and short, and cut off in the middle of what is happening.
C. S. Lakin[7]

CONTROLING THE FLOW OF TIME

The flow time in a scene is largely controlled by the amount of information given about what is happening. It is the editor's task to find the sweet spot between giving enough information so the viewer can see what is happening, and so much that the pace of a scene drags. This pacing varies for different audiences, usually with very young children being given the most information and teenage and art film audiences given the least.

- Ideally, you would shoot enough coverage so the editor has plenty of options to adjust both the emotional impact and the pacing of each scene. However, when shooting, sometimes scenes have to be shot more quickly than planned. The director will often be guided by the cinematographer about suggestions on how to combine several shots in one or which shots can be cut. However rushed you are, in all but the very shortest of single-shot scenes, you should always make sure there is a cut-away or point at which the editor can switch between one shot and another.

The flow of time over a full film can be lengthened by having long gaps of story time between scenes. In Chapter 7 (page 178), there is an example of a shot of a brother giving his sister her lunch, then seeing one shot of her on the bus, then the story resuming in full when she is at school. The following scene could just skip directly to the end of the day to where the child comes home hurt or, if the intention was to skip a whole generation, the next scene could be the sister sending her own offspring to school. Visual devices to show time skipping include:

- Visual continuity devices which link the two scenes, such as *Forrest Gump* (see page 186) with his eyes closed as a boy cutting to him with eyes closed as a man many years later.

- Graphic matches in which the visual elements of color or shape link both shots.

- Cuts on action, where one shot transitions to another related shot halfway through an action.

- Matches on a visual theme as in the example from *Grease* on the next page, the same shot in fantasy and reality.

Cuts/matches on action in *The Graduate* DP Roger Surtees.

Another way to show the passing of time is to include a series of shots of significant world events.

188

Some transitions have also become conventions used to imply a change in time:

- A quick dip to black and fade up to edit out a section is common in interview shots.

- A slow fade to black and back up into a different scene suggests that more time has passed than in a quick fade.

- A dip to white is also common, usually for a jump forwards in time.

When these are created in camera, pay particular attention to whether the action should be completed before the transition or during it. If there is movement in the frame, it is usually best to have the frame start and end clear.

SPEEDING UP TIME

Montage

One of the simplest ways to compress or speed up the passing of time is to shoot a montage of (usually short) shots that are edited into a sequence, to condense the passing of time and information.

- When shooting montages, be aware of the eye trace of your viewer. It is uncomfortable for the viewer to have to dart their eyes from one part of the screen to another very quickly, so when shooting shots for a montage, frame significant elements in the center of the frame.

- If more than a couple of shots don't require the entire crew, they can be shot as B roll or with a reduced unit.

Grease DP Bill Butler.

> Montage can also be used to convey a character's confusion with shots that zip from one thing to another, and don't settle on anything for long.

Fast Motion

Time base and frame rate

Your time base is how many frames per second will be played out to the viewer.

Your frame rate is how many frames you shoot per second. If your frame rate is higher than your time base, your footage will be slowed down. If it is lower, it will be speeded up. (See C3 for techniques of under-cranking and over-cranking for fast or slow motion.)

Time Lapse

Time lapse is an extreme version of under-cranking and requires:

- A static camera (so the shot won't appear to jump or blur).

- A camera that can be set to shoot for time lapse, i.e. a single frame at set intervals or an intervalometer that will control it externally.

- A method of changing your exposure to account for light changes from day to night.

> If shooting time lapse when there is a light change, e.g. from day to night, ideally you need a system that will allow for 'ramping', i.e. changes in exposure as the light conditions change. Alternatively, you would have to monitor and change the exposure when the light conditions change.

C: SHOTS AND STORYTELLING

Frames from *The Assassination of Jesse James by the Coward Robert Ford* DP Roger Deakin, adapted to illustrate time-lapse photography.

- Calculating how many frames to shoot for the finished shot length you want, by using online calculators or apps or the following formulae:

 Period of time you are shooting measured in seconds, e.g. 24 hours × 60 minutes × 60 seconds = 86,400

 Divided by the time base of your project

 Divided by the length of the shot

 The result tells you how many seconds between each frame you need to shoot to get the shot length you want in the period you are shooting.

 For a 24-hour time lapse when shooting at 25fps, to end up with a 40-second shot, the calculation is as follows:

 $$\text{Shot length} = \frac{86,400}{25 \times 40} = 86.4 \text{ seconds}$$

 The result is 86.4, so you need to shoot 1 frame every 86.4 seconds.

For static time lapse, where a central person is still and everything is moving (usually in fast motion) behind them, either:

- Have the actor stand very still and shoot time lapse; *or*
- Film the actor in front of a green-screen and add the time-lapse video to the background.

EXPANDING OR SLOWING DOWN TIME

Time seems to slow down in moments of great stress and anticipation, or when we are very bored or trapped. There are several techniques to make time last longer on screen than it does in the story.

Simultaneous Time

The simplest, and one of the most effective, methods for expanding time is used in many films including *The Untouchables*.[8] Shots of actions and reactions that happen simultaneously are shown one after the other, so time is slowed down and drawn out, which makes the scene take longer to show than it would have taken to happen.

The same technique is used in drama and documentary or in TV shows where the viewer has to wait to find out the winner and, whilst waiting, they are shown the hopes and fears on their faces and the faces of their loved ones.

These techniques involve shooting several views of what is happening at the same time and allow the editor to adjust the duration of an important moment in a story, and create the desired amount of buildup and tension or fear.

In this scene from *The Untouchables* DP Stephen H. Burum, time is slowed down and anticipation is built up by showing what is happening or about to happen to each character, and their reactions.

Noticing what would otherwise go unnoticed.

A dull or boring moment is virtually never shown by holding an uninspiring shot, because this would disengage the audience. It is often shown by a shot or shots of what a character is looking at, to try to alleviate the boredom. What the character is looking at should subtly tell us about character, story or environment. For example, if the character is looking at a wall, they may notice it bubbled or peeling in a way they wouldn't have done before. Bubbles in paint suggest age or decay. Don't make these inferences too heavy-handed, but you should consider the implications of each shot you take.

> We all know the expression 'a watched pot never boils.' It actually does, but if we stare at it for a few minutes, we start noticing lots of little things, like the way the bubbles form at first slowly on the bottom of the pot, then grow bigger and start rising faster to the surface. We might notice when the steam starts forming like wisps of ghosts and hovering over the surface of the water. We might hear the clock ticking in the background, the neighbor's dog howling . . . our attention shifts when time seems to slow down . . . when forced to wait, we have nothing else to do but notice things that normally pass us by.
> C. S. Lakin

High Speed/Slow Motion Shots

> You can argue that slow motion is an overused device in storytelling. It isn't always the right technique – as it's quite flashy it can end up drawing attention to the cinematography and away from the story.
> David Wright[9]

Slowing time down requires shooting more frames in one second than you are going to show in one second. This is called over-cranking.

If your time base is 25fps and you shoot at 30 or 35fps, you will slightly slow down and smooth out movement.

If you go a little faster, 35–40 frames per second, the speed feels slightly dreamy or unreal. It is important to understand the effect of the speed you are using on the story you are telling.

High speed shots can be shot at anything from 50fps to 4000fps depending on your camera. High speed shots lengthen a single moment. They can be beautiful and very powerful, but only if used judiciously for moments where the information or emotion really needs expanding and exploring. In addition to the shots shown here, see the elevator scene in *The Shining*[10] that amplifies the terror of the blood coming from it, and again in an elevator scene in *Drive*[11] two short but very important moments are slowed down so their length matches their importance. See Cinefix[12] for some good examples of slow motion moments.

High speed is used frequently and effectively in commercials, where it is used to explore both what is being sold, and importantly the emotional result of the purchase. Commercials aren't 'selling' objects or services; they are usually selling the happiness, security or confidence that they want the viewer to think comes from buying something, and it is often these emotions that are conveyed in slow motion.

Specialist high speed cameras such as the Phantom and Weisscam shoot at far higher frame rates than standard cameras. High-speed cameras can shoot up to a maximum of 10000fps. In some cases, shooting at the highest speeds can only be done at a lower resolution, and in many cases an external

Over-cranking used in the iconic title sequence of *Reservoir Dogs* DP Andrzej Sekula.

High speed explosion shot in *The Hurt Locker* DP Barry Ackroyd.

> One in five commercials that I shoot uses a phantom (high speed camera). Shooting high speed is no longer a specialist thing.
> Andrew Boulter[13]

C: SHOTS AND STORYTELLING

On a commercial we wanted to shoot 300fps but couldn't afford a Phantom, so we reduced the sensor image to 2k on a RED Epic so we could go to 240fps on our main camera.
Roberto Schaefer

recorder is required that can write data faster than the camera can internally. When shooting high speed, consider:

- The maximum frame rate of your camera.

- Whether the highest frame rate on your camera requires you to shoot at a lower resolution (this is not necessarily prohibitive, but you need to be aware of it for your workflow, and because if you are working on a smaller sensor you will need shorter focal length lenses to get the same angle of view).

- How much extra light you will need, because increasing the frame rate will give you a faster shutter speed, resulting in far less light reaching the sensor.

 The faster the frame rate, the faster the shutter speed, so the more likely you are to push up the ISO, because at 1000fps you need just over an extra 5 stops of light. To avoid pushing the ISO up too high you need much more light, and this in turn makes it hard to produce a good-quality soft light.
 Andrew Boulter

- How long you can shoot at the highest frame rate, which usually depends on the write speed of your recording device or card, i.e. how many Mbps it can write at and the size of the buffer, which stores the data while it is being written.

- If you need an external recorder, because external recorders usually have faster write speeds.

- Giving each clip a unique clip number, to make it easier to find in post.

- If you are panning while shooting verticals, opt for a camera with a global shutter rather than rolling shutter (see page 199). Phantom cameras have rolling and global shutter options.

Any cards sold with the Mbps specified are showing the read speed. The read speed is always faster than the write speed and is irrelevant when recording.

Bullet time

Bullet time in *The Matrix*
DP Bill Pope.

Bullet time, as shown in *The Matrix*,[14] appears to be an extreme version of high speed cinematography but is actually multi-camera photography. When tests were done to try and achieve shots in extreme slow motion, that travelled round the actor, it was found not to be possible to move the camera quickly enough to travel round a person while they were falling. After extensive testing, the decision was made to go right back to the early photography Muybridge technique of taking a series of frames on different cameras and putting them together to make a moving image. As in high speed cinematography, it uses the principle of shooting more frames per second than will be played back, but a series of cameras are already in position around the subject and triggered to shoot in a very fast sequence to record enough frames to capture the fall in what appears to be a circular movement.

Speeding up and slowing down time

When speeding up and slowing down time, be aware of the capabilities of different cameras, but avoid the latest tricks and trends if possible. Look at scenes using fast and slow motion that have stood the test of time. Compare films using slow motion in similar ways, e.g. *The Wild Bunch*,[15] *Bonnie and Clyde*,[16] and *The Untouchables*, which all use intermittent slow motion in their final action or shoot out sequences.

Be conscious of why you are slowing down or speeding up the action, and be sure to frame so you see what you really want to draw attention to.

- Cover the whole scene in normal and fast or slow motion so the editor can cut in and out where needed.

- Check for compatibility between your shutter speed and light sources to avoid flicker (see page 196).

Simply slowing down the speed of a video clip increases the duration. If you slow down the footage shot at, say, 25fps with a 180-degree shutter angle, in post-production you will see more of the motion blur than would normally be noticeable, and if you slow the shot down substantially, the shot may appear stuttered, because there aren't enough frames to create smooth motion. Plug-ins such as Twixter can interpolate (calculate and create) the in-between frames to reduce this effect, but create additional work in post-production and don't work on all kinds of movement. Ideally, always shoot slow motion high speed.

Time re-mapping

This is a post-production technique also first used in *The Matrix*. It allows footage to be sped up and slowed down during a shot. It is currently out of fashion in drama but is still used in documentary to, for example, show a presenter moving from one place to another in fast motion, and then slow down while they explore it.

This kind of time re-mapping is heavily stylized but can reduce or avoid the need for B roll, because it effectively means more scenes can be shot as oners.

THE EFFECT OF SHUTTER SPEED, SHUTTER ANGLE AND FRAME RATE ON THE LOOK OF A FILM

> The 'normal' look depends on what viewers are used to. In video games, the 50fps or 60fps aesthetic is the standard and this is the look accepted as 'real' for gamers.

The Hobbit: An Unexpected Journey DP Andrew Lesnie.

Viewers expect to see a degree of motion blur, which makes a film look 'filmic'. Any variation of this affects the viewer's perception of the shot or scene. At any given frame rate, if the shutter angle is greater than 180 degrees, more motion blur than would otherwise appear will be seen. If the shutter angle is less than 180 degrees, less motion blur will appear. If there is less motion blur than the viewer expects to see, it looks over-sharp and unreal and this is the reason that films shot high speed, such as 48fps for *The Hobbit: An Unexpected Journey*,[17] are considered by many as uncomfortable for the viewer and harder to watch, despite the additional resolution achieved by having more frames per second on screen.

C: SHOTS AND STORYTELLING

View Ray Tsang *Frame Rate Vs Shutter Speed*[18] on Vimeo to see examples of the effect of different combinations of shutter speed.

One technique used by some DPs when shooting action films such as *Quantum of Solace*[19] is to shoot just the action sequences at 48 or 50fps, and adjust the time base of the sequence, so they don't appear in slow motion, but do retain a crispness and clarity that allows the audience to see the action clearly. There is still motion blur on very fast shots, but there is a clearly visible increased sense of crispness to the action scenes.

- When you double the frame rate but keep the same shutter angle, you will need one extra stop of light.

Another technique to reduce motion blur is to keep the 24 or 25fps frame rate but change to a 90-degree shutter angle, to retain sharpness in action scenes. *Saving Private Ryan*[20] and *The Bourne Supremacy*[21] use narrower shutter angles.

Shooting at a higher frame rate will always result in a faster shutter speed and so produce less motion blur. In *Quantum of Solace*, DP Roberto Schaefer uses 50fps (so a shutter speed of 1/100th of a second), which keeps the action crisp and clear during the fight scenes.

> *I wouldn't shoot at 50 frames because I don't like the hyper-real look . . . for action scenes, I shoot with a 90-degree shutter not at 50fps.*
>
> *Likewise, when shooting rain at 25fps I use a 90-degree shutter.*
> Andrew Boulter

- When you keep the same rate but half the shutter angle, you need one extra stop of light.

Motion blur as a physical result of time passing while the frame is being recorded is arguably a structuralist way of showing the passing of time (see C7).

The two options will come across differently and should be tested for prior to shooting. The faster frame rate may look smoother and clearer, whilst the narrower shutter angle may convey an unnerving and disjointed feeling because of the almost subliminal jumps between frames caused by the shutter only being open for a quarter of the frame rate.

Moving the shutter angle in the opposite direction, making it larger than 270 degrees, creates a slower shutter speed. Movement blur/dragging will be visible within the frame. If used creatively, as in *Chungking Express*,[22] this has the effect of emphasizing the rush of time. This rendition of time passing doesn't occur in 'real life' but is understood by audiences.

A larger shutter angle will result in increased motion blur, but as shown in *Chungking Express* DP Christopher Doyle (left), this is less visible when Faye is static than (right) when Cop 223 is moving. In the right-hand shot the camera is panned at the same speed as the cop so he stays sharp but we see movement blur in the background.

194

Motion pictures convey stories over time. Seeing the physical trace of time on the image over time is part of the language of film.

Duration is to consciousness as light is to eye.
Terry Flaxton[23]

(left) *The Darjeeling Limited* DP Robert Yeoman, (center and right) *The Assassination of Jesse James by the Coward Robert Ford* DP Roger Deakins.

If you step away from a standard frame rate and 180-degree shutter angle, the difference in look caused by increased or decreased motion blur will be more noticeable the faster the movement of the action or camera, but will be evident throughout the film. Adjusting the shutter speed and angle is useful when appropriate to your story and should be considered when planning and visualizing your film. Alternatively, or additionally, it can also be a useful technical way to help you reduce or increase the light reaching the sensor without adjusting the ISO or aperture, and allow you to shoot at settings or in situations that wouldn't otherwise be possible.

EXERCISE: Practice changing shutter speed and frame rate on fast-moving subjects. Repeat the same subject at different shutter speeds and angles so you can compare like with like.

Also practice panning to match the speed of the action, as in the *Chungking Express* example opposite. This will keep what is moving static and show movement blur in the background.

Interlaced or Progressive Frames

In live television, particularly sports, to keep the action clearly visible, there is less motion blur than in virtually all other genres. This is due to the use of interlaced frames used in live TV and sports rather than progressive frames, used in virtually everything else.

All frame rates discussed throughout this book have been 'p', which stands for progressive. Progressive frames are created by the camera scanning all the data in an image from top to bottom to record it. Depending on the resolution of the sensor and recording format, this results in a particular amount of data being recorded for each frame, and so each second of playback. If you shoot at a higher frame rate to get less motion blur, more data is produced.

Interlaced frames only scan half of the data for each field and then merge them together to create one image in playback.

The shutter opens for each field, so recording 50i (50 interlaced fields) will produce the same number of frames and data as 25p.

This results in crisper images with less motion blur, and is used often for sports and live TV. The benefit of shooting interlaced is that, because only half an image is recorded at one time, you get the faster shutter speed and less motion blur, but without any increase in data being recorded.

This means no extra bandwidth is needed for broadcast.

Two interlaced fields are required to make one frame. Half the image is recorded in the first field, and half in the second. They are then interlaced/joined together to make one frame.

It is this saving on data and bandwidth that explains why interlaced is used in broadcasting.

Interlaced footage is sharper, but because of the reduced motion blur looks less 'filmic' than progressive. There can be other downsides of shooting interlaced: it can suffer from juddering and create saw-toothed edges on moving objects, it is harder to re-sample and re-size, and may suffer from Interline Twitter,[24] which, although usually corrected by anti-aliasing filters, can make it difficult to play on computers. Unless otherwise requested for specific reasons, always shoot progressive.

FLICKER FLICKER FLICKER: LAMP CHOICES, SHUTTER SPEEDS HZ, FLICKER AND PHASING

Frame rate, shutter speed and shutter angles are not only chosen to control the look of a film. They are also a key part of avoiding flicker. Flicker is a dimming and brightening of light seen in all or part of the screen that is usually imperceptible to the eye, and often to the monitor, when filming but would be very visible in your finished film. Flicker is caused when there is an incompatibility between your shutter speed and shutter angle and the electric Hz frequency powering the lamps. Flicker is not created in natural light. Understanding how and why flicker is created, and how you can prevent and check for it, will help you avoid it.

Mains AC power supply runs at a Hz (Hertz) frequency that defines how many times per second the power cycles on and off. If the power supply is running at 50Hz, this means the electricity flowing into the lighting is cycling ON-OFF 50 times per second.

Depending on the construction of the bulb, the light produced by some types of lamps cycles at the same rate as the Hz frequency. You won't be able to see the light levels going up and down, but unless your camera is set to a shutter speed that will synchronize it to only take a frame on the ON part of the electrical cycle, your camera will pick up the flicker and you will see it on playback.

Prior to shooting, check the frame rate you are shooting on a flicker free chart or app (most camera manufacturers have them) to find out the range of shutter speeds and angles you can use to avoid flicker at the frame rate you are shooting. **It is crucial to use the exact frame rate because, e.g., the correct shutter angle to avoid flicker at 23.97fps will be different to that for 24fps.**

If you don't take this simple step of checking the correct speeds and angles, and flicker is created, the footage is virtually always unusable.

THE DIFFICULTY IN MONITORING FOR FLICKER IS THAT:

- You don't usually see flicker by eye.

- You don't usually see it on the monitor.

- You will see it on playback on most screens.

THE COMPLICATION WITH MANAGING FLICKER IS THAT:

- Different countries use different Hz frequencies for their lighting.

- Some lamps flicker, some lamps don't.

- Some lamps that don't usually flicker will flicker at high or very high speeds.

- Some lamps flicker when they are faulty or the bulb is at the end of its useful life.

- It only takes one flickering lamp to cause a problem.

TO AVOID FLICKER:

- Learn which bulb types cause flicker and which don't (see below).

- Find out the Hz rate in the country where you are shooting. Fortunately, there are only two options. In the Americas, Caribbean and South Korea, the frequency of AC (alternating current) running

through electrical mains is 60Hz. In the UK, Africa, Australia, most of Asia and Russia, is 50Hz. (However, in Japan they have two sets of electricity grids, so either Hz rate may be in use.)

- Double the Hz rate to find the voltage and divide the frame rate into it. If you can't divide it exactly, or if you are using anything other than a 180-degree shutter angle, use an app or calculator to find the shutter speed and angle you need.

> Some cameras have a frequency setting that can be swapped to NTSC or Pal.
>
> If your camera has this option, select if you are in an NTSC or Pal region, and then you will be able to safely use any of the frame rates or shutter speeds your camera offers.

- Check the waveform monitor to see if any part of it is wobbling up and down. If only one lamp is flickering, it may only affect part of the set and only be visible on part of the waveform.

 N.B. When shutter speed and lamp flicker rate are slightly out of phase, they will slide in and out of phase such that the light may not flicker noticeably for long periods of time, but will then ramp into and out of a period of flicker.
 Art Adams

NORTH AMERICA		
Your Frame Rate	Safe Shutter Speed	Safe Shutter Angle
60p/60i	Any	Any
50p/50i	1/60. 1/120	300, 150
30p	Any	Any
25p	1/40, 1/60. 1/120	225, 150, 75
24p	Any	Any

MOST OF EUROPE AND ASIA		
Your Frame Rate	Safe Shutter Speed	Safe Shutter Angle
60p/60i	1/100	216
50p/50i	Any	Any
30p	1.33.3, 1/50. 1/100	324, 216, 108
25p	Any	Any
24p	1.33.3, 1/50. 1/100	259.2, 172.8, 86.4

A thin filament means a big change in brightness when the AC current cycle switches direction and the filament cools during that transition. (Larger filaments take longer to cool and are less prone to flicker.) The effect is especially pronounced if the bulb is dimmed, as the filament cools more between cycles.
Art Adams[25]

Continuous lamps

Tungsten and halogen bulbs are continuous lamps. They don't flicker at low speeds because the hot filament still glows between power cycles, and the light is constant. This means you can shoot with them irrespective of your frame rate and shutter angle, but if you use them at high speeds, the very fast camera shutter speeds may catch a tiny fraction of a second when the filament is a little cooler and so the light will be darker.

LED lamps or any lamps that operate on batteries will be flicker-free, but LEDs that are powered by AC might cause flicker at speeds above 50fps, especially if no transformer is used to step the power down to 12V DC.

Non-continuous lamps

Kinoflos and HMIs, etc. are *not* continuous. They flicker along with the Hz cycle. If you use the flicker charts above or check with apps how to adjust your shutter angle and speed, you should be okay for normal speeds of up to 50fps. If you don't check, you may get flicker.

Practical Lamps

Lamps found on location or practical lamps, such as table lamps used on set, will have a variety of different bulb types. Some of them may cause flicker, particularly, but not only, when dimmed. Small low energy halogens can be particularly troublesome. If the light output of a practical is relatively small, you may not always spot the flicker on the waveform so shoot a short test and playback on a flicker monitor or on several monitors (with varying refresh rates) or send it to the post house you will be using, to check for flickering on practical lamps. When playing back your footage, view it at normal speed and at high speed. Flicker shows more when viewed at high speed (if you have a DIT, they should always check for flicker). If flicker is seen, check if you can adjust the shutter speed and shutter angle to eliminate it. If not, you will have to change the lamps causing the flicker. Fluorescents (which often flicker) can be replaced with flicker-free Kino Flos. Other lamps can often be replaced with battery-powered LEDs to avoid flicker.

> You will not get flicker if you shoot only using natural light. If necessary, consider shooting outside but tight to avoid the background.

Flicker and High Speed Cinematography

Phasing of lamps and shutter speeds which are used in high speed cinematography becomes trickier. High speed cameras hit such high speeds, even tungsten flickers. For simple shoots, the effect of this can be lessened by using larger lamps, because the higher the wattage, the longer it takes for the filament to cool down, but this doesn't eliminate the cause and isn't good enough for critical shots.

- When using HMIs or Kinos for high speed, be sure to order high speed ballasts and flicker-free lamps.

- Check for flicker on the waveform and on playback.

- You can test either a full lighting set-up, or it may be more useful to test for flicker on one lamp at a time, to find out which one or ones are creating a problem.

You can check for flicker by recording a short test and playing back on a monitor, but it can be difficult to spot. A flicker monitor is very reliable, but if you don't have one, there are two techniques described by Matthew Rosen[26] that could be useful. One technique uses a false color monitor which displays flicker as pulsing. The other (used more often) uses a luma waveform monitor (not an in-camera one) where you will see part or the whole of the green line wobbling up and down if you have flicker in part or all of the frame. It will stop wobbling once you have resolved all flicker issues.

RED have a flicker-free video calculator tool. David Satz[27] also has a flicker calculator and detailed information about individual lamps.

Cinematography Electronics[28] publish shutter speed and angle charts to avoid flicker; one for 50Hz (used in Europe, parts of Asia and Africa) and another for 60Hz (used in North America), as well as a currently free app. See links at www.routledge.com/cw/hoser).

If a result of 'none' appears on a flicker calculator, this means that no shutter speeds are likely to eliminate flickering at the chosen frame rate, in which case using continuous or natural lighting is recommended. This usually happens when the frame rate is set greater than twice the power frequency.

No guarantees with charts and apps

There are **no guarantees** that using charts or apps will avoid flicker because, for example, artificial lighting may flicker independently of the power source, or when near failure or improperly seated. It is only by shooting tests that you can be sure that there will be no flicker. (See Red.com.[29])

8: SPEED AND TIME

Removing Flicker or Rolling Bars When Shooting Monitors

Flicker arises due to the incompatibility between the frame rate and shutter angle and the light produced by some lamps at a particular Hz frequency. The light produced by monitors will also flicker if phasing is incompatible. Unfortunately, correct phasing for screens is not the same as correct phasing for lamps. Dark bars can appear to roll down the screen when shooting monitors or TV screens. If there is a clear scan or synchro scan setting on your camera, try this first, as it may well remove any rolling bars. Otherwise, the easiest option to avoid this is to swap your screens to LCD or OLED screens and laptops, where you will rarely have a problem.

On other monitors, flicker occurs because the screen's refresh rate is different to the frame rate you are filming at. If you can change the refresh rate to match your shutter speed, it should disappear (you may also be able to change the color temperature of your screen to better match your environment). You can't change the refresh rate on all screens, in which case you will need to change your shutter speed or the frame rate you are shooting at, but do check this doesn't create problems of lamp flicker. This can take some time, so another option is to shoot a blank screen and replace it later.

UNDERSTANDING AND AVOIDING THE ROLLING SHUTTER EFFECT

Lastly, there is one more concern that affects fast pans and motion shots. The rolling shutter effect is when vertical lines appear slanted, and can occur on cameras with a rolling shutter. This effect is caused because effectively one frame is made up of a series of image bands as the shutter rolls down the frame. If the camera or the subject is moving during the exposure of a single frame, the position of an object when the first band is exposed may be different to when the last band is exposed, creating slanted or wobbling uprights in the shot.

Most, but not all, cameras with CMOS sensors have rolling shutters (including ARRI and RED).

Rolling shutter issues are more problematic on some models and makes than others because they are affected by the read-/roll-out times of the sensor.

Read-out time is the speed at which the image is delivered (turned into data) and the sensor is cleared for the next shot.

In most cases, if you aren't shooting verticals with fast pans, you shouldnt have a problem.

- If the rolling shutter effect occurs, any one or a combination of changing the shutter speed and slowing down the speed of the pan or camera move should get rid of it.

- Always check for rolling shutter on a large monitor, not on an EVF or small on-camera monitor, as you may not see it on those.

The rolling shutter effect results in uprights appearing at an angle. Photo by Greg Krycinski.

> There are technical difficulties in making a CMOS sensor with a global shutter, so many manufacturers use a rolling shutter but continue working to speed up the read time.

> The type of shutter you have doesn't make any difference to the time the frame is exposed for, so you don't need to adjust your shutter speed for rolling or global shutters.

- The rolling shutter slanted building or 'wobble' effect should be tested for prior to your shoot so you know what shooting circumstances may cause problems.

- There are some rolling shutter fixes in post, but these take longer and involve compromises, so shouldn't be relied on.

Global shutter

This turns all pixels on and all off at same time. There is a small cost in light and dynamic range when you have a global shutter, and arguably a less cinematic look, but none of the bending and static movement that can sometimes occur with rolling shutters.

Examples of CMOS sensor cameras that use global shutters include Sony PMW-F55, Blackmagic Design Production Camera 4K, URSA 4K and URSA Mini 4K.

EXERCISES: Practice combining the creative and technical effects of controling speed and time. Use shutter speed/fps and shutter angle to convey a scene of someone who combines walking and running to get somewhere or escape from somewhere. Decide on the place and the reason, to help you develop your ideas on how to shoot the scene.

- Cover the whole scene in normal and fast or slow motion.

- Vary the shutter angle for parts of the scene for a motivated reason – perhaps something changes the feeling or behavior of the person.

- Include static shots in which the action passes by quickly and shots where you pan with the action.

- Maintain the same exposure throughout the scene.

- Include close-ups as well as wide shots.

- Compare cuts of the scene with different frame rates and degrees of motion blur.

NOTES

1. Tarkovsky, Andrei. *Interviews*. Ed. John Gianvito. Mississippi: University of Mississippi Press, 2006.
2. *Funny Games*, directed by Michael Haneke (Austria, 1997), film.
3. *Boyhood*, directed by Richard Linklater (USA, 2014), film.
4. *Forrest Gump*, directed by Robert Zemeckis (USA, 1994) film.
5. *Orlando*, directed by Sally Potter (USA, 1992), film.
6. *Rope*, directed by Alfred Hitchcock (USA, 1948), film.
7. Lakin, C. S. "Show, Don't Tell, How Time Is Passing". *Live Write Thrive*. https://www.livewritethrive.com/2013/11/20/show-dont-tell-how-time-is-passing/
8. *The Untouchables*, directed by Brian da Palma (USA, 1987), film.
9. David Wright (DP) in discussion with the author (September 2016)
10. *The Shining*, directed by Stanley Kubrick, (USA, 1980), film.
11. *Drive*, directed by Nicolas Winding Refn (USA, 2011), film.
12. Cinefix, "Top 10 Slow-Mo Moments of All Time". *YouTube*. https://www.youtube.com/watch?v=rLgmfSGQAkE
13. Andrew Boulter (DP) in discussion with the author (September 2016)
14. *The Matrix*, directed by the Wachowski Brothers (USA, 1999), film.
15. *The Wild Bunch*, directed by Sam Peckinpah (UK, 1969), film.

16 *Bonnie and Clyde*, directed by Arthur Penn (USA, 1967), film.
17 *The Hobbit: An Unexpected Journey*, directed by Peter Jackson (USA, 2012), film.
18 Story & Heart, "Frame Rate vs. Shutter Speed". *Vimeo*, 2015. https://vimeo.com/138261651
19 *Quantum of Solace*, directed by Marc Forster (USA, 2008), film.
20 *Saving Private Ryan*, directed by Steven Spielberg (USA, 1998), film.
21 *The Bourne Supremacy*, directed by Paul Greengrass (USA, 2004), film.
22 *Chungking Express*, directed by Kar Wai Wong (USA, 1994), film.
23 Flaxton, Terry. "The Cinematographer's Eye, The Academic's Mind and the Artist's Intuition". *Academia*, March 22, 2012. https://www.academia.edu/1486325/The_Cinematographers_Eye_The_Academics_Mind_and_the_Artists_Intuition
24 Stump, David. *Digital Cinematography: Fundamentals, Tools, Techniques, and Workflows*. Abingdon: Focal Press, 2014.
25 Adams, Art. "Flicker: Why On-Set Monitors Fail Us". *ProVideo Coalition*, February 27, 2017. https://www.provideocoalition.com/flicker-set-monitors-fail-us/
26 Rosen, Matthew. "Eliminating Camera Flicker". *YouTube*, November 18, 2014. https://www.youtube.com/watch?v=pJzGl_xEtVo
27 Satz, David. "About Flicker Problems". *David Satz*, n.d. http://www.davidsatz.com/aboutflicker_en.html
28 Cinematography Electronics Inc. "Support". *Cinema Electronics*. https://cinemaelec.com/support (March 28, 2018)
29 Ibid.

SECTION D

Shooting Creatively and Efficiently When Working Alone

9
Solo Shooting: Documentary and Television

There are a far greater number of cinematographers working in documentary and television than in all other areas of film production combined. Whether producing documentary, entertainment or news footage, this chapter provides guidance by looking in detail at how to manage equipment, workflow, sound and lighting, as well as how to assess optimal camera settings when working alone.

The chapter looks closely at different documentary forms; how to shoot for them and how to interact appropriately with contributors to create the desired program type. These 'modes' of shooting underlie the structure of the majority of documentary and television production worldwide.

Whether you work alone at the start of your career or throughout it, learning to shoot well without the assistance of others is invaluable.

Georgina Burrell cinematographer/shooting PD operating the camera, pulling focus and watching with her other eye to anticipate action and shot changes.

LEARNING OUTCOMES

This chapter will help you:

1. Understand and acquire the range of skills required for different types of solo shooting
2. Shoot for different types or 'modes' of documentary films and understand how to apply these to other genres within TV and film production
3. Work effectively with contributors
4. Create sequences that can be cut
5. Operate smoothly and effectively
6. Keep yourself and your equipment safe
7. Record sound when working alone

D: SHOOTING CREATIVELY AND EFFICIENTLY ALONE

THE FREEDOM AND SCOPE OF WORKING ALONE

When you start, make sure you know how to do certain things well and then expand on that.
Josh White[1]

There is a flexibility and fluidity of shooting alone that is very different to working with a large crew. When shooting your own projects, you can often experiment, test out new equipment and techniques and re shoot anything that doesn't go to plan.

Shooting for others is very different. Within the time available you must ensure there is enough coverage, the shots will cut together and any of the agreed looks or styles are created. If whoever hired you doesn't like what you shoot, they usually won't consider whether they were expecting the impossible or explain what, or why, they just won't hire you again.

I'm often asked, but it is very tricky to work alone [on low budget drama or music shoots]. You are responsible for focus and movement and lighting. If you do it, keep it all manageable. The more you can do with your shot choices and imagination, the better.
Josh White

In *Samsara* director/cinematographer Ron Fricke uses documentary to visually convey the human experience.

It is rarely advisable to shoot music videos or dramas alone, but documentary and TV are frequently shot just by one cinematographer, either alone or with a director.

Most documentary cinematographers find that documentary has a wonderful fluidity, both when shooting individual projects and as a continually evolving genre. Many great drama cinematographers, including Chris Menges BSC ASC and Haskell Wexler ASC, started in documentary. Others, like Ron Fricke and Peter Gilbert, have great careers in documentary. Documentary shooting allows and requires you to develop skills in scene construction and working with natural light.

A lot of good DPs come out of documentary; you learn to make a story and work with light.
Chris Menges BSC ASC[2]

Not all TV camera people come from a cinematography background. In television, there is now a trend for researchers to move up to become Assistant Producers, Shooting APs then Shooting PDs (Producer Directors). Some cinematographers now move across into these roles, and find they have at least as much to offer as those who start in the production department. These roles require the ability to understand stories, write, shoot, work with contributors, record sound and edit. Few people have all of these skills, so for those without a cinematography background many camera houses (particularly mid-range ones) offer training, either one-to-one or in groups, on specific cameras.

Docs are wonderful in their ability to shape shift and use all sorts of different storytelling tools, . . . My students are super engaged in their docs, probably because it is something they can do without a ton of hoopla, and also because they can really represent their own view of the world.
Dana Kupper[3]

TYPES AND MODES OF DOCUMENTARY

There are many types of documentary. Some involve integrating with the people you are filming so they feel you are almost invisible; others involve interacting with them. Working alone allows you to find your strengths and which type of documentary shooting suits you.

Titicut Follies. Shooting this film relied on director Frederick Wiseman and cinematographer John Marshall creating a degree of trust and having an unobtrusive working style that allowed both the patients/inmates and the staff of Bridgewater state hospital for the criminally insane to continue their 'normal' behavior.

In *Fahrenheit 911* (left) Cinematographers including Kersten Johnson, and in *Biggie and Tupac* (right) cinematographer Joan Churchill, the presence and influence of the filmmakers is visible on screen.

Bill Nichols described six modes of documentary,[4] which remains a useful way to understand the different types of documentary and TV shot today.

Documentary makers share reference points in the same way all cinematographers and directors do. The shared reference points for documentaries usually relate to the first time a particular documentary form was used, so it is well worth looking at both early and contemporary examples.

Expository or Traditional Documentary

An unseen narrator presents an argument showing the documentary maker's view of the world, with no alternative perspective shown. Still used in programs such as *America's Most Wanted* and in nature documentaries. There are also more current forms of expository documentary, such as *National Identity*.[5] This involves shooting a mixture of:

- Observational footage.

- Interviews (often with experts). Eyelines for interviews in expository documentaries are usually close to camera, not directly into it.

- Shots of additional information, e.g. maps, charts or graphs.

- B Roll: including GVs (general views of location, etc.) and cut-aways of action and reactions. B Roll supports the narration and allows the editor to cut between takes.

Be sure to discuss the argument being presented in pre-production so you shoot what is needed.

National Identity Cinematographers Rena Pilgrim, Lia Gajadhar, Jason A Russell, Neil Marshall from the Errol Barrow Centre for Creative Imagination University of the West Indies, Barbados.

Observational Documentary

Used as a standalone documentary form or as parts of other forms of documentary.

As a single form, Observational Documentary (ob-doc) attempts to show aspects of the world as they happen and show the participants' behavior as if no filmmakers were there. Pure observational documentaries have no voice-over commentary or music.

However, the choice of what to film and how to film it has a huge impact on the viewer, so whilst the absolute 'vérité' or truthfulness of this documentary form is questionable, it remains one of the most powerful and convincing forms of documentary. See *Hoop Dreams*[6] and *Titicut Follies* (page 206).[7] This involves:

- Shooting activities and events as they happen on location whilst ensuring that the editor has enough material to cut to show a consistent flow of the action.

- Making sure people being filmed do not appear to be aware of the camera and never look directly into it.

- Shooting some B Roll for very occasional cut-aways or for locating the action, e.g. the outside of a hospital.

Your choice of what to shoot completely changes the viewers' perception of events, e.g. whether to show protesters being hurt by police or them damaging property. Shooting observational documentary requires skills of anticipation, framing and watching the action with one eye whilst watching your framing with the other.

The Participatory Mode

Participatory documentaries involve and show the active participation of the filmmaker. Used in documentaries, such as *Living with Michael Jackson*,[8] this mode allows the interviewer to directly interview and interact with the contributors. This makes the viewer feel like the filmmaker is their proxy, asking questions on their behalf and they (the filmmaker) are often heard on camera asking direct questions. The objective is to find out the contributors' thoughts and feelings by observing and interviewing them without appearing to influence them. This involves shooting:

- Observational footage.

- Interviews, usually with the contributors, either in the observational location or elsewhere, with eyelines that are often straight into camera or very close to it.

In *Sicko* cinematographers Andrew Black and Jamey Roy, shots are selected to clearly illustrate points rather than for the audience to infer a meaning from a story.

The Performative Mode

Used currently in TV and documentary, the filmmaker is not only evident as an interviewer but as a participant in the activity who has a point of view that may be at odds with the contributors'. In Nick Broomfield's *Heidi Fleiss*[9] and Michael Moore's *Sicko*,[10] the films do not pretend to be objective, and any observational footage is obviously meant to support the filmmakers' points of view. The filmmaker often appears on camera, so cannot be the cameraperson, but as above, Nick Broomfield (for example) is often shown recording sound whilst interviewing. This involves shooting:

9: SOLO SHOOTING: DOCUMENTARY AND TELEVISION

- Observational footage.
- Interviews, usually with the contributors in the location and often with the filmmaker on camera.
- Some B Roll.

The Reflexive Mode

This is a super-current form of documentary, despite having been around since the 1920s, starting with films like Dziga Vertov's *Man with A Movie Camera*.[11] Reflexive films fit right into the current debate about what is fake and what is real, and how films are constructed both technically and in terms of presenting the truth. Contributors are aware of how they are being presented, even if this does not reflect their sense of themselves. The audience is asked to question what is being shown. Sarah Polley's *Stories We Tell*[12] is an excellent example of a contemporary reflexive documentary with wide appeal and virtually universal positive reviews.

Shooting reflexive documentaries involves similar shot lists to expository documentaries, but portions of the compositions and sequences are often stylized, to disturb the continuous flow and construction of reality.

In *Stories We Tell* Cinematographer Iris Ng, shots capture both the filmmaker's process and emotional challenges when making the film, as well as the subjects and people that the film is ostensibly about.

In one of the earliest examples of a reflexive documentary, *A Man With A Movie Camera* DP Mikhail Kaufman, the process and power of both capturing and showing forms part of the film.

The Poetic Mode

The poetic mode doesn't use narrative conventions such as continuity editing and a specific location. Poetic documentaries use artistic and expressive shots to create a mood that shows the filmmaker's emotional response to the subject. The editing is usually rhythmic and the films are often set to music. There is a cross-over between poetic documentary and art films and (interestingly) commercials, film title sequences and music videos (See *Sans Soleil*[13]).

D: SHOOTING CREATIVELY AND EFFICIENTLY ALONE

Koyaanisqatsi
cinematographer Ron Fricke.

The Poetic mode involves shooting shots that may include:

- Visual exploration and experimentation.
- The manipulation of speed and time.
- The creative or abstract use of light and shade.
- Changes in focus or soft ethereal shots.
- Changes in exposure.
- Reflections to distort or change the shape of subjects during a shot.

PREPARATION

Find out about the purpose of any particular scenes before you shoot because there isn't always time to discuss when it's all happening on the day.
Dana Kupper

Both when being interviewed for the job and when preparing for the filming, find out as much as possible about the film that is being made and about the director, so you know how you can help and what sort of input they need from you.

Story

What is the story? Whose story is it and what is their point of view? What are the deeper meanings of the film?

Ask which scenes or events the director thinks will be key and find out what they hope to get in terms of story from them.

> *In [TV] pre-production discussion it's a lot about focusing the director's mind so they think about what [shots] they will need in post and what look they want. They look to you to lead with ideas. They are often young and have come up through researching stories and don't always know what they are doing in terms of style and post-production.*
> Georgina Burrell[14]

Style

You need to find out the documentary format and if there is a set house or particular look that is wanted.

Anticipate and discuss any difficulties with what is being proposed, so adaptations can be made or time allowed to get what is needed. Talk about what you think would work. Watch examples to see how shots and scenes are constructed, if you are unfamiliar with the style.

> *If I'm joining a long-running show I select three episodes from each of the previous series so I can see what they have done before and which direction they are going in.*
> Georgina Burrell

Before a job I have a chat with the director about style, to find out if it's going to be calm and static or fast-paced and moving. Some directors are specific about what they want or there may be a house style for the program. For others, our discussion is more about me giving options for the director to think about.

There is a current fashion for directors to want very shallow depth of field but they don't understand the technical limitation. I let them know that the shallower the depth of field, the more likely they are to get some shots soft, gauge their response, then say that I will see what I can do.
Josh White

Content

– What is the balance between observation documentary, pieces to camera and B Roll?

– Are you looking, for example, to film similar things in each situation?

– If time is passing, do you need to shoot shots to show this?

– What are the key shots or ideas the director would like you to capture?

Way of working

Does the director want to cue you to start shooting, or leave you to it and just suggest any extra shots when they see them?

Will the director call the roll and cut, or will you and the sound recordist (if there is one) communicate between yourselves?

PERMISSIONS

This is a small task but of huge importance. It is an essential legal requirement without which the footage cannot be broadcast. Find out who will be getting release forms signed, giving permission for the footage to be used. Often you are you required to get on camera releases where the person gives their name, address and permission for shooting.

WORKFLOW AND RECORDING SETTINGS

You need to know the aspect ratio and resolution you will be working with, how long the post-production turnaround is, and who will be grading the footage, so you can make the best recommendations for shooting. If there will be no post-production, shoot LUT at a codec that is larger than required by the largest platform the film will be shown on, and expose and white balance as accurately as you can to ensure that the color and brightness of the shots in the scene are consistent. If there will be some post-production grading, shoot in Log in a codec (often Prores with 4:2:2 color sub-sampling) and with as high a bit rate as you can without needing to change recording mags more often than is practical (see C5). You also need to know what time code to use, what the data backup system will be, and who is responsible for backing up data and who to hand over the footage to.

In television there is always post-production, but it isn't always what I hope it will be.

When I shoot S-Log2 the graders are familiar with how to handle it and what they can do with it.

They have more flexibility with S-Log3 but on programs with a tight turnaround I've seen it messed up enough times – for example, by the grader just applying a Rec.709 LUT when I've sent instructions that this won't be right for the piece. So now I'm more inclined to shoot S-Log2.
Georgina Burrell

If there is no time or money for post, I don't shoot Log. I make the brightness and contrast how it is intended to look and I apply a LUT [which adjusts the color contrasts and sharpness] in camera so there is little or no flexibility if the production want to alter things later. I speak to production first about which option they prefer and at the moment it is about 50:50. For web-based applications I recommend shooting with a LUT but for TV I prefer to shoot Log. Not all my clients understand the workflow process and sometimes on set I find myself switching to a different LUT on the monitor to see if they prefer that look, but only when I'm not burning it into the footage.
Josh White

LENS CHOICE AND CAMERA SETTINGS

To shoot documentary you need the key photographic knowledge covered in Chapter 3 so that you can choose camera settings that will require as few changes as possible when shooting. This allows you to concentrate on the action and your shot choices.

- Pre-select the depth of field you need. Choose a lens wide enough to give you the depth you need.

- Even if a wide lens is not needed for depth of field, use a wide enough lens to avoid camera shake if hand-holding. A wide lens will also make the viewer feel closer to the action, while a longer lens will make the viewer feel like they are observing from afar.

- Set a frame rate that is suitable for your region: usually 23.98 in the Americas and Caribbean, and 25 for UK and Europe, Australia and almost everywhere else.

- Make sure you and the sound recordist are recording at the same frame rate, to avoid huge syncing problems. Even if you have a separate sound recordist, always record a guide track on the camera so it is available for post-syncing (with Plural Eyes or an equivalent) if there is a sound problem.

- Stick, in almost all circumstances, to a standard 180-degree shutter angle.

- The current trend is to shoot 1920 x 1080 (resolution) but increasingly productions are shooting 4k so you must check with production.

- Set the agreed recording format. Log is very popular for documentary because it gives a wide dynamic range, but if your footage won't be graded you need to shoot with a burnt in LUT.

- Set white balance to 3200K (for interiors lit with practical lamps) (see C11b) or 5600K (for daylight or daylight balanced interior lights) or 4300K if in mixed light situations.
 Or white balance the camera once in each location, unless the lighting changes. If you work in unusual lighting conditions, like sodium street lights or a factory, shoot a color chart.

- Use time of day time code and numbering system, if possible.

Before starting to shoot a scene, take a few minutes to set your settings. Once you are set and shooting, all you need to do is:

- Change aperture when needed for each shot and ISO if you can't get the level of exposure you need using aperture.

EQUIPMENT CHOICES, SAFETY AND PREPARATION

- Pack a small light kit that you know how to get the best out of and is flexible enough to do a range of work.

- Pack consistently so you always know what you have with you.

- Bring a backup for every essential, especially cables.

- Have plenty of batteries and cards with you.

- If necessary, keep some heavy backup kit such as block batteries in the car, but, other than that, keep all equipment either on the tripod or rig you are using or physically on you in a backpack.
 Only put it down when shooting if you are sure no one is nearby who might take or damage it.

- Don't leave your gear unattended.

- Lock it up if you do.

- Deputize others to carry **and be responsible for** certain pieces of equipment, such as tripod legs, monitor or slider, only if you think they won't lose it. If in doubt, send an email or sms note so there is a record that they are responsible.

> An on-board light is a must-have. A translucent umbrella can be very useful even if the interviewee has to hold it to protect them from rain or harsh sunshine. A reflector and a reflector stand are useful in all but run and gun situations.

Photo by Gavin Garrison.

I have a wireless monitor on a Portabrace for the director to wear, the batteries last for 8 hours, but when they take it off at lunchtime they can leave it lying around or lose it, so I collect the monitor at lunch time and switch it off.
Josh White

Sometimes the production specifies the camera they want me to use. If I don't think it is right for the job, I say why and usually they swap.

I usually use a black-and-white viewfinder with focus peaking in red plus zebras (for exposure). For high contrast situations, though, I need a color viewfinder, which makes exposing easier.

Then it's about a camera with the best ergonomics. I prefer a viewfinder not just an LED so you can see it in all situations (you can't see a monitor in bright light). The buttons should be where you want them – so you don't have to go deep into the menus for things you use regularly. There mustn't be buttons that sit too close to the shoulder or in positions where they can be accidentally pressed.
Georgina Burrell

Insurance can be purchased for a single day or for a set period.

- Don't skimp on insurance and, if working for free, say that your time is free but production must cover your insurance.

Many solo shooters have a bundled insurance policy covering public liability, kit and hired equipment to certain value and, in some countries, kit can be insured when in a vehicle with a specific lock or alarm system.

- Never forget to do a dummy check when leaving a location to check nothing is left behind.

D: SHOOTING CREATIVELY AND EFFICIENTLY ALONE

I have built up my kit over time and currently have a Sony FS7 which is great in low light and a monitor for the director. I have Samyang cine primes which are good quality and fast and help avoid the need to light just to get an exposure. This makes my kit smaller, easier to carry and gives fewer health and safety problems, especially around the public.

I do sometimes use lamps when the public are around if I need to create a glossier look.

I have a carbon fiber tripod that is light but quite sturdy and a good video head. Tripods and glass hold their price and stand the test of time. I have a 1m slider. The rule of thumb is that the shorter the slider, the more often you use it. I also have a hand-held rig, a GoPro and plenty of batteries, cards and filters.

Josh White (Since first interviewing Josh, he is now working on a larger variety of productions and budgets so is now hiring cameras based on the needs of each job).

Make sure you can:

- Assemble and work quickly with your equipment.
- Carry it all safely.
- Have enough cards and batteries to last all day.
- Have the camera ready, set up in a bag, ready to go.

SHOOT PROCEDURE

I give the director a wireless monitor and I wear an earpiece so they can speak to me. I ask them to make comments in my ear so I get feel of their style and we get on the same page. Depending on the director, they sometimes want to just leave me to it if they trust me, but I prefer if they can see what I can see and know what I am shooting. It also helps ensure that I don't miss something.

Don't worry if things don't go as planned. Capture in the best way you think.
Josh White

- Arrive, if possible, with the camera already set up, and a lightweight kit.
- Find out what you are doing and have any final discussions.
- If not already discussed, find out how the roll and cut will be called and who will take the lead with shot choices.
- Work with sound, and wear headphones so you can hear what is happening

So much of the story comes from what is being said. I always wear headphones to hear the sound it – clues me in what is happening in the scene, and where I should be looking. I have found certain camera people resistant to this idea; seems weird but true.
Dana Kupper

- Look for safety hazards, particularly trip hazards that may affect you or your contributors. Remove, tape down or stabilize anything necessary.

COVERING A SCENE AND SHOOTING FOR THE EDIT

Find out roughly what your access time is, so you know whether to focus your attention on a few key shots or if you can pick up B roll and reaction shots as you go.

9: SOLO SHOOTING: DOCUMENTARY AND TELEVISION

If there has been no discussion, think for a few moments before you start shooting or while you are shooting an initial wide.

> (Discussing shooting scenes on 'M25' Motorway series)
>
> *The first thing I do is look to see what I can get without getting killed.*
>
> *I get an overview of situation while doing a wide, then circle the accident; looking to see where I see the action and if I can shoot it with a background that works to support the story. Just moving a little bit makes a huge difference to what you pick up visually.*
>
> *I carry on circling and get closer shots of what is happening. The story is mainly with the ambulance crew's responses rather than the person lying on the floor. With this kind of documentary, it doesn't matter if you cross the line but I make sure I get cut-aways and GVs for context and so it will cut.*
>
> Georgina Burrell

While you are shooting, refresh your mind about what the story of the film is and think about how the action playing out in front of you will help tell that story.

Use your legs and your eyes. Move around your subject until you find the angle that both tells the story and maximizes the visual potential in your shots. Moving your position can change the background and changes how elements such as practical lamps affect the lighting and composition.

- Shoot a wide shot to establish the scene.

- If possible shoot a developing shot in which you or the subject moves, to give the viewer a sense that the story is unfolding in front of them.

- If you repeat any moving shot in a wide and a close version, make sure you are traveling in the same direction so they will cut together.

- Shoot shots of the action which are specific to the story in one or more sizes, e.g. if you are filming a cookery show, be sure to take wide, mid and close-up shots of the cooking.

In these frames from a single developing shot in *Jungle Gold*, cinematographer Georgina Burrell develops a shot from an establishing wide shot to a medium-close dialogue shot as the story unfolds.

D: SHOOTING CREATIVELY AND EFFICIENTLY ALONE

- To make sure shots will cut together smoothly, if possible, ask the people you are filming to pause for a moment while you quickly move in for a medium shot.

- Likewise, if necessary, ask for the action to be repeated for a close-up.

Stay on the same side of the line (see C7) when shooting if at all possible. The whole scene doesn't have to stay one side of the line but make sure there are several shots that work together without jumping all over the place in the way it would if you crossed the line.

If you shoot a shot that shows you moving from one side of a person to the other, i.e. crossing the line, it will not cause a problem during the edit.

The line should connect the actors

Think of the line joining the two characters but also extending beyond them (rather than running between them). Shooting anywhere in the green ticked purple area will keep the people on the same side of the frame (unless they move!).

As shown in this scene in *Revolutionary Road* DP Roger Deakins, if you keep filming while you cross the line, the viewer will understand why the people you are filming have swapped sides. (Try not to swap sides until there is a story motivation to do so, and then stay on that side).

Change your angle slightly between the wide and tight shots, to avoid jump cuts.

- Change your angle slightly as you move in from wider to tighter shots or it can be tricky to cut them together.

- Shoot reaction shots in one or more sizes to show the impact of what is happening if possible.

- Cut-aways showing parts of the action but don't include speaking.

- Cut-aways of objects relevant to the action.

- GVs of the area to give a sense of place.

- Permissions if required.

- Hold your shots for at least 3 seconds.

- Give handles, i.e. a few extra seconds before and after the usable part of each shot.

- Include transitional shots if possible, such as allowing someone to fill the frame as they leave, which allows for a cut.

- Mark shots you like with a thumbs-up or a verbal note, but don't cover the lens for focus adjustments or looking round the set – whip pans and random effects achieved when not really shooting often get used.

When I am filming a documentary, I usually struggle for the first shoot or two, the subjects are nervous, I'm not sure what the story is yet, but as we go on I find the groove.
Dana Kupper

These shots from *The Tribe That Hides From Man* Cinematographer Chris Menges show that shots conveying the energy of the action are just as important as those that show what is happening.

How you mark your stamp as a documentary cinematographer is what action you choose to shoot, how well that tells the story, how well you make the light and the location work for you and, very important, the additional shots (not just B roll) you shoot that support the main action.

For example, in the hunting sequence that Chris Menges shot for in Adrian Cowell's *The Tribe That Hides from Man*,[15] he creatively used a sequence of shots, switching between silhouettes and fully exposed shots creating impressions of the action, not just wide shots of it.

I wanted to convey the feeling of the power of the men's arms in close-up so started 'throwing' the camera around.
Chris Menges

CREATING SCENES WHEN SHOOTING OBSERVATIONAL DOCUMENTARY

Shooting observational documentary 'ob-doc' is one of the two core documentary skills and can only truly be learned by practice. When shooting ob-doc, you should not interrupt the action.

EXERCISE: Get permission to shoot at any activity. Spend long enough there for people to get comfortable with you. Look, listen and assess what is happening. Anticipate where the action will be and where the most telling reactions will be.

Experiment with two sorts of coverage:

1. Developing shots showing the action and the reaction, or develop from a wider shot to a more detailed look at the center of the action. Move while shooting and zoom (during the move) slightly, if appropriate, to change the frame as needed. Be aware of your depth of field and focus pull as you or the subject moves.

 Shoot cut-aways of details of the action that will allow the editor to break up the developing shots.

2. Shooting wide and tighter shots of the action and reactions while the action is in progress. This involves very tricky decisions about when to re-frame without losing a key moment of the action.

Because you don't know how long it will be before the story emerges, you need to be able to hold the camera for long periods. Make sure the camera is in a comfortable position or you won't be able to think straight or work properly without injury. Observational documentary is almost always shot hand-held or with a hand-held rig. It is usually shot with a zoom, but at night (or if you need to be as small and light as possible), a prime lens, which is far lighter and will open up to a wider aperture, may be more useful.

I tell the sound recordist not to follow me but that I will follow him/her. We are both listening for the story. If I'm not in a position where I can shoot the story I make sure I am shooting visuals that will support it.
Georgina Burrell

It is instinct. Don't chase the action . . . let it come to you.
Chris Menges quoting Alan King

D: SHOOTING CREATIVELY AND EFFICIENTLY ALONE

SOLO SHOOTING TECHNIQUES

Operating

One of the key benefits of being hand-held is that you can follow the action easily. To shoot hand-held, set the camera up so it is as comfortable and steady and balanced on your shoulder as possible so you don't feel like you are fighting it. To be as stable as possible when shooting, spread your weight evenly over both feet, with your feet shoulder width apart. Keep your arms close to your body and when possible use a third object for additional support, such as a wall or a tree. Camera stability can be greatly increased by the use of a rig, but the bigger the rig, the more offputting it can be for contributors. (See C10 for further hand-held guidance.)

EXERCISE: Practice walking and hand-holding the camera, paying particular attention to starting and stopping smoothly. For documentary work, the ability to move smoothly and to be able to lunge forward to create a push in rather than a zoom is very important. Similarly, moving from side to side smoothly is essential. Flexibility and fluidity of movement are more important to creating interesting hand-held movements than strength.

Practice walking with a person coming towards you, and parallel with you. Take extra care when you are walking backwards. If possible have someone lead you or watch for you to make sure you don't fall. Camera operators don't routinely use 'rear view mirrors' but a wrist-strap rear view mirror could help.

The longer the lens, the more camera shake shows, so opting for a shorter focal length and moving closer can help reduce shake. Practice on longer lenses but shoot on ones you know you can hold steadily. If your subject is moving, camera shake is slightly less noticeable but can result in the viewer feeling queasy.

Focus

Using a wider lens closer to your subject helps increase depth of field, but when working in the evening or indoors you usually also need to pull focus. When working alone you often focus pull on the barrel of the lens. The focus marks on each lens are different, so you have to learn to focus pull on each lens.

The focus marks are closer together for distances that are further away.

It is simply a case of learning which direction you are turning your hand for infinity, which for close focus, how much to turn your hand when you are close to your subject, how little to turn it when you are further away, and being conscious of how sharp the image is.

Pulling focus while shooting requires getting to know how much further to turn the barrel to adjust the focus when your subject is close than when it is far away, and is a skill only acquired through practice. Photo by Andi Graf.

It may also be useful to attach a zoom bar for fast and smoother zooms. Photo courtesy of Arri (www.arri.com).

You can monitor with focus peaking to see if the shot is in focus, but you cannot escape the need to learn how to pull focus on the barrel of the lens. Autofocus is available on some cameras and a few, including a couple of APS-C DSLRs, have a useful but not perfect focus tracking system. Autofocus cannot be relied on for anything but the simplest shots.

> *When I'm working alone I have the focus peaking [and zebras for exposure] on all the time. The issue with focus peaking is that it is a bit generous, so I'm not sure if a shot is completely pin sharp.*
>
> *It's also not as useful when the subject is moving, because the peaking doesn't pick up as much contrast [which autofocus relies on] in the image.*
> Josh White

See Chapter 2b for focus peaking and Chapter 3 for waveform.

Many cameras have a focus magnifier, which allows you to check focus by magnifying the image on the viewfinder without affecting what you are recording. If it is deep in the menu system, you can assign a button on your camera to function as a focus checking magnifier (but check which part of the image it magnifies, because the part you are interested in isn't always the middle).

If your camera has a touchscreen autofocus, it can be a handy reference point but can cause problems if you touch (and so refocus) on something during the shot.

Depth of field and hyperfocal distance calculators can be found online. It is very useful to look up what kind of depth you have on the lenses and distances you are likely to work at. The hyperfocal distance of a lens is the distance to focus at that keeps everything from half the distance to infinity sharp. On a very wide lens, e.g. 12mm, if the aperture is at 2.8 and the focus set at 8.8 feet, everything from 4.4 to infinity will be in focus. This could allow you to set the focus and leave it where it is if you go no closer than 4.4 feet to your subject. On a longer lens it is rarely useful because, e.g. a 32mm lens at 2.8 means you would need to be 17.5 feet from your subject.

EXERCISE: Practice focusing on someone who is static, perhaps sitting at a desk or doing something that doesn't involve much movement. Move towards or away from them creating different shots at various sizes. Practice pulling from their hands to their face, to what they are doing and to the background. It is important to practice pulling to the background because, whenever someone clears frame, you need to pull to the background while they cross frame, to avoid a disconcerting pull or sudden obviously soft background.

Repeat the exercise with the person moving. This requires judging distances on the fly, which is more complicated. (See C2 for additional focusing techniques.)

Exposure

Using auto exposure gives an average brightness for a shot. If the shot changes as the camera or people move, the average will be different so the shot automatically becomes brighter or darker. This would result in shots that need a lot of difficult adjusting in post-production, even if nothing changes within a single shot. If auto exposure is used for whole scenes, the shots will often be very difficult to match.

Many documentary cinematographers:

- Use auto exposure to find a rough starting point for exposure.

- Turn auto off and adjust it as required for the look of the scene.

- Use zebras and/or a waveform monitor while shooting, to show which areas of the frame are exposed to a particular IRE, and watch for changes as you shoot.

A waveform can be laid over the image so you can see exactly where the IRE levels are on each part of the frame, to check that they are as high or low as you want them to get a suitable exposure. *Under Jesus* DP Tomas Tomasson.

D: SHOOTING CREATIVELY AND EFFICIENTLY ALONE

"I set the zebras to 70% and look for them to start to show as a T on face." Georgina Burrell.

"I set the zebras to 75% and look for them to start to show on the highlights of the face." Josh White.

Zebras are stripes which can be seen on your EVF or monitor. Zebras can be set wherever you find them most useful.

All exposure advice is dependent on the comparative brightness you want to achieve between your subject and the background and the mood of the shot. As a guide for interviews and 'everyday' documentary shooting: 70% IRE is often used for the main areas of light skin and 75% for the brighter areas. Depending on the complexion, darker skin is usually exposed at between 35 and 50% IRE. For the brightest highlights of dark or light skin, 90% should be the limit, and likewise for the highlights in the rest of the shot.

Some cinematographers set zebras to 95 or 100% just to show which areas are clipping, and many set them to switch between, e.g. 70 and 95%.

If shooting with Log, these numbers will usually be 10–20% lower, depending on which Log option is being used, so you must check before you shoot.

I also have a waveform monitor overlaid on an image so I can see where face is to keep the exposure consistent over different shots. I expose a white skin tone a stop and a half brighter than grey [around 65% IRE], a mid-brown skin tone either as mid grey or half a stop over mid grey [around 50–55% IRE] and a black skin tone between half a stop and one and a half stops lower [35–45% IRE], depending on the complexion.
Josh White (see C11a for exposure).

Shot from *The Boxing Gym* cinematographer John Davey to illustrate that zebras at 90% should show only the brightest of highlights on a light or dark skin.

After my first sitting in on a color grading session, I realized that to get good details in the darker areas I needed to expose them higher than they will be in the final image to keep plenty of detail. I now assign function buttons in the camera to show the highlight areas and the low light areas so I can see the bright and dark bits and anything being lost or blown.
Josh White

LIGHTING AND LIGHTING EQUIPMENT

Safety

- Light or other cables with the potential to cause a trip hazard should be taped down, and make sure any light stands are weighted down and stable.

- Don't use power from anywhere that doesn't have a current electric safety certificate or the equivalent in the country you are working in.

- If using more than a total of 2kw of light from a domestic supply, you need to check the amperage available.

- When working with electricity, avoid all contact with water. Cover equipment if raining and put it on groundsheets.

When working alone you are usually working with or supplementing available light. What you need depends on the job you are doing, so the more you can find out before you start, the better. If necessary,

buy or hire lamp/s that will make your life easier. If unsure what you will be shooting, you need a flexible kit that ideally: fits in one bag, is battery operated (preferably with v lock batteries that don't run out quickly), doesn't need large stands or can be used with table-top stands.

> *I bought a battery-operated lamp with magnets on the back. On this job we pretty much always had a vehicle I could stick the lamp to and, although the color temperature was a bit cool, it was in keeping with the mixed lighting coming from the different cars so worked really well. I also had a lamp on board the camera for fill when I needed it.*
> Georgina Burrell

A flexible small kit would include:

- An on-board lamp for your camera, ideally with a magic arm, to position it slightly to the side.
- One lamp for raising levels for interiors or working as a key light inside or outside if needed.
- One lamp that will pick up the eyes to give an accent when shooting interviews.
- One lamp that could be a back light or pick up something in the background, or in a lower light situation be a smaller key.
- A 5-in-1 reflector kit and stand.

If you can't use all the kit at once, there is no point having it with you.
Josh White

LED lamps are useful as they are cool and safe. They can often be switched between color temperatures or come with filters. Small LEDs are not usually strong enough to provide a key and, in cheaper models, not designed for film; the color temperature is inconsistent and the build quality and barn doors are flimsy. They can also cause flicker when the batteries are dying, which is not usually noticed until later. Think about the light coverage you are getting for price and how long your kit will last.

Lighting and Color Temperature in Observational Documentary

It is important that lighting isn't distracting for the participants in observational documentaries. In most cases, you work with available light, supplement it with additional practical lamps or change the bulbs in light fittings that are out of shot, to the highest output the fittings can take (they would create burnt-out areas if they were in shot). If working for a long period of time in a location, this is usually the best route. If needed, you can bounce light from the ceiling or into a wall to increase the light level. Try to minimize working with mixed color temperature light, but if you do, set the camera to 4300K (halfway between tungsten and daylight), so, although the color temperature differences cannot be graded out, you will have the option to make the scene warmer or cooler.

An LED panel set for side lighting. It is a relatively large setup for a hand-held rig but is possible because the weight is spread evenly onto the hips when using an Easyrig rather than being on the back, shoulder or arms. Photo courtesy of Easyrig.

LIGHTING AND SHOOTING INTERVIEWS

Shooting interviews is the second of the two core documentary skills. For fuller details of lighting techniques, see C11–13. When interviewing or recording pieces to camera on location, a straightforward approach is to:

- Look for an area where there is the least background noise and where you can turn off any fans or AC.
- Use a motivated key light (such as daylight through a window or a practical lamp that can be seen in shot).

D: SHOOTING CREATIVELY AND EFFICIENTLY ALONE

> Some programs or series involve on-the-fly interviews as below and set piece interviews that are intended to follow a 'House Style'. To re-create a precise 'look', it may be better to find a place where you can block off the daylight and set up your own lamps.

- Balance the key if necessary with fill from the camera or a reflector.

- If that isn't possible, set up a lamp as your key light. (In documentary it is far more common to use a 3/4 front lamp that can quickly supplement the available light than in drama; where a 3/4 back light is often preferred.)

- Open or close curtains or blinds to increase or decrease the brightness of different parts of the room if available.

- Alternatively separate the subject from the background by either moving them or the camera position so there is a different color or a contrasting level of light behind them.

These techniques were used in the examples below. In addition, I shot stills against windows for each of the interviewees to add an additional visual strand to the film.

The Spirit of Mikvah Director/Cinematographer Tania Hoser.

When shooting:

- Make sure the interviewer is at the same height as the lens to avoid the interviewee appearing to look up or down.

- Keep the interviewer close to the camera, because the interviewee will always appear to be looking far further to the side of the camera than they really are, which may look unnatural. As per the central image above keep the interviewee's eyeline close to the camera. Here, the interviewer's head was virtually touching the matte box.

- When shooting alone, to avoid the interviewee looking directly into the camera (which makes them appear to be directly addressing the viewer rather than communicating with the interviewer), position yourself so they can look at you or ask them to look at the edge of the matte box or stick a piece of tape on it for them to look at.

- Watch to check the interviewee's eyeline remains consistent during the shot. If the interviewee glances directly into camera or way out of frame, those parts of the shot won't be usable and should be repeated if possible.

Eyelines appear to be far further to the side of the camera than they really are: (left) interviewer is standing next to the camera, (center) interviewer is virtually touching the matte box, (right) if shooting alone, ask the interviewee not to look directly at you into the camera, unless you want them to appear to be addressing the viewer.

- Interviews are usually shot as medium wides or close-ups. If you pop in for close-ups during shooting, you risk losing crucial moments while you re-frame because you won't be able to just zoom in. It is also difficult for the editor to cut between wider and closer shots of your interviewee from exactly the same direction, so they will also have to cut in cut-aways.

I highly recommend that you stay on one size when shooting interviews (trust me on this!), but ultimately it is up to the director whether you shoot one size or pop in for CUs. If there is any doubt in the director's mind, stay on one size. Fortunately, if you have the option to shoot 4k footage and your finished piece is the currently more common 1080p (approx. 2k), you will be able to crop in during post-production to create closer shots. Despite the slight difference in the look between the 4k wider footage and the 2k closer footage, this is a good option if available.

Another solution is to shoot with two cameras: one for wide and one for close-ups. Alternatively (if your second camera is a GoPro or something that will be difficult to match in), shoot from a substantially different perspective so the editor can cut dynamically between the different angles.

- Always shoot cut-aways of either the interviewee's hands or suchlike, or parts of the room, so the editor can cut between sections of the interview.

In virtually all cases, interviewees are happy to be on camera, so there is no ethical issue about starting to record before the interviewee thinks you are shooting. Often the most interesting, relaxed and useful footage is shot during this time.

If you are responsible for release forms, you can either get them on camera or on paper (or both).

I ask for (the interviewee to give) their name, and to spell it and give their email address and permission on camera. On shoots where the interview is being given in pressured situations I follow up by sending a form over because it isn't fair (and may not be legal) to rely on permission that has been given when someone is in shock.
Georgina Burrell

Whatever your starting point, interviewing skills can be improved and developed.

- Show your interest and enthusiasm about who your interviewee is and what they have to say. Try to get them to think more deeply about what you are discussing, rather than just telling you what they already know.

- Learn how to ask open questions rather than closed ones, e.g. 'What do you like about math?' not 'Is math your favorite subject?'

D: SHOOTING CREATIVELY AND EFFICIENTLY ALONE

- Actively and fully listen to what they say and what their body language tells you.
- Wait for a reply which gives them time to think.
- Don't cut in; this avoids having your voice overlapping with theirs in the sound track, and making the shot unusable.
- Repeat the last line they said if you want to find out more about it.

CINEMATOGRAPHER'S GUIDE TO RECORDING SOUND

Sound people are well worth their money. Given the choice of a camera assistant or a sound recordist, I would always choose a sound recordist.
Josh White

Sound is more important than pictures – if you get the sound you can always find pictures to work, but not the other way around.
Georgina Burrell

With online video you can get away with sub-standard pictures, but bad audio will lower people's perception of the overall quality much more.
Kim Plowright[16]

If working with a sound recordist, the sound is usually recorded on a separate recorder and onto the camera. The recordist will give a time code feed to camera so that sound and camera time codes match up. You help the recordist by signaling if the boom is coming into frame and keeping your framing consistent in repeated takes.

Unfortunately, much of the time, the vital role of recording sound also falls to the cinematographer. Therefore, it is important to know how to simply and effectively record sound and when to insist that a sound recordist is hired. Whether it is the cinematographer or sound recordist responsible for sound, the production requires:

- Clean clear on mic (see page 226) recordings of all dialogue.
- A 30-second 'atmos' track of the ambient sound of each environment you shoot in, without **any** speaking, bangs, bumps or identifiable sounds.
- 'Wild tracks' (see page 227) of anything, such as a glass being put down on a table or a clap, seen in frame.

What adds complexity to the recording of sound is that when we listen to something, our ears filter out noises we aren't interested in, but the microphone cannot. Therefore, to avoid recording unwanted noises, endeavor to shoot somewhere that the background noise is low, and ensure any important dialogue is recorded when there are no extraneous noises such as aircraft, shouts or car horns. If necessary repeat all or parts of shots until 'clean' (uninterrupted) sound has been recorded. When working indoors, turn off ACs or heaters, photocopiers or other machines creating a hum, and close all windows.

Avoiding unwanted sounds is very important, but there is more to recording sound than this. I am very grateful to producer and recording engineer Kevin Porée for his help preparing the following cinematographers' guide to recording sound, which will help you ensure:

– The mic is powered if needed.
– Plugged in correctly.

- Positioned effectively.
- Not suffering from interference, wind or breathing noise, clothing rustle or cable noise.
- The correct recording options are selected.
- The recording level is in the right range and filters are used appropriately if needed.
- No cable noise is recorded.

Power

Dynamic microphones don't need additional power but aren't able to record the range of sound that condenser mics do. Being cheaper, they are usually less well made. Low-end clip mics are usually dynamic mics.

Capacitor/Condenser microphones, including the popular Røde VideoMic PRO, require power, usually from a 12v battery or from a 48v supply from the camera or recorder. Being powered allows capacitor mics to be more sensitive to sound than dynamic mics. Being more sensitive, they can record a higher level of the sound signal and suffer less from electronic noise that all mics, cameras and pre-amps generate, i.e. they have a better signal to noise ratio.

Most microphones built for filming have batteries. Wireless mics are almost always condenser mics, and always need batteries. If the mic is powered by batteries, it needs no additional other power. If a condenser mic doesn't have the option for batteries or they aren't available, it can be powered by phantom power from the camera, usually marked as Mic+48v.

DSLRs generally don't provide the option to phantom power a mic, because they don't have either a phantom power switch or a Mic+48v option. Most, but not all, other cameras do have one or other of these options.

> *Bring lots of spare batteries if using battery-powered mics, especially if you are using wireless mics or don't have the option of phantom power. Batteries don't last long and the mic won't work at all without power.*
> Kevin Porée[17]

Ensuring the mic is plugged in to the correct socket: Cam, Mic, Mic+48v, Line

When you listen to audio from a CD or audio device it is at **Line** level, which is a far higher level than the **Mic** level microphones record at.

To bring microphones up to line level you need to boost the signal with a pre-amp. The pre-amp will either be within the camera or in the microphone or within an audio recorder.

- If you are getting a feed into the camera from an external sound recording device, use the line input.
- If you are using an external recorder and plugging that into the camera, use the line input.
- If you are plugging a mic into the camera, use the mic input but check to see if it needs power.
- If it is a condenser mic and has its own batteries, use the mic socket.
- If you don't have batteries you can plug it into the Mic+48v socket if your camera has one.
- If your camera has a Cam recording level option, it is only for the camera's own inbuilt mic.

D: SHOOTING CREATIVELY AND EFFICIENTLY ALONE

Shotgun Cardioid Omnidirectional

The pick-up areas show where the microphone 'hears' clearly. Outside the pick-up areas the sound will be muffled and 'off mic'. Directional mics are very useful for reducing extraneous noises, but any dialogue must be on mic.

Positioned effectively

Omnidirectional mics sound the most natural because they record ambient sound from the environment as well as the voice. However, in most places you will be filming, the level of background ambient sound will distract from the voice, so a directional mic is used. The more directional the mic, the less background sound it picks up but the more directly it must point at the mouth of whoever is talking. If two people are talking either side of a table, a highly directional mic will not pick up both people effectively. You would need to either set up a mic for each of them on a stand or, if using a mic on camera, make sure it has a broad enough pick-up range to cover the position of the people speaking.

If the person is outside the pick-up range of the mic, the voice quality is noticeably compromised and it sounds 'off mic', which is why taking the time to set up lavalier or radio mics is advisable when working alone. A sound recordist would also consider the sonic perspective of the dialogue and position the mic at a distance that would best reflect the focal length of the camera, but this isn't something you can do when working alone and without a range of mics.
Kevin Porée

When using a lavalier mic (a wired or wireless mic clipped onto someone's clothes), position the mic between 6 and 9 inches away from the person's mouth. Most lavalier mics are omnidirectional, so record sound from all round them, but being placed relatively close to the mouth, the sound of the voice is far louder than the background noise.

Not suffering from wind noise, clothes rustle or cable noise

Microphones cannot differentiate between sound vibrations and any form of touch vibrations, so will record both.

- Use a mic cover inside to avoid breathing noise.
- Use a windsock/'dead cat' if outside.
- If concealing a clip or radio mic in someone's clothing, make sure the clothing isn't touching the mic – place a small piece of rolled-up camera tape or tack or something to keep the clothes off the mic.

(left) The H4n recorder has an integrated stereo mic, (center) mic cover, (right) windsock/'dead cat'.

Cable noise is caused by vibrations when the cable is touched or jiggled, which are picked up by the mic itself and interpreted as noise. A sturdy, thick, well-built cable will produce less noise then a thin, brittle, cheap cable. If there is a wired cable, do not touch or allow anything to touch the cable during recording. Interference can also come from the plug not being firmly in the mic or into the camera. Taping the cable into a small loop near the plug reduces this.

Recording Options and Radio Mics

The simplest and cheapest set-up is with a wired cable between the mic and camera. Unfortunately, trailing cables restrict movement, which is why wireless radio mics are often preferred. If using radio mics, the mic and receiver must be tuned into the same channel. If using more than one wireless mic, each mic needs to have its own channels, to avoid interference.

A perfectly good option if you don't have radio mics or can't record onto the camera is to plug a clip mic into a mobile phone and use that to record on and post-sync later. The mic will need to be 6–9 inches from the person's mouth and the phone concealed.

Recording Levels

In film sound recording, the dBFS (Full Scale Decibel Scale) is used, in which at 0db audio will distort irretrievably.

To be safe, most people record dialogue at −12db, which gives a lot of headroom if someone raises their voice (there is no advantage to recording higher than this, i.e. in the red zone). Make sure you know where 0db is on your camera. There will probably be a bar graph with a red zone from −3db.

> *When I'm recording sound, I put a wireless radio mic on one channel and use the camera mic on the other. I keep an eye on the sound levels and any extraneous sounds, like wind noise or rustling, and that's it. If the sound requirements are more complex, they need a sound recordist.*
> Josh White

> Røde VideoMic PRO are good directional on-board mics, but for interviews using a lavalier mic or boom mic is a far better option.

> Although recording levels don't have to exactly match mixing levels, they are useful guidelines, because when you record around those levels you should be okay.
>
> When mixing for film, dialogue is mixed around −12dB, background music around −18dB.
>
> SFX peak around −10dB but usually around −15dB.

Lavalier/clip mic.

Most cameras have limiters that can be applied to the recording and are supposed to be a safety device to stop the sound recording level going above zero by squashing the level down if needed. They do this by squeezing down the highest-level sound but it cannot be effectively un-squeezed later. When the limiter kicks in, the sound is audibly odd. However, sound recorded with a limiter sounds marginally better than distorted sound. It is far better not to use a limiter, set the level lower, adjusting it up or down when needed or moving the mic away when necessary. It is usually not possible to do either of these when working alone, but if something distorts, you can take a wild track (a separate recording of the sound that distorted), and post sync it later. A wild track can be recorded with the same mic and camera, but when recording a wild track, sound is prioritized, so you can move closer if necessary.

D: SHOOTING CREATIVELY AND EFFICIENTLY ALONE

In Camera Audio filters

Use bass cut if you are recording dialogue. This allows all dialogue frequencies to be recorded but doesn't waste space recording the full spectrum of frequencies, resulting in a higher signal to noise ratio and a cleaner sound.

A low pass/treble cut filter can be useful for reducing hiss.

When recording music and audio SFX, don't use either filters, because you want to retain all the frequencies to get the fullest sound.

DOCUMENTARY FILMING ASSESSMENT RUBRIC

If possible, go and see the footage while it is being cut. Seeing what does and doesn't work and why editing choices are made will stand you in very good stead when shooting.

This simple Rubric will allow you to assess your work while you are learning. Set your aims for each project or test you shoot, and work towards Level 4 in all areas.

Level	Camera	Sound	Scene Construction	Core of Story	Documentary Structure
1	Several shots incorrectly focused, exposed or framed badly	Sound either clipping or too low or other problems	Coverage not sufficient to tell story	Core of story does not come through	Incoherent documentary film structure
2	Most shots OK but a few have basic errors as above	Some errors as above, and not all sound on mic	Location and action shots are covered	Little understanding of the subject or people is shown	Rudimentary documentary form visible
3	No technical errors, and lighting and exposure used creatively on some shots	Sound levels good throughout and all or mostly all on mic	All the above is good and scene construction and compositions include background appropriately	Action and reaction shots and cut-aways help tell the emotional or psychological story creatively	Good application of a specific documentary mode
4	Exposure, lens choice and light used appropriately and imaginatively throughout	Sound levels good, all on mic and good range of wild tracks	Coverage is imaginative, locations are used well to support the story and the potential for light to help tell the story is also incorporated into the shot selections and scene construction	Good anticipation and understanding of the emotional core of story, and covering emotional story with good anticipation and use of reaction shots	Imaginative use of the form or mode to engage the viewer in a new or appropriate way in accordance with core aspects of the subject

NOTES

1. Josh White (DP) in discussion with the author (September 2016)
2. Chris Menges BSC ASC (DP) speaking at Cinefest, Arnolfini Centre, Bristol, September 2016
3. Dana Kupper (documentary cinematographer) in communication with the author (August 2017)
4. Nichols, Bill. *Introduction to Documentary*. Indiana: University of Indiana Press, 2010.
5. *National Identity*, directed by Jason A. Russell (Barbados, 2013), film.
6. *Hoop Dreams*, directed by Steve James (USA, 1994), film.
7. *Titicut Follies*, directed by Frederick Wiseman (USA. 1967), film.
8. *Living with Michael Jackson*, directed by Julie Shaw (UK, 2003), television documentary.
9. *Heidi Fleiss: Hollywood Madam*, directed by Nick Broomfield (1995), TV film.
10. *Sicko*, directed by Michael Moore (USA, 2007), film.
11. *Man With A Movie Camera*, directed by Dziga Vertov (USA, 1929), film.
12. *Stories We Tell*, directed by Sarah Polley (Canada, 2012), film.
13. *Sans Soleil*, directed by Chris Marker (France, 1983), film.
14. Georgina Burrell (DOP/shooting PD, georgieb.tv) in discussion with the author (May 2017)
15. *The Tribe That Hides from Man*, directed by Adrian Cowell (UK, 1970), TV film.
16. Kim Plowright (Freelance Producer and Product Manager, and a Senior Lecturer at the National Film and Television School) in discussion with the author (September 2016)
17. Kevin Porée (music producer and sound engineer) in discussion with the author (July 2017)

SECTION E

Camera Operating and Methods of Moving the Camera

10
Camera Operating

Good camera operating is clearly visible in the finished film. Most, although unfortunately not all, poorly operated shots lie on the cutting-room floor. Camera operating requires intuitive skills of anticipating action, understanding the psychology of movement and knowledge of the practical and technical aspects of moving the camera. There are now fewer dedicated camera operators, so it is increasingly important for all cinematographers to have good operating skills.

This chapter looks at the operator's role in devising shots and working the ACs and Dolly grip to ensure they work from start to finish. It looks at how to work with props and furniture to optimize frames and how to make shots match in terms of content and eyeline. It goes on to detail all the elements you must scan the frame for during a take. This is followed by a look at the effect of different techniques of camera operating, how to achieve consistent framing and how to use screen space to help tell the story.

Camera operator Lucy Bristow ACO and 1st AC Gordon Segrove on the set of *Me and Orson Welles*. Photo by Liam Daniel.

The chapter concludes with an insightful and thorough account of hand-held camera work by Sean Bobbitt BSC, including how to work with contributors and how to move smoothly and safely.

> ### LEARNING OUTCOMES
> *This chapter will help you:*
> 1. Operate steadily and safely by choosing and using good operating positions and appropriate equipment
> 2. Use framing, headroom and leadroom for storytelling in a consistent and effective way
> 3. Work effectively with the 1st AC and Dolly grip
> 4. Understand which types of equipment produce what type of movement
> 5. Understand the operator's role in keeping eyelines consistent and positioning artists and props to make shots match
> 6. Know what to look for during a take and when to call if errors are made
> 7. Learn techniques to map out and memorize a space so you can move freely
> 8. Work effectively with actors or contributors when operating the camera

E: CAMERA OPERATING AND MOVING THE CAMERA

BENEFITS OF HAVING A DEDICATED CAMERA OPERATOR

Operating is normal at my level unless there is a Steadicam day. When I'm not operating I can help director devise the movement. It makes my input as a DP stronger; I become more involved in the creative essence of the project. It is very hard to wear the operator's hat and the DP's, because of the physical exertion and the technical stuff of keeping the frame consistent and scanning the frame for lots of different things. It's massively better if you have an operator so you can keep an overview.
Paul Mackay[1]

DP Eun-ah-Lee and Doo Soo Kim 2nd AC, with Robert Ko 1st AC on left of frame on the set of *Front Cover*. Photo courtesy of Laura Radford Photography.

Most DPs and all those who shoot documentaries operate the camera unless a specialist Steadicam, crane, motion control or drone operator is needed. However, although operators are now rare, other than on big budget shoots, there are considerable benefits to having a separate camera operator and director of photography. When you are learning cinematography, and when working on unpaid shoots, there is a great deal to gain and nothing to lose by having a separate camera operator. The operator can set up and rehearse the shot with the grip and 1st AC while the DP is lighting, saving a lot of time. A separate operator also lets the DP spend more time with the director, watching and discussing shots.

Professionally, experienced operators are uncannily able to get the shot right on the first take, because they are used to working on films where there are difficult shots.

THE EFFECT OF CAMERA MOVEMENT ON THE VIEWER

The style of how the camera moves has a considerable impact on the viewer and should be discussed during pre-production.

When the camera is rock-steady, unless a very long lens is being used, the viewer isn't usually as conscious of the act of observing as when it is less stable.

Likewise, if the camera is moving smoothly on a track the viewer feels as if they have a more objective view over the characters and story than on an equivalent hand-held shot. Tracks give a supreme ability to glide, giving the viewer the feeling of being an omnipresent observer.

The benefit of operating the camera on a track is the ability to pan, tilt or swing as action changes and to favor whichever part of the frame best tells the story.

On a Steadicam there is slightly less precision in terms of framing, but the viewer feels more pseudo physically engaged in the process of watching due to the sense of floating that is associated with the Steadicam.

With the use of a less smooth rig or hand-held camera, the feeling of physical viewer engagement or 'stress' is greater because the movement becomes jerkier.

The small jerky movements give what is called frame energy. Eisenstein called it 'unmotivated camera mischief' and, in practice, it is called 'breathing' if it is slightly moving, or described as 'frame energy' if it is moving perceptibly.

It is the combination of camera movement and position that creates the viewer's perspective. For example, frenetic ER-type of camera movement is intended to convey a feeling of the viewer being in a fast-paced atmosphere, by finding and losing the subject as you would if you were in a very busy environment. Unfortunately, this kind of movement can be ineffective if it is used as a blunt instrument visual style throughout.

> Jay P. Morgan's tutorial on Camera Movement, 'How to Create Emotion,'[2] shows how different camera movements affect the same scene.

The type of movement and frame energy wanted should underlie operating and equipment choices. Once the shoot starts, the operator is responsible for bringing that style to life and making adjustments as appropriate for each scene or shot.

> *On 'Buried' we mounted a custom-made wooden tray on a head, then put the camera on a steady bag, which I then operated with hand-held grips to give the frame slight movement; a sense of breathing. That rig could also be put on a dolly for tracking.*
> Lucy Bristow ACO[3]

DEVISING SHOTS

When moving shots are being devised, the operator and grip are often given the frame at the start and end, and sometimes the midpoints of the shot.

> *The camera operator makes suggestions about how to refine and improve shots, but doesn't take the lead during blocking on set, because there would be too many voices. You are responsible for making sure that every stage of every shot works compositionally. It is usually the operator that sees if the middle of the shot isn't working. It has to work throughout, because you never know how the editor will use it. Re-devise the shot if it isn't working or if you can see how it can be improved. You might get people blocking each other or something not working as well as it should. You often have to adjust things. The first take doesn't always work well. You can still ask for adjustments; you are always looking to improve the shot.*
> Lucy Bristow

I find the start and end frame myself, then leave it to operator and grip.
Roberto Schaefer[4]

WORKING WITH OTHERS

Working with the Grip

The operator and grip make sure the shot is achievable with the equipment available, in the space you are shooting, or suggest alterations to the shot if necessary.

An experienced grip will configure the best dolly or support for the shot, but an inexperienced grip will often need instructions from the operator about where to put the platforms, extensions and seats on the dolly.

> *During rehearsals, I practice the move, make sure the grip and I are clear where the shot begins and ends, and that the grip knows the right time to start, which may need to be initiated slightly before the movement. I use a monitor to check and review if I'm not sure the move has worked well.*
> Lucy Bristow

Photo courtesy of Chapman/Leonard.

Working with the AC

During rehearsals, the operator finds the best points at which to pan and tilt the camera, and if and when to conceal zooms (or focus pulls) so they aren't noticeable, by timing them while the camera is moving.

E: CAMERA OPERATING AND MOVING THE CAMERA

The AC needs to be able to see the shot and assess the focus distances throughout. It is particularly difficult for the focus puller to assess distances if they can't see the action. A monitor with focus peaking can help, but the operator needs to watch out to see if the focus goes soft and remember which point or points were soft, so decisions can be made about what and if to re-shoot in another take.

Positioning Artists

On some films, moving shots are improvised or vary from shot to shot, so the operator and focus puller must respond to the movement of the actors as they happen. In others, they are precisely timed to achieve the optimal framing from start to finish. To co-ordinate the movement of the camera and the actor so the shot flows seamlessly and works throughout, it can sometimes help to ask if the actor can walk more quickly or slowly or on an arc from one place to another, to make their move take longer. Movements on an arc are often called 'bananas'! Bananas are also often very helpful in preventing one actor blocking another from view during shot.

Positioning Props

These movements of props, etc. are called 'cheats' (e.g. 'let's cheat the sofa left by 9 inches') and should be cleared with the props department and continuity.
Lucy Bristow

The operator may also ask for props to be re-positioned so they work better in the frame, or to be removed if they aren't seen to make the space easier to work in. The operator has a significant role in positioning props so they work best in the frame and also makes sure prop positions match and work in wider and tighter shots. This is because the camera angle is virtually always changed slightly between shots, so the positions of people and objects within the frame change and may either not look right or block parts of the frame that should be seen. It is also because on a wider shot you may see the whole of an object, whereas on a tighter one you might just see an odd corner or sliver of it in frame.

To make sure the wide and close shots match, are well composed and appear where possible to have the same content, furniture and props can be 'cheated', i.e. moved without the audience realizing anything has changed, to achieve the best composition for both wide and close shots.

EXERCISE: Practice creating wides, mediums and close shots, and position actors and props so they appear at similar distances apart in all three shot sizes.

> A similar process, but one that requires more visual memory, is to move the props and furniture so that you can shoot in one direction while making it appear you are shooting in another. This is an important skill to acquire, because it can save a great deal of lighting time and allow more suitable backgrounds to be used.

FRAMING

The operator needs to be familiar with all aspects of framing and scene construction (see C6 and C7) and pay particular attention to making sure the starts and finishes of shots work without jarring.

If the camera and artist are both moving at the start of the shot, the actor may start outside the frame, and as they enter frame the camera picks up the movement and moves with them. If a move starts during shot, it should usually be motivated either by action or sometimes by a change of emotion. The precise timings make a considerable difference to both the story and the polish of the shot and are one of the operator's skills.

The position of the flowers would need to be adjusted in the wide shot (bottom) to appear to be in the same position as they are in the tight shot (top).

It's best to hold the shot at the end to let people or vehicles exit frame before cutting the camera, (otherwise, the shot will be inconclusive). While the subject is clearing the frame, the AC needs to pull focus to the background. Each take needs to be consistent, so all other crew know what is in and out of shot.
Lucy Bristow

Leadroom

One of the key things that distinguishes a good operator is the ability to nuance movement and framing for action as it happens and to do it purposefully and consistently during a film. When you watch films, look for how movement and camera operation lead the eye. Meaning is significantly altered by leadroom, which is how close the person gets to the edge of frame in the direction they are moving (the term leadroom is used for both moving and static shots, as discussed in C6). The meaning is different if a person reaches the edge of frame before they stop rather than stopping halfway through it or just after they enter it. Reaching the edge of frame can either signify the person's intention to leave the space they are in or show they are constrained by it. If the camera is static this sense of constraint is amplified. For static shots, how close the person gets to the edge of frame is usually decided by the director but for moving shots the precise point is, in practice, often up to the operator.

EXERCISE: Set up a camera in an area where there is a great deal of movement, e.g. a park, a market or on the street. Get yourself comfortable and familiar with the locks and tensions that control the resistance on your tripod head. Put some music on your headphones and swap, from time to time, between tracks with different moods and beats. Watch the actions and interactions that you can see, and allow yourself to be absorbed whilst you practice understanding leadroom as you let your operating flow with the action.

- Practice how to follow something for as long as you can.
- Work on smooth transitions from one subject to another.
- Switch smoothly between fast movement and slow movement.
- Stay with people as they move back and forward in the frame and see what difference how far into the frame you let them come makes to what their intention appears to be.
- See if you can anticipate where they will stop.
- Also practice letting them go out of frame and see what difference having a static frame or moving one makes as someone leaves.

You will find that you need to be both watching the frame and watching what is happening around the frame to anticipate the action.

These skills of using both eyes simultaneously, observation, framing and understanding how people move and interact are crucial to cinematic storytelling and apply in all genres. You can control the flow of the story with how you position the people, but in order to be able to do this you must understand the story.

Headroom

Traditionally, the starting point for headroom in shots where the person is the main focal point is to have the eyes a third of the way down the frame and a little higher in extreme wide shots.

Trends in headroom change slightly over time and are part of the visual style and language of the film, so should be discussed before the shoot. Headroom will be affected by any hats or hairdressing that affect the height of the head. Once you have decided where your headroom should be, learn how to consistently keep the same headroom:

- Start the shot in the same position by aligning the top of the frame with something you can see. This is especially important if someone is walking into an empty frame, so you don't have to suddenly adjust the frame.

- Always know the framing for the start, end and midpoints of a move. Remember what you will see at the top and sides of the frame at each point, and look for them as you move.

- Repeating the camera move in the same way each take will help ensure that you find the same frame each time.

Even a relatively small amount of difference in the headroom between shots can make it appear as if the head is bobbing up and down in the frame.

Scanning the Frame

When working on set, there is usually less freedom and more to think about than when you are practicing. You have many things to concentrate on and are often not standing upright and comfortably. Make sure that, wherever you are filming, you find the position where you have the most balance and freedom of movement. You will be able to concentrate, move better and sustain the shot for longer.

- Scan for anything that shouldn't be in the frame and anything that is standing out inappropriately, e.g. people wandering into frame, coffee cups.

- Look for mics dipping into frame, boom poles cutting across corners, flag stands, lights or tracks showing. Signal to the boom op if the boom is about to come into frame. It helps if there is an edge around the frame you are shooting in your viewfinder. If not (which is increasingly the case, as more productions shoot on the full sensor), you need to operate with one eye open.

- If a period film, look for cars or TV aerials, etc. (they can be sorted in post, but if they can be framed out it is better).

- If close up, look for nets on wigs or glue, neck and radio mics.

- Look for lumps and bumps on track that create little jolts which will show on screen.

- Flag up any major focus issues and remember which parts of the shot were soft.

- Likewise with continuity errors, because if actions happen at different times during a shot, the editor has fewer options for when to cut.

I sometimes use a monitor to operate, but usually only if it's physically hard to get my eye to the eyepiece. If there is a lot going on in a scene, it can help concentration to use a viewfinder.
Lucy Bristow

- Make sure that, unless specifically requested, none of the actors or background artists look directly into camera.

- Be aware of what eyelines mean and that they match from shot to shot. If necessary, suggest where the artist looks or have an X in camera tape put on the matte box so they know where to look.

- Ensure that headroom remains consistent.

- Point out (discreetly) if actors are not hitting marks, as it affects both focus and continuity. The shot can be adjusted to make it easier for them if needed.

- During rehearsals, any moiré problems (see C3) should have been spotted by costume or the DP, but if you see them, point them out.

While operating I'm thinking about not panning too far left or high and what my constraints are and I'm compensating for actor's movement, etc. I'm not concentrating on the light. Sometimes it feels very Zen and sometimes like a prison.
Paul Mackay

EYELINES

Which direction actors are looking in is primarily dictated by where the camera is placed. However, the detail of positioning eyelines and keeping eyelines consistent is largely the operator's responsibility.

The closer the actor's eyeline is to the lens, the more involved the viewer is. The further away from the matte box, the more detached the viewer is from the conversation (see C7). The script supervisor will write down if characters are looking camera left to camera right or vice versa, but won't note down how close to the lens they are looking. It is important for the operator to notice and make sure eyelines work consistently.

CROSSING THE LINE

Above and beyond basic line control, the operator and script supervisor take a lead when working in complicated situations. Practice shooting three-way dialogue, because it is the most frequently used situation that causes confusion about the line.

There is a magic triangle for eyelines: if you have 3 people in a scene, a swift way of covering dialogue is to shoot with the camera in between each actor, i.e. three camera positions, then you will get correct eyelines for everyone.
Lucy Bristow

SELECTING EQUIPMENT

There are a variety of camera supports available for both static and moving camerawork (see C2a and C4a). To decide what is best for you, think about the job you are doing, how much of the shoot will be hand-held, the weight of your camera, the position the camera needs to be in, i.e. whether it will be used at low, high or eye height, as well as the spaces you are working in, the set-up time and costs of your equipment. It is important to choose equipment that will allow you to operate comfortably and effectively without twisting your spine, bending your back or carrying weight out of alignment with your body.

Use a long eyepiece rather than bending over the camera or over time you will get a curvature of the spine.
Sean Bobbitt[5]

(top) Petra Korner. Photo courtesy of Samosa Stories, (bottom) Josh White. Photo by William Milman.

E: CAMERA OPERATING AND MOVING THE CAMERA

Martyn Culpan 1st AC checking the camera is balanced.

Geared head operating handles can be positioned to wherever is most suitable for a particular shot.

What Type of Camera Head for Which Type of Movement

Make sure the camera is balanced on the head because, if it isn't, it will respond differently each time you operate with it, so it will be hard to consistently frame shots and may be unsafe.

Ensure there is enough friction on a fluid head so that the movement is controllable and, likewise on a geared head, that the gearing is set so each turn of the handle makes the amount of camera movement required. The friction on a fluid head should be set so you have to push slightly to create a movement, rather than so loose that it moves very easily, as this makes it far more likely to jolt or stop suddenly.

Different camera heads are preferable for different kinds of movement.

Fluid heads, geared heads (see C4a) and Dutch heads (which allow a sideward tilt up to 90 degrees) have different advantages for different shots.

Geared heads are best for precision of starts, stops and speed changes and repeatability. They are also great for whip pans. They are more expensive than fluid heads and require an operator who is experienced with them, so are mainly used on larger films and when cranes are used. Because the operator is using two separate handles to control the pan and tilt movements, it takes practice to control a geared head to make it more precisely.

I borrowed a geared head from Movietech and put a small DV camera on it. I followed my (then) small child around the room and learned to instinctively use the handles. There's no other way to learn than to practice.
Lucy Bristow

Which Camera Supports for What Type of Movement

You can use anything to move the camera if it keeps the camera safe, moves the way you want it to and won't hurt anybody. Think about what type of movement will work best to tell your story, then what your options are for achieving it within the scope of your production. In low budget shoots, a lot of creative ingenuity is used in making moving shots possible. The principles and requirements of anything that moves the camera are:

- The broader and softer the contact with the ground, the less the bumps will show, so large, softish tires will show fewer bumps than thin, hard tires.

- The closer the camera is to the center of gravity of whatever is supporting it, the more stable it will be.

- If the camera is positioned off center or is cantilevered, it should be braced.

- The camera must be supported and/or strapped securely, and not fall, whatever movement is being used.

> Prior to the availability of drones, I have seen cameras suspended securely and safely from rope between trees to create a flying shot. I have also seen a light camera secured within a very strong bag so it could be carried and swung whilst filming.

10: CAMERA OPERATING

- You need to be able to start and stop smoothly, control the speed of travel and operate the pan and tilt as required during the movement.
- The more 'Heath Robinson' your contraption is, the more you may need to practice operating it, but *never* take risks with your or the camera's safety.

The direction of the camera movement takes the viewer on a physical journey, but the way the camera moves affects the viewers' perception of what they are seeing. Different pieces of equipment create different types of movement and suit particular shooting situations. All tools for camera movement take time to set up, may not be available at all times and do not override the need for a camera operator to be able to hand-hold the camera and move smoothly and effectively.

> *I like moving the camera, but it takes time. I think about whether the situation needs a move. Can I make the characters move instead and work with panning and tilting, or can I use a slider?*
> Paul Mackay

Rigs for Hand-Held and Smooth Movement

A range of rigs that allow the weight of the camera to be re-distributed, and keep the camera steady, have been developed. The market is rapidly changing. When selecting which rig is is best, consider the size, weight, cost and kind of movement produced by each option. (See C4a for set-up details of these.) Pay particular attention to whether you need the camera at eye height, higher or lower, and if you need to spin or tilt the camera.

Curved and padded shoulder plate to allow the rig to sit comfortably on the shoulder.

Shoulder rig: A shoulder rig is now considered to be standard for hand-held shots. With many shoulder rigs, the camera can be set to sit on the shoulder or forward of it.

Shots with a shoulder rig produce less camera movement than without it, and so are used any time other than when visible hand-held movement is wanted, but still tend to show both the movement of walking and adjustments made to the camera position. Smaller cameras are more sensitive to showing movement,

The rig should be balanced with weights (or spare batteries) so that it doesn't pull forwards, backwards or side to side. A well-set-up shoulder rig should be balanced so, without hands, it doesn't fall forwards or backwards. This allows you to remove one hand from the grips to focus pull, if needed during shot.

> *A hand-held camera can become very uncomfortable if it is very large or used for a long time. A workaround may be found but if possible . . . Strip any of the unnecessary equipment from the camera, in order to make it as light as possible, then make sure it's well balanced front to back, and ergonomically sitting on your shoulder as an extension of your body.*
> Lucy Bristow

Easyrig: The Easyrig (or equivalents) comes in sizes for small and large cameras. Easyrig have jacket designs for men and women. A rig allows you to hand-hold for very long periods, without feeling the weight of the camera on your shoulder, back and arms, as you do when just using a shoulder rig. It is easy to set up and you can pan and tilt the camera without restriction, as you would hand-held. It is designed primarily for static shots, because it transfers the weight from your back to your hips. This means

Here a bean bag is used to make the camera more comfortable for the operator, and a focus whip is being used for the follow focus to be operated slightly away from the camera without the need for a wireless remote. Photo courtesy of Laura Radford Photography.

E: CAMERA OPERATING AND MOVING THE CAMERA

that the natural movement of your hips is visible when you walk. The camera can be quickly detached from the rig when necessary, though.

The Easyrig can be positioned at a range of heights. You can position it up to the height of the top bar and down as far as you can reach. The Easyrig connection requires a top handle, so you may need to add one before you use it. The footage still looks hand-held, but you can work for longer, and be steadier, because you won't be as tired as when shooting hand-held.

> *The Easyrig was not designed as a cheap Steadicam. It was designed to take the weight of your back and put it on your hips in static hand-held shots. When you move it transmits the movement of your hips into your arms.*
> Sean Bobbitt

Steadicam: The Steadicam articulates an arm on springs, to stop the camera moving up and down as you walk. This creates a distinct floaty look that has become part of the visual language of cinema, so Steadicams should not be discounted purely because of the increased availability and technical steadiness of gimbals. There are small and large Steadicams and many alternative brands.

> The Black and Blue[6] show a good run-through of camera positions and uses of the Steadicam.

When using a Steadicam, you can pan and tilt the camera, but many models need the camera to be set to either a high or low height and can't be adjusted much while shooting. It takes practice to set up a Steadicam quickly (see C4a) and, likewise, takes practice to pan and tilt effectively during shot.

Gimbal: Gimbals create smooth movement without shake that is reminiscent of a track although less repeatable. They provide the opportunity to create sophisticated shots with relatively little equipment. Gimbals correct for pan, tilt and often for roll, but you can turn off e.g the correction for pan or tilt if you need it in a shot. Unfortunately, a 3-axis gimbal doesn't correct for the vertical movement (up and down) as you walk.

> *With a 3-axis gimbal, if you want to eliminate the up and down stride, you'll need to keep the gimbal parallel to the ground. Hold the camera out in front of you always and lock your arms. Then, when you walk, bend your knees slightly and take short steps.*
> Camcorder HQ[7]

2- or 3-axis gimbal rigs are held forward of the operator's body, so (especially for large cameras) can be heavy and awkward. For all but the very lightest cameras, a combination rig is advisable.

Combination Rigs: Combinations of an Easyrig or equivalent and a gimbal will make it far easier to hold for longer periods and the gimbal should compensate for the walking movement that would otherwise be visible when using an Easyrig.

Photos courtesy of Easyrig.

Matthew Lingerfelt, a Steadicam operator with CNN. Photo by Brad Fallen.

10: CAMERA OPERATING

A 2-axis gimbal corrects for pan and tilt. A 3-axis gimbal corrects for pan, tilt and roll. A 5-axis gimbal corrects for pan, tilt, roll, horizontal and vertical movement.

Combination rigs with a Steadicam-type mechanism and gimbals result in 4- or 5-axis stabilization that will keep the camera steady as it moves, and may also (as with the ARRI Trinity) allow for the camera to be swung from low mode to high. At the lower end of the market, Rotoreyes and Aerobotix have also combined the two technologies.

(left) ARRI Maxima gimbal with Rig. (right) ARRI Trinity. Photos courtesy of Arri (www.arri.com).

Sliders

Sliders are effectively small tracks put on top of tripods for smooth and repeatable camera moves. They are easy to use and quick to set up. Longer sliders – over approximately a metre (depending on the weight of the camera) should be supported by two tripods. Sliders are very flexible; you can, for example, put a slider on a dolly, so you can move forward and sideward at the same time.

A motorized slider incorporates a tiny programmable dolly that can be programmed for precise movement, so creates a simple version of motion control useful for animation or precise VFX shots.

E: CAMERA OPERATING AND MOVING THE CAMERA

Rolling Spider

A Rolling Spider is a wheeled spreader that can be placed on track or a smooth floor. Rolling spiders are often less useful than you would think they should be, because lightweight tripods with spreaders are often unstable and they only work well on a perfectly even floor. There are, however, as shown, versions of rolling spiders that allow you to place a tripod on a lightweight track which makes them far smoother.

Dolly and track

Dollies are strong, reliable, flexible and, importantly, allow repeatable movement. Dollies can be combined with jibs or with risers that create straight up and down movement, or with cranes. They can a take time to set up, but once set they can be adapted quickly.

Dollies are used to carry both the camera and the operator (and sometimes the AC), smoothly and safely, to allow the camera to be operated during a moving shot. Dolly substitutes may not be as well balanced or safe as a professional dolly and, as with all dollies, will be bumpy if the ground isn't smooth, and they don't have the option of being used on a track.

(top) A Wally Dolly, photo courtesy of Liquid Productions, allows a tripod to be used on tracks and is similar to a rolling spider (bottom) that can either be used to move in any direction on a flat surface or locked so the tripod stays static when required. Photo (top) courtesy of Liquid Productions.

A crane (which may be used alone or on a dolly) allows the camera or camera and operator to be raised or lowered during a shot and is far more precise and flexible than a drone. Photo by David Condrey.

(left) Dolly on track, photo courtesy of Chapman/Leonard, (middle) hoover dolly. Photo courtesy of Chapman/Leonard. (right) Dana dolly, which functions much like a slider. Photo by Adrian Pircalabu.

TECHNIQUES AND TOOLS FOR SHOOTING HAND-HELD

Photos courtesy of Liquid Productions.

All camera operators should be able to use a hand-held camera and achieve relatively steady shots. There are many reasons directors ask for a hand-held shot. It may be because of the flexibility and look of hand-held is wanted but sometimes it is when they would like a Steadicam but don't have one, or are pushed for time and need the scene covered quickly. If this is the case, it is important to re-conceive the scene as hand-held with all the flexibility that brings. Shooting hand-held allows freedom of movement by the actors or contributors and lets the camera operator move in response to them, developing and changing shots while filming.

> Improvised drama is different to shooting documentary 'on the fly'. Usually the scene is improvised in rehearsal and then the same or similar action and blocking is used in the take, so the operator can prepare and knows the optimal position for each key moment of the scene.

> *A lot of places aren't Steadicam friendly but you can get in almost everywhere hand-held. The last scene of the day is often hand-held, though, when you are right up against it time wise.*
> Sean Bobbitt

Irrespective of whether you are using a rig, Steadicam or a simple hand-held grip, you will need to move safely and accurately within the space you are filming. I am grateful, and indebted, to Sean Bobbitt for the following summary of his excellent 96-minute BSC ARRI workshop at Cameraimage (one of the pre-eminent festivals of cinematography) 2013[8] and our recent discussion.

> *This is the way I find best to operate. Other operators find their own way. Finding what is best for you comes from practice and experience.*
> Sean Bobbitt

Choosing the Optimal Focal Length

The wider the field of view, the less movement is visible, and the deeper the depth of field. A 16mm or 18mm lens is very forgiving in terms of stability and depth of field, which is good, but if you are working close to the actors, it will distort their faces. If I am working close in with actors, I use anything between 27 and 32mm to have the least wobble without distorting the features of the actor. The choice of focal length is restricted by the size of the set and what makes the framing throughout the movement work best.

> All focal lengths referred to apply to 35mm film or Super 35 digital sensors.

E: CAMERA OPERATING AND MOVING THE CAMERA

> If the focus puller's face drops with the focal length and stop you are using, you may want to think again.

The better you get, the longer lenses you can hand-hold, but at 50mm plus you can't hide the camera movement, especially if you are moving quickly. You also need to give the focus puller a chance: 50mm at 2 feet gives a depth of around 1/4 of an inch at an aperture of T2, so, with the best will in the world, you may be asking for the impossible. You can increase the light a bit to give them a better stop, but usually the best thing to do is choose a slightly wider lens, even a 40mm will make quite a bit of difference for depth of field.

How to Operate Smoothly and Steadily While Moving

> Take extra care when you are going backwards. Have a 'spotter' – someone to hold and guide you. Negotiate how strong you want the spotter's hold to be. Do you want to feel a consistent steady pull? Or just for them to tap you or move you if you are going off track or are about to bump into something?

To hold actors in frame when walking, walk in step with them; as they step forward, you step backwards. This conceals the camera move and the distance between you and the actor stays the same.

Keep the headroom consistent in your frame and the shot will look stable. Work on your foot movement and balance.

To avoid excessive strain on the ligaments and joints, don't put your or the camera's weight beyond your knee.

Warm up, look after your body, do stretches for your knees, hips and back. It is part of your job to not to pull a hamstring or do your back in, and stay fit for the job you are on and for your whole career.

Wear boots with ankle supports, particularly on uneven ground – don't operate in flip-flops.

Knee braces give added lateral stability, which is needed if you end up putting your body weight (and the added weight of the camera) out of the natural alignment of the body and can't keep the weight over the knee (which is where it should be).

Knee pads, and more commonly elbow pads, also offer protection when you bump into things, and knee pads make it easier to kneel for longer.

Fingerless gloves protect your knuckles and have gel inserts on the inside for your hands, so you can keep a solid grip without getting blisters. Use fingerless cycle gloves, not woolly ones.

A lumbar support helps protect your back, which is put under considerable strain the more twisted or bent it is. The further the weight of the camera is from the center of gravity, at the core of your body, the greater the strain.

Find your own way of moving; bend the knees and move smoothly. Think about the way you put your feet down. Brace yourself against something when possible (for additional steadiness or support), especially if you have to hold yourself steady for a long time.

I have always done yoga, which has been helpful in strengthening the arms and legs, and particularly the core and back muscles. It helps with balance, the ability to move smoothly and hold a position.
Lucy Bristow

Choose a camera that suits and is well balanced for you to hand-hold.
Sean Bobbitt

Take up any concentration sport that requires balance and stability, fluidity and controlled breathing. You can gain strength and knowledge of how to align your body from martial arts. You will use these skills when you move and when you raise or lower yourself.

Practice kneeling and standing smoothly, and then moving with the camera on your shoulder.

Have the camera fully set up beforehand and let someone else put the camera on your shoulder, so you aren't twisting your spine as you put it on.

Wait until everything is ready for a take before putting the camera on your shoulder.

Hold the camera tight to your face so your shoulder, face and hands, which will be forward holding the hand grips, make a stable triangle with three points of contact. Then use your two legs, and another point of contact, to create a second triangle of stability. Being in physical contact with a wall, door,

or anything you can lean against provides that additional third point of contact and support that makes you far more stable and balanced. If you have a long take, position something at the appropriate point to rest against, or arrange to have a box or tripod brought in for you to lean on or against.

> Create Two Triangles
> *If you only take one thing away from this, it should be to create two triangles. One with your head, camera and hands and the other with your two legs and something like a wall or a door, that gives you a third point of contact for stability.*
> Sean Bobbitt

Keep the weight of the camera over the center of your body, stand with your leading leg slightly in front of the other, shoulder width apart, and bend your knees slightly, for maximum stability.

(top left) DP Ian Mcgocklin, good straight back, operating position, (top right) creating a support triangle for maximum steadiness, (bottom) Ian Mcgocklin, grip Tommy Stalk spotting for Ian and holding the battery, Symon Mynk pulling focus and Unit Stills photographer Vera Rodriguez on the set of *This Too Shall Pass*.

The further away from the center of your body you hold the camera, the less stable it is and the more strain is forced onto the weakest point of your body, particularly if you are in a twisted or bent position. Any single, unwise, hand-held position can create or exacerbate muscular skeletal weaknesses. Likewise, regular or lengthy poor posture or positioning can bring on or worsen existing problems. Stronger muscles only reduce the strain for short periods of time.

Operating in a comfortable, sustainable position allows you to move the camera more smoothly and concentrate on your operating, rather than your body, so you are safer and your shots are likely to look better.

Learning to Move Safely Within a Space

When you have devised your shot, look at the furniture and props you will see in shot, and have anything you don't see (or need as a rest or a marker) removed if possible. Have all cables or other hazards cleared.

- Mentally map out the space; walk and count the paces between positions in the room when you are setting up shot.
- Count the paces between your starting points for each part of the move and the position of any potentially harmful objects or furniture, so you know how many paces you can safely walk.
- Touch the potential hazards to create physical memories, so your body knows where they are.
- Work out how many steps grace you have, i.e. if you should be moving five paces to do your move, how many extra you can move before you hit a hazard.
- Practice your moves and walking in the space until you know it.

E: CAMERA OPERATING AND MOVING THE CAMERA

> Having a pre-arranged spotting system is vital when shooting documentary where you are not being directed so much and creating shots on the fly.

- Have a system worked out with your spotter so they either hold or guide you, or just tap you to say when to stop or if you are getting near a hazard. Make sure your spotter knows when you will be turning, particularly if it will be fast, so they can clear frame.

- Practice moving while having one eye open and one to camera so you can see where you are going. You need to be able to register where you are, and where you need to be going, whilst still scanning the frame for action and composition. Likewise, if you are using a monitor, you need to be able to be aware of the wider environment, whilst also watching the monitor.

- When rehearsing the scene, concentrate on where your feet are. Lift them up when you move, especially when walking backwards, to avoid tripping, but plant them carefully so you don't jolt as you put them down.

If moving backwards (when people are walking towards you), always have a spotter to watch and make sure you stay safe, avoid obstructions and move in the right direction. Photo courtesy of Easyrig.

- When walking sideward or in a circle, cross over one foot behind the other; this takes practice.

- Doorways are difficult. Don't have your elbows sticking out, and 'commit' to your movement to go through them.

Working with Actors

Establish a rapport with whoever you are filming. Walk up to them when you are first on set and establish a connection by chatting about something you have in common – this can be as simple as that you are both looking forward to a nice cup of tea. Connecting with the artists stops you being seen as a threat, and when people feel they know you they don't need to be on alert when you are around. Then break off contact with them and get on with your job. Avoid direct eye contact when you are filming; let it be about the camera and them, not about you. Start far away, then work your way towards them.

> In documentary it is a different dynamic; it is more about making yourself invisible.
>
> Meet the contributors as early as possible, before filming begins. Have a casual conversation, find common ground to show they you are a normal person. Show that you are concerned and that you will look after them. Make a fuss. Let them know that what you are doing is in their, and the film's, best interest.

When shooting documentary or when working with untrained actors, avoid sudden movements. Think of it as if you are working around a wild animal, and stop if people start to bristle. Turn away to shoot something else, then slowly come back to them. When there is a break, re-introduce yourself and have a chat. This will establish that when you are working you are professional but you are still a nice person. This way, they will trust you, and you will 'disappear' for them.

- Know and understand the story, so you can be involved in the performance and feel when to stop and let the actor move or when to stay or follow them.

- Always read the script and watch rehearsal to be sure you know what is going to happen.

- Anticipate movements and have your weight balanced, and your body in a position so you can move smoothly.

- Know when the first step is coming. A good actor will give a little tell in their body language that they are about to move, or you should learn which line is the actor's audio cue for their move. Knowing when people will stand up is also very important. An experienced actor will move to front of chair and then come up, or adjust their speed of getting up to suit the camera.

- Think about how to position your body when you are choreographing and rehearsing your shots, and what points you can settle in, with your body in a good position for the next part of the move.

> Choose which shots to hand-hold. Not every shot in a hand-held scene is necessarily shot hand-held. It can be tricky to do a hand-held cut-away over someone's shoulder of a detail of a letter, for example, so these cut-aways can be done on a loose head (a camera head with very little friction wound in).

> Also, plan with your spotter where they will be, and if any different holds or guides will be needed at different stages of the shot.

- Take a couple of deep breaths and slowly exhale before the shot; you are oxygenating your muscles, so from that point on you can take shallow breaths. After a few minutes, you will suffer from oxygen depletion, so breathe as you need but time your breaths in relation to the shot, and hide your breathing during movement.

- Walk in step with the actors and keep the same amount of room above the head, to make it look like the movement is smooth and steady. If the person is tall, extend your step. If that isn't possible, the shot may be better on a Steadicam or dolly.

- Keep horizons level but not in middle of frame. Think about the background in relation to subject, and move your angle if you need to, so you don't see objects growing out of an actor's head.

When shooting hand-held scenes that aren't choreographed, Blain Brown has an excellent method of covering the scene.

> - *On the first take, follow the dialogue. Do your best to stay with the actor who is speaking. This is the dialogue pass.*
>
> - *On the next take, pan back and forth to stay with the person who is not talking. This will give you lots of good reaction shots, which are important. It will also give the editor lots of things to cut away to. This is the reaction pass.*
>
> - *For the third take (if you do one) improvise: follow the dialogue sometimes, go to the nonspeaking actor sometimes, occasionally back up to get a wide shot; whatever seems appropriate. This is the freeform pass.*
>
> *All these together will give you a scene you can cut together smoothly and give the editor lots of flexibility to cut the scene.*
>
> Blain Brown[9]

Practice using Sean Bobbitt's techniques of moving (see page 247) and Blain Brown's suggestions for covering an improvised scene (above).

KEY POINTS FOR SELF-ASSESSMENT

When looking back at your work, assess:

- If the movement and any frame energy helps tell the story more successfully than if it was static.
- Is headroom and positioning consistent throughout, unless altered for specific creative reasons?
- Are the eyelines consistent, unless altered for specific creative reasons?
- Do you move seamlessly with the action and do your shots start and stop smoothly?
- Are there any noticeable zooms, focus pulls or adjustments made that aren't concealed by movement?
- Are there any distracting bumps or jolts?
- Is there anything in shot that shouldn't be?

NOTES

1. Paul Mackay (DP) in discussion with the author (September 2016)
2. Morgan, Jay P. "Camera Movement Tutorial: How to Create Emotion". *The Slanted Lens*, May 9, 2013. https://www.youtube.com/watch?v=_P3oxjnFr0c
3. Lucy Bristow ACO (camera operator) in discussion with the author (September 2016)
4. Roberto Schaefer ASC AIC (DP) in discussion with the author (September 2016)
5. Sean Bobbitt BSC (DP) in discussion with the author (September 2017)
6. Luzi, Evan. "A Beginner's Guide to Basic Steadicam Positions". *The Black and Blue*, 2017. https://www.youtube.com/watch?v=iDMRB5cCrzY
7. Camcorder HQ. "What is a Gimbal? How to Stabilize Video Using the Latest Video Accessory". November 30, 2017. http://www.camcorder-hq.com/articles/what-is-a-gimbal
8. ARRIChannel. "ARRI WORKSHOP – Sean Bobbitt, BSC – CAMERIMAGE 2013". *YouTube*, December 12, 2013. https://www.youtube.com/watch?v=IHcYjKpJb-I
9. Brown, Blain. *Cinematography: Theory and Practice: Image Making for Cinematographers and Directors*. Massachusetts, USA: Elsevier, 2012.

SECTION F
Light and Lighting

11a
Lighting: The Fundamentals of Lighting, Light Metering and Exposure

Learning the fundamentals of how light behaves will allow you to anticipate how it will look in different circumstances. This chapter looks at hard and soft light, and how it can be used to shape and model a subject. It also looks at how light is absorbed or reflected by different surfaces, skin textures and the environment. The chapter then goes on to look at how light can be monitored and measured so that the optimal exposure for the look of the shot you want can be selected. Several approaches to exposure are looked at, and the importance of exposing consistently is highlighted. The chapter finishes by looking at if, when and why to make adjustments to your ISO, or when to adjust the aperture during a shot.

> **LEARNING OUTCOMES**
>
> *This chapter will help you:*
>
> 1. Understand what Key light is and recognize the difference between soft and hard key light
> 2. Understand what fill light is and assess how the environment will affect the level of fill
> 3. Measure key light and fill light, calculate lighting ratios and use fill light to adjust lighting ratios
> 4. See the effect of different qualities of light even when there is no contrast ratio and the light is 'flat'
> 5. Understand IRE levels and use them to help you decide how to expose your image
> 6. Use False Color and Waveform Monitors to monitor light levels
> 7. Read light meters to assess lighting ratios and set exposures
> 8. Evaluate how and why to adjust your exposure when shooting in Log, LUT or RAW
> 9. Assess light levels in different shots so you can keep exposures consistent (if appropriate) throughout a scene
> 10. Understand the implications of HDR on exposure and dynamic range
> 11. Know three different approaches for choosing optimal exposure

F: LIGHT AND LIGHTING

KEY LIGHT

Key light can be any kind of light, from any kind of light source. What makes it a key light is that it is the main light on your subject. A key light can be hard or soft.

Hard Key Light

The sun outside on a clear cloudless day creates hard light and so does a bare bulb in a room. Hard light produces a distinct and quick transition or 'fall-off' between the bright and shaded side of who or what is being filmed. Hard light is created by a relatively small-size source of light (small relative to the space it is in). The sun might not seem like a small source, but it takes up a small proportion of the sky.

Soft Key Light

Soft light produces a gentler transition between the lit and unlit side of who or what is being filmed. On a hazy day, when the sun hits light/hazy clouds (through which it can still penetrate), the clouds become the source and, being far bigger than the size of the sun, the light is softer. Likewise, when the bare bulb is put inside a Chinese lantern, the light source becomes bigger. The larger and more diffused the light source, the softer the light.

A hard light source (from the right-hand side) creates a fast transition from light to shade and a hard-edged shadow.

A soft light source (from the right-hand side) creates a slow transition from light to shade and a soft-edged shadow.

(left) A hard key light is used in this shot from *Blood Simple* DP Barry Sonnenfeld, (right) a soft light is used in this shot from *Albert Nobbs* DP Michael McDonough.

(top) The egg is lit with a hard light from a 3/4 back position, (bottom) a white cloth is placed opposite the light to reflect/bounce light back. This results in a far lower contrast ratio between the bright and dark side of the egg.

Choosing whether to light a person with hard or soft light has a considerable dramatic effect, and is one of the first things considered when choosing your key (main) light.

EXERCISE: Experiment with creating hard and soft key light, as in these examples, with an egg. Then bring in a white card to use as a reflector to bounce the light back from it. Take a shot with the reflector very close, then move it back so it reflects less of the light.

Next (as shown below) change the color of the environment by hanging either dark or light cloths around the area you are shooting, and repeat the shots.

Then (gently) rub in some moisturizing cream or oil on your eggs and repeat the shots.

You will see that environments make a huge difference to the ambient fill level, which is the amount of light bounced back without additional reflectors. You will also see that the closer the reflector, the stronger the fill light. Additionally, you should

11A: LIGHTING: THE FUNDAMENTALS OF LIGHTING

be able to see, particularly if you are able to work with a range of different-colored eggs, that different tones, textures and surface qualities greatly affect how much light is reflected or absorbed. These effects apply in very much the same way to skin tones. The amount of light reflected from skin can be increased by using moisturizer and decreased by using powder (this is one of the bases of how the camera and makeup departments work together).

Setting up simple lighting scenarios is invaluable for learning, because, whether you are using a simple torch and tracing paper to soften the light or film lamps and extensive grip equipment, the principles of the effect of hard or soft light, lamp position, height, tone and texture remain the same.

FILL LIGHT AND LIGHTING RATIOS

In practice, if the balance of light between the lit side and the unlit side, created by the environment you are in, is not how you like it (which it usually isn't), you can bounce the key light back or use another lamp to create fill light. If this isn't possible, or you need a quick way to increase or decrease the fill light, you can move your subject closer to a wall that will bounce light back or, if necessary, move to a different environment.

The difference in the brightness of the key light and the fill light is measured in aperture 'stops', but expressed as a ratio of the amount of light on each side (because stops are a logarithmic scale, the ratio doubles for each 1-stop increase). Measuring the light and using lighting ratios is a useful way to keep the balance between the lighting on the key side and fill side consistent between shots (see C3 for an introduction to apertures).

Irrespective of how dark or light a shot is, the lighting ratio will affect the look and mood. Lighting ratios have a psychological effect on how the viewer reads a scene, so some genres, such as comedy, tend to use higher lighting ratios, and others, such as drama, tend to have lower ones. These are not rules, but conventions to consider when starting to think about how to light a film.

(top) In this shot, the cream walls of the room reflect light, which creates fill and lowers the contrast between the lit and unlit side of the egg, (bottom) black screens placed around the egg prevent light being reflected, so the contrast is higher. This effect has been increased by choosing a darker egg for this shot.

(left) This shot, from *What Happens In Vegas* DP Matthew F. Leonetti, has a low lighting ratio between the brighter and darker side of the face (a little less than 2:1), (right) In this frame from *Their Finest*, DP Sebastian Blenkov uses a higher lighting ratio (approximately 8:1).

Ratio	Number of stops' difference between key and fill	Key	Fill
1:1	0	8	8
2.1	1	8	5.6
3:1	1.5	8	4.8
4:1	2	8	4
8:1	3	8	2.8
16:1	4	8	2
32:1	5	8	1.4

If both sides of the face measure f8 the ratio is 1:1

If the key light is f8 and the fill is f2.8, the ratio is 8:1.

F: LIGHT AND LIGHTING

In these shots from *Mad Max: Fury Road* DP John Seale, there is a higher contrast ratio between the dark and light side of the face in the wider (top) frame than in the closer (bottom) frame.

(top) The 'flattest' and least interesting lighting of these three shots. (middle) Evenly lit using a soft light from a high angle from the direction of the camera creates light and shade within the frame. (bottom) Soft even lighting counterbalanced by a top light works beautifully in this shot in *The Shining* DP John Alcott.

Irrespective of the genre there is a tendency (but not a rule) for closer shots to have a slightly lower lighting ratio than wide shots, particularly in dialogue shots.

In the same way that lighting ratios are used for consistency between the key and fill light, lighting ratios are often also used to keep consistency between the key light and the background environment. This doesn't mean the background has to be evenly lit, but that you can measure key areas within the background and keep them consistent.

FLAT LIGHT

In the examples above, either soft or hard light is positioned from the side so it creates a brighter and darker side to the egg – it is just the speed of the transition that changes depending on whether it is hard or soft, fast for hard light, and slow for soft.

Flat light is when the light levels are even on both sides and occurs either when light is coming evenly from all directions, such as on a very cloudy day or when lights have been used to light both sides of the face evenly. Light is also even and flat when it comes from exactly the same direction as the camera. When discussed, flat light is often considered to be unaesthetic but, like all types of lighting, it depends on how it is used and modified. On a misty early morning the light may be flat but glowing. Alternatively, if it is lighting the subject evenly but positioned so that it falls only on part of the background to create light and shade within the frame, this can also add interest and draw the viewers' attention to the subject.

The effect a light has on a subject and the rest of the environment depends on the position of the key/main light in relation to the subject, how strong the light is compared to the background, whether it is hard or soft and if anything is blocking part of it. Chapters 12 and 13 explore shaping and controling light and how this is done on sets and location to create shape and texture on the subject and to balance light within the environment, as appropriate for the story.

MONITORING AND MEASURING LIGHT

(top) False color shot of Martyn Culpan against a dark background, (bottom) false color and waveform monitoring of a shot of open doors between a light walled camera prep room and the adjoining prep room. The waveform is higher for the adjoining room because that room was brighter.

256

11A: LIGHTING: THE FUNDAMENTALS OF LIGHTING

There are many tools for measuring light, and many techniques for exposing. You don't need to use all of them. Learning about what each does allows you to find the tools and techniques you find most useful. Most cinematographers find the tools and techniques that work for them in most situations, but use alternatives when the situation requires it.

As discussed in C3, the camera monitor shouldn't be relied on for assessing exposure. False color and waveform monitors can be used, though, because they reliably show IRE levels, which are not dependent on monitor technology and calibration.

IRE

The IRE (Institute of Radio Engineers) level is effectively a percentage of the total voltage of the video signal.

Irrespective of whether you are working with a camera that has 8 stops of dynamic range or one that has a 14 stops' range, it will record a video signal that can go from 0 to 100% IRE. If the camera has 8 stops' range it will take 8 stops to get between 0 and 100; or, if 14, it will take 14 stops between where the camera records nothing but noise in the shadows at 0 IRE and clips highlights at 100 IRE. For this reason, changing a stop on a camera doesn't equate to a specific increase or reduction in IRE level. What is most useful about any scope or monitor that shows IRE is that you are seeing an accurate level of the strength of the signal being recorded. Try opening and closing stops on a camera and watching the IRE level go up and down, and seeing how many stops it takes to move the IRE level from its lowest level to its highest.

Viewing IRE levels is useful for:

- Determining which parts of the image are too bright or dark.

- Seeing how much the luma level has changed when you change the lighting, aperture, ISO or shutter angle, etc.

- Maintaining the same subject at the same brightness in different shots or scenes. This can be done if you place them at the same IRE level. Remember that to maintain exactly the same grain and dynamic range, you would also need to keep the ISO the same.

The optimal point to set the exposure varies, depending on the scene you are exposing and whether you are shooting Log, LUT or RAW (see overleaf).

> This does not mean that cameras can record the same range of brightness levels: a camera with a dynamic range of 14 stops will record further into both the bright and the dark areas than a camera with 8 stops' dynamic range.

> You should not be recording your blacks at 0%, or there will be too much noise, or your whites at above 95%, as they will show no detail and will start to clip. Also remember that less detail is recorded in the image at either end of the dynamic range.

(top) False color shown on shots of camera charts. The areas with exposures of 58 IRE are gray, while those with 85 IRE are shown as yellow, and areas over 100 are shown as red. The waveform in the bottom right of the frame corresponds to the false colors showing the brightest parts of the frame reaching the top of the waveform.

(bottom) The exposure has been lowered so the shot is darker, making the false colors for the lower end of the IRE range appear. Likewise, these correspond with the positions of the waveform monitor (false color and waveform monitors can be used together or separately).

F: LIGHT AND LIGHTING

False Color

False color is one way to display IRE levels. False color monitoring allows you to see your image on a monitor, but shows the brightness of each part of it as a different color. False color is very easy to use. Most monitors and EVFs can show false color. To expose using false color:

- Make sure you are framing the image you will be shooting. Have the actors or stand-ins in place and watch the shot through, to see how things change as the camera and actors move.

- Check and, ideally, ensure that the most important parts of your image are between 15 and 85%, that none of your image is near 0%, and that none or only a few spectral highlights are at 100%. These numbers will vary if you are shooting in Log.

False color metering is always useful, but it is particularly beneficial when:

- Using strong contrasts, so you can check how high a lighting ratio you can use without over- or under-exposing parts of your image.

- You want to check how much brighter your subject or subjects are than the background, so they will stand out from it.

- When shooting green-screen, to check the whole screen is at the same level.

- When shooting low key scenes, e.g. in moonlight or candlelight, when you may need the whole scene dark but don't want to expose so low that you will end up with noise or lack of detail in the image.

N.B. For most (but not all) cameras, false color is translating what is being sent to the monitor into false color. So, if you are recording in RAW and sending a Rec.709 image to the monitor (you can't send a RAW image because it isn't possible to view RAW), what is being translated into false color has fewer stops' dynamic range than what you are recording in RAW. If you are shooting Log, you can view the Log in Rec.709 to expose to and then switch back to Log, to monitor other aspects of your shot.

Whether technically ideal or not, many DPs view false color on the monitor when recording in RAW and use that to guide their exposure on the bases that: if it looks OK in Rec.709, and the dark areas you want to see detail in aren't below 15%, any skin tones you want to appear correctly exposed are between 35 and 75% for daylight scenes (depending on the complexion) and your highlights aren't above 95%, you will be fine in RAW, because you will be recording a greater dynamic range than you see on the false color monitor.

Again, whether technically ideal or not, many DPs light to Rec.709, decide where to put their exposure on the IRE level and then let it drop down, as it will when they switch to Log. They find that putting it into Log brings the exposure down as it should do.

Beware of using this technique if shooting HDR, because you will not know what is visible in the shadows and highlights, and may see things you don't want to see. If shooting HDR, you should always monitor in HDR.

Also, beware that if you subsequently decide not to shoot RAW, but to burn in a LUT that is designed to adjust the contrast or light levels to create a particular look, you can end up with parts of the image either clipped or too dark. If burning in a LUT, make sure you monitor with the LUT or ideally that you can switch between Rec.709 and the LUT.

> **For daylight scenes, the starting point guidelines for the brighter side of the face are 35–50% for darker complexions, 50–60% for mid-range and 65–75% for lighter skin tones. These really are just starting points. In a high key shot of a model, you may shoot a very light skin tone close to 90 IRE or, for the same light skin tone in a low key candlelight shot, you may place them at 50% or less.**

> **Camera manufacturers advise on the optimum IRE levels when using Log. Check the figures for the camera you are using, but the figures are often around 42% for an 18% gray card and 61% for a 90% white card. These are the levels that will give you the largest possible dynamic range. They are not definitive instructions about where to expose, unless maximum dynamic range is your key criterion.**

11A: LIGHTING: THE FUNDAMENTALS OF LIGHTING

- Be aware that false color is user adjustable, so check if the colors have been adjusted on the monitor you are using.

FALSE COLOUR KEY

| WHITE | BLUE | LIGHT BLUE | DARK GREY | BRIGHT PURPLE | MEDIUM GREY | GREEN | LIGHT GREY | DARK YELLOW | YELLOW | ORANGE | RED |

0 2 10 20 42 48 52 58 78 84 94 100 108

IRE LEVEL

Waveform Monitor

The IRE levels can also be shown as a waveform using a waveform monitor. The waveform can be laid over the image, so you can see exactly where the IRE levels are by seeing if the waves are at appropriate heights on the image. A waveform can also be used as an insert at the corner of the screen, as above.

It shows similar information to the false color monitor, but because you don't have to know which color signifies which level, some people find them easier to use.

- If you want to expose the skin tones of your main actor at, say, 60%, you can either zoom in a little or just look at the part of the frame they are in. You can then adjust your iris until the waveform is at 60% IRE.

- Waveforms can also be shown for individual colors, which is useful when you want to maintain a particular color at a particular brightness across the screen, e.g. when doing green-screen work.

If there is no button on the outside of the camera to switch to False Color or Waveform, go into the menu system and assign a button to do this prior to the shoot.

Vectorscope

A vectorscope shows the hue and saturation (intensity) of the colors. A vectorscope is the color equivalent of a histogram (see C3) and is very useful for precisely matching colors between shots. Vectorscopes are an important tool both on set and in color grading. If the colors show at the same point on the vectorscope in two shots, they will be the same. Monitors are not good for judging colors, because they usually can't display all the colors you are recording and are affected by viewing conditions and calibration.

- The position of the point on the vectorscope tells you the color, and the further away from the center it is tells you how saturated the color is.

- The outer ring of the vectorscope shows colors at 100% saturation, while the inner points show 75% saturation, which is considered the broadcast limit.

There are techniques for white and black balancing with a vectorscope.[1]

(top) Natural light being used to shoot a scene in *Under Jesus*, (bottom) the waveform is laid over the image, allowing DP Tomas Tomasson to see exactly what IRE level are in each area of the frame.

F: LIGHT AND LIGHTING

LIGHT METERING AND MEASUREMENT

Monitors are great for seeing the results of your lighting, but meters are more useful while you are in the process of lighting, because a meter allows you to measure the effect of each lamp as you set it.

Most cinematographers set either the key light or any light that needs to be at a specific level first, then the other lamps are balanced to it and adjusted as needed. Meters allow you to measure the effect of each lamp and also to communicate precisely with your gaffer, e.g. 'bring the wall down a stop' or 'bring the fill up half a stop'.

Using a meter also allows you to track the numbers and measurements for your shots. If you keep a note of the meter readings you have used, you can re-create matching lighting set-ups on different days, or at different locations if necessary. You will also be able to look at the finished film and assess how well the light levels you used worked out.

When using a meter, you are:

- Not dependent on either the monitor or looking through the camera to measure the light.
- Able to measure lighting ratios by measuring each light separately.
- Aware of exactly how much you need to bring the level of light up or down from a particular lamp.

(top left) The Gambian flag's three colors are primary red, green and blue and show on the primary color points on the vectorscope (top right). The green of the gender queer flag (bottom left) is not primary green, it is a secondary color so shows a little distance away from the primary green point on the vectorscope. The purple color used in this flag is exactly opposite the green in the color spectrum, so is shown opposite on the vectorscope. The gender queer flag colors are less saturated than the Gambian flag ones, so don't show as far out on the vectorscope.

You can see the differences in illumination with a waveform or false color monitor, but the best way to see the specific difference in the light falling on one side of the face or another, especially when lamps are being set up, is to use a meter.
Steven Poster ASC ICG[2]

Sun:
1,650,000,000fc (foot candles)

Incandescent lamp:
70,000,000fc

Fluorescent lamp:
between 5fc and 15,000,000fc

Road surface under artificial lighting:
0.5–2fc

Light Measurements

A light meter can be used to measure light falling on a subject or light being reflected from it. Some current light meters or light meter apps can store your information and calculate filters or stops required in specific situations. There are some that also allow you to save certain calculations and settings as pre-sets. A lot can be achieved by monitoring light in false color or waveform, but a light meter helps you when lighting and when scouting locations, so even a basic one is a very worthwhile investment.

Light meters are most frequently used to measure stops (see opposite) but can also be used to measure:

Foot candles: Foot candles (fc) are used to measure illuminance, which is the light being emitted – for example, by the sun or a lamp. A foot candle is the light from a standard candle at a distance of one foot.

Summer at noon:
100000 lux

Heavily overcast sky:
5000 lux

Office with artificial light: 500 lux

Moonlit night: 25 lux

Lux: How much light falling on a unit area is measured in lumen per meter square or lux.

A foot candle equals 10.08 lux.

Foot candles are used more frequently than lux, but either measurement is useful for gaffers, so they know how much light a lamp is producing at a certain distance. Different bulbs and light sources produce greatly different amounts of light per watt, so having a measurement of the light, irrespective of the lamps' wattage or the camera settings that make up the stop a meter reads, is helpful in deciding if a bigger, smaller or different type of lamp should be used to raise or lower the level of light.

Kelvin: Color temperature meters measure Kelvin (see C3).

11A: LIGHTING: THE FUNDAMENTALS OF LIGHTING

Cinematographers or gaffers use color meters to measure the color temperature of light from lamps during testing, to check they are as they should be. Color temperature meters are also used in color-critical situations for VFX scenes. Some color meters have different options for digital and film metering, because not all modern lamps (particularly some domestic fluorescents and LEDs) produce the full color spectrum of light.

The iPhone can be fitted with a Luxiball adaptor to measure color, although this has to be calibrated with another color meter first (see C3).

Stops

In cinematography the term stop is used in several ways. For:

- Opening or closing the aperture to let double or half the amount of light, e.g. in 'open up a stop'.

- Increasing or decreasing the amount of light falling on something by double or half, e.g. 'lose a stop on the wall, please'.

- The aperture you set your lens at to expose your shot at the brightness you want, e.g. 'I am shooting at a stop of 5.6'. The stop is usually set on the lens but sometimes it can also be adjusted via the camera menu.

- Stops are also the standard measurement used by cinematographers when using a light meter. The stop your light meter shows you is what aperture to set to get an 18% gray/50% IRE exposure level at the shutter speed and ISO you have set in the meter.

Exposure Values

Exposure values are useful when using meters if you want to maintain the same exposure, but change the shutter speed or ISO for creative reasons.

- Calculate your stop after having set the shutter speed and ISO, then switch to EV to read the EV value. Make any changes to aperture ISO and shutter speed and check the EV hasn't changed.

Measurements are not the only way to communicate with your crew, though. Particularly if you have an experienced gaffer, you can also talk in terms of lifting or dropping certain areas of the set or changing the mood (see C13).
Dana Kupper[3]

Setting a Meter

To set any light meter (other than color temperature meters):

- Set the ISO.

- Set shutter speed, which may be called T (for time) on your meter, remembering the shutter speed is half the frame rate. If shooting 29.97 or 30fps, use 1/60th, and if using 23.97 or 24fps, use 1/48 if your meter has it; if not, 1/50 is close enough.

- Remember to adjust the shutter speed if you use any other shutter angle than 180 degrees. If you use 90 degrees (half the shutter speed), change from, e.g., 1/50 to 1/100.

- If you use 359 degrees, double the shutter speed so you are using the same shutter speed as your frame rate – change from, e.g., 1/50 to 1/25.

Shutter speed on a meter is often called 'time'. On many meters the reading can't be taken unless the shutter speed/time is displayed.

F: LIGHT AND LIGHTING

Incident Meters

An incident meter measures light falling on it, so you have to put it in the position of what you are measuring, e.g. in the same position a face would be.

Incident meters are usually used with a semicircular dome. The The dome reads the light falling on it from all sides, in a similar way a face does. You can swap the dome for a flat disk to better read the light falling on a flat surface.

- Put the dome in the position of who or what you are shooting, and position the dome so it is facing the camera.

- If you want to measure the light from one side only, shade off the light from the other side with your hand. This allows you to compare how much light is reaching your subject from your key light, and how much from your fill light or how much is falling from them both.

- Incident meters tell you what exposure to set the camera at to make an 18% gray card correctly exposed at 50% on the IRE scale. It is not telling you this is the exposure to use, just where 18% gray is. You may well not be shooting something that is 18% gray. If you want what you are shooting to look brighter than 18% gray, you have to open up your stop to make it brighter and the IRE higher. If you want it to look darker, you have to close your stop down to make it darker.

When using an incident meter, measure the light in the areas of the set you are interested in and then walk around the set with the meter to see how the light level changes, and if the changes throughout the set are within an acceptable range before making your decision about what stop to expose at.

(top) Light falling on the dome of the light meter, (bottom) to read the level of light falling from one light, block off the light coming from other lights with your hand.

If you don't have a gray card, test the position of either your hand or a particular object compared to a gray card on a waveform monitor when you have the opportunity. You can then use that same object, wherever you are on any shoot, as a reference point instead of a gray card.

This high key shot by Wouter de Jong would need an exposure brighter than 18% gray/50% IRE. Whatever the incident meter tells you, you would need to open up the aperture to make it brighter. How much you would have to open it up depends on the look you want and the dynamic range of your camera.

Spot Meters

- To use a spot meter, point the meter to a specific part of a subject *from the position of the camera*. Make sure the circle you see in the viewfinder is only over the area you want to read, and press the button.

Spot metering allows you to measure the light being reflected back from any point on the set. Different surfaces and colors absorb or reflect back different percentages of the light falling on them, so when you measure them with a spot meter you are reading the actual brightness you will be recording. If you know the dynamic range of your camera, in the recording format and ISO you will be using, you will know how many stops different the levels can be.

I find it very simple to select an exposure based on spot meter readings. Once the lights are set, I use my spot meter to measure the part of the shot I think should be exposed as 18% gray (on a light skin this is often just at the point the key light starts to fall off into the fill or shadow area, whereas on a mid tone skin it is usually in the key light but not in the highlights on the skin),

then compare that with the other points of interest in the frame. If I know the dynamic range and like how bright I find that each part of the shot will be compared to where I will be exposing, that's great. If not, I increase or reduce the light falling on a particular object or move the position of the object until it is at the desired light level.

It is important to bear in mind that spot meters read reflected light, and on shiny surfaces this can change considerably if the subject or camera moves.

The advantages of spot metering are that you can:

- Measure key points of the image and map/match them to the dynamic range of your camera at the ISO you are using.

- Check that the brightness of, for example, a face is the same from shot to shot or scene to scene or if re-shooting at a later date.

- Measure, match and maintain foreground and background brightness.

- Know exactly how much any specific hot spot or shadow needs to be adjusted.

- Take measurements of hot spots such as windows, and light sources, when location scouting.

No Film School have a very good tutorial on how to read a light meter.[4]
Koo Ryan

Spot meter.

Some incident meters have an attachment that converts it from an incident meter to a spot meter, but many of these don't have a one-degree spot needed to measure small areas in your frame. It would be inadvisable to rely solely on a spot meter if it doesn't have a one-degree spot, because you may not be able to measure the precise points you need (which defeats the point of taking spot readings).

This spot metering technique could be considered a practical application of Ansel Adams' zone systems, which plots areas of the shot into ten brightness levels to allow you to see how far apart each area is and ensures that each part remains within the dynamic range.

EXPOSURE

High Dynamic Range and Standard Dynamic Range

The dynamic range of a camera is the range in which it can capture the lightest and darkest areas of an image without losing detail.

How much of that detail is shown depends on how much has been captured and what type of screen it is shown on. You may capture 14 stops of dynamic range but, e.g., only 8 may be shown on a TV screen. The 14 stops you record are compressed to be shown on the screen, but in practice not everything at the top and bottom end is visible, whereas on an HDR screen it is all visible.

When shooting in standard dynamic range you need to be aware of how much detail will be shown in the highlights and the shadows of your shot, to ensure you see enough detail. When shooting in high dynamic range you need to be aware of how much detail will show in the highlights and shadows, to make sure you don't show too much detail and see things you don't want to.

With HDR you see further into the darker areas, so not only will more detail be shown but noise will be more visible too. It is therefore advisable to avoid raising the ISO when shooting in HDR.

(left) A one-degree spot (available in most dedicated spot meters) allows precise reading of small areas of the frame. A three- or five-degree circle (provided in some meters that double up as incident and spot meters) isn't small enough to read a particular point.

F: LIGHT AND LIGHTING

Standard dynamic range screens condense the dynamic range recorded by the camera, High dynamic range screens expand it (the dotted area indicates the additional dynamic range on HDTVs).

HD Screens approx 19 stops dynamic range.

HDR screens - information expanded. Additional detail seen through dynamic range

HDR screens must be brighter to show detail in all areas

Camera with 14 stops dynamic range.

Standard dynamic range screens, approx 8 stops dynamic range. Slightly higher for HDTV.

Brightness information condensed on standard dynamic range screens

In HDR you will see further into the highlights, so if there are details that will be visible, e.g. areas outside a window that in SDR would not be visible, you will need to either blur them or adjust your exposure so they are even brighter, so they stay outside the dynamic range of the camera.

HDR display doesn't just affect the top and bottom of the dynamic range, they will also allow more detail to be shown in the mid-ranges, allowing additional detail to be seen in skin textures, hair, costume and throughout the set. This means that you must work more closely with hair, makeup, costume and design, so that the amount of displayed works for your shot rather than against it.

Camera manufacturers produce guidance for HDR shooting with their sensors, but other than the extended range the same principles apply to exposing for either standard or high dynamic range.

> Because of the need to avoid raising the ISO when shooting in HDR, you may need more lights than you would when shooting SDR.

Understanding and Using the Sensitometric/Response Curve

Whilst an HDR screen will allow more detail to be seen in the shadow and highlight areas of an image, it can only show what has been recorded. The limits of what a camera can record depend on its dynamic range, but the amount of detail recorded near both the bottom and top of the dynamic range is less than in the center, and to compound this our eyes are more sensitive to details in the mid-ranges.[5] To assess how much detail can be seen at how many stops above or below exposure, you should test (see C4b) and/or look at the response curve. The response curve is sometimes called a sensitometric curve which was a film term used for measuring the responsiveness of film to light.

As shown in Chapter 3, ISO also affects dynamic range. Raising the ISO reduces the dynamic range that can be recorded.

264

11A: LIGHTING: THE FUNDAMENTALS OF LIGHTING

The reason to look at the response curve is that the recording of detail in the shadows and highlights doesn't abruptly change from full detail to no detail. The curve shows when and how quickly the transition between the camera recording full detail and no detail occurs.

In these diagrams (right), the y-axis (vertical) shows the amount of detail recorded and the x-axis (horizontal) shows the exposure. In the straight-line portion of the curve, the same amount of detail is recorded at each exposure level. Where the line is flat, no detail is recorded.

The shoulder of the curve shows at what point and how quickly the details in the highlights are lost. The toe (sometimes called knee) of the curve shows how quickly they are lost in the shadows. The shape of the curve at the shoulder and knee indicates the speed of the loss of detail. In the second diagram, the dynamic range of the straight-line portion can be found by counting the number of stops between the toe and the shoulder.

It is useful to look at a response curve, but it must be the correct one, because the shape depends on how the image is processed, so will vary not just according to the camera sensor but also depending on whether you are shooting RAW, the version of Log you are using, or the behavior of the LUT if you are using a burnt in LUT. You can often, but not always, find a useful response or gamma curve for the camera and format you are shooting online.

- Make sure you record in the straight line of the curve to be sure to be recording information about any areas you want to see. The more information you record in the straight-line portion, the smoother the gradations from light to shade, and the more detail can be seen in the finished shot.

Looking at the diagram, you can also see:

- If you place your exposure (the 18% gray level) lower than 50% IRE you will have more space available in the straight-line portion of the curve, to record detail in your highlights. This can be useful for high key scenes.

> All other things being equal, placing your exposure lower requires less illumination, and placing it higher requires more.

No detail is recorded where the line is flat, and far less detail at the shoulder and toe, which are the points the curve starts to flatten out. To see detail there must be visible changes of brightness so the steeper the line the more detail/changes of brightness can be shown at any given stop.

Illustrative comparison example of how many stops of dynamic range can be recorded in RAW, Log and LUT.

265

F: LIGHT AND LIGHTING

Both shots are correctly exposed, but neither would be the same as suggested by IRE 'rules' and guides (top) *Dark Shadows* DP Bruno Delbonnel, (bottom) also by Delbonnel *Miss Peregrine's Home for Peculiar Children*.

- If you place your exposure above the 50% IRE level, there will be more space available in the straight-line portion of the curve, to record details in your dark areas.

N.B.

- Much of the information and guidance written about exposure suggests that there is an optimal position for the exposure of skin tones. Whilst this may produce useful guidance, it is not a rule. The relative brightness of a face in shot depends on how you want it to appear on the screen.

- *Noting down your exposures for certain shot types will help you build up a body of knowledge, which you can adapt in each new situation.*

Dynamic Range, Latitude and Exposure

The terms dynamic range and exposure latitude are often used interchangeably, but it is more useful to use them as:

- Dynamic range for the range of levels that your camera can record.

- Latitude for the range of levels within the shot you are shooting.

Used this way, if your latitude is 3 stops smaller than your dynamic range, you can adjust where you place exposure by up to 3 stops, and still keep the whole shot within the dynamic range.

The difficult situations when exposing are when you need detail in the dark areas, but there are also hot spots of bright areas in the frame. Digital images don't respond well to clipping, but if you have to reduce your exposure so much to avoid clipping the light areas that you put the dark ones into the toe of the curve, you will need to increase the light level in the dark areas or bring down the level of the bright ones with flags, NDs or grads even if this takes time.

Three Techniques for Exposure

There are several approaches to choosing exposure, each with its pros and cons, and each may suit you or be more appropriate for a particular project. Choose the most suitable approach and ideally use it throughout a film to keep your exposure decisions consistent and logical and avoid difficulties in post-production.

1. Exposing 18% gray at 50% IRE is most useful to get the broadest dynamic range.

2. Adjusting the exposure to favor the darker areas in a low key scene by counterintuitively opening your aperture up so they look brighter and read higher on the IRE level than they will be in be in your finished shot. The opposite can be done for high key shots, i.e. closing the aperture down so the light areas are further down the IRE level than they will be in the finished shot. This allows more detail to be recorded in the areas you are most interested in, but is dependent on having both latitude (as above) and post-production grading to adjust the brightnesses.

3. Expose as high as possible, so long as the highlights aren't clipped. This is useful to retain details in the dark areas (if your film will be graded). It shouldn't be seen as a blanket approach and applied thoughtlessly, because if you have to reduce the exposure to avoid clipping you can end up shooting important areas of your shot at far too low a level. You can also end up shooting

different shots at different exposures. In post-production this would mean the grader not only has to change the brightness of each shot individually, but also has to adjust for different levels of noise in each shot. If you use this approach, only raise your exposure a little and try to keep IRE levels consistent throughout each scene.

Changing the Aperture in Shot

Don't change the aperture for minor corrections during the shot. It is better to leave this to the grader. Where there are very considerable lighting changes during a shot, e.g. going from inside to outside, adjust/pull the stop on a move, so it is least noticeable. Bear in mind that pulling stop (sometimes known as 'riding the aperture') will always change the depth of field. Another option is to use a variable ND filter and twist it, to allow more light during the shot instead of a stop pull.

> With all the tools and techniques for exposure, what can still trip you up?
>
> *If monitors or the viewfinder are calibrated incorrectly or if someone puts in the wrong filter so the filter factor (amount of light reduced due to the filter) is wrong . . . or the shutter angles are set incorrectly . . . or if anyone changes any of the digital setting.*
>
> *. . . Always check the data, it's at the top and bottom of the monitor of viewfinder screen.*
> Roberto Schaefer

NOTES

1. Rosen, Matthew. "Tutorial on Cinematography – How Cinematographers Read Vector Scopes". *Kinetek*, March 18, 2016. https://www.youtube.com/watch?v=28epRF6Cy4A
2. Steven Poster ASC ICG (DP) in conversation with the author (March 2017)
3. Dana Kupper (documentary cinematographer) in communication with the author (August 2017)
4. Koo, Ryan. "How to Use a Light Meter – an Excellent Cinematography Tutorial from Ryan E. Walters". *No Film School*, January 3, 2012. https://nofilmschool.com/2012/01/light-meter-excellent-tutorial-ryan-e
5. Adams, Art. "Hitting the Exposure Sweet Spot". *ProVideo Coalition*, December 24, 2012.

11b
Lighting: Natural and Available Light

Lighting with natural light provides the ideal opportunity to learn how light behaves in different environments and how various and beautiful it can be. Using natural light is an essential cinematographic skill but, if approached thoughtfully, also provides a superb foundation for lighting with lamps. When lighting with film lamps you are almost always trying to emulate natural light.

The chapter starts by looking at how to assess natural light and any available sources of light when location scouting. The principles of softening light with diffusion, using different surfaces to bounce light so as to reduce the lighting ratio or negative fill to increase it are looked at. The chapter then gives guidance for shooting at 'magic hour', 'blue hour', and using ambient light or firelight and when shooting night exteriors or interiors without additional lamps. The chapter looks in depth at how to control ambient and natural light when shooting interviews or interior scenes. It concludes with techniques for shooting day for night for both interiors and exteriors.

LEARNING OUTCOMES

This chapter will help you:

1. Assess and work with natural light in interior or exterior locations
2. Shoot in the following situations using available light:
 a) Interior or exterior interviews or drama
 b) Observational documentaries
 c) Night exteriors
 d) Magic hour
 e) Blue hour
 f) Firelight
 g) Day for night interior and exteriors

NATURAL LIGHT

Most of the time, when cinematographers use film lamps the aim is to create 'natural' light at the moment it works best for the story but to make that light more controllable and last longer. The more you know about how natural and available light behaves, the more easily you can replicate it when using lamps.

> *There is nothing more complex and exciting than real light . . . Natural light informs what you might do with a brut or arc.*
> Chris Menges

Natural light comes from the sun, moon and occasionally from natural phenomena such as lightning. Natural daylight provides good levels of light that doesn't reduce over large areas, which allows the actors or contributors to move freely without becoming too bright or dark. This can make untrained cast feel far more comfortable than working under film lamps.

> *We didn't use lights because we wouldn't have got that film [Kes] using lighting . . . Studio light is a hostile light to be in and if you are working with someone who hasn't been in a film before you have to use light in a way that doesn't distract . . . you need a light that is sympathetic and doesn't intrude.*
> Chris Menges[1]

AVAILABLE LIGHT

Available light is any source of light not supplied by the film crew, and includes natural sources such as daylight or moonlight and man-made sources such as the lights already in a building. The terms available and ambient are often used interchangeably, but when used correctly ambient light refers to the level of the light created by the available light.

Practical lamps are light sources seen in shot, such as desk or table lamps, streetlamps, car headlights, torchlight and firelight.

When working with natural light:

- Scout/recce locations and look for how the light behaves at different times of day and from different directions.

- Try to ensure the shoot is scheduled, so you can be at the location at the best time for the light.

- Be as prepared as possible if the weather is not ideal.

- Always carry a minimum of light-modifying equipment to bounce, diffuse and block light.

- Bring additional light-modifying equipment if needed.

Shot in the same lighting conditions. Moving round so the water was back lit (bottom) created a far stronger image.

ASSESSING LOCATIONS FOR NATURAL LIGHT

When assessing light in locations, you should look at how and where the light falls and which direction it will be coming from at different times of day. Use an app, such as Sun Seeker, or a flight logistics calculator, to see which position the light will be coming from when you plan to shoot, and check if there is anything that will block the light when you might be shooting. If you are scouting an indoor location, make sure you either look out of the window or go outside to check for anything that may obstruct the light during the shoot time. Bear the following in mind:

- Different environments greatly affect how the light behaves. A lighter environment will give more fill light and a darker environment will give less.

- The color of the environment will affect the color bias of the image and give a color cast to the light that bounces back from it. If the skin tone is close to the surrounding color, it will take on the tone and, if it is different, it will still absorb some of the color but this will merge with the skin tone.

- Reflective surfaces affect how light bounces. If the textures are absorbent, bounce will be minimized and, if they are smooth and shiny, it will be maximized. Assess the textures and also look to see if there are any very reflective surfaces that will create hotspots of light that are likely to show in the frame. See if they can be covered or removed.

- How it may look if the weather is different; if you could still make it work or if the shoot would have to be re-scheduled.

- If there is any haze or mist when you scout, note the time and weather conditions so you know if and when it might be the same when you shoot.

> To find the direction the light is coming from, raise your hand and see where the shadow falls. To assess how hard it is, place your palm in the light facing the direction it is coming from. Use two fingers from your other hand to cast a shadow on your palm. The closer you have to take your fingers to your palm to create a distinct shadow, the softer the light is.

> Notice how the natural light falls and changes while you are shooting. A silhouette or other visual effect may be created that helps to convey your story.

In a shot for *I Dream of Flying* Director/Cinematographer Tania Hoser, the projector was warming up and created this interesting silhouette prior to a talk by video artist Lana Vanzetta.

Skin tones take on the color of the environment, as shown in shots from (left) *Mad Max: Fury Road* DP John Seale, and (right) *Lord of the Rings: The Fellowship of the Ring* DP Andrew Lesnie.

F: LIGHT AND LIGHTING

When recceing, you are not just assessing the practicality of shooting in a location, but also looking for locations that offer wonderful lighting opportunities that would be either very tricky or expensive to recreate with artificial lighting.

- If the camera or subject moves, look for places where the light changes as the move occurs.

Both the light and the geometry of the composition change as the campervan goes under the bridge in *Little Miss Sunshine* DP Tim Suhrstedt.

- Don't just wait to be shown locations by production. Create a file of places with interesting available light in your area, and keep shots and notes when you scout a new area for a film.

When recceing locations, we found a cave that had a beautiful top light and scheduled the shoot around light and tide times. *Faluma* DP Tania Hoser and University of the West Indies EBCCI cinematography class.

ASSESSING LOCATIONS FOR AVAILABLE LIGHT

If you are scouting a location where you will use the available lighting, use a full color meter (see C11a) to measure the color temperature of each type of lamp or light source. Whenever possible, avoid shooting in a mixture of different-color-temperature lamps and sources, which will result in patches of slightly different colors in the image and will be very difficult to grade. You can mix daylight and interior lamps, but either as per C12, use filters to reduce the differences between them or, if you shoot with different-colored light sources, be sure that they work for your image rather than against it. See C14 for mixed color temperatures.

When using available light locations, it is often better to turn some or all the lamps off. Find out if you can turn off lamps or, if they won't get too hot, if you can block or cover them with specifically designed heat-resistant black wrap. If they are fluorescent, they may be cool enough; if they are tungsten, they won't be. Always shoot tests when you scout a location. If you can't use the camera you will be shooting the film on, use a stills camera.

ASSESSING LOCATIONS FOR LIGHTING BY CONTRAST

When you scout locations, you are looking for the potential to make light and shade work in your shots, not just how much light is available. Light creates definition either through modeling when it is brighter one side than the other, which shapes a subject, or through contrast.

Contrast can be created by having a background that is either (or both) a different color or brightness than your subject.

Practice moving a person in a location to increase and decrease the contrast from either an available light source such as a window or by moving the camera position to change what is behind them.

WORKING WITH THE WEATHER

In terms of lighting, the biggest bugbear when shooting in natural light is when the sun is moving in and out of clouds. Shots taken with the sun out won't cut with those taken with it in. If at all possible, wait for the light you want.

If you shoot in shade, you could block the sun in the close-up.

If you shoot a wide shot in full sun, you would have to add light or use a reflector to try to simulate the sun if the sun is needed in the close-up.

Each compromise requires equipment and time, so you will have to decide which option is most appropriate and practical. The look of the wide is usually a priority and, although wide shots are usually taken first, occasionally you may find that shooting the close-up shots first will allow you to wait to get the light you want for your wide later. Check a detailed forecast of local weather to help you decide.

Whilst it is the production department that looks up the weather and adjusts the schedule if they can, once on set the cinematographer or gaffer is expected to be able to read the clouds and assess roughly how long you will have to wait for the light.

A pan glass is essential for looking towards the sun, to avoid hurting your eyes. If a pan glass isn't available, put your hand up to block the sun and look at how far the clouds are away from your hand to help you assess how long you have before the clouds cover the sun.

The speed and direction the clouds move in depends on the wind. What complicates this is that there may be several layers of cloud at different heights, and each of these is affected by different wind speeds and directions. Ventusky[2] shows the different wind speeds and directions at different heights, so if there is more than one layer of cloud you can assess how fast and in which direction each layer is moving. This level of mapping is usually used by pilots,

Gaffer Jordan Holtane using a pan glass to assess how long before the clouds will create shade on the set of *This Too Shall Pass* DP Ian McGlocklin.

Shape is more clearly defined in the parts of the frame where the head is seen against the light from outside. *Halloween: The Night He Came Back!* (fan film). Director/DP Dave McRae.

> It is essential that any light-modifying equipment is tied down so it won't blow over on the artists or crew and that any reflectors don't rustle and make sound impossible to record. When the wind picks up, put on extra weights to stabilize equipment or have people hold the stands to keep them steady.
>
> See C2 for keeping yourself, your crew and equipment safe in rain, heat, sand and hazardous environments.

F: LIGHT AND LIGHTING

but on a shoot that is heavily dependent on exteriors, it is well worth being as knowledgeable as possible about the movement of the clouds.

If the weather is against you when shooting, both you and production should have a Plan B for either how to adjust the schedule so you can shoot when the weather is right or how to adapt the shot for the wrong weather. You may find the best bet is to have something in mind so (rather than wasting production time) you can quickly and creatively adapt nearby locations to shoot something either equivalent to what your scene is or a different scene from the film.

Shooting in the Rain

Shooting in the rain affects the light and the look of the environment.

If sound is being recorded, it will be difficult to avoid the rain being heard. If sound isn't a problem, you can use the following techniques, which can help make it look like it isn't raining:

- Keep the ground out of frame.

- Keep the actors dry under umbrellas until you shoot.

- Shoot with a canopy over the artist but keep it out of frame.

- Use a longer lens and go further back and open up the aperture. Using a wider aperture and longer lens will give a shallow depth of field and a narrower angle of view, so you see less of the background.

- Place the camera inside or in a truck, or put a large umbrella over the camera, ensuring the tips are arranged so that drips go either side of the lens.

It is essential that camera equipment be protected at all times through the use of ground sheets, plastic bags, etc. (see C2).

SHOOTING DAY EXTERIORS

- The sky should be mostly inside the dynamic range or out of shot. Ideally, shoot Log or RAW to retain as much detail in all areas of the dynamic range as possible. If you have to shoot with a burnt in LUT, reduce the contrast to retain as much detail in the highlights (sky) and shadows as possible. If the skyline is above your main subject, you can use a graduated ND filter to reduce the brightness of the sky without affecting the foreground.

- In most cases, the light falling on the person you are filming shouldn't create hard, unflattering shadows, and the eyes should be visible.

- Reflect light back from the key light to fill the face if needed. If the bounced light is too strong or uncomfortable, move the reflector further back or aim the bounced light slightly off the subject.

- Re-position the person you are filming if possible, to get the best combination of lighting and background.

- You should always have reflectors with you and ideally a five-in-one set.

- If you are hiring a van, hire a white one – so you can position it to act as a large reflector.

When shooting in natural light, re-positioning the subject and/or using a reflector is the easiest way to adjust the lighting. Looking for the light is part of devising the shot, not an additional element thought about afterwards.

11B: LIGHTING: NATURAL AND AVAILABLE LIGHT

- Although not a natural light, it is also useful to carry a battery-powered LED lamp with you.

- Keep the person you are filming comfortable and avoid them having so much bright direct or bounced light on their face that they squint.

- If you position the subject in shade or diffuse the light on them, the level of light on the background shouldn't be so much brighter that it is either clipped or looks unnatural.

- Blur the background if it is distracting, by opening up the aperture to produce a shallow depth of field. Use an ND or variable ND filter to reduce the light levels, so you can open up the aperture.

- Use a flag or eyebrow to avoid flare (caused by light hitting the lens) if the sun is low or you are shooting upwards.

- Watch out for mic or camera shadow, and adjust positions if needed.

Using Butterfly Frames and Five-in-One Kits and Reflectors

Reflectors are used frequently when shooting exteriors. It takes practice to angle the light to get the strongest reflection and to center it on your subject's face or where it is needed. The angle of incidence will always equal the angle of reflection, but reflectors can be manipulated or bent to catch and focus the light.

Butterfly frame being used to soften the light on the set of *This Too Shall Pass* DP Ian McGlocklin (directors Rya Kihlstedt and Louise Salter).

A five-in-one (reflector and diffusion) kit is very useful and has diffusion, black, white, silver and gold (or sun) fabrics that are pulled over a pop-out frame.

Styrofoam/polystyrene reflectors, cut to size, being used on the set of *Cut Sleeve Boys*. Photo courtesy of Laura Radford Photography.

F: LIGHT AND LIGHTING

The color of a reflective surface affects the color bounced back from it.

Practice bouncing sunlight using reflectors and look for the difference when using different-color reflectors – silver, gold, white and 'sun', which is very useful for creating a natural looking warm fill light. Learn to control the reflected light and anticipate the resulting changes to skin tone. Practice with the sun out and the sun in to learn how much closer you need to position the reflector when the sun is behind the clouds.

Reflectors can be purchased or made from any suitable material. The shinier the material, the harder and often brighter the reflected light is. Mirrors or silvered plasterboard/dry lining or reflective insulation can be cheap and effective large reflectors, but take care not to create such a hard light that it hurts the eyes of the person you are filming or makes them squint.

Gold reflectors (left) can make skin tones look very orangey, and 'sun' colored reflectors (right) create a warm but more natural-looking bounced light.

EXERCISE: Practice shooting with and without diffusion in hard sunlight. Move the position of the person and the camera so the sun is coming from different directions. As above, experiment with different types and colors of bounce boards or reflectors to create reflected fill light.

Shooting Exteriors without a Reflector or Diffusion Kit

A five-in-one kit and a reflector stand is usually considered an essential for shooting in natural light, unless you are a solo shooter and can't carry any additional equipment. If you don't have one, you can position something or ask someone to hold up a white sheet of card or paper or something that will bounce back light. If your camera van or vehicle is white, you can use that as a nice big reflector.

- Try to avoid shooting at midday, when the sun is highest and most likely to create nasty dark shadows on the eyes.

> If you shoot with the sun overhead, your diffuser will also have to be overhead, which makes it difficult to create directional light.

- When not using a diffuser, put the person you are filming in the sun and raise the camera height a little, so the person is looking up very slightly (to reduce harsh shadows in their eyes), and avoid the sky and the brightest areas of the background if possible.

- If appropriate for your shot, use a longer focal length, further away from the person, to have a narrower angle of view and to see less background.

- Use an ND filter so you can open up your aperture and have a shallow depth of field.

(top) Five-in-one kit diffuser creating a small area of shade which (bottom) makes the sunlight far softer and more flattering.

Or

- Try to find somewhere with a lighter floor surface or an environment that will bounce light back onto your subject (or fall back on using an on-camera LED lamp as fill).

- Shoot when clouds are overhead because there will be a lower contrast ratio and no harsh shadows.

- Place the person in available shade, such as a tree, and (as above) avoid too much of the bright background.

- If you shoot when there is high contrast (or if shooting with the sun behind the person), shoot on the LUT with the least contrast or Log or RAW and allow the face to be between 5 and 10% lower on the IRE scale than otherwise. In post-production, you will be able to bring the person's face up and the background down.

Reverses

After finding a good position and light to shoot in, simply reversing the shot may be problematic. The background or the light, or both, may well not work as well as your first shot. If it isn't simple to re-set for the reverse, you can cheat the reverse:

- Move the camera round until you see a different background to your first shot.

- Position the person in the reverse to complement the first shot.

- Make sure the eyelines match and the line is maintained, so each person appears to be on the same side of the frame as they were in the first shot (see C7).

This technique works if the light is above or from the side of the subject because, although in a cheated reverse the light isn't coming from the opposite direction as it would in real life, it is usually coming from a direction that is different enough to look credible. The only time this cheat doesn't work is if the light is low and visible and coming from the back.

MAGIC HOUR, EVENING AND NIGHT SHOOTS

Magic Hour

> When the sun is high in the sky there is very little interference as it passes through the atmosphere, so the light is bright and creates harsh shadows. When the sun is almost level to the horizon, the light is traveling through a lot more of the atmosphere, which reduces the intensity; the blue light is absorbed by any particles in the air, but the red and orange light pass through. This is why sunsets can be more spectacular in areas of pollution.
> The color temperature at magic hour is about 3500K.

Magic hour is neither magic nor an hour! It is 'magic hour' whenever the sun is low in the sky and creates soft, warm, moist and glowing, golden light with long shadows. How long it lasts depends on how close to the equator you are. It can range from a few minutes if you are very near the equator, to a few hours near the poles. If you are midway between, it lasts around 45 minutes before sunset and 45 minutes after sunrise. Magic hour is one of the most film-friendly, impressive natural light conditions. There are several benefits of shooting in magic hour: the dynamic range is low, so you rarely if ever clip the highlights, and if flare appears it usually works with (rather than against) the image.

F: LIGHT AND LIGHTING

Magic hour shots (left) *Mad Max: Fury Road* DP John Seale, (right) *A Very Long Engagement* DP Bruno Delbonnel.

Magic hour light sets a mood and tone for a wider area than could be artificially lit, so there is no substitute for it. It not only looks good but also resonates with positive associations.

Less positive scenes are more often shot either in harder daylight or after the warmth of the sun has gone, in blue hour (see below).

By applying the following principles, you can shoot well in magic hour and be encouraged to find and shoot in this and other wonderful natural light conditions.

In winter in northern latitude it [the sun] is low most of the time and a lot of the time the mountains were in the way, so there wasn't direct sunlight. It looked like magic hour, but it wasn't.
Emmanuel Lubezki (known as Chivo)[3] discussing shooting *The Revenant*

- Find out time of sunset.

- Scout to find out which direction the light will be coming from and how it will look in magic hour.

- Use a good forecaster to check weather conditions. To specifically check for sunset conditions try: http://www.cbsnews.com/news/how-meteorologists-can-now-forecast-the-best-sunsets/

- Check there will be nothing obstructing the sun during magic hour.

- Set the white balance for daylight, so the magic hour light will appear warm.

- Have all equipment set up and be prepared to shoot (having already done rehearsals) before magic hour comes.

- Shoot wides first – you can simulate close-ups later if needed.

- Know your shots and work quickly.

- Use bounced fill, if needed, when the sun is behind the subject.

- Don't try to flag off flare if you can see the sun.

You may prefer the look of the light towards the end of magic hour, but protect yourself by also shooting early (and bringing the light levels down in post-production), because the sky may change or you may have a delay and lose too much light. It will look much the same if you shoot earlier and bring the light levels down in post-production.

If the cloud cover is too thick, the color and effect of low shadows won't happen. However, the light will be very soft and will respond well to being warmed up by setting the Kelvin scale of the white balance on the camera to 4800 (which is halfway between tungsten and daylight).

Blue Hour

Blue hour or twilight is the short window of time after the sun goes down (or before it comes up). There is no direct sunlight, so there are no shadows, and, if not over-exposed, there is a rich, powerful blue to the sky. There are three types of shots best suited to 'blue hour': lighter subjects that will be visible in the fading glow of light, subjects against a slightly brighter sky which can be silhouetted against the evening sky, and evening exteriors in which practical lamps can also be seen.

Fading glow. Evening exterior with lights playing.

Two types of blue hour shots: (left) Fading glow of light in this shot from *Moonlight* DP James Laxton; (right) Evening exterior with lights 'playing'/visible in the distant town. Photo from Pixaby.com.

When the sky is a rich deep blue, tungsten lights will look very orange, which can sometimes appear too much. This can be reduced by putting 1/4 or 1/2 blue gel on tungsten light sources.

When to Shoot Moonlit Scenes

Blue hour is also ideal for shooting night shots, particularly if you don't have film lights. There is often still just enough light from the sky to get an exposure to see your actors, but practical light sources such as street lamps and cars will still read. You should have the colors desaturated, because we see less color at night and have the blue graded out to make it look like a true night scene and also to make any tungsten sources look less orange.

The window of blue hour is short and you will be losing light every minute so you should:

- Scout the location and observe it at blue hour and night so you know your camera position, what lights you will see in your wide shot and at which point, as darkness falls, you will lose your shot.
- Arrive early and rehearse before blue hour starts.
- Shoot wide shots first, before the sky is completely dark.

It was just street light . . . the position of the car was crucial. The lighting was minimal and we did a wet down.
Roberto Schaefer

Two shots from *Miles Ahead* DP Roberto Schaefer.

- Use any available sources such as car lights, street lights or shop lights, and place the action near these sources.
- Compose shots with more than one light source, i.e. one in foreground and one in background, to create depth.

Available light sources at night are often different colors; scout at night to see what colors the available light sources are and incorporate them into your lighting and shot design. *Moonlight* DP James Laxton.

- Shoot after rain or a wet down if possible, because reflected light increases the available light.

- For close shots, you may be able to block the light from the actors and shoot them day for night before blue hour.

- Alternatively, shoot the close shots before the light has completely gone and use a silver reflector to bounce back as much available light as possible.

- If you need to continue shooting as night falls, bring a couple of LED lights or torches with you if possible, to supplement the sources or provide fill light.

- Set your color temperature so moonlight looks cool (blue) (see C3 and C14).

- Don't be too concerned about fluctuating lighting ratios; they look more normal at night.

- Shoot with a wide-open aperture. Even if you can only afford one prime lens (usually a 50mm), make sure you have one available.

- Shoot at a wider shutter angle (to let in more light).

- Shoot RAW or low contrast.

Choose a camera with a high native ISO or one that works well at higher ISOs.

The Canon C300 and Sony AS7II are considered to work beautifully at ISO 2000; the Panasonic Varicam has two native ISOs, one of which is 5000; and the EVA1 also has two, with the highest being 2500. Test the noise floor with a raised ISO and, if you aren't happy, consider using a different camera, e.g. higher-end full-frame DSLRs, some of which have better low light performance than some Super 35 cameras, partly because they have a larger sensor – but be sure the footage can be made to match.

Notwithstanding your camera's low light performance, the later into the night you shoot and the less available light there is, the more noise you will get and the more you will rely on available practical sources.

Shooting in Firelight

Shooting with firelight as your light source creates warm tones and strong contrasts that can be very visually striking. It is relatively straightforward to shoot in firelight when there are no additional light sources, because you don't have to match color temperatures and can retain, increase or reduce the redness as much as desired in grading. Your subject will need to be close enough to the fire to get an exposure, but not get too hot or burnt. If necessary, keep the camera lens in full shade and protected from the heat with a heat jacket.

Shot using firelight as the only source. *Faluma* DP Tania Hoser and the University of the West indies EBCCI cinematography class.

When the flames themselves are in shot, use a meter to check the flame isn't more than 2 stops above 18% gray, i.e. not more than 2 stops above the exposure you set on your camera. Any higher, and you will lose the color of the flames and clip the highlights.

DAY INTERIORS IN AVAILABLE LIGHT

Day interiors using natural and available light can be very effective if locations and timings are chosen well. They can also be tricky to shoot. Uneven and changing light levels and mixed (color temperature) lighting can all be problematic.

Albert Nobbs DP Michael McDonough.

> *A lot of it was switching off lights . . . I learned to be organized and just make simple changes like swapping bulbs and moving things around.*
> **Chris Menges**

- Scout before the shoot, or check as soon as you arrive, to see which direction the windows are facing.

If the windows are north-facing, the light will be constant; if they are facing any other direction, the light will only shine through for part of the day. Use an app or flight logistics calculator to assess which hours and look outside to see if anything will block the light during those times.

Even if blinds or curtains are open, when more light is needed, clipping them further back or removing them can lift levels substantially.

If this doesn't provide adequate light, turn on the available lights and assess how the color temperatures mix. Your decisions about how and whether to use available sources comes down to taste and assessment of whether the color on the skin tone is unpleasant. If you use mixed color temperature, you need to keep them workably consistent so the skin tone doesn't alter dramatically in an unmotivated way from shot to shot.

This shot from *Under Jesus* DP Tomas Tomasson was scheduled to be shot when the light would shine through the window and create a strong back light that could also be used to bounce light back onto the characters.

> *In documentaries, I learned that one side can have warm light and the other cold.*
> **Chris Menges**

> **Light-colored locations with big windows are usually best shot without direct sunlight. For dark locations or when a dramatic effect or strong light is needed, it can work well to shoot when the light shines through, but be prepared to add diffusion or ND filters to the window.**

If the color temperature is mixed and you can't turn off the interior lights (or swap light bulbs to daylight-balanced bulbs), you may be able to cover them over with black wrap or gel them to reduce their color cast, e.g. wrapping 1/4 or 1/2 blue gel around a tungsten source may make it far more acceptable if shooting in daylight.

If this isn't possible, shoot at 4300K but avoid shooting as the light falls, because the balance between the exterior daylight and interior light will change continuously, making it very difficult for grading and cutting.

F: LIGHT AND LIGHTING

LIGHTING INTERVIEWS

- In most cases the natural light from the window is used as the key light. If it is too harsh, you can either diffuse it or position your interviewee where it creates an indirect key by bouncing off a wall or reflector.

- If your interviewee is supposed to be at a desk, take a wide with them at the desk first, then shoot your interview tighter in a better key light.

- If the key light is too hard and creates too high a contrast ratio, use reflected fill.

- Any curtains or blinds can be used to increase the light levels in some parts of the room and reduce it in others, to direct the viewer's eye.

- If natural key light isn't working and you have to use the available artificial light, be sure to white balance in the light that is being used on your interviewee.

- Consider placing an appropriate, practical lamp in the frame to add interest. Put a layer of ND inside the shade if it is too bright and a layer of color correction gel (see C14) if needed.

If you need to show the window in frame:

(top) *The Spirit of Mikvah* (bottom) *To Beat the Bullies.*

- Don't place the subject directly in front of the window.

- Check whether the darker and lighter areas of the frame, i.e. inside and outside the window, are within your dynamic range.

- If there are more than a few small spots of clipped highlights, expose the face up to 10 IRE lower and grade it up later.

- Consider raising the camera and seating the subject lower, if appropriate, to avoid seeing the sky outside.

- Shoot later in the day, when light levels are lower outside.

- Consider using a grad to reduce the level of light on the window and conceal the transition in the corner of the room or on the edge of the window.

AVAILABLE LIGHT NIGHT INTERIORS

- If the level of the ambient light is very low, use a lens with a wide aperture, an increased shutter angle and a higher ISO if needed.

- Consider positioning the action near practical lamps.

- Follow the suggestions for shooting at blue hour or shoot day for night.

DAY FOR NIGHT

Exteriors

If there are no light sources in your shot, and you are not able to shoot with additional lamps, even if you schedule to shoot at full moon, you will have great difficulty in getting enough exposure to achieve definition in your subjects and avoid noise. If done properly, shooting day for night can allow you to shoot night scenes in situations that would otherwise be impossible. It is also often easier and more practical to shoot in the daytime than at night.

Day for night shots: (left) *Mad Max: Fury Road* DP John Seale, (right) *Jaws* DP Bill Butler.

- Shoot on a dull day or when sun is behind clouds. If this isn't possible, don't show the sky. Some shadows are acceptable if they come from behind because they make it look like moonlight.

- Ensure actors are wearing darker clothes, because light ones reflect too much light.

- Where possible, shoot in darker-colored environments – light ones reflect too much light.

- Shoot tungsten white balance to create the bluer look of night.

- Lower the exposure so only the lightest part of the shot is exposed to 18% gray or thereabouts; most of the rest of the frame should be darker.

- Re-frame or flag off light areas if needed.

- Don't let any of your highlights clip.

- In post-production, apply a blue layer, reduce opacity and saturation, and adjust contrast.

Interiors

- Shoot when the sun is coming directly into the room and lower your exposure to make it look like a shaft of moonlight.

- Shoot when there is no direct sunlight coming into the room for a lower contrast look.

- Don't show the windows.

- Flag the light off the top part of the room.

- If using practical lamps, increase the power of the bulbs so they read in frame.

NOTES

1. Chris Menges BSC ASC (DP) speaking at Cinefest, Arnolfini Centre, Bristol, September 2016
2. Ventusky. *ventusky.com*, 2017. https://www.ventusky.com
3. Lubezki, Emmanuel. "'The Revenant' Cinematographer Emmanuel Lubezki talks finding the natural light". *GoldDerby*, December 15, 2015. https://www.youtube.com/watch?v=Im8MaR6R0u8

12
Shaping and Controling Light

Cinematography is rightly and frequently referred to as: 'Painting with Light'. Being able to control how and where light falls not only allows you to make spaces and subjects look three-dimensional; it also helps to create a visual tapestry of light, shade, color and tone that can define a film and help tell a story. This chapter looks at methods for controlling the direction, intensity, softness and color of light and how to control where it does and doesn't fall. The chapter starts by looking at the effect of direction and height on key, back and fill light, and which lamps to choose to emulate which natural sources. It goes on to look at the uses, tools and techniques for creating shapes and shadows, how to soften light or sharpen light and how to use it creatively to enhance reflections and refraction. The chapter then concludes with a detailed look at the four main type of light sources used in film lamps and the uses and benefits of different types of lamp housings.

LEARNING OUTCOMES

This chapter will help you:

1. Choose and position key light
2. Control the level and quality of fill light
3. Use back light for creating a rim or separation between your subject and the background
4. Use flags and cookies to cut off or break up light
5. Create softer or sharper shadows by adjusting positions of light sources and subjects
6. Reduce, increase and control reflections
7. Choose and use reflective surfaces
8. Learn the properties of the four main types of film light currently used
9. Know the main lamp housing and bulb arrangements to help you select the most suitable lamp type for your shoot

F: LIGHT AND LIGHTING

(Discussing lighting *Revolutionary Road*)
Locations like that only look good for about a half-hour or an hour at a certain time of day on a good day, but (production wise) you can't allow for that. It takes an enormous amount of light to maintain a naturalistic, consistent daytime feel inside.
Bill O'Leary[1]

Revolutionary Road DP Bill O'Leary.

Lamps are used to either supplement and enhance natural light, or create the light wanted in a studio set or a location where no natural light is available. Lighting a set, rather than using natural light, allows you to work for longer, re-create lighting set-ups as and when needed, and weave light from scene to scene as you want it, rather than rely on what is available. The more you learn about lamps, and practice using them, the better you will be able to anticipate the effect of light from specific lamps or other sources. The terms lamps and light or lights are often used interchangeably but incorrectly: a lamp is the housing for the bulb (light source), and the light is what shines from it and is seen.

Film lamps are stronger, more reliable, easier to control and position, have a more consistent and better color rendition, and create less flicker than domestic lamps. They are designed for the job, have barn doors or other methods to direct the light, and have clamps and attachments for them to be held in place by stands or supports. There is a huge array of lights and fittings available. Lights can be attached to drones, balloons, cranes, and even underwater lighting is available, so that any space or area can be lit.

Not having lamps will restrict the look you can create. If you are shooting outdoors at night, you don't want to rely on someone from the council choosing where to place the street lamps to do the lighting for you.
Oliver Stapleton[2]

However, learning to light, and lighting low budget projects, relies on practicing the principles of lighting and applying them with the equipment, space and budget you have.

When you start off you don't have all the lamps to learn with but you can still learn to light. Go to a hardware store; there are millions of ways to create lighting tools. Work with soft, hard, direct and indirect lighting and different lighting ratios. Try to understand and see light; its quality, direction and color. Work small, unless you can work large so you learn to do more with less.
Steven Poster[3]

If you don't have film lamps, domestic or work lamps, photofloods or bigger bulbs can be used or swapped in, to do much the same job as film lamps, unless you need very large sources. If using low budget options, the key is not to mix them, because the color of the light they produce isn't so consistent. Without professional equipment, positioning lamps safely and securely can be difficult, and placing lamps very high up isn't advisable. If a very high lamp is required, try to find a location where there is a balcony or similar that you can place the lamp on. Film Riot[4] show some alternatives to film lamps.

CREATING MOTIVATED LIGHT AND EMULATING LIGHT SOURCES

Light should virtually always appear to be motivated by sources in the environment, and the hardness or softness of the light should always be the same or similar to the natural source. It doesn't have to behave in exactly the way as it would in real life, though. You can make motivated light appear to fall as it might 'naturally' appear on any given day, or you can enhance how it appears in a shot or scene,

12: SHAPING AND CONTROLLING LIGHT

(left) *Sin City* Director/DP Robert Rodriguez, (right) *Grandma* DP Alan Stewart.

e.g. increasing the contrast or making it stronger on the actors, and less strong on the background, than it would in real life. The more narrowly you allow the light to fall, and the less 'natural' the level or effect of the light on the background, the more theatrical the lighting appears. The balance between naturalism and theatricality is part of the visual language of the film.

Where and how the light falls can create a striking visual impact, as can the use of silhouettes, reflection and shadows, but whatever the light, or however beautiful the effect, the light should be helping to reveal something about the inner story of the film.

Having control over the lighting increases your creative options.

As a cinematographer, you should be aware of the visual conventions that affect the meanings viewers attribute to different uses of light both within and between genres. More intuitively, you should let yourself watch and gain a feeling and awareness for how the qualities of light help the viewer feel the story as much as they see it.

Every element of every frame informs the audience. If you don't have control over those elements, they won't understand the story you are telling.
Steven Poster

Enjoy watching films and allow yourself to become familiar with the emotional impact of different types and uses of lighting: (left) *Amélie* DP Bruno Delbonnel, (center) *Raging Bull* DP Michael Chapman, (right) *Macbeth* DP Adam Arkapaw.

It is the feeling for image and light that helps guide a cinematographer to choose the look to create for a film or any given scene. It is their technique that allows them to create it. Sareesh Sudhakaran's Wolfcrow blog has a 'Learn the Techniques of Great Cinematographers'[5] series that is well worth looking at, and shows inspiring examples and useful technical information about the work of cinematographers, including Emmanuel Lubezki, Christopher Doyle, Bradford Young, Robert Richardson, Conrad Hall, Roger Deakins and several other wonderful cinematographers. What it doesn't show is why they use the particular techniques. As a cinematographer yourself, you should look to others for inspiration but develop your own ideas and motivation for how and why to light, rather than just learning techniques.

F: LIGHT AND LIGHTING

CONTROLING SHAPE WITH LIGHT

To learn how light behaves, use one lamp and either have someone move it round a subject or leave the light in the same place and move the camera position.

Front **¾ Front** **Side** **¾ Back** **Back**

Look at how the light creates shadows and affects the shape and the 'mood' of the shot. The exact effect of the light on your subject depends on both the lamp being used and the shape of the person or subject. Everybody's face shape is different and, however experienced you are, you will always need to look carefully to choose the best position for the light on your subject.

Room DP Raymond Stella.

(left) 3/4 back and (right) 3/4 front light.

Direction

The height and angle that you should position a lamp depends on:

- the direction and height of the source that is motivating it
- where it is practical to place the lamp
- the effect of the shape and shadow it creates on the subject

Simulated sunlight has to come from higher than internal sources, but doesn't have to come from its exact position in the sky. You can adjust the position of the lamp to get the best effect on your subject, as long as the light still appears to come from roughly the same direction as the source.

3/4 Front Lighting

The direction the light is coming from doesn't just dictate what can be seen. It also dictates what can't be seen. (You can tell the direction the light is falling from by the direction of the shadow.) If the light is positioned from 3/4 front, most of the subject is lit and the fall-off, i.e. the transition between light and shade, occurs to the far side where it is less visible in the shot – particularly on a face, because it is on the other side of the nose.

3/4 Back Lighting

In 3/4 back lighting (also known as short lighting), far more of the fall-off of the light is visible in the shot. There is also likely to be less of the key light illuminating the background.

In drama, 3/4 back lighting is often preferred on light skin, as it creates a more interesting sense of shape and a greater variety in tones, because the fall-off is visible on the face. In terms of seeing

the fall-off from light to shade, the darker the skin tone, the more gradual it is, so for mid to dark skin tones both 3/4 front and 3/4 back can allow the viewer to see the visually interesting transition between light and shade. For very dark skin tones, 3/4 front light usually shows more of the transition (particularly if the key light is hard), but 3/4 back light can be used to create a strong dramatic effect. See Nadia Latif's *'It's Lit! How film finally learned to light black skin*.[6]

Light and Texture

Flat light, whether coming evenly from both sides or from the front (i.e the same direction as the camera), creates the least texture, whereas side lighting creates the most texture. When using hard light, the texture is enhanced; when using soft light, it is still visible but less sharp. Combinations of hard and soft light can be used within the shot or on different parts of a single subject.

12 Years a Slave DP Sean Bobbitt.

MOTIVATED KEY LIGHT

Key light should usually appear to come from a natural or practical source. If the viewer knows or thinks they know where it is coming from, it is motivated. If it has no viable source from within or outside the space, it will distract the viewer's belief in the film space.

> *One-point lighting is the most beautiful thing. Choose the size, distance and source of the key light to tell your story. What height and angle it is, is really important.*
> Petra Korner[7]

In this shot, single-point lighting appears to be coming through small window openings. *Zayed* DP Petra Korner.

A key light can appear to be from any light source, including practical lamps and screens. To choose which type of light you want for your key, think about how the light from the source you are emulating would look. If it would create hard shadows, in the way sunlight does in a clear sky, you need a hard light. If it would wrap around the subject, like hazy sunshine, you would use a soft light.

In *Samsara* director/DP Ron Fricke (top) The skin texture is visible/exaggerated because the light skims the face as it comes from upper right of the frame and picks up every skin contour, which shows texture. (bottom) the skin texture is smooth because in this shot there is even front while the kickers (see page 293) at each side allow the shape of the head to retain its three-dimensional shape.

12: SHAPING AND CONTROLLING LIGHT

F: LIGHT AND LIGHTING

There are degrees of hardness and softness, though, so plenty of room for creative adaptation and being clear about what you want the light to look like will help you, or your gaffer, choose the best equipment to achieve it.

As below, an open face lamp produces very hard light but can be tricky to control. A Fresnel light has a lens on the front, which makes the light far more controllable and even, but is still hard. As above, the direction of the light doesn't have to be from exactly the same position as the motivating source, but close enough to be believable. When you position your key light, look at how it falls on the person or subject in shot. Lighting is an art not a science. Light falls differently on one person than it does on another. Also, consider how far you want the light to spread. Should it cover a wide area, or be quite narrow? This depends not only on the motivating source, but also on the style you want to create.

INTENSITY, DISTANCE, DROP-OFF AND THE INVERSE-SQUARE LAW

Having decided on the direction and hardness of softness of the light, you need to decide on its strength. Whether or not the actors move, or how far the light needs to spread at the same level of illumination, is an important factor in this.

If the actor is going to be moving, unless they are supposed to be moving out of the light, the level of light should remain consistent throughout their move, or reduce at the speed the viewer would expect, i.e. if an actor moves from the back to the front of a field to another, in unobstructed sunlight, the viewer wouldn't expect the level of light on them to change. However, in a dimly lit room at night, if the actor moves away from a small desk lamp, the viewer would expect the light to reduce more quickly. Film lamps don't behave in the same way as natural light. Light from a film lamp may appear very bright on an actor, but when they move a few feet the level of the light greatly reduces. This is one of the things that can trip you up as a new cinematographer: you may find you are able to get the light to look how you want it while the actor is still, but not when they move. The reason that light reduces more quickly than you would expect is due to the effect of the Inverse-Square Law. The effect of the inverse-square law is that if you

(top and middle) Key light from the television in *Little Miss Sunshine* DP Tim Suhrstedt, (bottom) hard 3/4 back key light. pixaby.com.

In this shot from *Their Finest* DP Sebastian Blenkov, the women are lit by the same key light. The level of the key light drops before it reaches the woman on the right. If she was positioned any further to the right, the drop-off would be too extreme.

12: SHAPING AND CONTROLLING LIGHT

Inverse-square law diagram showing that at double the distance the light spreads four times as wide, so the light level is reduced by 3/4.

Another way to see what proportion of light reaches different distances.

double the distance of the subject to the lamp, you only get a quarter of the strength of the light. If a person moves from 1 foot away from the light to 2 feet, you lose 3/4 of the light, i.e. most of it, but (as per the diagrams above), as a person moves further away from the light source, you lose proportionally far less for each additional foot they move. At 10 feet or more, you are losing relatively little per foot that the person moves.

The sun is a very powerful source, which is very far away, so when shooting an exterior there would be no perceptible drop-off in daylight, however far apart the people are. If you are simulating sunlight, you should take great care to maintain brightness levels. If your motivating source is an interior lamp, you can allow it to drop-off a little more quickly.

To avoid seeing a sudden reduction in the level of light as an actor moves the two main techniques are to either use larger lamps from further back or a series of lamps which appear to be the same source. This technique is used frequently, but it can take some time to make sure there is no overlap between the light from any of the lamps, because double shadows will be created if two key lights hit your subject at any one time.

There is a degree of variation of how quickly the light falls off from different types of lamps, which should be detailed in the photometric data for each lamp, but the principle still remains useful.

TECHNIQUES FOR CREATING FILL LIGHT

Fill light is the light used to reduce the ratio between the bright and dark side of the face or object. Fill light is a combination of ambient light from the environment, light bounced back from the key light, and any light positioned to reduce the lighting ratio between the bright and dark side.

Fill light shouldn't create shadows or fall on any unwanted parts of the set. If fill light appears to come from a different source, such as a TV or a fire, it doesn't have to be the same color as the key light. If there is only one apparent source of light in the room, the fill light should match it exactly.

(top) In this shot from from *Albert Nobbs* DP Michael McDonough, there is a low ratio (not much difference) between key and fill light. (bottom) In this shot from *Ali and Nino* DP Gökhan Tiryaki, there is a high ratio between key and fill.

F: LIGHT AND LIGHTING

Bounce Fill

When light bounces back from a flat surface, the angle of incidence is always the same as the angle of reflection. Unless the reflective surface used is mirrored, the level of the light arriving at the bounce board will always be greater than the level leaving it.

The angle of incidence equals the angle of reflection, so both the direction the light is coming from and the angle the bounce board is held at make a substantial difference to the amount of light thrown back onto your subject. It takes practice to ensure you are maximizing the light you can bounce back. If less fill is required, and it isn't possible to move further back, you can achieve this by angling the reflector in a slightly different way, so you are not bouncing back all the light hitting the reflector. Practice with a reflector or flat white card to develop your skills.

I use a lot of bounced fill; unbleached muslin is closer to skin tone.
Roberto Schaefer[8]

White reflectors or Styrofoam sheets are the most common surfaces used as reflectors, because they don't absorb any of the color spectrum so reflect back the color of the light that falls on them.

Different colors, textures and shapes can be used to reflect the light to change the color or make it harder. Silver reflectors harden the light and gold warms it up. An Elvis, which is gold and silver mixed, produces a reflection that usually matches warm sunlight. Other colors can be used if, for example, you want to make it appear that the fill light is coming from a practical source. The color of the set will affect bounced fill from the environment. If the color is distracting, you can lay sheets or fabrics down on the ground, to change the intensity color or quality of the fill light.

Lit Fill

Lamps can be used to produce fill light, either directly or by being bounced into a reflector. Fill should be soft and not create shadows on the subject. Chinese lanterns or soft box chimeras are often used for fill light. Chinese lanterns produce light that is omni-directional and are virtually always used from the camera position. Whatever lamp is being used for fill, it is less likely to produce shadows if it comes from the camera position, but can, and often is, positioned opposite the key light.

Negative Fill

Negative fill allows you to increase the contrast (and so the lighting ratio) between the light and the darker side of your subject, by not letting light bounce back from your environment. Position a black reflector, black flag or drape opposite the key light (in the same place you would have positioned a reflector),

Chinese lantern.

12: SHAPING AND CONTROLLING LIGHT

to stop the light bouncing back from the environment. The closer you can place the negative fill to the actor, the more effective it will be. If the environment is very light, you can position additional black flags or drapes to reduce bounced fill from the environment.

RIM LIGHTING WITH BACK LIGHT

(left) *Hugo* DP Robert Richardson, (right) *Meet Joe Black* DP Emmanuel Lubezki.

Back light can be used in a variety of ways. It can be used to separate a person or object from the background or create a rim around them. It can be used by itself, or with a key or key and fill. Classic back light comes from directly behind the subject and creates a glow of light around their hair, head or hat. Back light helps separate the subject from the background, which can be particularly important if they are the same color. Back light is usually a hard light that is kept quite narrow. If back light is used in shots where people are moving, it is tricky to avoid camera flare and keep the levels consistent over a wider area. This is why it is used more often on static than moving shots. Care should be taken not to overdo it, unless there is a clear motivation for your back light.

A back hair light can also be placed not quite directly behind the subject to produce a kick on the hair. A hair light is usually set behind and just offside, usually on the opposite side to the key, at about 3–4 feet above subject. A hair light may fall on the hair, and create a rim on the shoulders or back. It can help with modeling, particularly with dark-haired people wearing dark clothes, in a low key environment.

A kicker is a larger, but still hard, sharp light source directly behind the subject that creates an even rim around the body and, when used alone, creates a silhouette. It will need to be strong enough to create the effect, and controllable, so the light doesn't spill where it isn't wanted. A snoot is useful to direct the light.

Your use of light allows you to create shape and mood on your subject, but how they fit into, or stand out from, their environment depends on both the nature of the environment and the lighting you have created or allowed to fall on it (see C13).

Snoot.

CONTROLLING AND MODIFYING LIGHT

To enable you to work effectively in sets and locations, where you will be using many lamps, you need to be able to modify how each lamp behaves and control how and where the light falls. Practice the skills outlined below with any lamps you can borrow or make, to help enable you to control where it falls and how it looks.

F: LIGHT AND LIGHTING

Shade and Shadows

- The direction of a shadow depends on the angle of the lamp.

- The length of a shadow depends on the height of the lamp. The higher the lamp, the shorter the shadow.

- The sharpness of the shadow depends on how hard the light source is.

- The definition of the shadow depends on how close what is creating the shadow is to the surface the shadow is falling on. Place a finger over the palm of your hand, and you will see that the shadow gets smaller and sharper as your finger gets closer. This principle applies whenever you are creating and using shadows.

(left top) Low-level light creates long shadow (left bottom) high light creates a short shadow, (right top) the further away from the subject, the softer the shadow, (right bottom) the closer to the source of the shadow to the surface the shadow is seen on, the harder it is.

How and When to Use Flags and Barn Doors

Barn doors are attached to the front of a lamp housing and are used to cut off the light from unwanted areas. Often, barn doors aren't sufficient to block light off everywhere it falls, so solid flags are placed to stop light hitting where it isn't wanted. Flags come in a range of sizes and are placed between the light source and the areas it needs to be blocked (do not place flags very close to a hot lamp).

Barn doors being adjusted (N.B. This is with a low temperature LED lamp; tungsten lamps get hot and require gloves to adjust the barn doors). Photo courtesy of Arri (www.arri.com).

(right) and (center) Putting the barn doors close together won't make as defined a slash of light as (left) placing flags closer to where the shadow will fall. Photos by Adrian Pircalabu.

Place your hand between your light source and where you want the light flagged off, and assess the shadow to see where you want to place the flag.

Practice positioning flags to enable you to see that:

- The closer to the light source the flag is placed, the larger the shadow it creates.

- The closer the flag is placed to where the shadow falls, the smaller but harder edged the shadow is (so positioning the flag is usually a compromise between these two factors).

- The edge shadow of a flag can be concealed in the corners of a room.

- Flags can be angled to cover part of a wall.

- Flags can be moved during shot to show light changes, e.g. allowing light to be revealed that simulates a door opening.

- Flags can be used to prevent camera flare (that can't be stopped with an eyebrow).

- Drapes/Duvetyne (which is the 16oz weight fire-retardant fabric used for flags in the film industry) can be attached with Velcro and rolled down when needed, or draped over flags to extend them.

If space allows, have several flags standing by, with the flag blade positioned toward set, so that when in use they can be raised and lowered easily and securely.

In some countries, it is cheaper to have people holding the flags than hiring stands. Having someone hold a flag is an option, but usually only advisable if you are very short of time and only need it held for a couple of takes.

Creating Shadows of Blinds and Windows

Shadows can be used to create shapes of objects, such as a window or a venetian blind, to suggest there is a motivated source of light when there isn't one. Use an empty frame (old frames from yard sales can be useful) and put strips of gaffer tape across it, that will

Negative lighting can be used as creatively as illumination. At the top of this shot there is a flag with additional duvetyn (fire-retardant fabric) attached to it to create a 'cutter'/half box to cut light from two directions. The large black flag on the left of frame is to stop bounced light coming back and creating negative fill that increases the lighting ratio from one side of the face to the other. Photo courtesy of Laura Radford Photography.

On commercials, it is common to see a 'forest of flags' that allow light to fall on some parts of the frame and not on others. This is to draw the viewer's attention to precise parts of the frame or product. Photo courtesy of Arri (www.arri.com).

F: LIGHT AND LIGHTING

The effect of a Cookaloris can be created by a cookie or by a Dedolight with a proprietary projection attachment. Photo courtesy of Dedo Weigert Film.

Light can also be broken up by being reflected off a reflective but uneven surface, such as aluminum foil or patterned metals. Photo by Ansgar Werrelmann.

Nets are used to reduce the light on particular areas of the frame. Red-edged net reduces the light level by one stop, green-edged net reduces it by half a stop. Photo by Adrian Pircalabu.

create shadows. To create hard shadows, use a hard light source and a large frame, so you can place it closer to the subject.

Breaking Up Light

Cookaloris/Cookies are randomly patterned cut-outs that are used to create shapes. They are usually used to break up the light on the background, but can be used on the subject if positioned carefully, so the areas of light fall where wanted. They can be moved forward or backwards to adjust the size and definition of the shadows.

A Gobo is a similarly patterned, usually metal, cut-out that is used with a projector to create shapes on the background.

Dingle is foliage used to break up the light in the same way as cookies, but the leaves of the dingle will move randomly during the shot, depending on wind or deliberate movement. This can be very useful and effective for exterior shots.

SOFTENING OR SHARPENING LIGHT

Reducing Light Levels

The level of light produced by a lamp can be reduced by:

- Neutral density gel, which can be attached to the front of barn doors or to windows, to reduce the light level. ND comes in .3, .6 and .9. and is used when you want the nature of the light to stay exactly as it is, but at a lower level. Each .3 reduces the light by 1 stop.

- Dimming can achieve the same thing and is quicker, although (as below) in some situations dimming can alter the color temperature or possibly cause flicker.

- Moving a lamp further back. 'Backing off' reduces the level of the light but will usually make it spread out further, so you may need to put in flags or close the barn doors if you want it to stay on a specific area.

- Feathering/edging off is slightly turning the lamp so the subject isn't receiving the full light from the lamp, but is lit by the penumbra, which is the slightly shaded region on the edge of the brightest circle of light.

If light needs to be reduced rather than cut off from part of the set or subject, a net, which is the same as a flag but with a mesh net instead of solid duvetyne, can be used to reduce the level of light over a particular area.

A red edge to the net shows it reduces the light by one stop, and a green edge net cuts the light by half a stop.

12: SHAPING AND CONTROLLING LIGHT

The same color coding applies to scrims, which are put in front of an open face lamp to reduce its output. Scrims can come in full or half-size. When a half-scrim is used at the bottom of the lamp, it will cut off the light closest to the lamp and not the light further away. This can help reduce the effect of distance and drop-off/the inverse-square law.

If the level of light coming through a window needs to be reduced, ND gel can be attached to the window, although it can rustle if there is wind and it is not held securely. Alternatively, ND Perspex sheets can be made and, although initially more expensive, can be a good option if a specific location is going to be used extensively.

Diffusing Light to Soften It

Using the principle that the larger the source, the softer the light, placing a diffuser on a lamp will soften the light. Placing the same grade of diffusion on a large trace frame, further away from the lamp, will create an even larger and softer source (larger meaning bigger, not brighter).

Using additional layers of diffusion will make the light softer, but also reduce the level of light passing through.

The softer the light, the more smoothly it drops off between light and shade. There are a variety of diffusion materials that alter the way the light wraps round a subject; such as silks, frosts and spun glass. As long as the diffusion material is not close enough to the light source to burn, you can use any diffusion material to soften the light. Net curtains or trace are a popular low budget option. Fog (sometimes incorrectly called smoke) also diffuses light (see C14).

Practice using different materials, at different distances from a light source, to soften light.

A half-scrim is metal and heat-resistant, so can be placed in a purpose-built slot within a lamp head and rotated as required. Photo courtesy of Arri (www.arri.com).

> A shower curtain, net curtains or tracing paper can be used as a low budget options for diffusion. For studio work, or where budget allows, Chimera have developed a variable diffusion panel which allows adjustments to be made remotely.

Bouncing Light to Soften It

When light is bounced it is softened, because the source of the light falling on the subject is now the relatively large reflector or bounce board.

Jordan Holtane on the set of *This Too Shall Pass* diffusing an LED lamp to create a soft light for this car shot.

F: LIGHT AND LIGHTING

An Elvis is a silver and gold check bounce board which is equivalent to a sun-colored reflector. Photo by Adrian Pircalabu.

Try:

- Using different surfaces to reflect/bounce.
- Changing the position of the light source and the reflector to find the best position to bounce light.
- Taking the reflector closer to the subject to increase the brightness of the reflected light.

Making Light Harder

- A softer light source can be made harder by attaching a circular louver or rectangular egg crate to the front of it.
- Making the light pass through what is effectively short black tubes stops it spreading to the side, and makes the light source sharper and more directional.

Egg crate. Photo by Adrian Pircalabu.

REFLECTION

Reflections can be used to create a hard fill. They can also be used very creatively, and it is well worth practicing learning to both control them and be creative with them.

- The appearance of a reflection depends on how reflective (shiny) an object is.
- The strength of a reflection depends on how bright the subject that is being reflected is. If you want a stronger reflection, increase the light on what is being reflected.
- When creating or working with reflections, if you change the position of the subject or the shape of the reflected surface, you will alter where the reflection appears.
- The shape of a reflection depends on the shape of the surface it is being reflected on. A flat surface will not distort an image, but a curved surface will.

(top) *IT* DP Chung-hoon Chung, (middle) from pixaby.com, (bottom) Photo courtesy of Richard Morrison #Seen,

12: SHAPING AND CONTROLING LIGHT

- The size of the reflection will depend on how close the subject is to the reflective surface.

If you want to reduce reflections, for example on the surface of water so you can see into it, or avoid reflections on a car, a polarizing filter will reduce or remove them.

Alternatively, if you don't want to see the surrounding reflected on a surface such as a shiny car, surround all or part of it with white boards, so that only a neutral white reflection is seen.

Try:

- Increasing the light on the subject being reflected, to make the reflection stronger.

- Moving the subject closer, to increase the size.

- Curving a reflective surface (such as a drink can), to distort the shape of what you are reflecting.

- Using white boards, to create white reflections.

REFRACTION

Light waves can be made to change direction when they pass through a lens. This is how a lamp lens focuses light.

- Light is also refracted as it passes through water or any other liquid.

- Mixing electricity and water can be very dangerous, but bouncing light into a shallow pool of water with a mirror at the bottom of it, can create a very interesting dispersed dappled light.

- Likewise, having it pass through a water-tight vessel can create a sense of moving light. This is most commonly done by shooting in a walk-through aquarium.

LAMP CHOICES, PERSONAL PREFERENCES AND LIGHTING STYLES

To decide which types of lamp to use, consider: whether the light should be:

- Hard or soft.
- How powerful it needs to be and how far it must reach.
- If you need to blend it to create even coverage.
- If it needs to be used in a small space or close to subjects.
- If it would be helpful if it has a rectangular rather than a circular throw.
- What color temperature it should be.

Photo courtesy Rumen Chervenkov, RedMark Studios, Dubai.

Shooting car commercials is all about controling reflections.
Andrew Boulter[9]

Photo by Claudia Wizner.

F: LIGHT AND LIGHTING

Everybody is out of date in terms of lamps and lighting fixtures.
Petra Korner

Choosing the perfect combination of lamps for each shot of a film would make your lighting lists very long. In practice you select a range of lamps that you can work for most of the shoot. If a particular lamp is needed just for a few shots, hire it for a few days.

Most DPs work with a range of lamps they like and are used to. New options are added when needed for a particular purpose, or when significant developments in efficiency or ease of use are developed. The choices of lamps available are changing constantly. A good gaffer or rental house manager will be able to advise on lamp choices.

I like a strong back or a 3/4 back light, so I use open face lamps like a Mole Beam or HMI Fresnels 12k or 18k (to emulate the sun). Inside I add one or two four-tube fluorescents to give a wrap-around light (on the person) and another smaller source for a top or back light for their head.
Paul Mackay[10]

My kit of choice is now banks of LED lights. I like the ARRI sky lights that you can fit together, change color temperature and you can program them. They are very nice when supplementing daylight and you can get the exact color temperature to match outside. The main advantage of LED light is how fast and easy it is . . . You can get Fresnel LEDs, too. Arri do the LED L series and there is a LED Dedo kit – exactly like the old ones but more focused and with dual colors and dimmer. The dimmer only changes the color a tiny bit. You don't see it. I've measured it but it is insignificant.
Tomas Tomasson

LED lighting is rapidly improving in output and changing lighting forever. They can't produce the same look as a carbon ark or 18k HMI, though, so LED is limited in terms of power.
Oliver Stapleton

On Amityville: The Awakening, *we used banks of LEDs from Litegear as a hard source, but for big sources I use a big 20k HMI. I still miss the pure, hard light from Arcs.*
Steven Poster

I use HMIs and LEDs unless I am in a studio, in which case I generally shoot tungsten; it's cheaper for production and you have less problems such as flicker.
Andrew Boulter

Two movies ago, I made the leap to LEDs. I still prefer Tungsten lights over anything, because of the organic and beautiful light they produce, but the many advantages of LED are undeniable: most importantly, all LED sources on set can easily be controlled over an iPad by the gaffer. Not just output, but also color temperature! This is such a time-saver. These lights make gels a thing of the past, and that saves a lot of money in my expendables budget.

I feel less enthusiastic about HMIs and regular Kino Flos. Of course, I use HMIs, but mostly for their punch. They are a different animal in terms of feel. I would never use an HMI for moonlight, or on a period movie; they feel way too modern and not as organic as Tungsten.
Petra Korner

LIGHTING CONTROL

The time taken in dimming, changing color temperature or panning or tilting lamps makes a considerable difference to the set-up time on a shoot. Whether it is a pole you can spin a light with or a stand, etc., anything that reduces this time is helpful. Lights also often need to be controlled during a shot for lighting changes.

DMX controls

In the last ten years, there has been a big increase in the use of programmable lighting boards on a wide range of shoots.

DMX is the global industry communications protocol that allows lamps to be controlled from a board, which can turn them on or off, dim them, or change the color temperature if the lamp is able to do that. The control board can be programmed so the lighting can be changed during a shot or between shots. Using control boards speeds up lighting changes and modifications once the lamps have been put in place. All lighting manufacturers are starting to incorporate DMX into their lamps so they can be connected to a board. Currently most DMX boards are wired systems, but wireless options are starting to come into use.

The use of remote control lamps is fueling the cross-over between the big moving lights used in broadcasting and events and film lighting.

Photo courtesy of Arri (www.arri.com).

The harder it is to reach your lights and the longer it would take to change them, the more important a DMX board is. Lighting control boards are starting to be used on many types of films, but on large films they are already the norm.

HOW TO SELECT APPROPRIATE LAMPS

The type of light a lamp produces depends on:

- The light source; i.e. which type of bulb (or LED) is being used.
- The effect of different housing to soften or sharpen it, or make it more or less directional.
- The lighting controls, from spotting and flooding to dimming and, in some cases, changing color temperature.

It used to be that particular types of bulbs were always put in the same sort of lamp. Now, most bulb types can be used in most lamp housings. A light source that would be hard in an open face lamp can be softened somewhat in a lensed lamp or when diffusion is added, and a light source that is naturally soft can be made harder by the addition of a lens or an egg crate (which will focus it more) or by attaching a projector. If you learn the properties of each light source, the effect and use of each type of lamp housing, and the abilities of different types of controls and modifiers, you should be able to select the most useful lamps for your job from the very large array of lamps on offer.

Whether buying or choosing lamps, think about:

- How much light you are getting for your money.
- How much light for your power, i.e. their output efficiency.

F: LIGHT AND LIGHTING

> CRI (color rendering index) is how accurately and consistently a light source reproduces color. For film, bulbs need to be consistent and have a high CRI. An acceptable Color Rendering Index level for professional imaging is considered to be 90 or above. Lamps with lower CRI ratings mean these sources may produce too much green or magenta in their spectrums. Individual lamps may be problematic, so prior to a shoot the gaffer or DP should check the color temperature of each lamp.

- How suitable for your shooting situations they will be, e.g. in small spaces you may need lights that don't get too hot.
- If they produce hard or soft light.
- What color temperature they are.
- Their weight.
- How flexible and adaptable they are to being used for different purposes.
- Whether you are better off with fewer larger lamps or more smaller ones.
- Their CRI (Color Rendering Index).

Bulb Types

The following are by far the four most frequently used light sources in film lamps. In addition to he following, there are also Arcs, Zenons, and Molebeams, all of which are powerful, hard sources for specialist uses, including spotlights and simulating lightning.

Tungsten

Tungsten/Tungsten halogen bulbs come in a variety of fittings and shapes, and can be put in a wide variety of lamp housings. In an open face lamp, i.e. when there is no lens in front of the tungsten bulb, the light produced is hard.

Their color temperature is 3200K but when dimmed decreases, so it reduces and the light becomes more orange.

Luminous efficiency, i.e. light output in lumens per watt of power (350lm/w), is low, which is why they get very hot, very quickly (because most of the energy is turned into heat not light). Gloves are required when handling any parts of lamps with tungsten bulbs, and all but very small lamps can't be placed too close to actors.

> Both professional film and domestic tungsten bulbs have a CRI of 100, so domestic or industrial tungsten lights such as clamp lights can be a good low budget option. Tungsten halogen work lights are also a good option, particularly for larger sources.
>
> You can replace the bulbs with different-colored (usually daylight) bulbs, but the match between daylight and the light from the lamps will be less reliable than with professional film lights.

Color Rendering Index (CRI): 100.

They are flickerfree up to approximately 100fps (see C8).

In addition to my own notes in this and the following lighting sections, I have included the advantages and disadvantages listed by VMI lighting (UK) in their 'Short Walk Through the Minefield of Location Lighting'.[11]

Tungsten halogen bulbs. Photo by Adrian Pircalabu.

ADVANTAGES

- Cheap fittings and bulbs.
- Full spectrum of color (no spikes or greenish hue).
- Stable color rendition.
- Wide selection of fixtures, including open face and Fresnel.
- Small size of light source.
- Smooth dimming.

DISADVANTAGES

- 3200K color temperature only.
- Daylight correction will cut the light output by approx. 1 2/3 stops.
- Generates a lot of heat (around 95%).
- Mains power only.
- Short service life of the bulb.

HMI

HMIs produce hard light if in an open face or Fresnel lamp. Most HMIs are Fresnels. HMI bulbs are 5600K daylight but get bluer when dimmed. Luminous efficiency up to 1150lm/w. Larger units get warm or quite hot, but not as hot as tungsten.

HMIs require a ballast to start them and regulate their output. The cheaper magnetic ballast is not flicker-free and so must be used with the correct shutter speed and angle (see C8). HMIs draw twice the power of the bulb when striking, i.e. while they are being switched on, and take some time (30 seconds or more) to reach full power.

CRI: 95% or more.

They are not flicker-free unless a flicker-free ballast is used. Flicker-free ballasts produce some noise. Beware that if a flicker-free ballast has a silent mode, it may just stop it being flicker-free.

ADVANTAGES

- Daylight color temperature.
- High light output fixtures.
- High color rendering (no spikes or greenish hue, unless the bulb is nearing the end of its life).
- Wide selection of fixtures, including open face and Fresnel.

DISADVANTAGES

- Expensive.
- Generates large amounts of heat.
- Heavy and large fixtures.
- Mains power only for almost all fixtures (except for 200W pocket par).

HMI bulb. Photo by Adrian Pircalabu.

F: LIGHT AND LIGHTING

Fluorescent

Fluorescent bulbs are mainly tubes, although some are now also manufactured in a more traditional bulb shape. They are mostly available in either square or rectangular lamp housings that contain banks of bulbs. Kino are the predominant manufacturer of fluorescent film lamps.

Fluorescents provide a lovely soft even light. Fluorescents are also very cost-effective. Fluorescents are smaller and more powerful than LEDs.
Steven Poster

In an open face lamp, they produce a soft light. If used horizontally, Kino flos are good for creating a soft light that wraps around a subject. If used vertically, they can be used to create a slightly harder side light. The color temperature of Kinos can be tungsten 3200K or daylight 5600K, and the bulbs are interchangeable. When dimmed, they do not change color temperature, although if dimmed below 50% they can cause flicker.

Luminous efficiency is high, at 1000lm/w, which means the lamps are cool, and so can be used without gloves. A single bulb can be used to provide a small light source that can be squeezed into tight places, and used near actors.

The CRI of Kinos is 95+ as opposed to 65–70 for standard domestic fluorescent bulbs, which have a range of color temperatures, some of which have a magenta or green bias. Therefore, swap domestic bulbs for Kinos on location when possible.

Kinos have an in-built ballast at the end of the bulb to make them flicker-free, whereas domestic fluorescent bulbs don't.

For high speed shots, high frequency ballasts are available, making them flicker-free at standard speeds up to a point (see C8).

Individually, Kino Flo tubes are not particularly expensive and can be used to provide a compact, cool light source that can be held in position where needed.

ADVANTAGES

- Daylight and tungsten matched color temperature tubes available.
- Efficient technology means that lights run cool.
- High color rendering.
- Soft, due to diffused light from a large surface area.
- Inexpensive.
- Low power requirement.
- Safer than other bulbs when smashed.
- Lightweight, flexible and dimmable.

DISADVANTAGES

- Mostly mains power operation.
- No spot sources possible with this technology.
- Physically large fixtures.
- Color shift when dimming below 50%.

Fluorescent tube/bulb.

> Daylight balanced domestic or industrial fluorescent bulbs cost more than standard domestic fluorescents, are easier to match with daylight and have a better CRI, so replacing bulbs with daylight balanced fluorescents is a good low budget option if you can't afford Kinos.

LED

LEDs produce a soft light in an open face lamp, and dim with no color shift.

LEDs (light-emitting diodes) can either be 3000K, 6000K or can be RGB, which makes them adjustable to any color temperature. This is a big advantage, as, once rigged in a set or studio, there is no cost or time involved in changing the color temperature.

Luminous efficiency: up to 1500lm/w, which is very efficient, so the lamps are very cool and can be handled without gloves. They can be placed near actors in small spaces, such as cars, and integrated into the set. Flat LED panels or LiteMats can be attached to windows, to make it appear that light is coming from outside. Ribbons of LEDs can be integrated into the set almost anywhere.

CRI: 90+ for LEDs made specifically for film (domestic LEDs have a low CRI rating of between 25 and 60, which would make them produce odd colors if used on film).

When at full power, and powered by batteries or DC power supply, LEDs are flicker-free. When dimmed, flicker can, in some cases, be a problem.

LED panels, such as Celebs, are the new default soft light source, and often used for fill or ambient light on a set.

They are lightweight, so lamps such as LED sky panels can easily be hung from a grid.

Low power consumption makes them environmentally friendly, and they are insensitive to shock so don't break easily.

Not all LEDs produced commercially have a high CRI. The ones used for film lamps have to be hand-picked from production lines, to make sure that there are no randomly occurring differences in color temperatures between bulbs.
Paul Royalty[12]

LED panel showing tungsten balanced LEDs at uneven brightnesses. Photo by Adrian Pircalabu.

> A useful low budget option for simulating a computer screen or phone light is a flat LED domestic lamp, such as the one made by Energizer.
>
> As a domestic lamp, the CRI may not be suitable for general use when filming, but as a single-point source of light simulating a screen, it is not problematic for the color temperature to be slightly different to the rest of the shot.

There are LEDs available in virtually every housing, but LEDs are currently still expensive for their total light output. LEDs are generally still less powerful than tungsten lamps, so less suitable for wide shots, but for closer shots they can be put closer to the subject than most tungsten lamps, so are very useful.

Evenly bright film lamp LEDs. Photo courtesy of Arri (www.arri.com).

F: LIGHT AND LIGHTING

LED ADVANTAGES

- Highly efficient, requires very little power to be operated.
- Operated using DC battery power as well as AC mains power.
- Can be tuned to many different colors with the turn of a dial.
- Lamp life is extremely long: around 30,000 hours.

LED DISADVANTAGES

- Expensive.
- Large power LEDs are not yet available.

Lamp Housings

Open Face Lamps

Open face lamps don't have a lens in front of the bulb, so don't reduce the output from the bulb. They can be spotted or flooded to narrow or widen the spread of light, but particularly when spotted the light is brighter in the center than the edges. Because the light is not focused forward, it spreads in all directions and often spills out from the barn doors.

Open face lamps produce harsh, unflattering light with hard shadows, so are usually diffused if used as a key light, or bounced into a reflector or the ceiling, to become a larger softer source.

Open face lights were traditionally tungsten but there are now LED and HMI options.

Atlas Construction lights are tungsten halogen, and can provide a low-budget alternative to film lamps and have a color temperature of between 2800K and 3200K.

OPEN FACE LAMPS: ADVANTAGES

- Simple design
- Cheap
- Lightweight
- Produces a sharp-edged shadow

In an open face lamp, the bulb is directly visible Photo courtesy of Arri (www.arri.com).

DISADVANTAGES

- Fixture gets very hot
- Bulbs blow easily
- Difficult to control light direction

Fresnel Lamps

Fresnel lamps have a lens at the front that directs the light forward and creates a less harsh, more evenly spread light than from an open face lamp. Fresnel lamps are more suitable than open face ones for using directly on an artist. Available in a great many sizes, between 30W and 20000W,

there are tungsten, HMI or LED options available from different manufacturers. Tungsten Fresnels are 3200K and are usually cheaper, although also hotter, than LED or HMI equivalents.

FRESNEL LAMPS: ADVANTAGES

- Have a protective housing and front lens in case of bulb failure
- Produce an even and direct beam
- Are easy to control and soften
- Wide variation of beam angle control
- Beam can be augmented to create background shapes

FRESNEL LAMPS: DISADVANTAGES

- Expensive compared to open face lights
- Get hot (unless LED)
- Bulbs can be expensive (especially if HMI)
- Heavier than open face fixtures

Dedolights

Have magnifying lenses that make the beam more controllable and directable than a Fresnel. Dedolights can also have a proprietary projector attached. Dedolights are small lightweight lamps and are only used with relatively low-powered lamps but remain very useful because of their controllability and precise throw. They are often used to pick up small parts of the frame or to create eye-lights, etc. The Dedo Octadome Panura is a successful expansion of their range and is a soft light with a big soft box around it, which produces a nice, directional soft source.

Tungsten and LED Dedolight options are available.

Par lamps or par cans

Par lamps have a parabolic aluminized reflector.

The term PAR refers to the reflector type and can be used in fixtures that appear very different.

Mini Brutes arrange a series of (usually tungsten) par lamps to create a powerful, even light, that with additional diffusion creates a powerful even large soft source.

Par lamps are in open face heads and always come with a lens kit, so they can be spotted or flooded to varying degrees, depending on the lens used. Small, battery-powered 'pocket pars' are also available.

There are tungsten, HMI or LED options available from different manufacturers.

A Mini Brute is a panel with six par bulbs. Photo by Adrian Pircalabu.

A Fresnel lamp has a lens over the bulb to focus the light. Photo courtesy of Arri (www.arri.com).

Dedolight with projector attached. Photo courtesy of Dedo Weigert Film.

F: LIGHT AND LIGHTING

Bank and panels

Have a slim profile and can be used horizontally or vertically. Many of them are modular and can be connected together to create large light sources.

When using banks or panels, the beam of light is squarer, so for large spaces you don't have to blend circles of light.

- Banks or panels may contain tungsten Par lights, LEDs or Kino tubes.
- Kino and LED options are cool, so can be used close to artists.
- Tungsten par options are hotter, but can produce higher light levels.

The downside of lamps with grids of par bulbs is that they can give multiple shadows and may need to be further softened to merge the shadows. In the very large and powerful Wendy lights, the bulbs are closer together and offset, so the shadows aren't obvious and, at a distance, appear as one light. Wendy lights can be slimmer and cheaper than HMIs, and quarter Wendys are available as smaller sources.

> Bathroom or bedroom strip lights are a good low cost option that can be used as a bank of lights.

Kinoflo panel. Photo by Adrian Pircalabu.

Space lights

Traditionally space lights consisted of three 1k (kw) tungsten Nook lights with a skirt over them. Now, LED equivalents or sky panels with a skirt over them are used. Space lights are designed to create an even illumination over a large space, for green-screen work, to simulate sky light in a studio, or to provide a base light level before additional lighting is added.

If the white chimera silk is replaced with black silk skirts, the soft light is directed downwards, creating pools of soft light. LED sky panels are starting to replace space lights because their color temperature can be changed remotely, but LED panels are not appropriate for the black skirt option, which creates pools of light.

Space light. Photo by Adrian Pircalabu.

Chinese lanterns

Chinese lanterns are used as soft fill lights. They are supremely flexible, movable and dimmable, and are often used on a boom from the camera position, to provide a fill light during a moving shot. LED spring balls are the new equivalent to Chinese lanterns and serve the same purpose, but are more flexible in terms of color temperature and are cooler.

> Most low budget filmmakers make their own Chinese lanterns, either with a kit or with parts, including a dimmer, bought from a hardware store.

NOTES

1. O'Leary, Bill. "Revolutionary Road" *American Society of Cinematographers Magazine.* January (2009): 2.
2. Oliver Stapleton BSC (DP) in discussion with the author (July 2017)
3. Steven Poster ASC ICG (DP) in discussion with the author (March 2017)
4. Film Riot. "Quick Tips: DIY Lighting Kit!" *YouTube*, March 24, 2015. https://www.youtube.com/watch?v=qSTGnl7HHao
5. Sareesh Sudhakaran, "Learn the Techniques of Great Cinematographers". Wolfcrow Cinematography (n.d.). https://wolfcrow.com/understanding-the-cinematography-of-great-cinematographers/
6. Nadia Latif (2017) *'It's lit! How film finally learned to light black skin*. The Guardian September 21, 2017.
7. Petra Korner AAC (DP) in discussion with the author (September 2016)
8. Roberto Schaefer ASC AIC (DP) in discussion with the author (September 2016)
9. Andrew Boulter (DP) in discussion with the author (September 2016)
10. Paul Mackay (DP) in discussion with the author (September 2016)
11. VMI. "Lighting – a short walk through the minefield of location lighting for Film & TV". http://vmi.tv/training/useful-stuff/VMI_Guide_to_Lighting+
12. Royalty, Paul. *Litegear*, in discussion with the author (February 2017).

13
Lighting Locations and Studio Sets

Whilst a great deal can be achieved with natural light, using film lamps (or equivalents) allows you to create lighting that you might have to wait a long time for on location. Lamps can be used to model and shape the actors and environment, draw attention to different parts of the set and create a visual tone that helps tell the story.

This chapter provides a step-by-step guide to the process of lighting and what to look for when setting key, back, fill light and how to integrate and balance them with set lights. It gives guidance on lighting day and night exteriors and interiors on sets or locations, how to light difficult spaces such as stairs, halls and car interiors, and how to light a green-screen for VFX. It continues by looking at managing light changes during shots and how foggers and wet downs affect lighting and sets. The chapter finishes by looking at simple approaches to lighting that are effective when you have very little time and how to work effectively with the lighting department.

LEARNING OUTCOMES

This chapter will help you:

1. Make appropriate choices of lamps and lighting equipment when working on sets or locations
2. Plan an efficient order to light in
3. Understand why and how to shoot the master shot first, then adjust the lighting for medium and close shots
4. Understand the benefits and techniques for lighting the performance space and set separately
5. Know techniques for lighting very simply when you have very little time
6. Work effectively with the lighting department
7. Have techniques to light the following:
 a) Night interiors and exteriors
 b) Green-screen
 c) Car interiors
 d) Halls and stairways
8. Know how to work with smoke/fog

F: LIGHT AND LIGHTING

DIFFERENCES BETWEEN LIGHTING STUDIO SETS AND LOCATIONS

Lots of producers think that because current camera sensors are faster you don't need to light well. You still need to light because of the role lighting plays in telling the story, you just use less wattage . . . Faster sensors don't really speed me up. I'm not slow because I try to come up with simple solutions.
Roberto Schaefer[1]

Lighting allows the cinematographer to create the desired mood for the snooker hall and the precise levels wanted on the model and product. Photo by Ilya Rashap.

Given the choice between hiring lights and upgrading the camera to one that responds better in low light, I would almost always choose the lamps.
Josh White[2]

Lighting used to create shape and definition. *Pan's Labyrinth* DP Guillermo Navarro.

Dedo Panura soft lights used in conjunction with natural light on location. Photo courtesy of Dedotec Russia.

A location is any space used for filming other than a purpose-built studio. Shooting on location either involves working with ambient natural light and film lamps together (which requires adapting your lighting as and when the ambient natural light changes). Alternatively, you can block out the natural light, but this may well result in the location getting very hot.

- If working on location, it is essential to make sure you or your gaffer know the power supply available and work within its limits.
- Also, ensure that the lamps you take are practical to use within the space.

There are many ways to use lamps on location other than placing them on stands. They are often hidden behind furniture or props so they are not seen in shot. Alternatively, if they are light and cool enough, they can be supported by small table-top stands and placed on furniture or attached by clamps. In suitable locations, they can be suspended from a sprung bar known as a pole cat that creates a secure bar between two walls. Professional supports are purpose designed and will hold lamps up to specified weight securely, if used properly.

A studio set is created in a dedicated space for filming, is usually larger than a set on location and has no natural light coming in. Being larger than a location set and because there is usually at least one removable wall, it is usually possible to position lamps and cameras either higher up or further back, which helps keep them out of shot and means that, due to the inverse-square law, light will not fall off so quickly and actors can move further without light levels changing.

13: LIGHTING LOCATIONS AND STUDIO SETS

(top) Clamp and adaptable arm, (middle left) spigot to support a small lamp, (middle right) gaffer clamp with two spigots, (bottom) 'pole cat'. Top and middle left photos courtesy of Dedotec Russia, middle right and bottom photos by Adrian Pircalabu.

(top) Studio lighting grid, (bottom) design and lighting working hand in hand to create a high-contrast back-lit look on location. Top photo by Bastian George, bottom photo photo courtesy of Dedotec Russia.)

In a studio there is usually a larger power supply than available on a location and there may be a lighting grid. A sound stage is also soundproof. Not being affected by sound, light or activity outside allows you to work without being interrupted and to shoot scenes in whichever order is most appropriate. The cost of hiring a studio and creating the sets within it may seem high, but the speed and flexibility and potential for creativity should also be considered.

TIMING PRIORITIES AND PLANNING

When planning lighting, consider the time factor and the return on investment. How much time will this plan realistically take? Make sure that the 1st AD properly schedules it, so you are not scrambling to do a 2-hour setup in 30 minutes. Be truthful with yourself about how much time it will take. Ask yourself if the time invested will be worth it. For a simple shot of a character entering a building and going to the elevators, you could rig lights in a very high lobby and make it look like a commercial in 3 hours, but is it worth it? Is there another way to do it that is more efficient, but less 'perfect'? Will that work in the context of the story and film? We only have so many hours for filming, and need to be smart about how we use them. On the other hand, we don't want to get bullied into shooting bad footage because of bad planning. Pre-pro and the scout is your time to think about a workable plan and communicate your needs to production.
Dana Kupper[3]

F: LIGHT AND LIGHTING

Whether working in a studio or on location, on large-scale or small shoots, time is always a factor.

There is often not time to block the shots with the actors, so I talk to the director to find out what is happening and light it roughly, often by just supplementing the ambient light with a key light that is small enough to be able to be used as 3/4 front light. Then we rehearse and when the talent is in place I tweak the lighting and keep tweaking between takes.

I get a couple of minutes to adjust the light for close-ups, but not more. I usually reduce the lighting ratio when going in for close-ups and am more careful about going outside the dynamic range.

It's hard when lighting alone, and slower, because you can't see the process. I could use a wireless monitor, but prefer to actually see it.

When working alone the smallest lighting kit I take all fits into one 2 x 10-inch bag. I take 2 bi-color LED panels which can switch between daylight and tungsten. An Aladdin eye light, which is battery-powered and very lightweight, to pick up bits and pieces and 3 x Nano stands, which are lightweight, have a small footprint and fold up very small.
Josh White

I get a pre-rigging team on the master. I already know where everything is going to go, then bring in lamps for closer shots. . . the bigger the movie, the more you have to do that. Timings vary according to how many lamps you use compared to the size of your team and if you are in a studio or location.
Petra Korner[4]

The order of play for lighting depends on the production, schedule and crew. You do a scout and tech scout and then tell the gaffer, rigger and rigging grip the basics of what you want and how you want it. Hopefully by the time you get on set it's all sketched in. You have a run-through and tweak from there. You can find yourself in trouble if people don't work well on their own initiative – then you need to fill in about how things should be done. If you arrive and things aren't working as you thought they would, turn off lights rather than turning more on.
Roberto Schaefer

Just as you may adapt your plans on set, be prepared that the director may also have ideas for how the lighting should be adapted.

A DP can get sometimes get stuck on the ideas that they have in their head. I shot something recently, it needed it to be edgy . . . he DP didn't take the story into account. He made it look pretty, but that wasn't what the story called for. A DP needs to trust that the director is the captain of the ship.
Kellie Madison[5]

PRODUCTION DESIGN AND PLANNING

Design and art direction are important. In commercials, you can generally change things. I can get the color of the floor changed if I need to. Without good art direction, it would take longer and wouldn't look so good. If the set is bad, you can only make it look so good, but you can find yourself carrying the blame. Art Department is very, very important.
Andrew Boulter[6]

13: LIGHTING LOCATIONS AND STUDIO SETS

The location or design of the set will usually include motivating light sources such as windows, doors, interior lights, practical lamps and illuminated props such as TVs, consoles etc. The colors and textures within the environment will affect how light behaves, i.e. if it is absorbed, bounced or reflected, and have a considerable effect on the look you can create. Working with production design in pre-production allows you to influence the choices, so they work well for lighting. Choice of locations can have a huge positive (or negative) effect (see C11b) and make your work when shooting both more straightforward and more effective.

> *Production designers can be your best friend but sometimes they are just not up to scratch. Encourage them to build in as much set lighting as you can – you can always reduce it and turn things off. On* Quantum of Solace *the attention to detail was spectacular.*
> **Roberto Schaefer**

> *A set can be very powerful: if the designer understands light, you can create magic. I try to get the designer to include sources of light in the set or location.*
> **Chris Menges**[7]

(top) Set design with built in lighting in *2001: A Space Odyssey* DP Geoffrey Unsworth, (bottom) color palette, props and set dressing are as much a part of design as sets, *La La Land* DP Linus Sandgren.

Lighting Plans

Lighting plans should show the position of the camera and the position of any or all of the lights that you want to plan before the shoot. Small lamps to create accents or back lights are not usually included. There are two purposes for lighting plans. First, so you have thought through where you will place your lamps which saves time on the shoot and allows you to anticipate their effect. Second, to communicate with your gaffer or others who will be setting up the lamps when you aren't there. Plans should be appropriately simple or complex, i.e. including lamp types, sizes and wattages and any flags or diffusion depending on what information you need to convey to who.

Color Temperature Planning

To create an overall cool look, the color temperature of the camera should be set lower than the color temperature of the lights (see the left-hand frame from a morning scene in *Florence Foster Jenkins* below). For a warm look, it should be higher.

(left) Cool color temperature used in a morning scene and (right) warm color temperature used in evening scene. *Florence Foster Jenkins* DP Danny Cohen.

F: LIGHT AND LIGHTING

Adobe stock image.

Most monitors	6500K
HMI LAMP (noon sunlight) Daylight balanced LED	5600K
Early Morning/ Evening Sunset	3500K
TUNGSTEN	3200K
Tungsten balanced LED	3000K
Candle	1800K

The Kelvin (K) scale from infrared at the bottom to ultraviolet at the top showing the position in degrees of Kelvin of film lamps, equipment and natural light sources.

The color temperature of the lamps in use should match, or there will be odd color casts over parts of the set or actors. Older bulbs, lamp faults and dimming can all affect color temperature. On a larger shoot, in pre-production the gaffer should have checked the color temperature of each lamp to check that it is correct. If this hasn't been possible or one appears mismatched, check if the lamp is off color with a color meter and swap it out if needed. Occasionally, if a lamp is off you can put a filter on it to balance up the color temperature, but lamps are rarely off by a convenient filterable amount. It is important to keep an eye on color temperatures, particularly when lamps have been dimmed, because it is very difficult to grade out mismatched color temperatures in post-production and causes problems matching shots with VFX. When you want to create a warm shaft of light or, as in the morning scene at the bottom of page 315 the practical (in this case bedside) table lamps to appear warm, you need to choose an appropriate color temperature bulb or gel to modify it and, if you use more than one of the same type of lamp, be sure that they match. In this example they are warmer but not excessively warmer, so will have been modified by either adjusting the RGB balance if they are LEDs or by using gels.

Whilst maintaining color temperature is a technical task, the choice of when and where to create warm or cool light has a huge psychological impact on the viewer and is explored in C14.

THE ORDER AND PROCESS OF LIGHTING

When lighting, you choose where to put the lamps to model the actors and light the set, and which areas to block the light off. You must also choose where and when to use hard or soft light and what the color temperature of the light should be. It is very easy, once on set, to forget your research and planning. When dealing with the practicalities of lighting and seeing how the light falls on set (which may be different to how you thought when you drew lighting plans), remain guided by how you intend the light to look to ensure that it fits into the scheme for the whole film.

When lighting on set you are balancing the practicalities of the situation you are in with the aims you have whilst working within the time available and the dynamic range of the camera. It becomes a balance between using your experience and responding freshly to each scene you light. Having an organized, logical approach to lighting helps the team you are working with and helps you build a body of knowledge for the future.

I know short cuts for how to achieve certain shots . . . repeating techniques I've used before but adapting them for the current job.
Andrew Boulter

13: LIGHTING LOCATIONS AND STUDIO SETS

Having an organized approach and a clear concept of what you are trying to achieve in your mind helps stop you getting bogged down in the arrangement of what can be large quantities of lamps and light-modifying equipment on set. Photo courtesy of Dedo Weigert Films.

- Light from the camera position so you can see how the light is falling in frame.

- Light for the wide shot first and make sure the lighting can be adapted for the closer shots in the same direction.

- Which lamp is set first depends on which light level has the least flexibility. If you want the level of key light on an actor to be at the same stop across several scenes to get a consistent look, then set that first.

- If you only have a certain number of lamps to create your background lighting with, set that first and make your key light work with the level you can achieve on the background.

- If you need to include practical lamps and can't adjust how bright they are, then they might be the first level you measure and you will then have to set the level of the other lamps to work with them.

- Make sure that only one light is illuminating each area, because it prevents double shadows, makes lighting more logical and if you need to change one lamp it doesn't affect too much else.

- The exception to this is if you need to create a large soft key. You can pump a lot of lights through diffusion to create one large source, but beware that if you are seeing the ground you need to check for multiple shadows.

Light for the wide shot first, then lamps are brought in for the closer shots. (top two shots) *Pan's Labyrinth* DP Guillermo Navarro, (bottom two shots) *The Crown* DP Adriano Goldman.

317

F: LIGHT AND LIGHTING

Don't use too many lights, especially at the beginning. Single-source lighting can be the most beautiful thing. It's really important to know and understand your key light: what direction and angle it is coming from, and the quality, distance and size of it. Understand the story you are telling, and choose your light accordingly.
Petra Korner

On smaller shoots, many DPs set the key light first because it is a practical and logical way to ensure you get the look you want on your subject. If setting the key light first:

- Set the key light to come from the direction of the source that appears to be motivating it (such as a window, a practical lamp or TV screen), using a lamp that will give the required spread and color temperature.

- Move it slightly until you get the shape of lighting on your subject that you want and measure the light so you can gauge how much brighter or darker to make the rest of the lighting.

- Flag off any light from the key light that hits areas you don't want it to.

- Decide on the lighting ratio for the fill and whether to bounce or use a lamp to create it. If the set is light in color or going to be brightly lit, it would be more sensible to do this after the set lighting, as some light will bounce back from the set.

- Watch and measure the fill as it is set and adjust it for the desired lighting ratio. Then flag off any unwanted fill light from the rest of the set.

(top) In this shot from *The Grey Area*, the key light is from a light box. We simulated the light box with an open face lamp underneath a sheet of diffusion. Photo courtesy of Bhavan Rajagopalan. (bottom) In this shot in *Ali and Nino* DP Gökhan Tiryaki the key light is from the window.

The amount of fill you needs depends on how much light is being reflected in the environment and the lighting ratio you want on your subject.

Measurements are important but your eye and creative instinct are important too. This scene feels too happy, the mood should be gloomy. Why does it feel this way? What can I do to fix it – these are questions you ask yourself.
Dana Kupper

- Light the areas of the set you want to stand out and flag the light off the areas you don't want it (the set light should rarely be as bright as the key light, or it will draw the viewer's eye away from the action).

- Set practical lamps.

- Set additional lamps to emulate light from practicals that would fall on your subject, or set at any time during the shot and flag off any unwanted light from them.

- Set any additional lamps and flags to create accents of light where needed

It isn't crucial to light in this order, but it allows you to see the effect of the lamps as they build up and adapt your plan as you go. Giving the gaffer your plan or talking them through your ideas as soon as possible allows them to get distribution (the power supply and cables) and as many lamps and stands in place as early as possible, so saves time.

13: LIGHTING LOCATIONS AND STUDIO SETS

Lighting for Wide Shots

If your space is large, lighting the set and the performance space with different lamps makes sense and helps you make sure that each lamp is only doing one job. It also means that if you need to change the light on any one area or on one person, you don't have to alter much else.

It might seem like irony that the bulk of time is spent lighting the establishing (wide) shot. It's not on the screen for very long, but it creates the picture that the audience takes away with them; the book cover, the one that sets the mood and paints the world the film is set in.
Petra Korner

(left) *The Waiting Room* DP Tania Hoser, the wide shot was lit first using concealed lamps to light the columns on set and HMIs outside as the key light on the actors. Smaller HMIs were set up inside to create the key light for the closer shots. (right) In the bar scene in *Good Will Hunting* DP Jean-Yves Escoffier, many practical lamps are used as part of the lighting to achieve an overall light for the scene, but for this mid shot both an additional key light and either reflected or lit fill will have been brought in to create the optimal look and balance between the level of light on the actors and the background.

It isn't wrong if you find that a lamp does two jobs, e.g. a set light may provide a key or a fill at a particular point when an actor moves, but it is more straightforward not to design the lighting for double purposes. Using different lamps for different purposes helps keeps lighting simple and logical. In smaller spaces it is more likely that lamps will serve two purposes; for example, a key light on your actor may also serve to cover part of the background. This can work well if the actor is static, but watch carefully to see how any move affects the lighting. Also watch for unnatural and double shadows, and light from the side if needed to avoid this.

Lighting Medium Shots

When moving from a wide to a medium shot you have the opportunity to re-frame to feature the elements of the set that will help tell your story. In many cases, the lighting ratio is reduced slightly in medium shots, but on occasions it can be increased for dramatic effect. For example, if there is a window at the side of the frame in the wide, it can become a back light or be used to create a bright area against which to silhouette the actors.

Lighting Close-Ups

Light in close dialogue shots tends to be used in a more flattering way.

- Lamps are brought in closer if needed.
- Light is often softened.
- The lighting ratio is reduced.
- The aperture is opened up to soften the focus on the background.

F: LIGHT AND LIGHTING

Far from the Madding Crowd DP Charlotte Bruus Christensen, showing the contrast ratio far lower on the (right) MCU – medium close-up than on the (left) wide shot.

MCU with a high lighting ratio from *Lost Girl*, Season 2 DP David Greene.

Like all 'norms', this isn't a rule and the option to increase the lighting ratio for creative reasons between the wide and closer shots (particularly in non-dialogue close-ups) should also be considered.

SETTING LAMPS

Key Light

If your key light is narrow, astute actors will hit their marks or feel the light to find it. You can light broader if they can't manage that, but if you are shooting a film noir then you need them to hit their marks so the light hits them.
Roberto Schaefer

I like using what's called a 'skip bounce'. If I punch a very hard light into the floor, or a surface like a table, the actor gets an imperfect and strong bounce back, which carries the color of the environment. It's something that would be a coincidence in real life but looks great and less contrived than always conveniently aiming the sun at the characters.
Petra Korner

- To set a key light, first decide what light source it is emulating.

- Then look at the person who will be lit by it and see how the light would fall on them from that source during the whole of the shot if they move.

- The position of the key light doesn't have to be exactly the same as the source it is simulating and can fall more widely or tightly than it would in real life. This allows you the creative freedom to position the lamp to create the optimal lighting for your actor and cover any move they make.

- Choose lamps that will create the color temperature, hardness or softness of the key light that you want to simulate. Sunlight can appear to be hard or soft, as it varies in real life, but do keep fairly true to your sources: if the key light is from a computer, use a soft light to create a glow. If you want the scene to feel on edge, make the soft light more directional, but don't use a hard light or it won't be believable.

- Because light levels are reduced by diffusion, if you think you might need diffusion, add it first or use a slightly larger lamp than you need, so you can dim or diffuse it later without having to swap the lamp for a larger one.

- If the key light has to cover a larger area to allow for movement, either use a bigger lamp further away and then flag off any areas where you don't want the light, or use several lamps to cover

13: LIGHTING LOCATIONS AND STUDIO SETS

parts of the area but make sure they don't overlap (see C12). Also make sure the color temperature, hardness and direction all match, so the light appears to be coming from one source.

- As a person moves during a shot, their key can appear to come from a different source, i.e. when they move out of the window light and are then mainly lit by an interior light.

- Key light doesn't always have to come from the most obvious source. It could be a reflected light from a shiny object that creates a hard and interesting key light on an actor.

- If there isn't an apparent light source to motivate your light, you can simulate a source by putting gaffer tape strips in a frame and putting a hard light through it to cast shadows on your subject that look like blinds or a window frame. The wider the shot, the harder this is to do.

An alternative from of key lighting known as a skip bounce is achieved by bouncing a strong light into the floor or another reflected surface so that the reflected glow lights the subject.

The horizontal shadows created through the blinds and the shadows of the action reinforces the sense of being trapped very effectively in this shot from *Blood Simple* DP Barry Sonnenfeld.

Balancing Set Lighting and Key Light

One of the most significant immediate impacts on the viewer is how bright most of the background is compared to the actors.

In *Anna Karenina* DP Seamus McGarvey, theatricality is incorporated into the mise-en-scène (staging) of the film, which is shown in this shot by having a higher degree of contrast between the background action and the central characters.

321

F: LIGHT AND LIGHTING

The more even the balance between the level of light on the performers and the set, the less 'lit' the look (although if it is completely even, the eye will not be drawn as easily to the actors). The greater the difference and the narrower the key light, the more theatrical it looks.

The light sources that are designed into the set are the sources you simulate with your film lamps. If the designer or location scout includes interesting light sources, it gives you far more options of where to light from and options for creativity.

- You can add additional light sources – to simulate a window, for example, you can use a flat LED panel. Alternatively you can create additional sources with practical lamps, ideally replacing the bulbs with LEDs, because they are cool and controllable.

The lighting you create needs to match the period, the mood, the story and the moment, so the options are endless. For lighting design ideas, look at films with similarities of styles or periods but also look at other relevant visual sources such as art or illustrations or photographs. If your set is contemporary, an online image search – for example, for dining rooms can also help you come up with good ideas (this should be done in pre-production).

Remember that your job is both creative and functional. Be aware and check that no lamps or lighting equipment will be in shot as you move or pan the camera.

Both shots have a window as the motivation for their key light. (top) In this shot from *The Assassination of Jesse James by the Coward Robert Ford* DP Roger Deakins, the décor of the room is lighter, so the lighting ratio is slightly lower than in the darker décor in the bottom frame which is from *Ali and Nino* DP Gökhan Tiryaki.

Lighting large spaces

If you only have few lamps or very little time, large spaces can be lit simply by lighting something in the foreground, something in the middle distance and something in the background.

You can make sure either that the main action occurs in one of the lit spaces or that the action is silhouetted by a lighter area behind it.

Fill Light

Fill light doesn't have to be motivated, but if the surroundings are dark it would be odd to have a very low lighting ratio, as that wouldn't happen naturally.

The wider the shot, the more difficult it is to fill, especially when the camera is far away from the subject.

Fill light is usually either placed opposite the key light or from the position of the camera. Using a 3/4 back light as a key allows you to position the fill light near the camera and so control the level of fill in a wide shot without needing a large lamp set further back, to avoid your fill light being in frame.

If you want a higher ratio of 3:1 or more, i.e. to have the key stronger than the fill, you can often but not always, bounce the light. If you want a lower ratio, i.e. 2:1, or less, you usually need to use a lamp. If using a lamp, beware of double shadows.

Fill light doesn't have to appear to be from the same source as the key. It can be from a completely different source. Even when coming from a different source, it shouldn't create distracting double shadows.

Back Light

Should be positioned where it can't be seen and doesn't cause flare. A small lamp used for backlight may often be clamped to the top of a set or piece of furniture on set. Backlighting must be set precisely for your subject but usually affects little else on set so can be positioned at any point.

DRAWING ATTENTION TO DIFFERENT PARTS OF THE FRAME

Lighting is not just about deciding where light falls. It is just as much about deciding on the quality of the light and how and why to let the light fall on some areas and not on others. Once the shot has been lit, take an overview to assess how adjustments can be made to draw the viewer's eye to specific areas and away from others, to both tell the story and enhance the aesthetic of the image.

Practical Lamps

Using and adjusting the position of practical lamps allows you to draw the viewers' attention to parts of the frame, balance elements within it or create pools of light. They can also become the motivating light for close-ups. It can be helpful to have small additional lamps on standby, such as Dedolights that can emulate the light of a practical and allow it to reach a person or part of the set you want to highlight without spilling too far. Check on the monitor for any hot spots created by the bulbs in practical lamps. If needed, line the lampshade with ND gel or replace the bulb with LED ribbon wrapped round a tube such as the inside of a toilet roll.

Florence Foster Jenkins DP Danny Cohen.

F: LIGHT AND LIGHTING

Flags, Nets and Cookies

After your lamps are set, use additional flags and nets or cookies to reduce the level of light on particular areas or to break it up. If cookies or equivalents are used, they break up the light rather than reduce it, so watch from the camera position as they are set to be sure that the brighter areas are where you want them.

Creating Slivers and Accents

Another way to draw attention to part of the frame is (as per C12) to use a pair of flags, close together or black wrap, with a slit in it to create a sliver of light to pick up and accentuate part of the frame. Work with the gaffer so that, as soon as the main lamps have been set, some of the grips are setting the flags for slivers and accents while others are finalizing the lighting.

COLOR TEMPERATURE TWEAKS

Pay particular attention to adjusting color temperatures so that light matches light sources, and if you are using mixed color temperatures pay particular attention to the aesthetics of how well they are balanced, i.e. be really sure they look how you want, because mixed color temperatures are hard to alter in post-production. Use 1/8, 1/4 or 1/2 CTO or CTB filters to make adjustments, or color gels if you are creating color effects (see C14).

DIFFUSING WITH SMOKE – FOG

What is often called smoke on a film set is fog. Smoke is created by a chemical process when something burns and is dangerous. Fog is either water or oil particles suspended in the atmosphere and (unless unsuitable oils are used) is safe. Fog:

- Diffuses the light and, unlike a filter, has a greater impact on the light further away than the light closer to the camera.
- Makes any shaft of light passing through it visible, because the droplets are lit up by the light.
- Is visible and patchy throughout the frame if it is too heavy and isn't dispersed thoroughly.
- Even if evenly dispersed, it will still pick up light and add about 1 stop to the level of the ambient light.
- Changes the quality of the light and lowers contrast. A degree of contrast can be added in post without losing the effect of the diffused quality of light.
- Gives a slightly hazy atmosphere and can sometimes help a stark shot look more interesting, but shouldn't be relied upon to do so.

I use a Hazer cracked oil smoke machine, which gives an even coverage. I leave it running during the shot and the trickle of smoke helps maintain the level.

You want to see it, but only just; you don't want to see it moving. Have the smoke wafted away from the camera just before you shoot. It's never easy because of the variables of air conditioning, windows and temperature. I learned by trial and error . . . If you use smoke and shoot wide open, the smoke [and shallow depth of field] will hide what is going on in the background.
Chris Menges

13: LIGHTING LOCATIONS AND STUDIO SETS

DAY EXTERIORS

A lot can be achieved with sunlight, with or without diffusion or butterfly frames on bright sunny days (see C11b), but less so when the light is dull or changeable. It isn't necessary to use lamps for illumination, but changing the direction, intensity of color and shape of the light using lamps allows you to create the modeling and quality of light that you want.

- Usually wide day exteriors are not lit, but medium and close shots often are.

- HMIs are the most frequently used lamps for day exteriors. They are daylight balanced, are controllable and have a high output to power ratio.

- For day exteriors they are often put through trace frames to create a soft directional 'sunlight'.

- If using an HMI when the sky isn't overcast, watch out for (and avoid) double shadows.

- Bounce is usually reflected, but can be lit so long as the light exactly matches the color temperature of your key light.

DAY INTERIORS

When shooting day interiors, the window(s) are usually the most logical sources of light. Use an app or flight logistics calculator to work out what time of day the sun will shine into the room because, whether you use natural daylight or lamps as your source, the ambient level will be substantially increased when the sun is shining directly into the room.

If windows are seen in the shot, to see detail outside (depending on the dynamic range of your camera) they should read about three stops over key.

The mood if the interior is substantially affected by how much brighter the light coming from the outside seems to be than the rest of the room. If the décor of the room is dark, it makes it easier and more logical to have a greater contrast between the 'sunlit' areas and the rest of the room.

You can either: work with natural sunlight as your key light, compose your shot for the direction it falls and use lamps to match its brightness; or use lamps to create your 'sunlight' so that you have more control of the direction and intensity of it.

- If you need to work very quickly, try using a fill light to balance the natural key light on your actor, and bouncing a light into either the middle of the ceiling or the opposite corner from the key light to bring up the ambient level of the rest of the room.

In these shots from *Grandma* DP Alan Stewart, lighting was brought in for the a day exterior close-ups.

HMI Lamps put through two trace frames to create a soft, even simulated, sunlight indoors. Photo by Adrian Pircalabu.

F: LIGHT AND LIGHTING

Using this technique is quick and easy, but means you have to frame the shot for the natural key light.

- Alternatively, try placing a lamp out of shot above or next to the window or outside the window, to simulate the sunlight so you can adjust the direction it is falling to better suit your framing.

- If placing lamps outside, HMIs with diffusion are a good option, because they are powerful and daylight balanced, and with diffusion are very convincing as sunlight. If inside, particularly if space is limited, Kinos or LEDs are a good option, because they are soft, cool, can be daylight balanced and usually flatter, so can be placed very close to walls.

- To emphasize the strength of the sun and separate the person from the background, you can add in an additional back or rim light if it appears to be coming from roughly the same direction as the key.

- Use bounced or soft fill light to bring up the level of the rest of the room, to get the lighting ratio and the balance between background and foreground you want.

- Add accent lights or block lights off any areas you want to adjust.

When working in studios:

- Use space lights or sky panels to create an ambient level of light, and then use lamps as above to model your actors and light the set.

- To emulate early morning or late afternoon or evening, keep the light off the top of the room by adjusting the position of the lamps, the barn doors or using flags.

For kitchen and bathroom sets, I use space lights to give a general look, then create contrast with back light and use diffused fill to give a soft glistening look.
Andrew Boulter

NIGHT INTERIORS

When creating night scenes, the shadow areas – the 'negative spaces' – are the spaces filled by the viewer's imagination. When you visualize, it is not just about how the light will lead the eye, but also about how the dark will lead the imagination.

All light sources at night are less powerful than the sun, so have a faster drop-off than sunlight and won't bounce and create fill in the way that sunlight does. Night interior lighting covers a huge range of situations.

A number of conventions and working practices have developed that characterize night interior lighting. These don't have to be adhered to but are useful to know and adapt.

- The light is kept off the top of the room, either by being flagged off or by positioning the lamps so the top of the walls aren't lit.

Negative space is used to frame the action in both of these night interior shots. (left) this shot from *The Assassination of Jesse James by the Coward Robert Ford* DP Roger Deakins shows a fast drop-off between light and shade when the subject is close to the light source. (right) In this shot from *Inherent Vice*, DP Robert Elswit also shows the use of cool blue for moonlight, as compared to warmer interior lighting.

13: LIGHTING LOCATIONS AND STUDIO SETS

A United Kingdom DP Sam McCurdy.

- There is a greater difference in the brightness of the performance or lit areas than the rest of the set.

- Concealing lamps within the set is common, to create pools of light that illuminate parts of the room and leave the rest darker.

- Moonlight coming from outside is 'cooler', i.e. bluer, than the interior light. Blue or steel blue gels are often used for moonlight.

- Street light is only usually seen coming from outside when there appears to be no or few practical lamps in the shot. It appears 'warmer', more orange, than the interior. A mixture of gels – either CTO, straw or variations of mustard or yellow – is often used to create the color of street light.

When lighting,

- Use a lamp outside to produce your moonlight.
- If the moon is not your keylight, add an additional lamp to simulate your key.
- Use soft ambient light to bring up the light level of the room to avoid noise, if needed.
- Create pools of light with small tungsten lamps or LEDs in the areas your candles or practical are lighting.
- Keep your moonlight cooler than the interior light.

NIGHT EXTERIORS

- Create one strong key light (either with a single lamp or with a series of lamps that appear to be from one position) from the back. Adjust the height to get the length of the shadows you want. The earlier into the night or the closer to morning the shot should be, the longer the shadows; the lower the height of the lamp, the longer the shadows will be. HMIs are often used for night exteriors because of their high output and color temperature. On larger films, HMIs or Dinos (banks of par lamps) are often used on cranes.

- If people are moving in shot, your key light needs to be large and far away, or it will drop-off too quickly.

- Position the lamp carefully to create shadows that work for your frame.

- Shadows are usually hard at night so avoid using diffusion, which will also lower the output of the lamp, unless the light looks unnatural.

Drones and hot-air balloons can also be used to light large areas. For a low budget option use illuminated helium balloons, which have LEDs inside.

327

F: LIGHT AND LIGHTING

(top) *A United Kingdom*, DP Sam McCurdy using a wet down to create pools of reflected light and enhance the silhouettes. (bottom left) in *Django Unchained*, DP Robert Richardson creates a strong back rim light for definition. (bottom right) DP Robert Richardson uses a strong back light for the moonlight and a softer, warmer light from the oil lamp.

- The color gel used for moonlight is blue. Traditionally it was steel blue, but now people use whichever blue fits with the look they are creating, but be consistent throughout your film.
- For street lamps, use one of a range of orange gels.
- If desired, use smoke to add diffusion, raise the ambient light level by up to 1 stop and show any beams of light.
- Alternatively, wet down to add reflected highlights – but don't do both.
- Use a soft fill for a medium shot if desired.
- Fill more for close-ups depending on the lighting ratio required.
- If the key light isn't providing a suitable back light for the mid or close shot, bring in an additional lamp.
- If including other sources, such as street lights, car headlights, shop lights, or torches, check that the color temperature differences aren't too great and balance as needed.

13: LIGHTING LOCATIONS AND STUDIO SETS

WET DOWNS

In this night shot from *Dick Tracy* DP Vittorio Storaro, colors that are not usually visible at night are shown (human color vision decreases as darkness falls). The enhanced colors work alongside the increased reflections and spectral highlights achieved by the wet down to create the ethereal look of this shot.

When surfaces are wet, they shine and are more reflective, creating a little more bounced light and spectral highlights. The reflections also create points of interest in the shot.

LIGHT CHANGES DURING A SHOT

The four most commonly used types of light changes are:

- When one or more lights within the frame are switched on or off.
- Changes of light happen over time, e.g. from dawn to daylight, or from evening to night.
- Light changes when a door opens.
- Light for the whole scene transforms from one look to another.

When creating light changes:

- Light for the lightest state first and try to achieve as much as possible of the darker state by turning lamps off before adding additional lights to the set-up.
- Try to achieve the light change without pulling the stop, because this makes grading difficult and changes the depth of field. If you do need to pull stop, conceal it during a camera movement.
- Co-ordinate and rehearse timings with gaffer or lighting technicians and be sure the director is happy with the speed at which light changes happen, because it can be difficult to adjust them later.
- Practice placing and co-ordinate timings for flipping flags sideward or moving them in or out to simulate a door opening or closing.

F: LIGHT AND LIGHTING

LIGHTING GREEN-SCREEN

The purpose of a green-screen is to allow the green to be removed and be replaced by visual effects. The particular green is used because it is least likely to occur in skin tone or be used elsewhere on set. Design, costume and hair must ensure they don't use the same green. You must make sure that the green-screen is evenly lit and has no shadows on it.

- Use large soft lights to light it evenly. Try using space lights or sky panels if in a studio. Or try Kinos or LED panels if not. All these lamps can blend easily to create an even, soft light. (To cover the area needed for a green-screen, Kinos will usually be cheaper than LEDs.)

- If using other lamp heads, use a chimera (large soft box) to create a soft, even light.

- Check with a meter that the light levels are the same throughout.

- Don't let any light illuminating your performance area spill onto the green-screen. It helps to use a larger green-screen set back from the performance area if possible. If not, it can help to key light your performer with a 3/4 back or side light.

- Alternatively, green-screen can be shot outside on an overcast day when the light levels will be even. This can be a very effective low budget option.

- If possible, talk to the visual FX team and ask how they want it exposed (the optimum exposure depends on the program being used).

- Ask the VFX team if they would like cross marks on the green-screen, which helps them avoid parallax shift/distortions when putting images together.

CAR INTERIORS

LEDs that run on batteries or the car's DC 12-volt power are now the default (although not the only) light used to light car interiors. They give a soft, even light and can be positioned where needed.

They can be placed close to the subject, because they are cool.

They can be daylight or tungsten balanced or, using RGB versions, the color can be adjusted as required.

LEDs aren't always the right lamp for the job. You need to think about what the light should be doing and where it is supposed to be coming from.

HMI Par Sun Guns produce harder light and are often used to simulate street lighting coming into the car.

STAIRS AND HALLS OR CORRIDORS

Halls and corridors can be lit with:

- Light coming through open doors or windows.
- Overhead or wall fixtures, replaced with larger bulbs if needed.
- Either of the above, supplemented with additional soft lighting, usually from the camera position.

(top) Warm car interior lighting in *Moonlight* DP James Laxton, (bottom) In *Florence Foster Jenkins* DP Danny Cohen uses cool car interior fill light, complementing the colors of the exterior street lights.

Stairs can be lit with:

- Practical stair lighting on the edges of the steps.
- Light bounced into the top of the walls or ceiling.
- Practical lighting fixtures on the wall, with bulbs replaced if needed.
- LED ribbons or panels that are made to look like practical stair lighting.
- (If not seeing the ceiling in shot) a pole cat (see page 312) set up between the walls and a lamp attached to it to light from overhead.

The Conformist DP Vittorio Storaro.

If shooting upwards, stairway ceilings are often in shot, so it can be difficult to place lamps overhead.

If you try using a large lamp either behind the camera or pointing towards the camera, check how much brighter the actor is when they are near the lamp, because this may well look unnatural or odd.

Look at film references and also do an image search for examples of hall and stairs or stair lighting, for inspiration.

LIGHTING WITH VERY LITTLE TIME

The need to make a shot happen in next to no time happens to all cinematographers at some, or many, points. There are two options:

- Either use one strong key light with a high lighting ratio and a quick bounced fill.
- Or a single soft key from the direction of a motivated source rather than from the camera position.

WORKING WITH THE LIGHTING DEPARTMENT

The gaffer is head of the lighting department and plays an important role in a production by ensuring safe and consistent power supply. If it becomes unsafe to use the power because of the working conditions, weather or if the crew are too tired to work safely, it is the gaffer who 'pulls the plug' and so the unit has to warp.

There are two parts to the lighting department.

The first works from the power source to the lamp, including setting the position of the lamps. The second section looks after everything from the lamp to the subject, including trace frames, gobos, flags, nets and filters.

In the UK, both sections are supervised by the gaffer and they are all called sparks – other than the best boy, who is the first assistant to the gaffer and takes responsibility for managing the lamp heads. The sparks may also provide power for the monitor and rain protection for the camera.

In the USA, those working from distribution to setting the lamps are lighting technicians and supervised by the gaffer, who is the chief lighting technician. The second team, working from the lamp to the subject, are grips and supervised by the key grip. In all countries, the gaffer takes responsibility for the decisions about power supply, amperage and distribution.

Shooting and Managing the Power Supply Without a Gaffer

If you are working without a gaffer, you can distribute the tasks of setting lamps and grip equipment to anyone who is helping you. However, you must take responsibility for knowing the amperage that your lamps are drawing and checking it is within the limits of the power supply you are working with. If you are unsure and unqualified, pass the responsibility for finding someone who is qualified over to production.

To calculate how many amps you need to draw A = W/V, i.e. Amps = Watts/Volts. Make sure you know the voltage in the country you are working in, e.g. 120V for USA, 230V (is the most useful number) for UK and 220V for Europe.

If you know the amperage of your power supply, you can find out how many watts you can draw: use watts = volts x amps.

Do not use equipment made for use only at 120V in a country where the mains voltage is higher. Many items are dual voltage. You have to check. If it is only for 120V, you will ruin your equipment and run a high risk of fire.

If using higher voltage equipment in the USA, you will need a transformer.

Working with a Gaffer

I prefer to work with people who are better than I am at their jobs. I try to hire gaffers who know more than I do.
Roberto Schaefer

When working with a gaffer, how much detail you give about where the lamps should go and which lamps or grip equipment to use depends on the experience of the gaffer, what kind of working relationship you have and your preferred way of working. If you want to detail where the lamps and flags go, communicate your ideas clearly about which lamp to use, then give the direction, the height you would like the light to come from, if you want it to be hard or soft, and how far you need it to spread.

Alternatively, you could describe what you want the lamp to do and leave the choice of which lamp to your gaffer.

As your working relationship develops with your gaffer, passing as much work as possible to the lighting department allows you more time to work out additional lighting requirements and work on the shots or operating.

Once the lamps are set up, when you want to tweak them you can give the gaffer a measurement of how many stops to take an area up or down, or use a verbal scale from a 'nats' (very small) to a whole heap.

A good gaffer learns what the DP likes and will know how to get things done efficiently. A gaffer should also let you know if something is taking longer than expected and offer suggestions for solutions. If they don't, you should let them know that you would like them to help you out by keeping you informed.

When you are first learning to be a cinematographer it is very useful to work with lamps, ideally on other people's shoots. This enables you to learn how things fit together and understand the space and time it takes to set lamps and other equipment.

Lauren Haroutunian has made a useful video[8] showing lighting and production department working together and looking at a useful range of grip equipment.

NOTES

1. Roberto Schaefer ASC AIC (DP) in discussion with the author (September 2016)
2. Josh White (DP) in discussion with the author (September 2016)
3. Dana Kupper (documentary cinematographer) in communication with the author (August 2017)
4. Petra Korner AAC (DP) in discussion with the author (October 2016)
5. Kellie Madison (director) in communication with the author (March 2017)
6. Andrew Boulter (DP) in discussion with the author (September 2016)
7. Chris Menges BSC ASC (DP) speaking at Cinefest, Arnolfini Centre, Bristol, September 2016
8. Haroutunian, Lauren. "Pre-Lighting: FAN FRICTION". *RocketJump Film School*, December 11, 2015. https://www.youtube.com/watch?v=7yOTiScHmtw

SECTION G

Color, Image Control and Creating the 'Look' of the Film

Combining and Using All Aspects of Cinematography Creatively

14
Color, Image Control and the 'Look' of the Film

The look of a film affects how the story is perceived on visual, subliminal, psychological and emotional levels. Being inspired by the story and having the desire to share that with the viewer is what drives the search for the 'look' of the film and is the heart of the art of cinematography.

Bringing together knowledge of lighting, lens choice, aperture and shutter speed, the cinematographer controls the look of a film by nuancing the quality of light, color, sharpness and motion blur. There is no code for the meaning of each element, but it is the combination of how these elements work together that creates its impacts on the viewer.

This chapter starts by looking at the elements that make up the look of a film. It then goes on to look thoroughly at the creative use of color, color temperature and how to use charts to guide the colorist. This is followed by looking at the techniques for image control in black-and-white cinematography, and how color control affects contrast in black-and-white. The chapter then looks at the significance and techniques of sharpening and softening shots using flare, halation and diffusion. It concludes by comparing which aspects of the image are most effectively controlled when shooting with those that can be enhanced most effectively in grading.

> **LEARNING OUTCOMES**
>
> *This chapter will help you:*
>
> 1. Understand the role of color, color combinations and color palettes in creating the look of a film
> 2. Use white balance and mixed color temperatures appropriately
> 3. Shoot color charts appropriately to guide the color grader in post-production
> 4. Use different approaches for color and black-and-white cinematography
> 5. Understand the DP's role in combining all cinematographic knowledge and working with production design to create the look of a film
> 6. Combine choices of lenses, light and shutter speed or angle to increase sharpness where appropriate
> 7. Combine choices of lens, light and shutter speed or angle with diffusion, to soften the image where appropriate
> 8. Evaluate which aspects of the look you want to be carried out during the shoot and what should be done in post-production

G: COLOR, IMAGE CONTROL AND CREATING THE 'LOOK' OF THE FILM

IMAGINATION AND VISUALIZATION

DP Emmanuel Lubezki: (left) *A Walk in the Clouds*, (center) *The Revenant*, (right) *Birdman*.

Your job is to be the author of the visual aesthetics.
John Schwartzman ASC[1]

On each movie that I do, I like to find a specific language to tell the specific story.
Emmanuel Lubezki[2]

Photographic naturalness is something you absorb.
Oliver Stapleton[3]

The art of filmmaking evolves, and so does the audience. What appears natural and normal in a motion picture depends on what you are used to seeing. Black-and-white film was a norm before color was introduced. When video was developed, both how different it looked to film and its technical limitations made viewers feel it was unnatural. The video look became normalized in television production before finally moving across and eventually being used in the majority of movies. This was largely because digital developed substantially, and in many ways the gap between the look of video and film reduced. Nevertheless, what expanded in the process was viewers' visual flexibility and ability to quickly accept different looks as normal, so if you set up a visual convention at the beginning of a film that works for your story, the audience will accept the visual norm you create. The visual qualities and language used in film, TV and social media used to be very separate, but now there is an increasing crossing over of forms and conventions from one medium to another. This exponentially expands the possibilities for the language and look of film.

Some people start out on their journey to become a cinematographer driven by the desire to create images that convey a mood or tone, and to affect the viewer emotionally. They then learn the skills and techniques to be able to do so. For others the journey starts with learning the basics of cinematography, slowly building up their technical skills, and starting to find their cinematic voice when they feel confident with their techniques.

Creating a look doesn't always require a large budget. The location choice and color temperature used in this shot are important elements in the look. *Halloween: The Night HE Came Back* (fan film) director/DP Dave McRae.

Whichever route you take, at a certain point you will be ready to absorb ideas from great cinematographers. Both the words and the work of others can have a powerful effect on you. There are many good documentaries, such as *Visions of Light*[4] and *Cinematographer Style*.[5] Likewise, reviews and analysis such as *Wolfcrow*,[6] the cinematography series, magazines such as *American Cinematographer*, and some of the better cinematography sites online, take a close look at the techniques and aims of work in current and previous productions.

Watch scenes and reverse engineer, not only to look where the light comes from and what lenses have been used, but think about why. It is the 'why' that is the key to the higher levels of cinematography. Why this light, why these colors and why this look?

14: COLOR, IMAGE CONTROL AND THE LOOK OF THE FILM

In your discussions with the director and production designer, you are finding out both what and why they think particular visual elements and colors will work for the film. Notice their responses to reference films to see what they are visually excited about. Think about what inspires you about the project and allow that inspiration and vision to drive your decisions at all stages of the cinematographic process.

Good design and the ability to create a look doesn't rely solely on money. It is about finding locations or creating sets that offer the look, light and colors that work for your film.

The same shot was used for two different looks : (left) silhouettes as shown here and also with bounced fill light later in the day. *Faluma Ding Ding Ding* DP Tania Hoser and the University of the West Indies EBCCI cinematography class.

CONTROLING THE LOOK: FROM OUTSIDE TO INSIDE

When starting to think about the look of a film, it can be useful to think about the image being created from outside to inside. The location and production design are the canvas on which you work. The colors, tones and textures define the environment. The position of the lens and its focal length create the point of view that captures the aspects of it you want to show. The light reveals the parts of the frame that the viewer's eye is drawn to. The quality of the light helps convey the impact of the outside world on the location and the characters – quite literally how it shapes and models them. The aperture not only determines how bright the scene is but, by controlling the depth of field, defines how much is sharp and visible. Then the shutter speed and angle affect the sense of motion within the frame and, finally, the sensor of your camera affects how much detail, dynamic range and color are captured.

Duke of Burgundy DP Nick Knowland.

339

G: COLOR, IMAGE CONTROL AND CREATING THE 'LOOK' OF THE FILM

Two looks used for different story strands in *Babel* DP Rodrigo Prieto.

> Creating different looks for different times in your film is a key part of giving the audience a sense and feel of the visual strands of the film, and needs to be thought of as part of your planning.

The viewer quickly associates the look with the world of the film, but films often require more than one look. The looks should be distinct but must have a level on which they are cohesive. They shouldn't usually appear to be from completely different films. Create the looks, then view them side by side.

Work with a colorist to see how each look can be made both distinct but cohesive within the film.

Your plan for the film has to extend beyond production; you have to be as sure as you can be that the images will be graded as intended and actively take steps to find out or suggest what should happen in post and attend the grade or grades.
Roberto Schaefer[7]

WHAT TO CREATE DURING THE SHOOT AND WHAT TO LEAVE TO POST

In production, you create the image. In post-production, it can be refined and, usually, enhanced. The words used in grading include soften, lighten, increase, decrease, adjust – they are all modification words. Contrast from a light source can be increased or decreased but not (cost-effectively) created from scratch.

Global modifications in post-production affect the whole frame, whereas 'windows' are used to modify part of the frame. For each part of the frame that needs to be adjusted, a window must be set up, the modifications made and then it must be made to track across the frame if the action or camera moves. This takes time, and the amount of time you have for post varies depending on the production, and can be increased or decreased for reasons that are out of your control.

Your job as a DP is to create an image on set that, when worked on in post-production, produces the look you want for the finished film. You may well hear 'Leave it to post' when you are short of time, but the image you produce in camera needs to be able to stand alone. It can only be modified in post and, for a number of reasons, not everything promised is always done.

In post-production:

- You can't make hard light soft, or vice versa.

- You can't change the balance between hard light and soft light.

- Or change the balance of color temperatures within a frame.

- Some forms of diffusion filters affect the image differently in production than in post. Smoke works differently in production than in post.

- Many people feel that although shadows can be effectively enhanced in post, shadows created in post production aren't convincing, particularly on moving and complex shots.

14: COLOR, IMAGE CONTROL AND THE LOOK OF THE FILM

The Ideal: If you have a DIT and are able to work with them to produce graded dailies, this is a huge benefit. You will be able to see how the footage you are shooting will work with some of the tools available in grading. This will inform both your work on set and in the grading suite and help you ensure your exposure is optimal for the final image.

COLOR

It is easy to make color look good but harder to make it service the story.
Roger Deakins[8]

Color has a profound impact on the story. Choices of color play a very important part in location choice, production design, props, costume, hair and makeup. You can find visual breakdowns of the color of each shot of movies on sites such as moviesincolor.com and thecolorsofmotion.com.

The designer chooses the colors but the cinematographer controls how they are rendered onto the screen, by the use of lighting, color temperature control, filters and grading.

For some cinematographers and directors, one color or palette of colors can dominate throughout a film or a range of films.

Apocalypse Now, DP Robert Richardson.

Grand Budapest Hotel, DP Robert Yeoman.

G: COLOR, IMAGE CONTROL AND CREATING THE 'LOOK' OF THE FILM

Or a broader spectrum of colors can be used in itself as part of the creation of the look.

Nocturnal Animals DP Seamus McGarvey.

The girl's red coat is the only color within the black and white palette of this shot in *Schindler's List* DP Janusz Kaminski. The use of color here is associative; it symbolizes both her innocence and the blood of the Jewish people.

Color and Meaning

Color can be used to influence meaning in many ways.

- **Associative color:** Is a color scheme, or repetition of color through a storyline, that associates a color with a character or an idea.

- **Transitional color:** Is the use of changes in color to show transition within a character, usually of their state of mind, but sometimes connected to their physical location.

- **Connecting colors:** Are shared by characters, e.g. the use of the same color for clothes that their partner, or desired partner, wore in the previous scene.[9]

Colors have the power to influence how we feel, but despite the psychologist Robert Plutchick's wheel of emotions (see opposite),[10] which provides a code, in film a specific color doesn't always give

Transformers DP Mitchell Amundsen.

Tree of Life DP Emmanuel Lubezki.

"**There are colors that are traditionally connected with genres**: Warm reds for romance, de-saturated colors for apocalyptic films, cool blue for horror, fluorescent green for sci-fi and saturated, vibrant red for comedy, and for 'everything else', whether epic drama or bio, it's blue and orange. One theory is that this color treatment makes actors **'pop'** against the background, because on the color wheel skin tones are mainly in the orange range and their complementary color is blue; so when you take an orange-toned actor and push everything else into the opposing blue, the contrast makes everything pop and leaves you with the Hollywood look."[11]

14: COLOR, IMAGE CONTROL AND THE LOOK OF THE FILM

rise to a specific emotion. It is all about how the context of the color and the other visual and aural information are combined in the film, and how the use of a color develops during the film. Red, for example, usually creates a strong reaction, but it can be used to signify anything from hate and cruelty to passion and desire. The exact tone or hue of a color is usually modified to infer different meanings, so planning color concepts in pre-production is important, as there are many other things to think about when you are shooting.

The Color Wheel and Color Choices

The hue, saturation and intensity of color can be seen on a vectorscope (see C11a), so exact colors can be produced and color matches made. As a cinematographer, you should be conscious of the use, development, meaning and emotional power of the colors you are using, both when shooting and when grading.

Plutchick's wheel of emotions.

Primary, secondary and tertiary colors vary depending on the technology you are using. Here the primary colors for light, paint and print are shown as circles and the secondary colors they make are shown where they overlap.

343

G: COLOR, IMAGE CONTROL AND CREATING THE 'LOOK' OF THE FILM

In the RYB color wheel (left), the primary colors are red, yellow and blue. These are the primary colors in a subtractive system used by painters. Whether a color system is subtractive or additive depends on whether you have to add colors or subtract colors to get white. Think about the base you start with.

In a subtractive system used by painters, you start with a white surface, and if you mix all three colors together you will create black. You would then have to subtract all the colors to get white.

In digital film and lighting, the base is transparent and, if screened, would show as black. A combination of red, green and blue light added together would create a white image. This is why these three colors are the primary colors in the RGB system and it is because you have to add them together to create white that the system is called an additive system.

Printing, like painting, is also a subtractive system, but the technology works differently to painting, e.g. in printing, creating red requires magenta and yellow to be printed on top of each another. This is why printers have their own color wheel rather than working with the RYB or RGB one. In printing, a pure black is also required, so CMYK (cyan, magenta, yellow, black) is the palette from which printed colors are made.

When working with colorists in grading you work with RGB, but when working with designers you use the RYB color wheel shown here (left) with the associated secondary and tertiary colors.

You must be aware of the color palettes being used in the film not only for their emotional and visual significance, but also because of how lighting and filtration will interact with them. Try shooting with a selection of filters on a range of primary, secondary, and tertiary colors to see how the combination of colors and filters creates tones that you may not have expected.

The red–yellow–blue (RYB) color wheel.

Primary Colors

Anti Porno DP Maki Ito.

American Beauty DP Conrad Hall.

Secondary Colors

House of Flying Daggers DP Zhao Xiaoding.

Macbeth DP Adam Arkapaw.

14: COLOR, IMAGE CONTROL AND THE LOOK OF THE FILM

Tertiary, mixed or acid colors

'Acid colors' are mixed tertiary colors intended to be uncomfortable and disconcerting.

Billy Boys DP David Wright.

Birdman DP Emmanuel Lubezki.

Color palettes can be drawn from one area of the color wheel or they can be equally harmonious if they are balanced by colors on the opposite side. Director Wes Anderson often uses balanced colors to create calming color schemes. Complementary colors can also create a balance, such as red and green or yellow and purple. Likewise, triadic color – using colors at equal distance on the color wheel – can be balanced.

What creates imbalance is if one color doesn't fit the scheme or system of meaning it has been given in the film. That color will stand out, the audience will notice what doesn't fit, and it will create a sense of disharmony. See Channel Criswell[12] for some interesting examples of the uses of color.

> *People notice that I love to use color; there is always reason and thought behind it, though. I think about what the character is feeling and how color is reflecting that. I try to go beyond expectations.*
> David Wright DP[13]

(top) Complementary secondary colors in *Hero* DP Christopher Doyle, (bottom) primary colors in *The Hateful Eight* DP Robert Richardson.

Me and You DP David Wright.

345

G: COLOR, IMAGE CONTROL AND CREATING THE 'LOOK' OF THE FILM

Colored Light, Color Temperature and Creative White Balance

Colored Light: Including colored light in a shot is an easy way to affect the mood and color bias of a shot or scene. If you are working with neon lights or lights built into a set or on location, frame your shot so the colors that work best for the moment in the film are visible. If the light they produce doesn't spread to your actors or as far across the frame as you would like, bring in a lamp that produces a similar kind of (hard or soft) light to emulate the source and attach one of the very many colored gels available to match the color.

Color Temperature: We associate some environments with particular color temperatures, while others, even with ostensibly the same colored light sources, we accept in whichever color light they are shown in.

Hospital operating theatres are universally shown with cool blue lighting, as shown in (top left) *Awake* DP Russell Carpenter and (bottom left) *Dr. Strange* DP Ben Davis. Bars/pubs can be shown in either cool or warm colors (top right), cool lighting is used in this bar in *Lost in Translation* DP Lance Acord (bottom right) In this bar in *A Walk in the Clouds* DP Emmanuel Lubezki (bottom right) warm lighting is used despite the same type of practical lamps ostensibly being the source in both shots.

> You should still set the camera to the approximate white balance for your scene, even if shooting RAW. This is because the color temperatures will show on the monitor once the LUT is applied, and you also get more predictable exposures for the different-colored elements in frame.

It is not only because the same place appears a very different color at different times of day that we need to control color temperature. It is also because the warmth or coolness of the image affects the viewer's emotional response to it. Again, there is no strict and rigid rule of orange being emotionally warm (although it usually is) and blue being colder. It is a combination of color, tone, hue, saturation and the softness or sharpness that defines its meaning. A cool (blue) image can look incredibly tender and, occasionally (but far less often) a warm one can be made to look cold.

How warm or cool the light appears depends on the difference between the degree Kelvin the camera is set to record at and the color temperature of the light source or sources. If the camera is set to the same degree Kelvin as the lamps, it is neutral. If the camera is set lower than the light source, the light will appear bluer. If it is set higher than the light source, it appears redder. Other than those that can be controlled by color temperature, any global changes to color affecting the whole image

14: COLOR, IMAGE CONTROL AND THE LOOK OF THE FILM

Ali and Nino DP Gokhan Tiryaki.

are usually done with a LUT or in post-production. There is no benefit to using a color filter on the camera and it is better for post-production to have an image recorded in the full spectrum of light than in only part of it.

None of the coloring in the three frames above is more 'correct' than the other. Choose what is appropriate for your film and then be consistent.

Mixed Lighting: Is the creative use of different color temperatures within the frame. It is often used to show or re-enforce an emotional difference between the inside space and the outside. The outside may be shown as colder than the interior space, or as warmer and more desirable.

When different light sources inside, such as a desk light compared to a room light, have different color temperatures, the difference in color is made visible but often reduced, so it isn't so extreme. The smaller source, e.g. a cool white desk lamp in a room that is lit with warmer light, might be brought closer to the color of the light in the rest of the room. This can be done with color correction filters (as overleaf). Alternatively, RGB-controllable LEDs can be adjusted to become any color temperature that is wanted. What is important to remember is that, once color temperatures are mixed, although the overall color of the scene color can be changed, the difference in color temperature between the areas in the frame is locked in.

This in no way prevents you from shooting with mixed lighting, but does mean that the discrepancy between one color and another should only be apparent for a good reason.

To make sure the lights are at the color temperature you want them, or to check that no single lamp appears warmer or cooler, measure each light with a color temperature meter. This is usually done by the gaffer before the shoot, or done during a shoot if something doesn't look right or if the color temperature is very critical for green-screen or VFX.

(top) Warm firelight and cool moonlight in this shot from *Their Finest* DP Sebastian Blenkov, (bottom) In this shot from *Moonlight* DP James Laxton, the light on Juan inside the car is far warmer than the blue exterior moon and car lights seen outside.

> *I use a Luxi app with a ball that fits over the camera of my iPhone as a Kelvin meter. If you use this app, you would need to borrow a color temperature meter to calibrate it initially.*
> *Color temperature can be off for many reasons: the lighting coming through plastic glass, for example, can make a face look green, so I need to know how much to correct it by.*
> **Roberto Schaefer**

- It is important to ensure that you use color temperature consistently within a scene. If a warm (orange) light hits a green wall, it will appear brown. If it is lit differently during several shots in a scene, it will switch back and forth between green and brown as the scene progresses. You would never want the editor to have to cut around the color of a wall rather than the performance.

The amount I vary the color temperature from outside to inside depends on if I am emulating reality or not. In some situations, I light less naturalistically.
Tomas Tomasson[14]

347

G: COLOR, IMAGE CONTROL AND CREATING THE 'LOOK' OF THE FILM

Filters and Filter factors: If changing the color temperature of lamps with filters, it is important to know how much light will be reduced. Full CTO gels or filters shift the light from 5600K to 3200K. The filter factor is approximately 2/3, i.e. you lose 2/3 of a stop of light.

Full CTB filter shifts the light from 3200K to 5600K. The filter factor for this is nearly 2 stops, which is a significant reduction in light level and may mean the light from the lamp is no longer bright enough.

Both CTO and CTB filters come in 1/8, 1/4, 1/2 and full, and often in other strengths, such as 3/4 and 1 1/2, so the differences in color temperature can be subtle or pronounced.

Whether or not you are planning to use mixed lighting, full, 1/2 and 1/4 CTO and CTB are useful to have with you, so if you happen to need to use a tungsten lamp, in daylight or vice versa, or to adjust the color of a practical lamp, you can.

USING CHARTS AND COMMUNICATING WITH THE COLORIST

When shooting charts, we really need two set-ups. The chart exposed correctly in white light, and then the same chart in situ on set. If the colorist balances to a chart in set lighting, it will quite likely remove the ambience of the scene. The white light chart provides a set-up for post, and the in-situ chart then communicates exposure and color information that the DP wants left in the shot.
Kevin Shaw[15]

Charts are a very useful reference point for colorists and cinematographers. There are three key ways you can use color charts:

1. To show the grader how you want the colors to appear. To do this, shoot a color chart in neutral light at the same color temperature as your camera is set to, then shoot it again in the light you are using on set.

2. Shoot the charts in a slightly bluer light, so that when the grader makes the chart look gray the whole picture will be warmer. Alternatively, shoot it in a slightly warmer light, and the whole picture will be cooler.

3. To neutralize the color of the light where you are filming shoot a gray card.

The gray card is the single most important chart to shoot, as it gives a single point for the colorist to set to. Color charts and skin tone charts are also useful for precise detailing, particularly for color matching between shots and scenes.

If it isn't possible to shoot charts, giving the colorist clear written information – 'warm sunny day' or 'streetlamps are supposed to look orange' – will help them get the look you want and not grade out the colors you are using to tell the story. Charts are tools that enable precise technical color accuracy, but it is essential to also

LEE Filters 1/2 and full CTO (color temperature orange) (top) 1/2 CTO lighting gel (the equivalent filter used on the camera is also known as an 81 EF) (bottom). Full CTO, which is also known as 85.

This chart from DSC Labs can be used to test for dynamic range, lens definition, colors and skin tones. Image courtesy of DSC Labs.

14: COLOR, IMAGE CONTROL AND THE LOOK OF THE FILM

pass on the LUT used on set, particularly if it has been created or tweaked by the DIT. The LUT can be supported by any other reference material and shots that you can provide and, of course, ideally discuss the look you want with the colorist.

The use of color is a favorite way to tell the story and emotions of characters. I'll opt for mixed lighting and adjust Kelvin ratings to create an emotional effect. I try to do as much in camera as possible; as it's so easy for a colorist to manipulate an image, you have to work harder to make sure your vision is retained. If possible, I'll use customized LUTs on set, which definitely helps with this, but I'll also take Log stills from the DIT, grade them myself in Lightroom or Photoshop, then share with the director and colorist.
David Wright

LUTs can be used to create anything from subtle enhancements to extreme looks. ARRI Look Library. Photo courtesy of Arri (www.arri.com).

BLACK-AND-WHITE CINEMATOGRAPHY

The use of color has a significant impact on the look and meaning of a film. Black-and-white cinematography isn't just about taking out the color. It involves thinking about, creating and nuancing the look of your film in a different way; using tone, contrast, lighting and framing. There are many different monochrome looks. Two classic but quite different styles, Film Noir and Italian Neorealism (both being used in the 40s and 50s), show how form follows function, i.e. how the style created was a result not only of the type of stories being told, but also of the equipment crew and money available.

Noir (and the subsequent neo noir) films use low key and high contrast lighting to create chiaroscuro (light and shade) in a theatrical and evocative way that suits the subject matter, which is often crime and the underworld.

Neorealist films look very different and are lower contrast and use either broader lighting or were shot in daylight. This was partly because the filmmakers didn't have access to the budgets, lamps and crew available in Hollywood. It was also because the type of look and lighting suited the subject matter, which was often working-class people, as well as being easier for the often untrained actors to work in.

This shot from *Bicycle Thieves* DP Carlo Montuori shows broad lighting and a low contrast ratio, but a back light has been used to separate the background, which makes it look like a drama rather than an observational documentary.

349

G: COLOR, IMAGE CONTROL AND CREATING THE 'LOOK' OF THE FILM

In noir and neo noir, higher contrast and narrower lighting is used (top) *The Third Man* DP Robert Krasker, (bottom) the same principles used to create a more modern look in *Sin City* DP/Dir Robert Rodriguez.

Whether you shoot on a black-and-white or color sensor lighting certainly is not the same in black-and-white as it is in color . . . with color you tend to get separation in your image based just on the color of things. However, in black-and-white you have to separate things manually; often with back lighting or with harder shadows, and multiple layers of depth information, e.g. where in a color film you can get away with soft lighting without a back-light on an actor against a wall, because that wall is say blue, when you go black-and-white you really can't do that because it'll all just blend together . . . Also, obviously costumes will need to be picked carefully as will any hero props, for color. That comes down to testing.
Joshua Gallegos[16]

It isn't just lighting that creates different looks in black and white; filtration can be used either on the camera or in grading to affect contrast. A polarizing filter will add contrast to the whole image and particularly to the sky. Color filters will affect the rendition of colors within the image differently. Yellow filters tend to be the most popular and will darken blue skies and brighten red-, orange- and yellow-colored areas. Red filters increase contrast, while blue filters decrease it.

- When shooting in black-and-white, always bear in mind that what distinguishes parts of the image from each other is contrast. This doesn't mean the contrast has to be high but that the choices within lighting, location choice and production design should be made with contrast in mind.

- Test the use of filters and their effect on the color palette that will be predominant in your film.

- Also test the use of filters in grading.

Center and right show two very different black and white looks created from (left) this color shot. The look of the center image is partly created by using a yellow filter which lowers the contrast whereas the right image has a red filter which increases it. Photo by S. K. Walker.

It is important to test your whole workflow and ideally test several options of cameras and shoot tests with actors to get an idea of how they will read in black-and-white. Daniel Bruns[17] offers further advice on shooting in black-and-white, and Plot Point Productions[18] showcase some clips of black-and-white cinematography.

There are several manufacturers who have created camera models with black-and-white sensors. In many ways, the advantages of monochrome sensors are very similar to traditional monochrome film: image noise is lower at equivalent ISO speeds, and resolution is higher.

14: COLOR, IMAGE CONTROL AND THE LOOK OF THE FILM

However, not all advantages will be realizable, depending on intended use. For example, those familiar with traditional black-and-white photography may want to use lens-mounted color filters to control scene contrast. This might include using a red filter with landscapes, since these normalize the otherwise stark contrast between blue skies and green foliage, while also enhancing local contrast within each region. On the other hand, color filters also reduce available light by up to two thirds, thereby offsetting any sensitivity gain from monochrome.

One should also consider whether the quality of a monochrome sensor outweighs the flexibility of a color sensor. One can always convert color into monochrome afterwards, for example. Furthermore, with color capture, any arbitrary color filter can be applied in post-production to customize the monochrome conversion, whereas with monochrome capture, the effect of a lens-mounted color filter are irreversible. Overall, though, when output flexibility isn't needed, proper monochrome capture will always produce superior results.[19]

SHARPENING OR SOFTENING THE IMAGE

Irrespective of whether your film is being shot in color or black-and-white, there are several techniques that can be used to keep the image as sharp as possible or to soften it. If concepts such as clarity, decisiveness, action and speed are part of your film, you may want to consider ways to keep the image as sharp as possible. For more emotional and elusive subjects, you may want to consider diffusing it. It is the choice, application and combination of techniques that affects the look of the film.

Controling Image Sharpness

Sharpening the image, using a shutter angle of less than 180 degrees, affects the motion blur in each frame, which makes the image look sharper and can increase the sense of immediacy and alertness of the audience (see C3 and C8).

Shutter angle isn't the only way to create a clear, sharp image. Crisp, hard, clear natural light or the equivalent created with lamps, along with good-quality lenses with a high resolving power (i.e. ability to distinguish fine details), can be used to create a clear, clean and sharp look (also see saturation and glow on page 355).

In post-production, edge sharpening can be used to enhance the crispness of the image or parts of it.

In this shot the hard, clear, natural light at a high altitude creates sharp, crisp lighting. *Ali and Nino* DP Gokhan Tiryaki.

Controling Image Softness

Using a shutter angle of more than 180 degrees gives additional motion blur that can emphasize movement and soften the image. However, using softer lighting, lenses and diffusion are more appropriate ways to soften the image, unless motion blur is specifically wanted.

In this shot in *Slumdog Millionaire* DP Anthony Dod Mantle, the motion blur of the train is created by a wide shutter angle (wider than 180 degrees).

G: COLOR, IMAGE CONTROL AND CREATING THE 'LOOK' OF THE FILM

Camera Diffusion Filters

The filters I use if I'm shooting digitally are Hollywood Blackmagic, Tiffen Classic Softs and Black Satins. I like diffusion to be impressionistic and done mainly in camera. Filters like Hollywood Blackmagic's lower contrast and Classic Softs somewhat soften image.
Roberto Schaefer

Camera diffusion filters are used to soften this shot in *Miroslava* DP Emmanuel Lubezki.

Diffusion has an immediate emotional impact on the viewer. Diffusion filters change the look of the whole image, because diffused light spreads into what would be darker areas, which reduces the contrast. Different diffusion filters spread the light in different ways. They may affect the dark areas more significantly or create a soft defocused effect over the whole image. Each type of filter comes in different strengths, which can modify the effect, and are more appropriate for different-size shots (see below). If in doubt about strength, always use less rather than more. Over time you will develop your preferred type and strengths of diffusion, which can become part of your style as a DP. There are demo images of diffusion types and strengths on most filter manufacturers' websites and examples of tests online, e.g. ARRI.[20] In most cinematographers' experience, diffusion used in post-production is less subtle than diffusion used when shooting.

I use diffusion to try to break the harsh digital look, and bring a bit of the organic feel and magic back, which we were used to from film stocks, like softer skin rendition or a slight highlight halation. Most of the old diffusion filters don't work well with current high resolution cameras, and within our evolving visual sensitivities of what is considered 'too much'. I very much like the Schneider Black Classic Soft, the Tiffen Black Satin, Hollywood Blackmagic and Black Pearlescent, or the Tiffen Smoque for a more extreme, textured look. I never leave diffusion to post, because it always looks artificial. When people add diffusion digitally, it often ends up looking like cheesy commercials from the 80s.
Petra Korner[21]

Lacrimosa DP Petra Korner.

14: COLOR, IMAGE CONTROL AND THE LOOK OF THE FILM

When shooting with diffusion, remember:

- If you want to soften the look on a wide shot that you can't light, the only option you will have is to use a filter on the lens. In a close-up, you can choose whether to filter the lens or the light.

- Diffusion looks stronger on longer lenses, so don't assume you will use the same diffusion on all focal lengths.

- For some actors you may want to diffuse the close-up; for others, even in the same scene, you may reduce the diffusion or remove it.

- Beware of judging diffusion on a small on-set monitor. A large, high-quality monitor will help.

Lamp Diffusion Filters

There are two main differences between using diffusion on lamps rather than on the camera. First, different types of diffusion can be used on different parts of the frame to emphasize the effect in one area rather than the whole frame.

Second, there is a wide variety of different forms of diffusion that spread, direct the light and make it wrap around the subject in different ways. These differences are subtle, but are part of the way you can create a distinctive look. The impact is more visible on closer shots.

Smoke, Fog, Mist and Haze

Smoke used when filming is, in fact, fog, although it is always referred to as smoke. It would be dangerous to use real smoke, which puts burnt particles into the air. Fog is safe because it is just water or safe oil particles that are suspended in the atmosphere. Likewise, dry ice is safe. When shooting with smoke, remember:

- Fog puts particles into the air, and the effect is not as strong on what is close to the camera as it is further away, which makes it look more natural than a diffusion filter.

- Fog changes the quality of the light and lowers contrast, but the contrast can be added in post whilst retaining the effect of the diffusion on the quality of the light.

- It adds about 1 stop to the level of the ambient light, which can make it possible to get an adequate exposure somewhere that was otherwise just slightly too dark.

Miles Ahead DP Roberto Schaefer.

- It makes any shaft of light passing through it visible, because the droplets are lit up by the light.

- It should be dispersed (wafted) thoroughly before shooting, or it will be patchy and visible in frame.

Wafting is an art in itself and depends on the movement of the air in the location, the heat and the density of the fog. It is best to waft away from the camera rather than towards it, and turn over (shoot) just as the fog is clearing, i.e. still diffusing but not having visible heavier patches.

Mist: Is defined as fog that has a visibility of less than 1km and sits lower on the ground than fog.[22] Mist occurs most often on cool autumn mornings. Dry ice can be used to create a ground-clinging mist, or a chiller attachment and big hose can be added to most foggers to make it lie low like mist.

In Miles Ahead, *I used lettuce leaf cigarettes and a DF 50 (diffusion machine) for atmospheric haze.*
Roberto Schaefer

G: COLOR, IMAGE CONTROL AND CREATING THE 'LOOK' OF THE FILM

(left) Fog. Photo from pxhere, (center) Mist. Photo by Steve Buissinne, (right) Haze. Photo by Logga Wiggler.

Haze: Is caused by dry particles in the air and is most likely to be found in desert or dusty locations. Increased haze in the atmosphere can result in stunning sunsets, which means that sometimes the most polluted areas have the most spectacular sunsets.

Flare

Tree of Life DP Emmanuel Lubezki.

When flare is wanted, it can have a powerful impact on the look of the image. Flare also has a psychological and visual impact on the story.

It was classically used for a 'romantic' effect, but is now also commonly used in sci-fi films to signify something strong coming into the character's world. Flare substantially changes the look of an image by desaturating and diffusing it. Having no flare on one shot and a lot on another can create an odd sense of inconsistency, so additional flare can be added by shining a light at the lens when needed. This is part of the reason lens flare tests are done in pre-production. The type and intensity of flare depends on both the lens and camera being used.

Halation or Blooming

Halation, or blooming, is the glow of light that is visible around an over-exposed area of the image, blurring or spreading out the light. You may want a window to halate, to give the impression that there is an alien spaceship arriving outside, but it would be very odd in an interview. When used appropriately for the story, a back light that halates is very effective for drawing the viewer's attention to an actor and making them, or what is happening to them, appear very powerful. Creating a powerful rim light is usually

(top) *Apocalypse Now* DP Robert Richardson, (middle) *Green Mile* DP David Tattersall, (bottom) *Raging Bull* DP Michael Chapman.

achieved by over-exposing a back light by 3 or more stops outside the dynamic range of the camera. Alternatively, a psychologically similar effect can be achieved by using a striker (lamp designed to simulate lightning) or a low budget alternative of a very brief flash of an HMI or high-powered speedlights (flashes), either directly or through heat-resistant Venetian blinds. You should test before shooting, because on digital sensors clipping (see C3) can result in just a sudden change from detailed image to a white screen rather than the intended glow of halation. Of the digital cameras, the Alexa is reputedly the least bad at creating halation, but film is far better for this effect.

Saturation and Glow

When it rains, dust in the air is caught and removed as the water droplets fall to the ground. This leaves a crisper, clearer, less diffused look until the dust rises again. Water in the atmosphere creates spectral highlights on tiny particles of water, which can create a sparkly look if the sun or light is shining on them. This creates a clean, crisp atmosphere and helps produce saturated colors. Whilst rain can't be scheduled, wetting down the set with a bowser that sprays water into the air (rather than just hosing the ground) has a considerable effect on the look. Colors become richer, and blacks in particular become glossier, which is why it is a look favored for night shots.

(top) *The Shawshank Redemption* DP Roger Deakins, (bottom) *The Matrix* DP Bill Pope.

POLARIZATION

Polarizing filters are often used to reduce or remove reflections on car windscreens or reflective surfaces, and when you want to see into water, rather than the reflections on it. Polarization effectively reduces fill light and increases contrast, which helps reduce haze and enhance blue skies.

This makes colors more saturated and has a substantial effect on the overall look. Currently, the polarized look is considered out of date, but fashion is always subject to change and polarization remains an interesting element to creating a look. In most cases, if you are using a polarizing filter to affect the look (rather than to control reflections on an individual shot), it should be for either a whole film or for one distinctive look within it.

> *Polarizers reduce the amount of reflected light that enters the camera. They cut out the light from one direction. They are most effective at 90 degrees to the light source and maximum polarization will occur when your subject is at right angles to the sun. At 180 degrees [when the sun is behind you] polarization will be non–existent.*[23]

(top) Without polarizing filter, (bottom) with polarizing filter.

G: COLOR, IMAGE CONTROL AND CREATING THE 'LOOK' OF THE FILM

Two looks for different story strands in *Babel* DP Rodrigo Prieto which, amongst other things, are created by polarization, (left) polarized, (right) not polarized.

Polarizers are manufactured in a variety of strengths and orientations and are affected by lighting conditions, so tests should be carried out on location. If using a linear polarizer, it has to be in the right position so requires a rotating filter tray and should be checked and rotated as needed for each shot. If using a circular polarizing filter on the front of the lens, the front part of the filter needs to be rotated, avoid using circular polarizers, on wide-angle shots because you may get uneven polarization which will be particularly noticeable in the sky.

CHOICE OF LENSES

In terms of sharpness, lens manufacturers are going in one direction and cinematographers are going in the other.
Oliver Stapleton

Sharpness, resolving power, color rendition, the effect of flare and diffusion and the look of bokeh vary according to how lenses are constructed. For example, bokeh, the rings that appear around out of focus points of light, are smoother the more blades of metal are used in the construction of the aperture ring (particularly when the aperture is small). The lens coating, the construction and positioning of the glass elements affect internal reflections and how much flare a lens produces. Panavision anamorphic lenses, for example, have their anamorphic element in the front, which can create (often wanted) flare, whereas Hawk anamorphic lenses have their anamorphic element in the middle, which gives less flare, giving two very different options.

Viewing demo reels is useful but shouldn't replace testing because the look you create will vary according to the combination of camera, lenses, lighting, coloring and design being used on your film.

There is a noticeable difference between manufacturers' ranges of lenses and often between individual lenses. This is why extensive lens tests are done not just for resolving power and accuracy, but also for the look (see C4b). It is usually the DP who tests for the look of the lens. Zeiss lenses are renowned for looking sharp, and the older Cooke lenses and Angénieux give a softer, gentler look. The choice of lens should support the look that is being created, i.e. if you are creating a sharp, crisp look it would be unusual to choose a softer looking lens.

ARRI Master Anamorphics Flare Sets Showreel courtesy Arri (www.arri.com).

14: COLOR, IMAGE CONTROL AND THE LOOK OF THE FILM

I used to fight to shoot on film instead of digital, but now it has become more about the lenses. I want to break the digital feel and create the look I want. I prefer to shoot anamorphic, unless there is a good reason not to. I shoot a lot of widescreen but use anamorphic lenses, even if shooting 16:9, because it makes the image more three-dimensional and adds a layer of cinematic quality. A lot of anamorphic lenses are imperfect, which can add to the look, but I still need them to perform, to a certain degree, optically. I test until I find a set which matches.
Petra Korner

As soon as 4:3 sensors came out, a lot of music videos and commercials were shot on anamorphic (which squeezes a 2.35:1 image onto a 4:3 sensor). I shoot on anamorphic often and can now see the benefits and limitations. The lenses aren't very fast and can't close focus, so I end up having to use diopters. They are heavy and not truly sharp across the spectrum, unless you are shooting at T4. They are often great for movies but more fiddly for use on promos and commercials.
Paul Mackay

CAMERA CHOICE

Sometimes image is not the priority, it's what camera you can use. On a recent film we used a GoPro inside a van; the space was really constricted. It was a challenge.
Roberto Schaefer

The role of the camera in creating the look is connected with both the size and resolution of the sensor, how the layers of filters over it are constructed and the efficiency of the camera's processor (see C3). However, camera choice often comes down to far more practical factors. When choosing cameras, consider the needs of your shoot in terms of the native ISO that will help you most, the size of the camera and the size of the space you are working in. Importantly, also consider the budget and if, for example, an older model camera has all the functionality for your shoot and the same sensor as a new camera, so that you can spend more on lenses, lights or filters, which will make a more significant impact on the look of the film.

The Amira has the same sensor and processing as the Alexa. People choose the Alexa for Kudos but, although the Amira has a few practical limitations, it is great if you are on a budget.

The Panasonic Varicam (and now the EVA1) has dual native ISO of 800 and 5000. The Panasonic isn't as ergonomic as the Alexa, but the image it produces is very similar. The Panasonic uses a different codec, but people say they have mixed them without a problem in post.

For low-light work, if a Panasonic Varicam is out of your budget, DSLRs are better at a high ISO than many video cameras. The downside of DSLRs is their lack of full functionality and poor ergonomics.
Camera rental manager Anon

If your entire film takes place outdoors during the daytime, you are going to want a camera with a lot of dynamic range, so you don't need to rely on any additional fill lighting to ensure you retain detail in the shadow areas. A budget conscious option for this might be a camera like the Blackmagic Cinema Camera. However, if you are shooting mainly night shots with available light, this isn't the camera for you. [If you can't afford a Varicam] a camera like the C200, Sony A7SII or even a 5D MKIII might be better in that case, as it will have a far better sensitivity to low light.
Noam Kroll[24]

G: COLOR, IMAGE CONTROL AND CREATING THE 'LOOK' OF THE FILM

I tested a Red, a Sony F55 and an ARRI Alexa, but either I, or they, didn't like any of them. So, I tested ARRI 65 and Sony F65. Netflix went for the ARRI 65 in the end.
Oliver Stapleton

There may also be requirements from the commissioners or distributors. For example, having to originate in 4k for Netflix and have your camera choice signed off before you shoot.

Finally, but importantly, if you are using several cameras in your film or if your film is part of a series, you also have to consider how they will mix, because there can be difficulties in grading a scene with several cameras, as the colorists will bring the look down to the lowest common denominator, i.e. the lowest performing camera, so no shots stand out as odd.

In Lazy Town, *we had been using a Viper (which is now old technology) for years, but when the RED came out we discussed changing to it, but decided that as the look still worked very well for the project and the sensor size of the Viper allowed us to use long TV lenses and retain the depth of field we needed, there was no benefit to changing. We would have also needed bigger lights, and that would have affected the cost and time of the shoot.*
Tomas Tomasson

SHOOTING ON FILM

On a commercial, we wanted flare, so shot on film so I could use 50 ASA film to get cleaner flares without so many filters on the camera.
Tomas Tomasson

Shooting on film requires confidence and accuracy in exposing. Film arguably still looks different to digital. It has effectively a higher bit depth, so color is more finely defined. Film also flares and halates in a different, usually more attractive, way than digital. Film can also have a far lower ISO than digital, so can work well in situations where there is intense natural light. When shooting on film you need to be controlled about how much footage you are shooting, and confident enough that you can expose effectively for film. Practice both with stills and short ends of film stock left over from shoots. As a cinematographer on film, it is your responsibility to check the correct stop and settings are on the camera. If new to shooting on film, check both before and after each shot.

IMAGE CONTROL AND GRADING

When xxxx (DP) was working with a producer who loved everything to look glossy, he shook talcum powder on set just before turnover to soften the color.
DP Anon

Image control is very much a combination of how you shoot, how you work with the colorist and their skill and understanding of the film. It is a collaborative process that relies on the input of the DP and the skill of the colorist. Sometimes a producer or director may want to go in a different direction to the DP in the grade, so the need to oversee and sometimes negotiate the look of a film may continue long after the shoot.

The length and complexity of the grade can vary dramatically, though, from a few days to extreme cases, such as *The Revenant*,[25] which reportedly graded for between 15 and 18 weeks (see C5 for grading, color spaces and the full post-production workflow).

The degree to which DPs guide the colorist varies, often according to what the DP knows about grading. It is important to be informed about what can be done in the grading suite, and to assess how and where grading can be used to enhance your images. This will allow you to work with the grader and make the most of what it can offer.

Whilst the scope of grading is huge, and the direction of modern filmmaking is considered to take advantage of the new technology and tools, there is no guarantee that the image you want can or will be created in post. You can't rely on technology instead of learning your craft. Practice creating different looks, so you start to see each technical choice you make as part of the creation of the cinematic image. Bear in mind that it is not just your ability to create looks that is important, but it is your ability to find the heart of the story and create a look that is right for it.

EXERCISE: To assess your ability to create and control the image and color temperature you are shooting at, shoot a five-shot scene in one location twice, but create distinctively different looks for each.

Maintain the look across the scene, and include mixed color temperature lighting in one of the looks.

Define in words what each look is saying, to ensure you can communicate your ideas to others.

NOTES

1. John Schwartzman (ASC), oft quoted, original source not found
2. Yamato, Jen. "The Making of 'The Revenant': Meet Emmanuel Lubezki, the Man Who Makes Movies Beautiful". *Daily Beast*, December 26, 2015. https://www.thedailybeast.com/the-making-of-the-revenant-meet-emmanuel-lubezki-the-man-who-makes-movies-beautiful
3. Oliver Stapleton BSC (DP) in discussion with the author (July 2017)
4. *Visions of Light*, directed by Arnold Glassman, Todd McCarthy and Stuart Samuels (USA, 1992), film.
5. *Cinematographer Style*, directed by Jon Fauer (USA, 2006), film.
6. Wolfcrow. "Want to learn what makes a great cinematographer?" n.d. https://wolfcrow.com/blog/category/understanding-cinematography-series/
7. Roberto Schaefer ASC AIC (DP) in discussion with the author (September 2016)
8. Roger Deakins CBE (ASC BSC), oft quoted, original source not found
9. Channel Criswell. "Color in Storytelling". *YouTube*, July 29, 2015. https://www.youtube.com/watch?v=aXgFcNUWqX0
10. Plutchick, Robert. *Emotion: A Psychoevolutionary Synthesis.* University of Michigan, USA: Harper and Row, 1980.
11. The Verge. "How filmmakers manipulate our emotions using color". *YouTube*, October 11, 2015. https://www.youtube.com/watch?v=0ZZgiSUyPDY
12. Channel Criswell. "Color in Storytelling". *YouTube*, July 29, 2015. https://www.youtube.com/watch?v=aXgFcNUWqX0
13. David Wright (DP) in discussion with the author (September 2016)
14. Tomas Tomasson (DP) in discussion with the author (September 2016)
15. Kevin Shaw (Colorist Instructor and Consultant, Colorist Society International) in discussion with the author (December 2017)
16. Gallegos, Joshua. "Filming black and white in digital." *cinematography.com*, November 27, 2013. http://www.cinematography.com/index.php?showtopic=61537
17. Bruns, Daniel. "Shooting in Black and White". *Videomaker*, September, 2013. https://www.videomaker.com/article/c18/15702-shooting-in-black-and-white
18. Plot Point Productions. "Bright Night – Visions in Black & White". *Vimeo*, 2015. https://vimeo.com/134028599
19. Red. "Color vs. Monochrome Sensors". *Red.com*, 2017. http://www.red.com/learn/red-101/color-monochrome-camera-sensors
20. Soffer, Oren. "Diffusion Lens Filtration Test Shoot". *Vimeo*, 2016. https://vimeo.com/162283600
21. Petra Korner AAC (DP) in discussion with the author (September 2016)
22. Met Office. "What is the difference between mist and fog and haze?" November 15, 2017. https://www.metoffice.gov.uk/learning/fog/difference-mist-and-fog

23 Plumridge, Jo. "How to Use a Cirular Polarizer Filter". November 2017. https://www.lifewire.com/using-a-circular-polarizer-filter-492961

24 Kroll, Noam. "How to Shoot with Natural Light: 10 Tips". *IndieWire*, October 7, 2013. http://www.indiewire.com/2013/10/how-to-shoot-with-natural-light-10-tips-34217/

25 *The Revenant*, directed by Alejandro G. Iñárritu (USA, 2015), film.

SECTION H

Working in the Film and Television Industries

15
Starting and Developing a Career in Cinematography

Whether you are just starting out in the camera department, or moving up to become a DP, understanding the perspective of those who will hire or work alongside you will help you assess what you have to offer and how to progress your career.

This chapter looks at the skills, personality traits and expectations about members of the camera department from trainee to DP. Candid interviews recounting the experiences others have had will give you crucial insights and perspectives that would take many years to gather. The tools of self-assessment as introduced in Chapter 1 are now used to enable you to create a framework that can be used to build your career. The chapter concludes with examples, advice and insights from DPs working in many different genres, and at various stages of their career. These highlight the importance of a balance between technical capabilities, creativity and personal approach required across the industry.

> **LEARNING OUTCOMES**
>
> *This chapter will help you:*
>
> 1. Assess your personal skills, abilities, experience and interests
> 2. Understand the expectations of members of the camera department and the needs of the wider industry
> 3. Apply strategies for both starting and progressing your career
> 4. Understand, and have approaches to minimize, any discrimination you may face
> 5. Develop a successful career in the areas that interest you most

THE PERSONAL PICTURE

Although cinematography offers a wonderful opportunity to explore stories, image making and light, working in a camera department also involves long hours, job insecurity and, in many cases, the need to compromise either your work aims or your family life. If you are able to establish your career while you are young, you have a better chance of being able to sustain it if and when you take on more home or family responsibilities. There has never been a single tried and tested route to either getting into the film industry or progressing your career, but gaining an understanding of the bigger picture of the industry will help you make the most of your opportunities and present yourself in the best light.

THE BIGGER PICTURE

To gain an overview of where you and the whole camera department fit into the industry, think about filmmaking as both an art and business.

To develop a film project, a producer develops or finds an idea or story that:

- They believe there is a market for.

- Will recoup more than the cost of making the film.

- The producer can find financial backing for through their connections.

- Financial backers will see as something that they are prepared to risk their money on.

Many producers are passionate about stories, but the drive to tell a particular story and creative merit is just part of the mix when choosing a project that will achieve a return on investment (ROI).

The drive for ROI affects the camera department because the producer is responsible for making sure the film project stays on track. Cinematographers are hired to bring their skills and creativity to help realize the director's overall vision and to minimize the risk of the entire units work not being usable in the finished film. The Human Resources maxim that the best indicator of future success is past success is widely adopted in hiring within film, so cinematographers who have successfully shot similar films are favored.

Because a cinematographer depends on their crew to ensure all aspects of the footage is usable, when suggesting crew the obvious choice is people they have worked with successfully in the past. If they aren't available, then the choice is to work with people who have already done similar jobs. This clearly makes it difficult for newcomers.

Getting a Foot in the Door

If you have no knowledge, there is not much of an argument that you deserve to be paid.
1st AC Anon

Start small but have a plan. When you start out, you have so much to learn and so little to offer that you can mess up on a large shoot, so it is usually advisable to get some initial experience on smaller shoots. Occasionally, training schemes or opportunities come up, but in most cases you have to make your own opportunities.

- Join local filmmaking social media groups. Put up notices on local college social media or physical notice boards, to find opportunities for helping out in any capacity on a shoot.

- Join and attend real-life film networking groups in your area.

- Introduce yourself, find out what people are doing and assess if and how you can help. Focus on how you can help them, not vice versa, even if it is just bringing tea and carrying boxes.

- Connect on social media or ask for an email.

- Follow up your new contacts with a brief note to offer to help. Repeat a maximum of monthly, or longer if you know the person is busy or on a shoot. Judge who you should stay in touch with by thinking about whether you can realistically offer any useful help to them. If not, don't direct-message but keep them on your social media.

- When you have been on a few shoots, learned your way round a film set and learned some skills, put together a CV.

- Next, try to get some work or experience at camera houses.

- If there are camera houses or production companies not too far away, drop in a CV and follow up by popping in for a few minutes monthly to see how things are going.

- Network at any festivals or film events you can. These may lead to (usually unpaid) work experience.

- When you have a few things on your CV, join a talent management database, and social media groups that offer paid work.

- Embrace and enjoy what you are doing now (even if that is working on very small or amateur shoots), rather than what you want to do later.

- When you have enough to offer, try to get a trainee position on a larger shoot.

> Producers and directors of low budget shoots often want highly experienced people to work for nothing. Often, they get less experienced people than they hoped for but still expect top-notch work. Try to rise to the challenge, but be aware of unrealistic expectations and don't do anything that might ruin the footage.

CVs and Online Presence

- Concentrate on what you can do that is relevant to the job.

- A long-term commitment, like two years' employment in one job, shows you are reliable.

- Briefly mention DPs' work you admire.

- It is irrelevant to detail what you have shot on your CV as a camera trainee. Just mention your own movies and put a link at the bottom.

- Accept that there will usually be a very low response rate to your CV.

Social media is a good way to stay in touch. Put up nice pictures to show what you are doing – be subliminal. Calling or emailing used to be the way to do it, but not now. It's only when my crew aren't available that I have to look around. I prefer looking at social media to have my memory jogged about what people are up to. I still get 3 or 4 emails a day from people staying in touch, but all I can say is that I am busy and have crew for the coming projects. I also get emails from people who I've worked with abroad, but there is no point, unless they are coming to town.
Julian Bucknall[2]

> *I had connections, but even so my first 150 CVs didn't get me a single job.*
> 1st AC Anon

> *At Emerson my cinematography tutor put some of us in as interns on a feature for a day. I met some different people who I re-connected with.*
> Danna Rogers[1]

Once you have met people, stay in touch but don't stalk them.

As with all professions, when your social and work life crosses over online, a degree of care must be taken with what you post.

Mentors and Support

Finding someone to mentor you at all stages of your progression from trainee to DP will greatly help your progress by giving feedback and advice that will improve your confidence, so a mentor is invaluable, irrespective of whether they can also offer you contacts. However, your mentor won't be entering the industry at the same time as you. Their experience will always be different. They will have good advice, but you have to see how you can apply it to how things stand currently in the industry. Irrespective of whether you have a mentor, don't waste time when you aren't working. Read or watch your favorite DPs' work, and absorb their ideas and practice techniques.

> You are unlikely to find a mentor to help you get a foot in the door, but co-mentoring with one or two people in the same position can help.

Personality and General Approach

It is the crux of the whole industry, everyone agrees that it's 80% personality and 20% skill. We had a trainee who tried very hard but she stood behind you all the time – it was just annoying. She took nice pictures but we won't be working together again.
Julian Bucknall

When selecting people (for a training scheme) we could tell within 2 minutes who the right people were. Not just from their CVs but during the interview. One of the panel would be talking and two others would start discussing something about cameras. We kept the people who listened to the camera conversation.
1st AC Anon

The importance of personality is huge. This doesn't mean that everyone's personality has to be the same, but being positive, whatever the task, makes a huge difference. Personality, or more accurately approach, isn't the only thing that matters, though. It is essential to have the required skills.

When we needed a new trainee, the ACs asked at the camera house they were testing at which trainee had been in most and asked the most questions.
1st AC Anon

Fitting In with the Camera Department

The camera department is very hierarchical. A camera trainee should simultaneously know their place and not be a totally overawed and intimidated, or they come across as a wimp.

Don't try to mimic what may be a very narrow type of person on your unit. Be reliable, work hard, have focus and energy and be comfortable with yourself.

The person you are trying to help most is the person above you. It is their job you are training for and they are often the one that will request you are hired on another production.

Be fun, but it's more important to be focused . . . listen to the conversations of the producer, director and DP, but don't distract them.
Danna Rogers

Don't ask questions if people are busy, unless it is about something that needs to be done immediately. If you haven't been able to work it out for yourself, ask questions at the end of the day.

They need practicality, inquisitiveness and good handwriting. They shouldn't have to, but if needed they have to be happy to go and clean the car. Trainees need to make the work of the camera department go smoother whilst being amusing and having a positive personality. Appearance wise, they need to dress and appear relatively smart.
Julian Bucknall

A trainee needs to be presentable, mechanically minded, able and logical. They need to get a tray of coffees whenever there is the opportunity, rather than ask if people want coffee. If a shot is locked off and we are not busy, that's when they get to learn things like programming the Preston (follow focus) or lacing the camera. We don't want people who're just taking xxx a week so they can look at the lighting. Before we get to know someone (several weeks) we don't want them talking about the film they have made and sending us a link; what we are interested in is that they know the difference between coffees.
1st AC Anon

Self-Assessment: The Learning Cycle

This applies at each stage of your progress, not just as a trainee.

- List all the skills you have that currently make you helpful in the camera department.
- Also, make an assessment of your approach, style and ability to be flexible at work.
- Think about what skills and approach the people who you want to work with would ideally like you to have.
- Identify and try to resolve things that might stop you offering them what they need.
- Learn or develop the approaches or skills to fill the gaps.
- Also assess your job finding strategy: Keep a record of what you are doing in terms of networking, and compile a file of contacts.
- Make an assessment of how much time and money you can put into developing contacts and pursuing opportunities. Use the time you can put in wisely and don't stress if you can't do it full time, because you need to work to pay the rent.
- Look for people making films about subjects, causes or charities that interest you.
- Periodically self-assess as you progress. Note down what went right or wrong, and why, to see if you can address any repeating patterns.
- Compare your progress with other people's career only in order to see if you can gain anything from understanding their approach rather than envying their luck.
- Find a person or couple of people in a similar position to you and learn from, or mentor, each other.
- If trying to move straight in as a DP, try to find a small group of you who will gaffer or grip (work with nets and flags, etc.) on each other's shoots, so you learn from each other.

> *There are no annual work reviews or appraisals, and sometimes the only feedback you will get is not being asked back to work on the next job . . . Assess your current situation and what has worked or not on jobs at regular junctures. Listen to senior professionals . . . act on their advice . . . respect, humility, gratitude and manners go a very long way.*
> Matt Gallagher[4]

I was always politically minded: from I was 17 I started making CND films.
Chris Menges[3]

> A few years after I started out, I evaluated and noticed that all the men I knew were doing better than all the women I knew. That meant it couldn't just be me, but I still thought I must be doing something wrong. A mentor would have helped.

Getting Established in the Industry

> *Be a Cinephile:*
> *Know the protocol*
> *Know the equipment*
> *Think on your feet.*
> Danna Rogers

It used to be common to go from job to job with the same DP, but it doesn't often happen like that now. On TV jobs, the DP or focus puller usually recommend the 2nd AC or trainee. On features, it can be different.

> *[As a trainee] you struggle to get a big movie. To get asked back you have to stand out. It's tricky to find a balance between being standing out and being a fool. I thought was a bit of a loss at first, but he has totally taken off. He does the coffee thing; he can carry six four-way coffee trays on top of each other – people noticed that.*
> 1st AC Anon

I worked on TV and features; it's just the scale of the job that is different on features. I did that for 8 years. Now I've been focus pulling for 11 years. My oldest child is 6. I've done shorter shoots since he was born. I still do dailies on features but now mainly do commercials.
1st AC (male) Anon

I left school at 18, took a gap year and got some work as a runner. I decided after speaking to people that it would suit me to dive straight in as a trainee. I did a lot unpaid, particularly initially. I went to Uni but left after 6 months because people were calling. I got busier as I learned more. I was a trainee for 2 years, then was offered a job as 2nd AC on a TV drama, by a focus puller I had met whilst training. I struggled to get up to speed in the first few weeks but it was a good learning experience, and by the end of the 12-week drama I was ready to work as a 2nd AC.
Charlie England[5]

Charlie England. Photo courtesy of Charlie England.

I loaded until '93, on relatively small TV dramas, before I started focus pulling. Now I work on international features. Being on good terms with production is key to your CV being on the desk. They choose people who worked well and didn't get ludicrous about overtime or lose kit and went into the office to say 'hi'. Treat them like you are making the film together, not like everybody is making the camera department's film.
Julian Bucknall

I went to Emerson to study film production. I came here (LA) in my last semester because I took a class and had to have an internship. I interned at the Camera House, and they offered me a job.

I reached out to lots of people, by SMS and email, mainly through the Camera House. They gave me a list of people to pursue. I had also made a couple of friends there, who I went out with a few times, and there were some Emerson graduates who started shooting out here. There is a joke about The Emerson mafia, but it's good that there is a network.

I've now moved up to being a 1st AC, I got some opportunities, and was in a little over my head once or twice, but stayed cool. It was important to take the next step, as I have been in LA for just over 5 years.
Danna Rogers

FACTORS THAT AFFECT HOW WELL YOU FIT IN

In general, it is still middle-class entrants to the camera department. When teaching film to inner-city kids, nobody tackles the things that will really help them get work.
DP Anon

I don't know if everybody is middle class in the US, but there is a huge amount of nepotism. I didn't have that connection and made it. The Oscar-winning uncle of a DP I know got him his first job... his career progress was rapid.
DP Anon

Nobody finds it easy to get into the film industry. Even the most privileged cinematographer's children, who have a good idea of what is expected, aren't intimidated and are given useful contacts to pursue, have to launch, maintain and develop their careers for themselves. For those that don't have these advantages, it can be far harder. Understanding the following presumptions of the, usually middle-class, white, male, privileged entrants, and developing strategies to counter them, might help:

- That it will take several years to learn the skills needed on set.

- That it is worth taking the flack and a degree of teasing, from what can sometimes be cliquey crews or difficult individuals without becoming angry or demoralized. They aren't 'better' than you; they just have more experience in their particular job. Accept your low status on the job, but never let them make you feel, or think you feel, that this extends beyond the film set.

Middle-class advantage may also include:

- Being financially supported while taking film courses.

- The ability to work unpaid or for very little as an intern.

- Having a car to get to locations.

- Being available at short notice.

- Starting a family later.

> *I was lucky. I grew up and lived in London, and could live at home with no overheads whilst working as a trainee. You need to be available at short notice; the further down the food chain you are, the later in the planning process you are thought about. I now work with trainees in their 30s with children, which must be very tough.*
> Charlie England

What Happens When You Are One of Them, Not One of Us

EXERCISE: Ride a bike with the wind behind you, then turn around and ride with the wind against you. You usually can't feel the wind until it is against you. Whichever direction you are traveling, the wind isn't always with you or against you; it changes direction and intensity. A couple of rides on the same route will show you there is a prevailing wind, though, and, if you aren't lucky enough to be one of the people the prevailing wind in the film industry is favoring, you will find it takes more effort to make progress and you may move more slowly than others. It isn't impossible, though, and when the wind turns in your direction, however briefly, make the most of it.

The following are examples of what happens when you are 'othered'. This is based on a number of women's experiences, including my own. Elements of the following apply to all those who don't fit into what is statistically proven[6] as the predominantly male, heterosexual, middle class, white (in North America, Europe, the UK and Australia) demographic of the camera and lighting departments. The slower progress and greater difficulty for certain groups of people comes from an accumulation of any combination of the following. It isn't possible to say any one factor blocks any one person, but there are strongly arguable parallels with the fact that the ratio of selection in one of the sections in the Toronto film festival changed from 85% male to 50:50 when entry was done blind.[7]

- Reduced results for the same amount of effort put in to finding jobs, resulting in less experience than your male counterparts, who have been in the industry for the same amount of time, which when people are comparing you often puts you at a disadvantage.

> *When working at the BBC (some years ago), I went back to the stage to load mags at lunch time and saw the sparks and the producer sitting in a circle watching the monitor. They were watching porn. I had to walk by to get to the mags so, not sure what I should do, I said 'Is that your last production' as I walked by. The producer gave me a dirty look and I never worked for that crew again.*
> 1st AC (female) Anon

- Once on a job, having to prove yourself more than others do.

H: WORKING IN THE FILM AND TELEVISION INDUSTRIES

> *I had a gaffer who was hard on me until I had a standoff with him. I had to put up all the flags and nets for a day to prove myself.*
> DP (female) Anon

- More testing of what you know, i.e. other crew members asking you about technical things that you wouldn't ordinarily be expected to know.

- Slightly less willingness to share knowledge.

- Fewer opportunities for social sharing of information and establishing ongoing contacts, heightened if you have to head off after a shoot rather than going out socially.

- Apparent opportunities leading to nothing.

> *I was on a film industry placement scheme, but, despite being asked back for four films by the same crew when I was a trainee, when I completed my training, all the paid jobs went to the cameraman's son.*
> 1st AC Anon

- Career progress slower than male counterparts.

- Working less, earning less and doing more unpaid work, making it harder to invest in the appropriate kit.

> *It's also a struggle for female directors to get work. People say they want to support woman directors, but that needs to be followed up with action.*
> Kellie Madison[8]

- Your confidence being gradually sapped.

- Statistically it appears to be massively harder for women to move up from being and AC to a DP.

- If you do make it to become a DP, authoritative words or approaches that are seen as acceptable and appropriate for a man are often seen as pushy for a woman.

The cumulative impact of the above is a loss of confidence, which can affect both your work and networking skills, and cause a downward spiral, including:

- Having a feeling you aren't doing something that you should be and so trying too hard or being a perfectionist.

- Immediately replying to criticism by giving reasons for your actions.

- Feeling slightly anxious, so being slightly clumsier and less clear-thinking than usual.

- Coming across as either weak or, if over-compensating, coming across as self-deprecating or aggressive.

> This may have changed now, but as a 2nd AC, after putting in the legwork to visit many production companies, I eventually had some luck. Someone recognized me from my home town and said she would get me on the next shoot as a 2nd AC, but her boss told her that the director wouldn't work with women. Unfortunately, there is little unions can do to challenge missed opportunities. They can only help with in-work discrimination.

One of the major difficulties is that those who talk about negative experiences are seen as negative people. Currently, most women, or others who have been discriminated against, who have managed to get established don't talk about these issues. However, most have experienced them.

Diversity quotas or drives exist in some places, but are often seen as giving unfair advantages to those they are intended to support. The behavior outlined above isn't reduced by quotas and the effects of discriminatory behavior continues to limit people's potential. Thankfully, now there is growing awareness, there will hopefully be a consequent reduction of the more obvious forms of sexual harassment.

There was a big click when xxxxx came over 20 years ago and insisted on having girls in his department. There were rumors of sexpectations. After that, it was generally thought that girls in the camera department got there because of who they slept with. Now, a lot has changed.
1st AC Anon

In a highly competitive word-of-mouth world, it is easy to undermine someone's reputation, by questioning their abilities, which prevents them from being taken seriously and from progressing. For a long time, it was extremely difficult for women to progress from being camera assistants to DPs. Now that the assistant route is not the only route to becoming a DP (as below) and attitudes are beginning to change, the situation is not as bad as it was, but the opportunities to progress remain far from equal.

Solutions

Understanding these factors, knowing your role within the bigger picture of how a film is made and working on self-confidence are the biggest steps to counteracting exclusion.

It is possible for those outside the dominant type to get into the film industry, although the doors of opportunity are smaller. Notwithstanding the difficulty getting started and moving up grades, thankfully, once you are established in your work grade and accepted by your peers, there are far fewer, if any, problems.

The more confident you are, the more capable and less flustered you will feel. Confidence also goes a long way to making you comfortable with, rather than intimidated by, others, and helps make them feel comfortable working with you. The following can help build and retain your confidence:

- Learn as much as you can and prepare as much as possible before going on set, and continue to educate yourself.

- If you are told you are doing something wrong on set, say 'thank you' (because you have learned something) rather than 'sorry' (because you have made a mistake).

- On CVs, and particularly in interviews, always focus on what you know, rather than what you don't know.

> **When I started saying 'thank you' rather than 'sorry' when someone showed me a better way to do something, it made people feel more comfortable about helping me learn, and me feel more confident about what I was doing.**

Fake it until you make it.
Several DPs Anon

- Work on maintaining your confidence. Ideally, find a mentor or friend to support you.

- Remember that the people you are working with are benefiting from your work and not just doing you a favor by letting you be there.

- Looking neat and smart is essential. If you have the possibility of investing in good-quality work clothes or kit, that is a bonus.

- Stay focused on the work you are doing, avoid being distracted by unrelated conversation. If necessary, change the subject by asking about something you are doing now.

- Remember that there is a place for people who have the skills, approach and determination. Navigating obstacles is a part of the process of getting started for anyone and, with self-help and hopefully the help of others, there is no reason why you should be excluded.

- Take any additional opportunities of working on films with your 'group', be that women or a national, ethnic, religious or sexual orientation group.

LIVING WHERE THE INDUSTRY IS SMALL

There just isn't this (LA) kind of a film industry in Boston. There is longer between jobs and networks are tighter because it's smaller.
Danna Rogers

For those living in a country or area where the industry is smaller, there are usually fewer film productions, and the ceiling of opportunity is almost always lower. The upsides are that there are fewer filmmakers, so it is easier to learn skills and get established and recognized. In my experience in Barbados, there was a wonderful group of talented filmmakers who worked on more productions than they might have in a larger industry. If you live in a smaller industry area, it is important to maximize the opportunities and appreciate that many people have to do a lot of unpaid work in larger areas too. The difficulty is that, after you know what you are doing, there is little paid work. For those reaching the ceiling of opportunity in their own area, unless you can move without visa issues, it is very hard to build up relationships and find work internationally. There are no magic bullets, and it is not ideal, but playing a part in expanding the industry in your area may help:

> *The biggest thing I would say to young people . . . is that you need to realize the value of where you come from. When I first started, I had a real struggle with thinking things around me weren't as valuable because they weren't New York or Los Angeles or Chicago or Atlanta.*
>
> *Don't throw your small town under the bus. Use it as a backdrop for your story, as a safe space to go and collaborate with other artists who also want to help tell your story.*
> Bradford Young[9]

- Try to work on or develop low budget but high-quality films, maximizing your location, if appropriate, to help raise the profile of filmmaking in your area.

- Enter films into national and international film festivals to broaden your exposure.

> *If you are out of sync with what big industry wants you are better off with being in your own country . . . you might think you want the big toys but necessity is the mother of invention.*
> DP Anon

- Have a strategic approach to how you present yourself if international productions come into your area, by being a part of an easily contactable location and production service. International productions almost always prefer to work with reliable, comprehensive production services rather than reaching out to individuals.

- If you prefer to be findable as an individual, make sure you have an easily searchable, clear website with current contact details. If contacted, have a clear set of daily rates (prices) for different types of projects, in descending order from commercials and feature films, to TV films and then documentaries. Productions may negotiate with you on your rate, but will expect you to be clear about your pricing.

> **Avoid clashing keywords. For example, anyone searching for film and Caribbean will be swamped with *Pirates of the Caribbean* results.**

15: STARTING AND DEVELOPING A CAREER IN CINEMATOGRAPHY

> *I was a historian by education. The industry was too small to work often here, but then it developed. Now I teach cinematography in film school, shoot commercials and TV shows. I have shot seven features. I also like [taking stills and moving images for] the art world. My professional art and film work are not connected. Every other year, I shoot the TV show* Lazy Town. *The hours are family friendly and I like the change from commercials. I like the different things but, in my mind, would prefer to work just in features and art.*
> Tomas Tomasson (lives and works in Iceland)

Tomas Tomasson. Photo courtesy of Tomas Tomasson.

SPECIALIST ROUTES

> *I bought a Steadicam at the right time and worked with Tony Imi as a Steadicam operator.*
> Roberto Schaefer[10]

An interesting option, rather than starting as a camera trainee, is to start with a specialist skill that is currently in demand. You can then either cross over or find you are happy developing your specialist skill areas. Whatever you do, though, take it seriously, learn thoroughly and don't be immediately on the look out to cross over to your preferred role, or it will irritate people.

> *A DIT (Digital Imaging Technician) is on the same level of the hierarchy as a 1st AC. It is a wonderful job if your aim is to become a DP. The 1st AC is more involved, but as a DIT you are seeing the differences that the DP is making when they are creating the image.*
> *I was an IT support technician for five years, so had a basis of knowledge of systems, problem-solving and common IT concepts. Then I studied graphic design at college, which gave me a good sense of color, color theory and what makes a good image in terms of composition, contrast, etc. Both helped immensely with the transition into becoming a DIT. I know DITs who are more artistic and others who are more technically minded. You fall into working relationships with certain DPs depending on what is more important to them.*
> Matthew Hicks[11]

Other specialist roles include data wrangler, stereographer for 3D, VR cinematographer, drone operator, and a whole host of specialist grip roles from mini-jibs to cranes. Some are harder to move across from than others, and anything that involves expensive training or buying new equipment is a risk. The only downside is that, if you aren't careful, you can become pigeonholed and you get less of a range of experience.

BECOMING A CINEMATOGRAPHER

Whether you start as an assistant, in film school or come up through any other route, you need to not only create a great showreel but also know what the director, producer and 1st AD need and expect from you as a DP.

Put together your best work in your showreel. Show you can handle a variety of situations, from day to night exteriors and interiors, but don't include anything that isn't great. Ideally demonstrate that you have a specific style or choose three or four styles to put on your reel. Choose music or poetry that works with your images and represents you. The job of your showreel is to convey your work, your approach and your taste.

Be wary of employers who base decisions only on showreels, as they will almost inevitably be disappointed that not every frame lives up to the promise of a showreel. A good employer will ask to

> **If you get in at the bottom on big features, you can become very specialized too soon and get stuck there. On TV and small films, you learn more about the whole camera department.**

see full-length examples of your work, to understand how you approach different situations and see your cinematic interpretation of the stories. Likewise, when in discussion with a director or a company, make sure you see full-length examples of their work.

The Director's Perspective

The director wants you to visualize the film and shoot it in a way that maximizes its visual potential, whatever the budget or schedule. This isn't always possible and there can be a mismatch of understanding about what can be achieved. The less well planned the shoot and the tighter the budget, the more this shows.

> *I always wish that the relationship with director is great, but it often isn't.*
> DP Anon

> *You can't work with any director; you may be able to light anything but your cinematography involves an interpretation and your stage of the journey.*
> Vittorio Storaro[12]

> *The last DP I worked with brought his talent but he didn't believe in mine until I proved myself. He started directing the actors; it was disrespectful. We spent a lot of time on shots I knew wouldn't feature in the cut. We spent an hour on a shot where the character walked into the room. It is only the director who knows how all the shots will work together. The lighting was good in the finished film, but we probably won't work together again; it was too draining to fight for each shot.*
> Director Anon

> *I look for a DP who has experience, talent, is current with their visual language and that I admire their work.*
> Director Kellie Madison

> Q: What do you wish you'd known at the beginning?

> A: *That you are working for the director. You can advise but, in the end, it isn't your call. If you point out the issue and they still make what you consider is a bad call, you have to go for it, and whole heartedly. Beautiful shots are not always what is needed to tell the story!*
> Petra Korner[13]

> **The DP and director should maintain their own distinct roles. The director shouldn't instruct the gaffer and the DP should never start directing the actors.**

It is important to make the film look the way it needs to be and fulfill your ideas, but there is a fine art of balance and knowing how far to push your own agenda. There is a saying that 80% of the cinematographer's work is done for 20% of the audience. When achieving the best shot takes time and money, it can pit your aims against those of the production. They want the best but don't always have the scope to let you achieve it. You play a big part in how many shots can be achieved in a day but, equally, whilst the 80% of the audience may not immediately notice the difference between good and great cinematography, it does make the film feel different. It is a fine balance between the two aims. Knowing the story very well can help you decide which are the visual moments to hold out for.

The Producer and Production Department's Perspective

> *Making any type of media project is complex and stressful. A line producer looks after the costs, so needs to know about what happens in all the departments. The more people think about the film as a whole, the less likely they are to be requesting things that blow the budget.*

> *Want vs. need is the biggest thing with camera departments in general. A decent DP will need the works (lots of equipment) to get things done, just to keep them safe (in case they have forgotten something they might need). A great DP will only take the tools they need for the job. DPs should be realistic and not order a crane if you can do the same thing on a dolly.*
>
> *In theory, the DP is always right and gets what they want, but actually the producer asks for a breakdown to see what they are trying to do. I can understand the need for the best cameras and accessories, but accessories that just hit the market last week aren't really needed. There is also a lot of brand blindness, e.g. freak show do a video transitions system, that is the same as the Teradek wireless video systems . . . only the label is different but people won't accept that . . .*
>
> *If a DP is scatter-brained, it's not best but it's a big red flag if a DP doesn't want to learn something new. We want to work with people who are engaged with the art, because the (film) world is changing all the time, we want people who are students of craft. The top-level people never stop learning. They are always learning and reading and happy to talk . . . they are the ones that succeed.*
> Line Producer Anon

The quality of the finished film is important for the production department, but they are tasked with keeping the film on schedule and in budget. This can put the camera and production department at odds. However rushed things get, it is important to maintain good and effective working relationships.

> *It's irritating that things never happen as quickly as you want them to happen, and production are constantly asking how much time before you are ready to go. I have a decent sense of humor, but when I'm tired and others are being inefficient, it's really hard to keep it together, but you have to manage. I understand why DPs lose it (if gaffer hasn't noticed a light go on or something) but nobody wants a twit on set.*
> Paul Mackay[14]

Paul Mackay selfie. Courtesy of Paul Mackay.

Confidence, Charisma and Control

Irrespective of the route you take to get there, once you become a DP you are not only the cinematographer but also the head of the camera and department, and the buck stops with you. Whether you have a dominant personality or not, the mindset and appearance of responsibility will both help you and command respect from others. Shoulders back, assess each situation, think and speak clearly, remain focused and make decisions.

Most of the time, the camera department functions well, but when there are issues that the 1st AC can't deal with, you need to resolve them. Your word is final within the camera department. In theory, you are also head of the lighting department, but the gaffer takes all practical responsibility for the team members. On set, you communicate most with the gaffer during lighting, the director during blocking and shooting, the AC when shooting (unless you have a camera operator) and the DIT at the end of the day or in breaks.

Your personality and style will affect the experience someone will have of working with you. Whether you think so or not, everything you do and all the information about you available online goes to make up your personal brand.

Some (but by no means all) very successful DPs have a charisma and way of talking when working that makes them stand out. The 'rock star' DP is a phenomenon, but underlying that phenomenon is the ability to put into words visual concepts and the emotions that are driving how the scene will be shot and lit. If a DP uses inspiring and evocative words and can match them with equally inspiring and evocative lighting, their use of descriptive language can be a big plus. If a DP makes a big deal of talking up the lighting and the shots, but they don't live up to the hype, the DP just comes over as pretentious.

> *Xxx is very good; he has a specific personality on set and a way of enthusing with language. He personifies the light and refers to it as an artist, a Hieronymous Bosch or a Manet, and makes you feel good about what you are doing.*
> 1st AC Anon

Like any product or service, you can enhance what you are offering by what you say, and make everyone feel good about what they are doing. This positivity can make everyone working with you want to produce their best work.

STARTING AS A DP

> *I worked on a commercial with a DP in Morocco. He was 23 and had never seen a dolly or a jib arm, but his showreel is amazing. His dad is a stills photographer who owns a small studio in New York, and he (the son) made stuff with his Canon 5D, his dad's kit, and put together a cool showreel. There are now more DPs with less understanding of the mechanics of the set.*
> Charlie England

The director needs a DP who can help them visually interpret the story and realize that vision with the time and equipment available. Experience on set helps you do this, but it isn't essential to have worked professionally as a camera assistant. You will have gained a degree of experience on the shoots that go on your showreel and you will need to ensure that you have assistants who can help with any of the practicalities of setting up and using the equipment if you are not familiar with it.

To go straight in as a DP, you will need:

- An excellent showreel.

- A method of getting your work in front of directors who are shooting – either through networking, an agent, or both.

- The ability to handle yourself in unknown and difficult situations.

- A good crew you establish enough of a rapport with so they will both work with you and watch your back.

> *Many DPs jump straight in quite young. New technology has leveled up the playing field, so if you are talented and smart you can start (shooting) straight off. Some young DPs are doing very well. They will make mistakes of differing sizes, but hopefully breeze through and learn from them. Having started earlier, they will build up that (knowledge of shooting) side of things, more so when they are 40 years old they will have 20 years of experience.*
>
> *My main advice is to read, study, and get on set as much as possible. It is best to do both. Go and shoot stills and moving images as much as you can. Work out how to compose and expose images, read about shot storytelling, but also get out and shoot, but don't put all your cr-p online. You can't get rid of it and everyone will remember it. Tailor your online presence.*
> DP Anon

MOVING UP FROM AC TO DP

I benefited from ten years (assisting) in the camera department, learning how to work with actors, getting to know what everyone does on set, seeing how to light big sets and the technical aspects of working with a wide range of equipment. It's invaluable. My main advice to aspiring cinematographers is to study and get on set as much as possible. Shoot stills and moving images as much as you can, especially on film (as opposed to digital) . . .

If you can find someone to mentor you, you'll find yourself in an enviable situation – it will give you no end of confidence. I made my own films, then applied to the NFTS (UK National Film and Television School) at sixteen. Even though I was far too young to attend, they were kind and gave me lots of information and advice. I carried on experimenting myself and focused on making 16mm short films.

Q: What do you wish you had known that would have helped make your journey smoother?

A: I am philosophical. I think everything happened for the right reason.
David Wright

Moving up from being an AC to a DP allows you to bring many years of incredibly useful experience on set with you, but always represents a risk. There are no guarantees that the move will be successful and no guidance on how long to pursue your new role. All the DPs I spoke to and know took a substantial drop in their income, when they moved up, and some are still making far less than they did as ACs.

Leaving focus pulling and going into lighting (as a DP) was a cataclysmic shock. I expected a transition, but didn't expect it to be still going after four years. It financially destroys you; the drop in income, the level of insecurity and seeing on social media what (work) everyone else is getting, I'm still earning less than the (good) money I was on as a focus puller but I don't have the showreel to get me the work I want as a DP.
DP Anon

To make the move up to DP, it is essential to have a good showreel, showing the ability to shoot in a range of situations, an aesthetic sense and ideally your personal style, before moving up. This usually involves shooting unpaid short films and other projects. What can make this difficult is that, if you are a DP, you are often expected to bring or borrow a camera, and sometimes lighting kit, for the free films you work on.

I borrowed equipment from a rental house that knew me well from my work as an AC. The production had to pay insurance, delivery and pick-up, which was more than they thought it would be, but they shouldn't have expected that to be covered for them, and it was $1m of equipment.
DP Anon

The other important factor to enable you to get established is to get an agent, but this can also be trickier for some groups of people than for others. Agents are interested in both your talent and your existing network. They help you build from where you are. They don't do it all for you. At one time it was very difficult for women to get agents, even for those of us with numerous awards. Thankfully, now agents and some members of the industry recognise that women have as much to offer as their male counterparts. The work of the relatively few leading international female cinematographers, including (but not limited to) Charlotte Bruus Christensen, Ellen Kuras, Reed Morano, Rachel Morrison and Mandy Walker, has played a significant part in this change.

This does not mean that there is now a level playing field for all.

H: WORKING IN THE FILM AND TELEVISION INDUSTRIES

People in drama were fine with working with me as an AC, but they didn't want to know when I moved up to DP.
Georgina Burrell[15]

The percentage of males to females is 50:50 in film production courses, and close to that in specialist cinematography courses. In the last 20 years, the proportion of women shooting feature films has ranged from 2–5%. It is only marginally higher in documentary and TV.
Chris O'Falt[16]

The Oscar voting system is more balanced than it was, but this doesn't extend down the line into technical areas.
Ellen Kuras[17]

Georgina Burrell. Photo courtesy of GeorgieB TV.

Neither does this underestimate the difficulty of moving up from AC to DP for anybody.

There are almost as many stories of routes into starting shooting as there are DPs. They virtually always have three things in common:

- Building up a showreel on freebies and networking with directors.

 People get their break in different ways. I was an assistant and was asked to shoot the next film instead (of my DP) so effectively I stole his job . . . Another DP I know of was watching a Truffaut (film) being shot and when the DOP got sick said he could do it.
 DP Anon

- Grabbing any opportunity that comes up.
- Choosing the 'right' time to make the move.

Currently a combination of film school and learning on set is seen as the most likely to help you develop the combination of taste, technique and confidence with technology that it takes to become a DP. The current thinking is that there is much to be gained from a couple of years as a camera assistant but that you should not spend too many years before you move up.

People need to see you as a DP as soon as possible. So, if you're starting out, make the jump and make it fast (within 2–4 years). The sooner you can get into your wheelhouse (role) the better; otherwise you risk the danger of being pigeonholed.
Director Anon

The move up to DP is not right for all people. Over time, you may realize that you don't have the required drive and tenacity required to become a DP. There are many interesting careers in which you can utilize aspects of the knowledge you acquire in the camera department.

When I was trying to move up from AC to DP, I was aware that xxxx was out testing each weekend and I wasn't. I wasn't sure if that was because I wasn't confident or just not determined enough. I now work advising people like xxxx about equipment, but work within a large company.
Anon

DEVELOPING YOUR CAREER AS A DP

Continue learning throughout your career. It's good to get stomach aches and headaches and be challenged . . . find your passion . . . push yourself, keep learning and experimenting.
Roberto Schaefer

Test and be prepared. Plan for the worst and hope for the best, and always remember that you are employed to ensure there isn't a problem. Don't learn on the job, learn before the job, but if you do make mistakes, make sure you learn from them.

I vividly remember the day it clicked what light does, how lighting relates to the story.
Petra Korner

I started with my mum's Hi8 camcorder, making films with my cousin. We planned shots and edited in camera – our own versions of films that we liked. Horrors and comedies mostly. Making those films developed the intuitive aspect of how one shot follows another, as did looking closely at what I saw on TV and at the cinema.

Roberto Schaefer. Photo by Douglas Kirkland.

I was fueled by an interest in photography and drama, and was single-minded by the age of fifteen about where I wanted to go. University was a traditional route, where I got a good grounding in theory – film appreciation, deconstruction and how to read films. The course looked broadly at Asian and arthouse films, not just Hollywood movies.

After I graduated, I started working as a camera trainee and worked my way up the camera department, building my CV. When digital cameras came to the forefront, I sidestepped into DIT work (when working your way up or when working). As a DP you never stop learning.

Advice? Technical issues are less important to me these days. I used to worry that I didn't know enough, and it took time to accept that it's impossible to know everything and you shouldn't feel overwhelmed. As a DP it's your approach and ideas that are important, so you should focus on those things and the complexity of shoots won't be a problem any more. Trust yourself.
David Wright

I studied at a local university and worked my way up in my home area, initially with a low-end HD kit, working for local businesses. I now have better kit and great lenses, and work more widely. I don't live in London but have a London base. Most of my work is corporate and a lot of it involves traveling. A lot of it involves managing relationships and delivering what people want. The downside of living outside London is the difficulty in networking face to face. I have more work than I can manage some of the time, but never recommend anyone, because they can't be relied on for quality.
Josh White[18]

As time goes by, you are relieved that you work with fewer idiots, but eventually you realize that early on you were one of them.
DP Anon

Josh White. Photo by Danny Allen.

The whole self-selling thing is based on honesty. Marketing isn't about lying; it's about getting your message about what you are offering.
Kim Plowright[19]

H: WORKING IN THE FILM AND TELEVISION INDUSTRIES

I am passionate about drama and lighting. After NYU, I started working in a camera rental house in New York, then became a 2nd AC. When the time came to move up to pulling focus, I was more interested in lighting. Nobody wanted to hire a woman in a lighting rental house at the time, so I worked as an electrician (spark) and a best boy for a while, while continuing to shoot short films and music promos. I eventually got accepted into the graduate cinematography program at the American Film Institute in LA. I was the first from my class at AFI to get an agent and to shoot a big studio movie. I was very young and had a lot responsibility, but without the experience. I had theoretical cinematography knowledge and a lot of drive, but not necessarily the set experience or the life-wisdom. My biggest mistakes were of a political nature – when I should have fought for something or fired someone, or when I should have been less honest – but I am slowly getting wiser.
Petra Korner

Petra Korner. Photo courtesy of Samosa Stories.

Know who you are and where you come from. Know your history. We should be history makers.
Bradford Young[20]

Choose a film if you love the story . . . it is always script first.
Chris Menges

Never forget this is very precarious profession. A DP wants to carry on working, but it's a combination of things that just happen and how you approach finding work. Remain positive, accept all the work you can, but be aware it will be quiet at some points.
Andrew Boulter[21]

As a DP, make thank-you calls, give credits whenever you can, appreciate the people who have helped you and you have learned from. Choose scripts and projects that interest you and never stop learning.

Andrew Boulter.

NOTES

1. Danna Rogers (1st AC) in discussion with the author (March 2017)
2. Julian Bucknall (1st AC) in discussion with the author (September 2016)
3. Chris Menges BSC ASC (DP) speaking at Cinefest, Arnolfini Centre, Bristol, September 2016.
4. Gallagher, Matt. *Breaking into UK Film and TV Drama*. California, USA: Createspace, 2016.
5. Charlie England (1st AC) in discussion with the author (September 2016)
6. Women and Hollywood. "2016 Statistics". https://womenandhollywood.com/resources/statistics/2016-statistics/
7. Anderson, John. "Study shows how women directors get blocked in Hollywood." *Fortune*, October 6, 2015. http://fortune.com/2015/10/06/women-directors-hollywood/
8. Kellie Madison (director) in discussion with the author (March 2017)
9. Adams, Kirby. "Oscar-nominated Bradford Young: 'I am Louisville, Kentucky'". *Courier Journal*, February 22, 2017. https://www.courier-journal.com/story/entertainment/movies/2017/02/22/oscar-nominated-bradford-young-am-louisville-kentucky/98049594/
10. Roberto Schaefer ASC AIC (DP) in discussion with the author (September 2016)
11. Matthew Hicks (DIT) in discussion with the author (September 2016)
12. *Writing with Light: Vittorio Storaro*, directed by David Thompson (UK, 1992), film.
13. Petra Korner AAC (DP) in discussion with the author (September 2016)

14 Paul MacKay (DP) in discussion with the author (September 2016)
15 Georgina Burrell (DP/shooting PD, georgieb.tv) in discussion with the author (May 2017)
16 O'Falt, Chris. "'Mudbound': Why Rachel Morrison Deserves to Be the First Female Cinematographer Nominated for an Oscar". *IndieWire*, November 8, 2017. http://www.indiewire.com/2017/11/mudbound-cinematography-rachel-morrison-first-female-best-cinematography-oscar-nomination-1201895466/
17 Walker Art Center. "Filmmakers in Conversation: Ellen Kuras". *YouTube*. March 17, 2010. https://www.youtube.com/watch?v=bHnVrb4aPOI
18 Josh White (DP) in discussion with the author (September 2016)
19 Kim Plowright (Freelance Producer and Product Manager, and a Senior Lecturer at the National Film and Television School) in discussion with the author (September 2016)
20 Global Cinematography Institute. "'Advice to Young Cinematographers' with Bradford Young, ASC." *YouTube*, March 2, 2016. https://www.youtube.com/watch?v=YfGo9tdb4vA
21 Andrew Boulter (DP) in discussion with the author (September 2016)

APPENDICES

Appendix 1
Camera Department Roles and Relationships Overview

PRODUCER

Selects a project they can source finance to make. Finds distribution for the finished film to recoup the finance. Can hire and fire the DP.

PRODUCTION DEPARTMENT

Creates a schedule and budget. Organizes all aspects of the film production so that it stays on schedule and in budget.

DIRECTOR

Directs the actors and curates the creative ideas of each head of department (sound, design, camera, etc.) for the benefit of the film. Chooses people who bring the range of skills, taste and talent that will help them realize and enhance their intentions for the film. Can hire and fire the DP.

DIRECTOR OF PHOTOGRAPHY, ALSO KNOWN AS THE CINEMATOGRAPHER OR DP

Brings their knowledge, ideas and experience to the production to realize and enhance the director's intentions within the producer's budget. Chooses shots with the director, collaborates with the gaffer to carry out the lighting, and the grip and camera assistants to realize the shots. Works with the designers (production, costume, hair and makeup) and the DIT and colorist to create the look of the film.

CAMERA OPERATOR

Operates the camera on complex, larger budget shoots.

SPECIALIST CAMERA OPERATOR

Operates, and often supplies, specialist equipment such as Steadicams, drones and cranes.

DIT (DIGITAL IMAGING TECHNICIAN)

Works on set. Checks the digital image for errors and faults. Often oversees data management and back up to ensure post-production get the correct files in the most useful format. Works with the DP to produce a LUT that is laid over the image so the look wanted by the DP is visible to all.

1ST AC (FIRST CAMERA ASSISTANT), ALSO KNOWN AS THE FOCUS PULLER

Makes sure all required camera kit and accessories are ordered, available and working as they should. Stays by the camera during the shoot. Assembles equipment on the shoot and reconfigures it as needed for each shot. Prepares focus points and pulls focus during shots, prevents light directly hitting the camera lens and puts settings on the camera as requested by the DP.

2ND AC (SECOND CAMERA ASSISTANT), ALSO KNOWN AS THE CLAPPER LOADER

Organizes and manages the equipment. Puts on the clapper board, keeps records of technical details of the shots. Brings equipment to the 1st AC, helps with kit changes and setting marks for focus pulling. Manages batteries, mags for recording, to ensure they don't run out, sets up monitors and brings tea/coffee to the camera department, director, continuity and dolly grip.

CAMERA TRAINEE

Helps the 2nd AC with their tasks.

SPECIALIST ASSISTANTS

On larger shoots there may be a number of specialist assistants who are responsible for aspects of the camera assistant's job, e.g. monitor management, data management or specific pieces of equipment.

POST-PRODUCTION SUPERVISOR

Co-ordinates the transfers of image, editing, all sound work, VFX coloring and preparation of the film for distribution and display.

COLORIST/GRADER

Uses the tools available in grading to enhance the image. Works with and for the DP and director, to create the look of the finished film.

Appendix 2
Assessment Rubric

Level	Technical Ability	Composition/ Shot Choice	Technical Lighting	Creative Lighting
1	Several errors in: exposure, white balance, appearance of image noise or clipping, shutter speed or focus.	The size of the shot doesn't relate well to subject or setting or isn't sufficient to tell the story. Wide and tight shots don't match. Too much, too little, or inconsistent headroom or leadroom.	Several errors, such as: hot spots or unwanted flare, double shadows, light that falls off too quickly or appears unmotivated. Lighting stands, lamps or cables in shot.	The quality (softness or hardness) of the light doesn't suit the source that is motivating it and the lighting ratio is inappropriate.
2	A few errors as above.	Size of shot and headroom are appropriate, but the angle of the shots seems unmotivated or uncomfortable.	Occasional errors as above. Light is generally motivated.	At some points, the lighting is suitably motivated; at other times, it is inconsistent with the source.
3	All elements as above are good.	Angle of view and content are appropriate. Shots tell the story and shot choices work well together.	All the above is good and light is clearly motivated. Light is positioned to create shape and texture, rather than being flat.	The direction and quality of the light fits with the motivating source. The overall lighting largely suits mood, story and environment. Lighting ratio is appropriate.
4	All elements are well controlled and, where appropriate, focus shifts or exposure changes are used effectively.	As above, with shot choices that creatively tell the story and make the most of the set or environment.	As above and, where appropriate, light has been flagged off or blocked from parts of the shot to direct the viewer's attention as intended.	As above, with lighting throughout that supports the mood of the story and the environment. Filtration or diffusion has been used if needed and, where appropriate, changes of light appear convincing.

Appendix 3
What's the Problem?

Set this scene outside. You may change the names or the gender of either or both characters.

EXT. ANYWHERE – DAY

 SEAN
So, what's the problem?

 BARRY
No problem.

 SEAN
If there was no problem, you wouldn't be behaving like that.

 BARRY
I always do this.

 SEAN
Sure, you always do that when you're unhappy. What you unhappy about?

 BARRY
Nothing.

Barry walks away from Sean.

 SEAN
Barry.

 BARRY
It isn't what I expected.

 SEAN
What do you mean by that?

 BARRY
I thought it would be different.

APPENDIX 3: WHAT'S THE PROBLEM?

> SEAN
> OK, so it's different to what you expected. If it had been what you expected, would that make everything OK?
>
> BARRY
> Of course.
>
> SEAN
> Really?
>
> BARRY
> Well, probably.
>
> SEAN
> So you wanted more than you expected . . .

Appendix 4
Don't Do That, Kevin

You may change the names of the characters, and they can also be the same gender.

INT. ANYWHERE - DAY OR NIGHT

 GILLIAN
Don't do that, Kevin.

 KEVIN
Why not?

 GILLIAN
Because it hurts.

 KEVIN
You're too sensitive.

 GILLIAN
You make me sick.

 KEVIN
You really need to change your attitude.

 GILLIAN
Why?

 KEVIN
Because . . . [make up your own words here]

Index

3/4 back light 178, 254, 288–9, 290, 322, 330
3/4 front light 288–9, 314
1st AD 27, 29, 31, 45, 313

ACES 126, 128–130, 134
Ambient light 27 *see also,* available light, natural light
Anamorphic lenses 107, 138, 153, 356–357
Angle of view 142–146, 149–151, 158, 161, 274, 276
Aperture:
 aperture focus pulling/depth of field 38, 76, 108, 219, 246, 275
 aperture exposure 64, 66–69, 72–73, 267
 aperture lenses 81, 146, 153, 356
 aperture stops and metering 261
Archiving 134
Artifacts 28, 131
Artists, working with 29, 44, 236, 239, 248–249
Aspect ratio 24, 46, 115, 117, 137
 aspect ratio and composition 148, 160–162, 175
Assessment/Self-Assessment 17, 228, 250, 367, 387
Autofocus 40–41, 93, 219
Available light 221–222, 273–274, 269–277, 279

B Roll 172, 174, 207–208
B camera 150, 172
Backup *see* data management
Back/rim light 293, 326, 328, 354
Balancing the camera 84–89, 95, 218, 240, 241
Bars *see* rods and bars
Base plate 80, 88–90,
Batteries 34, 45–46, 102–103, 197
 batteries and flicker 221, 305
Bayer filter 57–58 *see also* debayer
Bit Depth 53, 60, 118–119, 129, 134
Bit Rate 115, 118, 125, 127
 constant bit rate 135
 variable bit rate 136–137
Black-and-white 118, 338, 349–351
Black balance/shading 104, 75
Blocking the scene 30 165–166, 171–172, 245
Blooming 60, 354
Blue hour 278–280

Bokeh test 107, 153, 356
Bounced light 221, 271, 292, 297, 298, 320–321
 bounced fill 254–255, 275–277
Bridge plate 89–91
Bulb types 302–306 *see also* HMI, tungsten, LED
Bullet time 192
Burnt in LUT *see* LUT
Butterfly frames 275, 325

Call Sheet 22
Camera assistants:
 1st AC, 2nd AC and trainee 8, 22, 26–27, 98, 235, 102–103, 366–369;
 see also clapper board, camera tests, record keeping, monitors, shoot procedure
Camera covers 35–36
Camera Department Hierarchy 24, 25, 29, 385–386
Camera Equipment:
 assembling camera accessories 91–94
 assembling cameras 78–90
 choosing cameras 77, 116–118
 cleaning 97
 preparation 101–103
 protecting 34–36
Camera heads 82–84, 95, 240–249
 leveling 83
Camera movement *see* movement
Camera operating *see* operating
Camera operator role 27, 30, 31, 177, 234–239, 246–250
Camera rental *see* rental
Camera sheets 28, 45
Camera supports 8, 84–85, 86–88, 239–245
 dollies 81, 244, 179, 235, 243, 244,
 gimbals 86–88, 242–243
 hand held/shoulder rigs 85–86, 241–242
 Steadicam 86–88, 234, 242
Car interiors 330
Career 206, 363–364, 367
 CVs and online presence 365
 discrimination 368–371
 getting established 367–368, 373–380
 getting started 364–365
 mentors 366
 personality and approach 366, 375–376
 specialized routes 373
 where the film industry is small 372–373

Charts; color, grey or test charts 74, 104–105, 109, 130, 348
Cheating 146, 236, 277
Chroma sub-sampling *see* compression
Choreography 177, 179, 182
Cinematographers toolbag 98
Cinematographer *see* Director of Photography
Cinematic language *see* visual language
CineTape 41, 92–93
Circle of confusion 69
Clapper Board 40, 43–45
Clean shot 146
Cleaning camera equipment and lenses 35, 97–98
Clipping 59–60, 111, 220, 266
Codec 62, 120, 121, 124–127, 136
Contributors, working with 206, 248–249
 see also permissions
Collaboration techniques 9–10, 15–16
 see also director DP collaboration
Color
 color and meaning associative, transitional, connecting 342–343
 color correcting 131–132
 color fringing test 105
 color gamut/color space 47, 114, 129, 130, 131, 134
 colored light 346
 color temperature 74–75, 221, 272, 281, 315–316, 324, 346–348
 color temperature meter 261
 color test for lenses 109
 color wheel 342–345
Colorist 116, 130–133, 340, 348–349, 358
Color grading/coloring 114, 122–123, 127–134, 211, 340–341, 358–359
 color grading and bit depth 118, 344
 measuring color for grading 259
Composition 141–143, 155–157, 160–163, 176–177, 236
Compression
 chroma subsampling 126,
 Inter-frame, 136
 Intraframe 136
 lossless 124–125, 137
 lossy 124–125, 136
Computer screen 305
Conform 134
Continuity 173–175, 188, 236
Continuous lamps 197

393

INDEX

Cookies 296, 324
Coverage *see* blocking
Creativity 10–15, 14–15, 155, 181
Crop factor 142, 149–151
Crossing the line 165, 174–175, 216, 239
Cutting/stopping the camera 31, 45
CVs *see* careers
CMYK 127, 344

Data mags and cards 26, 49, 211
Data Management/wrangling 26, 28, 48–51
Data rates 49, 120, 125, 128
Data Wrangler *see* DIT, *also see* Data Management
Day exteriors 274–277, 325
Day for night 283
Day interiors 281–282, 325–326
Dead pixel test 104
Debayer 58 *see also* Bayer filter
Depth of field 38–39 67–70, 152, 158
Developing shot 179, 215, 217
DIT Digital Imaging Technician 9, 27–28, 47, 123, 198, 373
Digital Report Sheet 28
Digital slate 44 *see also* clapper board
Diffusion 95, 340, 351–354
 diffusion camera filters 340, 351–354
 diffusion exteriors kit 276
 diffusion lighting 281, 297, 320, 353
 fog/smoke 324, 353
Diopters 39
Display referred transform 129
Director DP collaboration 170–171, 211, 374
Director of Photography – role of 4, 27, 385
Dirty shot 146
Discrimination *see* career
Distance and drop off *see* inverse-square law
Documentary:
 documentary equipment choices 213–4, 221
 documentary modes/types 206–210
 documentary shoot procedure and shooting for the edit 214–217
 documentary shoot settings and lens choice 212
 see also pre-production, solo shooting
Dolly/dollies *see* camera supports
Dolly Grip role 28, 235
DSLR 71 78 122, 136, 151, 219, 225, 357
Double shadows 291, 317, 319, 323, 325
Doublers 143
Dynamic range 56–57 59–66, 117–118
 and exposure 76, 120–121, 264–267, 257–58,
 and ISO 59
 SDR and HDR display 263–264
 test 109–110

Easyrig *see* Rig
Edge sharpness 133
Editing 65, 115, 128, 187–189
 pan and scan 116, 347
 see also shooting for the edit, workflow
Education/film school 6–10, learning cycle 16–17

Emulating or simulating light 286, 289, 291, 302 305, 320
ENG plate 89
Euro mount 81, 82
Exporting 135–136
Exposure 54–55, 62–66, 263–267. 281, 283, 348, 353
 exposure documentary and solo shooting 219–220
 exposure ideals and compromises 72–73
 exposure problems and solutions 66–67
 exposure techniques 266–267
 exposure triangle 72
 exposure Values 261
Expository documentary 207
Extenders 143
Eyeline 177, 222–223, 239
Eyebrow 93–95

False color 65–66, 256–259
Fast motion 71, 76, 189–190, 193
Fill light 254–256, 291–293, 322–333
Film school *see* education
Film time 186
Film, shooting on film 358
Filters 39, 94–95, 107
 black and white 350–351
 diffusion 352, 353
 graduated 60, 274
 lighting filters 316, 347
 ND/variable ND 66–67, 95, 108, 267
 see also Bayer filter, polarization
Filter factor 267, 348
Filter tests 107–109
Firelight 280–281, 347
Fish eye lens 151, 152–153
Five in one kits 275–276
Flags 294–295, 324, 326
Flare 27, 75, 153, 354, 356, 358
 flare test 107
Flat light 256, 289
Flicker, 28, 72, 196–199, 302–307
Fluid head 83, 240
Fluorescent 198, 261, 272, 300 304–305
Focal length 69–70 143–144 149
Focus and focus pulling 37–43, 91–92, 236
 focus peaking 42, 46, 219
 and storytelling 41, 158
Focus Puller *see* 1st AC
Focus tests 104–106
Fog 324, 353–354
Foot candles 260
Foreshortening 179
Frame energy 156, 180, 234
Framing 6, 149, 155–160, 236–239 *see also* composition
Frame rate 71–73, 76, 135–136 189
Frame height 162
Frame lines and guides 46, 102, 148
French flag *see* eyebrow
Full-frame sensors *see* sensors
Fps frames per second 71, 189, 193

Gaffer 9, 261, 318, 324, 331–332
 role and duties 33, 273, 312, 316,
Geared head 83–84, 240

Grey card *see* charts
Genre 5, 166–169, 342
 and aspect ratio 160–163
 shooting ratio 173
Gimbals *see* camera supports
Glow 321, 351, 354, 355
Grading:
 master grade 114, 116, 128–131
 Final grade 131–133, 134
 see also color grading
Graduated filters 95, 133, 266
Green screen 276, 330
Gray card *see* charts
Grip 28, 331 *see also* dolly grip

Hand held shooting *see* operating
Hand held supports *see* camera supports
Handles 173, 216
Hard light 254, 276, 289, 293, 296, 298, 320
Haze 75, 353, 354, 355
HD high definition 117, 123, 126, 135, 136
HDR high dynamic range 56, 117–118, 120, 131, 258, 263–264
Head *see* camera head
Headroom 159, 237–239, 246
Health and Safety 32–33, 220, 239, 246–248
High key and low key 55, 63–64, 111, 258, 265
High Speed 72, 191–193, 198
Histograms 64
HMI 74, 300, 303, 330, 355

IDT input display transform 130
Imagination *see* creativity
Image circle 150–151
Incident meters 262–263
Interlaced frames 195–196
Interviews 207–209, 221–224
Inverse square law 290–291
IR infrared pollution and IRND tests 67, 108
IRE 65–67, 219–220, 257–259, 265–266, 282
ISO 55, 58–59, 66–67, 111, 257, 263
 ISO black and white 350
 ISO and calculations/photography math 72–73
 native ISO 59, 66, 76, 280

Kelvin 74, 260–261, 278, 316, 347
Key light 254–256, 282, 288–290, 318, 320–322
Kuleshov effect 166

Lamps:
 lamp choices 221, 299–302
 lamp housings 9, 286, 301, 306–308
 see also bulbs, filters
Latitude 55, 266
Leadroom 159–160, 180, 237
LED 197, 221, 300, 305–306, 308, 322
Lenses 67, 94
 lens choice 152–154
 cleaning 97
 image circle 150–151

394

INDEX

lens mounts 80, 95, 106, 152, 154
lens performance tests; 104–109
Leveling the camera *see* balancing
Lifting 33
Light changes during shot 329
Light metering and measurement 54–55, 59, 63–66, 153, 256–263
Lighting controls 301
Lighting department 331–332
Lighting plans 314, 315, 316
Lighting procedure 30, 313–314, 316–318, 320–324
Lighting and contrast ratios 255–256, 291, 294–295, 314, 318, 320–323
Line *see* crossing the line
Linear story structure 187
Log Logarithmic footage 61–62, 119, 121–122, 124, 211–212, 265
 exposing with log 220, 258
Long lens 39, 42, 70 146–147, 234,
Lossless compression *see* compression
Lossy *see* compression
Low budget productions 78, 118, 154, 176. 177, 286
 equipment options 35, 104, 286, 297, 302–308, 355
 working practice 23, 81, 114, 206, 224
 see also production constraints
Low Key *see* high key and low key
Low light test 111
LUT Look up table 61–62 119 122
 burnt in LUT 123–124 128
 conversion LUT 129
 creating LUT from grade 133
 choosing for doc 211–212
Lux 260

Macro lenses 39, 152, 153
Magic hour 277–278
Magic lantern 122, 124
Mags *see* data mags
Male gaze theory 168–169
Master Grade 114, 116, 122, 128, 130–133
Master shot 155, 173, 314
Matte box 85, 90, 93–95, 103, 223
Mentor 365, 367, 377
Menu 78, 96, 103, 219
Metaphors and motifs 175–177, 182
Mics/microphones 224–226
Minimum focus 39, 69, 81, 92
Mist 353–354
Mixed lighting 221, 347–349
Moire 62
Monitors:
 flicker 196, 199
 for exposure levels 65–55
 focus peaking 42, 46–48, 131
 set up and calibration 131
 see also false color, waveform monitors, vectorscope
Montage 189
Motifs *see* metaphors
Motion blur 72, 73 193–195
Motivated light 221, 286, 289, 295, 322
Movement 156, 179–181, 234–235, 240–241

Natural light 74, 196, 269–274, 282, 290
 see also available light
National cinema 6
Native ISO *see* ISO
Negative fill 292–293, 295
ND filter *see* Filters
Netflix 128, 358
Nets 296, 324, 331, 367, 370
Night exteriors 279–280, 327–329 *see also* day for night
Night interiors 282, 326
Noise 55, 58–59, 76, 111, 267, 350
 noise in HDR 263
 noise and black balance 75
Noise floor 58, 64, 280
Non-continuous lamps 197
Non-linear story structure 187–188
Normal/standard lenses 144–146
NTSC video/TV system 47, 71, 197

Observational documentary/Ob Doc 170, 173, 207–209, 217, 221
Off-screen space 181
ODT output display transform 130
Oner *see* single shot scene
Operating 218, 233–239, hand held 245–249
Optical flat 35
Over-cranking *see* slow motion
Over exposure *see* clipping
Over the shoulder shots 145–146

Pace/pacing 166, 178–179, 181, 188
PAL video/TV system 47, 71, 197
Pan and scan 116 148
Participatory documentary 208
Performative documentary 208–209
Periscope lens 152
Permissions 211, 223
Photography math 67 73
Photosites 56, 59, 116, 137, 150
Pick-ups 32, 44, 45
Pixels:
 dead pixels104
 resolution 116
 screens, 65, 116, 137
 sensors 56, 62, 151
 sub-sampling 126
Planning *see* pre-production
Pole cat 312
PUGE picture lineup generation bars 65–66
Poetic documentary 209–210
Polarization 76, 350, 355–356
Post-production workflow *see* workflow
Power supply 45–46, 196–198, 220, 312, 331–332
Practical lamps 12, 198, 270, 278, 317, 322–323, 348
 color temperature 212, 221
Pre-production ACs 22
 see also camera equipment preparation, camera tests
Pre-production cinematographers 22–24
 see also scout, camera tests
Pre-production documentary 210–212
Prime lenses 39, 40, 91, 142, 146, 217, 280

Production constraints and parameters, 12, 181–182
Production department 21–22, 29, 45, 48, 114, 206, 374
Professional Practice 21, 25
Progressive frames 195–196
Props 29, 30, 163, 176, 236, 247
Prores 125, 126, 128, 134, 136, 211

Quadrant framing 156
QRP quick-release plate 34, 79, 87, 89

Rack focus 147, 158
Rain 35, 102, 194, 213, 274, 331, 355
 meaning and motif 176, 177
RAW 60–61, 118–121, 258, 265, 277
Ratios *see* lighting ratio
Real time 186–187
Rec.709 109, 114, 123, 120, 123, 258
Rec.2020 114, 115, 120. 123
Recce *see* scout
Record keeping 28, 45
Recording formats 60–62, 96, 115, 195, 212
RGB 127, 316, 344
Reflected fill *see* bounced fill
Reflections 30, 47, 76, 210, 298–299, 355
Reflectors 213, 254, 273, 274, 275–276, 292
Reflexive documentary 209
Rental houses 8–9, 24, 78, 80, 103, 300
Report sheets 28,
Resolution 56, 114–118, 128, 133, 135, 137
Response curve 264–265
Reverses 145–156, 159, 172, 277
Rigs/handheld rigs *see* camera supports
Rim light *see* back light
Rods/bars 90–91
Rolling shutter effect 199–200
Rule of thirds 159, 162, 161

Safety *see* health and safety
Saturation 75, 122, 259. 355
Scene referred transforms 130
Schedule/scheduling 22, 29, 274, 313
Screen direction 158–159
Screen space 145, 162–163, 181 *see also* composition
Screen time 186
Screens 116–117, 137, 161, 199, 263
 computer screens 305
 HDR screens 264
 viewing distance 131
 see also widescreen, greenscreen
Scrim 297
Scout/recce 23, 263, 270–273, 278, 281, 313
SD standard definition 116, 117, 126
SD cards 103, 49
SDR standard dynamic range 118, 131, 264
Self-assessment *see* assessment
Sensor 56–59, 77–78, 80, 116, 137
 black-and-white 350
 cleaning 98
 line 40
 moiré 62
 rolling and global shutter 199
 size and angle of view 149–150

395

INDEX

size and crop factor 151
size and depth of field 69, 152
see also dynamic range
Shadows and shapes 13, 287, 288, 294–296, 321
Sharpening light 298
Shoot:
 procedure step by step 29–32
 calling the roll 31
 shooting order 172
Shooting for the edit 75, 166, 173–175, 179, 214–217, 223, 249
Shooting ratio 29, 172–173
Shot list 24, 31, 162, 173
Shot reverse shot 146
Shot sizes 156–157
Show LUT 123
Shoulder rig see camera supports
Showreels 168, 373, 376–378
Shutter:
 global shutter 199–200
 rolling shutter 199–200
 shutter angle 71–72, 76, 193–197, 212, 261, 351
Shutter speed 3, 71–73, 193–195, 261
 and motion blur 71–72, 193–195
 see also flicker
Signal to noise ratio 58, 76, 225
Single shot scene 178–179, 181
Slate see clapper board
Slider 181. 182, 214, 243
Sliding base plate 79, 89–90
Slivers of light 324
Slow motion 71, 189, 191–193 see also high speed
Smoke see fog
Sodium street light 75, 133, 212
Soft light 13, 254–255, 289–290, 297
Softening the image 296–298, 351–353
Solo shooting 206, 218–219 see also documentary
Sound and sound recording 68, 71, 217, 224–228
Split field diopter 39
Spot meter 262–263

Squeeze 137–138, 153, 227, 357
Stairs, halls and corridors 330–331
SD Standard definition 116, 117, 126
SDR Standard dynamic range 116–118, 123, 263–264
Standard lenses see normal lenses
Steadicam see camera supports
Stereotypes 168 see also theories of representation
Still Photography 3, 10, 39, 71, 114, 149. 154
Stops 63, 261 see also aperture
Storyboard 23–24, 171
Story time 186, 188
Structuralist film theory 166
Stylizing 119, 168, 178, 182, 193, 209
Super 35 78, 142, 149–151

T-stops and F-stops 153
Teamwork see collaboration
Telephoto lenses 143 see also long lens
Tests/testing 8, 17, 23–24, 101–103
 color tests 109
 dead pixel 104
 dynamic range test 110
 filter tests 107–108
 low light 111
 see also lens tests, lighting tests, camera tests
Texture 23, 255, 264, 271, 289, 315
Theories of representation 168–169
Tight lenses see long lenses
Tilt shift lens 39, 152–153
Time base 71, 189, 191, 194
Time code 44, 212, 224
Time:
 flow of time 185–191, 210
 slowing down time 190–193
 speeding up time 189–190, 192
 see also bullet time, film time, real time, screen time, story time
Time lapse 189–190
Transcoding 28, 120, 125, 126, 128
Transitions 188–189
Trainee 8, 26, 32, 365–366

Tripod 80–82, 84, 89, 237, 244
Tungsten 74, 197, 198, 279, 302–303, 348
Two-camera shooting 172

Under-cranking see fast motion
Underwater 36
UHD ultra high definition 47, 115–117, 120, 123, 126, 135, 136

Variable ND 108, 267, 275
Vectorscope 109, 130, 259–260, 343
VFX 131, 134, 173, 243 330,
 bit depth required 60, 118
 color and green screen 261, 316
 shooting requirements 127
 suitable codec subsampling 126
Viewer perspective 144, 145, 162, 177, 182, 223
Vignetting 108, 150
Visual language 5–6, 156, 159, 168, 182, 242, 287
Visual metaphors see metaphors
Waveform monitor 65, 219, 257, 259, 262

Weather:
 protecting equipment 35
 shooting in changing weather 273–274
 working in 33
Wet downs 379, 280, 328, 329
White balance 74–75, 120, 121, 212, 278, 346
 auto white balance 75
Wide-angle lens 69, 70, 144–145, 356
Widescreen 148, 153, 160–162, 175, 357
Workflow 113–116, 192, 211–212
 color managed workflow see ACES
 creative workflow 14–15
 post-production workflow 128–136
Wrap 32, 45, 171

z-axis 148–149
Zebras 64, 219–220
Zoom lenses 39, 40, 43, 67, 94, 152, 218
Zooming during shots 217, 223, 235
Zoom lens and drift tests 106

THE COLLECTED PAPERS

OF

FREDERIC WILLIAM MAITLAND

IN THREE VOLUMES

VOLUME II

THE COLLECTED PAPERS

OF

FREDERIC WILLIAM MAITLAND

DOWNING PROFESSOR OF THE LAWS OF ENGLAND

EDITED BY

H. A. L. FISHER

VOLUME II

Cambridge:
at the University Press
1911

CAMBRIDGE UNIVERSITY PRESS
Cambridge, New York, Melbourne, Madrid, Cape Town,
Singapore, São Paulo, Delhi, Mexico City

Cambridge University Press
The Edinburgh Building, Cambridge CB2 8RU, UK

Published in the United States of America by Cambridge University Press, New York

www.cambridge.org
Information on this title: www.cambridge.org/9781107631618

© Cambridge University Press 1911

This publication is in copyright. Subject to statutory exception
and to the provisions of relevant collective licensing agreements,
no reproduction of any part may take place without the written
permission of Cambridge University Press.

First published 1911
First paperback edition 2013

A catalogue record for this publication is available from the British Library

ISBN 978-1-107-63161-8 Paperback

Cambridge University Press has no responsibility for the persistence or
accuracy of URLs for external or third-party internet websites referred to in
this publication, and does not guarantee that any content on such websites is,
or will remain, accurate or appropriate.

TABLE OF CONTENTS

VOLUME II

Papers of a less technical character are marked by an asterisk.

	PAGES
The Materials for English Legal History	1—60
Possession for Year and Day	61—80
The Introduction of English Law into Ireland	81—83
The Surnames of English Villages	84—95
Northumbrian Tenures	96—109
The History of the Register of Original Writs	110—173
Remainders after Conditional Fees	174—181
The "Praerogativa Regis"	182—189
A Conveyancer in the Thirteenth Century	190—201
A New Point on Villein Tenure	202—204
Frankalmoign in the Twelfth and Thirteenth Centuries	205—222
Review of "The Gild Merchant"	223—231
Henry II and the Criminous Clerks	232—250
Tenures in Rousillon and Namur	251—265
Glanvill revised	266—289
The Peace of God and the Land-Peace	290—297
History from the Charter Roll	298—312
*The Survival of Archaic Communities	313—365
The History of a Cambridgeshire Manor	366—402
The Origin of Uses	403—416
*Outlines of English Legal History, 560–1600	417—496

THE MATERIALS FOR ENGLISH LEGAL HISTORY[1]

A DISTINGUISHED English lawyer has recently stated his opinion that the task of writing a history of English law may perhaps be achieved by some of the antiquarian scholars of Germany or America, but that "it seems hardly likely that any one in this country [England, to wit] will have the patience and learning to attempt it[2]." The compliment thus paid to Germany and America is, as I venture to think, well deserved; but a comparison of national exploits is never a very satisfactory performance. It is pleasanter, easier, safer to say nothing about the quarter whence good work has come or is likely to come, and merely to chronicle the fact that it has been done or to protest that it wants doing. And as regards the matter in hand, the history of English law, there really is no reason why we should speak in a hopeless tone. If we look about us a little, we shall see that very much has already been achieved, and we shall also see that the times are becoming favourable for yet greater achievements.

[1] *Political Science Quarterly*, 1889.
[2] Charles Elton, *English Historical Review*, 1889, p. 155.

Let us take this second point first. The history of history seems to show that it is only late in the day that the laws of a nation become in the historian's eyes a matter of first-rate importance, or perhaps we should rather say, a matter demanding thorough treatment. No one indeed would deny the abstract proposition that law is, to say the least, a considerable element in national life; but in the past historians have been apt to assume that it is an element which remains constant, or that any variations in it are so insignificant that they may safely be neglected. The history of external events, of wars and alliances, conquests and annexations, the lives of kings and great men, these seem easier to write, and for a while they are really more attractive; a few lightly written paragraphs on "the manners and customs of the period" may be thrown in, but they must not be very long nor very serious. It is but gradually that the desire comes upon us to know the men of past times more thoroughly, to know their works and their ways, to know not merely the distinguished men but the undistinguished also. History then becomes "constitutional"; even for the purpose of studying the great men and the striking events, it must become constitutional, must try to reproduce the political atmosphere in which the heroes lived and their deeds were done. But it cannot stop there; already it has entered the realm of law, and it finds that realm an organized whole, one that cannot be cut up into departments by hard and fast lines. The public law that the historian wants as stage and scenery for his characters is found to imply private law, and private law a sufficient knowledge of which

cannot be taken for granted. In a somewhat different quarter there arises the demand for social and economic history; but the way to this is barred by law, for speaking broadly we may say that only in legal documents and under legal forms are the social and economic arrangements of remote times made visible to us. The history of law thus appears as means to an end, but at the same time we come to think of it as interesting in itself; it is the history of one great stream of human thought and endeavour, of a stream which can be traced through centuries, whose flow can be watched decade by decade and even year by year. It may indeed be possible for us, in our estimates of the sum total of national life, to exaggerate the importance of law; we may say, if we will, that it is only the skeleton of the body politic; but students of the body natural cannot afford to be scornful of bones, nor even of dry bones; they must know their anatomy. Have we then any cause to speak despondently when every writer on constitutional history finds himself compelled to plunge more deeply into law than his predecessors have gone, when every effort after economic history is demonstrating the absolute necessity for a preliminary solution of legal problems, when two great English historians who could agree about nothing else have agreed that English history must be read in the Statute Book[1]? In course of time the amendment will be adopted that to the Statute Book be added the Law Reports, the Court Rolls and some other little matters.

And then again we ought by this time to have learnt

[1] *Contemporary Review*, vol. XXXI. (1877–78), p. 824, Mr Freeman on Mr Froude.

the lesson that the history of our law is no unique phenomenon. For a moment it may crush some hopes of speedy triumph when we learn that, for the sake of English law, foreign law must be studied, that only by a comparison of our law with her sisters will some of the most remarkable traits of the former be adequately understood. But new and robuster hopes will spring up; we have not to deal with anything so incapable of description as a really unique system would be. At numberless points our mediaeval law, not merely the law of the very oldest times but also the law of our Year Books, can be illustrated by the contemporary law of France and Germany. The illustration, it is true, is sometimes of the kind that is produced by flat contradiction, teaching us what a thing is by showing us what it is not; but much more often it is of a still more instructive kind, showing us an essential unity of substance beneath a startling difference of form. And the mighty, the splendid efforts that have been spent upon reconstructing the law of mediaeval Germany will stimulate hopes and will provide models. We can see how a system has been recovered from the dead; how by means of hard labour and vigorous controversy one outline after another has been secured. In some respects the work was harder than that which has to be done for England, in some perhaps it was easier; but the sight of it will prevent our saying that the history of English law will never be written.

And a great deal has been done. It is true that as yet we have not any history of our whole law that can be called adequate, or nearly adequate. But such a work will only come late in the day, and there are

many things to be done before it will be produced. Still some efforts after general legal history have been made. No man of his age was better qualified or better equipped for the task than Sir Matthew Hale; none had a wider or deeper knowledge of the materials; he was perhaps the last great English lawyer who habitually studied records; he studied them pen in hand and to good purpose. Add to this that, besides being the most eminent lawyer and judge of his time, he was a student of general history, found relaxation in the pages of Hoveden and Matthew Paris, read Roman law, did not despise continental literature, felt an impulse towards scientific arrangement, took wide and liberal views of the object and method of law. Still it is by his *Pleas of the Crown* and his *Jurisdiction of the House of Lords* that he will have helped his successors rather than by his posthumous and fragmentary *History of the Common Law*[1]. Unfortunately he was induced to spend his strength upon problems which in his day could not permanently be solved, such as the relation of English to Norman law, and the vexed question of the Scottish homage; and just when one expects the book to become interesting, it finishes off with protracted panegyrics upon our law of inheritance and trial by jury. When, nearly a century later, John Reeves[2] brought to the same task powers which cer-

[1] *The History of the Common Law of England*, written by a learned hand (1713). There are many later editions.

[2] *History of the English Law* (4 vols., 1783-87). Originally the work was brought down to the end of Mary's reign; in 1814 a fifth volume dealing with Elizabeth's reign was added. An edition published in 1869 cannot be recommended.

tainly were far inferior to Hale's, he nevertheless achieved a much more valuable result. Until it is superseded, his *History* will remain a most useful book, and it will assuredly help in the making of the work which supersedes it. Reeves had studied the Year Books patiently, and his exposition of such part of our legal history as lies in them is intelligent and trustworthy; it is greatly to his credit that, writing in a very dark age (when the study of records in manuscript had ceased and the publication of records had not yet begun), he had the courage to combat some venerable or at least inveterate fables. Still his work is very technical and, it must be confessed, very dull; it is only a book for those who already know a good deal about mediaeval law; no attempt is made to show the real, practical meaning of ancient rules, which are left to look like so many arbitrary canons of a game of chance; owing to its dreariness it is never likely to receive its fair share of praise. Crabb's *History of English Law* is a comparatively slight performance[1]; it adds little if anything to what was done by Reeves.

But particular departments of law have found their

[1] George Crabb, *A History of English Law* (1829). George Spence, in the first volume of his *Equitable Jurisdiction of the Court of Chancery* (2 vols., 1846), has given a learned and valuable account of the development of the common law, perhaps the best yet given. In 1882–83, Ernest Glasson published his *Histoire du Droit et des Institutions de l'Angleterre*; but this does not go very far below the surface. Heinrich Brunner in Holtzendorff's *Encyklopädie* has published a most useful sketch of the French, Norman and English materials for legal history; the part relating to England has been translated into English by W. Hastie (Edinburgh, 1888); this translation I have not seen.

historians. What we call constitutional history is the history of a department of law and of something more —a history of constitutional law and of its actual working. For men of English race, constitutional history has long had an interest; they can be stirred by the politics of the past, for they are "political animals" with a witness. It would be needless to say that in this quarter solid and secure results have been obtained, needless to mention the names of Palgrave, Hallam, Stubbs, Gneist. Still, for modern times, much remains to be done. In relation to those times "constitutional history" but too frequently means a history of just the showy side of the constitution, the great disputes and great catastrophes, matters about which no one can form a really sound opinion who is not thoroughly versed in the sober, humdrum legal history of the time. But this work will certainly be done; the "general historian" will see more and more clearly after every attempt that he cannot be fair, that he cannot even be very interesting, unless he succeeds in reproducing for us not merely the facts but the atmosphere of the past, an atmosphere charged with law.

Again, other parts of the law have been submitted to historical treatment; in particular, those which in early times were most closely interwoven with the law of the constitution, criminal law[1] and real property law[2], while the history of trial by jury has a literature of its own and the history of some early stages in the de-

[1] James Fitzjames Stephen, *History of the Criminal Law* (3 vols., 1883); Luke Owen Pike, *History of Crime* (2 vols., 1873).

[2] Kenelm Edward Digby, *Introduction to the History of the Law of Real Property* (1875).

velopment of civil procedure has not been neglected[1]. But every effort has shown the necessity of going deeper and deeper. Everywhere the investigator finds himself compelled to deal with ideas which are not the ideas of modern times. These he has painfully to reconstruct, and he cannot do so without calling in question much of the traditional learning, without tracing the subtle methods in which legal notions expand, contract, take in a new content, or, as is sometimes the case, become hide-bound, wither and die. This task of probing and defining the great formative ideas of law is one that cannot be undertaken until much else has been done; it is only of late that the possibility and the necessity of such a task have become apparent, but already progress has been made in it. We are not where we were when a few years ago Holmes published a book which for a long time to come will leave its mark wide and deep on all the best thoughts of Americans and Englishmen about the history of their common law[2].

And here let us call to mind the vast work done by our Record commission, by the Rolls series, by divers

[1] Melville Madison Bigelow, *History of Procedure in England* (1880).

[2] O. W. Holmes, Jr., *The Common Law* (1882). *The History of Assumpsit*, by J. B. Ames (*Harvard Law Review*, April, May, 1888), is a masterly dissertation on some of the central ideas. In many articles in magazines, American and English, one may see a freer and therefore truer handling of particular themes of legal history than would have been possible twenty years ago; and the best text writers, though their purpose is primarily dogmatical, have felt the necessity of testing such history as they have to introduce instead of simply copying what Coke or Blackstone said.

antiquarian societies, towards providing the historian of law with new materials. Let us think what Reeves had at his disposal, what we have at our disposal. He had the Statute Book, the Year Books in a bad and clumsy edition, the old text-books in bad and clumsy editions. He made no use of Domesday Book; he had not the *Placitorum Abbreviatio,* nor Palgrave's *Rotuli Curiae Regis*; he had no Parliament Rolls, Pipe, Patent, Close, Fine, Charter, Hundred Rolls, no Proceedings of the King's Council, no early Chancery Proceedings, not a cartulary, not a manorial extent, not a manorial roll; he had not Nichols' *Britton*, nor Pike's nor Horwood's Year Books, nor Stubbs' *Select Charters*, nor Bigelow's *Placita Anglo-Normannica*; he had no collection of Anglo-Saxon "land books," only a very faulty collection of Anglo-Saxon dooms, while the early history of law in Normandy was utter darkness. The easily accessible materials for that part of our history which lies before Edward I have been multiplied tenfold, perhaps twenty-fold; even as to later periods our information has been very largely supplemented. Where Reeves was only able to state a naked rule, taken from Bracton or the Statute Book, and leave it looking bare and silly enough, we might clothe that rule with a score of illustrations which would show its real meaning and operation. The great years of the Record commission, 1830 to 1840, the years when Palgrave and Hardy issued roll after roll, such years we shall hardly see again; the bill, one is told, was heavy; but happily the work was done, and there it is[1]. A curious memorial it may seem of the age of

[1] Yes, but by no means all of it is in print. The nation was

"the radical reform," of the time when Parliament, for once in a way, was really showing some interest in the ordinary, every-day law of the realm, and was wisely freeing it from its mediaeval forms. But in truth there is nothing strange in the coincidence; the desire to reform the law went hand in hand with the desire to know its history; and so it has always been and will always be[1]. The commencement in 1858 of the Rolls series is, of course, one of the greatest events in the history of English history, and in that series are now to be found not only most of our principal chronicles, but also several books of first-rate legal importance, Year Books never before printed and monastic cartularies. The English Historical Society published Kemble's collection of Anglo-Saxon charters, the Camden Society published Hale's *Domesday of St Paul's* and several similar works. More recently the Pipe Roll Society started with the purpose of "dealing with all national manuscripts of a date prior to 1200," and the Selden Society with the purpose of "printing manuscripts and new editions and translations of books having an important bearing on English legal history." Such work must chiefly be done in the old country, but it would be base ingratitude were an Englishman to forget that the Selden Society owes its very existence

attacked with one of its periodical fits of parsimony, and the consequence is that there exist volumes upon volumes of transcripts made by Palgrave or under his eye. Very possibly the commissioners were for a while extravagant, still it was hardly wise to stop a great work when the cost of transcription was already incurred. However, these transcripts will become useful some day.

[1] Some of the coincidences are very striking: thus "fines" were abolished in 1834; in 1835 the earliest fines were printed.

English Legal History 11

to the support that has been given to it in America. And then again the original documents themselves are now freely and conveniently accessible to the investigator, and a very great deal has been done towards making catalogues and indexes of them. Our Public Record office, if I may speak from some little experience of it, is an institution of which we may justly be proud; certainly it is a place in which even a beginner meets with courtesy and attention, and soon finds far more than he had ever hoped to find. Then, lastly, there has been a steady flow of manuscripts towards a few great public libraries. He who would use them has no longer to go about the country begging favours of the great; he will generally find what he wants at the British Museum, at Oxford, or at Cambridge. No, most certainly we do not stand where Reeves stood[1].

But perhaps we have not yet cast our eyes towards what will prove to be the brightest quarter of all, the study of our common law in the universities. Not only are there law schools, but (and this is more to our point) we on this side of the water have the pleasure of reading about schools of political science, schools in which law is taught along with history and along with political economy. Surely it cannot be very rash in us to say that the training there provided is just the training best calculated to excite an interest in the history

[1] To any one who proposes to investigate the English public records the following books will be of use: C. P. Cooper, *An Account of the Public Records* (2 vols., 1832); F. S. Thomas, *Handbook to the Public Records* (1853); Richard Sims, *A Manual for the Genealogist* (1856); Walter Rye, *Records and Record Searching* (1888). The Annual Reports of the Deputy Keeper of the Public Records are also very useful.

of law. Possibly that interest may be sufficiently keen and sufficiently patient to tolerate the somewhat dreary information which it is the purpose of this article to afford. An attempt to indicate briefly the nature and the whereabouts of our materials may be of some use though it stops short of a formal bibliography. In the course of this attempt the writer may take occasion to point out not merely what has been done, but also what has not been done, and in this way he may perhaps earn the thanks of some one who is on the outlook for a task.

To break up the history of law into periods is of course necessary; but there must always be something arbitrary in such a proceeding, and only one who is a master of his matter will be in a position to say how the arbitrary element can best be brought to the irreducible minimum. It would be natural to make one period end with the Norman Conquest; and though, if no line were drawn before that date, the first period would be enormously long, five or six hundred years, still we may doubt whether our English materials will ever enable us to present any picture of a system of English or Anglo-Saxon law as it was at any earlier date than the close of the eleventh century. By that time our dooms and land books have become a considerable mass. If we stop short of that time, we shall have to eke out our scanty knowledge with inferences drawn from foreign documents, the *Germania* of Tacitus, the continental "folk laws," notably the *Lex Salica*. In that case the outcome will be much rather an account of German law in general than an account of that slip of German law which was planted in

England: a very desirable introduction to a history of English law it may be, but hardly a part of that history. Passing by for a moment the deep question whether the English law of later times can be treated as a genuine development of Anglo-Saxon law, whether the historian would not be constrained to digress into the legal history of Scandinavia, Normandy, the Frankish Empire, we shall probably hold that the reigns of our Norman kings, including Stephen, make another good period. The reign of Henry II there might be good reason for treating by itself, so important is it. "From Glanvill to Bracton" might be no bad title, though there would be something to be said for pausing at the Great Charter. The reign of Edward I, "the English Justinian," has claims to be dealt with separately, or the traditional line drawn between the Old Statutes and the New might make us carry on the tale to the death of Edward II. "The period of the Year Books"—Edward II to Henry VIII —is, so far at least as private law is concerned, a wonderfully unbroken period. If a break were made in it, the accession of Edward IV, the beginning of "the new monarchy" as some call it, might be taken as the occasion of a halt. The names of Coke and Blackstone suggest other halting places. After the date of Blackstone, the historian, if an Englishman dealing solely with England, would hardly stop again until he reached some such date as 1830, the passing of the Reform Acts, the death of Jeremy Bentham, the beginning of the modern period of legislative activity; if an American, he would draw a marked line at the Declaration of Independence, and it would be pre-

sumption in an Englishman to guess what he would do next. But on this occasion we shall not get beyond the end of the middle ages, and for the sake of brevity our periods will be made few.

I. *England before the Norman Conquest.*

The materials consist chiefly of (1) the laws, or "dooms," as they generally call themselves; (2) the "land books" and other diplomata; (3) the ecclesiastical documents, in particular canons and penitentials.

(1) We have first a group of very ancient Kentish laws, those of Ethelbert (*circa* 600), those of Hlothar and Eadric (*circa* 675), and those of Wihtred (696). A little earlier than these last come the dooms of the West-Saxon Ine (690). Then follows a sad gap, a gap of two centuries, for we get no more laws before those of Alfred; it is to be feared that we have lost some laws of the Mercian Offa. With the tenth century and the consolidation of the realm of England, legislation becomes a much commoner thing. Edward, Ethelstan, Edmund, Edgar issue important laws, and Ethelred issues many laws of a feeble, distracted kind. The series of dooms ends with the comprehensive code of Canute, one of the best legal monuments that the eleventh century has to show. Besides these laws properly so called, issued by King and Witan, our collections include a few documents which bear no legislative authority, namely, some statements of the *wergelds* of different orders of men, a few procedural formulas, the ritual of the ordeal, and the precious *Rectitudines Singularum Personarum*, a statement of

the rights and duties of the various classes of persons to be found on a landed estate, a document the date of which is at present very indeterminate. Some further light on the law of the times before the Conquest is thrown by certain compilations made after the Conquest, of which hereafter; to wit, the so-called *Leges* of the Confessor, the Conqueror, and Henry I. With scarce an exception these dooms and other documents are written in Anglo-Saxon. An ancient Latin version [*vetus versio*] of many of them has been preserved, and testifies to the rapidity with which they became unintelligible after the Conquest[1].

The dooms are far from giving us a complete

[1] Some of the dooms, forgotten for many centuries, were printed by William Lambard in his *Archaionomia* (1568). An improved and enlarged edition of this book was published by Abraham Whelock (Cambridge, 1644). A yet ampler collection was issued in 1721 by David Wilkins, *Leges Anglo-Saxonicae Ecclesiasticae et Civiles*. In 1840 these works were superseded by that of Richard Price and Benjamin Thorpe, *Ancient Laws and Institutes of England*, published for the Record commissioners both in folio and in octavo; the second volume contains ecclesiastical documents; a translation of the Anglo-Saxon text is given. Meanwhile Reinhold Schmid, then of Jena and afterwards of Bern, had published the first part of a new edition, *Die Gesetze der Angelsachsen*, Erster Theil. In 1858, having the commissioners' work before him, instead of finishing his original book he published what is now the standard edition of all the dooms, *Die Gesetze der Angelsachsen* (Leipzig, 1858), an excellent edition equipped with a German translation of the Anglo-Saxon text and a glossary which amounts to a digest. Yet another edition has for some time been promised by F. Liebermann. The manuscripts are so numerous and in some cases so modern and corrupt, and the study of the Anglo-Saxon tongue and of the foreign documents parallel to our dooms is making such rapid progress, that in all probability no edition published for some time to come will be final.

statement of the law. With possibly a few exceptions there seems to have been no attempt to put the general law in writing; rather the King and the Wise add new provisions to the already existing law or define a few points in it which are of special importance to the state. Hence we learn little of private law, and what we learn is implied rather than expressed; to get the peace kept is the main care of the rulers; thus we obtain long tariffs of the payments by which offences can be expiated, very little as to land-holding, inheritance, testament, contract, or the like. We have no document which purports to be the *Lex* of the English folk, or of any of the tribes absorbed therein; we have nothing quite parallel to the *Lex Salica* or the *Lex Saxonum*. Again, we cannot show for this period any remains of scientific or professional work, and we have no reason to suppose that any one before the Conquest ever thought of writing a text-book of law.

(2) The diplomata of this age consist chiefly of grants of land ("land books"), for the more part royal grants, together with a comparatively small number of wills. The charters of grant are generally in Latin, save that the description of the boundaries of the land is often in English; the wills are usually in English. The latest collection of them will contain between two and three thousand documents[1]. If all were genuine,

[1] The standard collection is (or until lately was) the great work of John Mitchell Kemble, *Codex Diplomaticus Aevi Saxonici* (6 vols., 1839–48), published for the English Historical Society, with excellent introductions, a work not now easily to be bought. Kemble marks with an asterisk the documents that he does not accept as genuine. Benjamin Thorpe's *Diplomatarium Aevi Saxonici* (1865), is a small collection of much less importance. Walter de Gray Birch, under

English Legal History

about one hundred of them should come from the seventh century, and about two hundred from the eighth; of course, however, many of them are not genuine, or but partially genuine, and perhaps the history of law presents no more difficult problem than that of drawing just inferences from documents which have either been tampered with or very carelessly copied. Invaluable as these instruments are, the use hitherto made of them for the purpose of purely legal history is somewhat disappointing. The terms in which rights are transferred are singularly vague and the amount of private law that can be got out of them is small. However they have only been accessible for some forty years past and their jural side[1] has not yet been very thoroughly discussed. A few of the land books contain incidental accounts of litigation, but for the oldest official records of lawsuits we must look to a much later age.

(3) Besides these we have ecclesiastical documents,

the title *Cartularium Saxonicum*, is publishing a collection which will contain all Kemble's documents and more also and which will be based on a new examination of the MSS.; two volumes of this work are already completed. John Earle's *Handbook to the Land Charters and other Saxonic Documents* (1888), is a most useful work, containing many typical charters which are critically discussed chiefly from the standpoints of philology and the diplomatic art. For close study the following are invaluable: Bond's *Facsimiles of Ancient Charters in the British Museum* (4 vols., 1873-78; photographs of about 120 documents), and the photozincographed *Facsimiles of Anglo-Saxon Manuscripts*, edited by W. Basevi Sanders, 3 vols.

[1] Some of the legal points in these documents are discussed by Brunner, *Zur Rechtsgeschichte der römischen und germanischen Urkunde* (1880). Kemble's introductions are still of the highest value.

canons and penitentials[1] which must not be neglected. During this period it is impossible to draw a very sharp line between the law of the church and the law of the realm. It is highly probable again that the penitential literature had an important influence on the development of jurisprudence, and it often throws light on legal problems, for instance the treatment of slaves.

Materials being scanty, all that is said by the chroniclers and historians of the time and even by those of the next age will have to be carefully weighed; use must be made of Beda's works and of the Anglo-Saxon Chronicle. But the time had not yet come when annalists would incorporate legal documents in their books or give accurate accounts of litigation.

For the continental history of this same period there are two classes of documents which are of great service, but the like of which England cannot show: namely, formularies, that is, in our modern language, "precedents in conveyancing," and estate registers,

[1] The classical collection of the Councils has been David Wilkins, *Concilia* (1737, 4 vols.). The first volume goes far beyond the end of this period, goes as far as 1265. For the first time before 870 this is superseded by vol. III. of *Councils and Ecclesiastical Documents relating to Great Britain and Ireland*, by Arthur West Haddan and William Stubbs (Oxford, 1869-73); a yet unfinished work, the first volume of which refers to the British, Cornish, Welsh, Irish, and Scottish churches. This collection contains, besides the Councils, many other ecclesiastical documents and what seems to be the best part of the penitential literature. Canons and penitentials are also to be found in vol. II. of the *Ancient Laws and Institutes*, but it is said that they were not very discriminately edited. The history of penitentials seems to be an intricately tangled skein.

that is, descriptions of the manors of great landowners showing the names of the tenants and the nature of their services. We have, as it seems, nothing to set beside the *Formulae Marculfi* or the *Polyptyque* of the Abbot Irmino. The practice of conveying land by written instrument seems never to have worked itself thoroughly into the English folk-law, and the religious houses and other donees of "book-land" seem to have been allowed to draw up their own books pretty much according to their taste, a taste inclining towards pompous verbosity rather than juristic elegance. Still, it is possible that a very careful comparison of the most genuine books would lay bare the formulas on which they were constructed and show a connection between those formulas and the continental precedents. That we should have no manorial registers or "extents" from this period is much to be regretted; it suggests the inference, very probable for other reasons, that the manorial system formed itself much more rapidly in France than in England.

That we shall ever be able to reconstruct on a firm foundation a complete system of Anglo-Saxon law, of the law of the Confessor's day, to say nothing of Alfred's day or Ethelred's, may well be doubted; the materials are too scanty. The "dooms" are chiefly concerned with keeping the peace; the "land books," considering their number and their length, tell us wonderfully little, so vague, so untechnical, is their wording. Still the most sceptical will not deny that within the present century a great deal of knowledge has been secured, especially about what we may call the public law of the time. And here of course it is

important to observe that the old English law is no unique system; it is a slip of German law. This makes permissible a circumspect use of foreign materials, and it should be needless to say that during the last fifty years these have been the subject of scientific research which has achieved very excellent results. The great scholars who have done that work have not neglected our English dooms; these indeed have proved themselves invaluable in many a controversy. The fact that they are written, with hardly an exception, in the native tongue of the people, whereas from the first the continental lawgiver speaks in Latin; the fact that they are almost absolutely free from any taint of Roman law; the fact that their golden age begins with the tenth century, when on the continent the voice of law has become silent and the state for a while seems dissolved in feudal anarchy—these facts have given our dooms a high value in the eyes even of those whose primary concern was less for England than for Germany or France. There is good reason then to hope that the main outlines of the development even of private law will be drawn, although we may not aspire to that sort of knowledge which would have enabled us to plead a cause in an Anglo-Saxon hundred moot.

How much law there was common to all England, or common to all Englishmen, is one of the dark questions. After the Norman Conquest we find a prevailing opinion that England is divided between three great laws, West-Saxon, Mercian, Danish, three territorial laws as it would seem. On the surface of the documents the differences between these three laws seem rather a matter of words than a matter of sub-

stance; but neither by this nor by the universality of the later "common law" are we justified in setting aside a theory which writers of the eleventh and twelfth centuries regarded as of great importance. In earlier times the various laws would be tribal rather than territorial; but we have little evidence that the Kenting could carry with him his Kentish law into Mercia in the same way that the Frank or Bavarian could preserve his national law in Lombardy; the fact that there was not in England any race or class of men "living Roman law," may have prevented the development of that system of "personal laws" which is a remarkable feature in the history of the continent. There is much evidence, however, that in the twelfth century local customs were many and important. The difficulty of reconstructing these will always be very great unless some new materials be found; still, work on Domesday Book and on the later manorial documents may succeed in disclosing some valuable distinctions.

In noticing what has been done already, it should be needless to mention Kemble's *Saxons in England* or his introductions to the various volumes of the *Codex Diplomaticus*. It will be more to the point to mention with regret that Konrad Maurer's *Angelsächsische Rechtsverhältnisse* is to be found only in the back numbers (volumes I., II., III.) of the *Kritische Ueberschau* published in Munich. The *Essays in Anglo-Saxon Law* (Boston, 1876), by Adams, Lodge, Young and Laughlin, should be well known in America. The public law is dealt with in the constitutional histories of Palgrave, Gneist, Stubbs; also by Freeman, in the first volume of his *Norman Conquest*. To name the

books of foreign writers in which Anglo-Saxon law has been touched incidentally would be to give something like a catalogue of the labours of the "Germanists." The influence of the Danes in the development of English law has until recent years been too much neglected. It is the subject of an elaborate work by Johannes C. H. R. Steenstrup, *Danelag* (Copenhagen, 1882). This constitutes the fourth volume of the *Normannerne* (1876–82).

II. *Norman Law.*

If the history of the law which prevailed in England from 1066 to, let us say, 1200 is to be written, the history of the law which prevailed in Normandy before 1066 will have to be studied. Such study will always be a very difficult task, because, unless some great discovery remains to be made, it will be the reconstruction of law which has left no contemporary memorials of itself. We have at present hardly anything that can be called direct evidence of the legal condition of Normandy between the time when it ceased to be a part of the West-Frankish realm and a date long subsequent to the conquest of England. It is only about the middle of the twelfth century that we begin to get documents, and even then they come sparsely. What then we shall know about the period in question will be learnt by way of inferences, drawn partly from the time when Normandy was still a part of Neustria, when its written law consisted of the *Lex Salica* and the capitularies; partly from the Normandy of Henry II's reign and yet later times; partly again from what we

find in England after the Norman Conquest. Much will always remain very dark, and there is reason to fear that a perverted patriotism will give one bias to English, another to continental writers—an American might surely afford to be strictly impartial. But enough has happened of late years to show that if historians will go deeply enough into legal problems a substantial accord may be established between them. The extreme opinions are the superficial opinions, and they are falling into discredit. The doctrines of Stubbs, Gneist and Brunner have a great deal in common. It is impossible now to maintain that William just swept away English in favour of Norman law. It is quite undeniable that new ideas and new institutions of far-reaching importance "came in with the Conqueror." Hale made a good remark when he said:

> It is almost an impossible piece of chymistry to reduce every *Caput Legis* to its true original, as to say, this is a piece of the Danish, this is of the Norman, or this is of the Saxon or British law.

But even the chemical metaphor is inadequate, for the operation of law on law is far subtler than any process that the world of matter has to show. It is not that English law is swept away by any decree to make room for Norman law; it is much rather that ideas and institutions which come from Normandy slowly but surely transfigure the whole body of English law, especially English private law. Much evidently remains to be done for Norman law, much that will hardly be done by an Englishman; but already of late years a great deal has been gained, and the student of Glanvill must have the coaeval *Très ancien Coutumier* constantly in his hand.

In three very accessible places Heinrich Brunner has sketched the history of law in Normandy: (1) *Das anglonormannische Erbfolgesystem* (Leipzig, 1869); (2) *Die Entstehung der Schwurgerichte* (Berlin, 1871); (3) *Ueberblick über die Geschichte der französischen, normannischen und englischen Rechtsquellen*, in Holtzendorff's *Encyclopädie der Rechtswissenschaft* (1882), page 297. In his view, Norman law is Frankish: Frankish institutions take out a new lease of life in Normandy, when they are falling into decay in other parts of the quondam Frankish Empire.

The chief materials[1] for Norman legal history are:

(1) *Exchequer Rolls.* We possess, in whole or in part, rolls for the years 1180, 1184, 1195, 1198, 1201–03[2]. They answer to the English Pipe Rolls.

(2) *Collections of judgments.* We have several private collections of judgments of the Exchequer in the thirteenth century, beginning in 1207[3], drawn from official records not now forthcoming.

(3) *Law books.* We have to distinguish:

(i) A compilation, of which both Latin and French

[1] In the following remarks I rely partly upon Brunner, partly upon Ernest Joseph Tardif, who is engaged upon editing the Norman Coutumiers.

[2] Thomas Stapleton, *Magni Rotuli Scaccarii Normanniae* (2 vols., 1840–44). A fragment of the roll of 1184 was published by Leopold Delisle, *Magni Rotuli Scaccarii Normanniae Fragmentum* (Caen, 1851).

[3] These are most accessible in Leopold Victor Delisle's *Recueil de Jugements de l'Exchiquier de Normandie au XIII^e siècle* (Paris, 1864). A collection of judgments delivered in the "Assizes" between 1234 and 1237 (Assisae Normanniae) will be found in Warnkönig's *Französische Staats- und Rechtsgeschichte*, vol. II., pp. 48–64.

versions exist, known as *Statuta et Consuetudines Normanniae*, or *Établissements et Coutumes de Normandie*[1]; but this compilation proves to be composed of two different works: (*a*) a treatise which Brunner gives to the last years of the twelfth or the first years of the thirteenth century, and which Tardif dates in 1199 or 1200; and (*b*) a later treatise compiled a little after 1218 according to Brunner, about 1220 according to Tardif.

(ii) Then comes the *Grand Coutumier de Normandie*. The Latin version of this, which is older than the French, calls itself *Summa de Legibus Consuetudinum Normanniae*, or *Summa de Legibus in Curia Laicali*, and was composed before 1280 and probably between 1270 and 1275[2].

There are a few later law-books of minor importance.

(4) *Diplomata*. Normandy is poor in diplomata of early date and, according to Brunner, many of those that exist are still unprinted; but in the *Collection de Documents Inédits* is a small but ancient (1030-91)

[1] The former has lately been edited by Tardif under the title, *Le très ancien Coutumier de Normandie* (Rouen, 1881); the latter may be found in A. J. Marnier's *Établissements et Coutumes, Assises et Arrêts de l'Exchiquier de Normandie* (Paris, 1839).

[2] This was first printed in 1483; there have been many subsequent editions. The Latin text can be found in Johann Peter Ludewig, *Reliquiae Manuscriptorum* (Frankfort and Leipzig), vol. VII.; the French in Bourdot de Richebourg, *Coutumier Général*, vol. IV. For some time past a new edition of the Latin *Summa* by Tardif has been advertised as in the press. The authorship of the work has been discussed by Tardif in a pamphlet entitled *Les Auteurs présumés du Grand Coutumier de Normandie* (Paris, 1885).

Cartulaire de la Sainte Trinité du Mont de Rouen, edited by Deville in 1841; Leopold Delisle has published a *Cartulaire Normand de Philippe Auguste, Louis VIII, Saint Louis, et Philippe le Hardi* (Caen, 1852); and there exists in the English Record office a manuscript collection made by Léchaudé d'Anisy, entitled *Cartulaire de la Basse Normandie, from various Norman Archives*[1].

III. *From the Norman Conquest* (1066) *to Glanvill* (*circa* 1188) *and the Beginning of Legal Memory* (1189).

We may classify the materials thus: (1) laws; (2) private collections of laws and legal text-books; (3) work done on Roman and Canon law; (4) diplomata; (5) Domesday Book, surveys, public accounts, etc.; (6) records of litigation.

(1) *Laws*. It is, as we shall see, a little difficult to draw the line between the first two classes of documents. No one of the Norman Kings was a great legislator; but we have one short set of laws which may in the main be considered as the work of the Conqueror; besides these we have his ordinance separating the ecclesiastical from the temporal courts and another ordinance touching trial by battle. Henry I's coronation charter (1100) is of great value,

[1] From this and other sources, some very important documents are printed by way of appendix to M. M. Bigelow's *History of Procedure* (London, 1880); as to their date, see Brunner, *Zeitschrift der Savigny Stiftung*, II., 202. Tardif, in his edition of the *Très ancien Coutumier*, p. 95, has given a list of unprinted cartularies.

and Stephen's second charter (1136) is of some value. Henry II was a legislator; we have from his day the Constitutions of Clarendon (1164), the Assize of Clarendon (1166), the Assize of Northampton (1176), the Assize of Arms (1181), and the Assize of the Forest (1184); but we have reason to fear that we have lost ordinances of the greatest importance, in particular the Grand Assize and the Assize of Novel Disseisin, two ordinances which had momentous results in the history of private and even of public law.

(2) *Private collections of laws and legal text-books.* Our first class of documents shades off into the second class by the intermediation of the so-called *Leges Edwardi, Willelmi, Henrici Primi.* A repeated confirmation of the Confessor's law (*lagam* not *legem* or *leges Edwardi*) apparently led to several attempts at the reproduction of this "good old law." First we have an expanded version of the code of Canute (Schmid's *Pseudoleges Canuti*); then we have the *Leges Edwardi Confessoris*, a document which professedly states the result of an inquiry for the old law made by the Conqueror in the fourth year after the Conquest; but the purest version that we have alludes to the doings of William Rufus. Then we have a highly ornate and expanded version of the probably genuine laws of the Conqueror mentioned above: it looks like work of the thirteenth century. Then there is another set of laws attributed to the Conqueror, which as it appears both in French and Latin may be conveniently called "the bilingual code"; its author made great use of the laws of Canute; its history is in some degree implicated with the forgery of the false

Ingulf. These various documents demand a more thorough criticism than any to which they have as yet been subjected[1]. Of much greater importance is the text-book known as the *Leges Henrici Primi*. Until lately it was usual to give this work to the reign of Stephen or even of Henry II, on the ground that the author had used the *Decretum Gratiani*; but his last critic, Liebermann, says that this is not so, and dates the work between 1108 and 1118; this earlier date seems for several reasons the more acceptable[2]. The writer has made a large use of the Anglo-Saxon

[1] The "Leges" will be found in the Record Commissioners' *Ancient Laws*, and in Schmid's *Gesetze*. The best version of the Conqueror's ordinances, together with the charters of Henry I and Stephen and the various assizes of Henry II, is in Stubbs's *Select Charters*, which book now becomes indispensable. An earlier collection of the laws of this age, which is still useful, is Henry Spelman's *Codex Legum Veterum*, published from Spelman's posthumous papers by David Wilkins in his *Leges Anglo-Saxonicae*. Some points about the "Leges" are discussed by Stubbs in the Introduction to vol. II. of his edition of *Roger Hoveden* (Rolls Series), and by Freeman in his *Norman Conquest*, vol. v. app. note kk.

[2] Liebermann's article on the date of the *Leges Henrici* is in *Forschungen zur deutschen Geschichte*, Bd. XVI.; his book on the *Dialogus de Scaccario*, mentioned below, has some critical remarks on the *Leges Edwardi*. The lost legislation of Henry II may be partially reconstructed by means of Glanvill and Bracton. There is yet room for a great deal of work on the assizes and "leges." We have reason to believe that there once existed an important law book of Henry I's day, but it is not now forthcoming; what is known about it will be found in Cooper's *Account of the Public Records* (1832), II., 412. For the strange history of "the bilingual code" reference should be made to the famous article in the *Quarterly Review*, No. 67 (June, 1826), p. 248, in which Palgrave exposed the Ingulfine forgery, and two articles by Riley in the *Archaeological Journal* (1862), vol. XIX.

laws, which in general he treats as still in force, but on occasion he stops gaps with extracts from the *Lex Salica, Lex Ripuaria*, the Frankish capitularies and some collections of canons; he has one passage which comes by a round-about way from Roman law; it is taken from an epitome of the Breviary of Alaric. Altogether he gives us a striking picture of an ancient system of law in course of dissolution and transformation; a great deal might yet be done for his text, which in places is singularly obscure.

The end of Henry II's reign is marked by the *Tractatus de Legibus et Consuetudinibus Angliae*[1], usually, though on no very conclusive evidence, attributed to Ranulf Glanvill, who became chief justiciar in 1180, and died a crusader at the siege of Acre in 1190. This book, always referred to as "Glanvill," was apparently written at the very end of Henry's reign, and was not finished until after 1187. It is the first of our legal classics, and its orderly, practical brevity contrasts strongly with the diffuse, chaotic, antiquarian *Leges Henrici*. This is due in part to the fact that the

[1] The treatise was printed by Tottel without date about 1554; later editions were published in 1604, 1673, 1780; an English translation by Beames in 1812. It will be found also in the official edition of *Acts of Parliament of Scotland*, vol. I., where it is collated with the Scottish law book *Regiam Majestatem*. It will also be found in David Houard's *Traités sur les Coutumes Anglo-Normandes* (1776), and in Georg Phillips' *Englische Reichs- und Rechtsgeschichte* (1827–28). An ancient French translation of it, not yet printed, exists in Mus. Brit. MS. Lands, 467. A new edition in the Rolls Series by Travers Twiss is advertised. The evidence as to Glanvill's authorship will be briefly canvassed in the *Dictionary of National Biography*, s.v. Glanvill.

author deals only with the doings of the King's Court, which is now beginning to make itself a tribunal of first instance for all England at the expense of the communal and seigniorial courts, partly also to the fact that he knew some Roman law and made good use of his knowledge in the arrangement of his matter. The great outlines of our land law have now taken shape, and many of the "forms of action" are already established.

The *Dialogus de Scaccario*, written, as is supposed, by Richard Fitz Neal, bishop of London, between 1178 and the end of Henry II's reign, is hardly a "law book," but is an excellent and valuable little treatise on the practice of the Exchequer and the whole fiscal system, the work of one very familiar with his subject. This book, written by an administrator rather for the benefit of the intelligent public than for the use of legal practitioners, stands alone in our mediaeval literature and must be invaluable to the historian of public law[1].

(3) *Work upon Roman and Canon law.* In dealing with any century later than the thirteenth, the historian of English law could afford to be silent about Roman and Canon law, for, though these were studied and practised in England, and in particular many of the ordinary affairs of life, testamentary and matrimonial

[1] The *Dialogue*, which was at one time cited as the work of "Gervasius Tilburiensis," was appended by Thomas Madox to his beautiful *History of the Exchequer* (1st ed. in one vol., 1711; 2nd ed. in two vols., 1769), one of the greatest historical works of the last century. It will also be found in the *Select Charters*. It is the subject of an essay by Felix Liebermann, *Einleitung in den Dialogus de Scaccario* (Göttingen, 1875).

English Legal History

cases, were governed solely by the Canon law, still these laws appear in a strictly subordinate position, are administered by special courts, and exercise very little, if any, influence on the common law of England. But a really adequate treatment of the period which lies between the Norman Conquest and the accession of Edward I would require some knowledge of Roman law and its mediaeval history, also some knowledge of the earlier stages in the development of Canon law. Lanfranc, the right-hand man of the Conqueror, was trained in the Pavian law school, where Roman doctrines were already leavening the mass of ancient Lombard law; his subtle arguments were long remembered in Pavia. The influence of the Lombard school on Norman and English law is a theme worthy of discussion[1]. Then in Stephen's reign, as is well known, Vacarius[2] lectured in England on Roman law; it has even been conjectured that the youth who was to be Henry II sat at his feet[3]. Vacarius wrote a book of

[1] Lanfranc's juristic exploits are chronicled in the *Liber Papiensis*, *Monumenta Germaniae, Leges*, IV., pp. xcvi, 402, 404, 566. It is not absolutely certain that this Lanfranc is our Lanfranc. The Pavian law school, which was engaged in reducing the ancient Leges Longobardorum, a body of law very similar to our Anglo-Saxon dooms, into rational order, would have afforded an excellent training for the future minister of the Norman Conqueror; and the close resemblance of some of our writs and pleadings to the Lombard formulas has before now been remarked.

[2] Carl Friedrich Christian Wenck, *Magister Vacarius* (Leipzig, 1820), gives an elaborate account of Vacarius's work (the title of which was *Liber ex universo enucleato jure exceptus et pauperibus praesertim destinatus*), together with many passages from it. One of the few MSS. is in the library of Worcester Cathedral.

[3] Stubbs, *Lectures on Mediaeval and Modern History*, p. 303.

Roman law, designed for the use of poor scholars, a book that is extant, a book that surely ought to be in print. His school did not perish, his scholars glossed his work. There are extant, again, several books of practice of the twelfth century and the first years of the thirteenth, which good critics believe to have been written either in Normandy or in England. Among them is one that has been ascribed to William of Longchamp, who became chief justiciar of England. In many quarters there are signs that an acquaintance with Roman law was not uncommon among cultivated men. Glanvill's work was influenced, Bracton's work profoundly influenced, by Roman law. Some of Henry II's most important reforms, in particular the institution of definitely possessory actions, may be traced directly or indirectly to the working of the same influence. The part played by Roman and Canon law in this critical stage of the formation of the common law deserves a minuter examination than it has as yet received[1].

[1] As a starting-point the investigator might take Savigny, *Geschichte des römischen Rechts im Mittelalter*, Kap. 36, and E. Caillemer, *Le Droit Civil dans les Provinces Anglo-Normandes, Mémoires de l'Académie Nationale de Caen* (1883), p. 157. Caillemer gives what remains of the treatise of William Longchamp, and will put a student on the track of what is known about "Pseudo-Ulpianus," Ricardus Anglicus, who is identified with Richard le Poor, bishop of Salisbury and Durham, and William of Drogheda. The lectures of Stubbs on the history of Canon law in England, *Lectures on Mediaeval and Modern History* (1886), Lects. 13, 14, are of great interest. The old learning as to the history of Roman law in England is found in Selden's Dissertation suffixed to *Fleta* (more of this below); see also Thomas Edward Scrutton, *The Influence of Roman Law on the Law of England* (Cambridge, 1885).

English Legal History 33

(4) *The diplomata* of this period are numerous and of great interest; they are brief, formal documents, contrasting strongly with the lax and verbose land books of an earlier age; they are for the more part charters of feoffment and grants or confirmations of franchises; they have never been properly collected. Charters of liberties granted to towns should perhaps form a class by themselves, but those coming from this age are not numerous[1].

(5) *Domesday Book, surveys, public accounts, etc.* By far the greatest monument of Norman government is Domesday Book, the record of the survey of England instituted by the Conqueror and effected by inquests of local jurors; it was completed in the summer of 1086[2].

[1] Few aids would be more grateful to the historian of law or even to the historian of England than a *Codex Diplomaticus Normannici Aevi*. As it is, the documents must be sought for in the Monasticon and the cartularies and annals of various religious houses. Some of these have been published in the Rolls Series; those of Abingdon, Malmesbury, Gloucester, Ramsey and St Albans (Mat. Par. *Chron. Maj.* vol. VI.), may be mentioned. A useful selection for this and later times is given by Thomas Madox, *Formulare Anglicanum* (1702), with good remarks on matters diplomatic; another small selection of early charters has just been edited by J. Horace Round for the Pipe Roll Society. Stubbs, *Select Charters*, gives the municipal charters of this time.

[2] *Domesday*, or the *Exchequer Domesday*, as it is sometimes called, was published by royal command in 1783 in two volumes; in 1811 a volume of indexes appeared; in 1816 the work was completed by a supplementary volume containing (*a*) the *Exon Domesday*, a survey of the south-western counties, the exact relation of which to the *Exchequer Domesday* is disputed, (*b*) the *Inquisitio Eliensis*, containing the returns relating to the possessions of the church of Ely, and two later documents, viz. (*c*) the *Winton Domesday*, a survey of

The form of this document is generally known; it is primarily a fiscal survey; the liability for "geld" in time past, the capacity for paying "geld" in time to come are the chief points which are to be ascertained; it has been well called "a great rate book." Incidentally, however, it gives us a marvellously detailed picture of the legal, social and economic state of England, but a picture which in some respects is not easily interpreted. Of late it has become the centre of a considerable literature[1]; but the historian of law will have to regret that a great deal of labour and ingenuity has been thrown away on the impossible attempt to solve the economic problems without first solving the legal problems.

The other public records of this period consist chiefly of Pipe Rolls, that is, the rolls of the sheriffs'

Winchester in the time of Henry I, and (*d*) the *Bolden Book*, a survey of the Palatinate of Durham in 1183. Since then (1861–63) the *Exchequer Domesday* has been "facsimiled" by photozincography; the part relating to each county can be bought separately. The *Inquisitio Comitatus Cantabrigiensis*, published by N. E. S. A. Hamilton in 1876, contains the returns made by the jurors of Cambridgeshire to the Domesday inquest.

[1] Among the works relating to Domesday may be mentioned the following: Henry Ellis, *A General Introduction to Domesday Book* (Rec. Com., 2 vols., 1833); Samuel Heywood, *A Dissertation upon the Distinctions in Society and Ranks of the People under the Anglo-Saxon Governments* (1818); James F. Morgan, *England under the Norman Occupation* (1858); several works of Robert William Eyton, *A Key to Domesday* [Dorset], *Domesday Studies* [Somerset] (2 vols., 1880); *Domesday Studies* [Stafford] (1881); appendixes to vol. v. of Freeman's *Norman Conquest*; *Domesday Studies* (1888), a volume of essays by various writers edited by P. Edward Dove (a second volume of this work is promised).

accounts as audited by the Exchequer. Chance has preserved one very ancient roll, now ascribed to 31 Henry I. No other roll is found until 2 Henry II, but thenceforward the series is very continuous[1]. These rolls throw light directly on fiscal machinery and administration, indirectly on numberless points of law. The feudal arrangement of England, the distribution of knights' fees and serjeanties, the obligation of military service and so forth are illustrated by documents of Henry II's reign contained in the *Black Book of the Exchequer*[2].

(6) *Records of litigation.* Though we have evidence that before the end of Henry II's reign pleas before the king's court were enrolled, we have no extant plea rolls from this age. Accounts of litigation must be sought for in the monastic annals; when found they are too often loose statements of interested parties. However, a good many transcripts of procedural writs have been preserved and these are of the highest value. Before our period is out we begin to get a few "fines" (*i.e.* records of actions brought and compromised, already a common means of conveying land); in four cases the original documents are preserved, in other cases we have copies.[3]

[1] The *Pipe Rolls* of 31 Henry I, 2, 3, 4 Henry II, 1 Richard I and 3 John (this last from the Chancellor's antigraph) were edited for the Record Commissioners by Joseph Hunter. The Pipe Roll Society has now taken these documents in hand and published the rolls for 5-12 Henry II.

[2] The *Liber Niger Scaccarii* was edited by Thomas Hearne (2 vols., 1728).

[3] Melville Madison Bigelow, in his *Placita Anglo-Normannica* (London, 1879), has collected most of what has been discovered

In passing we should note that the chronicles of this age are fruitful fields. Not only do they sometimes contain documents of great importance, laws, ordinances, diplomata, but they also supply many illustrations of the working of law and from time to time give us contemporary criticism of legal measures and legal arrangements.

On the whole we have no reason to complain of the tools provided for us. We cannot say of England, as has been said of France and Germany, that between the period of the folk laws and the period of the law books lies a dark age which has left no legal monument of itself. In particular the *Leges Henrici* serve to mediate between the dooms of Canute and the treatise of Glanvill. The lack is rather of workmen than of implements. But it is to be remembered that it is only of late years that those implements have become generally accessible; also that we have had not only to learn but also to unlearn many things, for the whole of the traditional treatment of the legal history of the Norman time has been vitiated by the great Ingulfine forgery, one of the most splendidly successful frauds ever perpetrated. A great deal of what went on in the local courts we never shall know; but in Henry II's

touching litigation between 1066 and 1189. For a newly found case, see F. Liebermann, *Ungedruckte anglo-normannische Geschichtsquellen* (Strassburg, 1879), pp. 251–256; for Norman cases of great value and their connection with English law, Brunner's *Entstehung der Schwurgerichte* (Berlin, 1871). As to early plea rolls and early fines, reference may be made to the Selden Society's *Select Pleas of the Crown*, vol. I. (1887), Introduction; since that introduction was written five more copies of fines of Henry II's day have been found in Camb. Univ. Libr. MS. Ee. iii, 60.

day the practice and procedure of the king's court become clear to us, and subsequent history has shown that the king's court, becoming in course of time the king's courts, was to have the whole fate of English law in its hands. Towards the end of the period the history of law begins to be, at least in part, a history of professional learning.

There is no very modern work devoted to the legal history of this age as a whole, but it is the subject of Georg Phillips' *Englische Reichs- und Rechtsgeschichte* (1827–28). M. M. Bigelow's *History of Procedure* (London, 1880) has provided for one important department. Of course constitutional history has had a large share of attention, and books have collected round Domesday and round two other points, namely, frankpledge and trial by jury. As to the former of these two points, it will only be necessary to mention Heinrich Marquardsen's *Haft und Bürgschaft bei den Angelsachsen* (Erlangen, 1852), as this will put its reader in the current of the discussion. As to the latter, Brunner's brilliant book, *Entstehung der Schwurgerichte*, has already been named; William Forsyth's *History of Trial by Jury* (1852), and Friedrich August Biener's *Das Englische Geschwornengericht* (Leipzig, 1852), are useful, though chiefly as regards a somewhat later time.

IV. *From the Coronation of Richard I to the Death of Edward I.*

Our sources of information now begin to flow very freely, and so much has already been printed that very probably the historian would find it easier to paint a life-like picture of the thirteenth century than to accomplish the same task for either the fourteenth or the fifteenth. We may arrange the materials under the following heads: (1) laws; (2) judicial records; (3) other public records; (4) law books; (5) law reports; (6) manorial law; (7) municipal and mercantile law.

(1) *Laws.* For reasons which will soon appear, we use the untechnical term "laws" rather than any more precise term. Neither Richard nor John was a legislator; they give us nothing that can be called laws except a few ordinances touching weights, measures, money, the prices of victuals. At the end of his reign, however, John was forced to grant the Great Charter (1215); this, if it is a treaty between the various powers of the state, is also an act declaring and amending the law in a great number of particulars: to use terms familiar in our own day, *Magna Carta* is an act for the amendment of the law of real property and for the advancement of justice. The various editions (1215-16-17-25) of the charter being distinguished, we note that it is the charter of 1225 which becomes the *Magna Carta* of subsequent ages and which gets to be generally considered as the first "statute." The term "statute" is one that cannot easily be defined. It comes into use in Edward I's

reign; supplanting "provisions," which is characteristic of Henry III's reign; which had supplanted "assize," characteristic of Henry II's, Richard's, John's. Our extant Statute Rolls begin with the statute of Gloucester (1278), and it is very doubtful whether before that date any rolls were set apart for the reception of laws. Some of the earlier laws of our period are to be found on other rolls, Patent, Close, *Coram Rege* Rolls: others are not to be found on any rolls at all, but have been preserved in monastic annals or other private manuscripts[1]. In later times of course it became the settled

[1] The laws must be sought primarily in editions of the *Statute Book*, in particular in the *Statutes of the Realm*, published for the Record Commissioners, the first volume of which work (1810) contains the Charters of Liberties besides the earliest statutes. Stubbs's *Select Charters* is invaluable for this period, especially as giving the documents relating to the revolutionary time which preceded the Barons' War. Blackstone, *The Great Charter* (1759), is a learned and useful work. It should be remembered that the text of the earliest statutes is not in all respects very well fixed, *e.g.* it is possible to raise doubts as to the contents of the statute of Merton. There is yet room for work in this quarter. Also it should be noticed that editions of the statutes, including the Commissioners' edition, contain Statuta Incerti Temporis. In lawyers' manuscripts these were found interpolated between the Statuta Vetera, which end with Edward II, and the Statuta Nova, which begin with Edward III, like the Apocrypha between the two Testaments; hence they came to be regarded as statutes of the last year of Edward II. Some of them are certainly older, and some of them were certainly never issued by any legislator, but are merely lawyers' notes; in the Year Books their statutory character is disputed; "apocryphal statutes" seems the best name for them. To make a critical edition of them would be a good deed. Perhaps the most interesting is the Prerogativa Regis, apparently some lawyer's notes about the king's prerogatives. Coke's *Second Institute* is the classical commentary on the early statutes.

doctrine that in a "statute" king, lords and commons must have concurred, and that a rule laid down with such concurrence is a "statute." But with our improved knowledge of the history of Parliament we cannot insist on this doctrine when dealing with the thirteenth century. Some of the received "statutes" even of Edward I's day, to say nothing of Henry III's, were issued without any participation by the commons in the legislative act. After the charter of 1225 we have the statute (or provisions) of Merton (1236), the provisions of Westminster (1259), the statute of Marlborough (1267), all of the first importance; and upon these follows the great series of Edward I's statutes, a most remarkable body of reforming laws. Hale's saying about Edward I was very true:

> I think I may safely say, all the ages since his time have not done so much in reference to the orderly settling and establishing of the distributive justice of this kingdom, as he did within a short compass of the thirty-five years of his reign; especially about the first thirteen years thereof.

(2) *Judicial records.* The extant Plea Rolls (rolls of pleadings and judgments) of the king's courts begin in 1194 (6 Richard I), and though we have by no means a complete series of them, we have for the thirteenth century far more than any one is likely to use. These rolls fall into divers classes; there are *Coram Rege* (King's Bench) Rolls, *De Banco* (Common Pleas) Rolls, Exchequer Rolls, Eyre Rolls, Assize Rolls, Gaol Delivery Rolls. The enormous value of these documents to the historian is obvious; they give him a very complete view of all the proceedings of the

royal tribunals[1]. The rolls of the thirteenth century are in one respect better material than those of later times, since they frequently give not merely the judgment but the *ratio decidendi* expressed in brief, neat terms. We also begin to get by the thousand "feet of fines," *i.e.* records of actions brought and compromised as a means of conveying land. The light which these hitherto neglected documents throw upon the history of conveyancing will some day be appreciated[2].

(3) *Other public records.* The Pipe Rolls continue

[1] We are still behindhand in the work of exploiting the Plea Rolls. In 1811 the Record Commissioners published the *Placitorum Abbreviatio*, a collection of extracts and abstracts extending from Richard I to the death of Edward II, made by Arthur Agard and others in the reign of Elizabeth. Valuable as this book is, it can only be regarded as a stop-gap; our wants are not those of Elizabeth's day. In 1835 Palgrave edited for the Commissioners a few of the rolls of Richard I and John under the title *Rotuli Curiae Regis*; the residue of Richard's rolls are to be published by the Pipe Roll Society; the earliest rolls are not the most interesting. The present writer has edited *Pleas of the Crown for the County of Gloucester* (1884), the criminal part of an Eyre Roll of 1221; Bracton's *Note Book* (3 vols., 1887), near two thousand cases of Henry III's reign; and, for the Selden Society, *Select Pleas of the Crown* (vol. I., 1887), a selection of criminal cases from the period 1200-25. In 1818 the Record Commissioners published a large volume of *Placita de Quo Warranto*, mostly from Edward I's reign, which is full of precious information about feudal justice. But only a beginning has been made; in particular the very valuable Rolls of Exchequer Memoranda must be brought to light; their general character may be gathered from the few extracts printed at the beginning of Maynard's *Year Book of Edward II* (1678).

[2] Some of the fines of Richard's and John's reigns were edited for the Commissioners by Joseph Hunter (2 vols., 1835-44); the residue are to be published by the Pipe Roll Society. The fines of a little later date are far more valuable and show elaborate family settlements; but they are unprinted.

to give us the sheriffs' accounts; but their importance now becomes much less, since they are eclipsed by far more communicative rolls, namely, the Rolls of Letters Patent and Letters Close, the Fine Rolls and the Charter Rolls. These enable us to study in minute detail the whole of the administrative machinery of the realm; and, owing to the publication of those belonging to John's reign, the governmental work of that age can be very thoroughly understood and illustrated. The Charter Rolls contain copies of the royal grants made to municipalities and to individuals, and thus to some extent they supply the place of a *Codex Diplomaticus*. Then from Edward I's reign we have parliamentary records, a broken series of Rolls of Parliament, of Petitions to Parliament, and Pleas in Parliament[1].

(4) *Law books*. In England as elsewhere the thirteenth century might be called " the period of the law books"; that is to say, the historian of this period will naturally reckon text-books, notably one text-book, as among the very best of his materials.

[1] Published for the Record Commissioners are the *Close Rolls*, 1204-1224, edited by T. D. Hardy (2 vols., 1833-44); the *Patent Rolls*, 1201-1216, by Hardy, with a learned Introduction (1 vol., 1835); the *Oblate and Fine Rolls* of John's reign, by Hardy (1 vol., 1835); *Excerpts from the Fine Rolls*, 1216-1272, by Charles Roberts (2 vols., 1835-36); the *Charter Rolls*, 1199-1216, by Hardy (1 vol., 1837). The *Rolls of Parliament* (6 vols. and Index) were officially published in the last century, but at least so far as the first period (Edward I, II, III) is concerned, this edition leaves much to be desired. Many materials for the illustration of parliamentary business have since come to light, and vast numbers of early Petitions to Parliament still remain unprinted. Of the *Hundred Rolls* hereafter.

English Legal History 43

(*a*) Bracton's *Tractatus* (or *Summa*) *de Legibus et Consuetudinibus Angliae* is by far the greatest of our mediaeval law books. It seems to be the work of Henry of Bratton, who for many years was a judge of the king's court and who died in 1268. It seems also to be an unfinished book and to have been composed chiefly between the years 1250 and 1256. It covers the greater part of the field of law. In laying out his scheme the author has made great use of the works of Azo, a Bolognese civilian, and thence he has taken many of the generalities of law; he may also have made some study of the Roman books at first hand; but he was no mere theorist; at every point he appeals to the rolls of the king's court, especially to the rolls of two judges already dead, Martin of Pateshull and William of Raleigh; his law is English case law systematized by the aid of methods and principles which have been learnt from the civilians. A *Note Book* full of cases extracted from the rolls has recently been discovered, and there is some reason for thinking that it was made by or for Bracton and used by him in the composition of his treatise[1].

[1] An edition of Bracton was published in 1569 and reprinted in 1640; a new edition has been given in the Rolls Series by Travers Twiss (6 vols., 1878–83); the editor however was hardly alive to the difficulty of his task and failed to observe that the very numerous MSS. present the work in several different stages of composition. A more adequate edition is much wanted. It should show what Bracton borrowed from Azo, and also, when this is important, what he declined to borrow from Azo; it should give all the cases cited by Bracton which are not already printed in the *Note Book*, or such of them as can yet be found on the rolls; it should settle the pedigree of the MSS., distinguish the author's original work from his after-

(*b*) *Fleta* is the work of an anonymous author, seemingly compiled about 1290. It gets its name from a preface which says that this book may well be called *Fleta* since it was written "in Fleta," *i.e.* in the Fleet gaol. In substance it is an edition of Bracton much abridged and "brought up to date" by references to the earlier statutes of Edward I. It has however some things that are not in Bracton, notably an account of the manorial organization; this the writer seems to have obtained from what we may call "the Walter of Henley literature," to which reference will be made below.

(*c*) Bracton and *Fleta* are Latin books: *Britton* is our first French text-book. It seems to have been written about 1290. The writer made great use of Bracton and perhaps he used *Fleta* also; but he has better claim to be treated as an original author than has the maker of *Fleta*. He arranges Bracton's material according to a new plan, and puts his whole book into the king's mouth, so that all the law in it appears as the king's command. Who he was we do not know; he has been identified with John le Breton, a royal judge and bishop of Hereford; but the book, as we have it, mentions statutes passed after the

thoughts and from the glosses by later hands, some of which glosses (never yet printed) are of great interest. Five years of hard work might give us a really good edition. The *Note Book* alluded to above was brought to light by Paul Vinogradoff in 1884 and has since been published (1887).

Bracton's relation to Azo is the subject of an excellent tract by Karl Güterbock, *Henricus de Bracton und sein Verhältniss zum römischen Rechte* (Berlin, 1862), translated by Brinton Coxe (Philadelphia, 1866).

bishop's death. To judge by the number of existing manuscripts, Bracton and *Britton* both became very popular, while *Fleta* had no success[1].

(*d*) Selden had a manuscript purporting to contain Bracton's treatise abridged by Gilbert Thornton in the twentieth year of Edward I; Thornton was chief justice. Selden's manuscript is not forthcoming and he did not know of any other like it. Possibly, however, Thornton's abridgement is represented by some of the existing manuscripts which give abbreviated versions of Bracton's book.

(*e*) Works of minor importance are two little treatises on procedure by Ralph Hengham, known respectively as *Hengham Magna* and *Hengham Parva*; a small French tract of uncertain date, also on procedure, known from its first words as *Fet assavoir*; and various little tracts found in manuscripts under such titles as *Summa ad cassandum omnimoda brevia*, *Summa quae vocatur Officium Justiciariorum*, *Summa quae vocatur Cadit Assisa*, *Placita placitata*, and the like. They are of an intensely practical character, but deserve to be collected[2].

[1] *Fleta* was printed in 1647 and again in 1685; these editions are faulty but are accompanied by a learned dissertation coming from Selden. Part of *Fleta* was edited anonymously by Sir Thomas Clark in 1735. An admirable edition of *Britton* has been published by Francis Morgan Nichols (2 vols., Oxford, 1865). *Britton* was first printed by Redman (without date) and was again printed in 1640; a translation of part of it was published in 1762 by Robert Kelham. *Britton* and *Fleta* are also to be found in Houard's *Traités sur les Coutumes Anglo-Normandes*.

[2] "Fet assavoir" appears at the end of the editions of *Fleta*. The two Henghams appear in Selden's edition of Fortescue's *De*

(*f*) To Edward II's reign, or perhaps to the end of his father's, we must attribute the interesting but dangerous *Mirror of Justices* of Andrew Horne, fishmonger and town clerk of London[1]. It is the work of one profoundly dissatisfied with the administration of the law by the king's judges. As against this he appeals to myths and legends about the law of King Alfred's day and the like, some of which myths and legends were perhaps traditional, while others may have been deliberately concocted. Intelligently read it is very instructive; but the intelligent reader will often infer that the law is exactly the opposite of what the writer represents it to be. It has done much harm to the cause of legal history; it imposed upon Coke and even in the present century has been treated as contemporary evidence of Anglo-Saxon law.

(*g*) There is hardly any book more urgently needed by the historian of English law than one which should trace the gradual growth of the body of original writs, *i.e.* of the writs whereby actions were begun; such writs were the very skeleton of our mediaeval *corpus juris*. The official *Registrum Omnium Brevium* as printed in the sixteenth century (1531, 1553, 1595, 1687) is obviously a collection that has been slowly put together. It is believed that extant manuscripts still offer a large supply of materials capable of illustrating

Laudibus (1616). Some of the minor tracts seem never to have been printed.

[1] A poor version of the French text of the *Mirror* was issued in 1642, an English translation of it by William Hughes in 1642, 1768 and 1840. A critical edition of this curious book would be of great value.

English Legal History

the process of its growth. Some of the manuscript collections of writs go back to Henry III's reign, and occasionally have notes naming the inventors of new writs[1]. Here is a field in which excellent work might be done.

(5) *Law reports.* Just at the end of the thirteenth century there appear books of a new kind, books whose successors are to play a very large part in the legal history of all subsequent ages; we have a few Year Books of Edward I's reign[2]. These are reports in French by anonymous writers of the discussions which took place in court between judges and counsel over cases of interest; whether they bore any official sanction we do not know. They are of special value as showing the development of legal conceptions, which is better displayed in the dialectic process than in the formal Latin record which gives the pleadings and judgment in their final form; we learn what arguments were used and also what arguments had to be abandoned. But for the period now in question we can

[1] Thus a Cambridge MS. Kk, v, 33, gives a very early Registrum Brevium in which we may read how a number of writs were invented by William Raleigh. The earliest register known to me is in Mus. Brit. MS. Cotton. Julius D. II.

[2] Happily the Year Books of Edward I remained unprinted until very lately; the consequence is that we have a good edition of them. Between 1863 and 1879 Alfred J. Horwood edited for the Rolls Series five volumes containing cases from the years 20, 21, 22, 30, 31, 32, 33, 35 Edw. I. Before his death he had begun work on the Year Books of a later age, and the inference might be drawn that he was unable to find any more reports of Edward I's reign. But he seems to have nowhere stated that this was so, and a cursory inspection of the manuscripts induces the belief that they have not yet been exhausted.

only give the Year Books a secondary place among our materials.

(6) *Manorial law.* Of late years our horizon has been enormously extended by the revelation of vast quantities of documents illustrative of manorial law and custom, a department of law which has hitherto been much neglected, but which is of the very highest interest to all students of economic and social history.

(*a*) In the first place we have numerous "extents" of manors, *i.e.* descriptions which give us the number and names of the tenants, the size of their holdings, the legal character of their tenure and the kind and amount of their service; the "extent" is a statement of all these things made by a jury of tenants. Such extents are found in the monastic cartularies and registers. Among these we may mention the *Boldon Book*, which is an account of the palatinate of Durham, the *Glastonbury Inquisitions*, the *Cartulary of Burton Abbey*, the *Domesday of St Paul's*, the *Register of Worcester Priory*, the *Cartularies of Gloucester, Ramsey*, and *Battle*. A few of those mentioned at the head of our list take us back into the twelfth century. There are still several cartularies which ought to be printed. The *Hundred Rolls* compiled in Edward I's reign give us the results of a great inquest prosecuted by royal authority into "the franchises," *i.e.* the jurisdictional and other regalia which were in the hands of subjects; we thus obtain an excellent picture of seignorial justice. But for certain counties and parts of counties these *Hundred Rolls* give us far more, namely, full "extents" of all manors. They thus serve to supplement and correct the notions which we might form if we studied

only the ecclesiastical manors as displayed in the cartularies[1].

(*b*) Almost nothing has yet been done towards the publication of a class of documents which are quite as important as the "extents," namely, the earliest rolls of the manorial and other local courts. We have a few older than 1250, a considerable number older than 1300[2]. They show the manorial system in full play, illustrate all its workings and throw light on many points of legal history which are not explained by the records of more exalted courts[3].

[1] The *Boldon Book* was published as an appendix to the official edition of *Domesday*, vol. IV., and again by the Surtees Society; the *Glastonbury Inquisitions* were printed for the Roxburghe Club; an abstract of the *Burton Cartulary* for the Salt Society; the *Black Book of Peterborough* for the Camden Society at the end of the *Chronicon Petroburgense*; the *Domesday of St Paul's* and the *Worcester Register* (both with valuable introductions by William Hale Hale) and the *Battle Cartulary* for the Camden Society; the *Gloucester and Ramsey Cartularies* are in the Rolls Series. The *Hundred Rolls* were published by the Record Commissioners (2 vols., 1812–18). The publications of the Camden Society are often in the market.

[2] The Selden Society's volume for 1888, *Select Pleas in Manorial and other Seignorial Courts*, gives extracts from some typical rolls of the thirteenth century and may serve to stimulate a desire for further information.

[3] There are several little treatises on the practice of manorial courts. Some of these in their final shape belong to the next period and are represented by the *Modus tenendi Curiam Baronis*, two editions, by R. Pynson (n.d.—1516–20?); *Modus tenendi unum Hundredum*, Redman (1539); *Modus tenendi Curiam Baronis*, Berthelet (1544); *The Maner of kepynge a Courte Baron*, Elisabeth Pykeringe (1542?); *The Maner of kepynge a Court Baron*, Robert Toye (1546). But beside these there is a quite early set of precedents which seems never to have been printed. It generally begins "Ici

(c) Little known to the world, there is a small but complicated literature of tracts on "husbandry" and the management of manors. In whole or in part it is often associated with the name of a certain "Walter of Henley." The author of *Fleta* has made use of it in his well-known chapter on the manorial system. Further investigation will perhaps distinguish between two or three tracts that are intertwined in the manuscripts and presented in varying forms. An edition of all or some of these tracts has been projected. They bear directly rather on agricultural and economic than on legal history; but the historian of manorial law cannot afford to neglect them[1].

This department of mediaeval law, concerning as it does the great mass of the population, is beginning to attract the attention that it deserves. The traditional

poet home trover suffysaument...tut le cours de court de baron." It is found in several MSS., *e.g.* Mus. Brit. Egerton, 656; Add. 5762; Lands, 467.

[1] One of these tracts (in an English version) got printed very early without date or printer's name. "Boke of husbandry. Here begynneth a treatyse of husbandry whiche mayster Groshede somtyme byssshop of Lyncoln made and translated it out of Frensshe into Englysshe....The 1. chapitre. The fader in his olde age sayth to his sone lyve wysely.... Here endeth the boke of husbandry and of plantynge and graffynge of trees and vines." One of the tracts was published by Louis Lacour; *Traité inédit d'économie rurale composé en Angleterre*, Paris, 1856. These seem at present the only printed representatives of this "Walter of Henley literature"; but it appears in many manuscripts. For information on this subject I am indebted to my friend Dr William Cunningham, the author of *The Growth of English History and Commerce*, who proposes, I believe, to reprint in the second edition of his book the rare tract ascribed to Bishop Grosseteste of Lincoln. Some other of these tracts are, I hear, to be edited for the Royal Historical Society.

learning of lawyers about the manorial system went back only to comparatively recent times and their speculations about earlier ages had been meagre and fruitless. A new vista was opened by Erwin Nasse's *Ueber die mittelalterliche Feldgemeinschaft in England* (Bonn, 1869), which was translated into English by H. A. Ouvry (1871). H. S. Maine's *Lectures on Village Communities in the East and West* (1876) drew the attention of Englishmen to the work that had been done in Germany. Frederic Seebohm's *English Village Community* (1883) came into sharp conflict with what were coming to be accepted doctrines and must lead to yet further researches. In 1887 Paul Vinogradoff published at St Petersburg a Russian treatise in which much use was made of our manorial extents and rolls; a larger work in English by the same hand is expected. This of course is a department in which legal and economic history meet; and it has become clear that the historian of law must realize the economic meaning of legal rules while the historical school of economists must study mediaeval law.

(7) *Municipal and mercantile law.* The growth of municipal institutions, the development of guilds and corporations, are now recognized topics of "constitutional history." But a great deal remains to be done towards the publication of documents illustrating the laws and customs administered in the municipal courts. In particular there is much to be discovered about "the law merchant." Before the end of the thirteenth century the idea had been formed of a *lex mercatoria*, to be administered between merchants in mercantile

affairs, which differed in some respects from the common law. Throughout the middle ages the merchants had special tribunals to go to, and consequently very few of their affairs are noticed in the Year Books. Whether very much of this law merchant can be recovered may be doubtful, but until the archives of our cities and boroughs have been thoroughly explored by some one who knows what to look for, we shall do well to believe that something may yet be learned[1].

V. *From Edward III to Henry VIII.*

About the remainder of the middle ages we must speak more briefly. On the whole the law has no longer to be sought in out of the way or but newly accessible sources; it may be found in books which lawyers have long had by them and regarded not merely as evidence of old law but as authority, namely the Statute Book, the Year Books and the very few

[1] Thomas Madox's *Firma Burgi* (1726) is a vast mine of facts, and many will be found in *The History of Boroughs*, by Henry Alworth Mereweather and Archibald John Stephens (3 vols., 1835). For London, Henry Thomas Riley's *Monumenta Gildhallae Londoniensis* (Rolls Series, 3 vols. in 4, 1859-62) is the great book. A custumal of Ipswich is printed by Travers Twiss in vol. II. of the *Black Book of the Admiralty* (Rolls Series, 1873). A considerable number of other municipal custumals belonging to this and the next period are known to exist in manuscript. A little about the law merchant will be found in the Selden Society's vol. II., where some pleas in the court of the Fair of St Ives are given. A great deal about the legal treatment of merchants and mercantile affairs is collected by Georg Schanz, *Englische Handelspolitik* (2 vols., Leipzig, 1881).

text-books which this age presents. It would be a great mistake, however, to suppose that these sources should be exclusively used or that they are in the state in which they ought to be.

After Edward the Third's accession we can insist on a strict definition of a statute. The more important laws of a general character are placed on the Statute Roll and about their text there can seldom be any dispute; we have a good official edition of them. But the Parliament Rolls, an unfortunately broken series, also should be studied, as they often show the motives of the legislators and also contain some of those acts of Parliament which were not thought of sufficient general and permanent importance to be engrossed on the Statute Roll; a great deal that concerns trade and agriculture and villainage and the working of the inferior organs of the constitution, in particular the new magistracy, the justices of the peace, must be sought rather in the Parliament Rolls than among the collections of statutes. Again, most of the other series of non-judicial rolls mentioned above are continued; and though they are not of such priceless value for this as for former periods, they should certainly not be neglected by any one who wishes to make real to himself and others the working of our public law. A great deal of that law never comes into the pages of the Year Books and for that reason has remained unknown to us.

We turn to the law reports. A series of Year Books extends from Edward II to Henry VIII, from 1307 to 1535. They got into print piecemeal at various times; the most comprehensive edition is one

published in ten volumes, 1678–80. This edition has about as many faults as an edition can well have; it teems with gross and perplexing blunders. Happily it is not complete, and we have thus been enabled to contrast a good with a bad edition. It leaves a gap between the tenth and the seventeenth years of Edward III. This gap is being gradually filled up in the Rolls Series by L. O. Pike, who has already given the books for the years 11–14 Edward III; but there are several other considerable gaps to be filled, one for instance between the thirtieth and thirty-eighth years of the same reign, another representing the whole reign of Richard II. Henry VIII's long reign is scurvily treated, and though we begin now to get a little help from reporters whose names are known, from Dyer and others, still it is true that we have singularly few printed memorials of the law of this important time. An edition of all the Year Books similar to that which we now have in the Rolls Series for a few lucky years of Edward III would be an inestimable gain, not merely to the historian of law but to the historian of the English people.

One of the many excellent features of these newly published Year Books of Edward III's reign consists of further information about the cases there reported, which information has been obtained from the Plea Rolls. Often the report of a case in the Year Books is but partially intelligible to modern readers until they are told what are the pleadings and the judgment formally recorded on the official roll of the court. The Plea Rolls are extant. To print even a few rolls of the fourteenth or fifteenth century would be a heavy

task, so copious is the flow of litigation, so lengthy have the pleadings by this time become[1]. Still, in that new edition of the Year Books which is urgently needed, a brief statement of the recorded pleadings and judgment ought to be frequently given. But this is not the only use that should be made of the rolls. The Year Books, invaluable though they be (or would be were they made legible), are far from giving us a complete view even of the litigation of the period, to say nothing of a complete view of its law. They are essentially books made by lawyers for lawyers, and consequently they put prominently before us only those parts of the law which were of immediate interest to the practitioners of the time; an exaggerated emphasis is thus laid on minute points of pleading and practice, while some of the weightiest matters of the law are treated as obvious and therefore fall into the background. If anything like a thorough history of "the forms of action" is to be written, the Plea Rolls as well as the Year Books must be examined. The work of turning over roll after roll will be long and tedious, but greater feats of industry have been performed with far less gain in prospect. To give one example of the use of the Plea Rolls, let us recall Darnel's case, the famous case of Charles I's day, about the power of the king and the lords of the council to commit to prison. The question what were the courts to do with a man so committed could not be answered out of the Year Books, it had to be answered out of the Plea Rolls. These rolls contain an exhaustive history of the writ

[1] It is said that the rolls of the Court of Common Pleas for Henry VIII's reign consist of 102,566 skins of parchment.

of *habeas corpus*, the Year Books have little about it, for cases about "misnomer" and the like had been far more interesting to lawyers than "the liberty of the subject." And so it is to be suspected that the new principles of private law which appear in the Year Books of Edward IV—the rise of the action of assumpsit, the doctrine of consideration, the protection of copyholders, the conversion of the action of ejectment into a means of trying title to lands, the destruction of estates tail by fictitious recoveries—that all these and many other matters of elementary importance might be fully illustrated from the Plea Rolls, whereas the Year Books give us but dark hints and unsolved riddles.

The manor becomes steadily of less importance during this period; but that is no reason why the manorial rolls, of which we have now an ample supply, should be neglected; but neglected they have hitherto been. The historian should take account not only of growth but of decay also, and the records of this time should give the most welcome evidence as to the effect of great social catastrophes, the black death, the peasants' revolt, the dissolution of the monasteries, and also as to the formation of what comes to be known as copyhold tenure. And again, turning from country to town, we shall not believe that the development of the law merchant has left no traces of itself until some one has given a few years to hunting for them.

Still more important, at least more exciting, is the history of the jurisdiction of the Council and of the new courts which arise out of it, the Court of Star Chamber, the Court of Chancery. Much has been

recovered, but assuredly much more can be recovered. There are large quantities of Chancery proceedings to be examined; and it is impossible to believe that we shall always be left in our present state of utter ignorance as to the sources of that equitable jurisprudence which in course of time transfigured our English law, be left guessing whether the chancellors trusted to natural reason, or borrowed from Roman law, or merely developed principles of old English law which had got shut out from the courts of common law by the rigours of the system of writs[1].

With a few, and these late exceptions, the text-books of the time are of little value; with the thirteenth

[1] *The Proceedings and Ordinances of the Privy Council from* 1386 *to* 1542 were edited for the Record Commissioners by Nicholas Harris Nicolas (7 vols., 1834–37). There are two well-known monographs, Francis Palgrave, *Essay upon the Original Authority of the King's Council* (1834) and A. V. Dicey, *Essay on the Privy Council* (2nd ed., 1887). *The Calendars of the Proceedings in Chancery in the Reign of Elizabeth*, as published by the Commissioners (3 vols., 1827–32), contain some specimens of earlier proceedings beginning in the reign of Richard II. A calendar of proceedings in Chancery beginning with Richard's reign is in the press. Spence's *Equitable Jurisdiction*, mentioned above, affords much that is of historical value. But quite new ground was broken by L. O. Pike's essay on "Common Law and Conscience in the Ancient Court of Chancery," *Law Quarterly Review*, I, 443, and by O. W. Holmes' daring paper on " Early English Equity," *ibid.* 162. The suggestions thus made must be followed up; and it is believed that the materials for a history of the beginnings of equity are to be found at the Record office in great abundance. It is high time that they should be used. As to the Star Chamber, considering how important, how picturesque a part it played in English history, it is surprising that no very serious attempt should have been made to master the great mass of documents relating to it.

century died the impulse to explain the law as a reasonable system and give it an artistic shape. Still that is no reason why such books as there are should be left in their present dateless, ill-printed or even unprinted condition; the *Old Tenures*, the *Old Natura Brevium*, the *Novae Narrationes* want editors; and towards the end of our period we get some "readings" which should be published, such as Marrow's *Reading on Justices of the Peace*, a work which Fitzherbert and Lambard treated as of high authority. Littleton's *Tenures*, which marks the revival of legal and literary endeavour under Edward IV, has had enough done for it by its great commentator, in some respects more than enough, for the historian will have to warn himself against seeing Coke in Littleton[1]. Needless to say it is a very good book; and the last parts of it, now little read, are a most curious monument of the dying middle ages. They only become really intelligible and lifelike in the light of the Paston Letters and similar evidence, a light which reveals the marvellous environment of violence, fraud and chicane in which an English gentleman lived. Under Henry VIII, Fitzherbert begins the work of summing up our mediaeval law in his *Abridgement* and his *New Natura Brevium*.

[1] Early editions of Littleton's *Tenures* are numerous and some of them are precious; an edition by T. E. Tomlins, 1841, is probably the best. Any one who has heard of Coke upon Littleton has probably also heard of the fine edition of that book made by Francis Hargrave and Charles Butler; their notes, especially Butler's, are of real value even for the mediaeval period. The *Novae Narrationes* were printed by Pynson without date and were published again in 1561; both the *Old Tenures* and the *Old Natura Brevium* were printed by Pynson.

Sir John Fortescue's works give excellent illustrations of several legal institutions, notably of trial by jury, though as a whole they are rather concerned with politics than with law[1].

Here I must stop, without of course intending to suggest that history stops here. The historian of modern law—the historian, let us say, who should choose as his starting point the reign of Elizabeth—would have before him an enormously difficult task. The difficulty would lie not in a dearth but in a superabundance of materials. To trace the development of the leading doctrines at once faithfully and artistically would require not only vast learning but consummate skill, such a combination of powers as is allowed to but few men in a century. But the result might be one of the most instructive and most readable books ever written, one of the great books of the world. However, no one who feels the impulse to undertake such a work will need to be told how to set about it or whither to look for his materials. It is somewhat otherwise as regards the middle ages; those who have seen a little of our records printed and unprinted may be able to give a few acceptable hints to those who have seen less, and it is with some vague hope that the above notes may be of service to beginners that

[1] Fortescue's most famous work *De Laudibus Legum Angliae* was edited with important notes by Selden in 1616, and has since been edited by A. Amos. His writings will be found in the first volume of a luxurious book printed for private circulation by Lord Clermont, *Sir John Fortescue and his Descendants*. His tract on *The Governance of England* has been beautifully edited with an elaborate apparatus by Charles Plummer (1885).

they have been strung together; may they soon become antiquated, even if they are not so already! They should at least convey the impression that there is a great deal to be done for English mediaeval law; much of it can only be done in England, for we have got the documents here; but there is no reason why it should not be done by Americans. We have piles, stacks, cartloads of documents waiting to be read—will some one come over into England and help us[1]?

[1] As I have reason to believe that the difficulty of reading legal MSS. is greatly exaggerated by those who have made no experiment, I may be allowed to say that any one who knows some law and some Latin will find that the difficulty disappears in a few weeks. Of course I am not denying that from time to time problems may arise which only an experienced or perhaps a specially gifted eye can solve, but as a general rule our legal records from the beginning of the thirteenth century downwards are written with mechanical regularity; during the thirteenth century the writing is often beautiful; usually if one cannot read them this is because one does not know law enough, not because the characters are ill-formed or obscure.

POSSESSION FOR YEAR AND DAY[1]

THE respect paid by mediaeval law, French and German, to a possession which has been continued without interruption for year and day has become the centre of a considerable mass of learning and of theories. Here it will be sufficient to refer to two main doctrines[2]. On the one hand it has been asserted that the law of the German tribes which overwhelmed the Roman Empire knew an annual usucapio for land, admitted that the ownership of land could be acquired by peaceful seisin for year and day, with perhaps some saving for the rights of those who were under disability. "At the time when the Salian Franks invaded Gaul they still admitted that a possession prolonged for year and day would suffice to give ownership[3]." When French law becomes articulate in the twelfth and thirteenth centuries this brief

[1] *Law Quarterly Review*, 1889.
[2] Among the books which deal with the matter are the following:—Alauzet, *Histoire de la Possession en droit Français*; Esquirou de Parieu, *Études sur les Actions Possessoires*; Viollet, *Établissements de Saint Louis*, I. 110; Viollet, *Précis de l'Histoire du Droit Français*, 484; Bruns, *Recht des Besitzes*, 352–367; Albrecht, *Die Gewere*; Laband, *Die Vermögensrechtlichen Klagen*; Heusler, *Die Gewere*; Heusler, *Institutionen des Deutschen Privatrechts*, I. 56, II. 66–117.
[3] Viollet, *Précis*, p. 484.

prescription has perished; but it has left many traces of itself. In the twelfth century there are many towns in which possession, or at all events titled possession, for year and day will still bar all adverse claims. A little later we find that according to a very general custom the French possessory remedy, the plaint of novel disseisin (for this term is as well known in France as in England) will only serve to protect a possession that has endured for year and day; possession for year and day will no longer give ownership, but it is required for that seisin which the law protects; a shorter possession if protected at all is only protected by remedies which have their origin in Roman or Canon Law.

There is no need to point out how interesting this theory is that the Germans, or at all events the Franks, started with an annual prescription. Any supposition of their having borrowed it from the ancient Roman usucapio might for several reasons be dismissed, and we should seemingly be brought face to face with a striking similarity between the earliest stages of the two great bodies of law that have ruled the modern world.

On the other hand this theory has been strenuously denied. The barbarians knew no prescription. In course of time they borrowed from Roman Law the prescriptive terms of ten, twenty, thirty years; but it is in another quarter that we must look for the origin of that respect for year and day which was prevalent during the later middle ages. To explain this it is necessary to say that the German conveyance of the later middle ages was an "Auflassung," or "surrender'

effected in court, a proceeding closely analogous to our own "fine of lands." The person who obtained land under such a conveyance was there as here protected after he had quietly possessed the land for year and day. In some customs the protection amounted, as with us, to an extinction of all adverse claims, though there as here there was a saving for the rights of those who were under disability. In other customs after year and day the possessor, though not absolutely safe, had the enormous procedural advantage of being allowed to establish his title by his own oath without oath-helpers. The "Auflassung" seems even to have become the one and only means of conveying land, and the fiction of litigation having gradually dropped away it gave to Germany a system of registered titles such as we shall never obtain without stringent legislation.

Now this in Germany is the most important context of "year and day"; there is no trace of any such general rule as that possession for year and day will give ownership, or that possession not yet continued for that period is unprotected. It takes the action of a court of law to set this term running; the person in whose favour the "Auflassung" is made is put in seisin by the officer of the court and the peace of the court is solemnly conferred upon him and his possession.

That the requirement of litigious proceedings for the purpose of passing the ownership of land was not primitive, seems quite certain. It has been traced to two main causes. In the first place the rights of expectant heirs had to be precluded. Our own classical common law seems to stand alone among

the sister systems as regards what may be called its individualism, its refusal to admit that the family has rights, its assertion that the house-father's land is just his land and that he may do what he likes with it, that he may bequeath all his moveables to a stranger and leave his children penniless, that there is no community of goods between him and his wife. Practically similar results may have been obtained in all countries at least so far as the richer classes were concerned; but what in England was done by means of private settlements, by estates tail, remainders and so forth, was done elsewhere by general rules of law forbidding a man to alienate his land without the consent of his expectant heirs or enabling members of his family to compel a purchaser to resell the land at the price given for it. To get rid of these family rights one needs litigation real or pretended. Then in the second place it seems that in Germany the lords of jurisdiction were more thoroughly successful than they were in England in the endeavour to establish the rule that land within their jurisdiction could not be alienated without their leave, and this even when (to take a distinction which hardly appears in England) they were not lords of the land but merely lords of the jurisdiction. These two causes converted the safest mode of conveyance, an "Auflassung" before the court, into the only mode of conveyance. In England their power was less and, perhaps unfortunately, the extra-judicial feoffment lived on by the side of the judicial fine; but let us notice that during the middle ages one very great mass of English landholders conveyed their lands in court by surrender

Possession for Year and Day

into the hands of the lord of the court; now the German for "surrender" is "Auflassung[1]."

The phrase invariably used to describe the space of time which has legal results seems to point to an origin in judicial proceedings. It is not a year but "year and day," "an et jour," "Jahr und Tag." Now in German books this is glossed as meaning one year, six weeks and three days. Various explanations have been given of this, but all seem to point to the fact that the "day" is a "court day." One of the best accredited explanations is that the court is adjourned from six weeks to six weeks and that it sits for three days; the claimant is bound to make his claim at latest at the next session after the lapse of the year; thus as a maximum term he has a year, six weeks and three days[2]. Be this as it may, it is in connection with judicial proceedings that we first hear of year and day; in particular when a defendant in an action of land will not appear the land is seized into the king's hands, and if the contumacy continues for year and day the land is then adjudged to the plaintiff; during

[1] Dr Brunner, *Zur Rechtsgeschichte der Römischen und Germanischen Urkunde*, p. 286, has drawn attention to the importance of our fines and recoveries in the general history of law. Much that is interesting about the "Auflassung" will be found in Bewer, *Sala, Traditio, Vestitura*.

[2] Heusler, *Institutionen*, I. 57. In Leg. Will. Conq. I. 3, we have a period of month and day given. It will be remembered also that a defendant summoned to the king's court had to be waited for during three days—per tres dies expectabitur, Glanv. lib. I. cap. 7. Already in the thirteenth century the prolonged sittings of our king's courts must have made the original meaning of the additional day unintelligible.

the year and day it lies under the king's ban[1]. Now the suggestion is that in this contumacial procedure men saw the possibility of stable and effectual conveyances:—let the purchaser sue the vendor, let the land lie in the king's ban for year and day, then let it be adjudged to the purchaser, let him be put in seisin under the king's peace. According to this theory the reverence paid in the later middle ages to possession prolonged for year and day has its root not in a primitive usucapio, but in the king's ban.

And now let us turn to England and ask whether we have any evidence which bears upon these conflicting theories.

In the first place we have some negative evidence. In all the dooms and land books that come to us from the time before the Norman Conquest there is I believe not only no mention of year and day, but no proof of any limitation or prescription[2]. It seems highly improbable that there was any term, at least any short term, of prescription, otherwise we should surely find some impleaded church relying upon it. Then, to come to later times, the only terms of prescription or limitation that our common law admits (if indeed our "common law" can be said to admit any) are extremely long terms; it is thought no absurdity that an ousted owner and his heirs should have a century or thereabouts within which to recover their

[1] In England the land remained in the king's hand for but fifteen days; Glanv. lib. I. cap. 7.

[2] See the *Harvard Essays in A.-S. law*, p. 253. It is just possible that among ecclesiastics the Roman prescription of thirty years was respected.

land[1], or that the claimant of a prescriptive right in Henry III's time should be expected to assert that he has exercised it ever since the Norman Conquest. Then again these terms never seem to be the outcome of any general notion; they are imposed from time to time by statute or in earlier days by royal ordinance. Then again we never obtain any real acquisitive prescription for land or moveables; the true owner may be deprived of his remedies, but "it is commonly said that a right cannot die[2]." Certainly this does not look as though our law had at any time, however remote, contained the principle that quiet seisin for year and day will give ownership or bar claims. Lastly, when in Henry II's day we get a definitely possessory action for land it protects possession that has not endured for year and day, it will protect the very disseisor himself when he has been on the land for four days[3]. Thus in the main stream of the common law about possession and property there seems no place for year and day.

Still year and day is respected. Twice over Coke has given us a string of rules to illustrate the proposition that the common law has often limited year and day as a convenient time[4]. We will attempt to arrange his instances together with a few that he has omitted.

[1] Ordinance of 1237 in Bracton's *Note Book*, pl. 1217.
[2] Littleton, sec. 478.
[3] *L. Q. R.* IV. 29.
[4] Co. Lit. 254*b*; 5 Rep. 218.

I. *Instances relating to rights of ownership or possession in which there has been no exercise of royal or judicial power.*

(*a*) In Bracton's day it was the opinion of some that the intruder, as distinguished from the disseisor, gained no legally protected possession until after the lapse of a year[1].

(*b*) "By the ancient law," so says Coke following Broke, "if the feoffee of a disseisor had continued a year and day, the entry of the disseisee for his negligence had been taken away." This was not the law of Bracton's day, nor of Littleton's. Conceivably it was the law of some intermediate period, but contemporary proof of this is wanting[2].

(*c*) The effect of a descent cast in tolling an entry can be prevented by the entry and claim of the true owner made within a year and day before the death of the wrongful possessor. But this cannot be very ancient law, for the rule of Bracton's day protects even the disseisor himself[3].

II. *Instances in which there has been an exercise of royal or judicial power or in which the king's rights are involved.*

(*d*) After final judgment in a writ of right strangers had a year and day, reckoned from the execution of

[1] Bracton, f. 160 *b*, 161; *L. Q. R.* IV. 34.

[2] Co. Lit. 237, 254 *b*; *L. Q. R.* IV. 289.

[3] Quiet possession for year and day played a part in the custom of the Cornish miners. Such possession gave the "bounder" a provisional protection. But whether this is very ancient I do not know. See the various Acts of the Stannary Parliaments.

the writ of seisin, for putting in their claims; if they took no advantage of this they were barred.

(*e*) So in case of a fine strangers as well as parties and privies were barred if they made no claim within year and day from the execution of the writ of seisin.

(*f*) After judgment given in an action the plaintiff may obtain a writ of execution within year and day. Only for a year and day is the judgment kept in immediate suspense over the defendant.

(*g*) In the case of an estray if the owner, proclamation being made, does not claim it within year and day, it is forfeited. The right to estrays is a royal right.

(*h*) So in the case of wreck there is no forfeiture until after year and day. The right to wreck is a royal right.

(*i*) A villein dwelling on the ancient demesne cannot be claimed if he has lived there for year and day. This also looks like an outcome of the royal prerogative.

(*k*) The king has year, day and waste of the felon's land. For year and day it is under the king's ban.

(*l*) A protection shall be allowed for year and day and no longer. A protection of course is a royal boon.

(*m*) An essoin for sickness holds good for year and day.

III. *Miscellaneous.*

(*n*) The widow or heir has year and day for an appeal of death. This rule is statutory[1]; earlier law had not allowed any so long a time.

[1] Stat. Glouc. c. 9.

(*o*) There is no murder or manslaughter if the injured man live for year and day after the injury. May not this curious rule, which still has a place in our criminal law, be an outcome of the limitation of a time for an appeal of homicide? If the period began to run from the time when the wound was inflicted[1], then an appeal could never be brought in case the victim lived on for year and day.

Now looking at this medley of rules we shall probably agree that they afford few, if any, materials for the history of the ordinary law about ownership and possession. Our first class of rules is small and does not look ancient; two of the three rules in it are not as old as Bracton, the remaining rule was uncertain in his day.

The rule again which gives claimants a year and a day for asserting their rights after a final judgment or a fine does not seem to be ancient. Bracton very distinctly says that all who are not under disability are bound so soon as the indenture of the fine is delivered to the parties. And he argues that this gives them long enough for the assertion of their rights:—the indenture is not delivered until fifteen days after the compromise has been made in court, so there are fifteen days within which claims can be made, and fifteen days is the time usually allowed for the appearance in court of a defendant who has been summoned. We thus see that the levying of a fine is regarded as a summons to all whom it may concern, and we are enabled to connect this judicial conveyance with the

[1] See 4 Rep. 42 *a*; 2nd Inst. 320.

procedure against contumacious defendants. When a tenant in a real action will not appear the land is seized into the king's hand, and, unless the tenant replevies it within fifteen days, then it will be adjudged to the demandant. So in case of the fine, the true owner has but fifteen days in which to come forward and make his protest. How this time was enlarged from fifteen days to year and day I cannot say; but this happened in the interval between Bracton and *Fleta*[1]. In one way and another therefore the term of year and day seems to have become more and more popular as a term to be set to claims of various sorts and kinds. The further back we look the more restricted is its operation, the more closely does it seem connected with prerogatival rights, or with exercises of royal or judicial power.

It must be confessed however that a very different inference has been drawn by some foreign writers from materials very similar to those that have come before us. Some remains of the old prescription, they argue, are preserved, those chiefly which interest the king or other powerful persons. Thus the rule about estrays is a relic of the old general rule. Once there was no claim for goods which for year and day had remained in the possession of a finder. The king or the lord with regalities set up a claim to the custody of stray cattle and in his favour the rule was still

[1] Bracton, f. 436; *Fleta*, f. 443. See the so-called "Statute" Modus Levandi Finis, *Statutes of the Realm*, I. 214. It is noteworthy that Glanvill does not say that a fine has any effect on the rights of strangers. We may suspect that the law about this was evolved between his time and Bracton's.

operative; after year and day they were his own. Now we ourselves have texts of the twelfth century which seem to take us back to a time when the king's claim to estrays had not yet reached its full dimensions, and yet they mention year and day as a term which bars claims[1]. But according to my comprehension of them they neither lay down nor even suggest the general rule that the loser of goods has no action for them after year and day. The person who after the lapse of that time is to be protected against claims is a person who has claimed goods and had them delivered up to him upon giving security that he will produce them in court if some other demands them. It seems presupposed that the delivery is made to him by a lord who has a court; thus he is not merely a possessor but a possessor who has obtained possession under an exercise of jurisdiction.

So again, to touch for one moment the most controverted point, there are many who would connect the safety of the villein who for year and day has dwelt in a chartered town, with the famous title *De Migrantibus*[2], and there are some who would see in that provision of the *Lex Salica* a direct proof of the primitive German prescription. The "migrans" who has settled in a township contrary to the wish of any of its members becomes safe against them after lapse of a year. In one way or another a rule which had once compelled the folk of the township to put up with the presence of an intruder was twisted so as to

[1] Leg. Will. Conq. 1. 5. 6. On this see Jobbé-Duval, *Revendication des Meubles*, 21.
[2] *L. Sal.* 45.

give personal freedom to all who maintained themselves in the town for year and day. But whatever may have been the case in France, in England this rule has a very royal look; it is essentially a *privilegium*; the places in which it holds good are *loca privilegiata*, boroughs on which the king has conferred a special boon, or in later times all the manors of the royal demesne; it is much to the king's interest that his towns and his manors should be peopled[1].

On the whole, then, if we regarded only our common law the thought would probably never strike us that it contained the scattered fragments of an ancient rule under which possession continued for year and day ripened into ownership, or barred the claims of all who were not under disability.

Such is the case in the common law. But we have now to state some early evidence which has hitherto escaped attention. In the first place, there is a passage in the *Leges Henrici Primi* which may seem to imply some general rule to the effect that a person will to some extent or another be prejudiced by suffering year and day to go by without urging his proprietary claims[2]. Then again in the twelfth century

[1] Glanv. lib. v. cap. 5; Bract. 190 *b*; Brit. I. 200; Stubbs, *Introduction to Hoveden*, II. xxviii.

[2] Pueri autem ante xv. annos plenos nec causam prosequantur, nec in judicio resideant. De rebus hereditatis suae interpellatus post xv. annos defensorem habeat, vel idem respondeat, et calumpniam mittat in rebus suis ut nullus eos teneat uno anno et uno die sine contradictione, dum sanus sit et patriae pax. (Leg. Hen. 59, § 9.) The meaning of this seems to be that he who abates upon an infant heir gains none of the advantages of possession until a year and day after the heir has attained full age.

and the first part of the thirteenth some of the English boroughs, and those the most important, had charters which conferred some degree of protection upon a possession of land continued for year and day: at least if that possession had been obtained under a conveyance perfected in the borough court. Proof of this shall be given:—

Newcastle-upon-Tyne. Customs of the reign of Henry I as reported under Henry II.

Si quis terram in burgagio uno anno et una die juste et sine calumnia tenuerit non respondeat calumnianti, nisi calumnians extra regnum Angliae fuerit, vel ubi sit puer non habens potestatem loquendi. (*Acts of Parliament of Scotland*, I. pp. 33, 34; Stubbs, *Select Charters*, pt. III.)

Lincoln. Charter of Henry II.

Concedo etiam eis [civibus meis Lincolniae] quod si aliquis emerit aliquam terram infra civitatem de burgagio Lincolniae, et eam tenuerit per annum et unum diem sine calumnia, et ille qui eam emerit, possit monstrare quod calumniator extiterit in regno Angliae infra annum et non calumniatus est eam, extunc ut in antea bene et in pace teneat eam et sine placito. (*Foedera*, I. 40; Stubbs, *Select Charters*, pt. IV.)

Nottingham. Charter of Henry II.

Et quicunque burgensium terram vicini sui emerit et possederit per annum integrum et diem unum absque calumnia parentum vendentis, si in Anglia fuerint, postea eam quiete possidebit. (*Foedera*, I. 41; Stubbs, *Select Charters*, pt. IV.)

Bury St Edmunds. Statement by the burgesses of their custom in 1192 according to a chronicler of the time.

Burgenses vero summoniti responderunt se esse in assisa regis, nec de tenementis, que illi et patres eorum tenuerunt, bene et in pace, uno anno et uno die, sine calumpnia, se velle respondere

contra libertatem villae et cartas suas. (*Chron. Joc. de Brakel.* p. 56. Cam. Soc.)

London. Statement of custom, probably of the twelfth century.

Item si civis Londoniae terram aliquam per annum et diem sine calumpnia tenuerit, alicui in civitate manenti respondere non debet, nisi qui terram illam post calumpniatus fuerit talis aetatis tunc fuerit quod calumpniari eam nescierit, vel nisi longor [corr. languor?] impediat, aut in patria hac non fuerit. (Libertas Civitatum, Schmid, *Gesetze*, Anh. XXIII.)

Nottingham. Charter of John. 1200.

Et quicunque burgensium terram vicini sui emerit et possederit per annum integrum et diem unum absque calumpnia parentum vendentis si in Anglia fuerint, postea eam quiete possidebit. (*Rot. Cart.* p. 39.)

Derby. Charter of John. 1204.

The same words as in the charter of Nottingham last cited. (*Rot. Cart.* p. 138 b.)

Northampton. 1199–1215.

In a writ of right for lands in Northampton the tenant pleads that he has held the land for year and day, "et consuetudo ville est quod qui ita tenuerit non ponatur de cetero in placitum inde, et inde profert cartam domini regis per quam confirmat hominibus de Northantona quod nullus ponatur in placito de tenemento quod teneat infra burgum Northantone nisi secundum consuetudinem ville et ipse tenuit per unum annum et unum diem sine clamio quod ipsi apposuerunt." No judgment. (*Placit. Abbrev.* p. 76.)

York. Bracton's Treatise. 1250-60.

Item consuetudo est in comitatu (?) Eborum quod mulier infra annum a die mortis viri sui petere debet dotem suam, alioquin postmodum non audiretur. (f. 309.)

York. 1226.

Action for dower before justices in eyre. The tenant successfully pleads the following custom:—"et consuetudo civitatis est quod non debet ad tale breve respondere nisi calumpnia inde facta fuit infra annum." (Bracton's *Note Book*, pl. 1889.)

Leges Quatuor Burgorum.

Quicunque tenuerit terram suam per unum annum et unum diem quam fideliter emerit per testimonium vicinorum suorum xii in pace et sine calumpnia qui eam calumpniaverit post unum annum et diem et si fuerit in eadem regione et de etate et ipse infra dictum terminum clamium non moverit super hoc nunquam audietur. Sed si fuerit infra etatem vel extra regnum non debet amittere jus suum cum venerit ad etatem vel repatriaverit. (*Acts of Parliament of Scotland*, I. 22, 23.)

Now a rule which we find in London, York, Lincoln, Nottingham, Derby, Newcastle and the four great Scottish boroughs is a very important rule. I have not been able to find it in municipal charters later than those here cited, and I suspect that it went out of use in the course of the thirteenth century, oppressed by the common law. The Assize of Novel Disseisin in Bracton's day protected even untitled possession against extrajudicial force, so there was no great need for giving special protection to possession continued for year and day.

But what did these civic customs protect and what measure of protection did they give? To take the last point first, it seems fairly clear that they were bars not only to self-help but to judicial proceedings; they acted not as interdicts but as statutes of limitation, they conferred a final and not merely a provisional protection. But did they protect untitled possession if continued for year and day or did they merely protect titled possession? The language in which they are stated is unfortunately vague; and we may not assume that the custom was the same in all places. But the Newcastle custom requires that the possessor shall possess "juste," the Lincoln, Nottingham and Derby customs suppose that he has come to his possession by purchase; the Scottish custom supposes that he has come to his possession by purchase duly perfected in the presence of twelve of his neighbours. Having regard to the common law and to the practice prevalent in the boroughs of conveying tenements in the borough courts, we should not, I think, be unwarranted in believing that a conveyance so perfected was or had been a condition requisite to start the term of limitation, the lapse of which would bar all claims adverse to the possessor. In that case the conveyance before the borough court would be the civic counterpart of the fine levied in the king's court.

In this context we may notice that in 1200 the burgesses of Leicester obtained from the king a charter sanctioning conveyances made in their portmanmoot without any reference to year and day:—all purchases and sales of land in the town of Leicester

duly made in the portmanmoot of the said town are to be firm and stable[1]. Probably this did not give a mere licence to the Leicester folk to make their conveyances in court if they chose to do so, but gave to conveyances so perfected a special sanctity. Probably the main object of such a provision was to preclude the claims of expectant heirs. In the Scottish burghs the rule about year and day seems to have been closely connected with the vendor's obligation of first giving an option of purchase to the members of his family before he sought for a buyer outside the family circle[2], and it is certain that in England at the beginning of the thirteenth century it was still very doubtful how far our law would enable the socager to alienate his land to the disherison of his kinsmen. In the process which made the law of Bracton's day so very different from the law of Glanvill's day, the practice of conveying land in court, here by fine, there by surrender, probably played a large part; the desire for freely alienable land found vent in the use of judicial and quasi-judicial modes of conveyance.

Now it would not be an unheard-of thing for very ancient law to go on lurking in the chartered boroughs after it had been improved away from the country at large. The citizens of London, for example, went on purging themselves with oath-helpers in criminal cases long after less privileged persons had been forced to submit to trial by jury. Still in the face of what I

[1] *Rot. Cart.* 32.
[2] *Acts of Parliament of Scotland*, I. 356.

have called the negative evidence it is hard to believe that we have here the scattered fragments of a primitive English usucapio. I say "English," for the clauses that I have cited are so very similar even in their provoking reticence to clauses contained in many contemporary charters of French towns[1] that quite possibly they are of French parentage. It is indubitable that the privileges of French towns were known and envied in the English boroughs, and from France they may have borrowed this "possession annale." Thus the venue of the problem would be changed from England to France.

The problem is one in which three great countries are concerned and is not to be decided off-hand. But so far as regards our common law the English evidence seems decidedly against the supposition of a primitive prescription or usucapio effected by peaceful possession for year and day, and in favour of the supposition that the effectiveness of this brief term had its origin in exercises of jurisdictional power, in the king's ban or the court's ban. The statements that we get of civic customs are, it must be confessed, vaguer than we could wish; and what is said in the *Leges Henrici* is just enough to stimulate our curiosity. An investigation of the prevalence of the custom of conveying land in the borough courts, or of having conveyances registered in the municipal archives might throw much light on the question. At present we may conjecture that originally the only possession that could become ownership by the lapse of year and

[1] Alauzet, *op. cit.* 47; Parieu, *op. cit.* 56.

day was a possession sanctioned by real or fictitious litigation[1].

[1] In this context allusion has sometimes been made to the Welsh laws, a legal literature of very great interest which is crying aloud for a competent expositor. Now in the later versions of these laws we frequently meet with the term of year and day, and this term seems to serve as a term of limitation for claims of many different kinds, in particular for claims arising out of delicts. But, though I am utterly dependent on Mr Owen's translation, it seems to me fairly clear that the undisturbed possession of land for year and day was no bar to proprietary claims. On the contrary for such claims an enormously long time was open. No man holds his land in safety unless his father, grandfather and great-grandfather held it before him, and even then his safety is not perfect; he may have to share the land with a claimant who has yet older rights, for the right of an owner does not become utterly extinct until eight generations of his descendants have passed away. On the other hand we see that when litigated land has been adjudged to a demandant the lapse of year and day has the effect of barring the rights of the family of his vanquished opponent. (See the passages referred to by Mr Owen in his Index under "Year" and "Day," and then see such passages as Cod. Ven., bk. 2. c. 14, Cod. Gwent., bk. 2. c. 30, §§ 10, 11; Miscellaneous Laws, bk. 9. ch. 27, § 18; bk. 14. ch. 23, §§ 2, 3.)

THE INTRODUCTION OF ENGLISH LAW INTO IRELAND[1]

IT is well known that under John and Henry III several ordinances were issued with the object of enforcing English law in Ireland; they are noted in Mr Sweetman's Calendar of Irish Documents. When a change was made in English law a corresponding change was made in Irish law. In searching, however, for early copies of the English *Registrum Brevium*, the register of writs current in the English chancery, I have come across evidence of a measure which seems to have escaped the attention of historians, and yet to have been of considerable importance. Henry III, in 1227, sent over to Ireland a copy of the English register, and ordained that the formulas contained in it should be used in Ireland. A copy of this ordinance is found in the Cottonian MS., Julius D. II, a manuscript which belonged to St Augustine's, Canterbury. It is found on f. 143 b, and runs thus :—

Henricus Dei gracia Rex Anglie, Dominus Hibernie, Dux Normannie et Aquietanie, Comes Andegavie, Archiepiscopis, Episcopis, Abbatibus, Comitibus, Baronibus, Militibus, Libere Tenentibus, et omnibus Ballivis et Fidelibus suis tocius Hibernie salutem. Quum volumus secundum consuetudinem regni nostri Anglie singulis conquerentibus de injuria in regno nostro Hibernie justiciam exhiberi,

[1] *English Historical Review*, July 1889.

formam brevium de cursu quibus id fieri solet presenti scripto duximus inserendam et ad vos transmittendam, ut per ea que ad casus certos et nominatos in scripto isto justicia inter vos per breve et sigillum justiciarii nostri Hibernie teneantur. Teste me ipso apud Cant' decimo die Novembris anno regni nostri xij°, etc.

Upon this there follows a *Registrum Brevium* containing between fifty and sixty writs, beginning with the "writ of right patent." The interest of this is twofold. In the first place we have a solemn and authoritative introduction into Ireland of the English system of procedure. In the second place we have an official copy, or rather a copy of an official copy, of the English Chancery Register of "writs of course (*de cursu*)" from an extremely early date. I say an extremely early date, for at present I have seen no other register so ancient, and know of but two others which can be attributed to Henry III's reign. This would not be the place in which to speak of the importance of so old a formulary in our technical legal history, but the ordinance sending the English writs into Ireland may be of more general interest.

I am in duty bound to add that, to all seeming, Henry III was not at Canterbury on 10 Nov. 1227. He was there on 30 and 31 Oct., but on 5 Nov. he was at Rochester, and from 6 to 11 Nov. he was at Westminster. Also I must add that the ordinance is not on the patent roll or the close roll for the year, nor, as I gather from Mr Sweetman's calendar, on any other extant roll. This fact may be due partly to the length of the registrum which would have filled several membranes of parchment, partly to the fact that there was no good in enrolling formulas already current in

English Law into Ireland 83

the English chancery. As to the date, I can only guess either that the transcriber wrote "decimo" (in letters, not figures) in mistake for some other word[1], or that the copying of the writs took some days, and that the date of the ordinance was left in blank until the registrum was ready for transmission to Ireland. It will be observed that the king was at Canterbury within ten days or a week of the date thus given, and that the document is found in a Canterbury book. I cannot pretend to skill in palaeography, but the handwriting of the part of the Cottonian MS. that is in question seems to me nearly as old as the transaction which it records, while that the register belongs to the early years of Henry's reign is, as I think, very clear indeed from internal evidence.

[1] Possibly the mistake arose from the numeral "1°" being read as "10."—ED. *E. H. R.*

THE SURNAMES OF ENGLISH VILLAGES[1]

One of the great difficulties that has to be met if we attempt to picture to ourselves free village communities upon English soil lies in the fact that the vill or township of historic times has, as such, no court. I say "vill or township," for we have long ago come to use these words as synonyms. Mediaeval Latin was in this respect a more precise language than that which we now use, for it distinguished between the *villa* and the *villata*, between the *town* and the *township*, between the geographical area and the body of inhabitants. I am far from saying that this distinction was always observed, still it was very generally observed: the *villa* is a place, the *villata* a body of men. If a crime takes place in the *villa* of Trumpington, the *villata* of Trumpington ought to apprehend the criminal, and may get into trouble if it fails to perform this duty. Our present use of words which fails to mark this distinction seems due to our having allowed the word *town*, the English equivalent for *villa*, to become appropriated by the larger *villae*, by boroughs and market towns, while no similar restriction has taken place as regards the word *township*. Thus

[1] *The Archæological Review*, Nov. 1889.

Trumpington, we say, is not a town, it is a vill or township, and as nowadays few, if any, legal duties lie upon the inhabitants of a *villa* as such, we use the word *township* chiefly, if not solely, to denote a certain space of land, without even connoting a body of inhabitants with communal rights and duties. It is noticeable that in France also the word *ville*, which formerly was equivalent to our *vill* or *township*, has become equivalent to our *town* in its modern sense. I may add that, as a general rule, the modern "civil parish" may be taken to represent the vill or township of the later middle ages. The story of how it lost its old name and acquired a new one is somewhat complicated, involving the history of the poor-law. But the rough general result is that the old vill is the district now known for governmental purposes as "a civil parish."

But this by the way. Our present point is that the vill or township of historic times, or at least of feudal times, has as such no court. Why we must insert the cautious words "as such" will be obvious. The vill may well be a manor, and the manor will have a court. We may say somewhat more than this, for though in law there is no necessary connection between manor and vill, still in fact we find a close connection. Very often manor and vill are conterminous, and, when this is not the case, the manor is often found to lie within the limits of a single vill. And the further back we go the closer seems the connection, the commoner is it to find that vill and manor coincide. The reason why the connection seems to grow closer as we go backwards is, I take it,

this: that men were free to create new manors for a considerable time after it had become impossible for them to create new vills. The vill had become a governmental district not to be altered save by the central government. But, close though the connection may be, the vill and the manor are, if I may so speak, quantities of different orders. We may even be tempted for a moment to say that the vill is a unit of public law, the manor a unit of private law; the vill belongs to police law, the manor to real property law. But though there would be some truth in such sayings as these, we must reject them. The very essence of all that we call feudalism is a denial of this distinction between public and private law, an assertion that property law is the basis of all law. And turning to the matter now before us, we have only to repeat that the manor has a court, in order to show that the manor cannot be treated as merely an institute of what we should call private law.

Well, the difficulty to which I have alluded is this, that the township or vill has, as such, no court. In all the Anglo-Saxon dooms there seems no trace of the court of the township. The hundred is the lowest unit that has a tribunal; the "township moot," if it exists, is not a tribunal. But it is very hard to conceive a "village community" worthy of the name which has no court of its own. When we look at the village communities, if such we may call them, of the feudal age, when we look at the manors, we see that the court and the jurisdiction therein exercised are the very essence of the whole arrangement. All disputes among the men of the manor about the lands of the

The Surnames of English Villages 87

manor can be determined within the manor. Were this not so the manor would fall to pieces, and when in course of time it ceases to be so the manor becomes insignificant—is no longer in any real sense a community. A village community that cannot do justice between its members is not much of a community; its customs, its by-laws, its mode of agriculture, it cannot enforce; to get them enforced it must appeal to a "not-itself," to the judgment of outsiders, of jealous neighbours who will have little care for its prosperity or for the maintenance of its authority over its members. Our English evidence as to pre-feudal times seems, at least on its surface, to show that "the agricultural community," or township, is no "juridical community," by which I mean that it has no power *jus dicendi*; the hundred is the smallest "juridical community." This is a real difficulty, and it is apparently compelling some of us to believe that the township never was a "free village community"; that from the first the force that kept it together, that gave it its communal character, was the power of a lord over serfs, a power which in course of time took the mitigated form of jurisdiction, but which had its origin in the relation between slave and slave-owner.

Now I cannot but think that some evidence about these things might yet be discovered in that most wonderful of all palimpsests, the map of England, could we but decipher it; and though I can do but very little towards the accomplishment of this end, I may be able to throw out a suggestion (not, it must be confessed, a very new one) which may set more competent inquirers at work. That suggestion, to

put it very briefly, is this: that there may have been a time when township and hundred were identical, or rather—for this would be the better way of putting it—when the hundred, besides being the juridical community, was also an agricultural community. For this purpose I will refer to some evidence which seems to show that the vill of ancient times was often a much larger tract of land than the vill of modern times; that the area belonging to an agricultural community was not unfrequently as large as the area of some of our hundreds.

An English village very commonly has a double name, or, let us say, a name and a surname; it is no mere Stoke, but Stoke d'Abernon, Stoke Mandeville, Bishop's Stoke. These surnames often serve to mark some obvious contrast, as between Great and Little, in the west country between Much and Less, between Upper and Lower, Higher and Nether, Up and Down, Old and New, North and South, East and West; sometimes the character of the soil is indicated, as by Fenny and Dry; sometimes the surname is given by a river, often by the patron saint of the village church. Often, again, it tells us of the rank of the lord who held the vill; King's, Queen's, Prince's, Duke's, Earl's and Sheriff's, Bishop's, Abbot's, Prior's, Monks', Nuns', Friars', Canons', White Ladies', Maids', and their Latin equivalents, serve this purpose. Often, again, we have the lord's family name, d'Abitot, d'Abernon, Beauchamp, Basset, and the like; sometimes it would seem his Christian name, as in Hanley William and Coln Roger. In all this there is nothing worthy of remark, for if a place has started with a name

The Surnames of English Villages 89

so common as Stoke, Stow, Ham, Thorpe, Norton, Sutton, Newton, Charlton, Ashby, or the like, then sooner or later it must acquire some surname in order that it may be distinguished from the other villages of the same name with which the country abounds. It is not to our present purpose to point out that a good deal of history is sometimes involved in a very innocent-looking name; that, for example, the beck which gives its name to Weedon Beck is not in Weedon but in Normandy, still less to dwell on such curiosities as Zeal Monachorum, Ryme Intrinseca, Toller Porcorum, Shudy Camps and Shellow Bowells.

But very often we find two or more contiguous townships bearing the same name and distinguished from each other only by what we call their surnames. Cases in which there are two such townships are in some parts of England so extremely common as to be the rule rather than the exception. If, for example, we look at the map of Essex we everywhere see the words Great and Little serving to distinguish two neighbouring villages. Cases in which the same name is borne by three or more adjacent townships are rarer, but occur in many counties. Thus, in Herefordshire, Bishop's Frome, Castle Frome, Canon's Frome; in Worcestershire, Hill Crome, Earl's Crome, and Crome D'Abitot; in Gloucestershire, Coln Dean, Coln Rogers, Coln St Alwyn's; in Wiltshire, Longbridge Deverill, Hill Deverill, Brixton Deverill, Monkton Deverill, Kingston Deverill, also Winterbourne Dantsey, Winterbourne Gunner, Winterbourne Earls. Two patches of villages in the county of Dorset bear this same name of Winterbourne: in one place we find

Winterbourne Whitchurch, Winterbourne Kingston, Winterbourne Clenston, Winterbourne Stickland, Winterbourne Houghton; in another, Winterbourne Abbots and Winterbourne Steepleton. In the same county is the group of Tarrant Gunville, Tarrant Hinton, Tarrant Launceston, Tarrant Monkton, Tarrant Rawstone. On the border of Berkshire and Hampshire lie Stratfield Mortimer, Stratfield Turgis, and Stratfield Saye. Essex is particularly rich in such groups; close to Layer Marney, Layer de la Hay, and Layer Bretton, are Tolleshunt Knight's, Tolleshunt Major, and Tolleshunt Darcy; in the same county are High Laver, Little Laver, and Magdalen Laver; Theydon Gernon, Theydon Mount, Theydon Bois; also (and this is perhaps the finest example) High Roding, Roding Aythorpe, Leaden Roding, White Roding, Margaret Roding, Abbots' Roding, Roding Beauchamp, and Berners Roding. In Suffolk we find Bradfield St George, Bradfield St Clare, and Bradfield Combust; Fornham St Martin, Fornham All Saints, Fornham St Genevieve; while six neighbouring villages bear the name South Elmham, and can be distinguished from each other only by means of their patron saints.

That, taken in the bulk, these surnames are not primaeval is very obvious. There is no need to point out that many of them cannot have been bestowed by heathens, that they imply a great ecclesiastical organization, with its bishops, abbots, priors, monks, nuns, churches, steeples, crosses, and patron saints, for it is plain enough that many others are not so old as the Norman Conquest. Indeed, many of the family names which have stamped themselves on the map of England

The Surnames of English Villages

do not even take us back to the Conquest: they are the names not of the great counts and barons who followed Duke William and shared the spoil, but of families which rose to greatness on English soil in the service of the King of England; the Bassets, for example, are men who leave their mark far and wide. Ewias Harold and Stoke Edith in Herefordshire seem to tell of very ancient days (D. B., I. 183, 186); but such instances are rare. On the whole the inference that the map suggests is that these surnames of our villages did not become stereotyped before the end of the thirteenth century. And this is borne out by the usage of that time; one spoke then not simply of Weston Mauduit, Maisey Hampton, Eastleach Turville, but of Weston of Robert Mauduit, Hampton of Roger de Meisy, Eastleach of Robert de Tureville; a change of lord might still cause a change of name. The surnames of Prince's Risborough and Collingbourn Ducis can hardly belong even to the thirteenth century.

If now we turn to Domesday Book, not only do we see that many of these surnames are of comparatively recent date, but also we shall begin to suspect that many of our villages cannot trace their pedigrees far beyond the Norman invasion. In general, where two neighbouring modern villages have the same name, Domesday does not treat them as two. Let us look at the very striking case of the various Rodings or Roothings which lie in the Dunmow hundred of Essex. Already six lords have a manor apiece "in Rodinges"; but Domesday has no surnames for these manors: they all lie "in Rodinges." It is so with the

various Tolleshunts in the Thurstable hundred: there are many manors "in Tolleshunta." It is so with the numerous Winterbournes, with the Tarrants, with the Deverills. Now it might be rash to argue that the governmental geography of the Confessor's day treated the whole valley of the Roding as an undivided unit, that the whole of Tolleshunt formed one township, the whole of Deverill another; there may have been many townships as well as many manors "in Rodinges," though they had not yet acquired names, or officially recognised names. In some cases we seem to see the process of fission or subdivision actually at work. Domesday does give us a few surnames, but they are of a curious kind; by far the commonest are "Alia," and "Altera." Thus the two adjacent villages in Huntingdonshire which were afterwards known as Hemingford Abbot's and Hemingford Gray appear as Emingeforde and Emingeforde Alia. So we find Odeford and Odeford Alia, Pantone and Pantone Alia, and so forth. This clumsy nomenclature forcibly suggests that the two Hemingfords were already two, but had not long before been one. People are beginning to allow that Hemingford is not one village, but two villages; as yet, however, they can only indicate this fact by speaking of Hemingford and "the other Hemingford," "Hemingford No. 2."

Now these facts seem to suggest that in a very large number of cases the territory which was once the territory of a single township or cultivating community has, in course of time, perhaps before, perhaps after the Norman Conquest, become the territory of several different townships; or, to put it another way,

The Surnames of English Villages 93

that the township of the later middle ages is by no means always the representative of a primitive settlement, but is, so to speak, one of several coheirs among whom the lands of the ancestor have been partitioned. We need not, of course, believe that the phenomenon has in all cases the same cause. From the first, some of these settlements may have borne double names; a number of settlements along a winter-bourne may have borne the name of the stream, and have been distinguished from each other as the king's town on the winter-bourne, the monk's town on the winter-bourne, and so forth. This may have been so, though Domesday does not countenance any such supposition; but, at any rate, it is difficult to imagine that this is the correct explanation of any large number of instances. We can hardly believe, for example, that six different bodies of settlers sat down side by side, each calling its territory "South-Elm-Ham." The object of giving a name to a district is to distinguish it from other districts, but more especially from such as are in close proximity to it. We can hardly believe that, on a space of ground which had only one name, there had always been two or more different communities, each with its own fields and its own customs.

We thus come to think of the township—or if that term be open to objection, I will say, the lowest nameable geographical unit—of very ancient times as being in many cases much larger than the vill or township of the later middle ages, or our own "civil parish." In many cases we must throw three of these vills together in order to get the smallest area that had a name, and was conceived as a whole. We thus

seem to make the vill approach the size of a hundred. But what is the size of a hundred? This question may well remind us of the story of the witness who referred to "the size of a piece of chalk" as to a known cubic measure. The size of the hundred as it has come down to us may vary from 2 square miles to 300. But it is well known that the large hundreds have, generally speaking, all the appearance of being more modern than the small hundreds. It is to those counties that were the first to be settled by German invaders, to Kent, and Sussex, and Wessex, that we must go for our small hundreds. The Kentish hundred is quite a small place; there are several instances in which it contains but two parishes, and therefore (for I think that this inference may be drawn as regards this part of England) but two vills: indeed, if I mistake not, there is a case in which the hundred contains but one parish, and another in which it contains but part of a single parish. There are many hundreds in the south of England which hold but six, five, four parishes.

Thus, as we look backwards, we seem to see a convergence between the size of the township and the size of the hundred, and even were the convergence between them so slight that they would not meet unless produced to a point which lies beyond the limits of history and beyond the four seas, we shall thus be put upon an inquiry which might lead to good results. It seems, for example, a possible opinion that, though if we take any of our manorial courts and trace back its history, we shall not be able to trace it further than the age of feudalism or of incipient

The Surnames of English Villages

feudalism, shall never find that court existing as a court without a lord, still there may well have been a time when the agricultural community, the community which had common fields, had also a communal court, a court constituted by free men, and a court without a lord, a court represented in later days by the court of a hundred. Into such speculations I cannot venture, but the map of England suggests them[1].

[1] Speculations of this kind are also suggested by Lamprecht's *Deutsches Wirthschaftsleben*, and by Kemble's theory of the "mark." Of course I do not mean that the now existing hundreds of middle and northern England were ever agrarian communities; they may well from the first have been mere administrative and jurisdictional divisions, like our modern county court districts and petty sessional divisions, the model for such divisions having been found in the south of England, where already the hundred had lost its economic unity and become a jurisdictional division containing several townships or agrarian communities.

NORTHUMBRIAN TENURES[1]

In the thirteenth century there might be found in Northumbria—by which name I intend to include our five northernmost counties—certain tenures of land bearing very ancient names; there were still thegns holding in thegnage and drengs holding in drengage. These tenures, though common enough in the north, seem to have given the lawyers at Westminster a great deal of trouble by refusing to fit neatly into that scheme of holdings—frankalmoign, knight's service, serjeanty, socage, villeinage—which was becoming the classical, legal, scheme. Were they military tenures or were they not? They had features akin to those of serjeanty, other features akin to those of socage; nor were there wanting yet other features which according to some generally accepted rules would have been deemed to be marks of villeinage. I propose to collect here a little of what may be learnt about them.

And in the first place let us remark that in Northumbria the duty of military service occasionally appears under a very antique name; it is still "the king's utware." When a man is making a feoffment, it is of course a very common thing that besides reserving some service to be done to himself, he should also stipulate that the

[1] *English Historical Review*, Oct. 1890.

feoffee should discharge the service which the land owes to any overlords that there may be, and in particular the service, usually military service, that it owes to the king. Such a stipulation is, we may say, the medieval equivalent for the clause common in modern leases which throws on the tenant the burden of rates and taxes. So the feoffor stipulates for rent, or it may be for prayers, *pro omni servicio salvo regali servicio*, or *salvo forinseco servicio*; for, as Bracton explains, the service which was due from the tenement to the king while it was in the feoffor's hands is "forinsec service" as between the feoffor and the feoffee; it, so to speak, stands outside and is foreign to the bargain that they are making[1]. On the other hand, the feoffor may undertake that he himself will see to the discharge of this forinsec service. Now in Northumbrian charters, instead of reading about "royal service" or "forinsec service," we frequently read of the king's "utware":— thus one gives land *liberam et quietam ab auxilio et ab omni alia consuetudine excepta uthware quae ad dominum Regem pertinet*[2]—*libere et quiete nominatim a servicio Regis quod dicitur utware*[3]—*et a servicio Regis quod dicitur Wtware*[4]. Sometimes as between feoffor and feoffee it is the one of them, sometimes it is the other of them, who is to be answerable for the "utware." On

[1] Bracton, f. 36: "et ideo forinsecum dici potest quia sit [*corr.* fit] et capitur foris sive extra servitium quod sit [*corr.* fit] domino capitali." Note that a tenant's *dominus capitalis* is his *immediate* lord.

[2] *Rievaulx Cartulary* (Surtees Soc.), p. 215.

[3] *Newminster Cartulary* (Surtees Soc.), p. 19.

[4] *Newminster Cartulary*, pp. 86, 87, 118, 119.

meeting with such clauses our thoughts will at once go back to the well-known fragments of ancient English law, which teach us the rights of the thegn who had five hides to the king's utware, and of the ceorl who was so rich that he had five hides to the king's utware[1]. That this term had once referred to military duty there seems no doubt, and I think that it must have the same meaning in the charters of the twelfth and thirteenth centuries. It is a northern equivalent for *regale servicium* or *forinsecum servicium*, and though these terms were wide enough to cover other services besides military service, though they would for example cover the duty of doing suit to the communal courts, still the pleadings of the thirteenth century constantly put before us scutage as the typical royal and forinsec service, the incidence of which feoffors and feoffees have to settle by their agreements. Even in the fourteenth century the drengage tenants of the bishop of Durham were still nominally liable to do "outward," though whether they well knew what this meant may perhaps be doubted[2].

Another term frequently meets us which demands some explanation since it has become a progenitor of myths, namely, "cornage." Every one knows Littleton's tale about the tenants by cornage in the marches of Scotland, who are bound to wind their horns when they hear that the Scots will enter the realm[3]. Obvi-

[1] Schmid, *Gesetze*, Anh. v. 3; Anh. VII. 2, § 9.
[2] Bp. Hatfield's *Survey* (Surtees Soc.), p. 9: *et facit outeward in episcopatu quantum pertinet ad iiij. partes unius dringagii*; p. 10: *et faciunt oughtward quantum pertinet ad iiij. partes j. dringagii.*
[3] *Tenures*, sec. 156.

Northumbrian Tenures

ously it is an idle tale; one glance at the Boldon Book will teach us that. We cannot suppose that vast masses of men held by this horn-blowing tenure; but they paid cornage. It will be shown hereafter that near two centuries before Littleton's day, the origin of the payment had become obscure, and that the Northumbrians had already invented another fable about it, quite as marvellous as that which Littleton repeated. A passage in the one extant Pipe Roll of Henry I's day will direct our eyes to a more hopeful quarter. The see of Durham is vacant and the custodian of the temporalities accounts to the king for 110*l.* 5*s.* 5*d. de cornagio animalium episcopatus*[1]. A charter of Henry I is pleaded in John's day by which the king gives land which belonged to certain of his drengs to Hildred of Carlisle, "rendering to me yearly the *gablum animalium* as my other free men both French and English who hold of me in chief in Cumberland render it[2]." Often in northern charters we read of *neutegeld et horngeld.* In 1200, Gilbert fitz Roger fitz Reinfred held land in Westmoreland and Kendal by paying 14*l.* 6*s.* 3*d.* per annum of neutegeld. He obtained the king's charter commuting his service into that of one knight[3]. In 1238 a Cumbrian tenant holds by cornage *quod Anglice dicitur horngeld*[4]. Cornage, horngeld, neutgeld, beasts' gafol, must in all probability have originally been a payment of so much per horn, or per head for the beasts which the tenant kept and turned out on the common pasture. But we only

[1] *Pipe Roll*, 31 Hen. I, p. 131.
[2] *Plac. Abbrev.* p. 67. The printed book has *Tablum animalium*.
[3] *Rot. Cart.* p. 50.
[4] Bracton's *Note Book*, pl. 1270.

know it as a fixed sum, a sum which does not vary from year to year; very commonly a township as a whole is liable to pay a lump sum for cornage. Name and thing were known in Normandy also. Delisle gives an instance from 1451: Jean du Merle says that in his land of Briouse he has a right called cornage, that is to say, so much for every beast[1]. A much earlier instance may be found in a charter of 1099 by which Richer de Laigle grants the monks of St Evroul freedom from cornage, passage, and toll[2]. The interest of Littleton's fable does not lie within the fable itself, for that belongs to a very common class of antiquarian legends[3], but in the necessity for it. We only know cornage as a fixed and substantial money rent; as such it appears even in surveys of the fourteenth century; but according to Littleton tenure by cornage is not reckoned as a mode of socage, it is accounted sometimes a tenure by grand serjeanty, sometimes a tenure by knight's service[4]. How can this be?

We turn to the fate of the northern thegns and drengs. Thegns, of course, are to be found in all parts of Domesday Book; but we have special information as to certain thegns who held of the king in the land between the Ribble and the Mersey. Here the thegn is generally described as holding a *manerium*—one of them holds six *maneria*—though the hidage of their

[1] *Études sur la condition de la classe agricole en Normandie*, p. 65.
[2] Appendix to Prevost's edition of *Ordericus Vitalis*, vol. v. p. 195.
[3] See in *Whitby Cartulary* (Surtees Soc.), I. 129, Mr Atkinson's very interesting note about the duty of *horngarth*.
[4] Littleton, *Tenures*, sec. 156.

manors is small. They pay a rent of 2 ores per carucate; "by custom" they, "like the villani," make houses for the king, and fisheries, and inclosures, and buckstalls (*stabilituras*) in the woods, and on one day in August they send their reapers to reap the king's crops; the heir pays forty shillings for his father's land; if one of them wishes to quit the king's land he must pay forty shillings, and may then go where he pleases; the criminal tariff applicable to them is in some respects unusually mild; they attend the shiremoot and the hundredmoot. They seem bound to obey the orders of the serjeant of the hundred when he bids them go upon the king's service—this probably implies military duty—but if they make default they only pay a fine of four shillings. In close contact with these thegns we find a group of "drengs"—a name rare in Domesday Book—they hold a manor apiece, but of their service we have no particulars[1]. The tenure of these Lancashire thegns, if it is continued, will certainly provide a pretty puzzle for lawyers.

Next in the Boldon Book we may read much of the bishop of Durham's drengs. The typical dreng is described as feeding a dog and a horse, going to the bishop's great chase with two greyhounds and five cords, doing suit of court and carrying messages (*sequitur placita et vadit in legationibus*); sometimes he does boon works with all his men[2].

We soon come upon entries which, when read together, are perplexing. In Henry I's time the

[1] Domesday, I. 269 b.
[2] *Ibid.* IV. *e.g.* pp. 574, 580, 581, 583.

guardian of the temporalities of Durham, after accounting for the cornage of beasts and the *donum* of the knights, accounts for what is due *de tainis et dreinnis et smalemannis inter Tinam et Teodam*[1]. Are not the *smalemanni* of Durham the compeers of the *minuti homines* of Yorkshire and other counties? In Henry II's reign an account is rendered of "the aid of the boroughs and vills and drengs and thegns" of Northumberland[2]. Some years earlier the knights and thegns of the same county had joined in a *donum*[3]. Under Richard I the thegns and drengs of Northumberland paid tallage[3]. Under Henry III the thegns of Lancashire paid fifty marks to be quit of the tallage that had been imposed upon them[4]. A mandate of 1205 speaks of the serjeanties, thegnages, and drengages of the honour of Lancaster that have been alienated[5]. In John's reign thegns and drengs of Westmoreland and Northumberland paid fines to save themselves from military service in Normandy[6]; and this was early in the reign, while the law of the land was still respected. But a tenant who is bound to attend the king's banner even in Normandy, and who is subjected to tallage when he is at home, is not he a living contradiction in terms? But what shall we say of a tenant who must pay a fine when his daughter marries, and whose heir will be in ward to the lord? Is not this an amazing confusion of tenures, of the noblest with the basest, of chivalry with servility?

[1] *Pipe Roll*, 31 Hen. I, p. 101.
[2] Madox, *Exch.* I. 130.
[3] *Ibid.* 698.
[4] *Ibid.* 417.
[5] *Rot. Cl.* I. 55.
[6] Madox, *Exch.* I. 659.

Opinion fluctuates. In 1224 a general summons for military service was issued for the siege of Bedford, then occupied by Fawkes of Breauté. The sheriff of Cumberland was forbidden to distrain Richard of Levinton, since he did not hold of the king in chief by military service, but held by cornage only[1]. A few years later we hear of a tenant who holds by cornage, and is bound to follow the king against the Scots, leading the van when the army is advancing, bringing up the rear during its return[2]. This looks like an ancient trait, for at the time of the Conquest there were men on the Welsh march who were bound to a similar service, to occupy the post of honour when the army marched into Wales or out of Wales[3]. Among the documents which have been published under the title *Testa de Neville* are some important entries. One which seems to belong to Edward I's time mentions a number of tenants by cornage in Cumberland, and then adds, "All these tenants by cornage shall go at the king's command in the van of the army in the march to Scotland, and in the rear on its return." Some of them are considerable persons holding entire vills[4]. In Northumberland, we are told, the barony of Hephale was held by thegnage until King John commuted the thegnage into a knight's fee[5]. John's charter we have; the holder of the barony had formerly paid the king fifty shillings *nomine thenagii*[6]. We read of men who hold whole vills in thegnage, and who yet pay merchet

[1] *Rot. Cl.* I. 614.
[2] Bracton's *Note Book*, pl. 1270.
[3] Domesday, I. 179.
[4] *Testa*, pp. 379-381.
[5] *Testa*, p. 393.
[6] *Rot. Cart.* p. 51.

and heriot. Comparing two documents, we find that in the thirteenth century the distinction between thegnage and drengage is but little understood. One John of Halton holds three vills, Halton, Claverworth, and Whittington, in drengage (another account says thegnage), of the king; he pays forty shillings a year, pays merchet and aids, and does all customs belonging to thegnage[1]. Often the Northumbrian tenant in drengage or thegnage pays cornage, and must do *truncage*, i.e. must carry timber to Bamborough castle—a relic, is it not, of that *arcis constructio* which was a member of the *trinoda necessitas*[2]? Sometimes it is distinctly said that his services have not been changed since the days of William the Bastard. In Lancashire, also, there are many men who hold in thegnage; the duties mentioned are the payment of money rents and the finding of one judge (*judicem*), seemingly for the hundred and county courts. In passing, we notice a Lancashire entry about a serjeanty, which consists in blowing a horn before the king when he enters or leaves the county[3]:—are men already beginning to dabble in etymology and to seek an origin for cornage?

By comparing one of the entries with the Hundred

[1] *Testa*, pp. 389, 393.
[2] The *Newminster Cartulary*, p. 269, contains an interesting charter by Edgar, son of Earl Gospatric; he confirms to his sister a gift, made by his father, of land to be held in frankmarriage, *exceptis tribus serviciis, videlicet, communis exercitus in com*[*itatu*] *et cornagio et commune opus castelli in com*[*itatu*]. Here, we may say, is a modern version of the old clause about the *trinoda necessitas*. By a charter of King John the lands of the Abbey of Holmcoltram are freed from "castelwerks"; *Monasticon*, v. 506.
[3] *Testa*, p. 409.

Roll of 1275, we get the result that, in the opinion of some, drengage is free socage. A certain Henry of Millisfen holds Millisfen in chief of the king. One account of his tenure is that he holds in drengage, paying thirty shillings rent, doing *truncage* to Bamborough, paying tallage, cornage, merchet of sixteen shillings, heriot of sixteen shillings, relief of sixteen shillings, and forfeit of sixteen shillings; he ploughs once a year with six ploughs, reaps for three days with three men, owes suit of mill and pannage[1]. Elsewhere his services are described in much the same way, though merchet and heriot are not mentioned, and he is said to hold in free socage[2].

All this is extremely puzzling at Westminster. There the question takes this shape: Shall the lord have wardship and marriage of tenants in drengage and tenants in thegnage? Wardship and marriage have become extremely important things; service in the army by reason of tenure is fast becoming an archaism, for the time for distraint of knighthood and commissions of array is at hand. In 1238-9, it was decided that the wardship of the land of Odard of Wigginton belonged to the king, for Odard held of the king by serjeanty, to wit, that of going to Scotland in the van of the king's army and returning in the rear; "besides, he paid cornage[3]." In or about 1275, the barons of the Exchequer certified that a man, lately dead, held of the king in chief the vill of Little Rihull in Northumberland by a rent of twenty shillings, and a payment of fourteen pence for cornage, and that they

[1] *Testa*, p. 389. [2] *Rot. Hund.* II. 18.
[3] Bracton's *Note Book*, pl. 1270.

could not find that the king had ever had wardship of any of this man's ancestors; but this proved little, for no minority had occurred for some while past. They add, "Of all your tenants in chief by cornage in Cumberland and Westmoreland wardship and marriage are due to you; but we have not yet discovered whether they are due to you of those who hold of you by cornage in Northumberland[1]." Then in 1278 a case, which evidently was regarded as very difficult, came before the justices of the bench, and afterwards before the king's council. Robert de Fenwick held two manors in Northumberland of Otnel de l'Isle *in drengagio*. Agreement was made between them that the service of drengage should be remitted, and that Fenwick should hold of Otnel, rendering an annual rent of one hundred shillings, and doing whatever forinsec service was due from the said manors. The question was whether this tenure gave wardship in chivalry, to which the answer was that it did not. All depended on the nature of the "forinsec service" (if any) that Fenwick had to do. The jurors were asked what this forinsec service was. They replied, cornage and fine of court (*finis curiae*). Questioned as to what they meant by this, they told a wonderful story. Cornage and court fine, said they, are payments made to the king by the suitors of the county, hundred, and baronial courts for the remission of certain royal rights. A sum of fifty pounds a year is paid in respect of cornage (seemingly by some group of suitors, for the payment is a heavy one) to be quit of the following custom, namely, that if a man be impleaded and do not "defend"

[1] *Cal. Geneal.* 501.

(i.e. deny) the plaint word by word he shall be at once convicted. For "fine of court" fifty pounds was paid to the king twice in seven years for freedom from the following custom, namely, that the king's bailiff should come and sit in the baron's court and hear the pleas, and that so soon as the suitors should do anything against the law and custom of the realm, the king's bailiff should amerce them. The case was heard by eight justices and some other members of the council. They held that drengage is *certum servitium et non servitium militare*, also that cornage and fine of court are *certa servitia et non servitium militare*[1]. That the origin of cornage had been forgotten seems pretty plain. About the winding of horns there is no word[2].

The later history of these once common tenures might be an interesting theme. Probably many of them fell into the evergrowing mass of free socage; a few, by aid of the fable of the hornblowers, may have been still regarded as serjeanties, or as military tenures, at a time (and this occurred long before Littleton's day) when the military tenures were no longer military, except in name and in legal tradition. Again, it may be strongly suspected that many of the tenures in drengage went to swell the mass of "customary free-

[1] *Coram Rege Roll*, Pasch. 6 Edw. I, No. 37, m. 14d., No. 38, m. 7; imperfectly reported in *Plac. Abbrev.* p. 194.

[2] In a charter of Gospatric, son of Orm, for Holmcoltram, as given in the *Monasticon*, v. 609, the grantor undertakes to do for the monks *omne forense et terrenum servicium quodcunque ad dominum regem pertinet, scilicet de Noutegeld et Ondemot*. Noutegeld is probably the same as *cornage*; what *ondemot* may be I cannot guess, though it must be a moot of some kind; is it simply the hundred-moot?

holds" which appear in the north of England. In Bishop Hatfield's *Survey*, the tenants *in dringagio* are kept apart from the *libere tenentes* on the one hand, and from the *bondi* on the other. Indeed it might, I believe, be shown that the successors of these thegns and drengs went on doing their military, but not knightly, service in the Tudor age long after a summons of the feudal array had become a mere name. It was thus that in 1577 the council of the North spoke of certain tenants of the dean and chapter of Durham: "The said tenants be bounde by the custome of the countreye, and the orders of the borders of Englande annenst Scotlande to serve her majestie, her heirs and successors at everie tyme, when they be commanded in warrelike manner upon the fronteres or elsewhere in Scotlande by the space of fyftene daies without waiges[1]." And the tenants, who were disputing with their lords whether they had a right to the renewal of their lifehold estates, insisted on this same military feature of their tenure, namely, "serveing the Quene's Majestie and her noble progenitors upon the borders of Skotland at the burneinge of the Beken, or upon comaundment from the Lord Warden with horse and man upon their oune charges, by the space of fiftene daies at every time accordinge to the laudable use and custome of tennant right their used[2]." It looks as if the king's *utware* had outlived knight's service; but these tenants failed in their endeavour to establish a laudable use and custom of tenant right,

[1] *Rolls of the Halmotes of the Prior and Convent of Durham* (Surtees Soc.), p. xxxviii.
[2] *Ibid.* p. xliii.

and seem ultimately to have sunk into the position of mere tenants for life without right of renewal.

However it is rather of early than of late times that I would here speak. In Northumbria we seem to see the new tenure by knight's service, that is by heavy cavalry service, superimposed upon other tenures which have been, and still are in a certain sort, military. In Northumbria there are barons and knights with baronies and knights' fees; but there are also, thegns and drengs holding in thegnage and drengage, doing the king's *utware*, taking the post of honour and of danger when there is fighting to be done against the Scots. But as with the Lancashire thegns of Domesday Book, so with these thegns and drengs of a somewhat later day, military service is not the chief feature of their tenure—in a remote past it may have been no feature of their tenure, rather their duty as men than their duty as tenants—they pay substantial rents, they help the king or their other lord in his ploughing and his reaping, they must ride on his errands. They even make fine when they give their daughters in marriage; they, these holders of whole manors and of whole vills, of whose unfreedom there can be no talk, pay merchet. They puzzle the lawyers because they belong to an old world which has passed away. Perhaps Northumbria is hardly the part of England to which we should have looked for the most abundant relics of this old world; but surely it is only as such that we can explain the thegnage and drengage of the twelfth and thirteenth centuries.

THE HISTORY OF THE REGISTER OF ORIGINAL WRITS[1]

I.

De Natura Brevium, Of the Nature of Writs,—such is the title of more than one well-known text-book of our mediæval law. Legal Remedies, Legal Procedure, these are the all-important topics for the student. These being mastered, a knowledge of substantive law will come of itself. Not the nature of rights, but the nature of writs, must be his theme. The scheme of "original writs" is the very skeleton of the Corpus Juris. So thought our forefathers, and in the universe of our law-books, perhaps in the universe of all books, a unique place may be claimed for the *Registrum Brevium*,—the register of writs current in the English Chancery. It is a book that grew for three centuries and more. We must say that it grew; no other word will describe the process whereby the little book became a big book. In its final form, when it gets into print, it is an organic book; three centuries before, it was an organic book. During these three centuries its size increased twenty-fold, thirty-fold, perhaps fifty-fold; but the new matter has not been just mechanically added to the old, it has been assimilated by the old; old and new became one.

[1] *Harvard Law Review*, Oct. 15, 1889.

It was first printed in Henry VIII's reign by William Rastell. Rastell's volume contained both the Register of Original Writs and the Register of Judicial Writs. The former is dated in 1531; at the end of the latter we find accurate tidings—" Thus endyth thys booke callyd the Register of the wryttes oryggynall and judiciall, pryntyd at London by William Rastell, and finished the xxviii day of September in the yere of our lorde 1531 and in the xxiii yere of the rayne of our soverayn lord kyng Henry the eyght." Whether this book was ever issued just as Rastell printed it I do not know; what I have seen is Rastell's book published with a title-page and tables of contents by R. Tottel, in 1553. In 1595 a new edition was published by Jane Yetsweist, and in 1687 another, which calls itself the fourth, was printed by the assigns of Richard and Edward Atkins, together with an Appendix of other writs in use in the Chancery and Theloall's Digest. In 1595 the publisher made a change in the first writ, substituting " Elizabetha Regina " for " Henricus Octavus Rex"; the publisher of 1687 was not at pains to change Elizabeth into James II. In other respects, so far as I can see from a cursory examination of Rastell's book (which I am not fortunate enough to possess), no changes were made; the editions of 1595 and 1687 are reproductions of the volume printed in 1531, and the correspondence between them is almost exactly, though not quite exactly, a correspondence of page for page.

Coke speaks of the Register as "the ancientist book of the law[1]." In no sense can we make this

[1] Preface to 9 Rep.

saying true. But to ask for its date would be like asking for the date of one of our great cathedrals. In age after age, bishop after bishop has left his mark upon the church; in age after age, chancellor after chancellor has left his mark upon the register. There is work of the twelfth century in it; there is work of the fifteenth century, perhaps of the sixteenth, in it. But even this comparison fails to put before us the full ineptitude of the question, What is the date of this book? No bishop, no architect, however ambitious, could transpose the various parts of the church when once they were built; he could not make the crypt into a triforium; but there was nothing to prevent a reforming chancellor from rearranging the existing writs on a new plan; from taking "Trespass" from the end of the book and thrusting it into the middle. No; to ask for the date of the Register is like asking for the date of English law.

When we take up the book for the first time we may, indeed, be inclined to say that it has no arrangement whatever, or that the principle of arrangement is the principle of pure caprice. But a little examination will convince us that there is more to be said. Every now and again we shall come across clear traces of methodic order, and probably in the end we shall be brought to some classification of the forces which have played upon the book. The following classification may be suggested: (1) Juristic logic; (2) practical convenience; (3) chronology; (4) mechanical chance. Let me explain what I mean. We might expect that the arrangement of such a work would be dictated by formal jurisprudence; we might expect that the main

Register of Original Writs

outlines would be those elementary contrasts of which every system of law must take notice,—real, personal—petitory, possessory—contract, tort. Again, knowing something of the English writs, we might expect to find those which begin with " Præcipe " falling into a class by themselves; or, again, to find that those which direct a summons are kept apart from those which direct an attachment; or, again, to find that writs of " Justicies," *i.e.*, writs directing the sheriff to do justice in the county court, are separated from writs destined to bring the defendant into the king's own courts. Well, in part we may be disappointed; but not altogether: formal jurisprudence has had something to do with the final result, though not so much as might be expected. The printed book begins, and every MS. that I have seen, whether it comes from Henry III's day or Henry VI's, begins with the writ of right. Now, there is logic in this; for whatever actions are "personal," whatever acts are "possessory,"—and different ages hold different opinions about this matter,—there can be no doubt that the action begun by writ of right is "real" and "petitory" or "droiturel." Our Register then begins with the purest type of a real and droiturel action. And the logic of jurisprudence has left other marks, especially near the end of the book, where we find Novel Disseisin, Mort d'Ancestor, Cosinage and Writs of Entry, following each other, in what we shall probably call their "natural order." Still, such logic will not, by any means, explain the whole book. It would be quite safe to defy the student of "general jurisprudence" to

find Trespass, or Covenant, or *Quare Impedit*, by the light of first principles.

Then, again, practical convenience has had its influence. The first twenty-nine folios of the printed Register are taken up by the Writ of Right, and other writs which have generally collected around that writ. Then a new section of the book begins (f. 30–71); it is devoted to writs which the modern jurist would describe as being of the most divers natures; but they all have this in common, that in some way or another they deal with ecclesiastical affairs and the clerical organization. The link between this group and that which it immediately succeeds is (f. 29 b) the Writ of Right of Advowson. It is a Writ of Right; but having once come across the advowson it is convenient to dispose of this matter once and for all, to introduce the Assize of Darrein Presentment, which is thus torn away from the other possessory assizes, the *Quare Impedit*, the *Quare Incumbravit*, the *Juris Utrum*, and so forth. This brings us into contact, if not conflict, with the church courts; so let us treat of Prohibitions to Court Christian, whether these relate to advowsons, land, or chattels, and while we are about it we may as well introduce the *De excommunicato capiendo*, and so forth; then we shall have done with ecclesiastical affairs. Here, to use the terms that I have ventured to suggest, we see "practical convenience" getting the better of "juristic logic"; or, to put it in other words, matter triumphing over form. But form's turn comes again. We have done with the church; what topic should we turn to next? The answer is, "Waste." But why waste, of all topics

in the world? Because, until the making of a certain statute, duly noticed in our Register, the action of waste was an action on a royal prohibition against waste[1]. "Prohibition" is the link which joins "waste" to "ecclesiastical affairs."

Yet another principle has been at work. A section in the middle of the book is devoted to *Brevia de Statuto*, writs that are founded on comparatively modern statutes. What keeps this group of writs together is neither "form" nor "matter," but chronology; they are recent writs, for which neither logic nor convenience has found a more appropriate place. In short, we have here an appendix. But it is an appendix in the middle of the book. We can hardly explain its appearance there without glancing at the MSS.; but even without going so far we can still make a guess. When these statutory writs have been disposed of, we almost immediately (f. 196b) come upon what seems a well-marked chasm. Suddenly the Novel Disseisin is introduced, and then for a long while logic reigns, and we work our way through the possessory actions. If we find, as we may find, a MS. which has several blank leaves before the Novel Disseisin, which honours the Novel Disseisin with an unusual display of the illuminator's art, we have made some way towards a solution of the problem. At one time the book was in mechanically separate sections, and the end of one of these sections was a convenient place for a statutory appendix.

After all, however, it is improbable that we shall ever be able to explain in every case why a particular

[1] Stat. Westm. II., c. 14.

writ is found where it is found, and not elsewhere. The *vis inertiæ* must be taken into account. Writs collected in the Chancery; now and again an enterprising Chancellor or Master might overhaul the Register, have it recopied, and in some small degree rearranged; but the spirit of a great official establishment, with plenty of routine work, is the spirit of leaving alone; the clerks knew where to find the writs; that was enough.

The MS. materials for the history of the Register are abundant. The Cambridge University Library possesses at least nineteen Registers, some complete, some fragmentary; the number at the British Museum is very large. Over the nineteen Cambridge Registers I have cast my eyes. They are of the most various dates. In speaking about their dates it is necessary to draw some distinctions. In the first place, of course, it is necessary to distinguish between the date of the MS. and the date of the Register that it contains, for sometimes it is plain that a comparatively modern hand has copied an ancient Register. In the second place, as already said, it is useless to ask the date of a Register, or of a particular Register, if thereby we mean to inquire for the date when the several writs contained in it were first issued, or first became current; the various writs were invented in different reigns, in different centuries. The sense that we must give to our inquiry is this: at some time or another the official Register of the Chancery was represented by the MS. now before us; what was that time? It will be seen, however, that the question in this form implies an assumption which we may not be entitled to make,—the assumption that our MS.

fairly represents what at some particular moment of time was the official Chancery Register. I have as yet seen no MS. which on its face purported to be an official MS., or a MS. which belonged to the Chancellor or any of his subordinates. In very many cases the copy of the Register is bound up in a collection of statutes and treatises, the property of some lawyer or of some religious house. Often an abbey or priory had one big volume of English law, and in such volumes it is common to find a *Registrum Brevium*. Such volumes were lent by lawyer to lawyer, by abbey to abbey, for the purpose of being copied, and it is clear that a copyist did not always conceive himself bound to reproduce with mechanical fidelity the work that lay upon his desk. Thus, many clerks are quite content that the names of imaginary plaintiffs and defendants should be represented by A and B, while another will make "John Beneyt" a party to every action, and suppose that all litigation relates to tenements at Knaresborough. We have not to deal with the dull uniformity of printed books; no two MSS. are exactly alike; every copyist puts something of himself into his work, even if it be only his own stupidity. Thus, settling dates is a difficult task. Sometimes, for example, a MS. which gives the Register in what, taken as a whole, seems a comparatively ancient form, will just at a few places betray a knowledge of comparatively modern statutes. Gradually, however, by comparing many MSS., we may be able to form some notion of the order in which, and the times at which, the various writs became recognized members of the *Corpus Brevium*.

It will be convenient to mention here that one of the most obvious tests of the age of a Register is to be found in the wording of those writs which expressly mention a term of limitation. There are three such writs; namely, the Novel Disseisin, the Mort d'Ancestor, and the *De nativo habendo*. Now, at the beginning of Henry III's reign (1216), the limiting period for the Novel Disseisin seems to have been the last return of King John from Ireland, but in 1229, or thereabouts, there was a change, and Henry's first coronation at Westminster became the appointed date[1]; the Mort d'Ancestor was limited to the time which had elapsed since Richard's coronation. The Statute of Merton (1236), or rather, as I think, an ordinance of 5th Feb., 1237, fixed Henry's voyage into Brittany as the period for the Novel Disseisin, and John's last return from Ireland as the period for the Mort d'Ancestor and *De Nativo*[2]. Statute of Westminster the First (1275, cap. 39) named for the Novel Disseisin Henry's first voyage into Gascony, for the Mort d'Ancestor and for the *De Nativo* Henry's coronation[3]. As no further change was made until Henry VIII's day, this test is

[1] This change I infer from the cases in Bracton's *Note Book*. On 18 July, 1222, a writ was sent to Ireland, fixing Richard's death as the period for the Mort d'Ancestor, in order to assimilate Irish to English law. See Sweetman's *Calendar of Irish Documents*, vol. I., p. 160.

[2] Bracton's *Note Book*, vol. I., p. 106; vol. III., p. 230. Compare the Irish writ given in *Statutes of the Realm*, I., p. 4. The Statute of Merton in its printed form mentions not Brittany, but Gascony.

[3] As regards the Novel Disseisin the change, if any, was but nominal; the first "voyage into Gascony" of the Statute of 1275 was "the voyage to Brittany" of the ordinance of 1237. In 1230 Henry went to Brittany, and thence to Gascony.

Register of Original Writs

applicable only to the very earliest Registers. For Registers of the fourteenth century, however, we can use a somewhat similar criterion; when they mention Henry III, as they call him *pater noster*, or *avus*, or *proavus noster*. But, good though such tests may be, they are by no means infallible. A man copying an already ancient Register might well be tempted to tamper with phrases that were obviously obsolete; and, again, we shall have cause to doubt whether even in the Chancery itself a new statute of limitations always sets the clerks on promptly overhauling their ancient books and making the necessary corrections; great is the force of official laziness. Still, these writs which mention periods of limitation are the parts of the Register which first attract the critic's eye.

But there is yet another difficulty. Are we justified in assuming that there always, or ever, was in the Chancery, some one document which bore the stamp of authority, and which was *the* Register for the time being? I doubt it. The absolutely accurate officialism to which we are accustomed in our own day is, to a large extent, the product of the printing press. The cursitors and masters of the mediæval Chancery had no printed books of precedents. It is highly probable that each of them had his MS. books; that these books were transmitted from master to master, from cursitor to cursitor, and that they differed much from each other in details[1]. To have prevented them from differing would have been a laborious and a

[1] The "Cursitores," or "Clerici de cursu," were the clerks who issued the writs of course. The name of Cursitor street still marks the site of their ancient home. As to their duties, see *Fleta*, p. 78.

needless task. This thought will be brought home to us by several passages in the printed book. In the first place, it is full of notes and queries: the writer expresses his doubts as to the best way of formulating this or that writ; he tells us what some think, what others think, what some do, and what others do; occasionally he speaks to us in the first person, says *credo* and *je croye*, and even points out that this Register differs from other registers[1]. It is in this way that we may explain the somewhat capricious selection of writs that the printed book presents. It naturally includes all the common forms that are in daily use; but it includes also many forms of a highly specialized kind,— forms which set forth the facts of cases which have happened once, but are by no means likely to happen

[1] Thus, f. 3 b, "quaere comment le brief serra fait ou si le brief gyst"; f. 6 b, "quibusdam videtur quod debeat scribi in istis brevibus etc."; f. 9, "sapientes et jurisperiti dicunt"; f. 10 b, "secundum quosdam...sed alii dicunt"; f. 16, "et est contra registrum"; f. 27 b, "secundum quosdam fiant duo brevia"; f. 29 b, "secundum quosdam"; f. 97 b, "Nota quod non debet dici in brevi predicto *specialem auctoritatem ad hoc habentium* prout in quibusdam registris invenitur"; f. 108 b, "Nota per Thomam de Newenham; tamen alii clerici de cursu contradicunt"; f. 120 b, "Tamen quaere ... per plusors sages dit est"; f. 121 b, "Les Maistres de la Chancerie ne voudrient agreer a cest clause"; f. 133, "Nota quidam addunt in istis tribus brevibus, etc."; f. 134 b, "Vide de breve Statutum W. 2. c. 14 pro ista materia quia hic male reportatur"; f. 183 b, "Nota secundum quosdam...et ideo quaere inde"; f. 172 b, "Je croye que son brief nest pas le pire"; f. 184 b, "Credo quod istud breve vacat"; f. 200, "Ascuns gents dirent—"; f. 208 b, "In breve de post disseisina non dicatur *tam de illis*, etc., secundum Escrick"; f. 243 b, "Mes le brief...est le meillour come cest register voet"; f. 269, "Ista clausula...non continetur in statuto sed additur per quosdam jurisperitos."

Register of Original Writs

again. The Chancery undoubtedly had some power in itself to devise such "writs upon the special case"; not unfrequently it was ordered to make a writ suited to the very peculiar circumstances of a case which had been brought before the Council, or before the Parliament, just because none of the common writs would meet it[1]. Of such "*brevia formata*" we get a selection, but only a selection. Some are preserved because they will be useful as precedents, others, as it seems to me, because they are curiosities and not likely to form precedents[2]. In many quarters we see more signs of private enterprise than of official redaction. A considerable number of specially worded writs bear the name of Parning,— a number out of all proportion to the brief two years during which that famous common lawyer held the great seal. He had the good fortune, we may suppose, to have some industrious clerk for an admirer; his predecessors and successors were less lucky[3]. I greatly

[1] The necessity for specialized writs is often noticed in the endorsements on petitions to Parliament; *e.g.*, in those of 14 Edw. II, Ryley's *Placita*, p. 408, "Habeat breve novæ disseisinæ in suo casu"; p. 409, "Adeat Cancellarium et habeat ibi breve in suo casu"; p. 412, "Habeat breve de conspiratione formata [conformatum] in suo casu"; p. 423, "Habeat breve de conspiratione in Cancellaria in casu suo formandum"; p. 421, "Habeant brevia suis casibus conveniencia." So in the Register we find writs issued by order of the Council; *e.g.*, f. 64, "per consilium"; f. 114, a writ founded on a Parliamentary petition; f. 124, "per consilium"; f. 125, "per consilium."

[2] F. 64 b, "Istud attachiamentum est notabile valde"; f. 224, "Nota quod istud breve sigillatum fuit et quassabille ut dicebatur pro veritate."

[3] Parning appears on f. 13 b, 16 b, 35, 69, 99 b, 100 b, 132, 136; in some other cases, though he is not named, we can tell, from the

doubt, then, whether we have in strictness a right to speak about *the* Register of a given period, as though there were some one document exclusively or preëminently entitled to that name; rather we should think of *the* Register as a type to which diverse registers belonging to diverse masters and clerks more or less accurately conformed. About common matters these manuscripts agreed; about rarities and curiosities there was difference, and room for difference. There was no great need for a perfectly stereotyped uniformity; the fact that a writ was penned, and that it passed the seal, was not a fact that altered rights or secured the plaintiff a remedy; it still had to run the gauntlet in court, and might ultimately be quashed as unprecedented and unlawful. It is clear, indeed, that the granting of specially worded writs was regarded as an important matter, which required grave counsel and consideration; the masters were consulted as a body; sometimes it would seem as though the opinion of the justices was taken before the writ issued[1]. A chancellor, a master,

date of the writ, that it belongs to his chancellorship. He is the only Chancellor that appears prominently. A certain Herleston appears in three places, f. 49, 80 b, 261; f. 261, "Hoc breve concessum fuit...per cancellarium Lescrop et W. de Herleston,"— *i.e.* (as I understand it) this writ was granted by the Chancellor, G. le Scrope, the Chief Justice, and W. de Herleston; the date of this writ seems to be 19 Edward III. Herleston was a Master in Chancery under Edward III. So, again, one Thomas of Newenham gets mentioned as a maker of writs; he seems to have been a Master under Edward III and Richard II; apparently we owe to him a writ against a vendor of a blind horse, who warranted it sound; see f. 108, 108 b, 151 b.

[1] *Reg. Brev. Orig.*, f. 78 b, "Et les maistres W. de Aym. [Ayremine, Master of the Rolls?] et autres" expressed an opinion

Register of Original Writs 123

even a cursitor, cannot have liked to see his writs quashed; and, though writs were quashed very freely, as the Year Books witness, still, if I mistake not, it will be found that in most cases the fault lay rather with the plaintiff or his advisers than with the Chancery; he had got an inappropriate writ, but not one that was in any respect contrary to law. Any notion that the Chancery was a Romanizing institution, that the learning of the masters was the learning of civilians, is rudely repelled by the Register. Whatever academic training in Roman and canon law the masters may have had, they were English lawyers daily engaged in watching the development of English law in English courts, in reading the Year Books, and in "writing up" decisions in the margins of their Registers. Still, to return to my point, the granting of a newly worded writ was no judicial act; to grant one which could not be maintained was no act of justice; it might be a very proper experiment.

The Register of which I am speaking is the Register of Original Writs. The printed book contains also a Register of Judicial Writs. The difference between Original Writs and Judicial Writs is generally known. Roughly speaking we may put it thus: An original writ is a writ whereby litigation is commenced; its type

about a writ which does not commend itself to the annotator; f. 121 b, "Les Maistres de la Chancerie ne voudrient agreer a cest clause"; f. 131 b, "Ceux brefs furent enseales per tants les sages de la chancerie, per assent des serjeants le Roy et autres sages asses" [Nota quod hoc verbum *asses* non est verbum Anglicum sed verbum Franciscum]; f. 200, "Istud breve fuit concessum de assensu W[illelmi] de T[horpe] capitalis justiciarii et aliorum justiciorum de banco et clericorum de cancellaria."

is a common writ of trespass or debt, whereby the sheriff is directed to compel the defendant to appear in court and answer the plaintiff; on the other hand, a judicial writ is a writ issued during the course of an action, either before or after judgment; thus, the re-summons of one already summoned, a *venire facias* for jurors, a *fieri facias*, an *elegit*,—these may be taken as types of judicial writs. But, in strictness, we are hardly entitled to bring into our definitions any particularization of the character of the writs. The technical distinction seems to have been a simpler one: the original writ issues out of the Chancery, the judicial issues out of a Court of Law; we can say no more. It sometimes happens that the same writ can be obtained in the Chancery or in the Common Pleas; in term time one gets it from the court, in vacation one goes to the Chancery; such a writ will, therefore, have its place in both Registers, the Original and the Judicial[1]. And very many of the documents which find a place in the former cannot be described as writs originating litigation; they relate to litigation that has been already begun. A tenant in an action begun by writ of right puts himself on the grand assize while yet the action is in the court baron or county court; the writ summoning the electors of the grand assize will issue out of the Chancery, and we must look for it in the Register of Original Writs. The same Register contains numerous writs evoking litigation from the local courts,—writs of *pone, certiorari, recordari facias,* and so forth. But, further, the fully developed *Registrum Brevium Originalium* contains great masses of

[1] *Reg. Brev. Orig.*, f. 32, 69 b.

documents which neither originate nor evoke litigation,— pardons, protections, safe-conducts, licenses to elect bishops and abbots, orders for the election of coroners and verderers, letters whereby the king presents a clerk, fiscal writs addressed to the Barons of the Exchequer, writs to escheators, and so forth, in rich abundance; even letters to foreign princes, begging them to do justice to Englishmen, find a place in the collection[1]. Many of these formulas, it may be, were never known as *brevia originalia*, and some were not *brevia* at all; still, it would be very difficult to say where the original writs left off, for a great deal of what we might call fiscal and administrative work was done under quasi-judicial forms, and by the use of quasi-judicial machinery. The Exchequer, according to our ideas, was half law court and half financial bureau. The collection of the revenue, the management of the king's demenses and feudal rights, were carried on by means of writs, inquests, verdicts, very similar to those which determined the rights of litigants. And happy it may be for us that no stricter separation was made between ordinary law and administrative law. Our present point, however, must be merely that all this great mass of miscellaneous matter is collected into the Register of Original Writs, and thus gets mixed up with the formulas of ordinary litigation. The later the MS. of the Register the larger is the proportion which the administrative documents bear to the writs which originate or evoke litigation, and, as we shall see hereafter, the general scheme of the book had become fixed at a time when it was still chiefly made up of writs sub-

[1] *Reg. Brev. Orig.*, f. 129.

serving the process of litigation between subject and subject.

These things premised, it may be allowed me to make a few remarks about the early history of the Register.

It is highly probable that so soon as our kings began to interfere habitually with the ordinary course of justice in the communal and feudal courts, and by means of writs to draw matters into their own court, the clerks of the chancery began to collect precedents of such writs, and it well may be that some of the formulas that they used were already of high antiquity[1]. But the careful reader of Mr Bigelow's *Placita* will, as I think, be led to doubt whether before the reign of Henry II there was anything that could fairly be called a *Registrum Brevium*, and the student of Maddox's Exchequer will be inclined to hold that there were no writs that could be obtained "as of course" (*de cursu*) by application to subordinate officials. Nothing was to be had for nothing; the price of writs was not fixed, and every writ was, in the terms of a later age, "a writ upon the special case." Before the end of Henry's reign there had been a great change, though the practice of selling royal aid (theoretically it was rather "aid" than "justice" that was sold) was by no means at an end. Already when Glanvill wrote there were many writs drawn up "in common form"; so drawn up, that is, as to cover whole classes of disputes. Let us follow him in his treatment of them. Not impossibly he took them up in the order in which they

[1] Brunner, *Entstehung der Schwurgerichte*, p. 78, compares the *breve de recto* with the Frankish *indiculus communitorius*.

occurred in an already extant Chancery Register, and, as we shall see hereafter, the arrangement of the Register in much later times conforms, as regards some of its main outlines, to the arrangement of Glanvill's treatise.

In his first book he begins (cap. 6) with the *Præcipe quod reddat* for land, which he treats as the normal commencement of a petitory action. In the second book we have (cap. 8, 9) the writs of peace granted when a tenant has put himself on the grand assize; then (cap. 11) the writ summoning the electors of the grand assize, and (cap. 15) the writ summoning the recognitors. The third book, on warranty, does not give us any "original" writ. In the fourth book (cap. 2) occurs the Writ of Right of Advowson, the Writ (cap. 8) *Quo advocato se tenet in ecclesia*; a Prohibition (cap. 13) to ecclesiastical judges against meddling with a cause touching an advowson, and (cap. 14) a summons on breach of such a Prohibition. The fifth book, on serfage, gives us (cap. 2) the *De libertate probanda*. The sixth book turns to dower, and contains (cap. 5) the Writ of Right of Dower, a writ of *Pone* (cap. 7) for removing the case from the county court, the Writ (cap. 15) of Dower *unde nihil habet*, and the Writ (cap. 18) of Admeasurement of Dower. The seventh book, on inheritance or succession, has (cap. 7) the Writ *Quod stare facias rationalem divisam*, and (cap. 14) the writ to the Bishop, directing an inquiry into bastardy. In the eighth book comes (cap. 4) the Writ *de fine tenendo*, and several writs (cap. 6, 7, 10), *Quod recordari facias*, "evocatory writs" we may call them. In the ninth we have (cap. 5) the Writ *De*

homagio capiendo, the Writ of Customs and Services (cap. 9), a writ against a tenant who has encroached upon his lord (cap. 12), and the Writ *De rationalibus divisis* (cap. 14). The tenth book gives us the Writ of Debt (cap. 2), the Writ *De plegio acquietando* (cap. 4), a writ for a mortgage creditor calling on the debtor to pay (cap. 7), a writ calling on the mortgagee to render up the land (cap. 9), a writ calling in the warrantor of a chattel (cap. 16). From the eleventh book we gather only a writ announcing the appointment of an attorney. In the twelfth book we come to the Writs of Rights, strictly so called (*brevia de recto tenendo*), and a number of writs empowering the sheriff to do justice; namely, the *Ne injuste vexes* (cap. 10), the *De nativo habendo* (cap. 11), a Writ of Replevin (cap. 12, 15), a Writ of Admeasurement of Pasture (cap. 13), a *Quod permittat* for easements (cap. 14), a Writ *De rationalibus divisis* (cap. 16), a Writ *Quod facias tenere divisam* (cap. 17), a Writ of *Justicies* for the return of chattels unlawfully taken by a disseisor, and a few other miscellaneous writs, including a Prohibition to Court Christian against meddling with lay fee. In the thirteenth book come the possessory assizes. The fifteenth gives a hasty sketch of criminal business.

Glanvill's scheme of the law, or rather his scheme of royal justice, might, as it seems to me, be displayed by some such string of catchwords as the following: " Right " (*i.e.*, proprietary right in land), " Church," " Liberty," " Dower," " Inheritance " or " Succession," " Actions on Fines," " Lord and Tenant," " Debt," " Attorney," " Justice to be done by feudal lords and sheriffs," " Possession," " Crime." Now, some of the

main lines of this "*legalis ordo*," if I may use that term, keep constantly reappearing in the later history of the Register. At all events, two poles are fixed, —the *terminus a quo*, the *terminus ad quem*; we are to begin with "Right"; to end with "Possession." The reappearance of this scheme in the Register of later days is the more remarkable, because Bracton did not adopt it; as is well known, he begins with "Possession," and ends with "Right." We may make a further remark, which will be of use to us hereafter. Glanvill's twelfth book is most miscellaneous, and at one point resolves itself into a string of writs, which are given without note or comment. The idea which keeps the book together is that of justice done, not by the King's court, but by lords and sheriffs, in pursuance of royal writs. Such a tie is likely to be broken in course of time. Thus, the "Writ of Right Patent," the writ commanding a lord to entertain a proprietary action, is likely to find its proper place by the side of the *Præcipe quod reddat*, especially when Magna Charta has sanctioned the rule that a *Præcipe* is only to be issued when the tenant holds immediately of the king[1]. And so, again, the writs commanding the sheriff to do justice, writs of "*Justicies*," or "*Justifices*," will hardly be kept together by this bond; but in course of time,

[1] Originally a Writ of Right is so called, because it orders the feudal lord to do full right to the demandant, *plenum rectum tenere*; and in this sense, the *Præcipe quod reddat* is no Writ of Right. But when possessory actions have been established in the King's court, "right" is contrasted with "seisin," and all writs originating proprietary actions for land, including the *Præcipe in capite*, come to be known as Writs of Right. This has been remarked by Brunner, *Schwurgerichte*, p. 411.

as the king's own court extends, its sphere will fall into various subordinate places; thus, for example, " Debt by Justices in the county court" will become an appendix or a preface to " Debt in the Bench."

The arrangement of Glanvill's book is, however, sufficiently well known, and therefore, without further reflection upon it, I will pass on to describe the earliest *Registrum Brevium* that I have seen. Happily it is one to which we can affix a precise date, namely, the 10th of November, 1227. It is found in a MS. at the British Museum (Cotton, Julius D., II, f. 143 b),—a book that once belonged to the monks of St Augustine's, Canterbury. It forms a schedule annexed to a writ of Henry III, bearing the date just given, and directed to the people of Ireland. That writ recites that the king desires that justice be done in Ireland according to the custom of his realm of England, and states that for this purpose he is sending a formulary of the writs of course (*formam brevium de cursu*), and wills that they be used in the cases to which they are applicable. The writ was issued at Canterbury, and to this fact we probably owe its lucky preservation in a Canterbury book. The Register that it gives is about forty years younger than Glanvill's treatise, and affords the means of measuring the growth of law during an important period,—the period of the Great Charter. I will briefly describe its contents.

It begins with three Writs of Right (1, 2, 3), and we learn that these writs can only be had "*sine dono*"; that is, without payment, when the land demanded is but half a knight's fee or less, or the service due from it does not exceed 100 shillings, or, being a burgage

Register of Original Writs

tenement, the rent or the value of the buildings does not exceed 40 shillings a year. Then follows (4) the *Præcipe in capite*. Then (5) the *Novel Disseisin*, the period of limitation being stated as "*post ultimam transfretacionem nostram de Hibernia in Angliam*[1]"; and as an appendix to this we have (6) the Novel Disseisin of Common, and (7) the Assize of Nuisance, with variations. Next comes (8) the Mort d'Ancestor; the period of limitation is said to be *postquam coronacionem H. patris nostri*[2]. Then come (9) the assize of Darrein Presentment, (10) Prohibition to the bishop against admitting a parson, (11) Writ ordering a bishop to disencumber the church when he has admitted a parson contrary to such Prohibition, (12) Mandamus to a bishop to admit a presentee, (13) Writ of Right of Advowson, (14) Prohibition to ecclesiastical judges, (15) Writ against ecclesiastical judges who have disobeyed the Prohibition. This ecclesiastical group being finished, we find next (16) the Writ of Peace for a tenant who has put himself on the grand assize, and (17) a writ for the election of the grand assize. And here we have an interesting note: "*Et notandum quod in hac assisa non ponuntur nisi milites et debent jurare*

[1] This must be a blunder; it should have been "post ultimam transfretacionem patris nostri de Hibernia in Angliam."

[2] Here again there must have been some carelessness. The date referred to is the coronation of Henry II, the present king's grandfather. The mistake would seem to be due not to the monastic copyist, but to the Chancery clerk who drew up the document sent to Ireland, and was not careful to change into "avi" the "patris" which stood in a formula of John's reign, from which he was copying. See Sweetman's *Calendar of Irish Documents*, pp. 37, 160.

precise quod veritatem dicent non audito illo verbo quod in aliis recognitionibus dicitur scilicet a se nescienter." Unless I am traducing the copyist, something must have gone wrong with these last words. They were French, but he took them for Latin. In the grand assize the recognitor must swear, in an unqualified way, that he will tell the truth; while in all other recognitions he may add "a son ascient"; that is, "according to his knowledge." A small group of writs relating to dower (18, 19, 20) come next. Then follows (21) the *Juris Utrum*, which, it is remarked, lies either for the clerk or for the layman[1]. Next (22) comes the Attaint which can be brought against recognitors of Novel Disseisin, Mort d'Ancestor, Darrein Presentment, but not against the recognitors of the Grand Assize. Then (23) we have an action on a fine, "*Præcipe A. quod teneat finem,*" and (24) the action of *Warrantia Cartæ*. Writs of Entry are represented by but two specimens: the first is (25) Entry *ad terminum qui præteriit*, the second (26) is *Cui in vita*. Then we find (27) *quod capiat homagium*, (28) writs for sending knights to view an essoinee, and (29) to hear a sick man appoint an attorney. On these follow (30) the *De nativo habendo*, (31) the *De libertate probanda*, (32) the *De rationabilibus divisis*, and (33) the *De superoneracione pasturæ*. We pass to criminal matters, and get (34) the writ to attach an appellee to answer for robbery, rape, or arson, with a note that in case of homicide the appellee is to be attached, not by gage and pledge,

[1] This was a moot point in Bracton's day. Pateshull allowed the laymen the assize, but afterwards changed his mind. Bracton thinks this a change for the worse. Bract., f. 285 b.

Register of Original Writs 133

but by his body; as a sequel to this comes (35) the *De homine replegiando*. We return to civil matters, and find (36) the Writ of Services and Customs, and (37) the *Ne injuste vexes*. Then comes (38) Debt and Detinue. The only writ that falls under this head is a *Justicies*, and not, like Glanvill's Writ of Debt, a *Præcipe*; and there is this further difference, that the remarkable words, "*et unde queritur quod ipse ei injuste deforciat*," which occur in Glanvill's writ, and make it look so very like a Writ of Right, have disappeared. The supposed debt in the Irish Register is one of 20 shillings, and we have this important note: "In the same fashion a writ is made for a charter, '*quam ei commisit*,' or for a horse or for chattels to the value of 40 shillings, '*sine dono*' [*i.e.*, without any payment to the king], for if the debt or price exceeds 40 shillings the words must be added: '*accepta ab eo* [the plaintiff] *securitate de tercia parte de primis denariis ad opus Regis.*'" In Ireland, at all events, the king will only become a collector of debts for the modest commission of 33⅓ per cent.

To this succeeds (39) a Prohibition to ecclesiastical judges against dealing with lay fee, and (40) a writ to compel them to answer for breach of such a prohibition. Next occurs (41) a writ directing the sheriff not to suffer an infant to be impleaded, and (42) a *Recordari facias* applicable to a case in which a tenant has vouched an infant. Then we have (43) a *Justicies de plegio acquietando* for a debt of forty shillings or less; "*non habebit ultra xl. sol. sine dono.*" Then comes (44) a writ forbidding the sheriff to distrain R., or permit him to be distrained, to render ten marks to N., for which he is neither principal debtor, nor pledge; but "this writ does

not run in privileged cities, or where the debtor is the king's debtor." Another writ (45) forbids the sheriff to distrain R. for money promised to the king "for right or record," *i.e.* for money promised in consideration of the king's aid in litigation, if, without his own default, he has not got what he stipulated for. Another writ (46) forbids the sheriff to distrain a surety when the principal debtor can pay; but this writ is not to be issued when the debt is one that is due to the king. Then (47) comes a writ of Mesne by way of *Justicies*, and (48) the *De excommunicato capiendo*. Upon this follows (49) covenant "*si quis conventionem fecerit alibi quam in curia domini Regis cum vicino suo qui eam infringere voluerit de aliqua terra vel tenemento ad terminum si exitus illius tenementi non excesserint per annum xl. solidos*"; the writ is a *Justicies* "*quod teneat conventionem.*" We have then (50) a Writ of Dower, and (51) a Writ of Waste against a dowager. Miscellaneous writs follow: (52) a *Venire facias* for an assize; (53) a *Pone ad peticionem petentis*; (54) a summons for a warrantor; (55) a writ to inquire of the bishop touching the marriage of a woman claiming dower; (56) a writ directing a view of the land demanded.

So ends the Irish Register, an important document. It brings out very forcibly the king's position as a vendor of justice, or rather, as we have said, of "aid." We must, as it seems to me, believe, until the contrary be shown, that we have here a fairly correct representation of the writs that were current in England in 1227; the writs that were "of course" and to be had at fixed prices; but some may have been omitted as inapplicable to Ireland.

Register of Original Writs 135

Before making further comments, let us turn to an English *Registrum*, which, so far as I can judge, must be of very nearly the same date as this Irish *Registrum*. It is found in a Cambridge MS. (Ii. vi. 13), and may, I think, be safely ascribed to the early years of Henry III's long reign; for I can see no trace in it of the Statute of Merton. The book contains a copy of Glanvill's treatise, which is followed by a *Registrum*, and of this we will note the contents. I add references to Glanvill's treatise, and to the Irish Register; the latter of these I will designate by the symbol " Hib." while the Cambridge MS., now under consideration, I shall hereafter refer to as CA.

1. Writ of right addressed "Roberto de Nevill"; with several variations. (Glanv. XII. 2; Hib. 1.)
2. Writ of right "*de rationabili parte.*" (Glanv. XII. 5.)
3. *Præcipe in capite.* (Glanv. I. 6; Hib. 4.)
4. *Pone;* this will only be granted to a tenant "*aliqua ratione precisa vel de majori gratia.*" (Hib. 53.)
5. Writs of peace when tenant has put himself on grand assize. (Glanv. II. 8, 9; Hib. 16.)
6. Writ summoning electors of grand assize, "*et nota quod in hac assisa non ponuntur nisi milites et precise jurare debent.*" (Glanv. II. 11; Hib. 17.)
7. *De recordo et judicio habendo.*
8. *Procedendo* in writ of right.
9. Respite of writ of right so long as tenant is "*in servicio nostro in Pictavia vel in Wallia cum equis et armis per preceptum nostrum.*" Respites (Hib. 41) where a tenant or vouchee is an infant.
10. *Warrantia cartæ.* (Hib. 24.)
11. Entry "*ad terminum qui preteriit.*" (Cf. Glanv. X. 9; Hib. 25.)
12. Entry "*cui in vita.*" (Hib. 26.)
13. *De homagio capiendo.* (Glanv. IX. 5; Hib. 27.)

14. Novel disseisin[1]; limitation "*post ultimum reditum domini J. patris nostri de Hybernia in Angliam.*" (Glanv. XIII. 33; Hib. 5.)

15. Novel disseisin of pasture; same limitation. (Glanv. XIII. 37; Hib. 6.)

16. Mort d'Ancestor[2]; limitation "*post primam coronacionem R. Regis avunculi nostri.*" (Glanv. XIII. 3, 4; Hib. 8.)

17. *De nativo habendo*[2]; same limitation. (Glanv. XII. 2; Hib. 30.)

18. *De libertate probanda.* (Glanv. V. 2; Hib. 31.)

19. *De rationabilibus divisis.* (Glanv. IX. 14; Hib. 32.)

20. *De superoneratione pasturæ.* (Hib. 33.)

21. Replevin. (Glanv. XII. 12, 15.)

22. *De pace regis infracta;* writ to attach appellee by gage and pledge in case of robbery or rape. (Hib. 34.)

23. *De morte hominis;* writ to attach appellee by his body. (Hib. 34.)

24. *De homine replegiando.* (Hib. 35.)

25. Services and customs; a "*justicies.*" (Glanv. IX. 9; Hib. 36.)

26. *Ne injuste vexes.* (Glanv. XII. 10; Hib. 27.)

27. Debt; a "*justicies*"; "*reddat B. x. sol. quos ei debet ut dicit, vel cartam quam ei commisit custodiendam.*" (Glanv. X. 2; cf. XII. 18; Hib. 38.)

28. Prohibition to ecclesiastical judges against entertaining a suit touching a lay fee. (Glanv. XII. 21; Hib. 39.)

29. Similar prohibition to the litigant. (Glanv. XII. 22.)

30. Prohibition in case of debt or chattels, "*nisi sint de testamento vel matrimonio.*"

31. Attachment for breach of prohibition. (Hib. 40.)

32. *De plegiis acquietandis.* (Glanv. X. 4; Hib. 43.) Also (32 a) a writ forbidding the sheriff to distrain the surety while the principal debtor can pay. (Hib. 46.)

33. Mesne. (Hib. 47.)

34. Aid to knight lord's son or marry his daughter.

35. *De excommunicato capiendo.* (Hib. 48.)

36. Covenant; *justicies;* "*de x. acris terre.*" (Hib. 49.)

[1] I believe that this writ would have been antiquated after 1229.
[2] These writs seem older than 1237.

Register of Original Writs

37. Writ announcing appointment of attorney.
38. Writ to send knights to hear sick man appoint attorney. (Hib. 29.)
39. Writ sending knights to view essoinee. (Hib. 28.)
40. Darrein presentment. (Glanv. XIII. 19; Hib. 9.)
41. Prohibition in case touching advowson. (Glanv. IV. 13; Hib. 14.)
42. Writ of right of advowson. (Glanv. IV. 2; Hib. 13.)
43. Writ to bishop for admission of presentee. (Hib. 12.)
44. *Quare incumbravit.* (Hib. 11.)
45. Attachment for breach of prohibition. (Glanv. IV. 14; Hib. 11.)
46. Dower "*unde nihil habet.*" (Glanv. VI. 15; Hib. 18.)
47. Dower "*de assensu patris.*" (Hib. 19.)
48. Dower in London.
49. *Juris utrum.* (Glanv. XIII. 24; Hib. 20.)
50. Attaint; the assize was taken "*apud Norwicum coram H. de Bargo, justiciario nostro*[1]." (Hib. 22.)
51. *De fine tenendo;* the fine made "*tempore domini J. patris nostri.*" (Glanv. VIII. 6; Hib. 23.)
52. *Quare impedit.*
53. Writ of right of ward in socage.
54. Writ of right of ward in chivalry.
55. Assize of nuisance; vicontiel or "little" writ of nuisance; limitation "*post ultimum reditum domini J. Regis patris nostri de Hybernia in Angliam.*" (Cf. Glanv. XIII. 35, 36; Hib. 7.)
56. *Ne vexes abbatem contra libertates.*
57. *Quod permittat* for estovers; a *justicies.*
58. *Quod faciat sectam ad hundridum vel molendinum.*

[1] This seems a reference to an eyre of 1222.

II.

In a former number of this *Review* I have been permitted to draw attention to some materials for the early history of our common law which have been too long neglected, namely, ancient Registers of Original Writs. I then described two such Registers. One of them (which I refer to as Hib.) seems to be the Register that was sent to Ireland by royal order in 1227; while the other (which I call CA.) seems to be of almost even date, to be, that is, some forty years younger than Glanvill's, some thirty years older than Bracton's, treatise.

When we compare these two Registers together, the first remark that occurs to us is, that in substance they are very similar, while in arrangement they are dissimilar. From this we may draw the inference that the official Register in the Chancery had not yet crystallized; or, to put the matter in another way, that very possibly different officers in the Chancery had copies which differed from each other. Indeed, the official Register of the time may not have taken the shape of a book, but may have consisted of a number of small strips of parchment filed together and easily transposed. There is a certain agreement between them even in arrangement. Both have "Right" in the forefront, and occasionally give us the same writs in the same order. One instance of such correspondence is worthy of note, for it will become of interest to us hereafter. The following seems to be, for some reason or another, an established sequence: *De nativo habendo*,

Register of Original Writs 139

De libertate probanda, De rationalibus divisis, De superoneratione pasturæ, Replevin, *De pace regis infracta* (writs for the arrest or attachment of appellees), *De homine replegiando,* Services and Customs. Traces of this sequence will be found even when the Register, having increased in bulk fifty times over, gets printed in the Tudor days. The writs are arranging themselves in groups: a Writ of Right cluster, an Ecclesiastical cluster, a Liberty and Replevin cluster. But many questions are very open. Shall the Writs of Entry precede or follow the Assizes? Shall they be deemed proprietary or possessory?

Taking our two Registers together, we can form an idea of the writs which were "of course" in the early years of Henry.III; and these we may contrast with the writs which Glanvill gives us from the last years of Henry II. On the whole, we can record a distinct advance of royal justice; but there have been checks and retrogressions. The Writ of Right, properly so called, the *Breve de recto tenendo,* which commands the feudal lord to do justice, has taken the place of the simple *Precipe quod reddat* as the normal commencement of a proprietary action for land. This is a victory of feudalism consecrated by the Great Charter. Again, in Glanvill's day the jurisdiction over testamentary causes had not yet finally lapsed into the hands of the church; twice (VII. 7, XII. 17) he gives us a writ (*quod stare facias rationabilem divisam*) whereby the sheriff is directed to uphold the will of a testator. This writ we miss in the Registers; the state has had to retreat before the church. We are so apt to believe that in the history of the law all has been for the best, that it is

well for us to notice this unfortunate defeat,—for unfortunate it assuredly was, and to this day we suffer the evil consequences which followed from the abandonment by the king's courts of all claim to interfere with the distribution of a dead man's chattels. On the other hand, we see that the triumph of feudalism is more apparent than real; it has barred the high road, but royal justice is making a flank march. Glanvill (x., 9) has a writ which lies for a mortgagor against a mortgagee; or rather, we ought to say for a gagor against a gagee, when the term for which the land was gaged has expired. The alteration of a few words in this will turn it into a writ of entry *ad terminum qui præteriit*[1]. Such a writ of entry is given by our two Registers, and they also give the writ *cui in vita* applicable for the recovery of land alienated by a married woman. Curiously enough they do not give the writ of entry *sur disseisin*; though we happen to know that already in 1205 this writ, lying for a disseisee against the heir of the disseisor, had been made a writ of course[2]. This is by no means the only sign that the copies of the Register which got into circulation did not always contain the newest improvements. Still, here we see that a foundation has been laid for that intricate structure

[1] The development can be seen in Palgrave's *Rot. Cur. Reg.*, I. 341, "in quam non habuit ingressum nisi quia predicta B. ei commisit ad terminum qui preteriit"; II. 37, "quam pater A. invadiavit B. ad terminum qui preteriit"; II. 211, "quam ipse invadiavit C. patri predicti B. ad terminum qui preteriit," etc.

[2] *Rot. Pat.*, I. 32, contains a writ of this kind, with the note: "Hoc breve de cetero erit de cursu." Even from Richard's reign we have "in quam ecclesiam nullum habet ingressum nisi per ablatorem suum." *Rot. Cur. Reg.*, I. 391.

Register of Original Writs

of writs of entry which will soon be reared. It is very doubtful whether Glanvill knew the procedure by way of attaint for reversing the false verdict of a petty assize; but we find this securely established in our Registers.

Another noteworthy advance is to be seen in the actions which we may call contractual. The *Warrantia Cartæ* is in use, and so is the Writ of Covenant. We may doubt whether there is as yet any writ as of course which will enforce a covenant not touching land. The typical covenant of the time is what we should call a lease; but Glanvill (x. 8) told us that the king's court was not in the habit of enforcing "*privatas conventiones*" agreements, that is, not made in its presence and unaccompanied by delivery of possession. Debt and Detinue are still provided for chiefly by writs of *Justicies*, directing trial in the county court. "Debt in the Bench" seems, as yet, no writ of course, and the Irish Register shows us that, at least across St George's Channel, one had to pay heavily even for a *Justicies*. The excuse for such exaction, of course, was that no writ was necessary for the recovery of a debt in a local court; royal interference was a luxury. Lastly, we will notice that, as yet, we hear nothing of Account and nothing of Trespass.

The next Register that I shall put in is found in a Cambridge MS. I shall hereafter refer to it as CB. (kk., v. 33). Like the last, it is bound up with a Glanvill, and this, I may remark, is in favour of its antiquity. Edwardian Registers are generally accompanied, not by Glanvill, but by Hengham, or Fet Assavoir or Statutes: On the whole, we may, as I

believe, safely attribute this specimen to the middle part of Henry III's reign, to the period between the Statute of Merton (1236) and the Statute of Marlborough (1267), and I am inclined to think it older than the Provisions of Westminster (1259). In the following notes of its contents I will give references to the "Pre-Mertonian" Register CA., which I described on a former occasion:—

"*Incipiunt Brevia de Causa Regali.*"
1. Writ of right with many variations. (CA. 1.)
2. Writ of right *de rationabili parte*. (CA. 2.)
3. *Ne injuste vexes.* (CA. 26.)
4. *Præcipe in capite.* (CA. 3.)
5. Little writ of right *secundum consuetudinem manerii.*
6. Writs of peace when tenant has put himself on grand assize. (CA. 5.)
7. Writ summoning electors of grand assize, with variations. (CA. 6.)
8. [1]Writ of peace when tenant of gavelkind has put himself on a jury in lieu of grand assize, and writ for the election of such a jury.
9. *Pone* in an action begun by a writ of right. (CA. 4.)
10. [2]*Mort d'ancestor*, with limitation "*post primam coronacionem Ricardi avunculi nostri.*" (CA. 16.)
11. *Quod permittat* for pasture in the nature of Mort d'ancestor, with a variation for a partible inheritance.
12. *Nuper obiit.*
13. [3]Novel Disseisin, with limitations "*post ultimum reditum J. Regis patris nostri de Hibernia in Angliam.*" (CA. 14.) Novel Disseisin of pasture. (CA. 15.)

[1] The privilege of having a jury instead of a grand assize was granted to the Kentish gavelkinders in 1232. *Statutes of the Realm*, I. 225.

[2] The form seems older than 1237.

[3] This form seems older than 1237.

14. [1]Assizes of Nuisance: some being vicontiel, with limitation "*post primam transfretacionem nostram in Britanniam.*" (CA. 55.)

15. Surcharge of pasture. (CA. 20.)

16. *Quo jure* for pasture.

17. Attaint in *Mort d'ancestor* and Novel Disseisin. (CA. 50.)

18. Perambulation of boundaries.

19. [2]Writ of Escheat: claimant being entitled under a fine which limited land to husband and wife and the heirs of their bodies, the husband and wife having died without issue.

20. Darrein presentment. (CA. 40.)

21. Writ of right of advowson. (CA. 42.) A curious variation ordering a lord to do right touching an advowson; the writ is marked "*alio modo sed raro.*"

22. *Quare impedit.* (CA. 52.)

23. Prohibition to Court Christian touching advowson. (CA. 41.)

24. Attachment against judges for breach of such prohibition. (B. 45.)

25. *Ne admittas personam.*

26. Mandamus to admit parson. (CA. 43.)

27. Dower *unde nihil habet.* (CA. 46.)

28. Dower *ad ostium ecclesiæ.*

29. Dower in London. (CA. 48.)

30. Dower against deforceor.

31. Writ of right of dower.

32. *Warrantia cartæ.* (CA. 10.)

33. *De fine tenendo:* a fine has been made "*tempore J. Regis patris nostri.*" (CA. 51.)

34. *Juris utrum* for the parson. (CA. 49.)

35. *Juris utrum* for the layman. (CA. 49.)

36. Entry, the tenant having come to the land *per* a villan of the demandant.

37. Entry *ad terminum qui preteriit:* the tenant having come to the land *per* the original lessee. (CA. 11.)

[1] This form seems newer than 1237.

[2] This is called a Writ of Escheat; but it closely resembles the Formedon in the Reverter of later times.

38. Entry, the tenant having come to the land *per* one who was guardian.

39. Entry *cui in vita*. (CA. 12.)

40. Entry, the land having been alienated by dowager's second husband.

41. Entry sur intrusion.

42. Entry *ad terminum qui preteriit* for an abbot, the demise having been made by his predecessor.

43. Entry *sine assensu capituli*.

44. Escheat on death of bastard.

45. Entry sur disseisin for heir of disseisee, the defendant being the disseisor's heir.

46. Entry when the land has been given *in maritagium*.

47. Entry for lord against guardians of tenant in socage who are holding over after their ward's death without heir.

48. Entry for reversioner under a fine.

49. Writ of intrusion.

50. *Quod capiat homagium.* (CA. 13.)

51. False imprisonment: "*ostensurus quare predictum A. imprisonavit contra pacem nostram.*"

52. Robbery and rape: "*ostensurus de robberia et pace nostra fracta*, vel *de raptu unde eum appellat.*" (CA. 22.)

53. Homicide: "*attachiari facias B. per corpus suum responsurus A. de morte fratris sui unde eum appellat.*" (CA. 23.)

54. *De homine replegiando.* (CA. 24.)

55. *De plegiis acquietandis*: "*justifices talem quod...acquietet talem.*" (B. 32.)

56. *De plegio non stringendo pro debito*: do not distrain pledge while principal debtor can pay. (CA. 32 a.)

57. *Quod permittat* for estovers: "*justifices A. quod...permittat B. rationabilem estoverium suum in bosco suo quod in eo habere debet et solet.*" Variation for right to fish: "*justifices A. quod permittat B. piscariam in aqua tali quam in eadem habere debet et solet.*" (CA. 57.)

58. Debt: "*justifices A. quod...reddat B. xij. marcas quas ei debet*," vel "*catallum ad valenciam xii. marcarum quas* (sic) *ei injuste detinet sicut racionabiliter monstrare poterit quod ei debeat, ne amplius,*" etc. (CA. 27.)

59. Debt and Detinue before the king's justices. "*Precipe A. quod...reddat B. xij. marcas quas ei debet et injuste detinet* vel *catallum ad valenciam x. marcarum quod ei detinet, et nisi fecerit...summone ...quod sit coram justiciariis nostris...ostensurus quare non fecerit.*"

60. Replevin. (CA. 21.)

61. Suit to mill: "*justifices A. quod faciat B. sectam ad molendinum...quam facere debet et solet.*" (CA. 58.)

62. Customs and services: "*non permittas quod A. distringat B. ad faciendum sectam...vel alias consuetudines et servicia que de jure non debet nec solet.*"

63. Customs and services: sheriff is not to distrain B. for undue suit to county or hundred court, etc.

64. Customs and services: "*justifices A. quod...faciat B. consuetudines et recta servicia, que ei facere debet,*" etc. (CA. 25.)

65. Customs and services, by *precipe*: "*precipe A. quod faciat B. consuetudines et recta servicia.*"

66. Waste: "*non permittas quod A. faciat vastum...de domibus ...quas habet in custodia,* vel *quas tenet in dotem,*" etc.

67. Waste: attach A. to answer at Westminster why he or she has wasted tenements held in guardianship or in dower, "*contra prohibicionem nostram.*" (Hib. 51.)

68. [1]*De nativo habendo:* let A. have B. and C. his "natives" and fugitives who fled since the last return of our father King John from Ireland. (CA. 17.)

69. *De libertate probanda.* (CA. 18.)

70. *De racionabilibus divisis.* (CA. 19.)

71. *De recordo et racionabili judicio.* Let A. have record and reasonable judgment in your county court in a writ of right. (CA. 7.)

72. Annuity: "*justifices A. quod...reddat B. x. sol. quos ei retro sunt de annuo redditu,*" etc.

73. *Ne vexes.* Do not vex, or permit to be vexed, A. or his men contrary to the liberties that he has by our or our ancestor's charter, which liberties he has used until now. (CA. 56.)

74. Wardship in socage: "*justifices A. quod...reddat B. custodiam terre et heredis C.,*" etc. (CA. 53.)

[1] This form seems newer than 1237.

75. Wardship in chivalry, the guardian claiming the land: "*justifices*," etc. Variation when the guardian is claiming the heir's person. (CA. 54.)

76. Aid to knight son or marry daughter: "*facias habere A. racionabile auxilium.*" (CA. 34.)

77. Covenant: "*justifices A. quod...convencionem...de tanto terre.*" (CA. 36.)

78. Sheriff to aid in distraining villans to do their services.

79. Prohibition against impleading A. without the king's writ. "*R. vic. sal. Precipimus tibi quod non implacites nec implacitari permittas A. de libero tenemento suo in tali villa sine precepto nostro vel capitalis nostri justiciarii.*"

80. *Ne quis implacitetur qui vocat warrantum qui infra aetatem est.* (CA. 9.)

81. *Ne quis implacitetur qui infra aetatem est.* (CA. 9.)

82. Quod permittat: "*justifices A. quod...permittat B. habere quendam cheminum,*" etc., vel "*habere porcos suos ad liberam pessonam,*" etc.

83. Account: "*justifices talem quod...reddat tali racionabilem compotum suum de tempore quo fuit ballivus suus,*" etc.

84. Mesne: "*justifices A. quod...acquietet B. de servicio quod C. exigit ab eo...unde B. qui medius est,*" etc. (CA. 33.)

85. *De excommunicatis capiendis.* (CA. 35.)

86. Prohibition to ecclesiastical judges against holding plea of chattels or debt "*nisi sint de testamento vel matrimonio.*" (CA. 30.)

87. Prohibition to the party in like case.

88. Attachment on breach of prohibition. (CA. 31.)

89. Prohibition in cases touching lay fee. (CA. 28.)

90. *Recordari facias*, a plea by writ of right in your county court.

91. [1]*Quare ejecit infra terminum. Breve de termino qui non preteriit factum per W. de Ralee:* "*Si A. fecerit te securum,* etc.... summone, etc., B. etc., ostensurus quare deforciat A. tantum terre... quam D. ei demisit ad terminum qui nondum preteriit infra quem*

[1] Bracton, f. 220, notices this writ as a newly invented thing. He recommends, however, another form, which is a Precipe quod reddat; but the above is the form which ultimately prevailed. *Reg. Brev. Orig.*, f. 227.

terminum predictus (D) terram illam predicto B. vendidit occasione cujus vendicionis predictus B. ipsum A. de terra illa ejecit ut dicit," etc.

92. [1]"*Breve novum factum de communi assensu regni ubi de morte antecessorum deficit.*" This is the writ of cosinage.

93. *De ventre inspiciendo.*

94. [2]"*Novum breve factum per W. de Ralee de redisseisina super disseisinam et est de cursu.*" Sheriff and coroners are to go to the land and hold an inquest, and if they find a redisseisor to imprison him.

95. [3]"*Novum breve factum per eundem W. de averiis captis et est de cursu.*" After a replevin and pending the plea, the distrainor has distrained again for the same cause...*"predictum A. ita per misericordiam castiges quod castigacio illa in casu consimili timorem prebeat aliis delinquendi.*"

96. "*De attornato faciendo in comitatibus, hundredis, wapentachiis de loquelis motis sine breve Regis.*" A writ founded on cap. 10 of the Statute of Merton. Variation when the suit was due to a court baron.

97. Prohibition to ecclesiastical judges in a suit touching tithes.

98. Writ directing the reception of an attorney in an action. (CA. 37.)

99. *Precipe in capite.* (CA. 3.)

100. Writs directing sheriff to send knights to view an essoinee and hear appointment of attorney. (CA. 38, 39.)

101. Writ to the bishop directing an inquest of bastardy, the plea being one of "general bastardy."

102. Writ of entry sur disseisin, the defendant having come to the land *per* the disseisor.

103. *Quod permittat* for common by heir of one who died seised.

104. *Quare duxit uxorem sine licencia. Quare permisit se maritari sine licencia.*

105. [4]*Monstraverunt,* for men of ancient demesne.

[1] Another of Raleigh's inventions, which we may ascribe to the year 1237. Bracton's *Note Book*, pl. 92.

[2] Given by Stat. Mert., cap. 3.

[3] This is given by Bracton, f. 159.

[4] This will hereafter be attracted into the "Writ of Right group" by the Little Writ of Right for men of the Ancient Demesne.

106. Removal of plea from court baron into county court on default of justice.

107. Surcharge of pasture; "*summone...B. quod sit...ostensurus quare superhonerat pasturam.*" (CA. 20.)

108. Patent appointing justices to take an assise.

109. Prohibition to ecclesiastical judges against entertaining a cause in which B. (who has been convicted of disseising A.) complains that A. has "defamed his person and estate."

110. *De odio et hatia.*

111. Writ of extent. Inquire how much land A. held of us *in capite*.

112. Mainprise, where inquest *de odio et hatia* has found for the prisoner.

113. Writ of seisin for an heir whose homage the king has taken.

114. Writ of inquiry as to whether the king has had his year and a day of a felon's land.

115. *Warrancia diei*, sent to the justices.

116. Extent of land of one who owes money to the Jews.

117. Prohibition against prosecuting a suit touching advowson in Court Christian.

118. Writ to bishop directing an inquiry when bastardy has been specially pleaded: "*inquiras utrum A. natus fuit ante matrimonium vel post.*"

119. Writ announcing pardon of flight and outlawry.

120. Writ permitting essoinee to leave his bed. Dated A. R. 33.

121. Abbot of N. has been enfeoffed in N. by several lords who did several suits to the hundred court. You, the sheriff, are not to distrain the abbot for more suits than one "*quia non est moris vel juri consonum quod cum plures hereditates in unicum heredem descenderint vel per acquisicionem aliquis possideat diversa tenementa quod pro illis hereditatibus aut tenementis diversis, ad unicam curiam fiant secta diversa.*" Dated A. R. 43[1].

[1] In 1258-9 suit of court was a burning question. The Provisions of Westminster (cap. 2) laid down the rule, that when a tenement which owes a single suit comes to the lands of several persons, either by descent or feoffment, one suit and no more is to be due from it. This writ deals with the converse case in which several parcels of

Register of Original Writs

Our first observation would be, that the Register has quite doubled in bulk since we last saw it; and our second should, as I think, be, that chronology has had something to do with the arrangement of the specimen that is now before us. The last two formulas are dated, and probably constituted no part of the Register that was copied, but were added to it, having been transcribed from writs lately issued. But leaving these two last formulas out of sight, I think that the last thirty writs or thereabouts are, for the most part, new writs tacked on by way of appendix to the older Register. The line might be drawn between No. 90 and No. 91. The latter of these, the very important *Quare ejecit infra terminum*, is expressly ascribed to William Raleigh, Bracton's master, whose judicial activity came to an end in 1239. Then, No. 92, the Writ of Cosinage, is "*breve novum*," and we know that this was conceded by a council of magnates in 1237, and was penned by Raleigh[1]. Then again, No. 94 is attributed to Raleigh. It is the Writ of Redisseisin, given by the Statute of Merton. The last of this group of "Actiones Raleghanæ" (if I may use that term) deals with the recaption of a distress pending the action of replevin; in spirit it is allied to the Redisseisin[2]. The next writ, No. 96, is given by the Statute of Merton. The prohibition in tithe suits, No. 97, is the centre of a burning ques-

land, each owing a suit to the same court, come into one hand, and it lays down the rule that in this case also one suit is to be due.

[1] Bracton's *Note Book*, pl. 1215.

[2] The printed Registrum, f. 86, says, "istud breve fuit inventum secundum provisiones de Merton." But the Provisions of Merton, as we have them, contain nothing but distress.

tion; and so is No. 118, the writ directing the bishop to say whether a child was born before or after the marriage of its parents. One may be surprised to find this writ at all, after the flat refusal of the bishops given at the Merton Parliament. Of the other writs in this part of the *Registrum*, we may, I think, say that they form an appendix, and are not too carefully made, since some of them appeared in the earlier part of the formulary. Others may be writs newly invented, or old writs that have only of late become "writs of course." The *Monstraverunt* for men of ancient demesne, a writ of critical importance in the history of the English peasantry, is no new thing; but very possibly, until lately, it could not be obtained until the matter had been brought under the king's own eye, or at least his chancellor's eye. The same may, perhaps, be said of the equally important *De odio et hatia*.

In the next place, we see one of the causes at work, which, in the course of time, swells the Register of Original Writs to its great bulk. A group of what we may call fiscal or administrative writs have obtained admission among the writs by which litigation is begun. At present it is small; it includes two writs for "extending" land, and a writ directing livery to an heir whose homage the king has taken; in course of time it will become large.

But turning to the formulas of litigation, we see already a large variety of writs of entry; though as yet the tale is not complete for writs "in the *post*" have not yet been devised, and would perhaps be resented by the feudal lords. The Assize of Mort d'Ancestor is now supplemented by *Nuper obiit* and Cosinage. We

Register of Original Writs

see signs of growth in the department of Waste. We have something very like a Formedon. Annuity and Account have been added to the list of personal actions, but Trespass is yet lacking.

A few words about Trespass: The MS. registers that I have seen, fully bear out the opinion that has been formed on other evidence as to the comparatively recent origin of this action[1]. Glanvill has nothing that can fairly be called a writ of Trespass. His nearest approach to such a writ is "*Justicies*," ordering the sheriff to compel the return of chattels taken "unjustly and without judgment"; but the chattels have been taken in the course of a disseisin, and the plaintiff has already succeeded in an Assize[2]. In later days we do not find this writ; its object seems to have been obtained by the practice of giving damages in the Assize[3]. But already, in John's reign, we find a few actions which we may call actions of trespass. In some of these, where there has been asportation or imprisonment, the true cause of action in the royal court seems to be that which our forefathers knew as the "ve de naam"; "vetitum naami"; the refusal to deliver chattels or imprisoned persons upon the offer of a gage and

[1] I am happy in being able to refer to what is said on this point by "J. B. A." in *Harvard Law Review*, ii. 292. [See also *Harvard Law Review*, iii. 29.—Ed.] Of course Trespass (transgressio) was well enough known in local courts. "Trespass" and "Debt" were the two great heads of their civil jurisdiction.

[2] *Glanv.*, xii. 18; xiii. 39.

[3] Bracton, f. 179 b. "Item ad officium (vicecomitis) pertinet quod faciat tenementum reseisiri de catallis, etc., quod hodie aliter observatur, quia quaerens omnia damna post captionem assisae recuperabit."

pledge,—a cause of action which had definitely become a plea of the crown[1]. Also, it is in some instances a little difficult to distinguish an action of Trespass from an appeal of felony. Just the dropping out of a single word might make all the difference. Thus, on a roll of Richard's reign A. is said to appeal B., C., and D., for that they came to his land with force and arms, and in robbery ("felony" is not mentioned) and wickedly, and in the king's peace carried off his chattels, to wit turves; whereupon B. defends the felony and robbery, and says that he carried off the turves in question from his own freehold[2]. Attempts were made to use the appeal of felony as an action for trying the title to land,—a very summary action it would have been. But the court of John's reign would not suffer this[3]. On the rolls of the first half of Henry III's reign actions of Trespass appear, but they are still quite rare. The advantages of an action in which one can proceed

[1] *Rot. Cur. Reg.* ii. 34, "A. optulit se versus B. de placito transgressionis." Ibid. 51, "A. queritur quod B. vi sua asportavit bladum de sex acris terre quas disracionavit in curia Dom. Regis (but here the recovery of the land in the king's court is a special reason for its interference). Ibid. 120, "A. queritur quod B. dominus suus cum vi et armis prostravit boscum et cum forcia frequenter asportat ad domum suam, et quadrigas suas cum forcia in bosco suo de W. capit et adhuc unam illorum habet et detinet injuste." Ibid. 169, "A. queritur quod B. et C. intraverunt in terram suam de X. vi et armis et in pace Regis et averia sua ceperunt et ten" (*corr.* contra) "vadium et plegium tenuerunt." Ibid. 260, "A. queritur quod Episcopus Donelmensis cepit eum et imprisonavit et eum retinuit injuste quousque ipsum redemit et eum contra vadium et plegium retinuit."

[2] *Rot. Cur. Reg.* i. 38.

[3] *Selden Society*, vol. I. pl. 35, "appellum de pratis pastis non pertinet ad coronam regis."

to outlawry are apparent[1], but something seems to be restraining plaintiffs from bringing it. The novelty of the procedure is shown by the uncertainty of the courts as to its scope, particularly when the action relates to land, and title is pleaded by the defendant. We actually find an action of trespass leading to a grand assize. If title is to be determined at all in such an action, it must be determined with all the solemnity appropriate to a Writ of Right[2]. Bracton, however, who unfortunately has left us no account of this action, shows a reluctance to allow this writ "*quare vi et armis*" to be used for the purpose of recovering land[3], and a little later we find it repeatedly said that a question of title cannot be determined by such a writ[4]. So late as Edward II's reign it was necessary to assert

[1] Bracton's *Note Book*, pl. 85.

[2] *Rot. Cur. Reg.* ii. 120, "A. queritur quod B. dominus suus cum vi et armis prostravit boscum et cum forcia frequenter asportat ad domum suam...B. dicit quod A. non tenet vel tenere debet boscum illum de eo...A. ponit se in magnam assisam utrum ipse jus majus habeat tenendi de eo boscum vel ipse in dominico. Et B. similiter." Bracton's *Note Book*, pl. 835, " A. queritur quod B., C., et D. vi et armis et contra pacem Dom. Regis fuerunt in piscaria ipsius A...et E. (vocatus ad warrantiam) venit...et dicit...quod ipse debet piscari in eadem piscaria cum ipso A., et dicit quod antecessores sui ibi piscari solent et debent et piscati sunt scil. tempore Henrici Regis avi....A. dicit quod predecessor suus fuit seisitus de piscaria illa que fuit separabile suum...E. ponit se in magnam assisam."

[3] Bracton, f. 413.

[4] *Placit. Abbrev.* 142 (38 Hen. III), "Et quia uterque dicit se esse in seisina de uno et eodem tenemento et non potest per hoc breve de jure tenementi inquiri." Ibid. 162 (1 Ed. I), "Et quia liberum tenementum non potest per hoc breve de transgressione terminari."

against a decision to the contrary that in an action *de bonis asportatis* the judgment must be merely for damages and not for a return of the goods[1].

But meanwhile, Trespass had become a common action. This, on the evidence now in print, seems to have taken place suddenly at the end of the "Baron's war." In the *Placitorum Abbreviatio* we suddenly come upon a large crop of such actions for forcibly entering lands and carrying off goods, and in very many of these the writ charges that the violence was done "*occasione turbacionis nuper habitæ in regno.*" This may suggest to us that in order to suppress and punish the recent disorder, a writ which had formerly been a writ of grace, to be obtained only by petition supported by golden or other reasons, was made a writ of course,— an affair of every-day justice. Such MS. registers as I have seen seem to favour this suggestion. I have seen no register of Henry III's reign which contains a writ of Trespass, and it is not to be found even in all registers of his son's reign.

[1] *Placit. Abbrev.* 346 (17 Ed. II), "In hujusmodi brevi de transgressione secundum legem," etc., "dampna tantum adjudicari et recuperari debeant."

III.

Let us pass on to a new reign. Registers of Edward I's time are by no means uncommon. I believe that we have at Cambridge no less than seven which, in the sense defined above, may be ascribed to that age, and there are many at the British Museum. The most meagre of them is far fuller than those Registers of Henry III's reign of which we have spoken. To give an idea of their size I may mention a MS. at the Museum (Egerton 656), in which the writs are distributed into groups of sixty; there are seven perfect groups followed by a group which contains but fifty-one members; thus in all there are four hundred and seventy-one writs. This increase in size is of course largely due to the legislative activity of the reign, and this course makes the various specimens differ very widely from each other in detail. Still I think that I have seen enough to allow of my saying that very early in the reign the general arrangement of the Register had become the arrangement that we see in the printed book. A Register of Edward's day is distinctly recognizable as being the same book that Rastall published under the rule of Henry VIII. Not to lose myself in details about statutory writs, I will draw attention to one principle which may help towards a classification of these Edwardian Registers. That principle is expressed in the question—Does Trespass appear at all, and if so where? There are specimens

which have no Trespass; there are others which have Trespass at the end, in what we may regard as an appendix; there are others again which have Trespass in its final place, namely, in the very middle of the book.

Next I will give a short description of a specimen which I am disposed to give to the earliest years of Edward I. It is contained in a Cambridge MS. (Ee. i. 1) which I will call CC, and the following notes of its contents may be enough. For the purpose of making its scheme intelligible I have supposed it to consist of various groups of writs and have given titles to those groups, but it will be understood that the MS. gives the writs in an unbroken series, a series unbroken by any headings or marks of division.

1. *The Writ of Right Group*. This includes the Writ of Right; Writ of Right *de rationabile parte*; Writ of Right of Dower; *Praecipe in capite*; Little Writ of Right; Writs of Peace, and writs summoning the Grand Assize or Jury in lieu of Grand Assize; writ for viewing an essoinee; writs announcing appointment of attorney; *Warrantia diei; Licencia surgendi; Pone; Monstraverunt.*

2. *The Ecclesiastical Group*. Writ of Right of Advowson; Darrein Presentment; *Quare impedit; Juris utrum;* Prohibition to Court Christian in case of an advowson; Prohibition to Court Christian in case of chattels or debts; Prohibition against Waste[1]; Prohibi-

[1] The reason why Waste gets enclosed in this ecclesiastical group is obvious; the action of Waste is, or has lately been, an action on a prohibition.

tion in case of lay fee. Then follow seven specially worded prohibitions introduced by the note "*Ostensis formis prohibicionum que sunt de cursu patebit inferius de eis que sunt in suis casibus formate et sunt de precepto.*" After these come the *De Excommunicato capiendo* and other writs relating to excommunicates.

3. *The Replevin and Liberty Group.* Replevin; a writ directed to the coroners where the sheriff has failed in his duty is preceded by the remark "*primo inventum fuit pro Roberto de Veteri Ponte*"; *De averiis fugatis ab uno comitatu in alium; De averiis rescussis; De recaptione averiorum; Moderata misericordia; De nativo habendo*, the limitation is "*post ultimum reditum Domini J. Regis avi nostri de Hibernia in Angliam*"; *De libertate probanda;* Aid to distrain villans; *De tallagio habendo; De homine replegiando; De minis*, i.e. a writ conferring a special peace on a threatened person[1]. *De odio et atia* (with the remark that the clause beginning with *nisi* was introduced by John Lexington, Chancellor of Henry III).

4. *The Criminal Group.* Appeal of felony evoked from county court by *venire facias*; writ to attach one appealed of homicide by his body; writs to attach other appellees by gage and pledge.

5. *A Miscellaneous Group. De corrodio substracto; De balliva forrestarii de bosco recuperanda; Quod attachiet ipsum qui se subtraxit a custodia; Quod nullus*

[2] A. has complained that he is threatened by B. therefore "prefato A. de prefato B. firmam pacem nostram secundum consuetudinem Anglie habere facias, ita quod securus sis quod prefato A. de corpore suo per prefatum B." etc. It is a writ directing the sheriff to take security of the peace.

implacitetur sine precepto Regis. Various forms of the *Quod non permittat* and *Quod permittat* for suit of mill, etc.

6. *Account.* Account against a bailiff ("*Et sciendum est quod filius et heres non habebit hoc breve super ballivum domini* [corr. *antecessoris*] *sui, set ut dicitur executores possunt habere hoc breve super ballivum tempore quo fuit in obsequio defuncti*"; it proceeds to give a form of writ for executors in the king's court and then adds, "*Et hoc breve potest fieri ad placitandum in comitatu. Verumptamen casus istorum duorum brevium mere pertinet ad curiam cristanitatis racione testamenti*").

7. *Group relating chiefly to Easements and the duties of neighbours.* Aid to knight eldest son; *De pontibus reparandis—muris—fossatis; De curia claudenda; De aqua haurienda; De libero tauro habendo; De racionabile estoverio; De chimino habendo; De communa*, with variations; Admeasurement of pasture; *Quo jure; De racionalibus divisis; De perambulacione; De ventre inspiciendo.*

8. *Mesne, Annuity, Debt, Detinue, etc. De medio; De annuo redditu; De debito* (only two writs of debt, one a *precipe*, the other a *justicies;* the former has "*debet et detinet*," the latter "*detinet*"); *Ne plegii distringantur quamdiu principalis est solvendus; De plegiis acquietandis; De catallis reddendis;* (Detinue by *precipe* and by *justicies*); *Warrantia cartae.*

9. *Writs of Customs and Services.*

10. *Covenant and Fine.* The covenant in every case is "*de uno messuagio.*"

Register of Original Writs

11. *Wardship. De custodia terre et heredis; De corpore heredis habendo; De custodia terre sine corpore; Aliter de soccagio.* "*Optima brevia de corpore heredis racione concessionis reddende* [sic] *executoribus alicui defuncti.*"

12. *Dower.* Dower *unde nihil; De dote assensu patris; De dote in denariis; De dote in Londonia; De amensuracione dotis.*

13. *Novel Disseisin.* Novel disseisin, the limitation is "*post primam transfretacionem domini H. Regis anni*[1] [sic] *nostri in Brittanniam*"; *De redisseisina;* Assize of nuisance; Attaint.

14. *Mort d'Ancestor*, and similar actions. Mort d'Ancestor (no period of limitation named); Aiel; Besaiel ("*Multi asserunt quod hoc breve precipe de avio et avia tempore domini H. Regis filii Regis Johannis per discretum virum dominum Walterium de Mertone*[2] *tunc secretarium clericum et prothonotorium* [sic] *cancellarie domini Regis et postmodum cancellarium primo fuit adinventum quia propter recentem seisinam et possessionem et discrimina brevis de recto vitandum ab omnibus consiliariis et justiciariis domini Regis est approbatum et justiciariis demandatum quod illud secundum sui naturam placitent*"); Cosinage; *Nuper obiit* ("*Et hoc breve semper est de cursu ad*

[1] The occurrence of this word which may be a corruption of "avi" is not sufficient to make us doubt that in substance this Register belongs to Edward I's reign; though possibly a feeble attempt to "bring it up to date" may have been made at a later time.

[2] Walter of Merton seems here to get the credit which on older evidence belongs to William of Raleigh.

bancum in favorem petentis seisinam quod antecessor petentium habuit de hereditate sua et similiter ut vitentur dilaciones periclose que sunt in breve de recto").

15. *Quare ejecit infra terminum*, ascribed to Walter Merton[1]; Writs of Escheat.

16. *Entry and Formedon.* Numerous Writs of Entry, the degrees being mentioned (no writ "in the *post*"); Formedon in the Reverter; and a very general Formedon in the Descender[2].

17. *Miscellaneous Group.* License to elect an abbot; petition for such license; form of presenting an abbot elect to the King; pardons; grants of franchises; a very special writ for R. de N. impleaded in the court of W. de B.; *De languido in anno bissextili* (concerning an essoin for a year and a day in leap year); *Breve de recapcione averiorum post le Pone; Quod non fiat districtio per oves vel averiis* [sic] *carucarum; Ne aliquis faciat sectam ad comitatum ubi non tenetur; Ne faciat sectam curie ubi non tenetur;* some specially worded Prohibitions.

In substance this MS. seems to represent the Register as it stood in the very first years of Edward I. I do not think that any of the statutes of his reign have

[1] Here again Merton seems to be obtaining undue fame at the expense of Raleigh.

[2] "Praecipe R. quod juste," etc., "reddat H. unam virgatam terre...quam W. dedit M. et que post mortem ipsius M. ad prefatum H. descendere debet per formam donacionis quam prefatus W. inde fecit predicto M. ut dicit, et nisi fecerint," etc. What I have seen in this and other Registers favours the belief that there was a Formedon in the Descender before the Statute de Donis. See Co. Lit. 19a; Challis, *Real Property*, 69.

Register of Original Writs 161

been taken into account, and doubt whether even the Statute of Marlborough (1267) has yet had its full effect. There is no Writ of Entry "in the *post*," and some writs about distress and suit of court founded on statutes of Henry III still remain unassimilated in a miscellaneous appendix. The character of that appendix provokes the remark that the copyists of the Register may often have picked and chosen from among the miscellaneous forms of the Chancery those which would best suit the special wants of themselves or their employers. The *congé d'élire*, for example, looks out of place, and the petition for such a license still more out of place; but this is a monastic manuscript and these formulas were useful in the abbey.

I said above that Glanvill's scheme of the law, or rather his scheme of royal justice, might be displayed by some such string of catch-words as the following: " Right " (that is proprietary right in land), " Church," " Liberty," " Dower," " Inheritance or succession," " Actions on Fines," " Lord and Tenant," " Debt," " Attorney," " Justice to be done by feudal lords and sheriffs," " Possession," " Crime." Now I will venture the suggestion that the influence of his book is apparent on the face of the Register (CC) and all the later Registers. It begins with " Right " while it puts " Possession," a title which now includes the Writs of Entry as well as the Assizes, at the very end. After " Right " comes " Church," and after " Church " comes " Replevin and Liberty," a title the unity of which is secured by the fact that when a man is wrongfully deprived of his liberty he ought to be replevied. The middle part of the Register is somewhat chaotic, and so

it always remains; but it is really less chaotic than it may seem to some of us, whose heads are full of modern notions. We seem indeed to be carried backwards and forwards across the line which divides "personal" and "real" actions; Account, Annuity, Debt, Detinue, and Covenant are intermixed with actions founded on feudal dues and actions founded on easements, writs for suit of mill, suit of court, repair of bridges, actions of Mesne, actions of Customs and Services. The truth, as it seems to me, is that the line between "real" and "personal" actions as drawn in later books, is, at least when applied to our medieval law, a very arbitrary line. For example, there is an important connection between an action in which a surety sues the principal debtor (*de plegio acquietando*) and an action of Mesne, in which the tenant in demesne sues the intermediate lord to acquit or indemnify him from the exaction of the superior lord; this connection we miss if we stigmatise "Mesne" as a "real action" just because it has something to do with land. The action of Debt, again, is founded on *debet*; but so is the action for Customs and Services, at least in some of its forms. However I am not concerned to defend the Register.

In Edward I's day, partly it may be under the influence of Glanvill's book, it has become an articulate body. It will never hereafter undergo any great change of form, but it will gradually work new matter into itself. Such new matter will for a while lie undigested in miscellaneous appendixes, but in course of time it will become an organic part of the system. I will mention the most striking illustration of this process.

Hitherto we have never come across that action of

Register of Original Writs 163

Trespass which is to be all important in later days, and it seems to me a very noteworthy fact that there are Registers of Edward I's day that omit this topic. It gradually intrudes itself. First we find it occupying a humble place at the end of the collection among a number of new writs due to Edward's legislative zeal. Thus, to choose a good example, there is in the Cambridge Library a MS. (Ll. iv. 18) containing a Register which is very like that (Ee. i. 1) which we have last described. But when it has done with the Writs of Entry, it turns to Formedon, gives writs in the Reverter, Descender, and Remainder, and a number of specially worded writs of Formedon which bear the names of the persons for whom they were drawn:—we have Bereford's formedon, Mulcoster's, and Mulgrave's; clearly the Statute of Westminster II is in full operation. Then upon the heels of Formedon treads Trespass. It is a simple matter as yet, can be represented by one writ capable of a few variations—*insultum fecit et verberavit, catalla cepit et asportavit arbores crescentes succidit et asportavit, blada messuit et asportavit, separalem pasturam pastus fuit, uxorem rapuit et cum catallis abduxit.* Trespass disposed of, we have Ravishment of Ward; *Contra formam feffamenti; Ne quis destringatur per averia carucae;* Contribution to suit of court; Pardons; Protections; *De coronatore eligendo; De gaola deliberanda; De deceptione curiæ; cessavit per biennium; carta per quam patria de Ridal disafforestatur; Breve de compoto super Statutum de Acton Burnell,* and so forth and so forth in copious disorder. The whole *Registrum* fills fifty-two folios, of which no less than the last fourteen are taken up by the unsyste-

matized appendix. Another MS. (Ll. iv. 17) gives a Register of nearly the same date, perhaps of somewhat earlier date, for it does not contain the new Formedons. This again has an unsystematized appendix, and in that appendix Trespass is found. The place at which it occurs may be thus described :—the part of the Register that has already become crystallized, the part which ends with the Writs of Entry, having been given, we have the following matters: Pardon; License to hunt; Grants of warren, fair, market; *De non ponendo in assisam*, Writ on the Statute of Winchester; Leap year; Inquests touching the King's year and day; Contribution; Beau pleader; Trespass; Gaol delivery; Intrusion; *congé d'élire;* *Quo Warranto;* Trespass again; Writ on the Statute of Gloucester; Mortmain; Trespass again (*pro cane interfecto*); *ne clerici Regis compellantur ad ordines suscipiendos*,—as variegated a mass as one could wish to see. Other MSS. of the same period have other appendixes with Trespass in them. They forcibly suggest that the Register was falling into disorder, the yet inorganic part threatening to outweigh the organic.

There came a Chancellor, a Master, a Cursitor with organizing power; Trespass could no longer be treated as a new action; a place had to be found for it, and a place was found. It may be that this was done under Edward I: certainly in his son's reign it seems an accomplished fact. What was the place for Trespass? If the reader will look back at our account of the Register which we have called CC, he will find that we have labelled the third group of writs as "Replevin and Liberty," the fourth group as "Criminal." The

Register of Original Writs 165

connection between Replevin and Liberty is obvious, it is seen in the writ *De homine replegiando*, the writ for replevying a prisoner. The transition from Liberty to Crime is meditated by the writ *De odio et atia*, a writ for one who says that he is imprisoned on a false accusation of crime. Now when the time has come for taking up Trespass into the organic part of the Register, this was the quarter in which its logical home might be found. It was naturally brought into close connection with "crime." Throughout the Middle Ages Trespass is regarded as a crime; throughout the Year Books the trespasser is "punished"; and it is a very plausible opinion that the earliest actions of trespass grew out of appeals of felony; they were, so to speak, mitigated appeals, appeals with the "*in felonia*" omitted, but with the "*vi et armis*," and the "*contra pacem*" carefully retained. Already in the Register that I have called CB, a writ of false imprisonment has come in immediately before the writ for attaching an appellee. Then, in CC, a writ *De minis* has forced its way into the "Replevin and Liberty Group" so as to precede the writs against an appellee. This writ *De minis*, commanding the sheriff to confer the king's peace, the king's "grith" or "mund" we may say, on a threatened person, and to make the threatener find security for the peace is the herald of trespass: *De minis—De transgressione*, this becomes a part of our "*legalis ordo*."

The result in the fully developed Register is curious, showing us that the arrangement of the book is the resultant of many forces. Let us see what follows Waste. We have the *De homine replegiando*, then the Replevin of chattels, then, returning to men deprived of liberty, the *De nativo habendo*, and the *De libertate*

probanda; these naturally lead to the writ ordering the sheriff to aid a lord in distraining his villans. There follows the *De scutagio habendo*. Why should this come here? Because in older times villanage had suggested tallage; this had been the place for a *De tallagio habendo*, and then tallage had suggested scutage. Then in the printed Register we have the *De minis*; and then an action against one who has given security for the peace and has broken it by an assault, brings upon us the whole subject of Trespass, which with its satellites now fills some forty folios, some eighty pages. And then what comes next? Why, *De odio et atia*; we are back again at that topic of "Liberty and Replevin" whence we made this long digression. Meanwhile these criminal writs, these writs for attaching appellees which originally attracted Trespass to their quarter of the Register, have disappeared as antiquated, since persons accused of felony now get arrested without the need of original writs.

Similar measures were taken for writing into appropriate places the result of the legislation of Edward I; but the formation of new writs was constantly providing fresh materials. Some of these found a final resting-place at the very end of the Register, but for most of the statutory writs, a home was found in the middle. The occurrence of the Assize of Novel Disseisin marked the beginning of a new and logically arranged section of the work, a section devoted to Possession. It is between Dower and Novel Disseisin that the newer statutory writs are stored.

As already said, the printed Register is full of notes and queries. Many of these are ancient, some as old as the reign of Edward I. Speaking broadly one may

say that the Latin notes are ancient, the French notes comparatively modern. Some of them must have been quite obsolete in the reign of Henry VIII; but the "*vis inertiae*" preserved them. When once they had got into MSS. they were mechanically copied.

During the whole of the fourteenth century the Register went on growing, and by the aid of MSS. we can still catch it in several stages of its growth. Some of these MSS. show a Register divided into chapters, and thus make it possible for us to perceive the articulation of the book. As the printed volume gives us no similar aid, I will here set out the scheme of a Register which I attribute to the reign of Richard II. It is contained in a Cambridge MS. (Ff. v. 5). In the right-hand column I give the catch-words of its various chapters; in the left-hand column I refer to what I take to be the scheme of CC, the Register from the beginning of Edward I's reign, of which mention has already been made.

1.	The Writ of Right Group.	i.	*De recto.*
		ii.	*De recto secundum consuetudinem manerii.*
		iii.	*De falso judicio.*
		iv.	*De attornato generali; Protectiones.*
		v.	*De attornatis faciendis.*
2.	The Ecclesiastical Group, including Waste.	vi.	*De advocatione; De ultima presentacione; Quare impedit; juris utrum.*
		vii.	*De prohibitione.*
		viii.	*Consultationes.*
		ix.	*De non residentia; De vi laica ammovenda*, etc.

		x.	[1] *Ad jura regia.*
		xi.	*De excommunicato capiendo,* etc.
		xii.	*De vasto.*
3.	Replevin and Liberty Group.	xiii.	Replevin generally and *De homine replegiando.*
		xiv.	Trespass and Deceit (*transgressio in deceptione*).
		xv.	[2] Error.
[4.	Criminal Group dissolved.]	xvi.	*Conspiratio; De odio et atia.*
5.	[Miscellaneous Group. See cap. xix.]		
6.	Account.	xvii.	Account.
		xviii.	Debt and Detinue.
7.	Easements, Neighbourly Duties, etc.	xix.	*Secta ad molendinum; curia claudenda; Quod permittat,* etc.; *Quo jure;* Admeasurement of pasture; Perambulation; *Warrantia cartae; De plegiis acquietandis.*
8.	Mesne, Annuity, Debt, Detinue.	xx.	Annuity; Customs and Services; Detinue of Charters; Mesne.
9.	Customs and Services.		
10.	Covenant and Fine[3].	xxi.	Covenant.
11.	Wardship.	xxii.	Wardship.

[1] A group of especially stringent prohibitions called out by papal and ecclesiastical aggression.

[2] The topic of Error is suggested by Trespass, just as the topic of False Judgment is suggested by "Right."

[3] The action on a fine by original writ has disappeared, because fines are now enforced by *Scire Facias.* This is noted in the printed Register, f. 169.

Register of Original Writs 169

12.	Dower.	xxiii.	Dower.
		xxiv.	[1]*Brevia de Statuto* (Modern Statutory Actions).
		xxv.	*De ordinatione contra servientes* (Actions on the Statute of Labourers).
13.	Novel Disseisin.	xxvi.	Novel Disseisin.
		xxvii.	*De recordo et processu mittendo* (Writs ancillary to the Assizes).
14.	Mort d'Ancestor, and similar writs.	xxviii.	Mort d'Ancestor.
		xxix.	Aiel, Besaiel, *Nuper Obiit*, etc.
15.	*Quare ejecit.*	xxx.	*Quare ejecit; De ejectione firmæ.*
16.	Entry.	xxxi.	Entry *ad terminum qui preteriit.*
		xxxii.	Entry, *Cui in vita.*
		xxxiii.	Intrusion.
		xxxiv.	Entry for tenant in dower.
		xxxv.	Cessavit.
		xxxvi.	Formedon.
		xxxvii.	*De tenementis legatis.*
17.	Miscellaneous group.	xxxviii.	[2]*Ad quod damnum.*
		xxxix.	*De essendo quieto de theolonio.*
		xl.	*De libertatibus allocandis.*
		xli.	*De corrodio habendo.*
		xlii.	*De inquirendo de idiota ; De leproso amovendo*, etc.

[1] Here come two chapters of statutory appendix.
[2] Here begins a long appendix, consisting mainly of documents that may be called administrative.

xliii.	Presentations by the king, etc.
xliv.	*De manucaptione et supersedendo.*
xlv.	*De profero faciendo; De mensuris et ponderibus.*
xlvi.	*De carta perdonacionis se defendendo.*
Appendix.	*De indempnitate nominis.* Statutory writs; *Decies tantum*, etc.

A Register from the end of the fourteenth century is in point of form the Register that was printed in Henry VIII's day. If I might revert to my architectural simile, I should say that the cathedral as it stood at the end of Richard II's reign was the cathedral in its final form; some excrescent chantry chapels were yet to be built, but the church was a finished church and was the church that we now see. In the printed book we can detect but very few signs of work done under Tudor or even Yorkist kings, and though the Lancastrian Henries have left their mark upon it, still that mark is not conspicuous. I should guess that the last occasion on which any one went through the book with the object of adding new writs and new notes occurred late in the reign of Henry VI[1]. On the other hand we constantly find references to decisions of Richard II's time, and there are many signs that the book was revised and considerably enlarged in the middle of Edward III's reign; allusions to decisions given between the tenth and twentieth years of the last-named

[1] *Reg. Brev. Orig.* f. 12, 31, 58, 288, 289 b, 291, 308, show work of Henry VI's reign.

Register of Original Writs

king are particularly frequent, and we read more of Parning than of any other chancellor. This is a curious point. Robert Parning, as is well known, was one of the very few laymen, one of the very few common lawyers, who, during the whole course of medieval history held the great seal. He held it for less than two years; he became chancellor in October, 1341, and died in August, 1343; yet during this short period he stamped his mark upon the Register. The policy of having a layman (a "layman," that is, when regarded from the ecclesiastical not the legal point of view) as chancellor was very soon abandoned; few if any laymen were endowed with the statecraft and miscellaneous accomplishments required of one who was to act as "principal secretary of state for all departments." But within the purely legal sphere, as manager of the "*officina brevium*," a great lawyer who had already been chief justice may have found congenial work. After all, however, it may be chance that has preserved his name in the pages of the Register; just in his day some clerk may have been renovating and recasting the old materials and thus have done for him what some other clerk a century earlier did for William Raleigh.

During the fifteenth century the Register increased in bulk, but except in one department there seem to have been but few additions made to the formulas of litigation; the matter that was added consisted, if I mistake not, very largely of documents of an administrative kind,—pardons, licenses to elect and other licenses, letters presenting a clerk for admission, writs relating to the management of the king's estates, writs for putting the king's wards in seisin, and so forth, lengthy

formulas which conceal what I take to be the real structure of the Register. As a final result we get some seven hundred large pages, whereas we started in Henry III's day with some fifty or sixty writs capable of filling some ten or twelve pages. The department just mentioned as exceptional is of course the department of Trespass. Here there has been rapid growth; but I do not think that the printed book can be taken as fairly representing the law of the time when it was printed, namely 1531. It draws no line at all between "Trespass" and "Case." The writs that we call writs of "Trespass upon the special Case" are mixed up with the writs which charge assault, asportation, and breach of close, and are very few. Writs making any mention of assumpsit are fewer still, and I think that there is but one which makes the non-feasance of an assumpsit a ground of action[1]. I should suppose that the practice of bringing actions by bill without original writ checked the accumulation of new precedents in the Chancery, and it seems an indubitable fact that the invention of printing had some evil as well as many good results; men no longer preserved and copied and glossed and recast the old manuscripts. But when all is said it is a remarkable thing that a Register which certainly did not contain the latest devices should have been printed in 1531, reprinted in 1595, and again reprinted in 1687. The consequence is that Trespass to the last appears as an intruder. No endeavour has been made to reduce the writs that come under that head to logical order. The forces which have deter-

[1] *Reg. Brev. Orig.* f. 109 b, a writ against one who has "assumed" to erect a stone cross and has not done it.

mined the sequence of these writs seem chiefly those which I have called "chronology" and "mechanical chance"; as new writs, as they were made, were copied on convenient margins and inviting blank pages. There has been no generalization; the imaginary defendant is charged in different precedents with every kind of unlawful force, with the breach of every imaginable boundary, with the asportation of all that is asportable, while the now well-known writs against the shoeing smith who lames the horse, the hirer who rides the horse to death, the unskilful surgeon, the careless innkeeper, creep in slowly amid the writs which describe wilful and malicious mischief, how a cat was put into a dove-cote, how a rural dean was made to ride face to tail, and other ingenious sports. It would be interesting could we bring these Registers to our aid in studying the process whereby Trespass threw out the great branch of Case, and Case the great branch of Assumpsit; but the task would be long and very difficult, because the Registers are so many, and unless we compare all of them our means of fixing their dates are few and fallible. Of course, if the task concerned the history of Roman law it would be performed; but we are fully persuaded, at least on this side of the Atlantic, that our own forefathers were not scientific.

REMAINDERS AFTER CONDITIONAL FEES[1]

IF I venture to criticise a passage in Mr Challis's admirable book on the Law of Real Property, it is not with the intention of disputing anything that he says about the law as it now is, but merely in the interests of antiquarianism. With good warrant, as it seems, he lays down the rule that there cannot be a remainder after a conditional fee. He admits that there is "a somewhat obscure passage in Bracton" to the contrary, but thinks that "the clear and reiterated opinion of Lord Coke, which has the advantage of being manifestly in accordance with general principle, is more than sufficient to outweigh the opinion of Bracton; especially as the latter does not seem to be aware that his opinion, if true, would be a remarkable anomaly" (p. 64). This, we may all agree, is sound legal reasoning; but as to the mere historical question whether, before the passing of the *De Donis*, remainders were limited after conditional fees, I make no doubt that Bracton was right, for such remainders were common enough.

Perhaps the practice of creating them might be traced back even into John's reign. There is a fine of 1192 by which Bartholomew grants land to Mary for her life; after her death it is to "revert" to her son

[1] *Law Quarterly Review*, Jan. 1890.

Remainders after Conditional Fees 175

Hugh or (*vel*) to his heirs begotten on an espoused wife, and if he shall die without an heir begotten on an espoused wife, it is to "revert" to Stephen, brother of Hugh or (*vel*) his heirs (Hunter, *Fines*, Vol. i. p. 34). It was not all at once that men distinguished between "reverting" and "remaining," and we had better lay but little stress on this very early document with its somewhat ambiguous "vel." But before the end of Henry III's reign we may find instances which leave nothing to be desired in the way of precision. At some date before 1269, as is found by an inquest *post mortem*, one *W* gave lands to *T* and the heirs begotten by him, but so that if he should die without an heir begotten by him, then they should remain to his brother *L* and the heirs begotten by him; and if *L* should die without an heir of his body in the lifetime of his sisters *C* and *D*, then they should remain to *C* and *D* and their heirs (Roberts, *Calendarium Genealogicum*, 137). Here is a "strict settlement" made in 1256:—a fine is levied by which land is recognised to be the right of Warin, to hold of Wymund and his heirs to Warin and the heirs of his body; and after his death, if he shall die without issue, to Wymund (No. 2) and the heirs of his body; and after his death, if he shall die without issue, to Reginald and the heirs of his body; and after his death, if he shall die without issue, to Richard and the heirs of his body; and after Warin, Wymund (No. 2), Reginald, and Richard shall die without issue, then the lands shall revert to Wymund (No. 1) and his heirs (*Feet of Fines, Devon*, Hen. III, No. 492).

Having seen a few such settlements, I took up at random a parcel of fines belonging to Edward I's reign,

all earlier than the *De Donis*, namely, a parcel of Hertfordshire fines. Among the first fifty, no less than five contained remainders subsequent to conditional fees. In some cases there are several successive remainders. In some cases it is difficult to say whether the remainders are not contingent; difficult, because we know little about the early history of "the rule in Shelley's case." Take this for example:—To *A*, and *B* his wife, and his son *C*, and the heirs of the body of *C*; but if *C* shall die without an heir of his body, then the lands shall remain to the other heirs whom *A* shall beget on *B*, and if *B* shall die without an heir begotten by *A*, then to the other heirs of *A*. Or again:—To Roger and Nicholas and the heirs of the body of Nicholas, but if he shall die without an heir of his body, or if the heirs whom he shall have begotten shall die without heirs of their bodies (*de se*), then the lands shall remain to the nearest heirs of Roger. Or again:—To Thomas for life, and after his death to John and the heirs of his body; but if he shall die without an heir of his body, or if the heirs whom he shall beget shall die without heirs of their bodies (*de se*) *in the lifetime of Adam and Joan his wife*, then to Adam and Joan and the heirs whom Adam shall beget upon Joan. Or once more:—To Gilbert and the heirs of his body; but if he shall die without an heir of his body, *Agnes living*, then to Agnes for life, and after her death to Simon and the heirs of his body; and if he shall die without an heir of his body, then to Joan and the heirs of her body; and if she shall die without an heir of her body, then to the right heirs of Gilbert (see *Feet of Fines, Hertfordshire*, Edw. I, Nos. 4, 10, 25,

Remainders after Conditional Fees 177

35, 42, 118, 127). It may well be doubted whether the conveyancers of this age were fully alive to the distinction that we draw between vested and contingent remainders. I am inclined to think that if asked they would have said that every remainder after a conditional fee must be contingent. The almost invariable phrase with which they introduce such remainders is "et si forte contigerit," and no phrase could more clearly "import a contingency" than this does. Doubtless they had still many things to learn, but certainly they had learnt that there might be a remainder after a conditional fee.

In passing, I may remark that the "feet of fines" at the Record Office will prove invaluable, if the history of conveyancing is ever to be minutely written. They are precisely dated, well preserved, and admirably arranged, and I think that for the earlier members of the series we may even claim some authoritative value. In Edward I's time they had to be read solemnly in court before at least four justices, and though we must not argue that the court in any way guaranteed the validity of the limitations, still we shall have some difficulty in believing that documents thus publicly brought into open court habitually contained limitations of a kind utterly unknown to the law; they must at least have been very well known to the justices.

One of the most curious instances is that of a settlement made in 1278 by Thomas Weyland, who was already a justice of the Common Pleas and in the same year became Chief Justice. He is famous among our justices because he committed felony and abjured the realm. He held a manor of the Earl of Gloucester.

By fine he recognised this to one Geoffrey of Ashley, who thereupon granted it back to Thomas, Margery his wife and Richard his son, to hold to Thomas, Margery and Richard and the heirs of the body of Richard, so that Thomas and Margery should hold it of the chief lords of the fee during their lives, and after their deaths it should remain to Richard and the heirs of his body to be held of the right heirs of Thomas; and if it should happen that Richard should die without an heir of his body, then it should remain to the heirs male of Thomas begotten on Margery to be held of the right heirs of Thomas; and if it should happen that the said heirs begotten of Thomas should die without heirs of their bodies (*de se*), then it should remain to the right heirs of Thomas to be holden of the chief lords of the fee. This remarkable settlement came before the courts. After Weyland's felony and abjuration, the Earl of Gloucester made a determined effort to upset it, contending that he was entitled to an escheat. The case was so important and unprecedented that it was heard before the whole council, the justices of both benches and the barons of the exchequer, who finally after many doubts, which are stated on the Parliament Roll, upheld the fine (Rolls of Parliament, 1. 66). The validity of the remainders was not the point in question, for the wife of the fallen justice was yet living, and the argument for the earl was, to put it shortly, that the settlement was a fraud, a covinous attempt to deprive the lord of his feudal dues; but still we here see what a judge of the Common Pleas thought that he could do in 1278; not only could he create remainders after conditional

fees, but he could play some tricks with tenures which seem very odd to us who have the happiness of living under *Quia Emptores*[1].

"It is an indubitable fact," says Mr Challis "that by the common law there did exist a *formedon en reverter* for the benefit of the donor, as is expressly stated in the statute *De Donis*; while there did not exist a *formedon en remainder* in respect of conditional fees." But really there are two facts here: the former, the existence of the *formedon en reverter* is indubitable, while the latter, the non-existence of the *formedon en remainder* seems to me extremely doubtful. Certainly that writ was not expressly given by the statute, and no word in the statute implies that it is wanted. There are so many yet extant copies of the Registrum Brevium as it stood before the *De Donis*, that I should not like to speak confidently as to their contents. But even suppose we grant that there was as yet no "writ of course" suited to this case, this would prove but little, for in Henry III's reign the Chancery held itself very free to issue "brevia formata," writs adapted to special cases. Thus throughout the reign writs of trespass are occasionally found; but there seems to be strong evidence that they did not become "writs of course" until the last years of the reign. I cannot but believe that the conveyancers of the time knew their own business, and were not devising futilities when they limited remainders after conditional fees. The fines upon which I place reliance are obviously not the work of laymen, but of trained lawyers, and at the very least

[1] My attention was drawn to this case by Mr Cyprian Williams.

they prove "a general opinion in the profession" that such remainders were sanctioned by law.

It may be allowed me to add that our use of the word "remainder" is apt to suggest a false view of history. It may seem to us that a remainder is what remains when a smaller estate has been deducted from a larger. Were this the origin of the term it would be difficult to explain why we do not give the name "remainder" to reversions; for surely a reversion is what remains when a smaller estate has been deducted from a larger. But if we look at the documents of the thirteenth century we soon see that the word "remanere" did not express any such notion of deduction or subtraction. The regular phrase is that "after the death of *A*," or "if *A* shall die without an heir of his body," then "the said land" or "the said tenements shall remain to *B*," that is, shall await, shall abide for, shall stand over for, shall continue for, *B*. We may compare the then common phrase "loquela remanet," the parol demurs, the action stands over until some one is of age or some other event happens; or, to use a form of speech not yet forgotten, the action "is made a remanet." The term "remainder" does not therefore at this time serve to express that quantitative conception of "an estate" which is so remarkable a feature in the real property law of a somewhat later time, the conception that an estate has size, that, for example, a fee tail is larger than a life estate but smaller than a fee simple, that small estates may be "carved" out of larger estates. There seems to me to be no proof that such an idea had ever entered the head of Bracton or of any contemporary lawyer. They had not even the

terms in which to express it. In Bracton's mouth the word *status*, so far from being equivalent to the *estate* of our real property law, has no reference to proprietary rights, but means personal condition, means that which modern lawyers, having appropriated *estate* for another use, are once more obliged to call *status*. As the art of conveyancing develops, as new kinds of limitation are devised, we can see the word *status* and its French and English equivalents changing their meaning; instead of speaking simply of the land which their ancestors held, men are obliged to speak of their ancestors' estate (*status*) in the land, and more and more the word gets involved in those complexities of the land law which "the estates of the realm" suffer to exist. It may therefore be doubted whether even Mr Challis would succeed in convincing Bracton that his opinion about remainders was "a remarkable anomaly"; at least he would have to begin with some instruction in the very rudiments of the law. If he began by speaking of "the quantum of an estate in fee," the benighted old gentleman would, I fear, reply that a *feodum* is not a *status*, and that neither a *feodum* nor a *status* can be said to have quantity. The calculus of estates has not yet been invented.

THE "PRAEROGATIVA REGIS[1]"

Dr E. F. Henderson has raised[2] an interesting question, and one which, if I am not mistaken, has never received that full discussion which it deserves. What is the date and what is the nature of the document which passes under the title "Praerogativa Regis"? It used to be printed as a statute of the seventeenth year of Edward II. This, as I believe, was due to a mere accident. The lawyers of the later middle ages in their manuscripts drew a line between the "Statuta Vetera," which ended with the end of Edward II's reign, and the "Statuta Nova," which began with the beginning of Edward III's reign. Between the two, like an apocrypha between the two testaments, they inserted a group of documents about the date and the character of which they were uncertain, and among these documents the "Praerogativa Regis." Then, when the time for printing had come, the position in which these documents were found gave rise to the inference that they were statutes of some year late in the reign of Edward II. Now to this inference there is an objection which seems insuperable. A statute of Edward II's reign—an important statute,

[1] *English Historical Review*, April, 1891.
[2] *Ibid.* v. 753 (October, 1890).

if statute it were—would be upon the statute roll; but the "Praerogativa Regis" is not upon the statute roll, but has to be discovered in mere private manuscripts. Therefore I can agree with Dr Henderson when he rejects this date, but when he would make the document in question a statute of Henry III's reign then I most respectfully differ from him. It seems to me no statute, but a tract written by some lawyer in the early years of Edward I. May I be allowed to say a few words in defence of this opinion?

In the first place, throughout the whole document there is no word of command, nothing about "ordaining" or "establishing," nothing about "I" or "we," no reference to the quarter from which it proceeds. It is just an objective statement of the king's rights; the king shall have this, the king shall have that. Was ever any other English statute couched in such a form? I think not. Another question: Does any other statute condescend to tell stories? Here we have a story about the heirs of John of Monmouth (c. 14), and another story about the widow of Anselm Marshall (c. 15). But let us look at the matter more closely, taking as our guides Bracton, who wrote somewhere about 1255, Britton and Fleta, who wrote somewhere about 1290.

The first seven chapters afford me no matter for remark, save that in the fourth there is mention of "King Henry, father of King Edward." How Dr Henderson would deal with this passage I cannot guess; perhaps he regards it as an interpolation, for he can hardly endow Henry III with a spirit of prophecy. To my mind this passage tells us plainly that the document was written after Henry's death,

and also, though less plainly, that it was written during the life of his son.

The eighth and ninth chapters deal with alienations made by the king's tenants in chief and state a doctrine intermediate between that of Bracton on the one hand and that of Britton and Fleta on the other. It would be long to discuss this matter minutely, but the subjoined references[1] will show that while in Bracton the king's claim to check the alienations made by his tenants in chief goes hardly beyond the well-known provision of the charter of 1217, Britton has nearly and Fleta has quite arrived at the broad principle of later law—namely, that no tenant in chief of the crown can alienate the whole or any part of his tenement without the king's consent. Now in this respect our "Praerogativa" stands nearer to Bracton than to Fleta. No one who holds of the king in chief *by military service* may alienate *the greater part* of his land without royal licence; "but this is not wont to be understood" concerning "members and parcels of the same lands." Raising by the way the question whether statutes often tell us what "is wont to be understood," I here find a reason for saying that this document lies between Bracton and Fleta.

The eleventh chapter introduces a very curious topic, the king's rights in the lands of "natural fools." I believe that of these very valuable rights there is no trace in Bracton[2]; on the other hand Britton and Fleta know them well[3], and so far as my knowledge goes they begin to appear in the reign of Edward I. But,

[1] Bracton, f. 169*b*, 395; Britton, I. 222; Fleta, p. 178.
[2] See Bracton, f. 420*b*. [3] Britton, II. 20; Fleta, p. 6.

The "Praerogativa Regis" 185

further, Britton has a tale to tell of them, and a tale that I have never seen properly explained[1]. Speaking of a somewhat technical point in the law of guardianship, he touches on a case in which the lord, who otherwise would be guardian, is deprived of his usual rights by the fact that the heir is a natural fool. This rule, he says, was laid down by Robert Walrond, with the common assent of the magnates of the land, "and in his heir and the heir of his heir the statute first took effect." Robert Walrond, of course, is the person of that name who, as a royal judge and royal favourite, played a considerable part in "the misrule of Henry III." He pronounced the sentence of Winchester which disinherited the rebellious barons, and became rich with the spoil of those whom many regarded as national heroes and martyrs. He died in or about 1272. Coke, who did not know the fact that I am going to state, supposed that Britton's story related to a certain section in the statute of Marlborough (1267), which has to do with wardship, but nothing to do with idiots, and therefore he concocted a fable telling how the biter was bit, how the statute procured by Walrond nullified a certain device whereby Walrond had tried in his own case to evade the law of wardship[2]. I say that Coke concocted a fable, for the simple truth is this: that Walrond left an heir who was an idiot, and that this heir left an heir who was an idiot. That is what Britton means. The king's rights in the lands of idiots have their origin in some statute or ordinance issued on the advice of Walrond, and this first took effect in his heir and the

[1] Britton, I. 243.
[2] *Second Inst.* 109, a comment on Stat. Marlb. c. 6.

heir of his heir. I am not sure that Britton thought that the biter had been bit. It may be that Walrond foresaw that his heir would be an idiot; he had no children, and his brother's son, his heir presumptive, was, in Britton's language, "un soot." He may deliberately have preferred that his land should fall into the hands of his good friend the king rather than that it should fall into the hands of his lords, some of whom, like enough, had been his mortal enemies. For this was coming to be the choice; if an idiot was to be treated as an infant, then the idiot holding by military tenure would be in life-long wardship to his lord. Better the king than the lord[1].

Fleta also treats the king's profitable guardianship of idiots as the outcome of a recent statute[2]. Formerly, he says, the "tutores" of idiots used to be the guardians of their lands; this was in accordance with principle, for idiots are *quasi* infants; but many were thus disinherited, and therefore it was provided by common consent that the king should have the wardship of all born fools. There can, therefore, in my opinion, be little doubt that about this matter there was legislation in which Robert Walrond took part, and we

[1] I cannot pretend to any skill in genealogies, but the story seems to be this: In 1 Edw. I (1272–3) Robert Walrond was dead; his heir was Robert the son of his brother William; Robert was then about seventeen years old (*Cal. Genealog.* p. 194); he was an idiot (*ibid.* p. 706; *Rot. Parl.* 196), and from him the lands descended to his brother John, who was also an idiot; after John's death there was a great lawsuit between rival claimants (*Placit. Abbrev.* pp. 309, 310). The date of the first idiot's death I have not ascertained, but it occurred in Edward I's reign.

[2] Fleta, p. 6.

The "Praerogativa Regis"

must ascribe the new law to the last years of Henry III. Our "Praerogativa" then, was compiled after that change.

In its fourteenth chapter we have a story from Henry III's reign. John of Monmouth died; his heir was an alien, a Breton, and King Henry took his land. In the fifteenth we have another story from the same reign. On the death of William, Earl Marshall, his brother and heir, Anselm, entered on the lands that had descended to him without first doing homage to the king; he then died, and it was adjudged that his widow, Maud, daughter of the earl of Hereford, should have no dower, for her husband had entered as an intruder on the king. John of Monmouth I take to be the bearer of that name who died in or shortly before 1257[1]; he seems to have left as heiresses two aunts, who were of the family of Waleran. The tale about the Marshalls is not quite correctly told by this so-called statute. The inheritance did not pass immediately from William to Anselm; as is well known it came to five brothers in succession, of whom William was the eldest and Anselm the youngest; Anselm died in 1245, and his widow, Maud, died in or shortly before 1252[2]. These stories about what happened in the middle of the thirteenth century would hardly have been very interesting to lawyers in the fourteenth, when they would have been regarded as antiquated illustrations of well-established legal rules. That Edward II's parliament was at pains to tell them I should not easily believe.

We come to the chapter on which Dr Henderson

[1] *Cal. Gen.* p. 73; Courthope, *Historic Peerage*, p. 325.
[2] *Excerpt. e Rot. Fin.* I. 143.

relies. The king is to have year, day, and waste of the felon's land; the tenement is to be actually wasted. Britton mentions the wasting as a thing of the past; upon this Dr Henderson founds an argument that the "Praerogativa" comes from Henry III's day. But why, I must ask, may it not come from the early years of Edward I? Britton did not write until 1290 or thereabouts; at least his book as we have it was not written until then. This leaves some seventeen years during which the change in the law, if change there was, may have taken place, without our being driven to suppose that a document which mentions King Edward was written before his accession.

In Edward III's reign those who held that the "Praerogativa" was a statute believed it to be a statute of Edward I; but there were others who said that it was no statute at all, but a mere "rehearsal" of the common law[1]. Throughout the middle ages it never obtained an unconditional acceptance as part of the written law of England. In 1475 all the great lawyers seem agreed that it is no statute[2]. Littleton in particular is clear and emphatic. It is an "affirmance of the common law, for every statute mentions the date at which it was made, but this document is dateless; it is not a statute, no more than the 'Dies Communes in Banco,' the 'Dies Communes in Dote,' and the 'Expositiones Vocabulorum' are statutes. They are written in our books, but they are not statutes." Then Littleton tells how "my lord Markham" had disregarded the words of the "Praerogativa," and so, he

[1] Y. B. 43 Edw. III, f. 21 (Trin. pl. 12).
[2] Y. B. 15 Edw. IV, f. 11 (Mich. pl. 17).

The "Praerogativa Regis" 189

repeats once more, "it cannot be called a statute." What exactly these judges meant when they said that the document was a "rehearsal" or an "affirmance" of the common law is not in all cases very plain. But Littleton puts it on the same level with two documents fixing the "delays" which are to be given in actions—documents which perhaps may be described as "rules of court"—and with another document which certainly had no authoritative origin—namely, the "Expositiones Vocabulorum," a belated and not too intelligent attempt to give some certain meaning to *sake, soke, toll, theam*, and other Anglo-Saxon law words. Littleton very probably thought that great respect was due to the "Praerogativa"; it was a venerable statement of common law, and perhaps he believed that it had been issued by some person or body of persons having power to make statements of law which should command the respect of the justices; but certainly he did not think that its very words were law as the very words of a statute would be law. Markham had disregarded them, and Littleton was ready to do the like.

Whether it be purely private work or no I will not take on me to decide; it may have been a document issued by the king to his serjeants, possibly to his judges, instructing them as to the king's views of his own rights (at every doubtful point it leans towards royal claims); but at least I think that we ought to agree with Littleton, *ceo ne poet estre dit come un statute*.

A CONVEYANCER IN THE THIRTEENTH CENTURY[1]

AMONG the monuments of the legal industry of the great age which saw English law becoming a science, the age of Edward I, there are, I am assured, many collections of precedents in conveyancing, which await an editor. Lately, while looking for other things, I happed on three in our Cambridge Library: they are contained in the MSS. Ee. i. 1 (f. 225), Dd. vii. 6 (f. 55), Mm. i. 27 (f. 78). The first and third of these seem to belong to the period before the Statute *Quia Emptores*; the second is a little later. Of the first I may be allowed to say a few words. The book in which it is found belonged to the monks of Luffield Priory, which stood on the border between the counties of Buckingham and Northampton. It purports to be a work composed by one John of Oxford, and we may gather from its contents that John of Oxford became a monk at Luffield. It begins with a short preface touching the desirability of having written evidence of legal transactions—"Cum humana condicio vergat ad decliue et generaliter loquendo proniores sunt homines ad malum natura carnea quam

[1] *Law Quarterly Review*, January, 1891.

A Conveyancer in the Thirteenth Century 191

ad bonum," and ends thus: "Explicit modus, et ars componendi cartas, cyrograffa, convenciones, obligaciones, testamenta, litteras presentacionum ecclesie, et institucionum, suspencionum, certificacionum, edicionum et literarum dimissoriarum et litterarum pro pecunia patri a[1] scolari destinatarum[2] secundum Johannem de Oxonia et similiter quietarum clamacionum et manumissionum. Explicit expliciat, ludere scriptor eat." Let us see what forms this ancestor of our Jarmans and Davidsons thought profitable for mankind, and let us not omit to notice any dates that occur :—

1. Charter of feoffment in fee simple "tenendum de me et heredibus meis."

2. Alia carta que tangit condiciones utiles emptori. Charter of feoffment "tenendum dicto J. et heredibus suis vel cuicumque vendere legare vel assignare voluerit."

3. Charter of feoffment for life.

4. Charter of feoffment in frank almoign.

5. Carta de domo religiosa seculari concessa. Brother J. Master of the Hospital of S. John of Oxford and the brethren of the said place make a feoffment of land in the parish of All Saints, Oxford, to R. F. his heirs and assigns save Jews and any other religious house.

6. Carta de libero maritagio: to the husband and the heirs that he shall have by my daughter whom I have given him to wife, and in case she shall die without an heir *de se*, the land shall return from the husband to me, my heirs or assigns.

[1] pro pecunia pat'a (MS.). [2] destinatorum (MS.).

7. Carta de dote libera. I have given certain land to my wife by way of dower for her life.

8. Quitclaim to W. et heredibus suis et cuicumque vendere, dare, legare, vel assignare voluerit in perpetuum.

9. Another quitclaim supposed to be made by J. of Oxford.

10. Carta de maritagio. Feoffment of a burgage in municipio Oxonie to hold to husband and wife and their heirs proceeding from the wife. If the wife dies without an heir *de se* I will that the land revert to me my heirs and assigns without any contradiction on the part of the husband.

11. Carta de empcione redditus et servicii.

12. Carta specialis de vendicione terre...tenendum de me et heredibus meis sibi et heredibus suis et cuicumque et cuilibet dare vel legare vel assignare et quandocunque et ubicumque dimittere voluerit tam in prosperitate quam in egritudine excepto loco religionis et judeissmo.

13. Carta de confirmacione vicarie.

14. Sale of a villain for the purpose of manumission. I have granted and quitclaimed to H. my "native" R. with his progeny (*sequela*) and all his chattels for ever, for 10 marks of silver.

15. Consequent manumission. H. now manumits R. whom he purchased from A. B., and for further assurance hands over the deed of purchase.

16. Sale and manumission of a villain effected by a single deed. B. grants to W. one R. with his chattels and a virgate of land held by him in servitude in order that W. may manumit R. and make him free, "so that

Thirteenth Century

he with his whole suit and all the things aforesaid may remain a free man, rendering to me and my heirs 10 shillings a year." For this grant B. has received 10 marks from W.

17. Lease dated 1272. A conventio by which A. demises to W. all his land at Preston with the manor thereto belonging, to hold to him his heirs and assigns for 10 years at a rent of a pair of gloves or 6d., W. having given to A. £30 to deliver his land from the Jews. The lessee is to repair.

18. Alius modus cyrographi. Dated 1274. Lease for ten years of land with a manor and farming stock, which is valued; tenendum to the lessee his heirs and assigns for the said term; rent of ten shillings; £100 paid by lessee to lessor for this lease. The lessee finds pledges for the fulfilment of his obligation. Both parties pledge faith. Instrument executed in duplicate.

19. Cyrographum de acris terre. Dated 1274. Lease of an acre of arable land and half-acre of meadow for ten years. In the parcels the "aqua que vocatur Charewelle" is mentioned.

20. Cyrographum de burgagio dimisso ad firmam. Dated 1274. Demise of a burgage in the High Street (*magna strata*) and the parish of All Saints, Oxford; tenendum by the lessee his heirs and assigns for twenty years; rent twenty shillings. Lessor is to do the repairs; if the house falls down he will rebuild it; if lessee has to spend money on repairs he may hold the premises until he has been satisfied for his expenditure according to the view and award of good and lawful men.

21. Forma obligacionis de pecunia mutuata. In

respect of certain loans and purchases which took place in 1274, I am bound in certain sums to W., "vel suis certis procuratoribus vel heredibus suis vel executoribus hoc scriptum presens habentibus si de eo, quod absit, humanitus contigerit," to be paid by certain instalments, under penalty of twenty shillings to be paid to the fabric of the church of S. Mary at Oxford, and of twenty shillings to the said W. the principal creditor, and of the twenty pence "suo certo nuncio vel procuratori hanc literam defferenti," for their expenses. I have bound myself to this "fide media," and have found sureties A., B., C., who have constituted themselves principal debtors along with me for the said monies. We submit ourselves to the judgment of any court, whether spiritual or civil, chosen by the creditor. We submit to be excommunicated by the bishop or to be distrained in all our movables and immovables by the king's bailiffs; any goods taken in distress may be sold in our absence; the bailiff making the distress may have twenty shillings for his pains; the custodian of the crusaders in such a bishopric for the time being shall have twenty shillings of our goods for the aid of the Holy Land if we make default in payment of any instalment. We renounce the privilege of crusaders and every cavil, more especially the king's prohibition. We grant that the creditor or his proctor shall be believed without making oath.

22. Obligation by the Prior of Luffield and his Convent. We have sold to Alexander le Riche of Brakele all our wool, to be delivered to him or his attorney at the shearing in 1272. If we make default

Thirteenth Century 195

we subject ourselves to the jurisdiction and coercion of the Archdeacon of Northampton or of Buckingham, whichever Alexander may prefer, that he may compel us from day to day by ecclesiastical censure, until we satisfy Alexander by delivering the wool and paying costs and damages. Dated Luffield, 1st Aug., 1271. Note that two witnesses with the tabellio or notary are enough for a bond; for a chirograph there should be four; for a charter seven or nine, but at any rate an uneven number.

23. Forma obligacionis de ecclesia dimissa ad firmam. Dated 1272. Lease by rector to chaplain of land and tithes in Preston for four years. Lessee submits to ecclesiastical jurisdiction and renounces divers privileges, including royal prohibition.

24. Obligacio denariorum. Short bond. I am bound to R. in sixty shillings to be paid to him or his certain attorney bringing these letters, within a fortnight after 1st Aug., 1274, and I am bound to pay any damages and expenses to which he shall be put.

25. Modus componendi testamentum. Anno gracie 1274 coram domino Willelmo presbitero ecclesie Omnium Sanctorum, A. de B. et B. de C. vicinis meis et coram aliis ibidem existentibus, et hoc audientibus et videntibus, ego J. de N....condo testamentum in hunc mundum [corr. *in hoc modo*]. Various pecuniary legacies to pious uses, to the poor, &c., to marry my daughter, to my servant, for the repair of bridges. All my household utensils to be divided between my heir and my wife. Appointment of A., B., C., D. executors. " Et ut hoc firmum sit et stabile tam ego

quam predicti executores mei scriptum istud sigillorum nostrorum munimine roboravimus." Schedule of debts owed to and by the testator. (Note that the executors are present when the will is made and seal it.)

26. Alius modus testamenti. I., J. of Oxford, clerk, on Tuesday next, after the feast of S. Edmund A.D. 1274, make my testament. Pecuniary legacies to pious uses, and six marks to my mother. No residuary gift. Reference to the last precedent for the concluding formula.

27. Litera presentacionis ecclesie per patronum episcopo.

28. Presentacio ab episcopo ad decanum. R. bishop of Lincoln in the fifteenth year of his pontificate[1] addresses the Dean of Oxford, directing him to see whether a certain church is vacant.

29. Litera patens institucionis by R. bishop of Lincoln in the fourteenth year of his pontificate.

De episcopo ad decanum pro eodem.

Litera patens de decano pro eodem.

30. Litera certificacionis super ordinibus.

31. Litera citacionis by the Official of the Archdeacon of London. Dated 1271 in the church of S. Mary at Oxford.

32. Litera certificacionis super eodem; testifying that a citation has been made.

33. Litera suspencionis ab ingressu ecclesie.

34. Litera absolucionis.

35. Adam Prior of Luffield and his convent appoint "our beloved in Christ John of Oxford com-

[1] Richard of Gravesend was consecrated Bishop of Lincoln in 1258.

monachum nostrum" to be our procurator; giving him large and general powers.

36. Adam Prior of Luffield and his convent appoint their fellow monk, brother John of Oxford, to be their proctor in proceedings before the bishop of Lincoln. Given at Luffield on Tuesday next after the feast of S. Lucy A.D. 1273.

37. Litera procuracionis.

38. Litera edicionis. Ecclesiastical plaint of C. against N.; C. has been transcribing a book for N.; he was to be paid according to the estimate of good men; N. has broken the agreement; C. seeks justice.

39. Precedent for a letter by an Oxford student to his father.

40. Litera warantizacionis. The Master of the Temple announces that R. de F. the bearer of these letters, "our merchant and tenant," is travelling for our business and is therefore to be quit of tolls and tallages.

41. Litera acquietacionis. Release for a bailiff who has rendered his accounts.

42. Adam Prior of Luffield and his convent pray Oliver bishop of Lincoln to admit to priest's orders the bearer, namely, Walter of Mursele, deacon.

43. Adam Prior of Luffield excuses himself to the Archdeacon of Buckingham for not attending a synod at Aylesbury.

In its present form the treatise cannot be older than the year 1280, for it mentions Oliver bishop of Lincoln. This must be Oliver Sutton, who was consecrated in that year. The document in which Prior Adam is supposed to appoint John of Oxford proctor

for the convent may cause us some little difficulty, for it is dated in 1273, while the only Prior Adam of whom we can hear presided over the monastery from 1279 to 1287[1]. But many of the instruments are supposed to bear a somewhat earlier date, and at any rate I think it clear that the book belongs to the earlier years of Edward I's reign:—the Jews are still in England, and *Quia Emptores* is still in the future.

Now there are a good many points in this book on which at a proper time and place a commentary might be hung. Thus there is the attempt to make freehold land devisable "per formam doni," that is to say, to give the donee a power of devising it by making the gift to him his heirs and devisees. I am persuaded by Bracton's vacillating language[2], by a precedent that I have found in another collection, and by several actual deeds that I have seen, that this attempt very nearly succeeded, that the power of devise given by the Statutes of Henry VIII and Charles II was very nearly won in the middle of the thirteenth century. Then again when a lease of land is made for a term of years, it is made to the lessee "his heirs and assigns"; this however will surprise nobody who has looked at the earlier Year Books. Then again the manumission by way of sale is very interesting; this also I have seen in another collection. But on the whole the most curious documents are the bonds, the most curious because as yet no one has thought worth while to investigate the mercantile law of this period. The ordinary mercantile bond of the thirteenth century, if the transaction is a big one, is often a very elaborate

[1] *Monasticon*, IV. 346. [2] Bract. f. 18 b; 49; 412 b.

Thirteenth Century

affair, and in order to understand it we ought to know something of three different systems of law, the English Common law, the mediaeval Roman law, and the Canon law, for the obligor is made to submit himself to every conceivable jurisdiction English and foreign, temporal and spiritual. He has to renounce all manner of "exceptiones" given by Roman or given by Canon law, besides renouncing the writ of prohibition and submitting to extra-judicial distraint by the sheriff. Very curious too are the manifold devices by which the sin of usury is evaded, penal stipulations in favour of the relief of the Holy Land, or in favour of the building of Westminster Abbey, and agreements to accept the creditor's unsworn estimate of the "damages and costs" that he has been put to by being kept out of his money. The conveyancer of Henry III's day ought to have known a little of several kinds of law. When he drew a will he drew a document the validity and interpretation of which would be a matter for the ecclesiastical courts, and when he drew a bond he drew a document which he hoped would hold good by whatever law it might be tested. This leads me to venture a guess: Had Brother John been studying or teaching the art of draftsmanship in the learned city whence (perhaps not until he got to Luffield) he took his name? At Oxford of course Roman and Canon law were being read, and the latter at all events was not studied merely as a scholastic exercise but as a matter of practical importance, a "bread-and-butter science" if you will. Also it must have been almost necessary for every large monastery to have among its members some one who could readily draw all the documents of

common use in the management of large estates and the transaction of mercantile affairs. Some houses were deeply engaged in the wool trade, constantly making elaborate bargains with Lombard merchants; all must have been glad of a brother who at short notice would draw a charter of feoffment, a will, a lease, a mortgage, besides being familiar with those "briefs, citations, and excommunications" of which our Prayer Book still speaks. People must have been taught these things, and why not at the great seat of learning?

But I am keeping to the last by way of plum the most striking testimony to the connection of this book with University life. I have said that among the precedents there is one for a letter to be written by a student to his father—a letter asking for money, an old, old form of "common assurance," perhaps the oldest and the commonest. Once more I place it at the disposal of the studious but impecunious youth, premising that here and elsewhere the scribe of this Cambridge MS. has shown himself to be a careless workman.

Metuendo patri suo domino R. de B.—P. filius suus studens Oxonie pro salute famulatum in omnibus filialem. Precepit mihi vestra paternitas reverenda in discrecione mea ut statum meum et eventus mihi contingentes quam cicius possem vobis propallare. Quare vestre paternitati tremende post deum unico refugio, singulari me[e] miserie fulcimento parens, breviter ad presens significo me in optimo statu tam sanitatis anime quam corporis existere quod de vobis et karissima genitrice mea et domina, sororibus et aliis amicis

meis plus corporeis oculis intueri quam audire desidero.
Cum autem honestum sit studentis propositum, et artes
liberales ejus intencio intendat adipissi [*sic*], pro hoc
a patre largius meretur subveniri, unde paternitatem
vestram, de qua non modicam reporto fiduciam, dignum duxi deprecandam[1] et ea qua possum devocione
attencius supplicandam quatinus mihi vestro indigenti,
numismate carenti [*Angl.* in want of coin,] studium
exercenti, nihil quid[2] temporale lucranti, consilio et
auxilio destituto, nisi vestra mihi solita cicius suspiraverit benivolencia ad erudicionis mee sustentacionem,
quod[3] sederit vestro beneplacito[4] conferre dignemini,
in presenti facto taliter provisuri ne pro tali defectu
scolas relinquere, tempus amittere, domumque redire
compellar. Vivite, gaudete semper sine fine, valete.

[1] deprecandum (MS.).
[2] n¦l q̄ (MS.).
[3] The usual abbreviation of *quod*.
[4] beneplacita (MS.).

A NEW POINT ON VILLEIN TENURE[1]

In this paper, which was read before the Economic Section of the British Association at its meeting in 1890[2], Mr Ashley, who in his little book on Economic History has given the best popular sketch of "the Manor and Village Community" that has yet been published, discusses a few points in the history of villeinage. As regards remote times, he seems to be now more decisively inclined than he was three years ago to accept Mr Seebohm's theory, but seems to have no new evidence to offer. As regards the thirteenth century, he "purposely omits all reference to Bracton," on the ground that "so long as we are without a critical edition, and unable to distinguish Bracton's text from later accretions, it is possible to support by his authority almost any opinion as to villein tenure." This, as we think, goes much too far. No one has a worse opinion of the vulgate text of Bracton than that which we hold; but still, though a few details may be doubtful, Bracton's general theory of villein status and villein tenure becomes clearer,

[1] *Law Quarterly Review*, January, 1891.
[2] "The Character of Villein Tenure," by W. J. Ashley (*Annals of the American Academy of Political and Social Science*, Jan. 1891).

more definite, and more consistent every time that one reads it, and (at least so it seems to us) proves beyond doubt that early in Henry III's reign the king's judges were within an ace of granting to the free man who held in villeinage that protection of common law and royal justice which—the opportunity having once been lost—he did not gain for some centuries afterwards. For how many centuries afterwards? —in other words—When was it that the copyholder acquired an action against his lord? Now it is on this question of comparatively recent history that Mr Ashley has something to say that seems to us new and startling. We all know the famous section of *Littleton's Tenures* (sec. 77), which enshrines the dicta of Danby and Brian, and probably we have all been wont to think that those dicta solved a great question for good and all. But did Littleton write that section, or rather the latter half of it? "This passage does not appear either in an edition of Littleton printed about the year of his death, or in the issues of Pynson in 1516 and 1525. It occurs for the first time in the edition of Redmayne in 1530." This opens a very serious question, one upon which we shall not be in a hurry to make up our minds; and though we are not very favourably inclined towards Mr Ashley's explanation of the celebrated dicta as the attempts of Yorkist judges to gain favour with the poorer sort by whom their master was supported, still true it is that these dicta were, if the phrase be allowed us, as *obiter* as dicta could be, and if the Year Books fairly represent this matter, they long remained isolated dicta. We must confess that at the moment we have

no answer ready for Mr Ashley, and that in our opinion one more point in our legal history must now be considered doubtful. On the other hand, we think that Mr Ashley has made too light of the customary heritability of customary estates. It is quite true that some of the great religious houses were careful to prevent the dead tenant's heir from succeeding his ancestor. Thus, for example, in the lately published *Literae Cantuarienses* we find the monks of Christ Church in 1340 resisting an attempt of their villein tenants to establish a customary inheritance; and if in recent days the Dean and Chapter of Durham have had no copyholders, while the Bishop has had plenty, this seems due to the fact that the corporation aggregate was more far-sighted than the corporation sole, that the Prior and Convent enforced the rule that there should be no inheritance of their *bondagia*. Still in Court rolls of the thirteenth and fourteenth centuries, it is common enough to find a demandant claiming a villein tenement by inheritance "according to the custom of the manor," and alleging descent from heir to heir with all the same strict accuracy that would have been required of him had he been a freeholder pleading before the Common Bench. However, Mr Ashley's great point is, to our minds, the point about Danby, Brian and Littleton, and we are very glad that he has made it.

FRANKALMOIGN IN THE TWELFTH AND THIRTEENTH CENTURIES[1]

At the beginning of the thirteenth century a large and ever-increasing quantity of land was held by ecclesiastics, regular and secular, in right of their churches or religious houses by a tenure commonly known as frankalmoign, free alms, *libera elemosina*. The service implied by this tenure was in the first place spiritual, as opposed to secular service, and in the second place it was an indefinite service. Such at least was the doctrine of later days[2]. We may take this latter characteristic first. At all events, in later days[3] if when land was given there was a stipulation for some definite service albeit of a spiritual kind, for example a stipulation that the donee should sing a mass once a year or should distribute a certain sum of money among the poor, the tenure thus created was called, not frankalmoign, but tenure by divine service; the tenant might perhaps be compelled to swear fealty to his lord, and the performance of the service might

[1] *Law Quarterly Review*, October, 1891.
[2] But in 13 Edw. I (Fitz. Abr. *Counterple de voucher*, 118) it is said that frankalmoign is the highest and *most certain* of all services.
[3] Lit. sec. 133–8.

be exacted by distress or by action in the king's courts[1]. On the other hand, if the tenant held in frankalmoign, if the terms of the gift (as was often the case) said nothing of service or merely stipulated in a general way for the donee's prayers, then no fealty was due and only by ecclesiastical censures could the tenant be compelled to perform those good offices for the donor's soul which he had impliedly or expressly undertaken. Perhaps this distinction was admitted during the later years of the period with which we are now dealing; but we shall hereafter see that in this region of law there was a severe struggle between the temporal and the ecclesiastical courts, and very possibly an attempt on the part of the former to enforce any kind of service that could be called spiritual would have been resented. The question is of no very great importance, because stipulations for definite spiritual services were very rare when compared with gifts in frankalmoign[2].

Here, as in France, the word *elemosina* became a technical word, but of course it was not such originally. At first it would express rather the motive of the gift

[1] See the writ *Cessavit de cantaria*, *Reg. Brev. Orig.* 237 b, 238.

[2] A few instances of such definite spiritual services may be found already in Domesday, *e.g.* II. 133, 133 b, a tenant was to sing three masses every week. Gifts for the maintenance of lamps before particular altars and the like are not uncommon, and often they expressly say that the land is frankalmoign, *e.g. Reg. St Osmund*, I. 234 (1220–5), a gift of land to the church of Sarum in pure and perpetual alms to find a taper to burn before the relics on festivals. Sometimes it would have been difficult to draw the line between "certain" and "uncertain" services, as when land was given that its rents might be expended "tam in reparanda ecclesia quam in majoribus necessariis ecclesiae," *Reg. St Osmund*, I. 350.

than a mode of tenure that the gift creates. And so in Domesday Book it is used in various senses and contexts. In some cases a gift has been made by the king "in elemosina," but the donee is to all appearance a layman; in one case he is blind, in another maimed; he holds by way of charity and very possibly his tenure is precarious. To hold land "in charity" might well mean to hold during the giver's pleasure, and it may be for this reason that the charters of a later day are careful to state that the gift has been made not merely in alms but "in perpetual alms[1]." Then again in some parts of the country it is frequently noted that the parish priest has a few acres "in elemosina"; in one case we learn that the neighbours gave the church thirty acres in alms[2]. There are, however, other cases in which the term seems to bear a more technical sense;

[1] D. B. I. 293, "In W. tenet quidam cecus unam bovatam in elemosina de rege"; IV. 466, "Tenuit Edritius mancus in elemosina de rege Edwardo." In Dorsetshire, under the heading "Terra Tainorum Regis" (I. 84), we find "Hanc terram dedit Regina Dodoni in elemosina." In Devonshire, under the like heading (118), we find "Aluuard Mert tenet dim. virg....Regina dedit ei in elemosina." In Hertfordshire (137 b) we read how a manor was held by two thegns, one of whom was the man of King Edward, the other was the man of Asgar; they could not sell "quia semper jacuerunt in elemosina." This would seem to mean that they held precariously. See the curious entry, II. 5 b, which tells how Harold gave a hide to a certain priest of his, "set hundret nescit si dedit liberae [*sic*] vel in elemosina"; seemingly the hundred did not know whether the priest's tenure was free or precarious.

[2] D. B. II. 24 b; II. 189, the parish church holds sixty acres of free land "elemosina plurimorum." See the survey of Suffolk where the parish church generally holds some acres "of free land" in elemosina.

some religious house, English or French, holds a considerable quantity of land in alms; we can hardly doubt that it enjoys a certain immunity from the ordinary burdens incumbent on landholders in general, including among such landowners the less favoured churches[1]. And so again in the early charters the word seems to be gradually becoming a word of art; sometimes we miss it where we should expect to find it, and instead get some other phrase capable of expressing a complete freedom from secular burdens[2]. In the twelfth century, the century of new monastic orders, of liberal endowments, of ecclesiastical law, the gift in free, pure, and perpetual alms has a well-known meaning[3].

The notion that the tenant in frankalmoign holds

[1] D. B. I. 25 b, "Clepinges tenet Abbatia de Almanesches de Comite (Rogerio) in elemosina...se defendit pro xi. hidis. ... In eodem manerio tenet S. Martinus de Sais de Comite in elemosina xi. hidas"; I. 58, "Episcopus Dunelmensis tenet de Rege Waltham in elemosina"; I. 166 b, "Ecclesia de Cirecestre tenet de Rege duas hidas in elemosina et de Rege E. tenuit quietas ab omni consuetudine."

[2] Thus when Henry I makes gifts to the Abbey of Abingdon "to the use of the alms of the said church," we seem to get the term in a slightly different sense from that which becomes usual; he may well mean that the land is devoted to those pious works of the Abbey which belong to the almoner's department; *Hist. Abingd.* II. 65, 94.

[3] In comparatively late documents we may still find persons who are said to hold in frankalmoign who are not holding in right of any church. Thus in the *Whalley Coucher*, I. 43, William the clerk of Eccles gives land to his brother John his heirs and assigns, to hold in pure and perpetual alms of the donor and his heirs, rendering yearly a pound of incense to God and the church of Eccles. William's tenure may have been frankalmoign, but according to modern notions John's could not be.

his land by a service done to his lord seems to grow more definite in course of time as the general theory of tenure hardens and the church fails in its endeavour to assert a jurisdiction over disputes relating to land that has been given to God. The tenure thus becomes one among many tenures, and must conform to the general rule that tenure implies service. Still this notion, at least on the continent, was a very old one. A document of 817 contains a list of fourteen monasteries which owe the emperor aids and military service (*dona et militiam*), of sixteen which owe aids but no military service, and of eighteen which owe neither aids nor military service, but only prayers[1]. In English charters it is common to find the good of the donor's soul and the souls of his kinsfolk, or of his lord, or of the king, mentioned as the motive for the gift; the land is bestowed *pro anima mea, pro salute animae meae*. Sometimes the prayers of the donees are distinctly stipulated for, and occasionally they are definitely treated as services done in return for the land[2]; thus, for example, the donor obliges himself to warrant the gift "in consideration of the said service of prayers[3]." Not unfrequently, especially in the older

[1] Pertz, *Leges*, I. 223, 331; Viollet, *Histoire des Institutions*, I. 331. The translation of *dona* by *aids* may be a little too definite.

[2] *Cart. Glouc.* I. 197, "habendum in liberam elemosinam...sine aliquo retinemento ad opus meum vel aliquorum haeredum meorum nisi tantummodo orationes spirituales perpetuas"; *ibid.* I. 199, 289, 335, II. 10. Such phrases are common in the *Whalley Coucher Book*.

[3] *Cart. Glouc.* I. 307, "Nos vero...praedictam terram...per praedictum servicium orationum warantizabimus." The term "consideration" is of course a little too technical, but still the prayers seem regarded as having a certain juristic value.

charters, the donor along with the land gives his body for burial, by which is meant that the donees undertake the duty of burying him in their church[1]; sometimes he stipulates that should he ever retire from the world he shall be admitted to the favoured monastery, sometimes he binds himself to choose no other place of retirement; often it is said that the donees receive him into all the benefits of their prayers[2].

We have spoken as though gifts in frankalmoign were made to men, but according to the usual tenour of their terms they were made to God. As Bracton says, they were made *primo et principaliter* to God, and only *secundario* to the canons or monks or parsons[3]. A gift, for example, to Ramsey Abbey would take the form of a gift "to God and St Benet of Ramsey and the Abbot Walter and the monks of St Benet," or "to God and the church of St Benet of Ramsey and the Abbot and his monks," or simply "to God and the church of St Benet of Ramsey," or yet more briefly "to God and St Benet[4]." The fact that the land was given to God was made manifest by appropriate

[1] Litigations over the right to bury benefactors may be found, *e.g. Register of St Thomas*, Dublin (R. S.), 349, between the canons of St Thomas and the monks of Bective about the body of Hugh de Lacy; also struggles for the bodies of dying men, *e.g.* between the monks of Abingdon and the canons of St Frideswide's, *Hist. Abingd.* II. 175. See also a charter of John de Lacy in the *Whalley Coucher*, I. 33: "Know ye that I have given and granted to the abbot and monks of Stanlaw after my death myself, that is to say, my body to be buried."

[2] For an elaborate agreement about masses and other spiritual benefits, see *Newminster Cartulary*, p. 120.

[3] Bract. f. 12. [4] *Cart. Ramsey*, I. 159, 160, 255, 256.

Frankalmoign

ceremonies; often the donor laid the charter of feoffment, or some knife or other symbol of possession upon the altar of the church[1], sometimes he "abjured" the land and thus confirmed his gift by his oath[2]. Clauses denouncing excommunication and damnation against all who should disturb the donee's possession did not go out of use at the Norman Conquest, but may be found in charters of the twelfth century[3], nor was it uncommon for a great religious house to obtain a papal bull confirming gifts already made and thereafter to be made, and whatever might be the legal effect of such instruments, the moral effect must have been great[4]. We are not entitled to treat these phrases which seem to make God a landowner as of no legal value. Bracton more than once founds arguments upon them[5], and of course they very naturally suggest that land given in frankalmoign is utterly outside the sphere of merely human justice.

In later days the feature of tenure in frankalmoign which attracts the notice of lawyers is a merely negative feature, namely, the absence of any service that can be enforced by the secular courts. But here some distinctions must be drawn. The king might give land to a religious house "in free, pure, and perpetual alms," and in that case not only would no secular service be

[1] See *e.g. Cart. Glouc.* I. 164, 205; II. 74, 86, 97.
[2] See *e.g. Reg. St Osmund*, I. 356; *Chron. Melsa.* I. 309.
[3] See *e.g. Hist. Abingd.* II. 55; *Whitby Cartulary*, I. 200; *Whalley Coucher*, I. 17, 113.
[4] See *e.g.* Bull of 1138, *Hist. Evesham*, 173; Bull of 1140, *Cart. Ramsey*, I. 155; Bull of 1146, *Hist. Abingd.* II. 173.
[5] Bract. f. 12, 286 b.

due from the donee to the donor, but the land in the donee's hand would owe no secular service at all. But tenure in frankalmoign is by no means necessarily a tenure in chief of the crown; indeed it would seem that the quantity of land held in chief of the crown by frankalmoign was never very large. It will, of course, be understood that an ecclesiastical person might well hold lands, and hold them in right of his church, by other tenures. The ancient endowments of the bishops' sees and of the greater and older abbeys were from the Conqueror's reign onwards held by knight's service; the bishop, the abbot, held a barony. Besides this we constantly find religious houses taking lands in socage or in fee farm at rents, and at substantial rents, and though a gift in frankalmoign might proceed from the king, it might well proceed, and probably more often did proceed, from a mesne lord. In this case the mere gift could not render the land free from all secular service; in the donor's hand it was burdened with such service, and so burdened it passed into the hands of the donee[1]. If the donee wished to get rid of the service altogether, he had to go to the donor's superior lords and ultimately to the king for charters of confirmation and release. But as between themselves the donor and donee might arrange the incidence of this "forinsec service" as pleased them best. The words "in free, pure, and perpetual alms" seem to have implied that the tenant was to owe no secular service to his lord; but they did not necessarily imply that as between lord and tenant the lord was to

[1] Bract. f. 27 b.

Frankalmoign

do the forinsec service. And so we find the matter settled in various ways by various charters of donation:—sometimes it is expressly stipulated that the tenant is to do the forinsec service[1], sometimes the lord expressly burdens himself with this[2], often nothing is said, and apparently in such case the service falls on the lord.

Another rule of interpretation appears, though somewhat dimly. In accordance with more recent books, we have spoken as though a gift in frankalmoign, in free alms, always implied that no secular service was due from the donee to the donor. But the words generally used in such gifts were "free, pure, and perpetual alms," and in Bracton's day much might apparently turn on the use of the word "pure[3]." Seemingly there was no contradiction between a gift in "free and perpetual alms" and the reservation of a temporal service, and many instances may be found of such gifts accompanied by such reservations. This will give us cause to believe that the exemption from secular service was not the one essential feature of tenure in frankalmoign; and if we find, as well we may, that a donor sometimes stipulates for secular

[1] Hunter, *Fines*, I. 200 (3 John), "Ala dedit et concessit in puram et perpetuam elemosinam Deo et ecclesie S. Marie de B... totam terram suam...ita quod predictus prior et successores sui facient inde forinsecum servicium." *Cart. Glouc.* I. 167, gift in frankalmoign, "salvo tamen regali servicio"; *ibid.* 187, gift in frankalmoign saving the landgafol due to the king; *ibid.* 389, gift in free, pure and perpetual alms subject to a rent of pepper due to a superior lord and to royal service.

[2] *Cart. Glouc.* II. 17, 30, 98.

[3] Bract. f. 27 b; Bracton's *Note Book*, pl. 21.

service, though he makes his gift not only in free but even in pure alms, our belief will be strengthened[1].

The key to the problem is given by the Constitutions of Clarendon (1164). "If a dispute shall arise between a clerk and a layman, or between a layman and a clerk concerning any tenement which the clerk asserts to be 'elemosina,' and the layman asserts to be lay fee, it shall be determined by a recognition of twelve lawful men and the judgment of the chief justiciar, whether (*utrum*) the tenement belongs to 'elemosina' or belongs to lay fee. And if it be found that it belongs to 'elemosina,' then the plea shall go forward in the ecclesiastical court: but if it be lay fee, then in the king's court, or in case both litigants claim to hold of the same lord, then in the lord's court. And in consequence of such a recognition, the person who is seised is not to lose his seisin until it has been deraigned by the plea[2]." Let us observe how large a concession to the church the great Henry is compelled to make, even before the struggle with Becket has put him in the wrong. This is all that

[1] *Rievaulx Cart.* p. 29, gift by Bishop Hugh of Durham in free and perpetual alms at a rent of 60 shillings, payable to him and his successors; *ibid.* pp. 80, 226, 249. *Newminster Cart.* p. 73, gift by Newminster Abbey to Hexham Priory in free, pure, and perpetual alms at a substantial rent. *Malm. Reg.* II. 124, gift in free, pure, and perpetual alms to hold of me and my heirs "jure eleemosinario," rendering to me and my heirs one penny yearly. Bracton, f. 48, holds that in these cases the reservation being repugnant to the gift is of no effect.

[2] Const. Clarend. c. IX. In the *Gesta Abbatum*, I. 114, the St Alban's chronicler gives an account of litigation in Stephen's reign in which something very like an Assisa Utrum takes place.

Frankalmoign

those "avitae leges," of which he talks so frequently, will give him, and he claims no more. The clergy have established this principle:—All litigation concerning land held in almoign belongs of right to the ecclesiastical courts. All that the king insists on is this; that if it be disputed whether the land be almoign or no, this preliminary question must be decided by an assize under the eye of his justiciar. Thus the assize *Utrum* is established. It is a preliminary, prejudicial procedure; it will not even serve to give the claimant a possession *ad interim*; the possessor is to remain possessed; it decides not the title to land, but the competence of courts. Here then we find the essence of "almoign" as understood in the middle of the twelfth century:—the land is subject to no jurisdiction save that of the tribunals of the church. Even to maintain his royal right to decide the preliminary question of competence, was no easy matter for Henry. Alexander III freely issued rescripts which ordered his delegates to decide as between clerk and layman the title to English land, or at least the possessory right in English lands: he went further, he bade his delegates award possession even in a dispute between layman and layman, though afterwards he apologized for so doing. The "avitae leges," therefore, were far from conceding all that the clergy, all that the pope demanded[1].

[1] See the very remarkable series of papal rescripts in the *Rievaulx Cartulary*, 189-197; see also *Decret. Gregorii IX*, lib. IV. tit. xvii. cap. 7, where the pope admits that he has gone too far in ordering his delegates to give possession in a dispute between laymen, which came into the ecclesiastical courts in consequence of a question having been raised about bastardy. See also in the *Malmesbury*

They conceded, however, much more than the church could permanently keep. If as regards criminous clerks the Constitutions of Clarendon are the high-water-mark of the claims of secular justice, as regards the title to lands they are the low-water-mark. In Normandy the procedure instituted by Henry, the *Breve de Feodo et Elemosina*, which was the counterpart, and perhaps the model, of our own *Assisa Utrum*, seems to have maintained its preliminary character long after Henry's son had forfeited the Duchy; its object is still to decide whether a dispute belongs to the ecclesiastical or to the temporal forum[1]. In England it gradually and silently changed its whole nature; the *Assisa Utrum* or action *Juris Utrum*[2] became an ordinary proprietary action in the king's court, an action enabling the rectors of parochial churches to claim and obtain the lands of their churches: it became "the parson's writ of right[3]." Between the time of Glanvill and the time of Bracton

Register, II. 7, proceedings under letters of Innocent III for the recovery from a layman of land improvidently alienated by an abbot. In the *Gesta Abbatum*, I. 159-162, there is a detailed account of litigation which took place early in Henry II's reign between the Abbot of St Alban's and a layman touching the title to a wood; the Abbot procured letters from the Pope appointing judges delegate.

[1] *Ancienne Coutume* (de Gruchy), c. 117; Brunner, *Entstehung der Schwurgerichte*, 324-6.

[2] The term *Juris utrum* seems due to a mistake in the expansion of the compendium *Jur'*; it should be *Jurata Utrum*, in French *Juré Utrum*; see e.g. Y. B. 14 & 15 Edw. III (ed. Pike), p. 47; and see Bracton, f. 287, where the technical distinction between an *Assisa Utrum* and a *Jurata Utrum* is explained.

[3] Britton, II. 207.

Frankalmoign 217

this great change was effected and the ecclesiastical tribunals suffered a severe defeat[1].

The formal side of this process seems to have consisted in a gradual denial of the assize *Utrum* to the majority of the tenants in frankalmoign, a denial which was justified by the statement that they had other remedies for the recovery of their lands. If a bishop or an abbot thought himself entitled to lands which were withholden from him, he might use the ordinary remedies competent to laymen, he might have recourse to a writ of right. But one class of tenants in frankalmoign was debarred from this remedy, namely the rectors of parish churches. Bracton explains the matter thus:—When land is given to a religious house, though it be in the first place given to God and the church, it is given in the second place to the abbot and monks and their successors, or to the dean and canons and their successors; so also land may be given to a bishop and his successors; if then a bishop or an abbot has occasion to sue for the land he can plead that one of his predecessors was seised of it, just as a lay claimant might rely on the seisin of his ancestor: but with the parish parson it is not so; we do not make gifts to a parson and his successors; we make them to the church, *e.g.*

[1] According to Glanvill (XII. 25, XIII. 23, 24) the Courts Christian are competent to decide an action for land between two clerks or between clerk and layman in case the person in possession is a clerk who holds in free alms. So late as 1206 an assize *Utrum* is brought by one monastic house against another, and on its appearing that the land is almoign the judgment is that the parties do go to Court Christian and implead each other there; *Placit. Abbrev.* p. 54 (Oxon.).

"to God and the church of St Mary of Dale[1];" true, that if the parson himself be ejected he may have an assize of novel disseisin, for he himself has been seised of a free tenement, but a proprietary (as opposed to a possessory) action he can not bring, he can have no writ of right, for the land has not been given to a parson and his successors, it has been given to the church; he cannot therefore plead that his predecessor was seised and that on his predecessor's death the right of ownership passed to him; thus the assize *Utrum* is his only remedy of a proprietary kind[2]. In another context it might be interesting to consider the meaning of this curious argument; it belongs to the nascent law about "corporations aggregate" and "corporations sole." The members of a religious house can already be regarded as constituting an artificial person; the bishop also is regarded as bearing the "persona" of his predecessors—the vast temporal possessions of the bishops must have necessitated the formation of some such idea at an early time; but to the parish parson that idea has not yet been applied: the theory rather is that the parish church itself is the landowner and that each successive parson (*persona ecclesiae*) is the guardian and fleeting representative

[1] This remark seems fairly well supported by the practice of conveyancers in Bracton's time; thus *e.g.* a donor gives land "to God and St Mary and St Chad and the church of Rochdale," and contracts to warrant the land "to God and the church of Rochdale," saying nothing of the parson; *Whalley Coucher*, I. 162.

[2] Bracton, f. 286 b, 287. This may have been the reasoning which caused a denial of the assize to the parson when that parson was a monastery, a denial which an ordinance of 1234 overruled; Bracton's *Note Book*, pl. 1117.

of this invisible and immortal being[1]. However our present point must be that legal argument takes this form—(1) No one can use the assize *Utrum* who has the ordinary proprietary remedies for the recovery of land; (2) All or almost all the tenants in frankalmoign, except the rectors of parish churches, have these ordinary remedies; (3) The assize *Utrum* is essentially the parson's remedy; it is "singulare beneficium," introduced in favour of parsons[2]. This argument would naturally involve a denial that the assize could be brought by the layman against the parson. According to the clear words of the Constitutions of Clarendon, it was a procedure that was to be employed as well when the claimant was a layman as when he was a clerk. But soon the doctrine of the courts began to fluctuate. Martin Pateshull at one time allowed the layman this action; then he changed his opinion on the ground that the layman had other remedies; Bracton was for retracing this step, on the ground that trial by battle and the troublesome grand assize might thus be avoided[3]. One curious relic of the original meaning of this writ remained until 1285, when the Second Statute of Westminster gave an action to decide whether a piece of land was the

[1] Bracton, f. 287 b. The parson has not only the assize of novel disseisin, but he may have a writ of entry founded on the seisin of his predecessor. This being so the refusal to allow him a writ of right is already somewhat anomalous. But the writs of entry are new, and the law of the twelfth century (completely ignored by Bracton) was that the ecclesiastical court was the tribunal competent to decide on the title to land held in frankalmoign.

[2] Bracton, f. 286 b.

[3] Bracton, f. 285 b; Fleta, p. 332; Britton, II. 207.

elemosina of one church or of another church[1]. The assize had originally been a means of deciding disputes between clerks and laymen, or rather of sending such disputes to the competent courts temporal or spiritual, and the Constitutions of Clarendon contain a plain enough admission that if both parties agree that the land is "elemosina" any dispute between them is no concern of the lay courts.

We have been speaking of the formal side of a legal change, but must not allow this to conceal the grave importance of the matters which were at stake. The argument that none but parochial rectors have need of the *Utrum*, the conversion of the *Utrum* from a preliminary procedure settling the competence of courts into a proprietary action deciding, and deciding finally, a question of title to land, involves the assertion that all tenants in frankalmoign (except such rectors) can sue and be sued and ought to sue and be sued for lands in the temporal courts by the ordinary actions. And this, we may add, involves the assertion that they ought not to sue or be sued elsewhere. The ecclesiastical courts are not to meddle in any way with the title to land albeit held in frankalmoign. To prevent their so doing writs are in common use prohibiting both litigants and ecclesiastical judges from meddling with "lay fee" (*laicum feodum*) in the Courts Christian, and in Bracton's day it is firmly established that for this purpose land may be lay fee though it is held in free, pure, and perpetual alms[2]. The interference of the

[1] Stat. 13 Ed. I, c. 24.
[2] Bracton, f. 407; Bracton's *Note Book*, pl. 547, 1143. Compare the somewhat similar distinction, "entre lieu saint et lieu religieus," in Beaumanoir, vol. 1. p. 163.

Frankalmoign

ecclesiastical courts with land has been hemmed within the narrowest limits. The contrast to "lay fee" is no longer (as in the Constitutions of Clarendon) *elemosina*, but consecrated soil, the sites of churches and monasteries and their churchyards, to which, according to Bracton, may be added lands given to churches at the time of their dedication[1]. The royal court is zealous in maintaining its jurisdiction; the plea rolls are covered with prohibitions[2] directed against ecclesiastical judges; and it is held that this is a matter affecting the king's crown and dignity—no contract, no oath to submit to the Courts Christian will stay the issue of a prohibition[3]. But the very frequency of these prohibitions tells us that to a great part of the nation they were distasteful. As a matter of fact a glance at any monastic annals of the twelfth century is likely to show us that the ecclesiastical tribunals, even the Roman curia, were constantly busy with the title to English lands, especially when both parties to the litigation were ecclesiastics. Just when Bracton was writing, Richard

[1] Bracton, f. 407. Such lands constitute the church's *dos* or *dower*. See also f. 207 b.

[2] See Bracton's *Note Book* passim. The writ of prohibition is found in Glanvill, XII. 21, 22. It is found in the earliest Chancery Registers. Bracton discusses its scope at great length, f. 402 fol.

[3] In the twelfth century the donor sometimes expressly binds himself and his heirs to submit to the Church Courts in case he or they go against the gift; *e.g. Rievaulx Cartulary*, 33, 37, 39, 69, 159, 166. So in the *Newminster Cartulary*, 89, a man covenants to levy a fine and submits to the jurisdiction of the archdeacon of Northumberland in case he fails to perform his covenant. For a similar obligation undertaken by a married woman, see *Cart. Glouc.* I. 304. As to such attempts to renounce the right to a prohibition, see Bracton's *Note Book*, pl. 678.

Marsh at the instance of Robert Grostete was formulating the claims of the clergy—"He who does any injury to the frankalmoign of the church, which therefore is consecrated to God, commits sacrilege; for that it is *res sacra* being dedicated to God, exempt from secular power, subject to the ecclesiastical forum and therefore to be protected by the laws of the church[1]." It is with such words as these in our minds that we ought to contemplate the history of frankalmoign. A gift in free and pure alms to God and his saints was meant not merely, perhaps not principally, that the land is to owe no rent, no military service to the donor, but also and in the first place that it is to be subject only to the laws of the church and the courts of the church.

[1] *Ann. Burton*, p. 427. See also the protest of the bishops in 1257, Mat. Par. *Chron. Maj.* VI. 361.

REVIEW OF "THE GILD MERCHANT[1]"

THE *Gilda Mercatoria* of 1883 has become the *Gild Merchant* of 1890; the little German tract published at Göttingen has grown into two noble volumes equipped with appendixes, glossary, index, bibliography, "proofs and illustrations," "supplementary proofs and illustrations," and every device for the ease and contentment of readers that the Clarendon Press can command. As a secondary title for his book, Dr Gross has chosen *A Contribution to British Municipal History*; and if his English critics do not at once say that this is the largest contribution of new and authentic raw material that has been made by any one man to this unfortunate and neglected subject, he will not take this ill of them, when he knows what, in all probability, is the only exception present to their minds. "*Madox ist ein Forscher ersten Ranges.*" Dr Gross, when seven years ago he wrote this sentence, gave not the least among the many proofs that he was on the right track. No one is likely to make much of a "contribution to British municipal history" who does not know and admire his Madox; and yet, in a very popular history of England, a list of the authorities for the tale of our

[1] *Economic Journal*, June, 1891.

boroughs spoke of Merewether and Stephens, of Brady and Brentano, and said nothing of the *Firma Burgi*. Our boroughs have not been very happy in their historians; few have been able to approach the story of their early adventures without some lamentable bias towards edificatory doctrine, or some desire to prove a narrow and inadequate thesis. Madox was one of the few. "In truth, writing of history is in some sort a religious act." Coming from some people we should resent such words as cant: we do not resent them when they come from Madox. And now on our bookshelf we can place *The Gild Merchant* next to the *Firma Burgi*, and know that each of them is where it should be. Like his illustrious predecessor, Dr Gross has perceived that a very laborious induction is the one method that can deal with the complex subject-matter, and that if the theorist is to persuade such of his readers as are really worth persuading, he must give them not merely his theories, but the evidence which proves those theories; must give the very terms of the original documents candidly, accurately, and at length. The result is work that must perdure, a book that must become classical; for, put the case that all the author's speculations are unfounded, and will be disproved in due course, the evidence that he has been diligently collecting during the past seven years from the scattered and obscure archives of our towns will remain of priceless value to any one who would either contradict him or follow in his steps. When, if ever, his first volume has become obsolete, there will still be the second volume with its proofs and illustrations, and supplementary proofs and illustrations, its precious extracts

from rolls that have never been used before, rolls which are dispersed abroad throughout England, and for the continued existence of which we have no very perfect security.

Differing in this from some of his forerunners, Dr Gross does not believe that a history of the gild merchant can be a full history, or anything at all like a full history, of the English boroughs. He holds out to us the hope of another "contribution." He has, he tells us, collected much material bearing on the governmental constitution of the towns, in particular on the growth of "the select body." Also he has "almost ready for the press a comprehensive bibliography of British municipal history, comprising about 4000 titles, with a critical survey of the whole literature." But then comes a qualification or stipulation. "Whether it will ever be printed must probably depend upon the success of the present work." This puts us in a difficulty. We want these further contributions, but would like to purchase them without the expenditure of a falsehood. But what are we to say? To tell Dr Gross that his book will sell well? The falsehood, if such it would be, would not even deceive, for publishers keep accounts; and in truth to predict a great sale for such a book is impossible. Had Dr Gross wished to make a book that would attract the largest number of readers, he should have taken not Madox but Brentano as his model. He should have been brief; he should have been dogmatic; he should have cited few authorities, and been very positive about the meaning of those that he cited, and then, may be, there would have been for some years a general

agreement as to his infallibility. But if in such a context it be "success" enough to have made a book, which every one who knows anything about the matter of it will pronounce to be a great book, a book which every labourer in the same field must not merely read, but keep permanently at his elbow, then we claim an immediate fulfilment of the promise. We must have the "bibliography," we must have the "critical survey of literature," and the history of the select body, for the "success of the present work" is assured—it has already taken its place beside the *Firma Burgi*. Should any one ask for more success?

To give a summary of such a book is to do it an injustice; for happily it comprises those copious proofs and illustrations, in particular those Andover Gild Rolls, the like of which have not been printed, the like of which few readers of English history can have hoped to see. Nevertheless I will endeavour to set forth, in as few words as possible, the main points which Dr Gross has made.

There is no proof whatever of the existence of any gild merchant before the Norman Conquest. The importance of the Anglo-Saxon gilds has often been exaggerated. There is no proof that there were gilds in England before the ninth century. The meaning of "gegildan" in the laws of Ine and Alfred is extremely uncertain; but it does not necessarily point to gilds. Kemble and Schmid agree about this. It is in the highest degree doubtful whether the *Judicia Civitatis Londoniæ* can be fairly described as "the statutes of a London gild." The organisation of which they speak seems no voluntary brotherhood,

but a compulsory organisation for police purposes. At any rate they stand alone, and we may not draw general inferences from them. There is nothing to show that the "knight's gild" was, or became, a merchant gild, or that it had anything to do with the government of the town. Passing to Domesday Book, the survey does not, as is generally supposed, prove the existence at Canterbury of a burghers' gild and a priests' gild. The passage "*Burgenses habebant de rege xxxiii acres terre gildam suam*," may mean that they had thirty-three acres which were part of the property for which they paid "geld"—they held this land "in their geld." Dr Gross, on more than one occasion, appeals to the connection between "gild" and "geld." The history of the gild merchant begins with the Norman Conquest. The earliest distinct references to it occur in a charter granted by Robert Fitz Hamon to the burgesses of Burford (1087–1107), and in a document drawn up while Anselm was Archbishop of Canterbury (1093–1109). It is mentioned in various charters of Henry I, and it is one of the franchises commonly granted to the towns by Henry II, Richard and John. Dr Gross rightly, as it seems to me, insists, in many places, that the privilege of having a gild merchant is one among many franchises (*libertates*), that is to say, privileges which none but the king can grant. He never forgets, as some of his predecessors have forgotten, that in England the development of the boroughs is conditioned at every point by common law and royal power. Now the meaning of this franchise is best seen from an account preserved in the Domesday

Book of Ipswich, concerning what happened there in the year 1200. The men of Ipswich obtained a charter from King John which granted to them, among other rights, the right to have a gild merchant. They proceeded to organise themselves as a borough. They elected bailiffs, coroners, and capital portmen; and then, this done, they proceeded to establish a merchant gild, which was to be governed by an alderman and four associates. Here and elsewhere we see the merchant gild as something distinct from the governing body of the borough, or from the nascent municipal corporation. It is so everywhere, or almost everywhere. The gild is not the borough; the gild has officers, aldermen, skevins (*scabini*), stewards, marshals, cup-bearers, and so forth, who are distinct from the governing officers of the borough, the mayor, bailiffs, coroners, capital burgesses and the like; "the morning speech" of the gild brothers is distinct from the court and council of the borough, the portmote or burghmote; a gildsman is not necessarily a burgess, a burgess is not necessarily a gildsman. Some of the most important boroughs never have merchant gilds. There is no proof whatever that there ever was a gild merchant in London. The *communa* of London which John recognised was no gild merchant. The argument from a gild hall to a gild merchant is idle. The famous passage in Glanvill, which some have regarded as establishing the identity of the *communa* with the *gilda*, may be a gloss, and, at any rate, does not prove the proposition in support of which it is commonly adduced. There is no proof of a gild merchant having existed in such important towns as Norwich (Mr Hudson,

The Gild Merchant

in his admirable paper on the history of Norwich, has recently confirmed this), Northampton, or Exeter. Indeed, it is in the small mesne boroughs that the importance of the gild merchant reaches its highest point. In such boroughs the court is still under seignorial influence—the lord's steward still presides over it; and so the burgesses attempt to make their gild a general organ of self-government. It is a mistake, therefore, to make the municipal corporation of later days the outcome of a gild merchant. It is a mistake to make the grant of a gild merchant an act of incorporation, though, under the influence of the narrow theory put forward by Merewether and Stephens, English writers are now in the habit of assigning too late a date even for the definite and technical incorporation of the boroughs. But though we may not identify the gild merchant with the corporation or with the governing body, still we cannot regard it as a mere voluntary association of merchants. It is an organ of the borough, whose primary function is to maintain and protect that immunity from toll which is conceded by the borough charters. None but a gildsman may enjoy this immunity; within the borough those who are not gildsmen are excluded from trade or subjected to differential duties. Starting from this point, the gild claims to regulate trade. It further makes itself a board of arbitration, and in some cases it even assumes to act as a court of law, though in general it remains quite distinct from the regular borough courts. Then as to its subsequent history: the popular doctrine which tells of a prolonged struggle between the merchant gilds and the craft gilds, and the victory of the latter, is just the outcome of Dr Brentano's

imagination—he has read foreign history into English history. Certainly there is often enough a struggle between rich and poor, between the *majores* and the *minores*; but hardly is there any trace of a struggle between various gilds, between merchants and craftsmen. Certainly it is no general truth that the government of the boroughs gradually becomes more democratic; on the contrary the general rule is that it steadily becomes more aristocratic.

In three very interesting appendixes the Scottish Gild Merchant, the Continental Gild Merchant, and the Affiliation of Medieval Boroughs are discussed. Upon the last of these three topics Dr Gross has spent a marvellous amount of industry to very good purpose.

His theories, if they be accepted—and for my own part I am inclined to accept many of them—will hardly make a revolution. This is in part due to the fact that Dr Stubbs, in his treatment of our boroughs, has been, if possible, more cautious and circumspect than he always is. In part it is due to the fact that Dr Gross has committed an offence, hideous in the eyes of the medieval gildsman, that of "forestalling"; he has forestalled himself. Already, for some time past, the doctrines of the *Gilda Mercatoria* have been slowly working their way into English literature; and it is pleasant to record in this place that "economic" historians have hitherto shown a juster appreciation of Dr Gross's German thesis than has been shown by the generality of "general" historians. In 1888 Mr Ashley spoke of the Göttingen tract as "the best work on its subject," and more recently Dr Cunningham has described it as marking an epoch. Still, if Dr Gross has forestalled himself, few others have forestalled him.

His work is sterling original work. Some, of course, of his conclusions should be vigorously discussed before they are accepted, but there is none of them that does not deserve discussion. Now and again he speaks too severely of his predecessors and fellow labourers. When he says that "Most English writers servilely follow Brentano," we could wish that the adverb had not been written. Still there has of late been a great deal too little controversy about these things, and more than enough unquestioning acceptance of unproved assertions, in particular the unproved assertions of a writer of whom it is no blame to say that he had seen but a very small part of the evidence, a very small part indeed when compared with the documents which Dr Gross has read and pondered and published. Those who dissent from his doctrines, and who feel themselves aggrieved by his strictures, will have to admit that in combating him they borrow their weapons from the great store of arms that he has collected.

Will the day ever come when the boroughs of England will print their records? Nottingham has set a splendid example. Not every borough will be able to find so good an editor as Mr Stevenson; but still it is shame to our mayors and corporations that the work is not done. They should be peremptorily asked *quo warranto* they pretend to be proud of their towns; and on their failing to give a satisfactory answer, their franchises should be seized into the Queen's hand. Meanwhile our oldest England has to be thankful for what it can get from New England, the *Essays on Anglo-Saxon Law*, the *Placita Anglo-Normannica*, and last, but not least, the *Gild Merchant*.

HENRY II AND THE CRIMINOUS CLERKS[1]

If I venture to write a few words about the great quarrel between Henry and Becket, a quarrel which has raged from their day until our own, it is with no intention of taking a side, still less with any hope of acting as a mediator. But, as it seems to me, there is a question of fact (which is also in a certain sense a question of law) involved in this quarrel, about which we are apt to think that there is, and can be, but one opinion, while in reality there are two opinions. Possibly I may do some good by pointing out that this is so. Perhaps if we were better agreed about the facts of the case we should differ somewhat less about the merits of the disputants. At any rate it is not well that we should think that we agree when really we disagree.

What did Henry II propose to do with a clerk who was accused of a crime? This is a very simple question, and every historian of England has to answer it. Generally, so far as I can see, he finds no difficulty in answering it and betrays no doubt. And yet, when I compare the answers given by illustrious and learned

[1] *English Historical Review*, April, 1892.

Henry II and the Criminous Clerks

writers, it seems to me that there is between them a fundamental disagreement, of which they themselves are not conscious. The division list, if I were to draw it up, would be a curious one. Some of Henry's best friends would find themselves in the same lobby with warm admirers of Becket, and there would be great names on either side of the line. But I will not thus set historian against historian, for my purpose is not controversial, and I am very ready to admit that every writer has told so much of the truth as it was advisable that he should tell, regard being had to the scale of his work and the character of those for whom he wrote. Rather I would point out that, without doing much violence to the text, it is possible to put two different interpretations upon that famous clause in the Constitutions of Clarendon which deals with criminous clerks. I may be told that the difference between these two interpretations is a small one, one hardly visible to any but lawyers. Still it may be a momentous difference, for neither Becket nor Henry, unless both have been sorely belied, was above making the most of a small point, or insisting on the very letter of the law.

Let us have the clause before us:—

> Clerici rettati et accusati de quacunque re, summoniti a iustitia regis venient in curiam ipsius, responsuri ibidem de hoc unde videbitur curiae regis quod ibidem sit respondendum; et in curia ecclesiastica unde videbitur quod ibidem sit respondendum; ita quod iustitia regis mittet in curiam sanctae ecclesiae ad videndum qua ratione res ibi tractabitur. Et si clericus convictus vel confessus fuerit, non debet de cetero eum ecclesia tueri.

Now, according to what seems to be the commonest opinion, we might comment upon this clause in some

such words as these:—Offences of which a clerk may be accused are of two kinds. They are temporal or they are ecclesiastical. Under the former head fall murder, robbery, larceny, rape, and the like; under the latter incontinence, heresy, disobedience to superiors, breach of rules relating to the conduct of divine service, and so forth. If charged with an offence of the temporal kind, the clerk must stand his trial in the king's court; his trial, his sentence will be like that of a layman. For an ecclesiastical offence, on the other hand, he will be tried in the court Christian. The king reserves to his court the right to decide what offences are temporal, what ecclesiastical; also he asserts the right to send delegates to supervise the proceedings of the spiritual tribunals.

The words are just patient of this meaning. Nevertheless if we adopt it two things will strike us as strange. Why should Henry care about what goes on in the ecclesiastical courts if those courts are only to deal with breaches of purely ecclesiastical rules? If he did propose to send delegates to watch trials for incontinence, disobedience, and the like, he inflicted a gratuitous and useless insult upon the tribunals of the church. And then let us look at the structure of the clause. In its last words it says that after a clerk has been convicted or has confessed, the church is no longer to protect him. Has been convicted of what? Has confessed what? Some temporal crime it must be. But the phrase which tells us this is divorced from all that has been said of temporal crimes. We have a clumsy sentence: "A clerk, if accused of a temporal crime, is to be tried in the king's court; but if he be

accused of an ecclesiastical offence, then he is to be tried in a spiritual court; and when he has confessed or been convicted [of a temporal crime] the church is no longer to protect him." And what, if this interpretation be correct, is the meaning of the statement that when he has confessed or been convicted the church is to protect him *no longer*? If he is to be tried like a layman in a temporal court, the church will never protect him at all.

Let us attempt a rival commentary. The author of this clause is not thinking of two different classes of offences. The purely ecclesiastical offences are not in debate. No one doubts that for these a man will be tried in and punished by the spiritual court. He is thinking of the grave crimes, of murder and the like. Now every such crime is a breach of temporal law, and it is also a breach of canon law. The clerk who commits murder breaks the king's peace, but he also infringes the divine law, and—no canonist will doubt this—ought to be degraded. Very well. A clerk is accused of such a crime. He is summoned before the king's court, and he is to answer there—let us mark this word *respondere*—for what he ought to answer for there. What ought he to answer for there? The breach of the king's peace and the felony. When he has answered—when, that is, he has (to use the words of the enrolment that will be made) "come and defended the breach of the king's peace, and the felony, and the slaying, and all of it word by word," then, without any trial, he is to be sent to the ecclesiastical court. In that court he will have to answer as an ordained clerk accused of homicide, and in that court there will be a

trial (*res ibi tractabitur*). If the spiritual court convicts him it will degrade him, and thenceforth the church must no longer protect him. He will be brought back into the king's court—one of the objects of sending royal officers into the spiritual court is that he may not escape—and having been brought back, no longer a clerk but a mere layman, he will be sentenced (probably without any further trial) to the layman's punishment, death or mutilation. The scheme is this: accusation and plea in the temporal court; trial, conviction, degradation in the ecclesiastical court; sentence in the temporal court to the layman's punishment.

This I believe to be the meaning of the clause. The contrary opinion can only be upheld if we give to the word *respondere* a sense that it will hardly bear. No doubt if nowadays one says that a man will have to answer for his crime at the Old Bailey, one means that he can be tried there and sentenced there. But we ought not lightly to give to *respondere* so wide a meaning when it occurs in a legal document. It means to answer, "to put in an answer," to plead, "to put in a plea." The words of our clause are fully satisfied if the clerk, instead of being allowed to say, "I am a clerk and will not answer here," is driven to "defend" —that is, formally to deny—the breach of the king's peace and the felony, and is then suffered to add, "But I am a clerk, and can be tried only by the ecclesiastical forum." According to this opinion Henry did not propose that a clerk accused of crime should be *tried* in the temporal court, and he did not propose that *a clerk* should be punished by a temporal court. The clerk was to be tried in the bishop's court; the convict

who was to be sentenced by the king's court would be no clerk, for he would have been degraded from his orders.

Even if this clause stood by itself we should, so I venture to think, have good reason for accepting the second as the sounder of these two interpretations. If we look to the words it seems the easier; if we look to the surrounding circumstances it seems the more probable. But we do not want for contemporaneous expositions of it. In the first place I will allege the letter addressed to the pope in the name of the bishops and clergy of the province of Canterbury.

Qua in re partis utriusque zelus enituit; episcoporum in hoc stante iudicio, ut homicidium, et si quid huiusmodi est, exauctoratione sola puniretur in clerico; rege vero existimante poenam hanc non condigne respondere flagitio, nec stabiliendae paci bene prospici, si lector aut acolythus quemquam perimat, ut sola iam dicti ordinis amissione tutus existat[1].

According to this version of the story there is no dispute between king and clergy as to the competence of any tribunal; the sole question is as to whether degradation—a punishment which can be inflicted only by the ecclesiastical court—is a sufficient penalty for such a crime as murder. Still more to the point are the words of Ralph de Diceto.

Rex Anglorum volens in singulis, ut dicebat, maleficia debita cum severitate punire, et ordinis dignitatem ad iniquum trahi compendium incongruum esse considerans, clericos a suis iusticiariis in publico flagitio deprehensos episcopo loci reddendos decreverat, ut quos episcopus inveniret obnoxios praesente iusticiario regis exauctoraret, et post *curiae traderet puniendos*[2].

[1] *Materials for the Hist. of Thomas Becket*, v. 405.
[2] R. de Diceto, I. 313.

Now this, of course, is as plain a statement as could be wished that the second of our two interpretations is the right one, that the accused clerk is to be tried by his bishop; and those who contend for the contrary opinion seem bound to maintain that the dean of St Paul's did not know, or did not choose to tell, the truth. Still it may be said of one of these witnesses—the author of the letter to the pope—that he is Gilbert Foliot, Becket's bitter antagonist, and of the other that he may have had his version of the tale from Foliot, and that, though a fair-minded man, he was inclined to make the best case he could for the king; and I must admit, or rather insist, that in the last words of the passage that I have cited from him Ralph de Diceto is making a case for the king, for he is in effect telling us by the phrase that is here printed in italics that we ought to read our Gratian and see how strong the king's case is.

But we may turn to other accounts. In the tract known as *Summa Causae* the king is supposed to address the bishops thus:—

> Peto igitur et volo, ut tuo domine Cantuariensis et coepiscoporum tuorum consensu, clerici in maleficiis deprehensi vel confessi exauctorentur illico, et mox *curiae* meae lictoribus *tradantur*, ut omni defensione ecclesiae destituti corporaliter perimantur. Volo etiam et peto ut in illa exauctoratione de meis officialibus aliquem interesse consentiatis, ut exauctoratum clericum mox comprehendat, ne qua ei fiat copia corporalem vindictam effugiendi[1].

Thereupon "the bishops," who in this version take the king's side, urge that the demand is not unreasonable. *Episcopi dicebant secundum leges saeculi clericos*

[1] *Materials*, IV. 202.

exauctoratos curiae tradendos et post poenam spiritualem corporaliter puniendos. Thomas replies that this is contrary to the canons—*Nec enim Deus iudicat bis in idipsum.* He argues that the judgment of the ecclesiastical court must put an end to the whole case. It condemns a clerk to degradation. Either this judgment is faulty or it is a complete judgment. It ought not to be followed by any other sentence.

The story as told by "Anonymus II" is to the same effect. The king's demand is thus described:—

ut in clericos publicorum criminum reos de ipsorum [sc. episcoporum] consilio sibi liceret quod avitis diebus factum sua curia recolebat; tales enim deprehensos, et convictos aut confessos *mox degradari*, sicque poenis publicis sicut et laicos subdi, tunc usurpatum est[1].

To this the bishops reply, not that a lay tribunal is incompetent to try an accused clerk, but *Non iudicabit Deus bis in idipsum.*

Yet more instructive is "Anonymus I." The king's officers, instigated by the devil, took to arresting clerks, investigated the charges against them, and, if those charges were found true, committed them to gaol. (We must note by the way that even these royal officers, though instigated by the devil, do not condemn these clerks to death or mutilation; they are sent to prison.) The archbishop, however, held that though these men were notoriously guilty, the church ought not to desert them, and he threatened to excommunicate any who should pass judgment upon them elsewhere than in the ecclesiastical court. Thereupon the king, admitting the reasonableness of this assertion

[1] *Materials,* IV. 96.

(*necessitate rationis compulsus*), consented that they should be given up to the bishops, upon condition that if they should be degraded by their ecclesiastical superiors they should then be delivered back to the temporal power for condemnation (*ita tamen ut et ipse [archiepiscopus] eos meritis exigentibus exordinatos suis ministris condemnandos traderet*). Thereupon Thomas, as is usual, is ready with the *Nemo bis in idipsum*[1]. This is an instructive account of the matter, because, as I read it, it distinctly represents Henry as not venturing to make the claim which he is commonly supposed to have made. No doubt he would like to try clerks in his court, but he knows that the church will never consent to this.

Testimony that could be put into the other scale I cannot find. True, it is often said that the king wants "to draw clerks to secular judgments (*trahere clericos ad saecularia iudicia*)." This was Becket's own phrase[2]; and though I do not think that it was strictly and technically true, I think that in the mouth of a controversialist it was true enough. Henry did propose that clerks should be accused in his court, and he did propose that punishment should be inflicted by the temporal power upon criminals who were clerks when they committed their crimes. The archbishop might from his own point of view represent as a mere sophism the argument that during the preliminary proceedings in the lay court there was no judgment, and that during the final proceedings there was no clerk. But we can hardly set this somewhat vague phrase, "to

[1] *Materials*, IV. 39.
[2] Letter by Thomas to the pope, *ibid.* v. 388.

Henry II and the Criminous Clerks

draw clerks to secular judgments," in the balance against the detailed accounts of Henry's proposals which we have had from other quarters, in particular against the plain words of Ralph de Diceto.

But we have yet to consider the story told by Herbert of Bosham. He says that the king was advised that his proposed treatment of criminous clerks was in accordance with the canons, and that the advice was given by men who professed themselves learned *in utroque iure*. Herbert sneers at these legists and canonists as being *scienter indocti*; still he admits that they appealed to the text of the canon law. He puts an argument about that text into their mouths, and then proceeds to refute it in the archbishop's name. Now of course if Henry really proposed to try criminous clerks in a temporal forum he had no case on the Decretum Gratiani, and no one would for one moment have doubted but that he was breaking canon after canon. However we have Herbert's word for it that the king's advisers thought, or at all events said, that the king's scheme was sanctioned by the law of the church, and with Herbert's help we may yet find in the Corpus Juris Canonici the words upon which they relied. It will, I suppose, hardly be questioned that Herbert may in the main be trusted about this matter, for he is here making an admission against the interest of his hero, St Thomas; he is admitting that the king's partisans professed themselves willing to stand or fall by the canon law. And the story is corroborated by phrases which are casually used by other writers, phrases to which I have drawn attention by italic type. When Ralph de Diceto

writes *curiae traderet puniendos*, when the author of *Summa Causae* writes *curiae meae lictoribus tradantur*, when Anonymus II writes *mox degradari*, they are one and all alluding—so it seems to me—to certain phrases in Gratian's book.

The debate, as I understand it, turned on two passages in the Decretum[1]. One of them is the following:—

Decr. C. 11, qu. 1, c. 18. *Clericus suo inobediens episcopo depositus curiae tradatur.*

Item Pius Papa epist. II.

Si quis sacerdotum vel reliquorum clericorum suo episcopo inobediens fuerit, aut ei insidias paraverit, aut contumeliam, aut calumniam, aut convicia intulerit, et convinci potuerit, mox [depositus[2]] curiae tradatur, et recipiat quod inique gesserit.

The other of the two is introduced by a *dictum Gratiani* which ends thus :—

In criminali vero causa non nisi ante episcopum clericus examinandus est. Et hoc est illud, quod legibus et canonibus supra diffinitum est, ut in criminali videlicet causa ante civilem iudicem nullus clericus producatur, nisi forte cum consensu episcopi sui; veluti quando incorrigibiles inveniuntur, tunc detracto eis officio curiae tradendi sunt. Unde Fabianus Papa ait ep. ii. Episcopis orientalibus....

On this follows Decr. C. 11, qu. 1, c. 31.

Qui episcopo insidiatur semotus a clero curiae tradatur.

Statuimus, ut, si quis clericorum suis episcopis infestus aut insidiator extiterit, mox ante examinatum iudicium submotus a clero curiae tradatur, cui diebus vitae suae deserviat, et infamis absque ulla spe restitutionis permaneat.

[1] *Materials*, III. 266–70.
[2] It will be seen hereafter that this word is not in the text of the pseudo-Isidore, nor is it in the *Decretum Ivonis*, p. 5, c. 243.

These passages, it will be seen, contain more than once the phrase *curiae tradere*. What is the true meaning of it?

This seems to me an almost unanswerable question, for it amounts to this: By what standard shall we, standing in the twelfth century, construe certain passages which we believe to come from two popes, the one of the second, the other of the third century, but which really come from a forger of the ninth century, who, it is probable, has been using at second or third hand a constitution of the fifth century, when we know also that these passages have very lately been adopted, though not without modification, by a highly authoritative writer of our own days?

Apparently the disputable phrase takes us back in the last resort to a constitution of Arcadius and Honorius which was received into the Theodosian code[1]. It begins thus:—

Quemcunque clericum indignum officio suo episcopus iudicaverit et ab ecclesiae ministerio segregaverit, aut si qui professum sacrae religionis obsequium sponte dereliquerit, continuo eum curia sibi vindicet, ut liber illi ultra ad ecclesiam recursus esse non possit, et pro hominum qualitate et quantitate patrimonii vel ordini suo vel collegio civitatis adiungatur; modo ut quibuscunque apti erunt publicis necessitatibus obligentur, ita ut colludio quoque locus non sit.

Then with this in his mind—or rather with the West Goth's *interpretatio* of it in his mind, or yet rather with some epitome of that *interpretatio* in his mind—the pseudo-Isidore inserted certain clauses into the decretals that he was concocting for Pope Pius I

[1] Lib. XVI. tit. ii. l. 39.

and Pope Fabian[1]. What he says in the name of Fabian we need not repeat, for it is fairly enough represented by the second of the two passages from Gratian that are quoted above[2]. What he says in the name of Pius is this:—

> Et si quis sacerdotum vel reliquorum clericorum suo episcopo inobediens fuerit aut ei insidias paraverit aut calumniam et convinci poterit, mox curiae tradatur. Qui autem facit iniuriam, recipiat hoc quod inique gessit[3].

There is here enough difference between Gratian and Isidore to make us doubt whether the one fully understood the other. But yet a third time did the great forger return to this theme. To the pen of Pope Stephen he ascribed

> Clericus ergo qui episcopum suum accusaverit aut ei insidiator extiterit, non est recipiendus, quia infamis effectus est et a gradu debet recedere aut curiae tradi serviendus[4].

Now of course the phrase in the Theodosian code, *continuo eum curia sibi vindicet*, has nothing whatever to do with the point at issue between Henry and Becket. The clerk who has been degraded from, or who has renounced, his holy orders is to become a *curialis*; he is to become obnoxious to all those duties and burdens, those *munera*, by which in the last days of the empire the *curiales* are being crushed.

[1] Hinschius would trace these passages to that epitome of the *Breviarium Alarici* which is represented by the Paris manuscript, *sup. lat.* 215. See Hænel, *Lex Romana Visigothorum*, pp. 246-8.

[2] Fabianus, XXI. (ed. Hinschius, p. 165).

[3] Pius, X. (Hinschius, p. 120).

[4] Stephanus, XII. (Hinschius, p. 186).

Henry II and the Criminous Clerks 245

I suppose that no words of ours will serve as equivalents for the *curia* and the *curialis* of the fourth and fifth centuries; even German writers, with all their resources, leave these terms untranslated. I suppose that if Henry had wished to substitute for the words of Arcadius and Honorius a phrase which should express their real meaning, and be thoroughly intelligible to his English subjects, he would have said, *Clericus degradatus debet scottare et lottare cum laicis.* It would seem also that Becket and his canonists knew something of the history of the words *tradatur curiae*, and were prepared to go behind Gratian. But what I am concerned to point out is that on the text of the Decretum Henry had an arguable case. Here, he might say, are words that are plain enough. A clerk disobeys or insults his bishop; *mox depositus curiae tradatur, et recipiat quod inique gesserit.* What can this mean if it be not that the offender, having been deposed by his bishop, is to be handed over to the *curia*, the lay court, for further punishment? Very well, that is what I am contending for. Further punishment after degradation does not infringe your sacred maxim *Nemo bis in idipsum*, or if it does then you are prepared to infringe that maxim yourselves whenever to do so will serve your turn.

But more than this can be said. Not very long after Henry's death the greatest of all the popes put an interpretation on the phrase *curiae tradere*. Innocent III issued a constitution against the forgers of papal letters. The forgers, if they be clerks, are to be degraded and then

postquam per ecclesiasticum iudicem fuerint degradati, saeculari potestati tradantur secundum constitutiones legitimas puniendi, per

quam et laici, qui fuerint de falsitate convicti, legitime puniantur [c. 7, X. 5, 20][1].

This seems plain enough. Henry, had he been endowed with the gift of prophecy, might well have said, "Here, at any rate, is an exception to your principle, and for my own part I cannot see that the forgery of a decretal—though I will admit, if you wish it, that it is wicked to forge decretals—is a much worse crime than murder, or rape, or robbery."

But this is nothing to what follows. Innocent III speaks once more (c. 27, X. 5, 40)[2].

> Novimus expedire ut verbum illud quod et in antiquis canonibus, et in nostro quoque decreto contra falsarios edito continetur, videlicet ut clericus, per ecclesiasticum iudicem degradatus, saeculari tradatur curiae puniendus, apertius exponamus. Quum enim quidam antecessorum nostrorum, super hoc consulti, diversa responderint, et quorundam sit opinio a pluribus approbata, ut clericus qui propter hoc vel aliud flagitium grave, non solum damnabile, sed damnosum, fuerit degradatus, tanquam exutus privilegio clericali saeculari foro per consequentiam applicetur, quum ab ecclesiastico foro fuerit proiectus; eius est degradatio celebranda saeculari potestate praesente, ac pronunciandum est eidem, quum fuerit celebrata, ut in suum forum recipiat, et sic intelligitur "tradi curiae saeculari"; pro quo tamen debet ecclesia efficaciter intercedere, ut citra mortis periculum circa eum sententia moderetur.

Now this, as I understand it, is an authoritative exposition of the true intent and meaning of the phrase *tradere curiae*, contained in those passages from the Decretum that have been printed above. It was a dubious phrase; some read it one way, some another; but on the whole the better opinion is not that of St Thomas, but that of King Henry II. And so

[1] *Reg. Inn. III*, ed. Baluze, 1. 574. [2] *Ibid.* 11. 268.

the king's advisers have this answer to the sneers of Master Herbert of Bosham :—We cannot hope to be better canonists than Pope Innocent III will be.

I am far from arguing that Henry's scheme ought to have satisfied those who took their stand on the Decretum. From their point of view the preliminary procedure in the king's court, whereby the civil magistrate acquired a control over the case, would be objectionable, and the mission of royal officers to watch the trial in the spiritual court would be offensive. But still about the main question that was in debate, the question of double punishment, Henry had something to say, and something which the highest of high churchmen could not refuse to hear.

This account of the matter seems to fit in with all that we know of the behaviour of Alexander III and of the English bishops. Had Henry been striving to subject criminous clerks to the judgment of the temporal forum, the case against him would have been an exceedingly plain one. A pope, however, much beset by troubles, could hardly have hesitated about it; no bishop could have taken the king's side without openly repudiating the written law of the church. But the pope hesitated and the English bishops, to say the very least, did not stubbornly resist the king's proposal. Even Becket's own conduct seems best explained by the supposition that until he grew warm with controversy he was not very certain of the ground that he had to defend. *Mox depositus curiae tradatur et recipiat quod inique gesserit*, was ringing in one ear, *Nec enim Deus iudicat bis in idipsum* in the other ear.

It is a curious coincidence, if it be no more than

a coincidence, that Henry's plan for dealing with criminous clerks—a plan which, as he asserted, was not his plan, but the old law of his ancestors—agrees in all its most important points with what, according to an opinion now widely received, was the scheme ordained by a Merovingian king in the seventh century. The clergy of Gaul had been claiming a complete exemption from secular justice. By an edict of the year 614 Chlothar II in part conceded, in part rejected their claim. If a bishop, priest, or deacon (clerks in minor orders were for this purpose to be treated as laymen) was accused of a capital crime, the accusation was to be made and the preliminary proceedings were to take place in the lay court; the accused was then to be delivered over to the bishop for trial in a synod; if found guilty he was to be degraded, and when degraded delivered back to the lay court for punishment. Merovingian grammar, to say nothing of Merovingian law, is a matter about which no one who has not given much time to its study ought to have any opinion. Still this opinion, put forward by Nissl, has met with great favour[1]. If it be true, then after five centuries and a half we find Henry reverting to a very ancient compromise. On this point I dare say little more, but it does not seem very certain that at any time the lay power in the Frankish state, or in the new principalities which rose out of its ruins, had ever, at least by any definite act,

[1] Nissl, *Gerichtsstand des Clerus*; Schröder, *Rechtsgeschichte*, 178; Viollet, *Histoire des Institutions Politiques*, I. 394. The settlement thus effected is not very unlike that defined by Justinian's Novels, 83 and 123.

Henry II and the Criminous Clerks 249

receded from the position which Chlothar II took up. I see no proof that the law laid down by Chlothar, the law laid down by Henry, was not the law as understood by William the Conqueror and by Lanfranc. The evidence that we have of what went on under our Norman kings is extremely slight. From cases such as those of Odo of Bayeux, of William of Durham, of Roger of Salisbury, we dare draw no inference about the general law. In none of these cases is there a sentence of death or mutilation. In the two latter the king can be represented as merely insisting on the forfeiture of a fief, and even great canonists would admit that purely feudal causes were within the cognisance of the temporal forum. Bishop William and Bishop Roger rely much less on the mere fact that they are in holy orders than on the great maxim of the pseudo-Isidore (his greatest addition to the jurisprudence of the world), *Spoliatus ante omnia debet restitui.* As to Bishop Odo, Lanfranc very probably would have had no difficulty in proving that the scandalously militant earl of Kent had put himself outside every benefit of clergy. It has not been proved that our Norman kings insisted on treating criminal clerks just as though they were criminal laymen, and on the other hand it has certainly not been proved that such clerks had enjoyed the full measure of exemption that Becket claimed for them. Henry's repeated assertions that he is a restorer, not an innovator, meet with but the feeblest of contradictions.

On the whole I cannot but think that the second of the two interpretations of the famous clause is the right one. If this be so all those modern arguments

which would contrast the enlightened procedure of the canon law with the barbarous English customs—I am not at all sure that in the England of the twelfth century the procedure of the ecclesiastical courts was one whit more rational than that of the temporal courts—are quite beside the mark. Henry did not propose that an accused clerk should be tried in the lay court; he was to be tried in a canonical court by the law of the church[1].

[1] In the middle of the twelfth century the English clergy were still using the ordeal, c. 3, X. 5, 37; and their only alternative for the ordeal in criminal cases was the almost equally irrational compurgation.

TENURES IN ROUSSILLON AND NAMUR[1]

Such books as these[2], appearing as they do along with Dr Vinogradoff's *Villainage in England*, should make us Englishmen ashamed of our old-fashioned "county histories" and persuade us that we have hardly come in sight of the true method of making our superabundant local records tell their most interesting tales.

France will be fortunate when all the lands which lie between the Channel and the Pyrenees are covered by books such as those which now illustrate her uttermost departments. Just outside her limits lies the country that M. Errera has studied. Châtelineau near the Sambre—canton de Châtelet, arrondissement de Charleroi—is the centre from which he starts for his researches among "*les masuirs*," the *mansionarii*, the messuagers, we may say, of Belgium.

Both M. Brutails and M. Errera have felt the influence of Léopold Delisle, and both of them, though they approach their subject-matter by different routes, endeavour to unravel some of those problems of medieval history which are in part economical in part

[1] *English Historical Review*, Oct. 1892.
[2] *Étude sur la Condition des Populations Rurales du Roussillon au Moyen Age.* Par Jean-Auguste Brutails. *Les Masuirs: Recherches historiques et juridiques sur quelques Vestiges des Formes anciennes de la Propriété en Belgique.* 2 vols., par Paul Errera.

legal problems. That neither the social economy, nor yet the law, of the middle ages can be profitably studied by itself is a truth the full meaning of which is always becoming more clearly apparent. A little while ago a German jurist writing a *Lehrbuch der deutschen Rechtsgeschichte* would hardly have thought that a map of a typical German village was one of the things that might be expected of him. Nowadays it is otherwise: he will give the map and discourse about methods of agriculture. Medieval land law is not to be understood apart from medieval agriculture. Both M. Brutails and M. Errera know this, and they also know the other half of the truth—namely, that we can only get at the economic facts of the middle ages through the medium of legal documents, documents which can only be interpreted by those who have studied the law. Indeed, in M. Errera's case the juridical interest of the problems is apt to get the upper hand; but this predominant jurisprudence, if it will perhaps deprive him of some English readers, who are like to be impatient of what they will call his "legal technicalities," will teach some others a very wholesome lesson—how little is gained by our easy talk of "village communities," how elaborate an analysis of the legal thought of the middle ages is necessary if we are really to understand the commonest economic facts. Both of our authors speak with reverence of Sir Henry Maine. It would seem as if Maine's teaching bore better fruit in France and Belgium than in England. But then both of our authors have before their eyes those terrible pulverising, macadamising methods of Fustel de Coulanges.

Even to one who knows next to nothing of

Roussillon and its history it is plain enough that M. Brutails' book is the work of a scholar who has collected evidence industriously, weighed it soberly, and arranged it lucidly. He gives us what we want where we expect to find it, and is careful to support his opinions by extracts from the numerous medieval cartularies that he has examined. His general theory of the law that prevailed in Roussillon during the later middle ages is that it was Frankish feudal law. It was not Visigothic, though a certain theoretical respect was paid to the *Forum Judicum*. The Saracens destroyed what was Visigothic, and for their own part contributed nothing towards the law of later times. When they were expelled they left behind them a *tabula rasa*, and thenceforth feudal law of the Frankish type reigned in Roussillon. Roman law, even after the Bolognese revival, exercised but little influence. Such a phrase as *les prétendus pays de droit écrit* will perhaps give some Englishmen a slight shock. M. Brutails, however, contends, and seems to represent a strong current of modern learning in contending, that *la division de la France en pays de droit écrit et en pays de droit coutumier, quelque ancienne qu'elle soit d'ailleurs, est une grave erreur historique*. To repeat a phrase already used, a certain theoretical respect is professed for Roman law, and some of its phrases, half understood, will adorn the style of the notary; but at bottom the law is not Roman. We would willingly have heard a little more than M. Brutails tells us about the famous " Usatici Barchinonensis patriae," for the relation between them and the medieval Roman law book known as the " Exceptiones Petri," or rather, perhaps,

between them and the yet earlier books whence "Petrus" took his matter, is an important point in the general history of European law and one which will not be settled until the "Usatici" has been carefully dissected. Our author is content to tell us that, according to common opinion, they were promulgated by Count Raymond Bérenger in 1068 (it interests us Englishmen to find a contemporary of William the Conqueror ready with *quia quod principi placuit legis habet vigorem*), but that some of the articles, notably some of the Roman articles, were inserted at a later date. However, his general conclusion is—*Le droit romain représentait dans nos pays le droit par excellence*, jura, *la plus haute expression de la justice; mais dans la pratique il ne fut jamais qu'un droit supplétoire.* He makes us think that if an English lawyer of the thirteenth century had wandered as far as the Spanish march, he would have found little to surprise him; and we are constantly reminded of the opinion which our kind neighbours, French and German, are for ever pressing upon us, namely, that English common law is a *Tochterrecht* of Frankish law, is, in short, just one more French provincial custom.

Thus one of the institutions with which he has to deal is the *alleu*. Whatever may be the original meaning of the term *alodium*, and whatever may have been the relation between it and the *beneficium* or *feudum*, it seems quite certain that there are ages into which we must not carry that sharp distinction between alodial ownership and dependent tenure which modern theorists have discovered or invented. M. Brutails remarks that if a tenant at a rent, instead

of sub-letting or sub-infeodating, transfers his whole interest to another person, substitutes that person for himself as tenant, he will say that he transfers the tenement *in alodium, ad alodem*, or the like. Even so we know that Norman clerks of the eleventh century, in their own country and in England, made no difficulty about saying *A tenet terram illam de B in alodio*. We are apt, as M. Brutails says, to give too sharp an edge to the legal terms of the middle ages, to treat them as fixed, whereas they were vague and fluid. The same term *dominium* has to serve for sovereignty and for ownership; the king's supremacy, the state's supremacy, has to appear as a *directité féodale* or not to appear at all. Thence spring the inept controversies of later lawyers. Louis XV has succeeded to the rights of Charlemagne in Roussillon, and, if we are to define the rights of Louis, we ought to know— which means in the present context that we ought to construct—the rights of Charles. M. Brutails is *juge au tribunal supérieur d'Andorre*, and as such must have ever in his mind a splendid example of that fusion of private property with political dominion which is characteristic of the middle ages. He is at his best when he is explaining how ancient law gets perverted when it is forced to solve modern problems. M. Errera has much to say about the same topic, much that is good; but by a practical example he shows us how unavoidable this process of perversion is. If *alodium* cannot always be translated by *dominium*, property, ownership, what shall we say of *tréfonds*? Is it not an intensified form of absolute property: does it not answer to our English "very

own"? Must not the *tréfoncier* of a piece of land be, among all the various people who have rights in or over that land, that one who is in a superlative sense its owner, *fundarius, seu, ut ita loquar, fundariissimus*? But then it was the use of this word in a document of 1479, which in these last years gave rise to a long dispute between the *masuirs* of Châtelineau and one of the departments of the Belgian government, of which dispute M. Errera's work is likely to be for the world at large the most important outcome. He contends that in the document in question the word *tréfonds* did not mean the ownership of the soil, but meant a seignory over the soil, and in this he may be right; still he more easily convinces us that in a given context the word does not stand for the ownership known to modern private law, than that it ever pointed to rights which we could correctly call purely political. And yet a modern court of justice has to make its choice, to force its dilemmas through all historical obstacles, and to decide that a disputed tract of land belongs to these masuirs, or to the commune of Châtelineau, or to the Belgian state as representative of a dissolved abbey.

As to the legal and economic condition of the individual peasant, we hear more from Roussillon than from Namur. When M. Brutails speaks of this he constantly reminds us of England. He hardly mentions a service or a due for which any reader of Seebohm or Vinogradoff could not supply a parallel. Such a passage as the following will seem very familiar —if we except two or three outlandish words—to those who have glanced at English custumals:—

"Hec sunt consuetudines castri de Taltavolio

[Tautavel] que sunt inter homines predicti castri et domini regis Majoricarum, scilicet quod homines qui non sunt domini Regis qui manent in predicto castro faciunt dicto domino Regi duas iovas quolibet anno, scilicet unam iovam in ciminterio et aliam in stivo, tamen si habent animalia cum quibus possint laborare. Item, homines qui sunt dicti domini Regis qui laborant cum animalibus faciunt dicto domino Regi in ciminterio et in estate et iuvant seminare bladum castri quousque sit seminatum ; tamen in istis non intelligimus illos qui sunt avenidissi. Item, omnes homines dicti domini Regis debent triturare bladum castri de Taltavolio in area et debent eum mundare quousque sit pulcrum et debent eum deferre cum suis bestiis ad castrum predictum, cum pane et vino tantum dicti castri. Item debent amenar molas molendinorum dicti castri de Taltavolio, cum pane et vino dicti castri," and so forth.

But if M. Brutails has discovered the whole, or anything like the whole, truth—and he seems to have been indefatigable in his search for it—it certainly follows that the labour which the peasant of Roussillon had to do for his lord was trivial when compared with that which was due from the English *villanus*. The English virgater would have made light of it. He would have said, " Here are 'boon-days,' it is true, but there is none of that steady 'week work' which oppresses me at home." Some of these peasants of Roussillon were, like the Roman *coloni*, bound to the soil ; they were *affocati* ; they were *homines de remensa*; they were obliged to a *continua statica*. M. Brutails seeks the origin of this in contract. A man binds

himself *facere in dicta grangia residenciam personalem cum tota familia sua, et facere fochum et locum, prout in mansis est consuetum*. He may promise this for a term of six years, or he may promise it for all eternity. But true slavery, we are told, disappeared in the eleventh century, or rather after that the only slaves were the infidels—very curious is this list of things sold, *mansus et fumus et ortus cum pertinenciis eorum et sarracenus et asinus et census denariorum et aliarum rerum*—and nothing that could be called serfage, nothing that Beaumanoir would have called *servage*, took the place of slavery. This book comes just at the right moment to enforce what Vinogradoff has been telling us, that, " in a sense, the feudal law of England was the hardest of all in western Europe."

In a valuable chapter M. Brutails speaks of the communes of Roussillon, denying by the way that they can be connected with the Roman *municipia*; still, according to the picture that he draws, communes and communal property have not played so large a part in the agricultural economy of this part of the world as some of us might have expected. The commune, in his eyes, has long been capable of owning, and has owned, land, but he does not allow himself any speculations about a time when lands normally belonged rather to communities than to individuals. He holds, as already said, that the profitable history of Roussillon goes back only to what, having regard to some other countries, we may call a pretty recent date. The evicted Saracens leave behind them a void, and this void is filled by conquerors who are already far gone in feudalism. Therefore it is not to Roussillon that we

must look for any primitive communalism. Communal property and communal *droits d'usage*, rights of pasture and the like, he would trace chiefly to grants made, or encroachments suffered, by feudal lords, lords who were already by law the lords of the land. On the other hand, M. Errera, who tells us comparatively little about the individual peasant, has a great deal to say about the village community. He has been brought to the study of medieval affairs by certain modern facts and modern difficulties. These he discusses at very great length, giving in full all the documents that bear upon them. Still, he cannot be charged with describing them too minutely. We best see the real complexity of the problems of medieval communalism when they are brought into contact with modern law, when a court of justice or a governmental bureau unravels all the known facts, and then confesses that it knows not how to deal with them. Very briefly, let us try to state the nature of the cases which have arisen of late years in Belgium, and which have made M. Errera an historian.

Within the territory of a certain village there is a large wood. This, to use an English phrase, has been dealt with as "a timber estate"; the timber periodically cut down upon it has been sold. This wood has not been treated as forming part of the ordinary *biens communaux* of the village. The profits of it have not been enjoyed by the commune, nor have they been divided among all the members of the commune; they have been enjoyed by a group of persons having some such name as *masuirs*. This group is defined in various ways in various villages. At Châtelineau, for

example, in order to be a *masuir* one must be domiciled and resident (*manant et habitant*) within the limits of the commune: one must have a house. To be a *mansionarius* one must have a *mansus*; also one must own within the ancient jurisdiction of the Court of St Bartholomew (the court which once belonged to the collegiate church of St Bartholomew at Liège) a *mesure* of meadow or a *jurnal* of arable land. The *mesure* being equal to some 23, the *jurnal* to some 31 *ares*, the number of these privileged persons may bear but a small ratio to the number of the inhabitants of the commune. At Châtelineau there were recently but 108 *masuirs*, while the sum of the population exceeded 8000. But though only a few of the inhabitants will get any profit out of the wood, still it is usual to find that, in some way or another, the communal assembly has taken some part in its management.

Well now, to whom does this wood belong; in whom is the ownership of it? The question is not one of a merely theoretical interest—far from it: the *masuirs* want to sell the land and divide the price amongst them, or they want to divide the land itself, so that each *masuir* may become the owner of a separate strip. In such a case several solutions may be possible. We may attribute the ownership (*a*) to the *masuirs* as a corporation, (*b*) to the *masuirs* as a group of co-proprietors, (*c*) to the commune. It is with problems such as this in his mind that M. Errera has been exploring the past history of many different villages.

Each case, of course, has its own peculiarities, and,

as we understand, its inherent difficulty is sometimes complicated by laws of the revolutionary age which suppressed all "lay corporations," and handed over their property to the state. A theory therefore which would make the *masuirs* of old times a corporation has to be rejected unless we do not shrink from the conclusion that ever since the beginning of this century these woods have been enjoyed by those who had no title to them. For the rest, we seem brought face to face in a practical fashion with, among other problems, the question that has been much debated in Germany ever since Beseler drew his famous contrast between *Volksrecht* and *Juristenrecht*. What is the true nature of the land-holding community of the middle ages? Is it a *universitas*, a juristic person; is it, on the other hand, just a group of co-owners; or is it a *tertium quid*? M. Errera will make us think of Gierke's answer and Heusler's answer and Sohm's trenchant dogma, "*Vermögensgemeinschaft mit körperschaftlicher Verwaltungsorganisation.*" M. Errera is much against any *solution individualiste*. In this, if foreigners may dare to take a side, we shall probably be at one with him so long as he is arguing as to what is expedient, or what ought to be. We may well think that a *solution communaliste* which treated these lands as *biens communaux* would make for the general good; still better would be legislation which provided a fair compensation for the "vested interests" of the *masuirs*. But when M. Errera argues that this *solution communaliste* is required by history, we are by no means certain that we can agree with him, though he has stated his case with skill and learning.

When we speak of one of two solutions of a prac-

tical legal difficulty as being the more historical, we are using a somewhat ambiguous term. We may mean that this solution will best reproduce, so far as modern means will allow, some state of affairs which we regard as having been original and rightful, and as having never been rightfully altered. On the other hand, we may mean that, so far from recurring to the old, we are completing the as yet unfinished work of history. A political revolution is in progress, one of those slow revolutions, let us suppose, which are always going on in England; shall we say that history requires a restoration or shall we say that history will only be satisfied when the revolutionary principles which have hitherto been but partially triumphant have attained to a full realisation? But let the term be taken in either sense, we have many doubts as to the superior "historicalness" of the *solution communaliste*. The conclusion to which, if we mistake not, M. Errera would like to bring us is that at some period these lands belonged to the village commune, that all the inhabitants of a given district had some right to enjoy them, and that the restrictions which have excluded many of the inhabitants to the profit of the few are of later date. We do not think that the documents industriously collected by him prove this, and yet a student of the parallel English documents would say that it requires much proof. At all events, in England, so soon as the curtain rises and we have clear history, the rights of the villagers in woods, wastes, and waters are normally bound up with the tenure by them as individuals of arable lands and houses; the commoners are, we may say, *masuirs*.

We cannot help suspecting that if M. Errera had

been able to obtain a more copious supply of documents from the early middle ages he would have found that so far back as he could trace these *droits d'usage*, they were intimately connected with the individualistic ownership of manses, and that he would have relegated any more definitely communal arrangement to the realm of prehistoric guess-work. As to the acquisition of the ownership of the soil, the evidence that he tenders seems to show that the *masuirs* and the communes alike rely for their title on pretty modern events. The *masuirs* of Châtelineau, for example, are the successors in the title of the chapter of St Bartholomew of Liège, and of the abbey of Soleilmont; it is only since 1749 that they have owned the debatable wood. Then if, on the other hand, the requisite historical solution is to be one in which historical tendencies are to achieve their accomplishment, we shall find much in M. Errera's book, and very much elsewhere, which will make us think that in these village affairs the tendency towards individualism has been until very lately the main historical tendency. So, at least, an Englishman is likely to think. Our own insular experience seems to be that out of a vague undifferentiated somewhat, which was neither merely a *universitas*, nor yet merely a group of co-owners, nor yet again any definite *tertium quid*, co-proprietorship, or, in other words, individualism, emerged as the most powerful, and, in course of time, as the all-absorbing, element. We could wish that foreign writers when they discuss the village community would face the fact that the term *biens communaux* has no English equivalent. The English village owns no land, and,

according to our common law, it is incapable of owning land. It never definitely attained to a "juristic personality." Far be it from us to say that this is other than a misfortune; but we are speaking of medieval history, and the English common law has some right to be regarded as an extremely conservative exponent of medieval principles; it has been stupid and clumsy, if you please, but, at any rate, it has kept a tenacious grip of ancient ideas. No doubt, too, it has been one-sided: it has utterly ignored all that it could not bring within narrow ancient formulas. All that we are concerned to urge is that already in the thirteenth century the corporative element was so feeble that law could ignore it and draw a hard line between the borough which can hold land and the village which cannot. Already the villagers, if they held land in undivided shares, treated themselves, and were treated by law, as a group of co-owners, each with his own proprietary right. We may have lost much by our individualism, but we evaded many most intricate difficulties. In one place M. Errera suggests as a solution of the problem of Châtelineau—*la propriété appartenait aux masuirs* ut universi *et la jouissance* ut singuli. This is a curious variation on Dr Sohm's formula—*Vermögensgemeinschaft mit körperschaftlicher Verwaltungsorganisation.* Sometimes it may seem to us that such phrases attribute legal theories to men who had none, and who were quite willing to accept any one of the many possible solutions of those practical questions which arose from time to time. At any rate, in England the *solution individualiste* long ago presented itself as the obvious solution.

If in speaking of these books we have said too little of Roussillon and Namur, too much of England, we may seek to excuse ourselves in the eyes of M. Brutails and M. Errera by saying, as we can with truth, that their work will be of great value to all Englishmen who are studying the history of property in land, and even to those who have England more especially in their minds.

GLANVILL REVISED[1]

WHEN I was editing for the Selden Society some precedents for proceedings in manorial courts I had occasion to remark that one of the manuscripts that I had been using—it lies in the library of our English Cambridge, and is there known as Mm. 1. 27—contained "a revised, expanded, and modernized edition" of Glanvill's treatise on the laws of England[2]. This remark brought to me from the American Cambridge a very kind note suggesting that more should be said of this revised Glanvill, and the editors of the *Harvard Law Review* have been good enough to permit me to say a few words about it in these pages. I hope that the circulation of their excellent magazine will not suffer thereby.

Almost the whole of the manuscript book in question seems to me to have been written by one man, though at many different times. It opens with a table of contents. Upon this follows a Registrum Brevium which I should ascribe to Edward I's reign (1272–1307), and not to the latest years of that reign. Then at the beginning of a new quire begins the revised

[1] *Harvard Law Review*, April, 1892.
[2] *The Court Baron*, Selden Soc., p. 6.

Glanvill. This, as I shall remark below, gradually degenerates into a mere series of writs. Then we reach "Explicit summa que vocatur Glaunvile." A few more writs follow, with some notes and the articles of the eyre. Then the correspondence which took place between Henry III and de Montfort on the eve of the battle of Lewes; then a short account of that battle (14 May, 1264). Then the king's writ to the mayor and bailiffs of York announcing that peace had been made. Then the following: "And in order that you may know of the events of the battle fought at Evesham between Worcester and Oxford on Tuesday the nones of August in the 49th year of King Henry, son of King John, between the lord Edward son of the King of England and the lord Gilbert of Clare Earl of Gloucester, and Simon of Montfort and his followers, who was slain on the same day, as was his son Henry and Hugh Despenser. [Here we come to the end of a line and a full stop. Then we have the following at the beginning of the next line:] In the 49th year of King Henry, son of King John, and the year of Our Lord 1265, at Whitsuntide, the following page (*subsequens pagina*) was written in the chapel of S. Edward at Westminster and extracted from the chronicles by the hand of Robert Carpenter of Hareslade, and he wrote this." The date is then given by reference to various events, ranging from the creation of the world downwards. It is the year of grace 1265; it is the 33rd year since King Henry's first voyage to Gascony; since his second voyage it is twelve years plus the interval between the 1st of August and Whitsuntide; it is twenty years from the beginning of the king's new

work at Westminster, and one year since the battle of Lewes. Thus we are brought to the foot of a page. At the top of the next page (and the structure of the book seems to show that nothing has here been lost) we find a precedent for a will, which is followed by a few legal notes written in French, and these bring us to the well-marked end of one section of the book.

The statement about Robert Carpenter, minutely accurate though it is meant to be, is none the less a very puzzling one. In the first place, "he wrote this," (*hic hoc scripsit*) is not free from ambiguity. Did he trace the very characters that we now see, or was he merely the author, the composer or compiler of the text that we now read? And then, whatever "wrote" may mean, what was it that he wrote? At Whitsuntide in the year 1265, at Whitsuntide in the 49th year of Henry III, he cannot have written anything about the battle of Evesham, for that battle was still in the future. We are told that he wrote "the following page," but the following page contains a precedent for a will, and contains nothing that could have been "extracted" from any "chronicles." I have not solved the difficulty.

Was the man who wrote this manuscript the man who revised and tampered with Glanvill's text? This also is a question that I cannot answer. On the one hand, what he gives us is not always free from mistakes of that stupid kind which we should naturally attribute rather to a paid copyist than to a man who was putting thought into his work. On the other hand, both in the Glanvill and in the other matters contained in this volume there are frequent allusions to one particular part of England, namely, the Isle of Wight and

Glanvill revised

the neighbourhood of Southampton and Portsmouth. Thus in Glanvill's famous passage about the privileged towns, which describes how by becoming a citizen of one of them a villain will become free,—a passage to which Dr Gross has lately invited our careful attention[1],—the name of Southampton has been introduced; and when the writer wants an example of a writ addressed to a feudal court, he supposes the court to be that held by the guardian of the heir of Baldwin de Redvers, Earl of Devon and lord of the Isle of Wight. Allusions to Baldwin and his family (the family de L'Isle, de Insula, that is, of the Isle of Wight) are not uncommon. But this question, whether Carpenter was the man who revised Glanvill's text, or whether he merely copied a text which had already been revised by some one else, is a question which we cannot answer until all the MSS. which profess to give Glanvill's treatise have been examined. In the meantime I will indulge in no speculations, but will simply describe what is found in the Cambridge manuscript.

A few words about the date of this revised version may however be premised. As it stands it cannot have been written before 1215, for it alludes to Magna Charta; before 1236, for it alludes to the Statute of Merton; before 1237, for it alludes to the Statute of ordinance of that year which fixed a period of limitation for divers writs[2]. Further, it alludes to the minority of Baldwin de L'Isle. This allusion may be ambiguous, for unless I have erred, there were two periods in

[1] Gross, *Gild Merchant*, I. 102.
[2] *Harvard Law Review*, III. 102.

Henry III's reign during which a Baldwin heir to the Earldom of Devon was an infant in ward to the king. The first of these occurred at the beginning of the reign[1]. The second opened in 1245, and must have endured until 1256 or thereabouts[2]. But our "Glanvill" also alludes to Isabella, Countess of Devon; and this seems to bring down its date to 1262, for in that year the last of these Baldwins died, and the inheritance passed to Isabella, who had married William de Forz, Count of Aumâle[3]. Then at the very end of the work we find a writ in which King Henry calls himself Duke of Aquitaine, but does not call himself Duke of Normandy or Count of Anjou. This writ must have been issued between Henry's resignation of the Norman duchy in 1259 and his death in 1272. Also it is a writ founded either upon one of the Provisions of Westminster (1259) or upon a clause in the Statute of Marlborough (1267) which re-enacted that provision; I think that it is founded upon the former. On the other hand, unless this be a trace of the Statute of Marlborough, I see no other trace of that comprehensive Statute. I see no mention of Edward I, and no allusion to any of the many Statutes of his reign. Almost immediately after the end of the Glanvill there come—and there is no transition from one quire to another—articles for an eyre of the 40th year of Henry III (1265–6), and then we have the passage which tells of Lewes and Evesham, and of what Robert

[1] *Annales Monastici*, I. 113; Courthope, *Historic Peerage*, 158.
[2] *Annales Monastici*, I. 99, II. 99; *Excerpts from the Fine Rolls*, I. 431.
[3] *Annales Monastici*, I. 499; *Calendarium Genealogicum*, I. 106.

Carpenter did in 1265. On the whole, I am inclined to suppose that the Glanvill was written within a short space on one side or the other of 1265, though it contains more writs of trespass than I should have expected to find at that date[1]. The man who wrote it —I mean the scribe from whose pen we get this manuscript of Glanvill—must have lived on into Edward I's reign. As already said, he copied a Register of that reign, and he copied various Statutes. I think that he copied the Circumspecte Agatis, which is ascribed to 1285. The Second Statute of Westminster (1285) is in the book, but was written by another hand.

If the revised Glanvill belongs, and I think that in its present shape it does belong, to the last years of Henry III, then it is somewhat younger than Bracton's work, and we may be not a little surprised that at so late a time some one attempted to refurbish the old text-book and bring it "up to date"; for in the interval there had been great changes in the law, and many new actions had been invented. We cannot say that success crowned the endeavour. The reviser seems to have started upon his task with the intention of explaining difficulties, correcting statements which had become antiquated, and inserting new writs and new rules at appropriate places. But ultimately he discovered that the work was beyond his powers, or perhaps he grew weary of it. He divides his text into "treatises" (*tractatus*). The following scheme will show how his "treatises" correspond to the "books" and "chapters," which we see in the printed volumes:

1. Tractatus de baroniis et placito terre = lib. I., II., III.

[1] *Harvard Law Review*, III. 177.

2. Tractatus de aduocationibus ecclesiarum = lib. IV.
3. Tractatus de questione status = lib. V.
4. Tractatus de dotibus mulierum, unde ipse mulieres nichil perceperunt et cum partem aliquam perceperunt = lib. VI., VII.
5. Tractatus de querela et fine facto in curia domini Regis et non observato = lib. VIII.
6. Tractatus de homagiis faciendis et releuiis recipiendis = lib. IX. cap. 1–10.
7. Tractatus de purpresturis = lib. IX. cap. 11–14.
8. Tractatus de debitis laycorum que solummodo super proprietate rei prodita erunt = lib. X. cap. 1–13.
9. Tractatus de placitis que super possessionibus loquuntur = lib. X. cap. 14–18.

At the end of what is the tenth book of our printed Glanvill, he begins a new, a tenth "treatise," "De placitis que per recognitiones terminantur," and he follows Glanvill down to a point which is in the middle of the third chapter of the eleventh book of our *textus receptus*. He has still to deal with part of the eleventh book, and then with the three remaining books. For a moment we think that he is going to follow Glanvill in his treatment of the possessory assizes. These possessory assizes are the subject-matter of Glanvill's thirteenth book. But from this point onwards the work degenerates into a mere Register of Writs, though among the writs a few explanatory notes will now and again be found. The compiler deals first with the possessory assizes, but then gives us writs of all sorts and kinds, many of which have been already dealt with in the previous "treatises." I hear him saying to himself, "After all, it is a hopeless job, this attempt to edit the old text-book. Glanvill, or whoever its author may have been, was a great man in his day, but his day is over, and we cannot bring it back.

Glanvill revised

Let us at all events have a really useful list of those writs which are current in our own time." This, however, does not prevent him from writing at the end of his register, " Here endeth the Summa which is called Glanvill."

I shall best be able to convey an idea of his work by giving the most remarkable passages which he adds to our *textus receptus* of Glanvill, and some of those passages in which he qualifies or corrects that text. But he is always qualifying or correcting it about little matters. For example, he glosses some very simple words; thus, "proceres, id est, barones," "equidem, id est, certe," "natiuitate, id est, nauitate." This last gloss shows that he is more familiar with French than with Latin. We see the growth of a technical language when Glanvill's essoin "de infirmitate reseantise," becomes "de malo lecti," and even "mall de lith," which is to be contrasted with "mall de venue." And so he corrects his author by writing "defendens, id est, tenens." Then by a marginal note he sometimes stigmatizes a passage as "Lex Antiqua," or " Jus Antiquum," and is fond of speaking of what is done "moderno tempore." Sometimes he marks the interpolations by the word " Addicio," or the word " Extra"; but he is not very careful in this matter. He (I am speaking as though the scribe of our MS. was also the man who made the changes in Glanvill's text) was not much of a Latinist, and I doubt whether he was a great lawyer. At any rate, he succeeds in obscuring some matters which are clear enough in our printed book.

I hope that the passages printed below will speak for themselves to any reader who has the *textus receptus*

at hand. A collection of variants cannot be lively reading, but it still may be a useful thing. I have only noticed the considerable changes, for, as already said, the reviser is constantly making minor alterations, some of which are called for by the evolution of the various courts, while others seem almost gratuitous substitutions of a modern word for one which is going out of fashion. For three passages I will ask attention. The reviser says twice over that the recognitors of the grand assize are not to use in their oath a certain word which is used by other jurors. That word he seems to write as *amuncient*. This I take to be *a mun cient* or *a mun scient*, and to mean *to the best of my knowledge*. Before now in these pages I have drawn attention to a similar remark in a Registrum Brevium—the phrase there I took to be *a son scient*[1]. In the grand assize you must swear positively that A or that B has the greater right. You must not talk about the best of your knowledge or anything of the kind.

In a curious passage about divorce, our writer speaks of divorce for blasphemy, and refers to the opinion of one whom he calls *aug' mag'*. The reference is, I believe, to a passage from Augustine (Augustinus Magnus) which is contained in the Decretum Gratiani. The canonists held "quod contumelia Creatoris soluit ius matrimonii[2]." Lastly, we have a remarkable statement to the effect that of old the goods of bastards who died intestate belonged to their lords, but that nowadays they belong to our lord the king by the

[1] *Harvard Law Review*, III. 111.
[2] c. 7, X. 4. 19; see the passage from Augustine in c. 28, qu. 1.

grant of our lord the pope. But without further preface I must produce my collection of variants.

INCIPIT TRACTATUS DE CONSTITUCIONIBUS LEGUM AC IURIUM REGNI ANGLIE TEMPORE SECUNDI HENRICI REGIS.

i. 5. Cum quis conqueritur domino Regi vel eius iustic[iariis] vel cancellariis[1] super iniusta detencione de aliquo libero tenemento si fuerit loquela talis...

i. 7. quindecim dierum ad minus, ut liber homo habebit respectum quindecim dierum et baro tres ebdomadas et comes unum mensem[2].

i. 8. At the end comes the following passage which is noted in the margin as an "Addicio"—Item moderno tempore[3] si quis summonitus fuerit ad respondendum de terra et implacitatus fuerit per breve de recto vel de ingressu vel per breve quod dicitur "precipe," et placitum illud fuerit coram iusticiariis, et primo die summonitus non venerit, capietur terra in manu domini Regis, et ad comitatum si placitum fuerit et primo die non venerit, ponetur per vadium et plegios ad respondendum de defalta et capitali placito ad secundum comitatum si placitetur de recto, et si ad secundum comitatum non venerit ipse qui implacitatur, capietur terra in manu domini Regis, et si per quindecim dies non replegiata ipsa terra in manu domini Regis fuerit, perdet tenens seisinam. Et replegiari debet tenementum illud de illo per quem in manu domini Regis capta fuerit ut de iusticiariis vel comitatu per breue domini Regis illis directo. Et sciendum quod postquam tenementum aliquod captum fuerit in manu domini Regis non potest tenens se essoniare nec defaltam facere nisi perdat tenementum illud per defaltam.

[1] Here and elsewhere a notice of the Chancery as the place where writs are obtained is interpolated.

[2] I do not remember to have seen this rule elsewhere.

[3] The procedure seems to have been made a little less dilatory than it was.

i. 12. ...vel plegios inueniet, scilicet, secundum antiquum statutum aut fidem dabit[1].

i. 13. ...iusticiariis nostris de banco[2]....

i. 18. This is preceded by a classification of essoins in a tabular form and the following remark—Nulla mulier debet in aliquo placito essoniari de seruicio domini Regis, quia non possunt nec debent nec solent esse in seruicio domini Regis in exercitu nec in aliis seruiciis regalibus.

i. 30. Omit—Huiusmodi enim publicus actus......primus dies similiter adiudicabitur utilis.

i. 31. ...et in nouis disseisinis, de ultima presentacione et in aliis consimilibus[3]....

corpus enim capietur vel attachietur de consilio iusticiariorum ut festinancius puniatur ille absens rettatus de pace domini Regis infrincta propter curie contemptum.

i. 32. In the margin over against the last sentences describing the imprisonment of a defaulting appellor stands—Jus antiquum.

ii. 3. The count is more elaborate: the demandant traces his pedigree step by step. The word "defendens" is glossed by "tenens." The fine for recreancy is 40, not 60 shillings—this, I think, is a mistake. The punishment imminebit super campionem victum vel super dominum suum si eum sursum caperet. This I understand to mean that the punishment for recreancy falls on the champion himself unless his hirer raises him from the field. By coming to the aid of the craven whom one has hired one exposes oneself to the recreancy fine.

ii. 7. In the famous description of the institution of the grand assize read regalis ista constitucio instead of legalis ista institucio:—an interesting variant.

Add at the end of this chapter—Et statim accedat tenens in propria persona sua quia non habebit respectum nisi xv. dies, et data fide quod sit tenens et quod in magnam assisam se posuerit, et habebit hoc breue sequens.

[1] It is enough nowadays that the essoiner should pledge his faith without finding a more material pledge.

[2] Here and elsewhere notices of "the Bench" are interpolated.

[3] Actions are being classified for the purpose of rules about essoins.

ii. 9. Prohibe custodibus terre et heredis Baldewini de Riueris Comitis Deuonie...

The writs of peace are treated at greater length. The chapter ends thus—Debent autem huiusmodi breuia irrotulari. Nullus vero tenens debet habere hec duo breuia "de pace de libero tenemento" et "de seruicio" per interpositam personam, hoc est per aliam personam quam per propriam, nisi sit de gracia, vel quia languidus, vel remotissimus et pauper[1].

ii. 11. Add at end—Notandum est quod in magna assisa non ponantur nisi milites et precipue [*corr.* precise?] iurare debent quod verum dicent, non addito verbo illo quod in aliis recognicionibus dicitur amuncient [*i.e.* a mun scient].

ii. 17. ...veritatem tacebunt, non addito hoc verbo quod in aliis recognicionibus adicitur, scilicet, amuncient. Ad scientiam autem...

ii. 19. ordinata *not* ordinaria[2].

iv. 4. After the writ of right of advowson comes—Aliud breue fere simile quod dicitur Quare impedit[3]. Then follows a writ De ultima presentacione. Then cap. 5.

iv. 9. The bishop is to distrain the clerk—et si episcopus hoc facere noluerit per iudicium curię debet dissaisiari de baronia sua et baronia ipsa tenebitur in manu domini Regis[4]. Tandem...

...eo ipso ecclesiam amittet? Solucio:—Equidem non amittet ut inferius monstrabitur. Sin autem...

iv. 11. ...remanebit assisa? Et non videtur quod ideo remanere debeat quia cum ille seisinam ipsius presentacionis aliquando habuerit eo quod ultimam presentacionem pater eius habuit, ergo quod recte petere possit seisinam patris eius non obstante aliquo quod factum sit de iure ipso presentandi. Si vero iterum...

iv. 13. Rex Priori de C. iudici a domino Papa delegato...

v. 1. Marginal note—Ad breue de natiuis sic potest obuiari, quod si ille qui ad vilenagium trahitur fugerit de terra domini sui

[1] If you put yourself on the grand assize, you must go in person for your writ of peace.

[2] This is a better reading of the original text.

[3] The *Quare impedit* is not one of the oldest actions.

[4] The bishops bitterly complained of this procedure, which made their baronies a security for the appearance of the clergy.

ante ultimum reditum domini Johannis Regis de Hibernia in Angliam a clamore domini petentis petitus liberatur quia breue non valet[1].

...breue de natiuis vicecomiti directum. On this follows a writ de natiuo habendo[2].

v. 2. Est autem breue tale quod dicitur breue de pace. [*Interlined*—uno modo antiquum breue formatum.] After this writ another—Aliud breue fere simile precedenti de eodem formatum: —the second writ ends with—et dic prefato H. militi quod tunc sit ibi loquelam suam prosecuturus versus predictum R. si voluerit. There is a small difference in form between the new writ and the old.

v. 5. Item si quis natiuus quiete sine aliqua reclamacione domini sui per unum annum et diem in aliqua villa priuilegiata ut in Suthamptona ut in·dominico domini Regis manserit, ita quod in eorum comunam, scilicet, gildam tanquam ciuis receptus fuerit, eo ipso a vilenagio liberabitur.

v. 6. Idem est si ex patre libero et matre natiua nisi fuerit patri libero desponsata.

Over the last sentence relating to the partition of the children— Jus antiquum[3].

Marginal note—Natiuus potest tenere terram liberam habendo respectum erga diuersos dominos et non e contrario quod terra libera de natiuo teneatur[4].

vi. 4. The paragraphs about the actions of dower are recast. The action for dower unde nihil habet is more rapid than that by writ of right. Therefore the widow should not accept any part of her dower unless she can get the whole, so that she may be able to say "nihil habet."

vi. 10. At the end—Si quis heres infra etatem mulierem desponsat et eam dotat de omnibus terris et tenementis de quibus

[1] This limitation was introduced in 1237; Bracton's *Note Book*, pl. 1237.

[2] Glanvill had apparently omitted to give the words of the writ.

[3] It is no longer usual to divide the children between the two lords.

[4] Free land may be held *by* a villain, but cannot be held *of* a villain.

heres est, et de omnibus que acquirere potest, mortuo herede ipso infra etatem et antequam seisinam terre sue habuerit, poterit ipsa mulier dotem perquirere per legem terre per hoc breue "unde nichil habet," eo quod dominus heredis cepit homagium heredis infra etatem existentis, et eo quod si implacitaretur de terra heredis infra etatem existentis vocetur ad warantum ipsum heredem [*sic*].

vi. 17. The following passage is marked "Extra" in the margin —Unde si aliquis liber homo qui tenebat de marito dicte mulieris sine aliquo herede obierit, et ipse liber homo ipsi mulieri in dotem assignatus fuerit, ipsa mulier de terra que fuit dicti liberi hominis sine aliquo iuris impedimento liberam habebit disposicionem ad ipsam cuicunque voluerit dandam inperpetuum, saluo seruicio heredis quod ipse liber homo facere consueuit pro dicta terra marito dicte mulieris et eius antecessoribus.

vi. 17. ...non remanebit assignacio dotis ipsius mulieris. Respondet autem qui infra etatem est de dote, de ultima presentacione, et de nova disseisina et de fide, si tamen infra etatem feofatus fuerit, respondet infra etatem si implacitetur.

vi. 17. ...Sciendum autem quod si in vita alicuius mulieris fuerit ab eo uxor eius separata per parentelam vel ob aliquam corporis sui (id est, uxoris) turpitudinem, scilicet, propter fornicacionem et propter blasfemiam ut dicit aug' mag' [Augustinus Magnus?] nullam vocem clamandi dotem habere poterit ipsa mulier, et tamen liberi possunt esse eius heredes et de iure regni patri suo vel matri si hereditatem habuerit succedunt iure hereditario. Set si uxor ipsa fuerit separata ab ipso viro eo quod contraxit matrimonium ante cum aliqua alia muliere per verba de presenti dicendo "Accipio te in uxorem," "Et ego te in virum," tunc eius pueri non possunt esse legitimi nec de iure regni patri suo vel matri succedunt iure hereditario. Notandum itaque quod cum quis filius et heres...

vi. 18. Omit from Si vero mulier aliqua plus...to the end of the book.

vii. 1. The passage Si autem plures habuerit filios mulieratos... is marked as Jus antiquum.

vii. 1. The passage Similis vero dubitatio contingit cum quis fratri suo postnato...is marked as Lex antiqua.

vii. 1.consequuturus esset de eadem hereditate. [Extra] Si quis habeat duos filios et primogenitus filius fecerit feloniam et captus et imprisonatus et pater suus obierit, postnatus frater eius nunquam terram ipsius patris optinebit nisi primogenitus frater obierit ante patrem. Veruntamen...

vii. 3. Item maritus primogenite filie, scilicet, cum habuerit heredem et non ante, homagium faciet capitali domino de toto feodo pro omnibus aliis sororibus suis. Tenentur autem postnate filie...

...secundum ius regni, homagium tamen secundum quosdam tenentur mariti postnatarum filiarum facere heredi primogenite filie set non marito suo ut dictum est et etiam racionabile seruicium. Preterea sciendum est...

...nisi in vita sua. [Extra] Set si maritus ipse in uxore sua hereditatem habens [*sic*] puerum genuerit, ita quod viuus natus fuerit, post decessum ipsius mulieris hereditatem illam omnibus diebus vite sue tenebit, siue infans ille mortuus fuerit, siue non, et hoc secundum consuetudinem Anglie. Item si quis filiam habuerit heredem......

vii. 5. ...racionabilem divisum facere secundum quosdam sub hac forma, precipue secundum cuiusdam persone consuetudinem, ut hii qui socagium tenent et villani, primo dominum suum de meliore et principaliore re quam habuerit, recognoscat, deinde ecclesiam suam, postea vero alias personas......secundum has leges Anglicanas et secundum alias leges, scilicet, Romanas. Mulier etiam sui viri voluntate testamentum facere potest.

vii. 7. [*Rubric*] Antiquum breue. De faciendo stare racionabilem devisum seu legatum alicuius defuncti.

vii. 8. Si quis autem auctoritate huiusmodi breuis predicti et modo moderno tempore vetiti[1] in curia Regis aliquid contra testamentum proposuit, scilicet quod testamentum ipsum non fuerit recte factum, vel quod res petita non fuerit petita ita ut legata...

vii. 10. ...veruntamen racione burgagii tantum vel feodi firme non profertur dominus Rex aliis dominis in custodiis, nisi ipsum burgagium vel ipsa feodi firma debeant servicium militare domino Regi.

vii. 12. ...infra etatem, id est, infra xv. annos...maiores, id est, de etate xv. annorum...

[1] The ecclesiastical courts have won a victory since Glanvill's day.

Quia generaliter dici solet quod putagium hereditatem non dimittit. Et istud intelligendum est similiter de putagio matris quia filius heres legitimus est licet non fuerit filius viri sui quem nupcie demonstrent.

vii. 13. Heres autem omnis legitimus est, nullus vero bastardus legitimus est, vel aliquis qui ex legitimo matrimonio natus non est, legitimus esse non potest.

vii. 14. ...et quoniam cognicio illius cause ad forum ecclesiasticum spectat [*instead of* et quoniam ad curiam meam non spectat agnoscere de bastardis].

vii. 15. A plea of special bastardy may be decided either in the ecclesiastical court or before the justices by an assize of twelve men.

vii. 16. ...succedere debet quia dominus non succedet racionibus predictis in capitulo de maritagiis. Dicendum est, ut dicunt quidam, quod illa terra remanebit in custodia dominorum capitalium quousque aliquis heres venerit ad ipsam clamandam. Si ipse qui eam dedit similiter bastardus sit et heredem de corpore suo non habeat, dicunt quidam quod dominus ipse si heredem non habuerit succedet et per hoc breue de eschaeta. [A writ of escheat follows.] Si quis autem intestatus decesserit omnia catalla sua domini sui [olim, *interlined*] intelliguntur esse, et tempore moderno domini Regis concessione domini Pape. Si vero plures habuerit dominos...

vii. 17. Certain of the clauses as to the lord's right to hold the tenement when there is doubt between two heirs seem to be stigmatized as Lex Antiqua. Thus...ad libitum suum. Lex Antiqua. Preterea si mulier aliqua...

Sciendum quod si quis conuictus fuerit de felonia et uxorem habuerit, ipsa uxor nunquam dotem habebit de terra que fuit viri sui de felonia conuicti[1].

viii. 1. The indenture of fine is more fully described. There are three parts and the king keeps one of them.

viii. 2. The precedent is that of a fine levied at Westminster on the Vigil of S. Andrew in the 13th year of King Henry.

viii. 3. Et sciendum quod nulla terra potest incyrographari nisi data fuerit in perpetuum vel ad terminum vite alicuius.

viii. 9. Sciendum tamen quod nulla curia recordum habet gene-

[1] A very doubtful point in the thirteenth century.

raliter preter curiam domini Regis. [Extra] Sciendum quod tres sunt homines in Anglia qui recordum habent, videlicet, justiciarii, coronatores, viredarii, non alii. In aliis autem curiis...

ix. 1. Et sciendum quod quando fit homagium domino, dominus capiet manus hominis sui similiter clausas sub capa sua vel sub alio panno, et homagio facto inuicem se osculabuntur.

Item quero utrum dominus possit distringere hominem suum veniendi in curiam suam sine precepto domini Regis ad respondendum de seruicio unde dominus suus conqueritur quod ei deforciat vel quod aliquid de seruicio suo ei retro sit. Equidem secundum quosdam antiquos bene poterit id facere. Secundum alios modernos non poterit quod ad aliquem effectum veniat, quia homo ille non respondebit de alio [*corr.* libero] tenemento suo nec de hoc quod tangitur [*corr.* tangit] liberum tenementum suum sine precepto domini Regis, quia forte incontinenti tale ostendat breue. [A writ Precipimus tibi quod non implacites A. de libero tenemento suo] Et ita poterit inter dominum et hominem...

ix. 2. ...pro solo vero dominio [*not* domino][1]...

ix. 11. ...Ille autem purpresture que super dominum Regem in regia via probate fuerint per xij. patrie, licet in alio casu aliter fuerit iudicatum, nichilominus in misericordia domini Regis remanebunt hii qui purpresturas illas fecerint...

...de suo honorabili tenemento [*not* contenemento]...

...et non infra assisam fuerit, hoc est si assisam dominus inde perquirere non poterit, tunc distringetur ut veniat ex beneficio et granto domini Regis in curiam domini sui ad id recitaturum [*corr.* adreciaturum], scilicet, de adresser[2]. Ita dico...

ix. 13. ...tempore H. Reg. tercii aui nostri Reg. H. filii Johannis Regis et per hoc sequens breue. Et sciendum quod istud breue in curia domini Regis non potest haberi nisi ipse diuise fuerint inter duas villas precipue, vel inter duo feoda et quod feoda illa diuersificarentur nomine, verbi gracia, La Scherde, Billingeham. Et preterea dicunt quod ad istud sequens breue adaptari poterunt duellum et magna assisa.

ix. 14. At the end follows a writ directing a perambulation of boundaries.

[1] A better reading.
[2] The writer takes to his French.

x. 1. ...cum quis itaque de debito quod sibi debetur curie domini Regis conquiritur, si placitum ipsum ad curiam domini Regis, scilicet, ad comitatum, trahere possit et voluerit, quia illud placitare poterit in curiis dominorum suorum, tunc tale breue de prima summonicione habebit...

The writ is not a Precipe but a Justicies to the sheriff. Instead of a sum of money a charter may be demanded : Eodem modo de catall[is], set catallum non oportet poni in breui nec debet, set eius precium quia diuersa catalla petuntur aliquando et non particule debiti separate, set coniunctim poni non possunt, set narrande sunt omnes particule debiti sicut debentur in placito quando breue inde placitatur, sic, Monstrat D. quod B. iniuste ei detinet unum quarterium frumenti de precio trium solidorum, et unam loricam de precio dimidie marce etc. Et sciendum quod si precium catallorum xxx. marcas in breui excesserit, debet petens dare terciam partem domino Regi per [*corr.* pro] hoc supradictum breue habendo quia breue illud tunc non est de cursu[1].

The case may then be removed from the county court by Pone.

Si autem quis per consilium et auxilium curie domini Regis tale sequens breue de debitis habendis perquirere poterit ut opus suum cicius et melius expediatur, tunc habeat tale breue. Then follows a Precipe for 40 shillings, quos ei debet et unde queritur quod ipse ei iniuste detinet.

x. 5. ...ex sequentibus liquebit. Si vero principalis vel capitalis debitor habeat unde reddere debitum illud et nolit cum possit, plegii eius respondeant pro debito, et si voluerint habeant terras et redditus debitoris quousque eis satisfactum fuerit de debito quod ante pro eo soluerunt, nisi capitalis debitor monstrauerit se inde esse quietum versus eosdem plegios. Et si ipse debitor paratus sit de debito illo satisfacere, plegii ipsius debitoris non distringantur quamdiu ipse capitalis debitor sufficiat ad solucionem debiti, nec terra vero nec redditus alicuius seisietur pro debito aliquo quamdiu catalla debitoris presencia sufficiunt ad debitum reddendum. Then follows a writ of Justicies to compel the principal debtor to acquit his sureties. This writ may be removed from the county court to the Bench. Some say that it will not be granted for a sum of more

[1] See *Harvard Law Review*, III. 112.

than 40 shillings except as a favor. Soluto eo quod debetur ab ipsis plegiis...

Dicunt autem quidam quod creditor ipse suo et legitimorum testium iuramento poterit hoc debitum de iure probare versus ipsum plegium, nisi plegium ipsum curia ipsa velit ad sacramentum leuare[1], quod pocius accidit, olim autem ante legem vadiatam in tali casu ad duellium perueniebatur. [c. 6] Inuadiatur autem res...

x. 6. ...Si autem in custodia sua deterius fuerit factum infra terminum per talliam [*instead of* per culpam[2]] ipsius creditoris computabitur ei in debitum ad valenciam deterioracionis...

x. 11. ...precium mihi restituendum. Omit the rest of c. 11.

x. 15. ...si certum vocauerit warantum in curia quem dicat se velle habere ad warantum, tunc dies ei ponendus est in curia, illo tamen emptore retento in prisona, quia hii homines qui rettati sunt solum de latrocinio per inditamenta et si imprisonati fuerint per legem Anglie, nulla eis facta [*corr.* facienda] est replegiacio, nec etiam de eis qui rettati sunt de morte hominis si imprisonati fuerint, sine speciali precepto domini Regis. Si vero ad diem illum...

...nisi warantus ille alium warantum vocauerit et cum venerit ad quartum warantum erit standum[3].

x. 17. Passage marked Extra—Item si quis captus fuerit cum aliqua re furata ipse qui furtum illud fecit non potest defendere se per duellium, ita quod dicat quod illam non furatus fuit, set si dicat quod res sua propria est bene potest ut dicunt quidam. Item si quis captus fuerit pro morte hominis, non potest iudicari de iure nisi voluerit se super veredictum visnetorum ponere, et si hoc voluerit [*sic*] seruabit prisonem. Si vero incertum vocauerit quis ad warantum...

x. 18. ...sed quid si conductor censum suum statuto termino non soluerit, nunquid in hoc casu licet locatori ipsum conductorem sua auctoritate expellere a re locata? Responsio, licet, si talis inter eos fuerit facta conuencio. [Here ends this book.]

xi. 3. ...extraneus extraneum uxor quoque marito. Here begins a new "treatise," De placitis que per recogniciones terminantur. It

[1] I doubt our author understood what Glanvill meant by "a sacramento leuare."

[2] This variant from the received text looks like a mere blunder.

[3] There is reason to believe that this is the true reading.

almost at once becomes a mere series of writs. The following notes may give a fair idea of its contents.

1. Novel disseisin; Limitation post primam transfretacionem nostram in Britanniam. Variations and notes.

Et sciendum est quod qui in seisina bona et placabili fuerit per unum diem, scilicet, ab aurora diei usque ad crepusculum, vel qui in seisina fuerit ut dictum est per unum diem et unam noctem, et inde eiectus fuerit, poterit recuperare per breue noue disseisine sine dubio. ...Differentia est inter feodum et tenementum; feodum est quod hereditabiliter tenetur; tenementum quod ad terminum vite tenetur. ...Dicitur autem tenementum, terra, mesuagium, redditus, molendinum, morra, marleria et alia consimilia.

2. Mort d'Ancestor; Limitation, last return of John from Ireland. Variations and notes.

3. Utrum. Note. Preterea sciendum est quod predicta communia placita ut recognicio de noua disseisina et de morte antecessoris non sequuntur coram iusticiariis domini Regis nec coram domino Rege, nec ad bancum, set in aliquo certo loco teneantur et capiantur ut in suis comitatibus[1]. Assise autem de ultima presentacione semper capiantur coram iusticiariis de banco et ibi terminentur.

4. Last presentation.

5. Attaint. Et sciendum quod istud predictum breue nunquam a domino Rege vel eius iusticiariis alicui conceditur sine dono, nisi de gracia, si sit pauper; et si petens conuictus fuerit, ibit ad prisonam, si vero lucratus fuerit, primi xij. iuratores imprisonantur donec ibi finem fecerint.

6. Redisseisin.

7. Disseisin; a special case.

8. Writs of right—addressed to the guardian of the heir of Baldwin, Earl of Devon, also to the bailiff of Abbot of Lyra.

Et si mesuagium petatur in aliquo burgagio tunc addatur hec clausula nisi redditus et edificium valeant per annum plus quam xl. solidos, quos clamat tenere de te in liberum burgagium.

Et notandum quod seruicium quod est in denariis non debet extendere [*corr.* excedere] xl. solidos et seruicium militare non debet esse minus quam medietas feodi unius militis, quia si fuerit

[1] Apparently a false interpretation of a famous clause in the Great Charter.

seruicium minus quam medietas feodi unius militis vel supra pro vero tunc non est breue de cursu[1].

9. Recordari facias. De falso iudicio.
10. Customs and services.
11. Mesne.
12. Account against bailiff or steward.
13. Quod permittat for easements and profits.
14. Entry. Many forms, including the *cui in vita*. The wife can be barred by her fine; si vero mulier ipsa coram iusticiariis de banco vel itinerantibus penitus virum suum contradixerit, cirographum de maritagio vel hereditate illa nunquam leuetur.
15. Warantia carte.
16. Protecting infants against litigation.
17. Covenant.
18. Escheat.
19. Ward.
20. Breue de occasione. This is Quare eiecit infra terminum.
21. Appointment of attorney.
22. Writs to bishops and prohibitions to Court Christian. Writs for arrest of excommunicates.
23. Replevin. De homine replegiando.
24. De rationabili parte.
25. Cosinage.
26. Dower ex assensu patris, etc.
27. Admeasurement of dower.
28. Admeasurement of pasture. Et sciendum quod homo non debet impetrare breue de admensuracione pasture super dominum suum.
29. Appeals of felony.
30. Trespass. Assault. Assault on plaintiff's wife.
31. Trespass by breach of pigeon house, by fishing in plaintiff's fishery, by breach of park and taking wild animals. Notandum quod qui conuictus fuerit per istam proximo dictam inquisicionem, non perdet vitam nec membra, eo quod columbe non sunt penitus domestice, nec pisces, nec etiam bestie, sicut boues, equi, vacce et huiusmodi talia.

[1] Compare *Harvard Law Review*, III. 110. The writer seems to have turned the rule inside out.

32. Writ directing that *A* shall have the king's peace, and that *B* do find pledges to keep the peace.

33. Trespass.

34. Replevin.

35. Writ of right. How the lord's court is to be falsified—Taliter autem probetur ipsa defalta, et sic abiuret curiam domini capitalis. Veniet ipse petens cum balliuo ipsius hundredi ad curiam dicti domini capitalis, et feret breue suum in manu sua et unum librum si voluerit, et stet super limitem illius curie et iuret super librum quod amplius per illud breue quod tenet in manu sua in curia illa non placitabit et quia illa curia ei defecit de recto, et tunc habebit breue balliuorum ad vicecomitem quod curiam illam abiur[auit] et defaltam probauit.

36. Odium et atia.

37. Quo iure.

38. Escheat.

39. Pone in replevin : Baldwin de L'Isle and William de L'Isle concerned.

40. Geoffrey parson of Serewelle [Shorwell, Isle of Wight], is in trouble for having procured the excommunication of Jordan of Kingeston who had brought a writ of prohibition against him. The writ is tested by R. de Turkebi[1].

41. Writ after judgment in a novel disseisin.

42. Revocation of writ ordering capture of an excommunicate.

43. Quod permittat habere pasturam for Walter Tho' the rector of the church of Arreton [Isle of Wight] against the Abbot of Quarr[2].

44. Trespass.

45. Novel disseisin.

46. Entry.

47. Aiel.

48. Casus Regis. P. habet duos filios, D. primogenitus est et A. postnatus. D. habet filium B. heredem et D. decedit, et P.

[1] Roger Thurkelby, justice of the Bench in the middle part of Henry III.'s reign. He died in 1260.

[2] In 1266 Walter Tholomei, rector of Arreton, executed a deed of exchange with the Abbot of Quarr, Hasley's *Isle of Wight*, App. p. cxxxvi.

decedit et capitalis dominus ponit in seisinam A. postnatum, et B. filius D. perquiret predictum breue de auo[1].

49. Waste.
50. Habere facias seisinam.
51. Trespass and imprisonment.
52. Contra forma feoffamenti. Henry of Clakeston and Alice his wife against William de Lacy. Recital—cum consilio fidelium nostrorum provideri fecerimus et statui necnon per totum regnum nostrum publicari ne qui occasione tenementorum suorum distringantur ad sectam faciendam ad curiam dominorum suorum nisi per formam feofamenti sui ad sectam illam teneantur, vel ipsi aut eorum antecessores tenementa illa tenentes eam facere consueuerunt ante primam transfretacionem nostram in Britanniam etc.[2] The king is H. dei gracia Rex Anglie, Dominus Hibernie et Dux Aquitanie.

Explicit summa que vocatur Glaunvile. This apparently by the same hand but in different ink. Then immediately a writ issued by H. King of England, Duke of Normandy etc. to B. de Insula. Then a count in an imaginary writ of right from the time of Henry III. Then the form of prohibition known as Indicavit issued by Henry when no longer Duke of Normandy concerning John vicar of Sorewelle, Jordan of Kingeston and William de L'Isle. Nota quod nullum tenementum potest incirographari in curia domini Regis alicui infra etatem existenti.

Item sciendum quod si quis perdiderit loquelam per paralisim et impotens sui fuerit, dominus Rex ponet custodem ad ipsum custodiendum et bona sua et dominus Rex nichil inde capiet. Et tribus de causis erit in custodia domini Regis, quia non debet esse in tuicione domini capitalis, quia dominus capitalis posset forte aliquid alienare de tenemento suo ad exheredacionem heredis. Item non debet esse in custodia heredis quia forte heres mallet ipsum esse pocius mortuum quam viuum. Item non debet esse in tuicione uxoris sue licet uxorem habeat, set in tuicione domini Regis, quia si esset, tunc optineret uxor dominium tocius ipsius

[1] This is the case of King John and Arthur; P = Henry II.; D = Geoffrey; B = Arthur; A = John. See Bracton, f. 267 b, 282, 327 b, where the casus Regis is discussed.

[2] See Provisions of Westminster (1259), c. 1.

tenementi, set per custodem domini Regis ut domina habebit racionabile estouerium suum. Et ita se habet lex Anglie siue tenuerit de domino Rege, siue non. Et si ipse implacitatus fuerit, ipse respondet pro eo qui positus fuerit ex parte domini Regis[1].

Si quis uxorem suam occiderit et conuictus inde fuerit, omnia bona ipsius conuicti erunt domini Regis, tamen per legem Anglie ipsa mulier que occisa fuerit partem suam catallorum mobilium habebit[2].

A page and a half of blank parchment. Then Capitula Itineris of 40 Henry III. Then other capitula as pleaded by Roger de Turkebi. The Assize of Bread and Beer. The correspondence between the King and the Barons before the battle of Lewes. Account of the battle of Lewes. Statement that the following page was written by the hand of Robert Carpenter of Hareslade at Whitsuntide 1265. Precedent for a will. A few legal notes in French. End of a quire.

In another part of the MS. (f. 87) there is a curious form of prayer apparently intended for the use of litigants..."sic me presens iudicium fac peragere, ut in tempore probacionis victor valeam apparere per Te, Saluator Mundi, qui viuis et regnas Deus per omnia secula seculorum. Amen. Pater noster, usque ad finem ter in honore Patris et Filii et Spiritus Sancti, et similiter eodem modo ter Pater noster in honore Raphaelis Archangeli, et similiter eodem modo ter Pater noster in honore Sancti Ezechielis Prophete, ut in placito tuo victor valeas existere, cum Aue Maria similiter dicta."

[1] This is an important note. The king's right to act as guardian of idiots and lunatics can, I believe, be traced to the last years of Henry III and no further. See *English Historical Review*, VI. 369.

[2] This curious note tends to show that at this time our law of husband and wife still entertained some notion of a community of goods. A man murders his wife and is hanged; the wife's share of movables is not forfeited, but goes to her kinsfolk.

THE PEACE OF GOD AND THE LAND-PEACE[1]

THE theme that Dr Huberti has chosen for elaborate treatment is fascinating; indeed, to an historian who would write about a great movement the whole middle ages will hardly offer a more fascinating theme. It has so many and such deep roots, so many and such luxuriant branches; it is of primary importance in the history of civilisation; it becomes implicated with other great themes, and yet it preserves its unity. He who would paint the *pax et treuga Dei* has a splendid if an arduous task before him.

In this book Dr Huberti aspires to show himself rather as an accurate draughtsman than as a colourist. He asks us not to overlook the three letters "zur" which stand upon his title-page[2]. His method may be briefly described; it is the commentator's method. What can be known of the earliest stages of the movement that is under review is to be found almost exclusively in documents which profess to give the canons that were made, the resolutions that were passed, and the oaths that were sworn at various councils and assemblies held in France—for France is the movement's "domicile of origin," and with France only is

[1] *English Historical Review*, April, 1893.
[2] *Studien zur Rechtsgeschichte des Gottesfrieden und Landfrieden*, von L. Huberti, vol. I. 1892.

The Peace of God and the Land-Peace 291

this first volume concerned—during the tenth and eleventh centuries. These documents our author prints at full length in his text. He attempts—this is not always an easy feat—to assign to each its proper date; he then carefully analyses its contents and discusses the relation which it bears to its predecessors and successors. This is the commentator's method, and regard being had to the nature of the subject matter, it may well appear to us as not only the most scientific, but also the most artistic method. It is very doubtful whether the most skilful word-painter could improve upon the language of these documents or substitute for it any that would be half so picturesque. Take, for example, these extracts from an oath exacted by Bishop Warin of Beauvais in the year 1023 :—

"Villanum et villanam vel servientes aut mercatores non prendam nec denarios eorum tollam, nec redimere eos faciam, nec suum habere eis tollam, ut perdant propter werram senioris sui, nec flagellabo eos propter substantiam suam.... Bestias villanorum non occidam nisi ad meum et meorum conductum.... Villanum non praedabo nec substantiam eius tollam perfide iussione senioris sui [pro fideiussione senioris sui?]. Nobiles feminas non assaliam, neque illas quae cum eis ambulaverint sine maritis suis, nisi per propriam culpam, et nisi in meo malefacto illas invenero; similiter de viduis ac de sanctimonialibus attendam."

The cautious particularity of the canons, resolutions, oaths, their provisoes and exceptions and saving clauses can only be brought home to us by the original documents, and yet they are the very essence of the story. Those who strive for peace are in the end successful,

because they are content with small successes, and will proceed from particular to particular, placing now the *villanus* and now the *femina nobilis*, now the sheep and now the olive tree, now the Saturday and now the Thursday outside the sphere of blood-feud and private war. When they are in a hurry they fail, for they are contending with mighty forces.

It is among Dr Huberti's merits that he does not underrate the might of these forces, that he perceives them to be moral forces. We miss the point and thread of the tale if we think that the movement is directed only against the brigand and the marauder, the robber baron who fears not God, neither regards man. It has also to contend against what has been, and is only by slow degrees ceasing to be, a righteous self-help. It has to aim not merely at the enforcement of law, but at the transfiguration of law. It cannot suppress, and we may say that it ought not to suppress, the blood feud, until it has something better, a true criminal law, wherewith to fill the void. Over and over again legislators under the influence of Roman law and Christian teaching have been too hasty; their laws have from the first been idle, or have become idle so soon as some strong king made way for a feebler son. Dr Huberti has spent pains over what we may call the background of his picture, and has therefore refrained from an indiscriminate use of those lurid colours in which some of his predecessors have delighted. There is a great deal that is good in self-help and vengeance, and, as a bishop of Cambrai thought, there is questionable wisdom in forcing men to swear impossible oaths.

The Peace of God and the Land-Peace

A new phenomenon appears late in the tenth century. Dr Huberti fixes as the occasion of its first appearance an ecclesiastical council held at Charroux in the year 989. That council pronounces a general prospective anathema against three classes of persons, (1) *infractores ecclesiarum*, (2) *res pauperum diripientes*, (3) *clericorum percussores*—a cautious anathema set about with provisoes. A council at Narbonne in 990, a council at Anse in 994 do the like. In Dr Huberti's eyes these are not merely *die ersten kirchlichen Friedensatzungen*, but also *die ersten Friedensatzungen überhaupt*. One has to quote his German words, for one could hardly translate them without some small misrepresentation of their meaning, for they are used in the performance of a delicate operation. There is something that is new about these canons of Charroux, and yet when we analyse them it is difficult for us to detect the novel element. Legislative attempts to limit the range of the blood feud are not new; excommunication as a punishment for sacrilege is not new; the privilege of sanctuary is not new; even a special care for the defenceless is not new. What is new, if I have caught Dr Huberti's meaning, is the fusion of old elements in a conscious endeavour to mark off by general definitions a sphere of peace from the surrounding sphere of feud, so that peace itself and for its own sake now becomes the object that is aimed at. Having defined the new phenomenon, he has to account for its appearance in a particular form, to wit, that of purely ecclesiastical canons, at a particular place and time, to wit, Aquitaine and the last years of the tenth century. This is a problem that he discusses at length,

and if his solution of it is not complete he certainly has fulfilled one of the conditions of success. Some of his forerunners seem to have fancied that they had given explanation enough when they had daubed the tenth century with plenty of black and red and left their readers to supply some such suppressed premiss as that when night is darkest dawn is nighest. But night is not really the cause of day, nor order of disorder. One does not account for "the temperance movement" by saying that drunkenness has been on the increase. Dr Huberti, therefore, tries to show that the Aquitaine of the age that saw the coronation of Hugh Capet was the predestined scene of the first "peace movements"; and in this context his newest and most valuable suggestion is that which would connect these movements with the survival of Roman law in Aquitaine and the emergence of the principle of territorial law.

The first movement spreads outwards from Aquitaine. We can see it in progress between the years 989 and 1039; it aims at placing certain things and certain persons outside the province of fair fighting and legitimate self-help. Meanwhile, however, a second movement has begun in Aquitaine about the year 1027, or even somewhat earlier. The chronological order of our documents is not, therefore, the logical order. We have to think of successive waves starting in Aquitaine, and while the first is yet breaking over northern Gaul the second is flowing in the south. The characteristic of this second movement is the attempt to put not merely certain persons and certain things, but also certain seasons beyond the limits of the feud—to establish, we may say, "a close time" even for the

militant classes. This, the true *treuga Dei*, makes its first recorded appearance, so our author argues, in a synod held at Elne, in Roussillon, during the year 1027. "The close time" is at first but a brief space: it extends only from noon on Saturday to daybreak on Monday; but already before 1041 its beginning has been thrown back to vesper-tide on Wednesday, so that but a very short half of every week is left open. Then other holy seasons get exempted, until at length almost the whole period that lies between Advent and the octave of Pentecost is close. Here again Dr Huberti is at pains to show how much and how little is new, and the task is not a very easy one, for the attempt to make Sundays and others festival days of rest and peace and immunity from legal process is old enough. What seems new is the conscious effort to use the sanctification of these days as a means for obtaining as much peace as possible and the application to them of the idea of "truce," of an armistice ordained by God and sanctioned by sworn contract.

The true "truce of God," which consecrates seasons, becomes part of that "peace" for which men are striving; they now desire *pacem et treugam Dei*. Many persons, many things, as well as many seasons are *taboo* to the decently conscientious man-at-arms, even to the reasonably prudent man-at-arms, for—and here there is a very interesting episode—both church and state will be against him if he exceeds the narrow boundaries of lawful warfare, and indeed the two powers can now afford to be a little jealous of each other and inclined to quarrel over the right to punish him. A great deal more remains to be said. In one

chapter Dr Huberti deals with the adoption of this originally French institution by the popes and the catholic church; in a last chapter he traces the legislation by which the French kings gradually destroyed that right of warfare, which in the thirteenth century had already become the distinctive privilege of *gentix hons*. Here he has paused. As yet, except when speaking of the canon law, he has confined himself to France or Gaul, and, unless I am mistaken, he is reserving even Normandy, about which there is much to be said, for separate treatment. We are allowed to hope that in connexion with Normandy he will tell us something of England, for the last word about "the peace of God and of our lord the king" has not yet been uttered. At any rate his next volume will concern itself with the German *Landfrieden*, an institution as essentially German as the *treuga Dei* is essentially French.

I dare say but little more of this first volume than that I have read it with great interest, and that some of its merits are more apparent at a second than they are at a first reading. This is due to the method that I have called the commentator's method. One gradually learns where to look for the main arguments which are at times hidden from view by subsidiary discussions. Signs of solid industry are everywhere apparent. There is a little more bickering with forerunners and fellow-labourers than is to our English taste. One sometimes wishes that Dr Huberti would leave Sémichon and Kluckhohn alone and just tell us his own version of the story regardless of other versions. Still his theme is one that has suffered from a too lax use of terms

The Peace of God and the Land-Peace

such as "peace of God" and "truce of God," and his efforts to establish a stricter usage, and one better warranted by the ancient documents, are praiseworthy and—so it seems to me—in the main successful.

At the same time I cannot but think that he has allowed his book to grow to an unnecessary size, and that the average quality of his matter would have been better if its quantity had been less. For example, he makes, as already said, the interesting remark that the country in which each successive "peace movement" begins is the country of the written, the Roman law. On this there follow some ten or twelve pages which deal with the survival of Roman law in Aquitaine and contain some paragraphs which are almost wholly made up of references. Such is one which begins thus: *Wir bemerken eine Beeinflussung durch Gaius in formulae Bituricenses* 9; "*dum lex Romana declarat etc.*"; *durch Paulus in formulae Turonenses* 17, *Turonenses* 16, *Marculfi* II. 19, *Bituricenses* 2; *durch Ulpianus in formulae Andegavenses* 41—and so forth. There is a place for all this erudition (which can be now somewhat easily collected), but it is not the place that Dr Huberti has found for it. It should be put where it will be looked for, and it will not be looked for here. Two or three well-chosen sentences, stating in general terms the results attained by those who have made the mediaeval history of Roman law the object of their researches, would have been far more to the purpose than this heap of notes.

HISTORY FROM THE CHARTER ROLL[1]

IN England so soon as the royal charter becomes distinguishable from the royal letter patent, the main formal difference between the two instruments is this, that whereas the letter patent usually bears a simple *Teste Meipso*, the charter professes to have been delivered by the king or by his chancellor in the presence of many witnesses whose names are given. We have a fairly perfect series of charter rolls beginning in the year 1199. Now it seems to me that an eminent service in the cause of history would be done by any one who would be at pains to copy and publish the lists of witnesses that are to be found on the charter rolls of the thirteenth and fourteenth centuries; and in the hope of suggesting this task to some one who can spend a few months in the Record Office, I have asked leave to print here the result obtained by the examination of the roll of one particular year, the thirty-seventh of Henry III (28 Oct. 1252—27 Oct. 1253). The task would not be very laborious, and the outcome of it would not be a very bulky book, but it would, so I venture to think, be a book which every one who was

[1] *English Historical Review*, April, 1893.

History from the Charter Roll

studying the history of the period that I have named would be bound to have always at hand and often in hand.

These lists of witnesses give us week by week and almost day by day the names of those men who are in the king's presence, and I need not say that if we are to know minutely how England is being governed, it is necessary that we should know who are the persons whom the king habitually sees. In the absence of any official lists of the king's councillors, it is only thus that we can learn—unless the chroniclers give us some fitful help—who the king's councillors are. There are times also in our history in which it is more important to know who are the men who day by day have speech with the king than to know the names of those who are his titular councillors.

A doubt may well occur to us as to whether there may not be fictions lurking in the charter rolls, whether when we read that on a given day the king delivered a charter with certain men as witnesses, we are entitled to infer that on that day those men were really and truly, and not by way of fiction, in the king's presence. But having looked at a good many rolls of the thirteenth century (I must not speak of much later times) this doubt seems to me to be unwarranted. We see the witnesses changing day by day and can in some measure account for the changes. At one time the king is enjoying himself at one of his rural manors or hunting lodges; the witnesses will be for the more part officers of the household, though it may happen that some bishop or earl will be paying him a casual visit, and if so will be named in the charter. Then the king

comes to Westminster for the despatch of business; the number of charters that he has to execute increases, and the quality of the witnesses changes; the great officers of state are mentioned, and, it may be, some of the judges. The king holds a parliament; the quality of the witnesses changes once more; four or five bishops, four or five earls or great barons will attest his deeds. Further, it often happens that several charters are dated on the same day and that the lists of the witnesses coincide but partially. Now if we were dealing with a chancery fiction, with some rule which declared that certain officers ought to attest, and therefore must be supposed to have attested, a royal charter, all this would hardly be true. If the scribe of the charter had before him some rota of "gentlemen in waiting," and thence took his list of supposed witnesses, we should surely expect that one list would do duty for a whole day. If then we find, as well we may, that two charters were dated on the same day, and that the archbishop of Canterbury attested one out of the two, we are, so at present it seems to me, justified in believing that on the day in question the archbishop was in the king's presence, that while he was there a charter was delivered, and that the other charter was delivered before his arrival or after his departure. In no other way can I account for the rapid variations in the lists of witnesses.

The roll that I chose was chosen at haphazard. It is not an unusually good specimen, for it is imperfect, but it comes from an important time, and many of the names upon it are the names of those councillors of Henry III, of whom Matthew Paris has told us so

History from the Charter Roll 301

much that we would willingly learn more. We see William of Kilkenny, the learned legist who keeps the great seal, Philip Lovel, who is acting as treasurer, Peter Chaceporc, the keeper of the wardrobe, and the great John Mansel, who seems to be "prime minister without portfolio." Sometimes a few justices, Roger Thurkelby, Gilbert Preston, Simon Walton, appear, though only for a moment. The most constant witnesses seem to be household officers, headed by Ralph fitz Nicholas, the steward of the household. Rarely are the official titles of these witnesses mentioned, though the Prior of Newburgh is called "our chaplain." Mansel is merely provost of Beverley, Kilkenny and Chaceporc are merely archdeacons. I put the more faith in these lists because there is no well-settled order in which the names occur. Those witnesses who are of highest rank come first, but there is no carefully observed sequence such as we should expect were we dealing with a legal fiction. Then the kinsmen of the king and queen are prominent; among them are Archbishop Boniface and the elect of Winchester. Now and again some bishop or baron who is not connected with the court appears and vanishes. And two of the parliaments or grand councils of the year leave an obvious mark upon the roll. On 26 January, 1253, there are four bishops, besides the archbishop, in the king's presence. Had we no other evidence than that which is afforded by this roll, we should be able to say that there was an important meeting early in May. I cannot but think that a brief calendar of the charter rolls would fix the date of many a parliament or council, of which

we as yet know little or nothing. But now I will leave this specimen in the hands of those who can judge whether such a calendar would not be a very useful thing, premising that what is here printed is but a rough specimen, and not a finished model.

Charter Roll of 37 Henry III.

1252

29 *Oct., Windsor.*—Geoffrey de Lusignan, William de Valence, John de Grey, William de Kilkenny, Robert de Muscegros, Robert Walerand, Bartholomew Pecche, Eble de Mountz (de Montibus), Robert le Norreis, Imbert de Pugeis.

Same, with Ralph de Bakepuz.

30 *Oct., Windsor.*—Lusignan, Valence, J. de Grey, Kilkenny, Ralph f. Nicholas, Muscegros, Walerand, Pecche, Walter de Thurkelby, Norreis, Bakepuz, John de Geres, Pugeis.

31 *Oct., Windsor.*—A[imer] bp elect Winchester, Richard E. of Cornwall, Lusignan, Valence, Peter de Savoy, John Maunsel, Kilkenny, John de Lexington, Walerand, Pecche, Norreis, Walt. de Thurkelby, Bakepuz.

2 *Nov., Windsor.*—A. bp elect Winchester, Lusignan, Valence, Savoy, Maunsel, Kilkenny, Lexington, Muscegros, Walerand, Pecche, Geoffrey de Langley, Stephen Bauzan, Norreis.

Also Philip Lovel, Pugeis.

Also E. Cornwall, Gilbert de Segrave.

3 *Nov., Windsor.*—P. de Savoy, J. de Grey, Kilkenny, Lovel, Segrave, Walerand, Bauzan, Norreis, Bakepuz, Pugeis.

3 *Nov., Windsor.*—Lusignan, Savoy, J. de Grey, Lexington, Peter Chaceporc, Kilkenny, Artald de S. Romano, Muscegros, Walerand, Bauzan, Norreis, Bakepuz, Pugeis.

4 *Nov., Windsor.*—Savoy, Lexington, Bertram de Crioll, Muscegros, Kilkenny, Walerand, Bauzan, Norreis, Walt. de Thurkelby, Bakepuz, Pugeis.

6 *Nov., Reading.*—W[illiam] bp Salisbury, Segrave, Kilkenny,

History from the Charter Roll 303

Lexington, Walerand, Pecche, William de Chaenny, Walt. de Thurkelby, Bakepuz.

Also Simon de Wauton, Gilbert de Preston, Pugeis.

9 *Nov., Marlborough.*—Lexington, Kilkenny, John Prior of Newborough, Segrave, Nicholas de Turri, Pecche, Chaenny, Walt. de Thurkelby, Pugeis.

10 *Nov., Marlborough.*—Humfrey E. of Hereford, Lexington, Kilkenny, Elyas Rabain, Segrave, Langley, Pecche, Chaenny, Walt. de Thurkelby, Pugeis.

12 *Nov., Marlborough.*—R[ichard] bp of Chichester, Lusignan, Earl of Hereford, Segrave, Kilkenny, Lexington, Pecche, Chaenny, W. Thurkelby, Pugeis.

12 *Nov., Marlborough.*—R. bp of Chichest., Earl of Gloucester, E. of Hereford, Lusignan, Valence, Kilkenny, Lexington, Segrave, Guy de Rochefort, Pecche, Pugeis, W. Thurkelby.

16 *Nov., Clarendon.*—Lusignan, Valence, Segrave, Lexington, Kilkenny, Rabain, Richard de Mundeville, Roger de Saunford, William de Chabbeneys, Chaenny, Pugeis, Geres.

Also Ralph fitz Nicholas, J. Maunsel, Walerand, de Turri.

17 *Nov., Clarendon.*—Lusignan, Valence, f. Nicholas, Lexington, Kilkenny, Segrave, Walerand, Chaenny, Walt. Thurkelby, Pugeis.

19 *Nov., Clarendon.*—A. bp elect Winchest., Earl of Cornwall, Lusignan, Valence, Maunsel, Kilkenny, f. Nicholas, Lexington, Muscegros, Walerand, Pecche, Chaenny, W. Thurkelby, Pugeis.

22 *Nov., Clarendon.*—A. elect Winton, Lusignan, Valence, f. Nicholas, Maunsel, Kilkenny, Segrave, Lexington, Walerand, Pecche, Rabayn, Pugeis, Geres, Thurkelby.

23 *Nov., Clarendon.*—Lusignan, Valence, Savoy, Maunsel, Kilkenny, Lexington, Walerand, Rabayn, Pugeis, Thurkelby.

24 *Nov., Clarendon.*—Lusignan, Maunsel, Kilkenny, f. Nicholas, Lexington, Rabayn, Walerand, Pecche, Pugeis, Thurkelby, Geres.

Same, with Langley instead of Pecche.

29 *Nov., Clarendon.*—Maunsel, Kilkenny, Chaceporc, Muscegros, Walerand, Langley, Pecche, Bauzan, Norreis, Pugeis.

Same, with Geres instead of Langley.

.[1]

[1] The charters for December and the greater part of January seem to be missing.

1253

1 *Jan.*, *Westm.*—R[obert] bp Linc., W. bp Worcest., f. Nicholas, Segrave, Reginald de Moun, J. de Grey, Walerand, Kilkenny, Roger de Thurkelby, Peter de Rivaux, Pugeis, Will. de Gernun.

26 *Jan.*, *Westm.*—Valence, Maunsel, Kilkenny, f. Nicholas, Crioll, J. de Grey, Segrave, Lexington, Walerand, W. de Grey, Norreis.

26 *Jan.*, *Westm.*—B[oniface] abp Cant., F[ulk], bp Lond., R[obert] bp Linc., W[illiam] bp Salisb., R[ichard] bp Chichest., E. of Hereford, Maunsel, Kilkenny, f. Nicholas, J. de Grey, Crioll, Walerand, Gernun.

28 *Jan.*, *Westm.*—Eler. abb. Pershore, Maunsel, Kilkenny, f. Nicholas, Crioll, J. de Grey, Walerand, W. de Grey, Norreis, Gernun, Lokington, Bakepuz.

Same, with Pecche and Bauzan, and without the abbot, W. de Grey, Norreis, Lokington, and Bakepuz.

28 *Jan.*, *Westm.*—F. bp Lond., R. bp Linc., W. bp Worcest., W. bp Salisb., R. bp Chichest., L. bp Rochest., Maunsel, f. Nicholas, Crioll, J. de Grey, Walerand, Lokington.

29 *Jan.*, *Westm.*—Maunsel, Kilkenny, f. Nicholas, Crioll, J. de Grey, Walerand, Guy de Rochefort, Will. de Chaenny, Bauzan, W. de Grey, Gernun, Bakepuz, Pugeis, Lokington.

1 *Feb.*, *Westm.*—f. Nicholas, Segrave, Kilkenny, J. de Grey, Walerand, W. de Grey, Gernun, Norreis, Walt. Thurkelby, Bakepuz, Lokington.

5 *Feb.*, *Merton.*—Earl of Warwick, J. de Grey, Stephen Lungespe, Kilkenny, Pecche, W. de Grey, Gernun, Norreis, St Maur.

7 *Feb.*, *Merton.*—P[eter] bp Heref., E. abb. Pershore, J. de Grey, Kilkenny, Wengham, W. de Grey, Norreis, Gernun, St Ermin.

8 *Feb.*, *Merton.*—P[eter] bp Heref., Kilkenny, J. de Grey, Chabbeneys, Pecche, W. de Grey, Gernun, Norreis.

9 *Feb.*, *Merton.*—A. elect bp. Winch., Kilkenny, J. de Grey, Hugh le Bigod, Roger de Thurkelby, Walerand, W. de Grey, Pecche, Gernun, Norreis.

10 *Feb.*, *Merton.*—Earl of Warwick, J. de Grey, Maunsel, Kilkenny, Walerand, Pecche, Eble de Mountz, W. de Grey, Gernun, Stephen de Salmis, Norreis.

13 *Feb.*, *Windsor.*—Earl of Warwick, J. de Grey, Kilkenny,

Walerand, de la Haye, N. de Turri, Roger de Sumery, W. de Grey, Norreis, Gernun.

17 *Feb., Windsor.*—Maunsel, Chaceporc, Kilkenny, J. de Grey, Walerand, Wengham, Segrave, de Turri, W. de Grey, St Maur, Gernun, Peitevin.

18 *Feb., Windsor.*—Earl of Cornwall, Segrave, J. de Grey, Maunsel, Kilkenny, Walerand, de la Haye, Wengham, Gernun, W. de Grey, Matthew Bezill, St Maur.

23 *Feb., Windsor.*—Maunsel, Chaceporc, Kilkenny, J. de Grey, Walerand, Wengham, Segrave, de Turri, W. de Grey, St Maur, Gernun, Peitevin.

Earl of Cornwall, Savoy, Maunsel, Chaceporc, Kilkenny, J. de Grey, de Mountz, W. de Grey, St Maur, Pugeis.

24 *Feb., Windsor.*—Earl of Cornwall, J. de Grey, Maunsel, Kilkenny, de Mountz, St Maur, Pugeis.

2 *March, Westm.*—John Maunsel, Chaceporc, Kilkenny, J. de Grey, P. Lovel, de Turri, de Mountz, St Maur, Pugeis, Peitevin.

2 *March, Westm.*—Maunsel, Kilkenny, Chaceporc, J. de Grey, Drogo de Barentin, Pecche, St Maur, Pugeis.

4 *March, Westm.*—Maunsel, Chaceporc, Kilkenny, J. de Grey, Simon de Wauton, Lovel, St Maur, Pugeis, Peitevin.

10 *March, Westm.*—Savoy, E. of Warwick, Maunsel, Chaceporc, Kilkenny, J. de Grey, Ralph de la Haye, Nich. de Molis, Rabayn, St Maur, Pugeis, Rog. de Lokington, Peitevin.

11 *March, Westm.*—E. of Warwick, J. de Grey, Maunsel, de Molis, Kilkenny, de la Haye, Rabayn, Chabbeneys, Pugeis, Lokington, Peitevin.

Also Savoy and Wengham.

12 *March, Westm.*—Earl of Warwick, J. de Grey, Kilkenny, Nicholas de Molis, Chaceporc, Wengham, Ralph de la Haye, Rabayn, St Maur, Pugeis, Peitevin.

13 *March, Westm.*—Earl of Warwick, Savoy, Maunsel, Kilkenny, J. de Grey, Wengham, St Maur, Pugeis, Lokington.

14 *March, Westm.*—Earl of Warwick, J. de Grey, Maunsel, Kilkenny, de Molis, Walerand, Pugeis, St Maur, Bakepuz, Haye, Peitevin.

14 *March, Westm.*—Maunsel, Chaceporc, Kilkenny, J. de Grey, Walerand, Wengham, W. de Grey, St. Maur, Pugeis.

16 *March, Westm.*—Maunsel, Chaceporc, Kilkenny, f. Nicholas, J. de Grey, Walerand, Wengham, W. de Grey, St Maur, Lokington, Pugeis.

17 *March, Westm.*—Maunsel, Chaceporc, Kilkenny, f. Nicholas, J. de Grey, Walerand, Wengham, de Molis, W. de Grey, Lokington.

18 *March, Westm.*—Maunsel, Chaceporc, Kilkenny, f. Nicholas, J. de Grey, Walerand, Wengham, W. de Grey, St Maur, Lokington.
Same, with Pugeis.

20 *March, Westm.*—Maunsel, Chaceporc, Kilkenny, f. Nicholas, J. de Grey, Wengham, W. de Grey, St Maur, Lokington, Pugeis, William de Gardinis.

Maunsel, Kilkenny, f. Nicholas, J. de Grey, Segrave, de la Haye, Walerand, de Molis, Drogo de Barentin, Peter Braunche, W. de Grey, St Maur.

f. Nicholas, Maunsel, Segrave, Kilkenny, Chaceporc, J. de Grey, Walerand, W. de Grey, St Maur, Bakepuz, Pugeis.

22 *March, Westm.*—Maunsel, f. Nicholas, Kilkenny, de Grey, Segrave, de la Haye, Walerand, W. de Grey, St Maur, Lokington, Bakepuz, Pugeis.

23 *March, Westm.*—Earl of Gloucester, Savoy, Maunsel, Chaceporc, Kilkenny, f. Nicholas, J. de Grey, Walerand, Segrave, Wengham, St Maur, W. de Grey, Lokington.

29 *March, Waltham.*—J. de Grey, Kilkenny, Walerand, Chabbeneys, W. de Grey, Pugeis, Bakepuz, Peitevin.
Same, with Warin f. Gerald and St Ermin instead of Chabbeneys and Pugeis.

29 *March, Waltham.*—Kilkenny, J. de Grey, Wengham, Walerand, Chabbeneys, W. de Grey, Pugeis, Bakepuz, Peitevin.

30 *March, Waltham.*—J. de Grey, Kilkenny, John Prior of Newborough, Wengham, Chabbeneys, W. de Grey, Pugeis, Peitevin.

J. de Grey, Kilkenny, Walerand, Wengham, Chabbeneys, Robert de Shotindon, W. de Grey, Bakepuz, Pugeis, Peitevin, St Ermin.

4 *April, Westm.*—J. de Grey, Kilkenny, Wengham, W. de Grey, Chabbeneys, Robert de Mares, Pugeis, Peitevin, St Ermin.

4 *April, Havering.*—Kilkenny, J. de Grey, Wengham, Chabbeneys, W. de Grey, Pugeis, Peitevin.
Also Maunsel, St Ermin.
Also Prior of Newborough.

History from the Charter Roll

6 *April, Havering.*—J. de Grey, Kilkenny, Wengham, W. de Grey, J. de Geres, Pugeis.
Also de Mountz, Bauzan, St Ermin.

8 *April, Havering.*—Kilkenny, J. de Grey, Ric. de Munfichet, Wengham, Rochefort, W. de Grey, Bauzan, Pugeis, Geres.

15 *April, Westm.*—Maunsel, Kilkenny, Prior of Newborough, J. de Grey, Wengham, de Mountz, W. de Grey, Bauzan, St Maur, Lokington, Pugeis.

16 *April, Westm.*—Maunsel, Kilkenny, Prior of Newborough, J. de Grey, Wengham, Rochefort, W. de Grey, St Maur, Pugeis, Lokington.

17 *April, Westm.*—Maunsel, Kilkenny, J. de Grey, Lovel, Wengham, Rochefort, W. de Grey, Bauzan, St Maur, Pugeis, Lokington, Bakepuz.

22 *April, Merton.*—S[ilvester] bp Carlisle, Maunsel, Kilkenny, J. de Grey, f. Nicholas, Wengham, W. de Grey, St Maur, Pugeis.

24 *April, Merton.*—f. Nicholas, Kilkenny, R. de Grey, Chaceporc, W. de Grey, Lokington...St Ermin, Geres [*imperfect*].

29 *April, Merton.*—f. Nicholas, Crioll, Kilkenny, R. de Grey, J. de Grey, Wengham, Rabain, W. de Grey, Lokington, St Ermin, Geres.

4 *May, Westm.*—A. bp elect Winchest., Earl of Warwick, Kilkenny, f. Nicholas, Crioll, R. de Grey, J. de Grey, Wengham, W. de Grey, Peitevin, Lokington, St Ermin.

5 *May, Westm.*—Earl of Warwick, f. Nicholas, Crioll, J. de Grey, Kilkenny, Wengham, W. de Grey, St Maur, Lokington, Walt. Thurkelby.

10 [?] *May, Westm.*—Savoy, Maunsel, Kilkenny, f. Nicholas, Crioll, R. de Grey, J. de Grey, Wengham, W. de Grey, Bauzan, St Maur, Lokington.

10 *May, Westm.*—Savoy, Maunsel, Kilkenny, f. Nicholas, Crioll, J. de Grey, Walerand, Wengham, Bauzan, W. de Grey, St Maur, Lokington.

F. bp London, W. bp Salisb., W. bp Durham, Earl of Norfolk, Earl of Warwick, Philip Basset, f. Nicholas, Maunsel, J. de Grey, Kilkenny, W. de Grey, St Maur, Bakepuz, Lokington, Pugeis, Peitevin.

B. abp Cant., Savoy, Maunsel, Kilkenny, f. Nicholas, Crioll,

J. de Grey, Walerand, Wengham...Bauzan, St Maur, Bakepuz, Lokington.

B. abp Cant., R. bp Linc., W. bp Durham, F. bp London, W. bp Salisb., W. bp Norwich, W. bp Bath and Wells, E. of Cornwall, E. of Norfolk, f. Nicholas, Maunsel, J. de Grey, Kilkenny, Crioll, Lexington, Walerand, W. de Grey, St Maur, Lokington, Bakepuz, Pugeis, Peitevin.

12 *May, Westm.*—Maunsel, f. Nicholas, Lexington, Crioll, J. de Grey, Kilkenny, Walerand, Wengham, W. de Grey, St Maur, Pugeis.

Savoy, Maunsel, f. Nicholas, St Maur, Pugeis, Lokington.

Savoy, Maunsel, f. Nicholas, Lexington, Crioll, Kilkenny, Walerand, Wengham, J. de Grey, St Maur, Pugeis, Lokington.

13 *May, Westm.*—Savoy, Maunsel, f. Nicholas, Lexington, Crioll, J. de Grey, Kilkenny, Walerand, Wengham, W. de Grey, Pugeis.

14 *May, Westm.*—Savoy, Maunsel, Chaceporc, Kilkenny, f. Nicholas, Crioll, J. de Grey, Lexington, Walerand, Bauzan, St Maur, Lokington.

15 *May, Westm.*—F. bp London, W. bp Salisb., Earl of Norfolk, f. Nicholas, J. de Grey, Kilkenny, Crioll, W. de Grey, St Maur.

15 *May, Westm.*—B. abp of Cant., A. elect bp Winch.,... f. Nicholas, Kilkenny, J. de Grey, Crioll, Walerand, W. de Grey....

16 *May, Westm.*—Savoy, Maunsel, Chaceporc, f. Nicholas, Lexington, Crioll, J. de Grey, Walerand, W. de Grey, Bauzan, Pugeis, Lokington.

22 *May, Westm.*—F. bp London, S. bp Carlisle, f. Nicholas, Lexington, J. de Grey, Pecche, Bauzan, W. de Grey, Lokington, Pugeis.

24 *May, Windsor.*—W. bp Durham, Kilkenny, J. de Grey, Walerand, Chabbeneys, Pecche, Bauzan, St Maur, Bakepuz, St Ermin.

25 *May, Windsor.*—J. de Grey, Kilkenny,...Rob. de Muscegros, Walerand, Pecche, Langley, Bauzan, St Maur.

29 *May, Westm.*—Chaceporc, Kilkenny, de Grey, Wengham, Pecche, Bauzan, Pugeis, St Ermin, Peitevin.

1 *June, Faversham.*—L. bp Rochester, Kilkenny, Crioll, W. de Grey, Pecche, Pugeis, Bauzan, Peitevin, Chaenny [*vacated*].

15 *June, Winchester.*—W. bp Bath, Chaceporc, Kilkenny, J. de Grey, Crioll, Lexington, Wengham, Walerand, St Maur.

18 *June, Winchester.*—Maunsel, Kilkenny, Crioll, J. de Grey, Lexington, Walerand, Wengham, Pecche, Bauzan, St Maur, Bakepuz, Pugeis.

19 *June, Winchester.*—B. abp Cant., A. bp elect Winchest., W. bp Worcest., P. bp Hereford, W. bp Bath, E. of Cornwall, E. of Gloucester, Guy de Lusignan, f. Nicholas, Maunsel, Kilkenny, J. de Grey, Lexington, W. de Grey, Gernun.

20 *June, Winchester.*—B. abp Cant., E. of Cornwall, E. of Gloucester, Maunsel, Kilkenny, f. Nicholas, Crioll, Lexington, W. de Vesy,...Gernun [*imperfect*].

f. Nicholas, Kilkenny, J. de Grey, Walerand, de Mountz, Pecche, Bauzan, Bakepuz...[*imperfect*].

21 *June, Winchester.*—B. abp Cant., E. of Cornwall, Maunsel, Kilkenny, f. Nicholas, Crioll, J. de Grey, Lexington, Walerand, Wengham, Pecche.

22 *June, Winchester.*—f. Nicholas, Kilkenny, Crioll, J. de Grey, Lexington, Walerand, Wengham, Pecche, Bauzan, W. de Grey, St Maur, Pugeis, Bakepuz.

23 *June, Southwick* [*Suwyk*].—Kilkenny, John f. Geoffrey justiciar of Ireland, f. Nicholas, Crioll, J. de Grey, Lexington, Walerand, Pecche, W. de Grey, Pugeis.

25 *June, Southwick* [*Suwyc*].—Joh. f. Geoffrey, Will. de Cantilupe, Chaceporc, Kilkenny, f. Nicholas, Crioll, J. de Grey, Lexington, Walerand, Wengham, Pecche.

27 *June, Southwick.*—Savoy...Crioll, Lexington, J. de Grey, Kilkenny, Wengham....

29 *June, Southwick.*—F. bp London, W. bp Worcest., Savoy, Kilkenny, f. Nicholas, J. de Grey, Crioll, Lexington, Walerand, Pugeis.

.[1]

[1] Part of the roll containing the charters of June is mutilated, and it seems probable that some membranes containing the charters of July are lost. In August the king left England for Gascony.

TALTARUM'S CASE[1]

THE name of the hero of what has long been, and in spite of anything that I can say will long be, known as Taltarum's case, was not Taltarum. I have lately seen the record of that case. It stands on the De Banco Roll for Mich. 12 Edward IV, m. 631. I wished to see whether the pleadings were correctly stated in the Year Book. In the main they are correctly stated, but I am able to supplement the report with a few details and to add a little local colour. It was a Cornish case, and concerned a messuage and 100 acres of land in Porhea (Portreath?). The plaintiff was Henry Hunt; the defendant was John Smyth. The action was on the Statute of 5 Richard II against forcible entry, and the plaintiff sued "tam pro domino Rege quam pro seipso." The original feoffor mentioned in the defendant's plea was Thomas Trevistarum. In the plaintiff's replication the famous recovery is alleged to have taken place in the Easter term of 5 Edward IV, before Robert Danby and his fellow justices of the bench. The writ stated that John Arundel, the lord of the fee, had remised his court. The demandant in it was Thomas Talkarum or

[1] *Law Quarterly Review*, Jan. 1893.

Talcarum. His name is written many times, now with a *k*, now with a *c*, never with a *t*. The vouchee was Robert Kyng. The well-known rejoinder about the settlement made by John Tregoz was pleaded only as to twenty-four acres, parcel of the land in question. As to the residue the plaintiff pleaded in a more general fashion that at the time of the recovery Humphrey Smyth was not seised of the freehold, and that therefore the recovery was void in law. The defendant demurred upon both replications and the plaintiff joined in demurrer. *Curia advisari vult*, and gives a day in next Hilary term for judgment. No judgment has been posted up on the Michaelmas roll, nor could I find any notice of the case on the Hilary roll.

On looking at the report in the Year Book I do not think that any judgment had been given when that report was written. The four judges—so it seems to me—were agreed about the two points in relation to which the case has so often been cited. (1) They were prepared to hold that a proceeding such as was afterwards known as a "recovery with single voucher" would serve to bar an estate tail if the tenant in the action was "in as of" that estate tail. (2) They thought that such a recovery would not bar an estate tail if the tenant was not "in as of" that estate tail at the time of the recovery. But so far as I can see they were hopelessly divided, two against two, about the question of remitter which was the thorniest question in the case. I have often attempted and often failed to understand what was the hypothetical state of facts which formed the basis of the argument about the remitter. It was therefore that I searched the roll. I

have only to report that what Mr Challis has justly called "the rambling obscurity" of the report correctly states the pleadings on the record. On the whole the hypothesis seems to be this. Talkarum, the recoveror, having obtained judgment, did nothing more during the life-time of Humphrey Smyth, the tenant in the action. Humphrey died seised; on his death Robert Smyth entered, and on Robert's death John Smyth entered. Then Taltarum entered on John and enfeoffed Henry Hunt, then John entered and cast out Hunt, and this was the forcible entry complained of. But I must confess that I am puzzled by those mysterious *absque hocs* with which the pleadings abound.

Leaving to Cornishmen the question whether Talkarum and Trevistarum are possible names, I cannot refrain from the remark that the name of Henry Hunt is beautifully simple.

THE SURVIVAL OF ARCHAIC COMMUNITIES[1]

I. THE MALMESBURY CASE.

THAT land was owned by communities before it was owned by individuals, is nowadays a fashionable doctrine. I am not going to dispute it, nor even to discuss it, for in my judgment no discussion of it that does not deal very thoroughly with the history of legal ideas is likely to do much good. I must confess, however, to thinking that if the terms "community" and "ownership" be precisely used,—if ownership, the creature of private law, be distinguished from a governmental dominion conferred by public law, and if ownership by a public community (*universitas, persona ficta*) be distinguished from co-ownership (*condominium*, joint tenancy or tenancy in common),—then this doctrine is as little proved and as little probable as would be an assertion that the first four rules of arithmetic are modern when compared with the differential calculus. But this by the way, for my present purpose is merely that of raising a gentle protest against what I think the abuse of a certain kind of argument concerning "village communities"—the

[1] *Law Quarterly Review*, Jan. 1893.

argument from survivals. Some quaint group of facts having been discovered in times that are yet recent, some group of facts which seems to be out of harmony with its modern surroundings, we are—so I venture to think—too often asked to infer without sufficient investigation that these phenomena are and must be enormously ancient, primitive, archaic, pre-historic, "pre-Aryan."

Of course I am not saying that there is no place in the history of law for inferences drawn from the present to the past. A historian who, when dealing with a particular age, let us say the eleventh century, refused to look at any documents that were not so old as that age, would not merely place himself under a self-denying ordinance of unnecessary rigour, he would often be casting away his most trustworthy materials. The student of Anglo-Saxon law, for example, who refused to look at Domesday Book, because it did not belong to "his period," would be guilty of pedantry and worse. The surest fact that we know of Anglo-Saxon land law is that it issued in the state of things, more or less intelligently, more or less fairly, chronicled by Norman clerks as having existed on the day when King Edward was alive and dead. But obviously the method which would argue from what is in one century to what was in an earlier century, requires of him who employs it the most circumspect management. I need not expand this warning into a lengthy sermon; it has been given once for all in words that shall never be forgotten—" Praetorian here! Praetorian there! I mind the bigging o't."

If these words should be always in the ears of every

The Survival of Archaic Communities 315

one who is hunting for "survivals," they should, so it seems to me, be more especially remembered by those who, not content with the phenomena which they can find in the open country, are looking for exceedingly ancient and even pre-historic remains within the walls of our English boroughs. Here if anywhere the danger of mistaking the new for the old is an ever-besetting danger.

To come to particulars:—When we see burgesses occupying land in severalty by a communal title—that is to say, occupying because they are burgesses and so long as they are burgesses—and when we see further that their occupation is subject to communal regulations, subject to the bye-laws made by the governing body of the corporation in the name of the corporation—we must not at once infer that this is a very ancient arrangement. In a very large number of instances the title by which a borough corporation holds its land—even land within or adjacent to the borough—is known to be a modern title; indeed it will I think be found that the borough "communitas" of the thirteenth century was but rarely a landowner; it generally owned valuable "franchises," but not land. In some cases the boroughs of the later middle ages profited by the liberality of individual burgesses; in other cases they profited by the Protestant Reformation, they acquired lands which had belonged to monasteries and to religious or semi-religious gilds; in yet other cases they obtained from the king or some other lord the ownership of soil over which they had for a long time past been exercising rights of pasture.

Now when land was thus acquired, what was to be

done with it? Let it at a rack rent, we moderns may say, carry the proceeds to the account of the borough fund, and then expend them on some object useful to the town at large, upon paving, lighting, water-supply, elementary education, or the like. But this is to impose upon our ancestors our own notions of right and wrong, and very modern notions they are. If we go back but a little way we find that the property of the corporation is regarded as being, not indeed the property of the corporators, but still property which the corporators may enjoy very much as they think best. Of course the corporators are neither joint tenants nor tenants in common of this property; they are to enjoy it because they are corporators, and "shares" in the corporation (if we may use that term) do not obey the common rules of private law applicable to cases of co-ownership, though often enough "birth" and "marriage" are titles to "freedom":—still they are to enjoy it. There is no other purpose for which it exists. No doubt the great reform of 1835 was a sadly needed reform; but the historian of our towns will have to point out that the harm that was to be remedied had been done much rather by the oligarchic constitution of the corporations,—in many cases a constitution deliberately fashioned for the purpose of making them the instruments or the playthings of politicians,—than by the prevalence of the notion that the property of the corporation should be enjoyed by the corporators. That notion was a very natural one, and we cannot blame our forefathers for having entertained it. The property of the corporation was not (except in quite exceptional cases) "impressed with a trust." No one

The Survival of Archaic Communities 317

had ever laid down the rule that the only possible "ideal will" of this *persona ficta* must be that of keeping a well-lit, well-paved, well-watched, healthy and cleanly town. And so if the borough had land the burgesses meant to enjoy it. If they let it they would divide the proceeds among them, perhaps in equal shares, perhaps bestowing preferential shares on their aldermen or chief burgesses. But they might well like to enjoy it *in specie*, to cut it up into allotments, to allow every burgess to hold an allotment so long as he was a burgess, paying no rent or a rent much lower than that which a stranger would have given:—a score of intricate variations on this theme might be devised. Especially if the corporation of a small borough acquired land hard by the houses of the corporators, some plan of allotting the land among the burgesses would very probably be adopted at some time or another. A burgess of such a borough would much rather have some little plot which during his lifetime he could call his own, than a dividend of a few shillings or a right to turn out beasts upon a waste.

If I am not mistaken, we can see this in our own day. At Bishop's Castle in Shropshire—so the commissioners of 1835 reported—the burgesses had a right of common on a pasture containing from ninety to one hundred acres, called the Moat Hill or Burgesses' Hill. "It is a right of common without stint, but being merely adapted for a sheep walk, it is represented to be of inconsiderable value[1]." Before 1880 this pasture had been turned into arable land, cut up into small portions held in severalty by several burgesses, each of

[1] *Municipal Corporations Report*, 1835, vol. IV. p. 2598.

them holding under a lease from the corporation at a rent of 5s. per acre for a term of sixty years, renewable for ever on a fine of £5[1]. How had this come about? There had been some dispute between the corporation and some of the burgesses. Some of the burgesses had enclosed pieces of the land, and then the matter was settled on the terms just mentioned.

At West Looe the members of the corporation had turned out their cattle over a certain down. The corporation, having passed through every stage of degradation, finally became extinct. In 1828 the commoners, without any Act of Parliament, enclosed two-thirds of the common, cutting that part up into seventy-three little plots which they let at small rents to certain members of their body, mostly poor fishermen of the village. "Did all the inhabitants have these inclosures?" "Many of the inhabitants had these inclosures; they were let at a yearly rent." "But how were they chosen?".... "They settled it among themselves; they never disputed it." "But some got back an equivalent [for their pasture right] by taking a piece which they rented, and others apparently got nothing?" "Quite so." "How was that settled?" "I think that it was settled in this way, that after paying a certain amount of money for the expenses and other matters, the general income was handed over to the overseers for the poor-rate." "The whole population had a certain benefit out of it?" "They all had a benefit from it." Then in stepped the Duke of Cornwall with seignorial claims to this soil, but seemingly very willing to do what was fair by the men of Looe; and

[1] *Report of* 1880, p. 15, Evidence, p. 503.

The Survival of Archaic Communities 319

by means of a conveyance to trustees all was, we may hope, settled for the good of all[1].

Now the question that I would ask is whether it is not very possible and even probable that what we see the men of Bishop's Castle and West Looe doing in the full glare of the nineteenth century, has been done by the burgesses of other boroughs in times that we cannot call archaic or primitive or prehistoric, times which lie well within the limit of legal memory.

Let us observe some few of the divers modes in which our burgesses have used the lands belonging to the boroughs, placing ourselves at the date of the great municipal reform.

Very often of course "burgesses" or "freemen" as such claim rights of pasture over soil of which the corporation is the owner, or (to speak more nicely) the tenant in fee simple. Sometimes the right of pasture is regarded as an appurtenance to a tenement in the borough. Thus in Clitheroe[2] the right to be a burgess was given by the tenure of certain burgage tenements. There were seventy-eight "free-borough houses," ten "borough houses," and fourteen "borough crofts." "The free borough houses formerly conferred a right of common of pasture for one horse and one cow, on the moors or commons within the borough. These are now inclosed. Borough houses and borough crofts were not entitled to such horse-gate and cow-gate."

Very often again all the "resident freemen" as such have pasture rights. Sometimes they have to pay

[1] *Municipal Corporations Report*, 1880, Minutes of Evidence, pp. 362–8.
[2] *Report of* 1835, vol. III. p. 1483.

small sums for it, sometimes not. Thus at Beverley[1] "the burgesses residing within the town have the privilege of depasturing cattle, being their own property, on lands belonging to the corporation, containing about 4217 acres. They are allowed to depasture three cows in Westwood pasture; one horse in Hurn Pasture; three beasts in Figham Pasture, and six beasts in Swinemoor Pasture from the 14th of May to the 14th of February. This privilege, if enjoyed to its utmost extent, would be worth £25 a year. Few enjoy it to that extent. Indeed the land would not support the cattle if all who were entitled so used it. Persons depasturing are subject to the payment of a small sum on every head of cattle depastured. This sum varies from 5s. 6d. to 16s. 6d. a head." At Doncaster[2] "every resident freeman is entitled to turn two head of cattle upon a tract of land belonging to the corporation, containing 142 acres, called the Low Pastures, during the summer season. This privilege is worth, to each freeman, about £1 per annum. A resident freeman may let this privilege to another resident freeman. The freemen are also entitled to the aftermath in a meadow called Crimpsall Meadow, containing about sixty-five acres. This privilege is worth very little; the eatage is soon consumed, it being without stint; it does not last more than a week or ten days."... "The Neatherd looks after the cattle depasturing on the low pasture, being the freeman's pasture. He is allowed 13s. 4d. a year, a pair of boots every year, a house and two acres of land rent free, of the value of about £10, and two

[1] *Report of* 1835, vol. III. p. 1459.
[2] *Ibid.* p. 1493.

The Survival of Archaic Communities

cattle gates on the low pasture worth about 10s. a year each."

Then at York[1] we find that the rights of the freemen vary from ward to ward. They "exercise a right of pasturage over several pieces of waste land in the neighbourhood of the city. Their rights in this respect vary according to the several wards in which they inhabit. The freemen inhabitants of ancient messuages in Bootham Ward are entitled to a right of pasturage for three head of cattle, either cows or horses, on a tract of land in the parishes of Clifton and Huntingdon, containing about 180 acres, subject to the payment of 10s. a year for every cow, and 12s. for every horse depastured; the number of freemen who exercise this right is about seventy. The freemen occupiers of houses in Monk Ward are entitled to depasture two heads of cattle, either horses, cows, or other beasts, on a tract of about 131 acres, subject to annual payment of 10s. for each beast; about 100 freemen generally exercise this right, and the number of cattle depastured is generally about 150. Freemen occupiers of houses in Walmgate Ward are entitled to pasturage for one head of cattle only, i.e. one cow with a calf, one mare with a foal, or one gelding, on about seventy-five acres of land, subject to the payment of 20s. for each beast; about 100 freemen exercise this right. The freemen inhabitants in Micklegate Ward, and certain parts of Bootham Ward, Monk Ward, and Walmgate Ward are entitled to pasturage for one gelding, or one mare with a foal, and two cows, upon several tracts of land, containing together 437 acres,

[1] *Report of* 1835, vol. III. p. 1745.

subject to an annual payment of 8s. for each horse, and 6s. for each cow; about 400 head of cattle are usually depastured on these lands. These annual payments for depasturing cattle are received by the pasture masters, and by them applied about the necessary expenses of guarding the cattle and keeping the lands in order."

Elsewhere we may find that not all, but only some of the burgesses, are entitled to pasture. At Lancaster[1] "the free burgesses are entitled to a right of common on Lancaster Moor; but in practice this common is used by almost every one who has property adjoining it. The eighty senior burgesses are entitled to an equal share in the net income, arising from some ground, called Lancaster Marsh, the property of the corporation. Lancaster Marsh was formerly a stinted pasture; and by an old custom, of the commencement of which there is no record in the corporation books, the senior eighty resident freemen were alone entitled to the herbage. The Marsh was inclosed in 1796, and the rents, still called Marsh-grasses, are now apportioned among the freemen, according to the old custom. This property is exclusively under the management of the Bailiff of the Commons: the leases are for seven years, at rack rent. The rents now produce about £4 to each of the eighty persons, and greatly exceed the value which the land possessed before the inclosure."

With these cases in our minds, we turn to others in which burgesses as such occupy land in severalty. The

[1] *Report of* 1835, vol. III. p. 1597.

The Survival of Archaic Communities 323

constitution of the corporation of Berwick[1] was democratic. There was no "select body"; but the whole corporation, consisting of the mayor, the four bailiffs and the other burgesses, assembled in guild managed the affairs of the corporation, made bye-laws and disposed of property in the same way as was generally done in other places by the common council. The number of burgesses was indefinite; men became entitled to be burgesses (1) by birth, (2) by servitude, and (3) by grant from the corporation. "There is a large tract of land lying near the town, which was granted to the corporation by charter 2 James I. The First Portion of this land consists of several farms, which are demised to tenants by the mayor, bailiffs and burgesses, the rent being reserved to the said mayor, bailiffs and burgesses, or their treasurer for the time being, and collected by him. The rent together with the proceeds of other property now forms a separate fund, out of which the salaries of the officers and other corporate expenses, are defrayed. These farms are called Treasurer's Farms. The Second Portion is subdivided into several parcels varying in quantities from an acre and a quarter to two acres and a half, and in value from £1. 13s. 9d. to £9 per annum. These are called meadows, and at an annual meeting of the burgesses, called a meadow-guild, are distributed as they become vacant by the death or non-residence of the last occupiers (or in case of widows, by subsequent marriage of the last occupiers), among the senior resident burgesses, and widows of burgesses, who succeed to the rights of their husbands as to

[1] *Report of* 1835, vol. III. p. 1435.

meadows and stints, though the charter has no provision in behalf of the widows; the most ancient resident burgess is entitled to choose the most valuable vacant meadow, and so on in succession down to the youngest, till the number of vacant meadows is exhausted. The number of these meadows is twenty-four. The burgesses may either occupy these meadows themselves, or let them to tenants, reserving rents to themselves. In practice they are generally let. The lands forming the Third Portion were, up to the year 1761, open fields, upon which each burgess was entitled to a certain right of pasture, but at that period they were inclosed, and have ever since been let, in guild, as farms to tenants for various terms of years, and are now demised by leases under the corporation seal, generally in farms of forty acres, or thereabouts. The rent of each farm is divided into a certain number of equal portions, generally eleven, but in a few instances twenty-two. At another annual meeting, called a Stint-guild, a portion is allotted upon a specific farm to each resident burgess or burgess's widow, or to as many of these as there are vacant portions. These portions are called stints, and like the meadows vary in value from £8 to £9 per annum. The number of these stints was increased about thirty years ago, by appropriating another portion of land to that purpose. The number of stints thus added is forty-four, making the total amount 561. The more ancient burgesses are in like manner entitled to a preference, as the more valuable stints become vacant, and the younger burgesses succeed to them, as vacancies occur by the death, removal, or promotion of their seniors. The portions of the rents called stints

The Survival of Archaic Communities 325

are paid annually by the treasurer of the corporation to the burgesses who are entitled to them. The burgesses in guild have, by their charter, a power of making bye-laws for the good rule and government of the corporation, and for preserving, governing, disposing, letting and demising of their lands, &c. In the exercise of this right the burgesses assembled in guilds make bye-laws to regulate the enjoyment of the meadows and stints, and have prescribed the conditions of husbandry under which meadows and stint lands may be broken up, and converted into tillage, and (in the case of meadows) the terms for which they may be let by the individual burgesses to whom they are allotted. They also decide upon the title of those who claim to enjoy meadows and stints, according to their bye-laws; and instances occur upon their records, of forfeitures both of meadows and stints, either absolute or for limited periods, inflicted by the burgesses in guild, for infraction of bye-laws, or other gross misconduct. But unless there be such forfeiture, or the party either become non-resident or relinquish his stint or meadow by choosing one of more value, he may remain in the enjoyment of the stint or meadow which has at the first been allotted to him, for the term of his life. Some burgesses are permitted to enjoy one stint only, others two stints, and others again one meadow and one stint."

At Nottingham[1] "the burgesses are entitled to a considerable right of pasture....They are also entitled, if resident, to take in order of seniority what is called a burgess-part, that is, an allotment of land in the

[1] *Report of* 1835, vol. III. pp. 1993–7.

fields or meadows at a small ground rent payable to the corporation, or a yearly sum in lieu of the allotment, at the discretion of the corporation. These burgess-parts are 254 in number. They are unequal in value and form, in fact, a sort of 'lottery.'... The rental of the proper estates of the corporation, free from any specific trust, and commonly called the Chamber Estate, for the year 1831-2 [amounted to more than £5000 and included a sum of £144. 18s. 6d., being the rents of burgess-parts]... The number of burgess-parts on the Chamber Estate amounts at present to 112.... They are either allotments of land in the fields or meadows, for which a small ground-rent, charged without reference to the actual value of the burgess-part, is paid to the corporation; or a yearly sum in lieu of the allotment, at the discretion of the corporation. These allotments are not considered as freeholds; but the common hall exercise the right of resuming them if they think proper during the life of the burgess. Resumptions of the burgess-parts have been frequent in late years. Instances have formerly occurred in which the parts were resumed without any money payment in lieu being made to the burgess. At present, a compensation in money is always given in the shape of an annual payment, which is fixed at rather more than the burgess could have made out of the land. These resumptions have taken place when the corporation were enabled to make more of the land than the burgesses could do, and have proved beneficial to the corporation estate."

Now that arrangements of this kind may really be pretty modern, we get various hints. I will speak

more especially of the case of Stafford[1]. The corporation are possessed of a piece of land called the Coton Field, containing about 192 acres. It appears that in ancient times the burgesses of Stafford claimed a right of common over three open fields, composing the manor of Coton, called Coton Field, Broad Field and Kingston-hill Field; but the claim was disputed by the owners of the Coton manor. In 1705 the differences between them and the corporation were arranged in the following manner. The corporation gave up all claim to the right of common over Broad Field and Kingston-hill Field, and William Fowler, the owner of the manor, in consideration thereof demised to trustees the Coton Field, for ninety-nine years, in trust, to pay him a yearly rent of £12, and then in trust for the mayor and burgesses, subject to the payment by the latter of £28 a year, for the support of the poor in the almshouse....The Coton Field is divided into portions containing each an acre, each of which is allotted to a burgess. Small rents, varying from four to six shillings are received from the occupiers, each of whom also pays, on his first entrance, 5s. on a tillage acre, and 10s. on any other acre. The gift of these acres is vested in the mayor for the time being. They are by no means confined to the poorer order of burgesses. Each of the members of the common council [mayor, ten aldermen and ten capital burgesses] invariably receive an acre; formerly they each held two, but of late years they have given up the one."

I can not but think that had the manner in which Coton Field was occupied in 1835 been brought to the

[1] *Report of* 1835, vol. III. p. 2028.

notice of some of our "survivalists," they would have pronounced it to be an interesting relic of archaic times. But the archaic times of which it tells are in truth the archaic times of Queen Anne or some king of that primeval dynasty, the illustrious house of Hanover. My reason for thinking that it would have been attributed to a much earlier age is to be found in what has been written concerning the borough of Malmesbury, more especially in what has been written about it by one to whom we all owe many thanks for his courageous and ingenious speculations, I mean Mr Gomme[1].

The facts are in brief these[2]:—In Malmesbury, as in many other boroughs, the titles to freedom are birth and marriage; that is to say, a son or a son-in-law of a free burgess is entitled "to take out his freedom." On so doing he becomes one of a class known as "the commoners." Before 1832 this would have given him a right to turn out beasts on certain unenclosed land. But in that year by Act of Parliament this land was enclosed, and dealt with in a somewhat elaborate fashion. Fifty acres of it were given to trustees, who were to apply the income in maintaining roads, fences, and the like. The rest was cut up into 280 allotments, the average size of which is an acre and a quarter; but though they vary in size their value is approximately equal, since it was arranged that the size of the allotments should vary inversely with their proximity to the town, the smaller pieces being those nearest to the

[1] Gomme, *Village Community*, p. 187.
[2] *Municipal Corporations Commission*, 1880, *Report*, p. 73, Evidence, pp. 127, 292, 831.

The Survival of Archaic Communities

town. When one becomes a freeman of Malmesbury one becomes entitled to succeed in order of seniority to one of these 280 plots; until one gets a plot one receives 8*s.* a year out of the income of the fifty acres held by the trustees. Now all this arrangement, primitive though it may seem to us, is quite new, the result of an Act of Parliament coeval with the Reform Act; before that Act such of the freemen of Malmesbury as were but "commoners" had, as their name implies, rights of common and no more.

But there is an older arrangement and there are other lands to be considered. A freeman may aspire to be a "landholder." The landholders are a body of fifty-five (formerly there were but forty-eight) persons, each of whom holds a several plot; these plots vary in size; together they make up about forty acres; they are divided into six "hundreds"; the number of plots in the hundred varies. The freeman who wishes for a plot puts down his name at the bottom of a list; a list of applicants is kept for each hundred; he can put his name on one of these lists or on several of them; if at the same meeting of the corporation several persons wish to enter their names on the same list, then they cast lots for priority. When a vacancy occurs in one of the hundreds owing to the death of a "landholder," the applicant whose name stands highest on the list of that hundred gets the vacant plot, and if his name is on the list of a second hundred it is struck off that second list, for he is not to have two plots. So much as to the "landholders." Above them in rank stand the twenty-four "assistant burgesses," each of whom has an acre in addition to his "landholder's part" and

his "commoner's part." Vacancies in this body of twenty-four assistant burgesses are filled from among the "landholders" by co-optation[1]; "in practice they are self-elected, though it is said that the aldermen and capital burgesses have a right to interfere." Then above the twenty-four stand the twelve "capital burgesses," who are elected by co-optation. On becoming a capital burgess one gives up one's "assistant burgess's part" and one's "landholder's part," but one retains the "commoner's part" and becomes entitled to a "burgess's part." These "burgess's parts" vary in size from five to sixteen acres. There are but twelve of these, and as there are thirteen capital burgesses, including the aldermen, the junior capital burgess for the time being has to do without a part, and instead thereof receives a small sum of money; but when another vacancy occurs he takes the vacant part. This he keeps, be it large or small, though other vacancies subsequently occur, but it is said that in the past there might be a general shifting of parts among the capital burgesses when one of the plots fell vacant. Then every year the capital burgesses elect an alderman (generally the aldermanship goes in rotation among them in order of seniority), and the alderman for the time being, in addition to his "burgess's part," enjoys a

[1] On pp. 74, 75 in their Report the Commissioners make two inconsistent statements about this. In one place they speak as though the assistant burgesses were a self-elected body, in another they speak as though the landholders became assistant burgesses in order of seniority. It is clear, however, from the evidence that the former statement is the more correct; see Questions, 5396–5400, 6286–6300, 6495–6500.

plot of five acres, known as "the alderman's kitchen"; out of the profits of it he is expected to provide a feast. The corporation also holds thirty-nine small leasehold properties, which are said to be vested in the capital burgesses and alderman; they are let at quit rents, at about £1 each, upon premiums which are paid to the alderman and capital burgesses. The various allotments lie together without fences or ditches between them; each man grows what he pleases, "wheat and potatoes and beans, and all sorts of things." "Very like a parish allotment?" "Yes, something of everything."

Very curious all this is, but I do not think that we have any warrant for supposing that any part of this elaborate system of allotment is of very great antiquity. When Domesday Book was made the burgesses of Malmesbury, as was often the case, were divided between the king and other lords, but most of them held of the king[1]. Then John granted the borough in fee farm to the Abbot of Malmesbury[2], and the abbey thenceforth drew a considerable revenue of burgage rents[3]. In the thirteenth century the burgesses of Malmesbury of the Merchant Gild held the heath known as "Portmaneshethe," and granted part of it to the abbot[4], but that they held any arable land by any communal title we do not know. With magnificent impudence they forged a charter whereby King Æthelstan, in consideration of their services against the Danes, granted them five hides of heath near his vill of Norton, by the counsel of Master Wolsinus his

[1] D. B. I. 64 b.
[2] *Rot. Cart.* I. 213.
[3] *Registr. Malmesb.* I. 117.
[4] *Ibid.* II. 150–5.

Chancellor and Odo his Treasurer[1]. To make free with Æthelstan's name was becoming fashionable in the boroughs: had not the men of Beverley, of Axbridge, of Barnstaple, charters from the same illustrious monarch[2]? Of this charter the men of Malmesbury procured a confirmation from Richard II, and another from Henry IV[3]. It is amazing that the king's chancery should have been deceived by this extravagantly clumsy imposture. Other royal charters, so far as I can learn, they had none until they obtained an elaborate instrument from Charles I and another from William III[4]. I am not disputing their title to the heath. Very probably they did but forge in support of ancient usage and prescriptive right. But as to the system of arable allotments we may well doubt whether any part of it belongs to the middle ages. In Charles I's day there was, and "from time immemorial" had been, a class of burgesses known as the "landholders." In William III's day the aldermen and capital burgesses were, and "for time immemorial" had been, holding certain tenements apart from the lands held by the burgesses, and to confirm their title a second corporation, to be called "The Alderman and Capital Burgesses," was erected by the side of the old corporation, known as "The Alderman and Burgesses," and was provided with a seal of its own. But we know what

[1] Kemble, *Cod. Dipl.* No. 1128 (vol. 5, p. 251).
[2] For Beverley see *Municipal Corporations Report of* 1835, p. 1453; for Axbridge, *ibid.* 1091; for Barnstaple, Hallam, *Middle Ages* (ed. 1837), vol. III. p. 46.
[3] Charter Roll, 12 Henry IV (2 July), memb. 1.
[4] Patent Roll, 11 Car. I (24 July) part 30; Patent Roll, 8 Will. III (14 Nov.) part 1.

The Survival of Archaic Communities 333

"from time immemorial" means in such a context. Why should not what happened in 1832 have happened more than once in earlier centuries? The burgesses have been using land as pasture ground, and somehow or another, by ancient or modern title, by purchase or prescription, the corporation which they form has become—or at all events they think that it has become—the owner of the ground. They enclose part of it and invent a scheme (even in 1832 such schemes could be invented) for providing alderman, capital burgesses, assistant burgesses, ordinary burgesses, with cultivable allotments. My own belief is that were the pressure of the Municipal Corporations Act removed, and had our borough corporations nowadays as few members as they had sixty years ago, such schemes would be very fashionable at the present moment, and were I a burgess, and were the choice given to me of receiving my "dividend" in the form of money, or in the form of pasture rights, or in the form of a small "severalty," I for my part should choose a several close. And then if there were not enough land to provide for all the burgesses without reducing each plot to an unprofitably small size, recourse would be had to some plan of rotation, or perhaps to the "archaic" drawing of lots.

Then to my eyes the scheme that came down into modern times at Malmesbury does not look very ancient; it speaks to us of the last of the middle ages or of the Tudor time, for it speaks to us of an elaborately differentiated corporation, a constitution in which class rises above class, a tripartite or quadripartite corporation. Now I think that those who have made a study of our boroughs will bear me out if I say that

this will hardly be as old as the thirteenth century. In that age many boroughs have as their governing body (under the mayor or the bailiffs) a body of twelve "law-men," twelve "capital port-men," twelve "chief burgesses," or the like. Such a body as this may in some cases be very ancient, though in others we can actually see its birth; but the appearance of a second and subordinate class of ruling burgesses is characteristic of a later time. Some boroughs, even great and opulent boroughs, never get beyond the first stage in the evolution of a governing body; to the end they have but a mayor and twelve aldermen. Most boroughs go further than this; below the twelve they develop a twenty-four (other numbers are sometimes found, but this duodecimal system is very common); below the twelve or twenty-four aldermen will appear the twenty-four or forty-eight common councillors, or perhaps there will be twelve capital burgesses and twenty-four assistant burgesses, or again these bodies will be known simply as "The Twelve" and "The Twenty-Four," or "The Twenty-Four" and "The Forty-Eight[1]." Occasionally, though this is much rarer, there are three classes: thus at Derby, nine aldermen, fourteen brethren, fourteen capital burgesses; at Lancaster seven aldermen, twelve capital burgesses, twelve common councillors; at York twelve aldermen, a body called the Twenty-Four, and seventy-two common councilmen; at Bury (to take a smaller town) six assistants, twelve capital burgesses, twenty-four burgesses of the common council. Now on the whole we

[1] Thus at Beccles the Twelve and the Twenty-Four; at Salisbury the Twenty-Four and the Forty-Eight.

The Survival of Archaic Communities 335

may safely say that the more complex the ruling body, the later is its constitution—later that is according to the normal order of events. Judged by this standard the constitution of Malmesbury, with its alderman, capital burgesses, assistant burgesses, landowners and commoners, is a modern constitution, and those who regard it as of great antiquity should admit that the burden of the proof lies upon them. There is nothing in the charters of Richard II and Henry IV, nothing in that wondrous document the forged charter of Æthelstan, to prove or even to suggest that it existed in the fourteenth century. When asked to call it or any part or trait of it prehistoric, I feel as if I were being told that Henry VII's chapel at Westminster was the work of "neo-lithic man[1]."

I am not contending that we must read this Malmesbury inscription as A[iken] D[rum's] L[ang] L[adle], but certainly there seems to me to be an

[1] Mr Gomme supposes (pp. 197-8) that the 280 commoners and the 24 assistant burgesses are relatively modern, so that "we have left as representatives of the archaic tribal constitution of Malmesbury the forty-eights and the thirteen." I cannot myself see any proof or probability that the forty-eight "landowners" are older than the twenty-four "assistant burgesses"; nor can I follow Mr Gomme in his argument that the commoners are a new class, a class that has come into existence since 1685, for it seems to flatly contradict the evidence that he has himself adduced on p. 188. Nor can I follow him in treating as "archaic" a certain rhyming formula about Æthelstan, which the burgesses are said to repeat when the plots of land are transferred, for even if we consent to call Æthelstan "archaic" we can hardly do the same for an English verse that rhymes. The one trait of the Malmesbury constitution that seems to me very rare is the division of the burgesses into six "hundreds."

almost infinite number of modes in which it may be deciphered without our being compelled to refer it to the age of Agricola. There are many reasons why the Monkbarns who is digging in an English borough should be careful to have an Edie by his side, or, still better, be his own Edie. In the first place, as I have been trying to explain, arrangements which may look to us very quaint—quaint because the number of land-owning boroughs will not be very large—can in quite modern times be the natural outcome of the fact that the borough owns land while the burgesses for the time being are entitled to get profit or enjoyment out of that land. In the second place, our English boroughs have been exercising for a long time past not merely a considerable power of regulating by express bye-laws the use of their proprietary rights, but also (and here lies the snare for the archaeologist) a large and indefinite power of declaring their own customs, of making the old look new and the new look old, of ascribing to time immemorial—even to the reign of King Æthelstan or, for the matter of that, King Arthur—arrangements which have existed for but eighty years or less. In the third place, whatever may be the case in a court of law, in a court of history the borough that would trace back its ownership of land even into the thirteenth century, should, so I think, be called upon to prove its assertion. This I say because in very many instances we know that a borough's title to its land is not so old as that century, and because in the voluminous records which bear on the manner in which land was owned in that century, we can, if I am not much mistaken, read but very

little of land being owned by *communitates*. Lastly, when we are speaking of the boroughs a leap from any century later than the thirteenth to any much earlier age is the most hazardous of all leaps, for the time which is thus skipped is, or at all events seems to me, the time when Englishmen are gradually and painfully, under the teaching of canonists and civilians, not without many a slip and blunder, learning to frame and use a new idea, that of the *universitas*, the *persona ficta*, learning (even Bracton could hardly do this) to distinguish between *res civitatis* and *res omnium civium*—a grand intellectual achievement comparable to the discovery of the differential calculus. I am not saying that until that achievement had been performed an ownership of land that might in some sort be called a communal ownership was impossible (far from it), but I do say that inferences drawn from an age when the borough "community" is a definite person, quite distinct from the mass of men who are the burgesses for the time being, to an age when this distinction was hardly, if at all, perceived, are perilous inferences[1].

II. THE ASTON CASE.

The hunter after relics of very ancient times—I speak of those spiritual things that we call "institu-

[1] I cannot follow Mr Gomme in his account of the Chippenham case; for one thing because he refers (p. 180) to Chippenham in Wiltshire a passage in the *Hundred Rolls* (II. 506) that belongs to the less known Chippenham in Cambridgeshire. This triumph over space seems to me hardly bolder than some of his triumphs over time.

tions," not of material potsherds—is, for reasons that I have tried to give, much less likely to be deceived by the pseudo-archaic when he is at work in the open country than when he is within the walls of a borough. Life has been slower in the village than it has been in the town; changes have been fewer; the piles of débris are neither so numerous nor so variegated; there will be fewer faults in the stratification: nevertheless, even when we are out in the fields it behoves us to be cautious. There is, or there should be, a broad gulf between the "Here is a funny old custom" of the antiquarian amateur and the "Here is a survival from the Norman, the Anglo-Saxon, the Celtic, the pre-Celtic, the pre-Aryan, the pre-historic age" of the scientific explorer. Nowadays many things are old, too old to be easily explicable, which none the less are not even mediaeval. Six centuries divide us from the Hundred Rolls, eight from Domesday Book, near thirteen from the laws of Æthelbert, and even the tiller of the soil sometimes—but I am wasting ink in these generalities.

The famous case of the Aston "village community" deserves a careful discussion, for the interpretation that we put upon it is likely to tinge our conception of large tracts of English history, economic and legal.

The English township of the fourteenth and later centuries, if it be not one of those privileged and befranchised townships that are called boroughs, is no corporation; the law does not personify it; it cannot hold land; it cannot sue or be sued. But further, it is not a "jurisdictional community." By this I mean that it has no court in which its members, or its "best and most

The Survival of Archaic Communities 339

lawful" members, can declare and enforce the common law or the village custom. Nay, the vill is not even a jurisdictional district, though it is a police district: there is no court of any sort or kind of or for the vill as such. Lastly (so far as I can see) the township is not a self-governing community; it has no governing body; it has no assembly. Often, it is true, the vill is also a parish, and during the last of the middle ages, as the permanent endowments of the parish churches, tithes and lands are absorbed by the religious houses, church rates become necessary, and with church rates assemblies of parishioners collected in the vestry of the church and presided over by the parson or churchwardens; but mediaeval law does not confuse the parish with the township; for it the parish is a purely ecclesiastical institution.

Would it were so nowadays! Why are we to be cursed with "parish councils"? I hasten to say that I am not about to meddle with any burning question of contemporary politics—I know my place—this is but an outbreak of pedantry. And yet perhaps there is something a little better than pedantry in it. Is our legal geography so rational, so simple, that we can afford to throw good words away? Is it necessary, now that the legal relief of the poor is no longer a semi-ecclesiastical matter, that we should ever be distinguishing (with such help as interpretation clauses may give) between the ecclesiastical parish and the civil parish and condemning ourselves to live in two parishes at once. "Civil parish" is about as good a term as "lay bishop" or "civil archdeacon" or "temporal diocese" would be. Might we not profitably

learn a lesson from America; might we not restore the township? This however is ultra-crepidation.

To return to our middle ages—it is well known that much that we have denied to the township, we must concede to the manor. It has a court, and that court is not merely a court of justice, it is also a bye-law-making and a precept-issuing assembly; the manor, we may say, has certain powers of self-government. True that when we examine it in the thirteenth century, the jurisdictional, legislative and governmental powers which this court has over one class of its "justiciables"—the freeholders, if any freeholders there be, are exceedingly feeble (upon very slight provocation the freeholder will be off to the king's court, where his individualistic complaints will find favourable audience), while over the other class of its justiciables—the holders in villainage—its powers, which are mighty enough, are regarded by the law as the mere will of the lord; but then it is possible for us to represent this state of things as being pretty modern, as the outcome in part of recent seignorial usurpations and in part of the yet more recent activity of a distinctively royal or national justice. The lord, it may be said, has mastered or even dispossessed the village assembly, but in so doing has been compelled to let slip from all effective control those lucky members of the community who can persuade the king's justices that their tenure is freehold.

I will not here argue either for or against this theory; rather I will point out one of the limits within which it is confined. Where manor and vill are co-incident, it will give us what is in some sort a village

The Survival of Archaic Communities

assembly. But manor and vill are by no means always coincident. I am not referring to the cases, common in the north of England, in which the manor comprised several vills. These might be accounted for by the supposition that the lord for his convenience had succeeded in fusing several village assemblies into one manorial court. But it might very well happen that the manor would comprise only a part of a village, that the manor would be made up of parts of different villages, that some part of the village would be in no manor at all.

I am not speaking of rarities. If when we take all England as a whole we can treat the coincidence of manor and vill as normal, this we cannot do if we confine our view to certain large districts of England. One of these districts is Cambridgeshire. Of many a Cambridgeshire village we may safely say that never —at all events never since some time remoter than that of the Norman Conquest—has the whole village coincided with a single manor or formed part of a single manor, that never has it had a single lord, save that lord of all lords, the king. The various freeholders who had land in it, including those who had villain tenants and kept courts for them, often traced their titles up to the king by very different routes, and it was a common thing that part of the village territory should belong to one great honour and part to another.

But more; there can I think be very little doubt that in the Cambridgeshire village the arable lands of the various manors and even of the various honours were often intermixed; that the manor like the virgate lay scattered about in the common fields—an acre here

and an acre there. So far as I can see on maps made before the modern inclosures, the village, though it may contain three or four manors, will usually have but one expanse of arable land, an expanse unbroken by ditch or hedge, an expanse that is known as "the field" of that village.

Now these cases seem to me to be cases of critical importance. They seem to put us to our choice between two paths, and, whether we pursue the one or the other we shall come to a conclusion which must govern our whole notion of English village history. Either, despite the provoking silence of our documents, we must find, or if we cannot find, then we must postulate, some organization of the township that is not manorial, some assembly of the township that cannot be explained by feudal principles; or else we must admit that the system of common field husbandry may be carried on from century to century—perhaps for six or seven centuries—though there is no village tribunal, no village assembly, capable of regulating and controlling it.

It is in this context that the famous case of the village of Aston in Oxfordshire should teach us something. What we know of it is gathered partly from a statement, which in 1657 was submitted to two eminent lawyers, Sir Orlando Bridgman and Mr Jeffrey Palmer, partly from a custumal compiled in 1583[1]. I will briefly set forth the principal facts, as I understand them,

[1] See the papers by Benjamin Williams in *Archaeologia*, vol. XXXIII. p. 269, vol. XXXV. p. 470; the case and opinion printed by Joshua Williams in *The Jurist*, New Series, vol. XII. pt. 2, p. 103; also Joshua Williams, *Rights of Common*, p. 86; Giles, *History of Bampton*; Gomme, *Village Community*, p. 157.

The Survival of Archaic Communities 343

premising a few words as to the whereabouts of Aston.

In the county of Oxford lies the hundred of Bampton, which contains some 42,070 acres. It comprises seventeen parishes, one of which is Bampton. The whole parish of Bampton with its hamlets contains 8,750 acres, and is composed of the following parts:—

	ACRES.
Bampton with Weald	4,970
Aston and Cote	1,870
Brighthampton (part of)[1]	410
Chimney	620
Shifford	880

Aston with Cote, then, is a hamlet of Bampton; in 1831 it contained 157 inhabited houses, while the whole parish contained 523.

Now in 1657 there were in Aston and Cote 16 hides of arable land, and four yard-lands or virgates were reckoned to the hide, so that there were 64 yard-lands. The size of an arable yard-land varied from 24 to $28\frac{3}{4}$ acres[2]. The affairs of the owners of these lands were regulated by a body of sixteen persons known as "the sixteens." "The sixteens" was not, I think, an

[1] Part of Brighthampton is in Bampton parish, part in Standlake parish.

[2] *Archaeologia*, XXXIII. 270-1. It seems evident that a considerable part of the lands with which we have to deal cannot have lain in what now is deemed the hamlet of Aston with Cote, for if, as Mr Benjamin Williams says, the arable yard-land at Aston contained on an average twenty-seven acres, then the sixty-four yard-lands contained 1,728 acres, but according to modern computation Aston with Cote contains but 1,870 acres, and so hardly any room is left for the meadows and the commons, which we are told were extensive.

elected body; each hide had a representative in it, and the practice seems to have been that the various persons interested in each particular hide should take it in turns to represent that hide for one year[1]. On the eve of Lady Day all "the inhabitants" of Aston and Cote met at Aston Cross "to understand who should serve for the sixteens for that year coming, and to choose other officers for the same year." These elected officers seem at this time to have been three grass-stewards and two "water-haywards." Before electing them the tenants divided themselves into two parties: the "hundred tenants" chose one grass-steward and one water-hayward; the "lord tenants" chose two grass-stewards and one water-hayward. The meaning of these terms "hundred tenants" and "lord tenants" will become plainer hereafter; meanwhile let us see what "the sixteens" had to do. Each yard-land consisted, as we have seen, of some 27 acres of arable land; these acres were intermixed in the common fields in strips of half an acre or less; but besides this, each yard-land comprised or had annexed to it a right of common for twelve rother-beasts or six horses and also for forty sheep. Then also each yard-land carried with it a right to a lot-mead. The meadow was laid out in sixty-four portions, and in every year each yard-land had one of these portions assigned to it. This assignment was effected by a lottery. Each yard-land had a wooden mark belonging to it, bearing some device;

[1] "Sixteen persons, one for every hide, take their turn yearly in the authority of the sixteen": Case for the opinion of Sir O. Bridgman. But the case goes on to speak of the sixteen as chosen, so this point is not very clear.

the marks were placed in a hat and the owner of the first mark that came out of the hat became entitled to the piece of meadow that was known as "the first set." Each owner then went to the meadow and cut in the grass of the portion allotted to him the device proper to his yard-land; he possessed that portion in severalty from the 1st of March to the 3rd of May, and was entitled to the crop of hay. Then also there were certain hams or home-closes of meadow, namely the Bull-ham, the Hayward's ham, the Worden-ham, the Wonter's-ham, the Grass-Stewards-ham, the Water-haywards-ham, the Homage-ham, the Smith's-ham, the Penny-ham, and the Brander's-ham, &c., which were "disposed of at the discretion of the sixteens; some to the officers whose names they bear, some to the public use of the town, as for the making of gates, bridges, &c., and some were sold [that is to say, the crops off them were sold] to buy ale for the merry-meeting of the inhabitants." Then also lying in the common fields were "several leyes of greensward...two years mowed and the other fed" that were disposed of at the discretion of the sixteens.

Thus the function of the sixteens was to supervise the allotment of the lot-meads, and to dispose according to their discretion of the hams and the leyes of greensward. We further find attributed to them a power of making such orders as they should "conceive beneficial for the inhabitants of Aston and Cote." They were to hold ordinary meetings three times a year, in Rogation week, in Whitsun week and upon Lammas Eve; but special meetings might be summoned for the redress of grievances, and the sixteens, or a majority of

them, might inflict amercements for breaches of their orders; they themselves also might be amerced "by the stewards and the body of the town," though the sum exacted was not to exceed fourpence. From the evidence before us it is impossible to say exactly what limits were conceived to exist to this power of making ordinances and decreeing punishments, but the sixteens do not seem to have aspired to act as a court of law; nor can we tell what authority they claimed over such of the "inhabitants" of Aston and Cote as had no proprietary interest in any of the sixty-four yard-lands. The custumal of 1593 was signed "by most of the substantial inhabitants of Aston and Cote"; the number of signatures was but eighteen. On the whole we have little reason for calling this community a governing community; rather it is a proprietary community.

The amount of communalism that is involved in it should neither be understated nor yet overstated. Each holder of a yard-land holds his arable land by a separate title, a title that is in no sense communal. Annexed to his arable land he has a right of pasture; this also he holds by a title that is in no sense communal. Again his title to a lot-mead is communal only in this sense, that the whereabouts for the time being of his "moveable freehold" or "moveable copyhold" is determined by a process of casting lots in which he takes part with his fellows. On the other hand "the sixteens" deal at their discretion with the "hams" and the "leyes of greensward." To judge by the names of the hams, there had at one time been more village officers than there were in the seventeenth century; for instance, there had been a village smith and a village wonter or

The Survival of Archaic Communities

mole-catcher, and to each of these a ham had been allotted. Even in the seventeenth century there were grass-stewards, who were bound to see that the mounds and fences were in good repair, and who also had to provide four bulls to run on the common pasture, in return for which provision they received eighteenpence for every cow that fed on the common. But whether we suppose the sixteens to have had all along a free power to decide who should occupy and take the profit of these hams, or whether we suppose that each ham had been devoted to the endowment of some communal office, we have in either case a state of things that cannot easily be expressed in the forms of our common law. Who owned these hams?

From the device of placing the ownership of the soil in some obvious lord of a manor we are precluded. This is the most remarkable feature of this remarkable case—the community at Aston was not a manorial community. Of the sixty-four yard-lands, forty belonged to the manor of Aston-Boges, or more correctly Aston-Pugeys, which was then held by a Mr Horde. Of these forty yard-lands, twelve were in the hands of copyholders, while the others had been let by the lord to tenants for terms of years from which we may gather that they had formerly been in his own hand. Of the remaining twenty-four yard-lands, nine were parcel of the manor of Shifford—they had formerly been copyhold, but of late had been enfranchised; four more yard-lands belonged to the manor of Bampton-Deanery, while "about twelve yard-lands" were "ancient freehold" held by some yet other title or set of titles not fully explained by the documents that are before us.

Those members of the community who were tenants of the manor of Aston-Pugeys seem to have been known as "the lords tenants," while the others were known as "the hundred tenants," probably because though they owed no suit to the manor of Aston-Pugeys, they did owe suit to the court of the hundred of Bampton.

If now we turn to the Hundred Rolls[1] and look for this community, though we shall fail in being able to identify with accuracy all of our sixty-four yard-lands and shall read nothing about the sixteens, we shall see the manor of Aston-Pugeys, or Bampton-Pugeys, which is in the hands of Robert Pugeys, Mr Horde's predecessor in title[2], the manor of Shifford which is held by the Abbot of Eynsham, and the manor of Bampton-Deanery, or Bampton-Exoniae, which belongs to the Dean and Chapter of Exeter. On the whole it seems that the occupants of the Aston fields are for the more part customary tenants of these three manors; those of the Pugeys manor are called "servi," those of the Exeter manor "villani"; but probably there are among them a few freeholders, some holding of the Abbot of Eynsham, while a very few may hold either immediately of the king, or of William of Valence, who has a manor of Bampton, to which the Pugeys manor is subordinate[3].

Now it has been stated by a learned and careful

[1] *R. H.* II. 688; and see 703, where the manor of Shifford appears. A correcter transcript is given by Vinogradoff, *Villainage*, p. 450.

[2] The title is traced in *Archaeologia*, XXXIII. 270.

[3] It is difficult to discover from the record which of the virgates mentioned in it are in the Aston fields.

The Survival of Archaic Communities 349

writer, who seems to have had access to documents not open to the public, that the manors of Aston-Pugeys, Bampton-Deanery, and Shifford were all of them held of this superior manor of Bampton[1]. Were this so, then the curiosity of the phenomenon that is before us would be much diminished. We might then explain the case in the following way—Once upon a time there was a great manor of Bampton which comprised (as great manors sometimes did) various sets of common fields, and therefore various groups of cultivators; one of these groups was the Aston group; the owner of this great manor created various sub-manors by interposing various mesne lords between himself and the cultivators. Let us say, for example, that the king has the manor of Bampton, he gives part of it to Imbert de Pugeys, part to Eynsham Abbey, part to the Dean of Exeter; each of the sub-manors thus created comprises part of the Aston group; the members of that group were then divided between various lords—no one court had a direct control over them all; some organization was necessary for the regulation of the course of agriculture, the definition of pasture rights and the like, and either by some definite treaty the lords created that organization of "the sixteens" which we see in the seventeenth century, or else they suffered it to grow up as a convenient machinery for preventing the disputes which would arise among their tenants, disputes which being inter-manorial could not have been determined by any manorial court. As to the

[1] Williams, *Rights of Common*, p. 87. "The hundred and manor of Bampton, which comprised all those three several manors, was a superior lordship."

few freeholding occupants of the Aston lands, if (as seems possible) they did not hold of any of these sub-manors, their presence might none the less be easily accounted for: if at any time after the passing of the statute *Quia Emptores* one of the lords enfranchised a yard-land, that yard-land would no longer be held of him, but would fall out of his manor.

One part of this hypothetical story is true. William the Conqueror had as part of the ancient demesne of the crown a great manor at Bampton (Bentone) worth the very large sum of £82 a year[1]. Out of this Henry III carved the Pugeys manor, by enfeoffing Imbert de Pugeys with thirty librates of land[2]. Then the same king granted the superior manor and the hundred of Bampton to William of Valence[3]. But in the face of such documents as have been accessible to me, it is not proved that either the Abbot of Eynsham's manor of Shifford or the Dean of Exeter's manor of Bampton-Deanery were held of the royal manor of Bampton. It is true that both the Abbot's men and the Dean's men had to attend the court of William of Valence; but then that court was a hundred court. The Abbot of Eynsham claimed the "villa" of Shifford under a charter of Æthelred the Unready, which confirmed yet earlier grants: but whether that charter comprised all or any of the Aston lands it would now be hard to say[4]. The case of the Exeter manor is

[1] D. B. I. 154 b. [2] *P. Q. W.* 664.
[3] *P. Q. W.* 668; Giles, *History of Bampton*, p. 128.
[4] Kemble, *Cod. Dip.* No. 714 (III. p. 339). Shifford was given to the Abbey by Æthelmar, to whom it was given by Leofwin; King Edgar had given it to Brithnoth. See D. B. I. 155, where, for

The Survival of Archaic Communities

somewhat clearer—the church of Exeter seems to have claimed it under a gift of Æthelstan[1], and we have a charter whereby William the Conqueror confirming a gift of Edwy gave to the church of Exeter a stretch of land at Bampton, Aston and Chimney[2]. If then we look for a time (I am far from saying we ought to do this) when the sixty-four yard-lands of Aston were all at the disposal of a single man, it is probable that we must go back far behind the Norman Conquest.

Still of course the question arises—Why should we not go back to an extremely remote age? And here it is that the argument from "survivals" shows its weakness. The case before us may be explained as readily by the hypothesis of an originally servile community which attained an unusual degree of freedom by being partitioned among various lords, as by the hypothesis of an originally free village upon which the manorial system has been clumsily superimposed. Then on the other hand we have no warrant for saying that our sixty-four arable yard-lands had any

reasons given in *Monast.* III. 1, the land appears as held by the Bishop of Lincoln. As Æthelred's book seems to treat the estate at Shifford as lying in a ring fence, as Domesday estimates this estate at but three hides, and as in Edward I's day the Abbot had at least twelve hides at Shifford apart from what he had at Aston, it seems probable that the Aston lands came to him in other ways, and in the *Monasticon* are notices of several charters giving him lands at "Estone." One virgate at Aston he held of Robert Pugeys, another he held in frankalmoigne "quo warranto nescimus."

[1] *R. H.* II. 690.

[2] This charter is No. 16 among the Exeter documents reproduced in Part II of the Anglo-Saxon MSS. (Ordnance Facsimiles). The land comprised in it seems to lie within a ring fence. See also D. B. I. 155.

existence as arable lands even at the date of Domesday Book. We read of Bampton and of Shifford, but it seems very doubtful whether this Aston is mentioned[1]. Is it not possible that the village or hamlet of Aston is of comparatively modern origin, that some time after the Conquest the lords of several neighbouring manors combined to "assart" a tract of waste land, partitioned it among their manors in such wise that each should have land of every quality—good, bad, indifferent—and for the settlement of their intermanorial affairs instituted an intermanorial congress of tenants or suffered such congress to institute itself? Such suppositions are easily made. Further research may at any moment disprove many of them; but others will grow in their places. The antiquary has always to be learning that an infinite number of meanings may be set on the mystical letters "A.D.L.L."

But the lessons that a prudent antiquary may learn from the village of Aston are not unimportant. In the first place we see that a cultivating group, and one which displays some unusually communal traits, may exist without a court capable of deciding disputes as to the titles by which the various members hold their shares. Some little power of imposing pecuniary penalties for breaches of customary rules may be requisite, will at all events be useful; but the power of imposing penalties, which is freely exercised in modern clubs of all sorts and kinds, must be carefully distinguished from a power of issuing execution for penalties, seizing the offender's goods or the like, and

[1] Besides this Aston there are at least three others in Oxfordshire—North Aston, Steeple Aston, and Aston Rowant.

The Survival of Archaic Communities

it is not said that the Aston "sixteens" aspired to this latter, this coercive, power. At any rate, over questions concerning title they had no jurisdiction. This being so, what at first sight looks to modern eyes like a very remarkable communalism, becomes less communal when it is examined. Each member holds his arable land, his pasture rights, even his lot-mead by a several title. He does not hold them because he is a member of this "field-community"; on the contrary, he is a member of this community because he holds them, because he has come to them by inheritance, by purchase, by devise, or by the grant of a manorial lord. Thus we conclude that it is possible for a village community to exist and to go on existing for some centuries, and to exhibit all those peculiar features that we see at Aston, though it is not a jurisdictional community, or at all events has but very few and very slight jurisdictional powers. All this is so, though the acres lie intermixed in the open fields, though this acre is copyhold of one manor, the next acre copyhold of another manor, the next ancient freehold which, so far as any one knows, belongs to no manor at all.

But more, so I think, can be learnt. When we speak of a "survival" we seem to imply that the phenomenon in question, though now it be rare and curious, has in the past been common; what is abnormal in one age was normal in another. In every particular case however the inference, which is thus shrouded from view by a fashionable term, may be required to make itself explicit and may be put upon its defence. In any particular case our curio—be it potsherd, be it institution—may turn out to have always

been a curio, may turn out to have been from first to last as unique a thing as any thing can be in this imitative world. Now to say that so far as one's own reading goes, the Aston case stands alone, would—this I fully admit—be no very grave argument. Besides retorts of a more personal kind, it is open to the answer—and in this I can see some plausibility—that while from the thirteenth century onwards the proceedings of courts of law, even of very petty courts, have been diligently recorded and preserved in large numbers, the proceedings of such a body as the Aston "sixteens" would not be put into writing, or no great heed would be taken of the books in which they were noted. Reasons again might be given—I am not sure that they would be very good reasons—why these non-manorial village assemblies have left hardly a mark in such cartularies, monastic annals and Year Books, as have yet been published. But these attempts to shift the burden of the proof backwards and forwards, and to draw inferences from silence, are not likely to compass any very satisfactory conclusion. It seems to me, however, that of the rarity of any institution or arrangement which can in any degree affect men's legal rights, we have one good test. If it be not rare, the law will have an obvious place for it, and will know exactly what to make of it. Of course some arrangement, some mode of conducting business, some class of transactions may, as it were, stand outside the sphere of law for a considerable time. Its legal consequences remain uncertain, possibly there will even be doubts as to whether it be lawful or unlawful. So far from denying this, I think that just in this context we ought to

insist upon it. Litigious as Englishmen are and have been for many centuries past, a great deal will always be going on even in England about which the law, if I may so speak, will have not yet made up its mind; but I think that in such cases if we have not to deal with rarities we have to deal with novelties. I think, for example, that if at the end of the middle ages our law, our exceedingly conservative common law, has no obvious place for a certain institution, we must, until the contrary be proved, incline to the conclusion that this institution cannot have been both very ancient and very common.

And now returning to Aston, we will ask once more the question—it is far from being a frivolous question —Who owned these "hams" and "leyes of greensward" which "the sixteens" claimed to dispose of "at their discretion"? or, to be more technical—Who was seised of them? In whom were the freehold and the fee? Mr Horde, when he sought Sir Orlando's advice, observed that the sixteens, being no corporation, could have no legal estate in the said hams. Bridgman, one is happy to say it, found an answer—"If the custom be a good custom, as I take it to be, the same custom will give the officers an interest as incident to their offices and [such an interest] may belong to an office, as in the case of the Warden of the Fleet." The great lawyer has recourse to the notion of official property; the owners of these hams are the sixteens; not the community itself, but the officers of the community; each year the land passes from one set of sixteen co-tenants to another set of sixteen co-tenants, as the tenancy of the Fleet gaol and (so it seems) certain

satellitic shops passes from warden to warden. Now this may have been a very happy use of the only category that was at Bridgman's command, the only category by means of which the common law of his day could have done substantial justice to the men of Aston. Still we cannot but feel that its application to the facts in question is an artifice; an artifice worthy of a great lawyer, it well may be, an artifice that the courts may approve, and which will bring them to a much desired result; but still an artifice. Our "village community" is saved, because the relation in which its "archaic moot" stands to its land, is so like the governorship of a gaol.

That Sir Orlando had to fetch his analogy from a remote field seems plain enough; but to this we must add—so I think—that he had to find it in an unfertile field, and in one that had but recently been brought under cultivation. Of course in his day it was undoubted law that "land may be appurtenant to an office"; but if we look for the cases which illustrated this proposition, we shall, I believe, find very few. There is just one standing illustration of it which does duty in report after report and text-book after text-book—there is land appurtenant to the Wardenship of the Fleet. Now I think that we have grave cause for doubting whether this classical instance was a very old one; but I am more concerned to insist upon its extreme rarity than upon its novelty. Our mediaeval law had little, if any, room for "official property." Within the sphere of ecclesiastical arrangements, it had by slow degrees developed the notion of the "corporation sole." At first the saint owns the land that has been given to him; in later and more rationalistic times his

The Survival of Archaic Communities

ownership is transferred to the personified "church"; and thence in yet later days it is transferred either to a "corporation aggregate" or to a somewhat analogous creature of the law, which here in England bears the odd title "corporation sole," while elsewhere it appears as the personified *dignitas* or *sedes*. But outside the ecclesiastical sphere, there has been no need, little room, for these feats of "juristic construction." Even the personification of "the crown" has been a slow process, and has never gone very far; he who would distinguish between "the crown" and the king, unless he be very cautious, is likely even in Coke's day to fall into "a damned and damnable opinion," is likely in earlier times to lose his head as a traitor. We got on well enough without official property, without "corporations sole" of a temporal kind. The non-hereditary royal officer, whose office involved an occupation of or a control over land, was seldom, if ever, conceived as being the owner, or to speak more accurately, the freeholder, of that land; he was but its *custos*, and the freehold was in the king. On the other hand, the offices—they were chiefly ornamental offices—which had become hereditary—were but seldom connected in any inseverable fashion with the tenancy of lands, save where the discharge of the office was regarded as the service due from the land, and in that case it was the office that was appurtenant to—or rather that was due from or issuing out of—the land, and not the land that was appurtenant to the office. I cannot but think that there must have been some highly peculiar and almost unique facts in the case of the Warden of the Fleet, which prevented it from falling into one

of these well-known categories. But at any rate the title "land appurtenant to an office" has, so far as I can see, been from first to last somewhat of a *caput mortuum* in our books; and yet it is under this heading that Sir Orlando Bridgman is constrained to bring the case of the Aston villagers.

Could he have worked out his theory in the thirteenth century? I seriously doubt it. If "the sixteens" existed in the Aston of that age—and I am not denying that they did—most of them were unfree men. Would it not have been grotesque to attribute to men, who had but precariously customary rights in their arable virgates, the freehold in the accessory hams and leyes? And then is it not law that if my villain acquires a freehold, I may seize it and appropriate it? And what if the sixteen co-owners misconduct themselves and refuse to perform their "official" duties? Has thirteenth-century law any mode of bringing them to book? Court of Chancery there is none for the enforcement of a trust. The king will hardly be induced to set in motion those prerogative processes of administrative law which can be brought to bear upon royal officers, including the ruling officers of the boroughs. The villagers must trust to pure common law, to the writs that are "of course," and I think that in easily conceivable circumstances they will have the greatest difficulty in enforcing their custom against their freeholding "officers."

Now the argument that the law of the later middle ages had no place, or at all events no obvious and convenient place, for such an arrangement as is discovered at Aston, might, were it tendered as a direct

The Survival of Archaic Communities 359

proof that such an arrangement cannot be very ancient, be encountered by the assertion that, on the contrary, the incapacity of the law to explain the phenomena may well be the incapacity of modern law to explain ancient phenomena, may well, in this particular instance, be the incapacity of feudal law to compass facts that belong to a prefeudal age, or (to use another set of terms) the incapacity of individualistic law to compass facts that belong to a communistic age. In the debate that would thus be raised much might be said on the one side and on the other; in particular, were I to enter into the discussion, I should like to raise the question whether it is very probable that these ideas of corporate ownership and official ownership, which we seem to see our English lawyers laboriously constructing in the fourteenth and fifteenth centuries, are in truth very ancient and even primitive ideas which have for a while been submerged and even destroyed by a flood of feudalism and individualism. But waiving this general question, we may yet learn a valuable lesson from the grave difficulties that our common law finds in the Aston case. Whatever we may think of very remote times, we seem to be driven to the conclusion that for several centuries before Bridgman's day arrangements similar to those which existed in this Oxfordshire village, had been exceedingly uncommon. The learned conveyancer, the future chief justice and lord keeper, does not tell Mr Horde that what is seen at Aston may be seen in a hundred other villages, that the ownership of land by "sixteens" or similar officers is a well-known thing; he does not suggest that the Aston community could make itself a corporation by

prescription; he sends his client all the way to the Fleet gaol for an analogy. But during the past centuries the open field system of husbandry had been, and in Bridgman's day it still was, exceedingly common, and this too in many a village which as a whole was not subject to any manorial control.

It seems to me that some of our guides in these matters are in danger of exaggerating the amount of communalism that is necessarily implied in the open field system of husbandry. We have of course the clearest proof that the system can go on subsisting in days when manorial control has become hardly better than a name, that it can subsist even in the eighteenth and nineteenth centuries. We have also, so I think, fairly clear proof that it can subsist from century to century in many a village that has no court, no communal assembly. No communal bye-laws and indeed no legal recognition of the communal custom are absolutely necessary for the maintenance of the wonted course of agriculture; the common law of trespass maintains it. As a matter of fact, a man cannot cultivate his own strips without trespassing on the intermixed strips of his neighbours. He must let them trespass on his land at the usual times and seasons, because at the usual times and seasons he will want to trespass on their land. The effect of this may be that his right to till his land as and when he thinks best will be much restricted; but the restraint will be set by the rights of other individuals, not by the rights or the bye-laws of a community[1]. In the village which

[1] *Report on Commons Enclosure, Parl. Papers*, 1844, vol. v. Qn. 4100, "The horses of one party ploughing, would unavoidably

has open fields we may see each of the neighbours owning his arable strips by a several title, enjoying his pasture rights by a several title. Even if there be lot-meads, each of these "moveable freeholds" may be held by a several title, and their rotation may be regarded as having been fixed once for all, and as being alterable by nothing short of an unanimous agreement or a statute of the realm. Open field husbandry has shown itself to be not incompatible with a very perfect individualism, a very complete denial that the village community has any proprietary rights whatever or even any legal organization.

This having been so in modern times, this (to all appearance) having been so throughout the later middle ages, are we quite certain that it has not been so from the beginning? I do not aspire to answer this question, still I cannot but think that some of our current theories are finding it too simple a question, are failing to notice the ease with which a common field husbandry, when once established by some original allotment of land, can maintain itself even though there be in the case nothing that we dare call a proprietary corporation or a self-governing community.

For my own part I cannot assume, as some in the

tread down and destroy the crop which was growing on his neighbour's land?" Mr T. S. Woolley—"Yes; it is almost impossible that land so intermixed should be cultivated with different crops; it becomes an almost necessary consequence that all must sow the same crops, and at the same time; unless all the lands be cultivated by one horse." This "almost necessary consequence" is one that is drawn by the common law of trespass.

heat of controversy seem apt to assume, that concerning the ancient history of the typical English village (I say "typical," for no one supposes that all our townships have had a similar history), we have just two theories to choose between and no more; that if we cannot accept as the normal starting point "great property," widespread servility and the Roman villa, we must begin by ascribing land-ownership to free village communities. The free village, the village which as a whole is free from seignorial control, I can somewhat easily believe in, for—so it seems to me—I can see many such a village in the pages of Domesday Book, many a village full of sokemen, who may fairly be described as free land-owners, though they have been commending themselves, one to this lord, another to that. Whether such a state of things is common or rare, typical or abnormal, a survival or a novelty—these are serious questions; but the village full of free land-owners we can readily conceive. On the other hand the village land-owning corporation, can we conceive this and carry back our concept into—I will not say archaic, I will say—Anglo-Saxon times? Did men distinguish between co-ownership (which in truth is just as "individualistic" as any several ownership can be) and ownership vested in corporations? Did they distinguish between the corporation and the group of corporators, between the *universitas* and the aggregate of *singuli*? Did the villager feel that when he reaped a crop, or turned out his beasts to pasture, he was exercising not a *dominium* but a *jus in re aliena*, that he was using land that belonged neither to him, nor yet to him and his neighbours, but

The Survival of Archaic Communities

to a quite other person, an invisible being, a thought? Did he again distinguish between manifestations of proprietary right and manifestations of governmental power? Was he certain—are we certain—that when the village moot (if any village moot there was) prescribed a particular course of agriculture, it was exercising land-ownership and not merely governing a district, not merely behaving as a modern town council behaves when it decides what buildings may be set up within the limits of the borough? May it not again be that such communalism as we find in the ordinary village of later times is in a large measure the result of seignorial pressure? In fine, is it not very possible that the formula of development should be neither "from communalism to individualism," nor yet "from individualism to communalism," but "from the vague to the definite"?—England, owing to its theoretically perfect feudalism, may not be so good a field for the pursuit of these questions as some other countries in which they are being diligently discussed. There is all the more reason why we should expressly raise them and keep them before our minds; otherwise it may fall out that we shall turn history topsy-turvy, and attribute to primitive man many an idea that he could not for the life of him have grasped.

NOTES.

1. *Township-moot and Vestry.*

So far as I am aware our only authorities for the term "township-moot" are a very few charters of the Angevin kings, such as Richard's for Wenlock Priory (Eyton, *Shropshire*, III. 237), Richard's for Chertsey Abbey (*Monasticon*, I. 433), and John's for Chertsey Abbey

(*Rot. Cart. Joh.* p. 6), in which the grantees are freed "ab omnibus schiris et hundredis requirendis, et placitis et querelis, et hustingis et portmanemot et tunsipemot." This will seem very remarkable when we consider the hundreds and thousands of instances in which the English names of other local assemblies, shire, hundred and halimot, are mentioned. The occurrence of the "tunsipemot," in close connexion with the "hustings" and the "portmanemot" suggests, so I think, that it was chiefly within the cities and boroughs that an assembly called a "townshipmoot" was to be found. But I am quite ready to believe that a manorial court sometimes bore this name. Often enough a manorial court was as a matter of fact a court of and for a vill. In Latin it will be called *Curia villae de X*, and, since we know that down to the end of the middle ages the word "moot" was the common English equivalent for "curia," it would be somewhat strange if a manorial court was never called a "townshipmoot." But though this be granted, we are still far enough from the proposition that every township as such has a moot, while the leap from the "townshipmoot" to the vestry seems to me a most perilous feat. After weighing all that has been said to the contrary by that able and zealous pioneer of history, Mr Toulmin Smith, it still seems to me that the vestry is a pretty modern institution; that we shall hardly trace it beyond the fourteenth century, that it belongs to the parish, a purely ecclesiastical entity, not to the township; that it is the outcome of the church rate, which in its turn is the outcome of the appropriation of tithes and the poverty of the parochial clergy; that the churchwardens also are pretty modern. Gradually the vestry may take upon itself to interfere with many things; the manorial courts are falling into decay, and the assembly which can impose a church rate may easily aspire to impose other rates; but the germ of the vestry is an ecclesiastical germ. The vestry belongs to the parish, and the temporal law of the thirteenth century knows nothing of the parish. If we take up a plea roll of that period we shall find the *villa* mentioned on almost every membrane; of the *parochia* we shall read no word unless we happen to stumble upon a dispute about tithes.

2. *The Warden of the Fleet.*

The Wardenship of the King's House and the Fleet Gaol was a hereditary office which was held in fee. In Edward I's day it was so held by one Ralph of Grendon (*Calend. Genealog.* I. 294). In Edward IV's day it seems to have been so held by a woman, Elizabeth Venur (Y. B. 4 Edw. IV, f. 6. Pasch. pl. 7). Charles II made a grant of the fee simple; Mr Huggins, of infamous memory, held it for two lives. I cannot say that never during the middle ages was it held at the king's will, but I believe that the well-known dicta about it refer to an office that is usually held in fee simple by one who not unfrequently demises it for lives or for years. I do not know of any very ancient dicta about it; but in the Year Books of Henry VII we come upon the now familiar example more than once. "Land may be appendant to an office as in the case of the Warden of the Fleet" (1 Hen. VII, f. 29. Trin. pl. 6). This is said in a case which seems to show that the same doctrine had been, and could be applied to some other offices, such as the wardenship of certain royal forests. "The Wardenship of the Fleet has land annexed to it, and this passes by grant of the office without any livery of seisin of the land" (8 Hen. VII, f. 4. Trin. pl. 1). "It has often been seen that the Warden of the Fleet has pleaded that he was seised of the office of the Fleet by the king's grant, and that he and all those whose estate he has have used to take a certain sum of money from everyone who had a place in this Hall for the sale of his merchandise" (12 Hen. VII, f. 15. Pasch. pl. 1). I should not be surprised if the shops in Westminster Hall were the main foundation for the whole doctrine. There, under the very eyes of the justices, the warden, his deputy or lessee, was taking rent from the occupants of the stalls. One had to ascribe to him some sort of interest in those stalls, but this sort had to be an odd sort, for it would have been impossible to hold that he was seised of the soil on which the king's palace was built. He has an official interest in the shops; it is a freehold interest, for he holds his office in fee or for life; and yet he is not seised of the land. There may have been some forest wardens, who were in much the same position, having a right to let land and pocket the rent arising therefrom, though the king was seised of that land; but I do not believe that the case was common. For the more part in our mediaeval law the link between land and office is tenure by serjeanty; a man holds the land by the service of filling the office.

THE HISTORY OF A CAMBRIDGE-SHIRE MANOR[1]

IT is not often that one has the good fortune of being able to study a series of mediaeval documents at one's own time and in one's own house; but this was given to me by the late Mr O. C. Pell, lord of the manor of Wilburton, in the county of Cambridge. He committed to my care a splendid line of court and account rolls which, though there were some gaps in it, stretched from Edward I to Henry VII, and now, the consent of his successor, Mr Albert Pell, having been very kindly given, I am able to lay before the readers of this Review a fairly continuous history of a particular English manor during the later middle ages; and to me it seems that at the present time we have some need for histories of particular manors, for I am convinced that the time has not yet come when generalities about *the* English manor and its fortunes will be safe or sound.

The manor of Wilburton, on the edge of the fen, formed part of the ancient estates of the church of Ely. It is fully described in two "extents," the one made in

[1] *English Historical Review*, July, 1894.

1221, the other in 1277[1]. Of these its late lord, who was deeply interested in its history, gave an account in the Proceedings of the Cambridge Antiquarian Society[2]. I shall here speak of them very briefly, for they are but the prelude to those documents which are the theme of this essay.

The two extents begin by describing the demesne land—that is, the land which is in the lord's own hand. In the extent of 1277 he has 216 acres ("by the lesser hundred and the perch of 16½ feet") of arable land, and besides this he has meadow land and a wide expanse of fen. In the next place an account is given of the holdings of the "freeholders" and "hundredors" (*de hundredariis et libere tenentibus*). Of these there are nine, one with 16 acres *de wara*, four with 12 acres *de wara* apiece, two with 6 acres apiece, two with 2½ acres apiece. This arrangement remained constant during the half-century which elapsed between the two surveys. These "freeholders and hundredors" pay small money rents—the holder of 12 acres pays 2*d.* a year—they owe two days' ploughing in Lent and two in winter, for which they receive 1*d.* a day; they have to attend the great boon day in autumn. They owe suit to the court of Wilburton and must attend the hundred court, which is in the bishop's hand; hence their designation as *hundredarii*. In the later extent it is expressly stated that they owe a heriot (best beast, or 32*d.*), a fine for marrying their daughters (32*d.*), leyrwite and tallage; the *gersuma*, or

[1] MS. Cott. Tib. B. 2; Claud. C. 11.
[2] *Report and Communications*, 1887, p. 162.

fine for marrying a daughter, is mentioned in the earlier extent.

In the court rolls the existence of freeholders can from time to time be detected. They owe suit of court; they are often amerced for not doing it or compound for it with a small sum of money. There are entries also which show that they still owe ploughing service and that some of them are very lax in performing it. Again, descents and alienations are sometimes presented and the heriot is still due. But on the whole these freeholders seem to have played only a small part in the manor; the names which occur on the court rolls are chiefly those of customary tenants.

In the extents the description of the freehold tenements is followed by the heading " De Operariis et Plenis Terris." The full land (*plena terra*) consists of 12 acres *de wara*. Of this thorny phrase *de wara* I will here say nothing—its interest lies in a remote past —save this, that as a matter of fact the full land at Wilburton really consisted of 24 acres. Of these full lands there are fifteen and a half. The holder of such a tenement pays 19d. a year—12d. as wite penny, 6d. as sedge silver, 1d. as ward penny. From Michaelmas to Hokeday he does two works a week according to the earlier survey, three according to the later; from Hokeday to Lammas three works a week, from Lammas to Michaelmas five works a week; and besides all this there is a good deal to be done which is not computed as part of the regular week work. On the whole the services, which are more elaborately described in the later than in the earlier of the two surveys, and

History of a Cambridgeshire Manor 369

which perhaps have become heavier during the interval, are of the familiar type[1].

Then there were 10½ cottage tenements, which even in Henry VII's day still preserved a relic of the Domesday terminology in the name "cossetles." The holder of each such tenement paid 7*d.* a year—4*d.* for wite pound, 2*d.* for sedge silver, 1*d.* for ward penny—and did two works in every week. The holders of the full lands and the cottiers owe suit to the lord's mill, a fine for marrying their daughters, leyrwite and tallage; they cannot sell colt or ox without the lord's leave.

We already see that a basis has been fixed for the commutation of labour into money. Every "work" in autumn is, we are told, worth one penny, and out of autumn every work is worth a halfpenny; we also see that one half-*cotaria* is held by a tenant who "at the will of the lord" pays 2*s.* a year in lieu of his labours; but the profit of the manor is reckoned mainly in "works." In the way of money rents the lord draws but 31*s.* a year from the manor, besides some small dues; on the other hand 3773½ "works" are owed to him, by a "work" being meant the work of one man for one day.

From 1221 down to the very end of the middle

[1] As it seemed that in 1277 the bishop was exacting from the Wilburton tenants a greater amount of "week work" than he exacted in 1221, I looked through some of the extents of other manors given in the two Cottonian manuscripts, and I found the same phenomenon at Lyndon, Stretham, and Thriplow. Apparently in all these cases the bishop had put on an extra work-day in every week between Michaelmas and Hoketide—and this in the thirteenth century. These Ely extents ought to be printed as soon as possible.

ages the manor seems to have kept with wonderful conservatism what we may call its external shape—that is to say, at the end of this period the distribution of the customary tenements into "full lands" and "cossetles," or cottier tenements, was still preserved, though the "full land" was often broken into two "half-lands."

At the beginning of the fourteenth century we see that some of the "works" were done in kind, while others were "sold to the homage." Thus there is an account for seventeen weeks in the winter of 1303-4 during which the temporalities of the see of Ely were in the king's hand; in this the bailiff and reeve, after charging themselves with the rents of assize (i.e. the fixed money rents), proceed to account for 10s. 10d. for 260 "winter works sold to the homage at the rate of a halfpenny per work." In a later part of the account we see how this number of "works" is arrived at:— the officers account for 1385 works arising from $15\frac{1}{2}$ "full lands" and 10 cottier tenements; they then set against this number the 260 works sold to the homage, 355 works sold to the executors of the late bishop, 57 works excused to the reeve and reaper, 38 works excused to the smith, 19 works due from a half-*cotaria* which has been let at a fixed rent, $14\frac{1}{2}$ works excused on account of the Christmas holiday, $363\frac{1}{2}$ works the amount of ploughing done, 258 works the amount of harrowing done, 20 works in repairing the ditch round the park at Downham, thus getting out the total of 1385 works.

A little later comes a series of accounts for some consecutive years in Edward II's reign. The basis of

History of a Cambridgeshire Manor 371

these accounts, so far as works come in question, is that 2943 winter and summer works, valued at a halfpenny apiece, are due, and 845 autumn works valued at a penny. These numbers seem subject to some slight fluctuations, due to the occurrence of leap years and other causes. Then the accountants have to show how in one way or another these works have been discharged, and in the first place they must account for "works sold." In the year ending at Michaelmas 1322 the accountants charge themselves with the value of 1213 winter and summer works and 60½ autumn works which have been "sold"; in the next year with the value of 1297½ winter and summer works and 170½ autumn works; in the next year with the value of 1496 winter and summer works and 149 autumn works; in the next year with the value of 1225½ winter and summer works and 218½ autumn works; in the next year with the value of 1023 winter and summer works and 247½ autumn works; in the next year with the value of 1381 winter and summer works and 63½ autumn works. In these and in the later accounts it is not usual to state to whom or in what manner these "works" were "sold"; but there can be little doubt that they were sold to those who were bound to do them—that is to say, when the lord did not want the full number of works he took money instead at the rate of a halfpenny for a winter or summer work and of a penny for an autumn work. The phrase "works sold to the homage," which occurs in the accounts of Edward I's time, may perhaps suggest that the whole body of tenants were jointly liable for the money which thus became due in lieu of works.

It will be seen that the number of "works sold" does not amount to half the number of works due. How were the rest discharged? In the first place some were released; thus the reeve, the reaper, and the smith stood excused; and then again holidays were allowed on festivals; thus the occurrence of the feasts of St Lawrence and St Bartholomew serves to discharge a certain number of the autumn works. But very many of the works were actually done; thus in one year 203 "diets" of ploughing between Michaelmas and Hokeday discharge 406 works; in the previous year 377 works had been discharged in similar fashion, in the year before that 406, in the year before that $420\frac{1}{2}$. Ploughing, mowing, harrowing, and the like are always wanted; other works are accounted for now in one fashion, now in another. In one year 26 works were spent on the vineyard at Ely, in another 3 works were spent in catching rabbits; but on the whole the *opera* are laid out in much the same manner in each successive year.

I have examined the accounts for the last six years of Edward II's reign; their scheme is as follows: the accountant is the reeve; his year runs from Michaelmas to Michaelmas. He begins by debiting himself with the arrears of previous years. The next item consists of "Rents of Assize." These are the old money dues payable by freeholders and customary tenants; they amount to no great sum—about £2—but show a slight tendency to increase, owing to the "arrentation" of some of the minor services; for instance, 19*d.* is accounted for in respect of a release of the duty of collecting sticks in the park at Somersham. Next

comes "Farm of Land," a single item of 32s. in respect of 24 acres of demesne land which have been let at a rent. By far the most important item is "Sale of Crops," a very variable item, fluctuating between £8 and £54. Then follows "Sale of Stock." Then comes "Issues of the Manor" ("Exitus Manerii"). Under this head the reeve accounts for the number of "works" that have been "sold," also on occasion for the price of fowls and turf. The "Perquisites of the Court" comprise not only the amercements, but also the fines payable on alienation of the customary tenements and the like. The last item consists of "Sales accounted for on the back of the Roll"; these seem to consist chiefly of sales of malt. The total income varies between very wide limits, rising to £66, falling to less than £20.

On the credit side the first heading is "Allowances" or "Acquittances." A sum of 3d. has to be allowed because the reeve is excused that sum from his rent. Under "Custus Carucarum" stand the cost of making and repairing ploughs, shoeing horses, and so forth. About 5s. per annum is spent in paying 2d. per plough per day for every one of the sixteen ploughs of the tenants engaged in the "boon ploughing" for winter seed and for spring seed. The "Cost of Carts" is sometimes separately accounted for; the cost of "Repairs of Buildings" is by no means heavy. Under "Minute Necessaries" fall the price of various articles purchased, also the wages of the only money-wage-receiving labourers who are employed on the manor —namely, a swineherd at 4s. 4d. per annum and an occasionally employed shepherd at 5s. a year.

"Threshing and Winnowing" are paid for as piece work. "Purchase of Corn" and "Purchase of Stock" are headings that need no comment. Under "Mowing and Harvesting" ("Falcatio et Autumpnus") we find no heavy charge; all that has to be paid for is the tenant's harvest dinner, and the wages during harvest of the reeve and "repereve." Sometimes under the head of "Forinsec" (or Foreign) "Expenses" occur a few small sums not expended directly on the manor.

The reeve then accounts for the money that he has paid into the exchequer at Ely, and then the account is balanced and generally leaves him in debt. Apparently the annual profit of the manor varied between very wide limits. The reason of this fluctuation is to be found chiefly in the sales of corn. The highest prices of the wheat sold in these six years are as follows:—

	s.	d.			s.	d.	
1321–2	12	0	per quarter.	1324–5	7	0	per quarter.
1322–3	11	0	,,	1325–6	5	0	,,
1323–4	7	2	,,	1326–7	3	4	,,

Such figures as these, though they may be familiar enough to economists, are worth notice, for they show us that however stable an institution the manor may have been from century to century, agriculture involved a very high degree of risk.

On the back of the account roll the reeve proceeds to account for the produce of the manor and the "works" of the tenants. First comes "Compotus Grangie" ("Barn Account"). The reeve has received so many quarters of wheat from the barn; so many have gone in seed, so many in provender for the

History of a Cambridgeshire Manor 375

manorial servants, so many remain in the barn. Rye, barley, pease, oats, and malt have to be similarly accounted for; the account is checked by tallies between the reeve, the reaper, and the barn-keeper. There are four ploughmen and one shepherd who are *famuli manerii* and in receipt of corn, each of them getting one quarter per week during some twelve weeks of the year. Next comes "Compotus Stauri" ("Account of Live Stock"), under which heading the horses, oxen, and pigs are enumerated. Then under "Compotus Operum" ("Account of Works") the reeve has to show, as explained above, how some 3700 works have been discharged, the autumn works, worth a penny apiece, being distinguished from the winter and summer works, worth a halfpenny. Thus in one of these years he has to account for 814 autumn works; he does so thus:—

Excused to reeve, reaper, smith	58 works
Excused in respect of a cottary let at a rent	7½ ,,
Excused on account of festivals	58 ,,
Sold	246½ ,,
Reaping, binding, and stacking 128 acres at 2 works per acre	256 ,,
Carrying	96 ,,
Garnering[1]	22 ,,
Stacking pease	10 ,,
Carrying dung	58 ,,
	812

Thus out of this batch of works more than half have actually been done.

[1] *In bladis mayand' in grangia.* The word *mayare* is new to me.

Now, glancing at the manor as a whole, we see that to a very large extent it is still dependent on the labours of its villains. The whole amount received by way of rent is but £2. 10s., or thereabouts, while the price of works sold brings in some £3 or £4. Almost all the regular agricultural work, with the exception of threshing and winnowing, is done for the lord by his tenants. He is as yet no great "employer of labour" in the modern sense; wages are a comparatively trifling item in his accounts. He generally employs a hired swineherd and a hired shepherd, and during some part of the year he has ploughmen, who are paid in grain. But the main part of his ploughing, reaping, mowing, harrowing is done by those who are bound to do it by status or tenure.

From the reign of Edward III there are no accounts; but turning to those of Richard II's time we find that the theory of the account, so far as "works" are concerned, is still the same. It is now reckoned that there are 2970 winter and summer works, worth a halfpenny apiece, and 813 autumn works, worth a penny apiece, to be accounted for. Some of these works are "sold," some not sold; thus in the year ending Michaelmas 1393 we find 183 works of the one class and 93 of the other class accounted for as sold. The number of works sold varies much from year to year. Many hundred works are still done in kind; but the number so done has been diminished, because no less than four full lands and nine cottier tenements "are in the lord's hand" and have been let out at money rents. This has introduced into the account a new element—

namely, "Rent of Bond Land" ("Firma Terre Native" or "Firma Terre Nativorum"), which brings in about £9 a year. A large number of *opera* has, therefore, to be subtracted on this score, e.g. 528 winter and summer works in respect of the said 4 full lands and 836 similar works in respect of the said 9 cottier tenancies. Exactly when or how the change occurred the extant accounts do not show. Already in the first year of Richard II there were 3 full lands and 8½ cottier tenements let at a rent for short terms of years and doing no work. But by connecting the accounts with the court rolls we are enabled to infer that these lands were vacated by villains who fled late in the reign of Edward III; thus the first full land on the list is that of John Thorold, who fled in 1376 or thereabouts, and of whose flight the court rolls continue to talk for the next forty years.

Turning, therefore, to the court rolls, we find many entries which seem to show that during the last half of the fourteenth century and the first quarter of the fifteenth the lord had great difficulty in keeping and finding customary tenants on the old terms. Some examples shall be given.

(1364) J. W., who held a full land, has eloigned himself outside the dominion of the lord, and altogether relinquished the said land, which has, therefore, remained in the lord's hand for default of a tenant; N. R. now comes and takes the land. (1365) N. R., mentioned in the last entry, has now relinquished (*omnino reliquit*) the land; his goods are seized into the lord's hand; they include beasts, swine, household utensils, &c., valued at 33s. 10d., exclusive of the corn. (1366) H. G., who held a half-land and cottage, has eloigned himself outside the lord's demesne; his goods and

crops are seized into the lord's hand. (1366) R. O., who held a full land, has eloigned himself and abandoned his land, taking with him a plough and a pair of quern stones, against the custom of the manor; let him be attached. (1370) J. C. held a cottage, but has relinquished it because of his poverty (*propter impotenciam*); so it has been seized into the lord's hand and is now let to J. G. for twelve years at a money rent. The tenement abandoned by R. O. is let in the same way. (1370) J. W. takes for twenty years a full land which is in the lord's hand for default of a tenant. In similar circumstances A. L. takes a half-land for twelve years. Several similar entries follow. (1371) S. T. takes for his life a half-land which is in the lord's hand for default of a tenant; he pays no fine, for he takes it unwillingly (*quia invito capit*). Other lands which are in the lord's hands are granted out provisionally until permanent tenants can be found. (1372) One full land, three half-lands, three cottages, and six half-cottages are in the lord's hand for default of tenants, but some of them have been temporarily let; tenants ought to be found for them, and let proclamation be made that any heir or other person who has any right in them do come and claim them. Proclamations to this effect are made at several successive courts. (1380) W. W., who held a messuage and a full virgate of customary land, has left the manor, waived his land, and carried off his chattels to Chesterton [which is ancient demesne]. J. M. removed the chattels for him, knowing him to be the lord's tenant. Let J. M. be distrained to answer for these chattels, and let a writ be sued out against W. W. [for being on the ancient demesne there can be no talk of seizing him]. (1384) W. S. surrenders a cottage and two acres of "native land," which he held for 5*s*. a year, for that this was too dear (*eo quod nimis cara*), as the whole homage testifies; it is granted to J. P. and his wife and their sequel at 3*s*. a year. A case of surrender follows, in which the new tenant is to pay 3*s*., instead of 5*s*., paid by his predecessor, the whole homage again testifying that the rent had been too high. (1387) It is ordered in many successive courts that a tenant be found for the lands lately held by J. A., which he has abandoned (*reliquit fugitive*). (1392) It is presented by the reeve that S. T., who holds a messuage and half a "cossetle," is unable to maintain the said tenement and do the services (*impotens est predictam terram et*

tenementum manutenere et defendere versus dominum); therefore the lord's officers must find a new tenant, and in the meantime answer for the issues.

Throughout the court rolls of Henry IV's reign cases continue to occur in which lands have been abandoned or " waived," and other cases in which rents are reduced. Thus (1401) it is presented that Agnes D., who holds a half-land, is unable to maintain it and do the services due to the lord, and that the jurors have provided R. N. to take the land; he is to pay 12*s.* rent instead of doing the services which Agnes did, and only pays 2*s.* by way of fine for admittance, because he is an unwilling tenant. The house is ruinous; the land is out of cultivation; one of his neighbours provides him with the requisite seed. (1409) Mariota, widow of J. N., who held a full virgate for life, has left the lord's domain, gone to Haddenham, taken a husband, and "waived" the land, so that it has come to the lord's hand. (1410) A cottier tenement formerly held at a rent of 4*s.* is granted out at a rent of 2*s.*

It is not necessary, perhaps not justifiable, to infer from this evidence that the customary tenants of Wilburton were in any absolute sense badly off, that they could not live and thrive upon their tenements. The true explanation may be, not that they were in distress, but that they saw a more attractive prospect elsewhere. An increased demand for hired labour and a consequent rise of wages may have been the forces which drove the peasantry to desert their holdings. Unfortunately there are neither accounts nor court rolls which testify to the immediate effects of the Black Death; but, so far as I can see, the bishop's

380 *History of a Cambridgeshire Manor*

difficulty in finding tenants, who will take the full lands on the old terms, begins at a somewhat later time and thenceforth increases.

Nor need we suppose that none of the tenants were contented with their lot. During the same period we find cases in which an heir or surrenderee is willing to promise the old services and to pay a fine on admission. To give a fair idea of the situation I will make notes of the various entries which relate to changes among the tenants of the 15½ full lands between 1364, when the court rolls begin, and the accession of Henry of Lancaster.

(1364) William Starling surrenders half a full land to the use of John Osbern. John Walter, who held a full land, late that of Andrew Cateson, has eloigned himself and relinquished his land; Nicholas of Roydon takes it, to hold at the accustomed services. (1366) Nicholas of Roydon has relinquished a full land; it is seized into the lord's hand. Aubin Willay has eloigned himself and relinquished one half-land; Henry Greneleaf has relinquished another. (1367) Richard Leycester takes the half-land formerly Aubin Willay's, to hold at a rent of 13s. until a permanent tenant can be found. (1367) Robert Osbern, who held a half-land, has deserted it. (1368) There are now in the lord's hand for default of tenants a full land late of Nicholas of Roydon, a full land late of John Thorold, a full land late of Robert Osbern, a half-land late of Aubin Willay, a half-land late of Henry Greneleaf, and two cottage tenements. (1369) Robert Tates takes the full land of Nicholas of Roydon for a term of seven years; he is to pay 5s. rent and to spend 2s. a year on improvements; he pays a fine of 3d. (1370) John Frost takes the half-land late of Robert Osbern for a term of twelve years at a rent of 13s. 4d.; he pays a fine of 6d. Aubin Willay takes as tenant for life a half-land, seemingly that which he relinquished in 1366. For half of it he is to pay a rent of 6s.; for the other he is to do the accustomed services. He pays a fine of 6s. John Atwell takes the full land

late of John Thorold for twenty years at a rent of 26s. 8d.; fine, 12d. Andrew Lessi takes the half-land late that of Edmund Prat, now in the lord's hand for default of a tenant, to hold for twelve years at a rent of 14s.; fine, 12d. Richard Cokayne takes the half-land late of Henry Greneleaf for twelve years at a rent of 15s.; fine, 12d. John Downham takes a half-land late that of Nicholas of Roydon for twelve years, rendering in the first year 4s. for half of it and the accustomed services for the other half, and afterwards the accustomed services for the whole; fine, 12d. (1371) Simon Teye takes a half-land, late that of Nicholas of Roydon, for his life at the accustomed services; no fine, for he is unwilling. John Downham, junior, takes a half-land, late that of Nicholas of Roydon, until a tenant shall be found who will do the accustomed services, to hold at a rent of 15s.; fine, 6d. There are now in the lord's hand a full land late of John Thorold, a full land late of Robert Osbern, a half-land late of Richard in the Lane, a half-land late of Henry Greneleaf, a half-land late of Nicholas of Roydon, besides seven of the cottage tenements

[*Hiatus in the rolls.*]

(1379) Walter Wiseman marries Alice, widow of Richard Sewyne, tenant of a full land, and is admitted for his wife's life; fine, 2s. (1381) Walter Wiseman has fled with his chattels to Chesterton; let a writ be sued out against him. The full land known as Thorold's is divided into four portions; one is granted to Richard Tates, another to Nicholas Dony, another to Richard Walter and John Scot, another to John Downham, senior, and John Parsce; in each case the tenure is for ten years at a rent of 6s. 8d.; fine, 6d. John Atwell has been holding the lands, but he could not do the services. (1382) Alice Cokayne surrenders a half-land, late that of Henry Greneleaf; it is granted to Aubin Willay and John Scot, at a rent of 14s., to hold for their lives or until a tenant be found who will do the ancient services. (1382) Richard Downham marries Ellen, widow of John Newman, tenant of a full land; he is admitted; fine, 13s. 4d. The full land "waived" by Walter Wiseman is granted to John Arnold and Margaret, his daughter, for their lives,

and the life of the survivor, at a rent of 26s. 8d. and suit of court in lieu of all service. (1382) John Atwell surrenders a full land to the use of John Warwick, who takes it from the lord for a term of twelve years at the accustomed services; fine, 18d. (1384) The tenement relinquished by John Arnold is in the lord's hand; the manorial officers answer for the issues. (1385) Anna Foldyng surrenders a messuage and a full land, for which she has been paying a rent of 29s. 4d., to the use of John Pontefyssche, who is admitted to hold at the same rent; fine, 8s.; John is to erect a chamber which Anna is to hold for her life, and is to demise to her an acre of the said land for life. (1386) Alice Cokayne, who held a full land for life as widow of Richard Cokayne, is dead; her son Andrew is admitted; fine, 6s. 8d. The tenement relinquished by John Arnold is still vacant. Nicholas Dony surrenders a parcel of a full land held by him at a rent of 6s. 8d. to the use of Richard Downham, who is admitted to hold to him and his at the said rent; fine, 12d. Simon Teye, who holds a half-land at the ancient services, is too feeble to do them; John Crombred takes the tenement to hold to him and his at the ancient services; fine, 6s. 8d. (1387) John Arnold's tenement is still vacant. (1389) John Downham, senior, tenant of a full land, is dead; his widow, Anna, is to hold for her life. Richard Downham and Ellen his wife, who in Ellen's right hold a full land, are too feeble to maintain the said land, and they surrender it, Ellen being separately examined; the lord grants it to Jacob Frost, to hold to him and his sequela at the accustomed services; fine, 3s. 4d., and no more, for he is an unwilling tenant; and since Richard and Ellen have let the tenement go out of repair and cultivation, Jacob is to have from them two mares (*iumenta*), price 15s., and four quarters of drage, price 8s., and they are to hear no more about the waste of which they have been guilty. Aubin Willay, who holds a half-land jointly with John Scot, surrenders his moiety to the use of John Downham, junior, who is admitted to hold at a rent of 7s. until a tenant be found who will do the ancient services; fine, 8d. Richard Downham surrenders his share of Thorold's tenement to the use of William Breche and Catherine his wife, who are admitted to hold to them and their sequela, at the rent of 6s. 8d., at which Richard held; fine, 8d. (1389) John Arnold's tenement is still vacant. (1390) John Atwell surrenders

History of a Cambridgeshire Manor 383

a full land, since he is too feeble to maintain it, to the use of John Warwick, who is admitted to hold to him and his sequela at the accustomed services; fine, 6s. 8d. John Arnold's tenement is still vacant. (1392) John Arnold's tenement is still vacant. (1393) Anna, widow of John Downham, senior, who held a full land for her life, is dead; her son, John Downham, junior, is admitted to hold to him and his sequela at the accustomed services; fine, 6s. 8d. John Arnold's tenement is still vacant. (1396) At the last court it was presented that Aubin Willay, who held a half-land, had gone away and waived it. He is now present, and on being examined states that he refuses and relinquishes the land, and he surrenders it to the use of Richard Scot, to whom it is granted at a rent of 12s., to hold to him and his sequela until some one shall come to take it at the accustomed services; and in case such a one appears, Richard is to have an option of continuing to hold at the said services, and should he reject this option is to receive from the incoming tenant the costs that he has laid out on the tenement; fine, 12d., and no more, because he is to build. John Arnold's tenement is still vacant. (1398) John Crombred, who held a full land, is dead; his widow, Ellen, is admitted to hold for her life; no fine. Richard Dony and Ellen, his wife, late widow of John Crombred, who hold a full land for the life of the said Ellen, surrender their estate, and the lord grants the said land to them and their heirs at the accustomed services; fine 2s. Nicholas Dony, holder of a half-land, is dead; his widow, Agnes, is admitted to hold for her life at the accustomed services; no fine. (1399) John Starling, holder of a full land, is too feeble to maintain the land, and surrenders it; the lord grants it to John Newman, to hold to him and his sequela at the accustomed services; fine, 6s. 8d. The outgoing tenant "demises" to the incoming tenant farming utensils and tillages, and pays 60s. to the incoming tenant in respect of waste, which money the incoming tenant is to spend in repairs. John Arnold's tenement is still vacant.

On the whole, after reading these entries our conclusion will probably be that, in the then state of the markets for land, labour, and food, the value of a full

land copyhold of the manor of Wilburton, to be held by the ancient services, was extremely small, and was often accounted a negative quantity by the tenant—that is to say, he would rather not have the land than have it. Happy in their posterity were those who endured and got their services commuted into rents.

We may now compare the accounts of Richard II's reign with those of Edward II's. The scheme remains the same, but some new headings have made their appearance. The "Rents of Assize" now bring in £2. 3s. 0¾d.; there is here a trifling increase. The old "Farm of Land," which brought in £1. 12s., is replaced by two headings—"Farm of Demesne Land" and "Farm of the Natives' Land." Under the former there is an increase during Richard's reign from 6s. 9d. to £1. 1s. 11½d. A good many small pieces, two or three acres apiece, of the old demesne have been granted out by entries on the court roll at money rents of about 1s. per acre. Under the "Farm of the Natives' Land" fall the rents paid for those relinquished full lands, half-lands, and cottages which have fallen into the lord's hand and been granted out at money rents; the amount of these rents rises during the reign from £7. 10s. to near £10. "Sale of Corn" brings in some £20, and "Sale of Stock" a very variable amount. The "Issues of the Manor" bring in some £2 and the "Sale of Wool" some £3. The "Sale of Works" is separately accounted for, and at the beginning of the reign still brings in £3 or £4. The "Perquisites of the Court" have fallen rather

than risen, and cannot be relied on for more than £2. There are now some sundry receipts which may raise the total by £1 or £2.

The credit side of the account presents some new phenomena. Under "Acquittances and Decay of Rent" we find that the rents with which the reeve now debits himself are by no means pure gain. As tenements fall into the lord's hand and are let out at new rents—rack rents—the old dues have to be forborne; they are not at once struck out of the account, but appear on both sides: it is conceived that the old rents have "decayed." Under this heading also various allowances to the tenants are comprised, and a sum is thus shown which rises from 9s. to 15s. Other headings of discharge are "Purchase of Corn and Stock" (very variable), "Cost of Ploughs" (£1 to £2), "Cost of Carts," "Repair of Buildings and Gates" (usually less than 10s., but rising to £5 when a new pigeon house is built), "Cost of Sheep and Fold" (less than £1), "Necessaries," "Threshing," "Servants' Wages" (there is a shepherd, sometimes a boy to help him; the whole of this item is 10s. to 15s.), and besides this there is the cost of the "Boon Ploughing" and of the "Harvesting" (the tenants' dinner).

An attempt has been made to bring out the net result of these accounts in a tabular form, in which are stated (1) the total of the items of charge, less arrears, (2) the total of the items of discharge, less money paid to the lord's use. During the fifteen years of Richard's reign for which accounts exist the excess of income over outgo varies between £23 and £50; its average is about £37.

	Year ending Michaelmas		
	1378	1379	1381
Income	47 1 10	45 18 2¼	57 12 0¾
Outgo	7 9 1¾	8 18 11¼	16 13 7
Balance	39 12 8¼	36 19 3	40 18 5¾
	1382	1384	1385
Income	49 19 10¼	48 2 0½	53 6 11
Outgo	12 17 1½	12 8 7	10 10 2½
Balance	37 2 8¾	35 13 5½	42 16 8¼
	1386	1387	1392
Income	36 19 3¾	46 0 4¼	60 17 9½
Outgo	13 12 6¼	15 17 5¼	11 17 0
Balance	23 6 9½	30 2 11	49 0 9½
	1394	1395	1396
Income	40 13 11¾	57 18 6	45 7 4¼
Outgo	7 9 10¾	25 6 11¼	14 9 9¾
Balance	33 4 1	32 11 6¾	30 17 6½
	1397	1398	1399
Income	48 16 0¼	47 4 6½	61 8 1½
Outgo	7 7 9	9 15 11	10 10 2¾
Balance	41 8 3¼	37 9 7¼	50 17 10¾

On the back of the roll, as of old, appear the "Barn Account," "Stock Account," and "Account of Works." The "Account of Works" for the year ending Michaelmas 1381, the year which saw the peasants' rebellion, is as follows:—

Ploughings:—[He accounts for] 232½ diets of ploughing, proceeding from 15½ full lands for 30 weeks and two days between Michaelmas and Hokeday, falling this year on the last day of April, from each full land every other week one diet of ploughing reckoned as two works.

Total, 232½ diets.

Of which in acquittance of the reeve and reaper, each of whom holds a half-land in respect of his office, 15 diets; and in default of 4 full

lands in the lord's hand and at farm, 60 diets; and in acquittance of 10½ full lands which are in work, in respect of the fortnight at Christmas, 10½ diets; and in ploughing the demesne land for wheat seed, 12 diets; and for spring sowing, 17 diets; and for diets sold, 118 diets.

<p align="center">Balanced.</p>

Somererthe:—15½ diets of ploughing, called Somererthe, proceeding from the said 15½ full lands; to wit, for each full land, 1 acre ploughed and reckoned as 1 work as per the terrier.

<p align="center">Total, 15½ diets.</p>

Of which in acquittance of the reeve and reaper, each of whom holds a half-land in respect of his office, and of the 4 full lands in the lord's hand and at farm, 5 diets of ploughing; and in ploughing the demesne land 10½ diets.

<p align="center">Balanced.</p>

Benerthe:—56 diets of ploughing proceeding from the *custumarii*, as well free as native, according to the teams that they yoke; in the year from each *custumarius* with all the beasts that he yokes, 4 diets, at 1*d.* per diet, as per the terrier.

Total, 56 diets, accounted for by ploughing of the demesne land.

Nederthe:—15½ acres of ploughing and harrowing proceeding from 15½ full lands at two seasons called Nederthe, from each full land at each season ½ acre ploughed and harrowed without food and without being reckoned as a work.

<p align="center">Total, 15½ acres.</p>

Of which in acquittance of the reeve and reaper, each of whom holds a half-land in respect of his office, and of the 4 full lands in the lord's hand and at farm, 5 acres ploughed and harrowed; and in ploughing of the demesne land 10½ acres.

<p align="center">Balanced.</p>

Winter and summer works:—[He accounts] for 2936¼ works proceeding from 15½ full lands and 10½ cottaries, from Michaelmas to Lammas (1 Aug.); from each full land 3 works per week and from each cottary 2 works per week; price of each work, a halfpenny.

Total, 2936¼ works; price of a work, one halfpenny.

Whereof in acquittance of the reeve and reaper, each of whom holds a half-land in respect of his office, 130½ works; and in default of the 4 full lands in the lord's hand and at farm, together with the full land of Walter Wiseman, which fell this year into the lord's hand at the end of November, 498½ works; and in default of the 8½ cottaries in the lord's hand and at farm 639½ works, and in acquittance of 10½ full lands which are *in opere* for 147 diets of ploughing, arising from the same as mentioned above, at 2 works per diet, 294 works; and in acquittance of the said 10½ full lands which are *in opere* for "somererthe" as per the terrier, 10½ works; and in cutting 760 bundles of thatch, called lawthatch, among the full lands that are *in opere*—to wit, each 100 bundles reckoned as 1 work—9 works; in cleansing wheat and rye for seed, 12 works; in harrowing the demesne land for sowing wheat and rye, 46 works; in making a new *murs*[1] for enlarging the lord's sheepfold, 37 works; in covering the same sheepfold, 32 works; in cutting the brushwood in the grove at Hadenham for inclosing the gardens, rabbit warren, "et le ponyerd," 36 (?) works; in aiding the carrying of the said brushwood to the carts which had been brought there, 6 works; in aid in "shredding" (*shridando*) of the said brushwood at the rabbit warren at Wilburton and drawing it inside, 12 works; in securing the ditch round the said warren, 3 works; in carrying dung outside the manor to the fields within the Christmas fortnight, 40 works; in repairing the wall round the manor, which had fallen down, 61 works; in scouring the ditch round the ponyard, 13 works; in digging the lord's vineyard at Ely, 13 works; in harrowing the lord's land for spring sowing, 102 works; in breaking the ground for the same sowing, 22 works; in carrying pease from the rick in the manor to the barn for threshing, 6 works; in weeding the lord's corn, 60 works; in shearing 173 sheep of the lord, 32 works; in scouring the ditch round the park at Downham, 15 works; in mowing, 7a. 3r. of meadow in Emedwe, 20 works; in cutting, binding, and shocking the forage there, 20 works; in mowing 24½ acres in Landmedwe, 38 works; in making the hay there, in addition to the help given by the servants, 38 works; in carriage of the said forage and hay with two carts for two days, 20 works; in stacking the

[1] I can only read the word thus.

History of a Cambridgeshire Manor 389

forage and hay in the manor, 8 works; in collecting dung in the manor in July, 6 works; in winnowing 161 qrs. 2 bus. of divers grain of the issue of the barn, as above, besides the 30 qrs. of barley for malting, 62 works; and in works sold, 484¾ works; and in 23½ works upon the account.

<center>Balanced.</center>

Autumn works :—[He accounts] for 814 works proceeding from the said 15½ full lands and 10½ cottages from Lammas to Michaelmas, during 8 weeks and 3 days, during which each full land works 5 days per week—to wit, Monday, Tuesday, Wednesday, Thursday, and Friday—and each cottaria works two days per week on days chosen by the bailiff.

Total, 814 works; price of each work, one penny.

Of which in acquittance of the reeve and reaper, each of whom holds a half-land in respect of his office, 41 works; and in default of 4 full lands in the hands of the lord, and at farm, 164 works; and in default of 8¼ cottaries in the hands of the lord and at farm, 144½ works; and in acquittance of the 10½ full lands which are *in opere* for two festivals falling on their work days within the said time—to wit, the Assumption of St Mary, on a Thursday, and the Decollation of St John, on a Thursday [21 works]; and in reaping, binding, and shocking 96½ acres of divers grain at two works per acre, 193 works; and in carrying the lord's corn, 28 works, besides the help of the manor carts; and in stacking the lord's corn, as well in the barn as outside, 12 works; and in driving the lord's plough while the servant (*famulus*) of the manor was thatching a rick of pease, 3 works; and in carrying dung out of the manor, 38 works; and in works sold, 169½ works.

<center>Balanced.</center>

We see, then, that at the very end of the fourteenth century many of the old "works" were exacted. In some years more were "sold," in some less. In the year ending Michaelmas 1397 only 8 out of 2970 winter and summer works were sold : some 800 were actually done; many of the others were discharged by

the fact that four of the full lands and no less than ten of the cottage tenements had fallen into the lord's hand and had been let by him either permanently or temporarily at money rents. And on the whole the economy of the manor is far from being an economy of cash payments. The lord is no great payer of wages. For the regular field work he has no need of hired labourers; his only permanent wage-receiving hind is a shepherd, but there are ploughmen who receive allowances of grain.

Passing on now to Henry IV's reign, we find that the old mode of reckoning is still preserved. There are still 2970 winter and summer works due, but 5 full lands and 10 cottier tenements have fallen into the lord's hand and bring in nothing but money; more than £10 has now to be accounted for as "Rent of Bond Lands," and a proportionate number of works has to be subtracted. Of the other works some are sold; in one year 204 of the winter and summer works are sold, while 114 have been discharged by harrowing. In 1407, however, the basis of the account was changed; it became a recognised fact that 6 full lands were no longer *in opere*, and the total number of winter and summer works to be accounted for was reduced to 1188, and that of autumn works to 378.

A great change seems to have taken place soon after this, during a period for which we have no accounts. In the first year of Henry VI (1423) the "Rent of Bond Lands" has risen to £22. All the "works" seem now to be released (*relaxantur custumariis domini*) except the boon ploughing:—76 "diets" of ploughing due from the customers, whether free or

bond. Very shortly after this, in or about 1426, another great change was made. The demesne of the manor, containing 246 acres of arable land and 42 acres of meadow, was let to farm at a rent of £8, and the demise of the land which had been actually in the lord's hand seems to have carried with it the right to the ploughing service; that service, therefore, no longer concerns the bishop while the lease lasts (*nichil hic quia conceditur firmario terre dominice cum firma sua*). The demesne land is let *cum operibus et consuetudinibus omnium custumariorum operabilium*. This soon leads to a great simplification and abbreviation of the accounts, an abbreviation to be measured in feet. The receipts are now the old assize rents, the rent of the demesne, the rents of the bond lands, the perquisites of the court; the *opera* are no longer brought into the account, and the purchases and sales of stock and crops disappear, for these of course concern the *firmarius*, not the lord. The *firmarius*, it may be noted, is just one of the men of the vill, one of the copyholders, as we now may call them; in the first instance he is the same man who is acting as reeve.

Thenceforward the bishop seems to have been able to keep the demesne land in lease, now one and now another of the copyholders taking it for a term of years: thus under Edward IV it was let for 16 years at a rent of £7. It is always recognised that the subject of this demise comprises "the customs and works of the customary tenants of the lord." Meanwhile the "Rent of Bond" or "Natives' Land," which has declined from £22 to about £17, remains constant.

Under Henry VII the situation is but little altered; the bond land brings in its £17, the demesne land £8, the demises of the latter are still described as including "all the works and customs of the customary tenants of the lord."

The evidence, therefore, seems to point to a great change under Henry V (1413-22). In the last year of Henry IV the rent of bond lands is entered at £11. 5s. 6d.; it is still reckoned that 1056 halfpenny works and 336 penny works are due; many of these are actually done in kind, though some are "sold." When the accounts begin again under Henry VI the rent of bond lands is £22. 2s. 10d., almost exactly double the old amount, and all the works that are accounted for are 76 diets of ploughing. This change was immediately followed by another—namely, the letting of the demesne—the *scitus manerii*, as it is sometimes called—together with the benefit of whatever *opera* remained uncommuted. Whether the commutation under Henry V was originally regarded as more than a temporary or revocable measure does not appear; practically it seems to have been a final step.

Two cases of commutation which occurred in the reign of Henry IV are noticed on the court rolls. J. N., who holds a full land by services and customs, has requested the lord that he may have his land at farm and not for customs and services, and the lord, seeing his weakness and poverty (*inopiam et debilitatem*) of his special grace has granted that he may hold his land at farm; and upon this comes J. N. and takes the land to hold to him and his by the rod at the

History of a Cambridgeshire Manor 393

will of the lord, according to the custom of the manor, rendering yearly to the lord 20*s.* rent for all labour services to the said lord belonging, and he gives the lord 2*s.* The other case is of a similar character: the lord of his special grace grants to J. D. a half-land, to hold to him and his sequela at a rent of 12*s.* for all services and customs, which land the said J. D. hitherto held by services and customs. It is specially noticed in this case that no fine (*gersuma*) is taken for this new grant.

Then, as already said, we find that in the first year of Henry VI (1422-3) all the customary tenants are paying money rents. It may be interesting to note the fate of the full lands.

> The reeve accounts for 26*s.* 8*d.* from John Downham and his fellows for the full land late of John Thorold.
>
> For 13*s.* 4*d.* from Andrew Somerset for a half-land.
>
> For 13*s.* 0*d.* from Thomas Stoney for a half-land, formerly Pratt's.
>
> For 12*s.* 0*d.* from Simon Dauntre and William Philip for a half-land, formerly of Henry in the Lane, demised to them for life.
>
> For 13*s.* 0*d.* from John Downham, senior, for a half-land, formerly of Henry Greneleaf.
>
> For 26*s.* 0*d.* from the full land called Sewyne's, demised to various tenants.
>
> For 12*s.* 0*d.* from Robert Scot for a half-land.
>
> For 12*s.* 0*d.* from Robert Newman for a half-land demised to him and his.
>
> For 12*s.* 0*d.* from Thomas Downham for a half-land demised to him and his sequela.
>
> For 24*s.* 0*d.* from John Newman for a full land.
>
> For 24*s.* 0*d.* from John Downham, senior, for the works of a full land recently released to him.
>
> For 24*s.* 0*d.* from Andrew Cokayne for the works of a full land recently released to him.

For 24s. 0d. from John Frost for the works of a full land recently released to him.

For 24s. 0d. from John Downham for the works of a full land recently released to him.

For 24s. 0d. from Richard Dony for the works of a full land recently released to him.

For 24s. 0d. from Andrew Frost for the works of a full land recently released to him.

For 24s. 0d. from Andrew Lessy for the works of a full land recently released to him.

For 24s. 0d. from Jacob Frost for the works of a full land recently released to him.

For 24s. 0d. from John Warwick for the works of a full land recently released to him.

Thus the basis of the commutation effected under Henry IV and Henry V seems to have been 24s. for the full land—that is to say, a shilling per acre with the messuage thrown in. During the fourteenth century the lord seems to have been able to obtain a higher rent—namely, 26s. 8d.—for the full land, and 13s. 4d. for the half-land. But even 24s. was too high a rent to be permanently maintained; before the end of Henry VI's reign it had been very generally reduced to 20s., and the total "Rent of Natives' Land" had fallen from £22 to £17. It might be an anachronism to say that these copyholders of the fifteenth century were paying "rack rents," but they were paying "the best rents that could reasonably be gotten."

When once the commutation has been effected and the demesne demised to a farmer, the manorial accounts cease to have any great legal interest. The lord of the manor has, in effect, become a landlord of the modern type. It can be no part of my undertaking

History of a Cambridgeshire Manor 395

to trace the ups and downs of his income; many of its items were now irrevocably fixed, while the rent that could be obtained for the demesne varied from time to time and lease to lease. On the whole his income seems to have fallen. About the years 1428 to 1432 the excess of income over outgo generally amounts to £30 or little less; thirty years later it has fallen to some £25, and it seems never to recover from this fall. An abstract of the account for the year ending Michaelmas 1507 will show how the matter stood at the beginning of another century.

Debit.	£	s.	d.	Credit.	£	s.	d.
Rents of assize	2	3	2¾	Allowance and decay of rent		14	0
Rents of " Natives' Land"	17	16	1	Repairs of barns	1	0	0
Rents of pieces of demesne land	1	6	10	Paid to the lord's use	28	8	6¾
New rent for small parcels of demesne		1	8	Balance due	30	2	6¾
					1	11	
Farm of the manor	8	0	0				
Issues of the manor (only one item, for liberty of fold demised)		1	0				
Perquisites of court		15	8				
Total	30	4	5¾	Total	30	4	5¾

The manor was granted by Bishop Martin Heton to Queen Elizabeth in the forty-second year of her reign (1599–1600). This appears from a survey of 8th Aug. 1609, when the manor was in the hand of

King James. Its revenue was then estimated as follows :—

	£	s.	d.
Rents of assize	2	3	2¾
Rents of assize of "native tenants"	17	16	1
Farms of demesne lands in the occupation of tenants	1	16	10
New rent		1	8
Issues of the manor		1	0
Farm of the "scite of the manor" let for a term of years by indenture	8	0	0
Perquisites of the court upon an average	3	9	11¼
Total	33	8	9

But the surveyor adds, "Ther is yearly allowed and deducted out of the value aforsayde for a decay of rente within the sayde mannor the some of xvij.ˢ 9ᵈ ob. but whether it may be repayred or not I have noe knowledge."

A good many of the ancient tenements have still to all appearance kept their shape; they are still held as integral wholes, though several are sometimes in the hand of one man. The full tenement, or "virgate," still pays in general a rent of 20s.; it consists of a house and curtilage, of twenty-four acres of arable scattered about in the common fields, of a few acres of meadow, and of rights of common of pasture. What is more, it still owes some labour service, the remains, so it would seem, of the old "boon works." Against the names of several of the tenants, in addition to the amounts of their rents, is set "*j. opera seminand' tritici et all' pro seminand' ordei,*" "*j. opera tritici all' ordei ut supra,*" "*iiij. opera ut supra,*" "4 daye workes *cum*

carucca firmarii," "*iiij. opera cum caruca.*" The benefit of these is enjoyed by the farmer (*firmarius*) of the demesne, of the *scitus manerii*. But while rents have remained fixed, the annual values of the copyholds, reckoned in money, have in all probability increased enormously. Against each tenement is set not only its rent but what seems to be an estimate of the amount beyond its rent that it might be expected to bring in if let at a rack rent. Thus of one small tenement the rent is 12*d.*, while after this stands *ann' val' dimittend'* 9*s. ultra r*—that is, the annual value of it if demised at a full rent is 9*s.* beyond the rent actually paid; in other words, the actual rent is but a tenth of the possible rack rent. In some cases the virgate which brings in £1 per annum is reckoned as worth £6 or £7 more. Even the demesne seems to be held by the termor on very beneficial terms (probably he has paid a substantial fine); as of old he pays but £8, while the annual value of his tenement seems to be estimated at £66. 13*s.* 4*d.* From a copy of the deed whereby King James sold the manor it would seem that he got £1261. 18*s.* 4*d.* for it, an absurdly large price if the purchaser was going to get but £33 a year. But whatever the purchaser could get by reletting the demesne or cultivating it himself, the time was past when he could hope to increase his receipts from the "natives' lands," and the evidence goes to show that the economic catastrophe of the sixteenth century, the influx of the precious metals, not to mention the debasement of the coinage, had greatly benefited the representatives of the "natives" at the cost of their lord.

At the risk of making this paper intolerably long I must add a few words about the legal status of the villains of Wilburton. There can be no doubt that in the thirteenth century the customary tenants, the holders of the full lands, half-lands, and other tenements, were serfs, *nativi*. This theory was kept up during the whole of the next century, and was brought home to them in practice. Thus in or about the fiftieth year of Edward III a number of *nativi* relinquished their lands and fled; for many years afterwards orders were given at every successive court for their recapture.

(1369) Andrew Thorold, a *nativus* of the lord, dwells at Lindon, Andrew in the Lane at Hidingham, Nicholas Bande at Hempstead, William Coppe at Cottenham; let them be seized and brought to the next court. (1372) Andrew in the Lane, Nicholas Bande, John Thorold and Robert his brother, Andrew Thorold, John and Nicholas, sons of Andrew Frost, *nativi domini*, are missing and ought to be seized. Such entries as these are found on the rolls of the fifteenth century also. (1467) Several *nativi domini* dwell at Crowland, Isleham, and elsewhere, and pay no clevage (head money); let them be attached. (1480) A similar entry. In Henry VII's day care is taken to record the fact that certain persons are serfs, and to state the whereabouts of their progeny. (1491) A. C., a native by blood of the lord, dwells on the lord's demesne, and has three sons and one daughter, whose names and ages are stated; J. B., another native, has two sons and one daughter; R. F., another native, has one daughter; another R. F. has a daughter; Agnes D.,

a nieve, dwells with W. B.; Joan D., a nieve, dwells at Chatteris; Ellen D., a nieve, dwells at Wilburton; let them be attached by their bodies to do fealty to the lord. Such an entry as this suggests that by this time it has become necessary to enumerate the "natives"; it is no longer to be assumed that all holders of customary lands are serfs; the difficulty that there had been of finding tenants had probably brought into the manor a number of outsiders who were not the bishop's born bondmen.

The practical incidents of servility are enforced during the fourteenth century. True that when a serf has once run away he is not recaptured; but there is a good deal of talk about recapturing him, though nothing seems to come of it. The "natives," however, who remain behind cannot marry their daughters, educate their sons, or sell their beasts without the lord's leave.

(1364) It is presented that H. N. sold a foal of his own increase (*de proprio incremento*) without the lord's licence; therefore he is amerced. (1367-9) Several similar entries. So in 1384 an amercement for selling foals to strangers without leave of the lord or supervision of the bailiff. (1372) Presentment that Richard Cokaygne has put his son John, aged eight years, to school without the lord's leave; he is amerced in 40*d*. At a later court Richard is licensed to send his son to school on condition that he does not take any holy orders without the lord's leave, the condition being enforced by a penalty of 100*s*. (1380) A. L., a *nativus* of the lord, at the time when he was reeve acquired, without leave of the lord, a messuage and some free-

hold land from W. S.; he now makes fine to the lord with 20s., that he may hear no more about this matter (*ne occasionetur*). (1384) A *nativus* pays 13s. 4d. for leave to marry a *nativa*, a widow who holds a full land, and for leave to hold that land jointly with his wife. (1385) Presentment that A. L. married his daughter to R. H., a *nativus* of the lord; A. L. pays 3s. 4d. that he may hear no more of this (*ne occasionetur de maritacione predicta*). (1394) J. F., a *nativus domini de corpore*, pays 18d. for leave to marry his daughter, *nativam domini*, to J. C., *nativo domini*; he pays no more because his daughter has been guilty of fornication—*comisit leyrwyght*—by reason whereof the lord had 5s. These marks of servility seem to disappear in the fifteenth century.

The terminology employed in the earliest surrenders and admittances is not stereotyped. The land is sometimes *terra nativa*, sometimes *terra custumaria*, sometimes simply a "full land" or "half-land," as the case may be. The *tenendum* is sometimes *sibi et suis*, sometimes *sibi et sequele sue*; "*secundum consuetudinem manerii*" appears at times, and occasionally "*ad voluntatem domini*." In Richard II's day, in the case of a grant to a man and his wife, we already find the full form, *tenendum J. et M. et heredibus et assignatis eorundem per virgam et ad voluntatem domini secundum consuetudinem manerii faciendo servicia antiqua pro predicto integro cotagio*. Thenceforward it is common to mention the rod, the will of the lord, and the custom of the manor; but the phrases "*sibi et sequele sue*," "*sibi et suis*" do not at once give way before "*sibi et heredibus suis*." In the middle of the fifteenth century

it became common to describe the tenant as holding *per copiam*.

The conclusions to which these rolls would lead us may now be stated in a summary fashion.

Before 1350 *or thereabouts.* The lord gets very little by way of money rent. His demesne is cultivated for him by the "works" of his customary tenants. More works are due than are wanted, and each year he "sells" a certain number of works at a customary rate—that is to say, he takes from the person liable to work a penny or, as the case may be, a halfpenny in respect of each work that he does not want. The customary tenants are for the more part, if not altogether, unfree men, and are treated as such.

From 1350 *to* 1410 *or thereabouts.* There is as yet no permanent commutation of work for rent. The lord, however, finds the greatest difficulty in keeping old and obtaining new tenants; his tenants, more especially the cottagers, run away and relinquish their tenements. The lord still hopes to obtain tenants on the old terms, but in the meanwhile has to make temporary grants or leases at money rents, and from time to time to reduce those rents. From the tenants who still hold on the old terms he still exacts a considerable number of works, while other works he "sells" to them year by year. Many of the tenants are still unfree, and are treated as such.

After 1410 *or thereabouts.* It having at last been recognised that many of the tenements are no longer *in opere*, and that there is no prospect of a return to the old state of things, a general commutation of all

works (except some ploughing) takes place. Perhaps this is not at once conceived as a final change, but practically it is irrevocable. The rents are the best rents that the lord can get, and in course of time it is necessary to reduce them. The demesne land, together with the benefit of such works as are uncommuted, is now let, for short terms of years, to a farmer. The lord of the manor becomes, in effect, little more than a receiver of rent. Very few practical traces of personal servitude remain, but we read of no formal emancipation of the bondmen, and the lord is careful to preserve a record of their bondage.

In the sixteenth century. Owing to the fall in the value of money, the copyholder gradually acquires a valuable right in his holding. His rent—less than a shilling an acre—becomes light. I will not generalise, but to me it seems that in this instance the copyholder's vendible interest is almost entirely an unearned increment, the product of American mines.

THE ORIGIN OF USES[1]

THE following account of the origin of our English *Use* forms part of a projected sketch of English law as it stood at the accession of Edward I. It will there follow some remarks upon the late growth of any doctrine of informal agency, by which I mean an agency which is not solemnly created by a formal *attornatio*. I have long been persuaded that every attempt to discover the genesis of our *use* in Roman law breaks down, and I have been led to look for it in another direction by an essay which some years ago Mr Justice Holmes wrote on Early English Equity (*Law Quarterly Review*, vol. I.). Whether I have been successful, it is not for me to say. I will first state my theory and then adduce my evidence.

The germ of agency is hardly to be distinguished from the germ of another institution which in our English law has an eventful future before it, the "use, trust or confidence." In tracing its embryonic history we must first notice the now established truth that the English word *use* when it is employed with a technical meaning in legal documents is derived, not from the Latin word *usus*, but from the Latin word *opus*, which

[1] *Harvard Law Review*, 1894.

in Old French becomes *os* or *oes*. True that the two words are in course of time confused, so that if by a Latin document land is to be conveyed to the use of John, the scribe of the charter will write *ad opus Johannis* or *ad usum Johannis* indifferently, or will perhaps adopt the fuller formula *ad opus et ad usum*, nevertheless the earliest history of "the use" is the early history of the phrase *ad opus*. Now this both in France and in England we may find in very ancient days. A man will sometimes receive money to the use (*ad opus*) of another person; in particular money is constantly being received for the king's use. Kings must have many ministers and officers who are always receiving money, and we have to distinguish what they receive for their own proper use (*ad opus suum proprium*) from what they receive on behalf of the king. Further, long before the Norman Conquest we may find a man saying that he conveys land to a bishop to the use of a church, or conveys land to a church to the use of a dead saint. The difficulty of framing a satisfactory theory touching the whereabouts of the ownership of what we may loosely call "the lands of the churches" (a difficulty that I cannot here pause to explain) gives rise to such phrases. In the thirteenth century we commonly find that where there is what to our eyes is an informal agency, this term *ad opus* is used to describe it. Outside the ecclesiastical sphere there is but little talk of "procuration"; there is no current word that is equivalent to our *agent*; John does not receive money or chattels "as agent for" Roger; he receives it to the use of Roger (*ad opus Rogeri*).

Now in the case of money and chattels a certain haziness in the conception of ownership, which I hope to discuss elsewhere, prevents us from making a satisfactory analysis of the notion that this *ad opus* implies. William delivers two marks or three oxen to John, who receives them to the use of Roger. In whom, we may ask, is the ownership of the coins or of the beasts? Is it already in Roger; or, on the other hand, is it in John, and is Roger's right a merely personal right against John? In the thirteenth century this question does not arise in a clear form, because possession is far more important than ownership. We will suppose that John is the bailiff of one of Roger's manors, that in the course of his business he has gone to a market, has sold Roger's corn, has purchased cattle with the price of the corn and is now driving them home. We take it that if a thief or trespasser swoops down and drives off the beasts, John can bring an appeal or an action and call the beasts his own proper chattels. We take it that he himself cannot steal the beasts; even in the modern common law he cannot steal them until he has in some way put them in his employer's possession. We are not very certain that if he appropriates them to his own use Roger has any remedy except in an action of debt or of account, in which his claim can be satisfied by a money payment. And yet the notion that the beasts are Roger's, not John's, is growing and destined to grow. In course of time the relationship expressed by the vague *ad opus* will in this region develop into a law of agency. In this region the phrase will appear in our own day as expressing rights and duties which the common law can protect and

enforce without the help of any "equity." The common law will know the wrong that is committed when a man "converts to his use" (*ad opus suum proprium*) the goods of another; and in course of time it will know the obligation which arises when money is "had and received to the use" of some person other than the recipient.

It is otherwise in the case of land, for there our old law had to deal with a clearer and intenser ownership. But first we must remark that at a very remote period one family at all events of our legal ancestors have known what we may call a trust, a temporary trust, of lands. The Frank of the Lex Salica is already employing it; by the intermediation of a third person, whom he puts in seisin of his land and goods, he succeeds in appointing or adopting an heir. Along one line of development we may see this third person, this "saleman," becoming the testamentary executor of whom this is not the place to speak; and our English law by forbidding testamentary dispositions of land has prevented us from obtaining many materials in this quarter. However, in the England of the twelfth century we sometimes see the lord intervening between the vendor and the purchaser of land. The vendor surrenders the land to the lord "to the use" of the purchaser by a rod, and the lord by the same rod delivers the land to the purchaser. Freeholders, it is true, have soon acquired so large a liberty of alienation that we seldom read of their taking part in such surrenders; but their humbler neighbours, for instance, the king's sokeman, are constantly surrendering land "to the use" of one who has bought it. What if the

The Origin of Uses

lord when the symbolic stick was in his hand refused to part with it? Perhaps the law had never been compelled to consider so rare an event; and in these cases the land ought to be in the lord's seisin for but a moment. However, we soon begin to see what we cannot but call permanent "uses." A slight but unbroken thread of cases, beginning while the Conquest is yet recent, shows us that a man will from time to time convey his land to another "to the use" of a third. For example, he is going on a crusade, and wishes that his land shall be held to the use of his children, or he wishes that his wife or his sister shall enjoy the land, but doubts, it may be, whether a woman can hold a military fee or whether a husband can enfeoff his wife. Here there must be at the least an honourable understanding that the trust is to be observed, and there may be a formal "interposition of faith." Then, again, we see that some of the lands and revenues of a religious house have often been devoted to some special object; they have been given to the convent "to the use" of the library or "to the use" of the infirmary, and we can hardly doubt that a bishop will hold himself bound to provide that these dedications, which are sometimes guarded by the anathema, shall be maintained. Lastly, in the early years of the thirteenth century the Franciscan friars came hither. The law of their being forbade them to own anything; but they needed at least some poor dormitory, and the faithful were soon offering them houses in abundance. A remarkable plan was adopted. They had come as missionaries to the towns; the benefactor who was minded to give them a house,

would convey that house to the borough community "to the use of" or "as an habitation for" the friars. Already when Bracton was writing, a considerable number of plots of land in London had been thus conveyed to the city for the benefit of the Franciscans. The corporation was becoming a trustee. It is an old doctrine that the inventers of "the use" were "the clergy" or "the monks.' We should be nearer the truth if we said that to all seeming the first persons who in England employed "the use" on a large scale were, not the clergy, nor the monks, but the friars of St Francis.

Now in few, if any, of these cases can the *ad opus* be regarded as expressing the relation which we conceive to exist between a principal and an agent. It is intended that the "feoffee to uses" (we can employ no other term to describe him), shall be the owner or legal tenant of the land, that he shall be seised, that he shall bear the burdens incumbent on owners or tenants, but he is to hold his rights for the benefit of another. Such transactions seem to have been too uncommon to generate any definite legal theory. Some of them may have been enforced by the ecclesiastical courts. Assuredly if the citizens of London had misappropriated the lands conveyed to them for the use of the friars, those darlings of popes and kings, they would have known what an interdict meant. Again, in some cases the feoffment might perhaps be regarded as a "gift upon condition," and in others a written agreement about the occupation of the land might be enforced as a covenant. But at the time when the system of original writs was taking its final form "the

use" had not become common enough to find a comfortable niche in the fabric. And so for a while it lives a precarious life until it finds protection in the "equitable" jurisdiction of the chancellors. If in the thirteenth century our courts of common law had already come to a comprehensive doctrine of contract, if they had been ready to draw an exact line of demarcation between "real" and "personal" rights, they might have reduced "the use" to submission and found a place for it in their scheme of actions; in particular, they might have given the feoffor a personal, a contractual, action against the feoffee. But this was not quite what was wanted by those who took part in these transactions; it was not the feoffor, it was the person whom he desired to benefit (the *cestui que use* of later days) who required a remedy, and moreover a remedy that would secure him not money compensation but the specific enjoyment of the thing granted. "The use" seems to be accomplishing its manifest destiny when at length after many adventures it appears as "equitable ownership."

I will now put in some of the evidence that I have collected :—

I. The employment of the phrase *ad opus meum* (*tuum, suum*) as meaning on my (your, his) behalf, or for my (your, his) profit or advantage can be traced back into very early Frankish formulas. See Zeumer's quarto edition of the *Formulae Merovingici et Karolini Aevi* (*Monumenta Germaniae*), index s.v. *opus.* Thus, *e.g.* :—

p. 115 "ut nobis aliquid de silva ad opus ecclesiae nostrae...dare iubeatis." (But here *opus ecclesiae* may mean the fabric of the church.)

p. 234 "per quem accepit venerabilis vir ille abbas ad opus monasterio suo [= monasterii sui]...masas ad commanendum."

p. 208 "ad ipsam iam dictam ecclesiam ad opus sancti illius... dono."

p. 315 (An emperor is speaking) "telonium vero, excepto ad opus nostrum inter Q et D vel ad C [*place names*] ubi ad opus nostrum decima exigitur, aliubi eis ne requiratur."

II. So in Carolingian laws for the Lombards. *Mon. Germ. Leges*, IV. Liber Papiensis Pippini 28 (p. 520): "De compositionibus quae ad palatium pertinent: si comites ipsas causas convenerint ad requirendum, illi tertiam partem ad eorum percipiant opus, duos vero ad palatium." (The *comes* gets "the third penny of the county" for his own use.)

Lib. Pap. Ludovici Pii 40 (p. 538): "Ut de debito quod ad opus nostrum fuerit wadiatum talis consideratio fiat."

III. From Frankish models the phrase has passed into Anglo-Saxon land-books. Thus, *e.g.*:—

Coenulf of Mercia, A.D. 809, Kemble, *Cod. Dipl.* v. 66: "Item in alio loco dedi eidem venerabili viro ad opus praefatae Christi ecclesiae et monachorum ibidem deo servientium terram..."

Beornwulf of Mercia, A.D. 822, Kemble, *Cod. Dipl.* v. 69: "Rex dedit ecclesiae Christi et Wulfredo episcopo ad opus monachorum... villam Godmeresham."

IV. It is not uncommon in Domesday Book. Thus, *e.g.*:—

D. B. I. 209: "Inter totum reddit per annum xxii. libras...ad firmam regis....Ad opus reginae duas uncias auri...et i. unciam auri ad opus vicecomitis per annum."

D. B. I. 60 b: "Duae hidae non geldabant quia de firma regis erant et ad opus regis calumniatae sunt."

D. B. II. 311: "Soca et saca in Blideburh ad opus regis et comitis."

V. A very early instance of the French *al os* occurs in *Leges Willelmi*, I. 2. § 3: "E cil francs hom...seit mis en forfeit el cunté afert al os le vescunte en Denelahe xl. ores....De ces xxxii ores averad le vescunte al os le rei x. ores." The sheriff takes certain sums for his own use, others for the king's use. This document can hardly be of later date than the early years of cent. xii.

VI. In order to show the identity of *opus* and *os* or *oes* we may pass to Britton, II. 13: "Villenage est tenement de demeynes de chescun seignur baillé a tenir a sa volunté par vileins services de emprouwer al oes le seignur."

The Origin of Uses

VII. A few examples of the employment of this phrase in connection with the receipt of money or chattels may now be given.

Liberate Roll 45 Hen. III (*Archaeologia*, XXVIII. 269): Order by the king for payment of 600 marks which two Florentine merchants lent him, to wit, 100 marks for the use (*ad opus*) of the king of Scotland and 500 for the use of John of Brittanny.

Liberate Roll 53 Hen. III (*Archaeologia*, XXVIII. 271): Order by the king for payment to two Florentines of money lent to him for the purpose of paying off debts due in respect of cloth and other articles taken "to our use (*ad opus nostrum*)" by the purveyors of our wardrobe.

Bracton's *Note Book*, pl. 177 (A.D. 1222): A defendant in an action of debt confesses that he has received money from the plaintiff, but alleges that he was steward of Roger de C. and received it *ad opus eiusdem Rogeri*. He vouches Roger to warranty.

Selby Coucher Book, II. 204 (A.D. 1285): "Omnibus...R. de Y. ballivus domini Normanni de Arcy salutem. Noveritis me recepisse duodecim libras...de Abbate de Seleby ad opus dicti Normanni, in quibus idem Abbas ei tenebatur....Et ego...dictum abbatem...versus dominum meum de supradicta pecunia indempnem conservabo et adquietabo."

Y. B. 21–2 Edw. I, p. 23: "Richard ly bayla les chateus a la oeus le Eveske de Ba."

Y. B. 33–5 Edw. I, p. 239: "Il ad conté qe eux nous livererent meyme largent al oes Alice la fille B."

VIII. We now turn to cases in which land is concerned:—

Whitby Cartulary, I. 203-4 (middle of cent. xii.): Roger Mowbray has given land to the monks of Whitby; in his charter he says "Reginaldus autem Puer vendidit ecclesiae praefatae de Wyteby totum ius quod habuit in praefata terra et reliquit michi ad opus illorum, et ego reddidi eis, et saisivi per idem lignum per quod et recepi illud."

Burton Cartulary, p. 21, from an "extent" which seems to come to us from the first years of cent. xii.: "tenet Godfridus viii. bovatae [*corr.* bovatas] pro viii. sol. praeter illam terram quae ad ecclesiam iacet quam tenet cum ecclesia ad opus fratris sui parvuli, cum ad id etatis venerit ut possit et debeat servire ipsi ecclesiae."

Ramsey Cartulary, II. 257–8, from a charter dated by the editors in 1080–7: "Hanc conventionem fecit Eudo scilicet Dapifer Regis cum Ailsio Abbate Rameseiae...de Berkeforde ut Eudo habere deberet ad opus sororis suae Muriellae partem Sancti Benedicti quae adiacebat ecclesiae Rameseiae quamdiu Eudo et soror eius viverent, ad dimidium servitium unius militis, tali quidem pacto ut post Eudonis sororisque decessum tam partem propriam Eudonis quam in eadem villa habuit, quam partem ecclesiae Rameseiae, Deo et Sancto Benedicto ad usum fratrum eternaliter...possidendam...relinqueret." In D. B. I. 210 b, we find "In Bereforde tenet Eudo dapifer v. hidas de feodo Abbatis [de Ramesy]." So here we have a "Domesday tenant" as "feoffee to uses."

Ancient Charters (Pipe Roll Soc. p. 21) (*circ.* A.D. 1127); Richard Fitz Pons announces that having with his wife's concurrence disposed of her marriage portion, he has given other lands to her; "et inde saisivi Milonem fratrem eius loco ipsius ut ipse eam manuteneat et ab omni defendat iniuria."

Curia Regis Roll No. 81, Trin. 6 Hen. III, m. 1 d. Assize of mort d'ancestor by Richard de Barre on the death of his father William against William's brother Richard de Roughal for a rent. Defendant alleges that William held it in *custodia*, having purchased it to the use of (*ad opus*) the defendant with the defendant's money. The jurors say that William bought it to the use of the defendant, so that William was seised not in fee but in wardship (*custodia*). An attempt is here made to bring the relationship that we are examining under the category of *custodia*.

Bracton's *Note Book*, pl. 999 (A.D. 1224): *R*, who is going to the Holy Land, commits his land to his brother *W* to keep to the use of his (*R*'s) sons (*commisit terram illam W ad opus puerorum suorum*); on *R*'s death his eldest son demands the land from *W*, who refuses to surrender it; a suit between them in a seignorial court is compromised; each of them is to have half the land.

Bracton's *Note Book*, pl. 1683 (A.D. 1225): *R* is said to have bought land from *G* to the use of the said *G*. Apparently *R* received the land from *G* on the understanding that he (*R*) was to convey it to *G* and the daughter of *R* (whom *G* was going to marry) by the way of a marriage portion.

Bracton's *Note Book*, pl. 1851 (A.D. 1226–7): A man who has

married a second wife is said to have bought land to the use of this wife and the heirs of her body begotten by him.

Bracton's *Note Book*, pl. 641 (A.D. 1231): It is asserted that *E* impleaded *R* for certain lands, that *R* confessed that the land was *E*'s in consideration of 12 marks, which *M* paid on behalf of *E*, and that *M* then took the land to the use (*ad opus*) of *E*. Apparently *M* was to hold the land in gage as security for the 12 marks.

Bracton's *Note Book*, pl. 754 (A.D. 1233): Jurors say that *R* desired to enfeoff his son *P*, an infant seven years old; he gave the land in the hundred court and took the child's homage; he went to the land and delivered seisin; he then committed the land to one *X* to keep to the use of *P* (*ad custodiendum ad opus ipsius Petri*) and afterwards he committed it to *Y* for the same purpose; *X* and *Y* held the land for five years to the use of *P*.

Bracton's *Note Book*, pl. 1244 (A.D. 1238-9): A woman, mother of *H*, desires a house belonging to *R*; *H* procures from *R* a grant of the house to *H* to the use (*ad opus*) of his mother for her life.

Assize Roll No. 1182, m. 8 (one of Bracton's Devonshire rolls): "Iuratores dicunt quod idem Robertus aliquando tenuit hundredum illud et quod inde cepit expleta. Et quaesiti ad opus cuius, utrum ad opus proprium vel ad opus ipsius Ricardi, dicunt quod expleta inde cepit, sed nesciunt utrum ad opus suum proprium vel ad opus ipsius Ricardi quia nesciunt quid inde fecit."

Chronicon de Melsa, II. 116 (an account of what happened in the middle of cent. xiii. compiled from charters): Robert confirmed to us monks the tenements that we held of his fee; "et insuper duas bovatas cum uno tofto...ad opus Ceciliae sororis suae et heredum suorum de corpore suo procreatorum nobis concessit; ita quod ipsa Cecilia ipsa toftum et ii. bovatas terrae per forinsecum servitium et xiv. sol. et iv. den. annuos de nobis teneret. Unde eadem toftum et ii. bovatas concessimus dictae Ceciliae in forma praescripta."

IX. The lands and revenues of a religious house were often appropriated to various specific purposes, *e.g. ad victum monachorum, ad vestitum monachorum*, to the use of the sacrist, cellarer, almoner or the like, and sometimes this appropriation was designated by the donor. Thus, *e.g. Winchcombe Landboc*, I. 55, "ad opus librorum"; I. 148, "ad usus infirmorum monachorum"; I. 73, certain tithes are devoted "in usum operationis ecclesiae," and in 1206 this devotion

of them is protected by a ban pronounced by the abbot; only in case of famine or other urgent necessity may they be diverted from this use. So land may be given "to God and the church of St German of Selby to buy eucharistic wine (*ad vinum missarum emendum*)"; *Selby Coucher*, II. 34.

In the ecclesiastical context just mentioned *usus* is a commoner term than *opus*. But the two words are almost convertible. On Curia Regis Roll No. 115 (18–9 Hen. III), m. 3 is an action against a royal purveyor. He took some fish *ad opus Regis* and converted it *in usus Regis*.

X. In the great dispute which raged between the archbishops of Canterbury and the monks of the cathedral monastery one of the questions at issue was whether certain revenues, which undoubtedly belonged to "the church" of Canterbury, had been irrevocably devoted to certain specific uses, so that the archbishop, who was abbot of the house, could not divert them to other purposes. In 1185 Pope Urban III pronounces against the archbishop. He must restore certain parochial churches to the use of almonry. "Ecclesiae de Estreia et de Munechetun...ad usus pauperum provide deputatae fuissent, et a...praedecessoribus nostris eisdem usibus confirmatae.... Monemus quatenus...praescriptas ecclesias usibus illis restituas." So the prior and convent are to administer certain revenues which are set apart "in perpetuos usus luminarium, sacrorum vestimentorum et restaurationis ipsius ecclesiae, et in usus hospitum et infirmorum." At one stage in the quarrel certain representatives of the monks in the presence of Henry II received from the archbishop's hand three manors "ad opus trium obedientiariorum, cellerarii, camerarii et sacristae." See *Epistolae Cantuarienses*, pp. 5, 38, 95.

XI. We now come to the very important case of the Franciscans.

Thomas of Eccleston, De adventu Fratrum Minorum (*Monumenta Franciscana*, I.), p. 16: "Igitur Cantuariae contulit eis aream quandam et aedificavit capellam...Alexander magister Hospitalis Sacerdotum; et quia fratres nihil omnino appropriare sibi voluerunt, facta est communitati civitatis propria, fratribus vero pro civium libitu commodata...Londoniae autem hospitatus est fratres dominus Johannes Ywim, qui emptam pro fratribus aream communitati civium appropriavit, fratrum autem usumfructum eiusdem pro libitu

dominorum devotissime designavit...Ricardus le Muliner contulit aream et domum communitati villae [Oxoniae] ad opus fratrum." This account of what happened in or about 1225 is given by a contemporary.

Prima Fundatio Fratrum Minorum Londoniae (*Monumenta Franciscana*, I.), p. 494. This document gives an account of many donations of land made to the city of London in favour of the Franciscans. The first charter that it states is one of 1225, in which John Iwyn says that for the salvation of his soul he has given a piece of land to the *communitas* of the city of London in Frankalmoin "ad inhospitandum [*a word missing*] pauperes fratres minorum [minores?] quamdiu voluerint ibi esse."

XII. The attempt of the early Franciscans to live without property of any sort or kind led to subtle disputations and in the end to a world-shaking conflict. At one time the popes sought to distinguish between ownership and usufruct or use; the Franciscans might enjoy the latter but could not have the former; the *dominium* of all that was given to their use was deemed to be vested in the Roman church and any litigation about it was to be carried on by papal procurators. This doctrine was defined by Nicholas III in 1279. In 1322 John XXII did his best to overrule it, declaring that the distinction between use and property was fallacious and that the friars were not debarred from ownership. Charges of heresy about this matter were freely flung about by and against him, and the question whether Christ and His Apostles had owned goods became a question between Pope and Emperor, between Guelph and Ghibelline. In the earlier stages of the debate there was an instructive discussion as to the position of the third person, who was sometimes introduced as an intermediary between the charitable donor and the friars who were to take the benefit of the gift. He could not be treated as agent or procurator for the friars unless the ownership was ascribed to them. Gregory IX was for treating him as an agent for the donor. See Lea, *History of the Inquisition*, III. 5–7, 29–31, 129–154.

XIII. It is very possible that the case of the Franciscans did much towards introducing among us both the word *usus* and the desire to discover some expedient which would give the practical benefits of ownership to those who could yet say that they owned

nothing. In every large town in England there were Minorites who knew all about the stormy controversy, who had heard how some of their foreign brethren had gone to the stake rather than suffer that the testament of St Francis should be overlaid by the evasive glosses of lawyerly popes, and who were always being twitted with their impossible theories by their Dominican rivals. On the continent the battle was fought with weapons drawn from the armoury of Roman law. Among these were *usus* and *usufructus*. It seems to have been thought at one time that the case could be met by allowing the friars a *usufructus* or *usus*, these terms being employed in a sense that would not be too remote from that which they had borne in the old Roman texts. Thus it is possible that there was a momentary contact between Roman law—mediaeval, not classical, Roman law—and the development of the English *use*. Englishmen became familiar with an employment of the word *usus* which would make it stand for something that just is not, though it looks exceedingly like, *dominium*. But we hardly need say that the *use* of our English law is not derived from the Roman "personal servitude"; the two have no feature in common. Nor can I believe that the Roman *fideicommissum* has anything to do with the evolution of the English *use*. In the first place, the English *use* in its earliest stage is seldom, if ever, the outcome of a last will, while the *fideicommissum* belongs essentially to the law of testaments. In the second place, if the English *use* were a *fideicommissum* it would be called so, and we should not see it gradually emerging out of such phrases as *ad opus* and *ad usum*. What we see is a vague idea, which developing in one direction becomes what we now know as agency and developing in another direction becomes that *use* which the common law will not, but equity will, protect. Of course, again, our "equitable ownership" when it has reached its full stature has enough in common with the praetorian *bonorum possessio* to make a comparison between the two instructive; but an attempt to derive the one from the other would be too wild for discussion.

OUTLINES OF ENGLISH LEGAL HISTORY, 560—1600[1]

OLD ENGLISH LAW.

WHEN we speak of a body of law, we use a metaphor so apt that it is hardly a metaphor. We picture to ourselves a being that lives and grows, that preserves its identity while every atom of which it is composed is subject to a ceaseless process of change, decay, and renewal. At any given moment of time—for example, in the present year—it may, indeed, seem to us that our legislators have, and freely exercise, an almost boundless power of doing what they will with the laws under which we live; and yet we know that, do what they may, their work will become an organic part of an already existing system.

Already, if we look back at the ages which are the most famous in the history of English legislation—the age of Bentham and the radical reform, the age which appropriated the gains that had been won but not secured under the rule of Cromwell, the age of Henry VIII, the age of Edward I ("our English

[1] *Social England*, ed. H. D. Traill. Cassell & Co., 1893.

Justinian")—it must seem to us that, for all their activity, they changed, and could change, but little in the great body of law which they had inherited from their predecessors. Hardly a rule remains unaltered, and yet the body of law that now lives among us is the same body that Blackstone described in the eighteenth century, Coke in the seventeenth, Littleton in the fifteenth, Bracton in the thirteenth, Glanvill in the twelfth. This continuity, this identity, is very real to us if we know that for the last seven hundred years all the judgments of the courts at Westminster have been recorded, and that for the most part they can still be read. Were the world large enough to contain such a book, we might publish not merely a biography, but a journal or diary, of English law, telling what it has done, if not day by day, at least term by term, ever since the reign of Richard I; and eventful though its life may have been, it has had but a single life.

Beyond these seven centuries there lie six other centuries that are but partially and fitfully lit, and in one of them a great catastrophe, the Norman Conquest, befell England and the law of England. However, we never quite lose the thread of the story. Along one path or another we can trace back the footprints, which have their starting-place in some settlement of wild Germans who are invading the soil of Roman provinces, and coming in contact with the civilisation of the old world. Here the trail stops, the dim twilight becomes darkness; we pass from an age in which men seldom write their laws to one in which they cannot write at all. Beyond lies the realm of guesswork.

Outlines of English Legal History 419

About the year 600, Ethelbert, king of the Kentishmen, by the counsel of his wise-men, caused the laws of his people to be set down in writing. He had just received the Christian faith at the hands of Roman missionaries, and it was in imitation of the Romans that he and his folk desired to have written laws. His reign overlaps the reign of Justinian, and perhaps he had heard how in the Far East the Roman Emperor had been legislating on a magnificent scale. English law begins to speak just when Roman law has spoken what will, in a certain sense, be its final words. On the continent of Europe the same thing had been happening. No sooner did the barbarian tribe feel the influence of Rome than it wished for a written code of laws. Ethelbert and his Jutes in Kent are doing what the Salian Franks did a century earlier when they wrote down their famous Lex Salica; but while on the Continent the laws of the conquering Germans are written in the Latin language of the conquered, in England the barbarians from the first write down their law in the language that they speak, the language which is to become English.

Ethelbert's laws have come down to us, though only in a copy made after the Norman Conquest. They may seem to us primitive enough. The emperor at Byzantium, could he have seen them, would assuredly have denied that they had any points in common with the Roman law-books, save that they were laws, and were in writing. Nevertheless, we cannot call them primitive in any absolute sense of that term. They are Christian. Let us look at the first sentence, the first recorded utterance of English law :—" God's fee

[property] and the church's, twelve-fold; bishop's fee, eleven-fold; priest's fee, nine-fold; deacon's fee, six-fold; clerk's fee, three-fold." Churches, bishops, priests, deacons, clerks—these are no archaic German institutions; they are Latin, they have Latin names which must be taken up bodily into the Teutonic speech of the new converts. Unfortunately (so we may now think), Germanic law has no written memorials of the days of its heathenry. Every trace but the very faintest of the old religion has been carefully expurgated from all that is written, for all that is written passes under ecclesiastical hands. Thus we may guess that a new force is already beginning to transfigure the whole sum and substance of barbaric law, before that law speaks the first words that we can hear. It is a wild plant that has already been torn from its native soil and set to grow in a garden. The change of faith, and the substitution of one order of religious rites for another, would in any case mean much, for we have reason to believe that the old law had in it a strong sacral element; but as it is, they mean the influence of the old civilised world upon the new barbarian world.

Ethelbert's laws consist of ninety brief sentences. Two will serve as samples:—"If one man strike another with the fist on the nose—three shillings." "If the eye be struck out let boot [*i.e.* amends] be made with fifty shillings." To call this brief tariff a code may seem strange, but there are not wanting signs that the wise-men of Kent are committing to writing as much of their traditional law as they can remember in the form of abstract propositions. No

Outlines of English Legal History 421

doubt much more law—in particular, a law of procedure—is known to them implicitly. If a concrete case were to occur, they would be ready with a doom; but when asked for general rules, these ninety are all that they can call to mind. Thus we may say that our legal history starts with an act of codification. This code became the basis of Kentish law. Subsequent kings in the course of the seventh century, Lothair, Edric, Wihtred, with the counsel of the wise, add some fifty new dooms to the written law of the men of Kent.

Then the scene changes to Wessex. In the middle of the seventh century the West Saxons received Christianity; before its end they had written laws, the laws of Ine. By the advice of his bishops and of the oldest and wisest men, Ine published a set of laws which tell us a good deal more than we can learn from the Kentish series.

The next legislator whose work has come down to us is the great Alfred. His laws are divided from those of his ancestor Ine by a period of two centuries or thereabouts. This is the one great gap in our continuous legal history. In the history of religion and learning and letters these centuries are far from being the darkest. They cover the time when Northumbria was for a while a centre of light—not for England only, but for the world at large. It may be that we have lost some things. It is fairly certain that Offa of Mercia, in the days of Mercia's greatness, issued written laws. When Alfred is king, when all England is becoming united under the vigorous princes of the West Saxon house, the three legislators whose names

are still remembered are Ethelbert of Kent, Ine of Wessex, and Offa of Mercia. From the manner in which Alfred speaks of them and of their laws we may gather that, heavy though our losses may have been, we have lost no document that testified to any revolutionary change in the law. Though nearly three hundred years have gone by since Ethelbert's death, his dooms are still in force among the Kentish people. Alfred tells us that he dared to add but little of his own to the work of his three great forerunners; and though we can see that during the last two centuries some new legal ideas have emerged, still the core of the law is what it was. What can be put in writing is for the more part a tariff of the sums that must be paid when deeds of violence are done.

The Alfred of sober truth is not the Alfred of legal legend—for the history of law has its legends—the inventive architect of a British Constitution; but his laws are the first member of a grand series—the capitularies, we might call them, of the English kings of the West Saxon house. Edward the Elder, Ethelstan, Edmund, and Edgar, with the counsel of their wise-men, legislate in a bold, masterful fashion. For the better maintenance of the peace, they sharpen the old rules and they make new rules. Written law accumulates somewhat rapidly; it is expected by this time that the doomsmen will be able to find in the "doombook," the book of written law, judgments apt for most of the cases which come before them. This series extends from the beginning to the end of the tenth century. The laws of Ethelred continue it into the eleventh century. His laws were many, for he had

to say the same thing over and over again; we can see on their face that they were ineffectual. He begs and prays men to keep the peace and desist from crime; he must beg and pray, for he cannot command and punish. The Danes were ravaging and conquering; the State tottered; the house of Cerdic fell. It was left for the mighty Canute to bring to a noble close the first great period in the history of English law, the period during which laws were written in the English language, the period which it is convenient to call Anglo-Saxon. Canute's code we must, if we have regard to the age in which it was issued, call a long and a comprehensive code. It repeats, with improvements, things that have been said before; the great Dane was able to enforce as laws rules which in the mouth of his predecessor had been little better than pious wishes; but it also contained many things that had not been said before. The whole economic and political structure of society was undergoing a great change. If by any two words we could indicate the nature of this elaborate process, we might say that tribalism was giving place to feudalism. Had Canute's successors been his equals in vigour and wisdom, perhaps the change might have been consummated peacefully, and by means of written laws which we now might be reading. As it was, there came to the throne the holy but imbecile Edward. In after days he won not only the halo of the saint, to which he may have been entitled, but the fame, to which he certainly was not entitled, of having been a great legislator. In the minster that he reared, king after king made oath to observe the laws of the Confessor. So far as we

know, he never made a law. Had he made laws, had he even made good use of those that were already made, there might have been no Norman Conquest of England. But then had there been no Norman Conquest of England, Edward would never have gained his fictitious glories. As it was, men looked back to him as the last of the English kings of the English—for of Harold, who had become the perjured usurper, there could be no talk—and galled by the yoke of their French masters, they sighed for St Edward's law, meaning thereby the law that had prevailed in a yet unvanquished England.

Now these enacted and written laws of our forefathers, representing as they do some four centuries and a half, representing as long a period as that which divides us from the Wars of the Roses, will seem a small thing to the first glance of a modern eye. They might all be handsomely printed on a hundred pages such as that which is now before the reader. A session of Parliament which produced no larger mass of matter we should nowadays regard as a sterile session. In the Georgian age many more words than are contained in the whole code of Canute would have been devoted to the modest purpose of paving and lighting the borough of Little Peddlington. It is but fair to our ancient kings and their wise-men to say that when they spoke, they spoke briefly and pointedly. They had no fear that ingenious lawyers would turn their words inside out. "God's fee and the Church's, twelve-fold"—they feel that they need say no more than this about one very important matter. Also, we have to remember that life was simple; men could do,

men could wish to do, but few things. Our increasing mastery over the physical world is always amplifying the province of law, for it is always complicating the relationships which exist between human beings. Many a modern Act of Parliament is the product of the steam-engine, and there is no great need for a law of copyright until long after the printing-press has begun its work. For all this, however, it is true that these old written and enacted dooms contain but a part of the law which was enforced in England.

If we say that law serves three great purposes, that it punishes crime, redresses wrong, and decides disputes—and perhaps we need not go into the matter more deeply than this—then we may go on to say that in ancient days the two first of these three purposes are indistinguishably blended, while with the third the legislator seldom troubles himself. If he can maintain the peace, suppress violence and theft, keep vengeance within moderate bounds, he is well satisfied; he will not be at pains to enact a law of contract or of inheritance, a law of husband and wife, a law of landlord and tenant. All this can safely be left to unwritten tradition. He has no care to satisfy the curiosity of a remote posterity which will come prying into these affairs and wish to write books about them. Thus, to take one example, the courts must have been ready to decide disputes about the property of dead men; there must have been a general law, or various tribal or local laws, of inheritance. But the lawgivers tell us nothing about this. If we would recover the old rules, we must make the best that we may of stray hints and chance stories, and of those archaisms which we find embedded in the law of later days.

The laws of the folk, the "folk-right"—"law" is one of those words which the Danes bring with them—is known to the men of the folk, but more especially to the old and wise. The freemen, or the free land-owners, of the hundred are in duty bound to frequent the "moot," or court, of the hundred, to declare the law and to make the dooms. The presiding alderman or sheriff turns to them when a statement of the law is wanted. As yet there is no class of professional lawyers, but the work of attending the courts is discharged chiefly by men of substance, men of thegnly rank; the small folk are glad to stay at home.

Also, some men acquire a great reputation for legal learning, and there was much to be learnt, though no one thought of setting it in writing. We should assuredly make a great mistake were we to picture to ourselves these old hundred-courts as courts of equity, where "the natural man" administered an informal "law of Nature." For one thing, as will be said elsewhere, the law of the natural man is supernatural law, a law which deals in miracles and portents. But then, again, it is exceedingly formal. It is a law of procedure. The right words must be said without slip or trip, the due ceremonial acts must be punctiliously performed, or the whole transaction will go for naught. This is the main theme of the wise-man's jurisprudence. One suspects that sometimes the man who, in the estimate of his neighbours, has become very wise indeed, has it in his power to amplify tradition by devices of his own. We hear from Iceland a wonderful tale of a man so uniquely wise that though he had made himself liable to an action of a particular kind, no one could bring that action against him, for he and

only he knew the appropriate words of summons: to trick him into a disclosure of this precious formula is a feat worthy of a hero. But formalism has its admirable as well as its ludicrous side. So long as law is unwritten, it must be dramatised and acted. Justice must assume a picturesque garb, or she will not be seen. And even of chicane we may say a good word, for it is the homage which lawlessness pays to law.

We have called the written laws "tariffs." They prescribe in great detail the various sums of money which must be paid by wrong-doers. There are payments to be made to the injured person or the kinsfolk of the slain man; there are also payments to be made to the king, or to some other representative of the tribe or nation. The growth of this system of pecuniary mulcts gradually restricts the sphere of self-help and vengeance. The tie of blood-relationship has been the straitest of all bonds of union. If a man of one family was slain by the man of another, there would be a blood-feud, a private war. The State steps in and compels the injured family to accept the dead man's "wergild"—the dead man's price or worth, if it be duly tendered. King Edmund goes so far as to insist that the vengeance of the dead man's kinsfolk is not to comprise the guiltless members of the slayer's clan. The law's last weapon against lawlessness is outlawry. The contumacious offender is put outside the peace; he becomes the foe of all law-abiding men. It is their duty to waste his land and burn his house, to pursue him and knock him on the head as though he were a beast of prey, for "he bears the wolf's head." As the State grows stronger, less clumsy modes of

punishment become possible; the criminal can be brought to trial, and definitely sentenced to death or mutilation. We can watch a system of true punishments—corporeal and capital punishments—growing at the expense of the old system of pecuniary mulcts, blood-feud, and outlawry; but on the eve of the Norman Conquest mere homicide can still be atoned for by the payment of the dead man's price or "wergild," and if that be not paid, it is rather for the injured family than for the State to slay the slayer. Men of different ranks had different prices: the thegn was worth six ceorls, and it seems very plain that if a ceorl killed a thegn, he had to die for it, or was sold into slavery, for a thegnly wergild was quite beyond the reach of his modest means. In the twelfth century the old system perished of over-elaboration. The bill that a man-slayer ran up became in the days of feudalism too complex to be summed, too heavy to be paid; for the dead man's lord, the lord of the place where the blood was shed, and it may be many other lords, would claim fines and forfeitures. He had to pay with his eyes or with his life a debt that he could not otherwise discharge.

As yet our Germanic law had not been exposed to the assaults of Roman jurisprudence, but still it had been slowly assuming and assimilating the civilisation of the old world. This distinction we must draw. On the one hand, there has been no borrowing from the Roman legal texts. We have no proof whatever that during the five centuries which preceded the Norman Conquest any one copy of a Roman law-book existed in England. We hear faint and vague tidings

of law being taught in some of the schools, but may safely believe that very little is meant thereby. The written dooms of our kings have been searched over and over again by men skilled in detecting the least shred of Roman law under the most barbaric disguise, and they have found nothing worthy of mention. That these dooms are the purest specimens of pure Germanic law has been the verdict of one scholar after another. Even the English Church, though its independence may often have been exaggerated, became very English. On the other hand, as already said, to become Christian was in a certain sense to become Roman. Whether, had an impassable wall been raised round England in the last quarter of the sixth century, England would not be a barbarous country at this day —that is a question which cannot be answered. As a matter of fact, we had not to work out our own civilisation; we could adopt results already attained in the ancient world. For example, we did not invent the art of writing, we adopted it; we did not invent our alphabet, we took the Roman. And so again— to come nearer to our law—we borrowed or inherited from the Old World the written legal document, the written conveyance, the will. The written conveyance was introduced along with Christianity; to all seeming, Ethelbert himself began the practice of "booking" lands to the churches. We have a few genuine "landbooks" from the seventh and eighth, many from the later centuries. For the more part they are written in Latin, and they were fashioned after Italian models; but at the same time we can see that those models have been barbarised and misunderstood; the English

scribes pervert the neat devices of Roman lawyers. Any phrase which draws a contrast between a nation's law and its civilisation is of course open to objection. But let us suppose that at the present day a party of English missionaries is setting forth to convert a savage tribe: perhaps no one of them would know enough of English law to carry him through the easiest examination, and yet they would take with them many ideas that are in a certain sort the ideas of English law. Without being able to define murder, they would know that in this country murderers are condemned to death; they would think that a written expression of a man's last will should be respected, though they might well doubt whether a will is revoked by the testator's marriage. So it was in the seventh century. From the days of Ethelbert onwards English law was under the influence of so much of Roman law as had worked itself into the tradition of the Catholic Church.

English Law under Norman and Angevin.

The Normans when they invaded England were in one important particular a less civilised race than were those English whom they came to subjugate. We may say with some certainty that they had no written laws. A century and a half ago a king of the Franks had been compelled to cede a large province to a horde of Scandinavian pirates. The pirates had settled down as lords of a conquered people; they had gradually adopted the religion, the language, and the

civilisation (such as it was) of the vanquished; they had become Frenchmen. They may have paid some reverence to the written laws of the Frankish race, to the very ancient Lex Salica and the capitularies of Merovingian and Carlovingian kings. But these were fast becoming obsolete, and neither the dukes of the Normans nor their nominal overlords, the kings of the Franks or French, could issue written dooms such as those which Canute was publishing in England. Some excellent traditions of a far-off past, of the rule of Charles the Great, the invaders could bring with them to England; and these transplanted into the soil of a subject kingdom, could burst into new life and bear new fruit—the great record that we call "Domesday Book" is a splendid firstfruit—but written laws they had none.

To all seeming, the Conqueror meant that his English subjects should keep their own old laws. Merely duke of the Normans, he was going to be king in England, and he was not dissatisfied with those royal rights which, according to his version of the story, had descended to him from King Edward. About a few points he legislated. For example, the lives of his followers were to be protected by the famous murder-fine. If a Frenchman was found slain, and the slayer was not produced, a heavy sum was to be exacted from the district in which the crime was done. The establishment of a presumption that every murdered man is a Frenchman until the contrary is proved—a presumption highly advantageous to the king's exchequer—gave rise in later days to the curious process known as "the presentment of Englishry."

The hundred had to pay the fine unless the kinsfolk of the dead man would testify to his English birth. But this by the way. William had also to regulate the scope of that trial by battle which the Normans brought with them, and in so doing he tried to deal equitably with both Normans and English. Also it was necessary that he who had come hither as in some sort the champion of Roman orthodoxy should mark off the sphere of spiritual from that of temporal law by stricter lines than had yet been drawn in England. Much, again—though by no general law—he altered in the old military system, which had lately shown itself to be miserably ineffectual. Dealing out the forfeited lands amongst his barons, he could stipulate for a force of armoured and mounted knights. Some other changes he would make; but in the main he was content that the English should live under their old law, the law that now bore the blessed Edward's name.

And so again when on the death of Rufus—from Rufus himself we get and we expect no laws—Henry seized the crown, and was compelled to purchase adherents by granting a charter full of all manner of promises, made to all manner of people—the promise by which he hoped to win the hearts of Englishmen was that he would restore them to Edward's law with those amendments that the Conqueror had made in it. Henry himself, great as a governor, was no great legislator. A powerful central tribunal, which is also an exacting financial bureau, an "exchequer," began to take definite shape under the management of his expert ministers; but very few new laws were

published. The most characteristic legal exploits of the Norman period are the attempts made by various private persons to reconstruct "the law of St Edward." They translate some of the old English dooms into Latin as best they can—a difficult task, for the English language is rapidly taking a new shape. They modify the old dooms to suit a new age. They borrow from foreign sources—from the canon law of the Catholic Church, from Frankish capitularies, now and again from the Roman law-books. But in Henry I's reign they still regarded the Old English dooms, the law of King Edward, as the core of the law that prevails in England. They leave us wondering how much practical truth there is in what they say; whether the ancient criminal tariffs that they transcribe are really observed; whether the Frenchmen who preside in court pay much attention to the words of Canute, even when those words have been turned into Latin or into French. Still, their efforts assure us that there has been rather a dislocation than a complete break in the legal history of England; also that the Frenchmen have not introduced much new law of a sufficiently definite kind to be set down in writing.

As yet the great bulk of all the justice that was done, was done by local courts, by those shire-moots and hundred-moots which the Conqueror and Henry I had maintained as part of the ancient order, and by the newer seignorial courts which were springing up in every village. The king's own court was but a court for the protection of royal rights, a court for the causes of the king's barons, and an ultimate tribunal at which a persistent litigant might perhaps arrive

when justice had failed him everywhere else. Had it continued to be no more than this, the old English law, slowly adapting itself to changed circumstances, might have cast off its archaisms and become the law for after-times, law to be written and spoken in English words. Far more probably "St Edward's law" would have split into a myriad local customs, and then at some future time Englishmen must have found relief from intolerable confusion in the eternal law of Rome. Neither of these two things happened, because under Henry II the king's own court flung open its doors to all manner of people, ceased to be for judicial purposes an occasional assembly of warlike barons, became a bench of professional justices, appeared periodically in all the counties of England under the guise of the Justices in Eyre. Then begins the process which makes the custom of the king's court the common law of England. Ever since the Conquest the king's court had been in a very true sense a French court. It had been a French-speaking court, a court whose members had been of French race, and had but slowly been learning to think of themselves as Englishmen. Its hands had been very free. It could not, if it would, have administered the Old English written laws in their native purity: for one thing they were unintelligible; for another thing in the twelfth century they had become barbarous— they dealt with crime in a hopelessly old-fashioned way. On the other part, there was, happily, no written Norman code, and the king did not mean to be in England the mere duke he had been in Normandy. And so the hands of his court were very free; it could

Outlines of English Legal History 435

be a law unto itself. Many old English institutions it preserved, in particular those institutions of public law which were advantageous to the king—the king, for instance, could insist that the sheriffs were sheriffs, and not hereditary *vicomtes*—but the private law, law of land tenure, law of possession, of contract, of procedure, which the court develops in the course of the twelfth century, is exceedingly like a *coutume* from Northern France. Hundreds of years will elapse before anyone tries to write about it in English; and when at length this is done, the English will be an English in which every important noun, every accurate term, is of French origin.

We may say a little more about the language of our law, for it is not an uninteresting topic. From the Conquest onwards until the year 1731 the solemnest language of our law was neither French nor English, but Latin. Even in the Anglo-Saxon time, though English was the language in which laws were published and causes were pleaded, Latin was the language in which the kings, with Italian models before them, made grants of land to the churches and the thegns. In 1066 the learned men of both races could write and speak to each other in Latin. We shall be pretty safe in saying that anyone who could read and write at all could read and write Latin. As to French, it was as yet little better than a vulgar dialect of Latin, a language in which men might speak, but not a language in which they would write anything except perhaps a few songs. The two tongues which the Conqueror used for laws, charters and writs were Latin and English. But Latin soon gets the upper hand, and

becomes for a while the one written language of the law. In the king's Chancery they write nothing but Latin, and it is in Latin that the judgments of the king's courts are recorded. This, as already said, is so until the year 1731; to substitute English for Latin as the language in which the king's writs and patents and charters shall be expressed, and the doings of the law-courts shall be preserved, requires a statute of George II's day.

Meanwhile there had been many and great changes. Late in the twelfth or early in the thirteenth century French was beginning to make itself a language in which not only songs and stories but legal documents could be written. About the middle of the thirteenth century ordinances and statutes that are written in French began to appear. Just for one moment England puts in a claim to equality. Henry III "þurȝ Godes fultume king on Engleneloande" issued one proclamation in English. But this claim was either belated or premature. Under Edward I French, though it cannot expel Latin from the records of litigation, becomes the language in which laws are published and law-books are written. It continues to be the language of the statute-book until the end of the Middle Ages. Under Henry VII English at length becomes the speech in which English lawgivers address their subjects, though some two hundred and fifty years must yet pass away before it will win that field in which Latin is securely entrenched.

As the oral speech of litigants and their advisers, French has won a splendid victory. In the king's own court it must prevail from the Conquest onwards, but

in the local courts a great deal of English must long have been spoken. Then, however, under Henry II began that centralising movement which we have already noticed. The jurisprudence of a French-speaking court became the common law, the measure of all rights and duties, and it was carried throughout the land by the journeying justices. In the thirteenth century men when they plead or when they talk about law, speak French; the professional lawyer writes in French and thinks in French. Some power of speaking a decent French seems to have been common among all classes of men, save the very poorest; men spoke it who had few, if any, drops of foreign blood in their veins. Then in 1362, when the prolonged wars between England and France had begun, a patriotic statute endeavoured to make English instead of French the spoken tongue of the law-courts. But this came too late; we have good reason for thinking that it was but tardily obeyed, and at any rate, lawyers went on writing about law in French. Gradually in the sixteenth century their French went to the bad, and they began to write in English; for a long time past they had been thinking and speaking in English. But it was an English in which almost all the technical terms were of French origin. And so it is at the present day. How shall one write a single sentence about law without using some such word as "debt," "contract," "heir," "trespass," "pay," "money," "court," "judge," "jury"? But all these words have come to us from the French. In all the world-wide lands where English law prevails, homage is done daily to William of Normandy and Henry of Anjou.

What Henry did in the middle of the twelfth century was of the utmost importance, though we might find ourselves in the midst of obsolete technicalities were we to endeavour to describe it at length. Speaking briefly, we may say that he concentrated the whole system of English justice round a court of judges professionally expert in the law. He could thus win money—in the Middle Ages no one did justice for nothing—and he could thus win power; he could control, and he could starve, the courts of the feudatories. In offering the nation his royal justice, he offered a strong and sound commodity. Very soon we find very small people—yeomen, peasants—giving the go-by to the old local courts and making their way to Westminster Hall, to plead there about their petty affairs. We may allow that in course of time this concentrating process went much too far. In Edward I's day the competence of the local courts in civil causes was hemmed within a limit of forty shillings, a limit which at first was fairly wide, but became ever narrower as the value of money fell, until in the last century no one could exact any debt that was not of trifling amount without bringing a costly action in one of the courts at Westminster. But the first stages of the process did unmixed good—they gave us a common law.

King Henry and his able ministers came just in time—a little later would have been too late: English law would have been unified, but it would have been Romanised. We have been wont to boast, perhaps too loudly, of the pure "Englishry" of our common law. This has not been all pure gain. Had we

Outlines of English Legal History 439

"received" the Roman jurisprudence as our neighbours received it, we should have kept out of many a bad mess through which we have plunged. But to say nothing of the political side of the matter, of the absolute monarchy which Roman law has been apt to bring in its train, it is probably well for us and for the world at large that we have stumbled forwards in our empirical fashion, blundering into wisdom. The moral glow known to the virtuous schoolboy who has not used the "crib" that was ready to his hand, we may allow ourselves to feel; and we may hope for the blessing which awaits all those who have honestly taught themselves anything.

In a few words we must try to tell a long story. On the continent of Europe Roman law had never perished. After the barbarian invasions it was still the "personal law" of the conquered provincials. The Franks, Lombards, and other victorious tribes lived under their old Germanic customs, while the vanquished lived under the Roman law. In course of time the personal law of the bulk of the inhabitants became the territorial law of the country where they lived. The Roman law became once more the general law of Italy and of Southern France; but in so doing it lost its purity, it became a debased and vulgarised Roman law, to be found rather in traditional custom than in the classical texts, of which very little was known. Then, at the beginning of the twelfth century, came a great change. A law-school at Bologna began to study and to teach that Digest in which Justinian had preserved the wisdom of the great jurists of the golden age. A new science spread outwards from

Bologna. At least wherever the power of the emperor extended, Roman law had—so men thought—a claim to rule. The emperors, though now of German race, were still the Roman emperors, and the laws of their ancestors were to be found in Justinian's books. But further, the newly discovered system—for we may without much untruth say that it was newly discovered—seemed so reasonable that it could not but affect the development of law in countries such as France and England, which paid no obedience to the emperors.

And just at this time a second great system of cosmopolitan jurisprudence was taking shape. For centuries past the Catholic Church had been slowly acquiring a field of jurisdiction that was to be all her own, and for the use of the ecclesiastical tribunals a large body of law had come into being, consisting of the canons published by Church Councils and the decretal epistles—genuine and forged—of the Popes. Various collections of these were current, but in the middle of the twelfth century they were superseded by the work of Gratian, a monk of Bologna. He called it "The Concordance of Discordant Canons," but it soon became known everywhere as the Decretum. And by this time the Popes were ever busy in pouring out decretal letters, sending them into all corners of the western world. Authoritative collections of these "decretals" were published, and the ecclesiastical lawyer (the "canonist" or "decretist") soon had at his command a large mass of written law comparable to that which the Roman lawyer (the "civilian" or "legist") was studying. A Corpus Juris Canonici begins to take its place beside the Corpus Juris Civilis.

Outlines of English Legal History 441

Very often the same man had studied both; he was a "doctor of both laws"; and, indeed, the newer system had borrowed largely from the older; it had borrowed its form, its spirit, and a good deal of its matter also.

The canonical jurisprudence of the Italian doctors became the ecclesiastical law of the western world. From all local courts, wherever they might be, there was an appeal to the ultimate tribunal at Rome. But the temporal law of every country felt the influence of the new learning. Apparently we might lay down some such rule as this—that where the attack is longest postponed, it is most severe. In the thirteenth century the Parliament of Paris began the work of harmonising and rationalising the provincial customs of Northern France, and this it did by Romanising them. In the sixteenth century, after "the revival of letters," the Italian jurisprudence took hold of Germany, and swept large portions of the old national law before it. Wherever it finds a weak, because an uncentralised, system of justice, it wins an easy triumph. To Scotland it came late; but it came to stay.

To England it came early. Very few are the universities which can boast of a school of Roman law so old as that of Oxford. In the troubled days of our King Stephen, when the Church was urging new claims against the feeble State, Archbishop Theobald imported from Italy one Vacarius, a Lombard lawyer, who lectured here on Roman law, and wrote a big book that may still be read. Very soon after this Oxford had a flourishing school of civil and canon law. Ever since William the Conqueror had solemnly

sanctioned the institution of special ecclesiastical courts, it had been plain that in those courts the law of a Catholic Church, not of a merely English Church, must prevail; also that this law would be in the main Italian law. In the next century, as all know, Henry and Becket fell out as to the definition of the province that was to be left to the ecclesiastical courts. The battle was drawn; neither combatant had gained all that he wanted. Thenceforward until the Protestant Reformation, and indeed until later than that, a border warfare between the two sets of courts was always simmering. Victory naturally inclined to those tribunals which had an immediate control of physical force, but still the sphere that was left to the canonists will seem to our eyes very ample. It comprehended not only the enforcement of ecclesiastical discipline, and the punishment—by spiritual censure, and, in the last resort, by excommunication—of sins left unpunished by temporal law, but also the whole topic of marriage and divorce, those last dying wills and testaments which were closely connected with dying confessions, and the administration of the goods of intestates. Why to this day do we couple "Probate" with "Divorce"? Because in the Middle Ages both of these matters belonged to "the courts Christian." Why to "Probate" and "Divorce" do we add "Admiralty"? Because the civilians—and in England the same man was usually both canonist and civilian—succeeded, though at a comparatively late time, in taking to themselves the litigation that concerned things done on the high seas, those high seas whence no jury could be summoned. So for the canonist

there was plenty of room in England; and there was some room for the civilian: he was very useful as a diplomatist.

But we were speaking of our English common law, the law of our ordinary temporal courts, and of the influence upon it of the new Italian but cosmopolitan jurisprudence; and we must confess that for a short while, from the middle of the twelfth to the middle of the thirteenth century, this influence was powerful. The amount of foreign law that was actually borrowed has been underrated and overrated: we could not estimate it without descending to details. Some great maxims and a few more concrete rules were appropriated, but on the whole what was taken was logic, method, spirit rather than matter. We may see the effect of this influence very plainly in a treatise on the Laws of England which comes to us from the last years of Henry II. It has been ascribed to Henry's Chief Justiciar — Viceroy, we may say — Ranulf Glanvill; and whether or no it comes from his pen (he was a layman and a warrior), it describes the practice of the court over which he presided. There are very few sentences in it which we can trace to any Roman book, and yet in a sense the whole book is Roman. We look back from it to a law-book written in Henry I's time, and we can hardly believe that only some seventy years divide the two. The one can at this moment be read and understood by anyone who knows a little of mediaeval Latin and a little of English law; the other will always be dark to the most learned scholars. The gulf between them looks like that between logic and caprice, between reason

and unreason. And then from the middle of the thirteenth century we have a much greater and better book than Glanvill's. Its author we know as Bracton, though his name really was Henry of Bratton. He was an ecclesiastic, an archdeacon, but for many years he was one of the king's justices. He had read a great deal of the Italian jurisprudence, chiefly in the works of that famous doctor, Azo of Bologna. Thence he had obtained his idea of what a law-book should be, of how law should be arranged and stated; thence also he borrowed maxims and some concrete rules; with these he can fill up the gaps in our English system. But he lets us see that not much more can now be done in the way of Romanisation. Ever since Henry II's time the king's court has been hard at work amassing precedents, devising writs, and commenting upon them. Bracton himself has laboriously collected five hundred decisions from the mile-long Rolls of the Court and uses them as his authorities. For him English law is already "case law"; a judgment is a precedent. While as yet the science of the civilians was a somewhat unpractical science, while as yet they had not succeeded in bringing the old classical texts into close contact with the facts of mediaeval life, the king's court of professional justices—the like of which was hardly to be found in any foreign land, in any unconquered land—had been rapidly evolving a common law for England, establishing a strict and formal routine of procedure, and tying the hands of all subsequent judges. From Bracton's day onwards Roman law exercises but the slightest influence on the English common law, and such influence as it exercises

is rather by way of repulsion than by way of attraction. English law at this early period had absorbed so much Romanism that it could withstand all future attacks, and pass scathless even through the critical sixteenth century.

It may be convenient, however, to pause at this point in the development of our judicial institutions, in order to trace the history of our legal procedure.

For a long time past Englishmen have been proud of their trial by jury, and proud to see the nations of Europe imitating as best they might this "palladium of English liberties," this "bulwark of the British Constitution." Their pride, if in other respects it be reasonable, need not be diminished by any modern discoveries of ancient facts, even though they may have to learn that in its origin trial by jury was rather French than English, rather royal than popular, rather the livery of conquest than a badge of freedom. They have made it what it is; and what it is is very different from what it was. The story is a long and a curious one.

Let us try to put before our eyes a court of the twelfth century; it may be a county court or a hundred-court, or a court held by some great baron for his tenants. It is held in the open air—perhaps upon some ancient moot-hill, which ever since the times of heathenry has been the scene of justice. An officer presides over it—the sheriff, the sheriff's bailiff, the lord's steward. But all or many of the free landowners of the district are bound to attend it; they owe "suit" to it, they are its suitors, they are its doomsmen; it is for them, and not for the president, "to find the

dooms." He controls the procedure, he issues the mandates, he pronounces the sentence; but when the question is what the judgment shall be, he bids the suitors find the doom. All this is very ancient, and look where we will in Western Europe we may find it. But as yet we have not found the germ of trial by jury. These doomsmen are not "judges of fact." There is no room for any judges of fact. If of two litigants the one contradicts the other flatly, if the plain "You did" of the one is met by the straightforward "You lie" of the other, here is a problem that man cannot solve. He is unable as yet to weigh testimony against testimony, to cross-examine witnesses, to piece together the truth out of little bits of evidence. He has recourse to the supernatural. He adjudges that one or other of the two parties is to prove his case by an appeal to God.

The judgment precedes the proof. The proof consists, not in a successful attempt to convince your judges of the truth of your assertion, but in the performance of a task that they have imposed upon you: if you perform it, God is on your side. The modes of proof are two, oaths and ordeals. In some cases we may see a defendant allowed to swear away a charge by his own oath. More frequently he will have to bring with him oath-helpers—in later days they are called "compurgators"—and when he has sworn successfully, each of these oath-helpers in turn will swear "By God that oath is clean and true." The doomsmen have decreed how many oath-helpers, and of what quality, he must bring. A great deal of their traditional legal lore consists in rules about this matter;

queer arithmetical rules will teach how the oath of one thegn is as weighty as the oath of six ceorls, and the like. Sometimes they require that the oath-helpers shall be kinsmen of the chief swearer, and so warn us against any rationalism which would turn these oath-helpers into "witnesses to character," and probably tell us of the time when the bond of blood was so strong that a man's kinsfolk were answerable for his misdeeds. A very easy task this oath with oath-helpers may seem in our eyes. It is not so easy as it looks. Ceremonial rules must be strictly observed; a set form of words must be pronounced; a slip, a stammer, will spoil all, and the adversary will win his cause. Besides, it is common knowledge that those who perjure themselves are often struck dead, or reduced to the stature of dwarfs, or find that they cannot remove their hands from the relics they have profaned.

But when crime is laid to a man's charge he will not always be allowed to escape with oaths. Very likely he will be sent to the ordeal. The ordeal is conceived as "the judgment of God." Of heathen origin it well may be, but long ago the Christian Church has made it her own, has prescribed a solemn ritual for the consecration of those instruments—the fire, the water—which will reveal the truth. The water in the pit is adjured to receive the innocent and to reject the guilty. He who sinks is safe, he who floats is lost. The red-hot iron one pound in weight must be lifted and carried three paces. The hand that held it is then sealed up in a cloth. Three days afterwards the seal is broken. Is the hand clean or is

it foul? that is the dread question. A blister "as large as half a walnut" is fatal. How these tests worked in practice we do not know. We seldom get stories about them save when, as now and again will happen, the local saint interferes and performs a miracle. We cannot but guess that it was well to be good friends with the priest when one went to the ordeal.

Then the Norman conquerors brought with them another ordeal—the judicial combat. An ordeal it is, for though the Church has looked askance at it, it is no appeal to mere brute force; it is an appeal to the God of Battles. Very solemnly does each combatant swear to the truth of his cause; very solemnly does he swear that he has eaten nothing, drunk nothing "whereby the law of God may be debased or the devil's law exalted." When a criminal charge is made—"an appeal of felony"—the accuser and the accused, if they be not maimed, nor too young, nor too old, will have to fight in person. When a claim for land is made, the plaintiff has to offer battle, not in his own person, but in the person of one of his men. This man is in theory a witness who will swear to the justice of his lord's cause. In theory he ought not to be, but in practice he often is, a hired champion who makes a profession of fighting other people's battles. If the hireling be exposed, he may have his hand struck off; but as a matter of fact there were champions in a large way of business. At least in some cases the arms that are used are very curious; they are made of wood and horn, and look (for we have pictures of them) like short pickaxes. Possibly they have been

Outlines of English Legal History 449

in use for this sacral purpose—a sacral purpose it is—ever since an age which knew not iron. Also we know that the champion's head is shaved, but are left to guess why this is done. The battle may last the livelong day until the stars appear. The accuser has undertaken that in the course of a day he will "prove by his body" the truth of his charge; and if he cannot do this before the twilight falls, he has failed and is a perjurer. The object of each party in the fight is not so much to kill his adversary—this perhaps he is hardly likely to do with the archaic weapon that he wields—but to make him pronounce "the loathsome word," to make him cry "craven." In a criminal case the accused, if vanquished, was forthwith hanged or mutilated; but in any case the craven had to pay a fine of sixty shillings, the old "king's ban" of the Frankish laws, and, having in effect confessed himself a perjurer, he was thenceforth infamous.

But long ago the Frankish kings had placed themselves outside the sphere of this ancient formal and sacral procedure. They were standing in the shoes of Roman governors, even of Roman emperors. For themselves and their own affairs they had a prerogatival procedure. If their rights were in question, they would direct their officers to call together the best and oldest men of the neighbourhood to swear about the relevant facts. The royal officers would make an inquisition, hold an inquest, force men to swear that they would return true answers to whatever questions might be addressed to them in the king's name. They may be asked whether or no this piece of land belongs to the king; they may be asked in a general way what

lands the king has in their district; they may be asked (for the king is beginning to see that he has a great interest in the suppression of violent crime) to tell tales of their neighbours, to report the names of all who are suspected of murder or robbery, and then these men can be sent to the ordeal. This privilege that the king has he can concede to others; he can grant to his favourite churches that their lands shall stand outside the scope of the clumsy and hazardous procedure of the common courts; if their title to those lands be challenged, a royal officer will call upon the neighbours to declare the truth—in other words, to give a verdict. It is here that we see the germ of the jury.

The Norman duke in his conquered kingdom was able to use the inquest with a free hand and on a grand scale. Domesday Book was compiled out of the verdicts returned by the men of the various hundreds and townships of England in answer to a string of questions put to them by royal commissioners. We have read how the stern king thought it no shame to do what the English monk thought it shame to write, how he numbered every ox, every cow, every pig in England. Thenceforward the inquest was part of the machinery of government; it could be employed for many different purposes whenever the king desired information. He could use it in his own litigation, he could place it at the service of other litigants who were fortunate enough or rich enough to obtain this favour from him. But throughout the reigns of our Norman kings it keeps its prerogatival character.

Then Henry II, bent upon making his justice

supreme throughout his realm, put this royal remedy at the disposal of all his subjects. This he did not by one general law, but piecemeal, by a series of ordinances known as "assizes," some of which we may yet read, while others have perished. For example, when there was litigation about the ownership of land, the defendant, instead of accepting the plaintiff's challenge to fight, was allowed to "put himself upon the king's grand assize." Thereupon the action, which had been begun in some feudal court, was removed into the king's court; and twelve knights, chosen from the district in which the land lay, gave a verdict as to whether the plaintiff or the defendant had the better right. In other cases—for example, when the dispute was about the possession, not the ownership, of land—less solemn forms of the inquest were employed; twelve free and lawful men, not necessarily knights, were charged to say whether the defendant had ejected the plaintiff. Before the twelfth century was at an end, the inquest in one form or another—sometimes it was called an assize, sometimes a jury—had become part of the normal procedure in almost every kind of civil action. Still there long remained many cases in which a defendant could, if he chose, reject the new-fangled mode of trial, and claim the ancient right of purging himself with oath-helpers, or of picking up the glove that the plaintiff had thrown down as a gage of battle. Even a prelate of the Church would sometimes rely rather upon the strong arm of a professional pugilist than upon the testimony of his neighbours. Within the walls of the chartered boroughs men were conservative of all that

would favour the free burgher at the cost of the despised outsider. The Londoners thought that trial by jury was good enough for those who were not citizens, but the citizen must be allowed to swear away charges of debt or trespass by the oaths of his friends. In the old communal courts, too, the county and hundred courts, where the landowners of the district sat as doomsmen, trial by jury never struck root, for only by virtue of a royal writ could a jury be summoned: this is one of the reasons why those old courts languished, decayed, and became useless. However, before the Middle Ages were over, trial by jury had become the only form of trial for civil actions that had any vitality. So late as 1824 a lucky litigant, taking advantage of his adversary's slip, presented himself at the bar of the King's Bench, prepared to swear away a debt—"to make his law" was the technical phrase—with the aid of eleven oath-helpers, and not until 1833 was this world-old procedure abolished by statute; but long before this, if the plaintiff was well advised, he could always prevent his opponent from escaping in this easy fashion.

We have spoken of "trial by jury." That term naturally calls up before our minds a set of twelve men called into court in order that they may listen to the testimony of witnesses, give a true verdict "according to the evidence," and, in short, act as judges of those questions of fact that are in dispute. But it is very long after Henry II's day before trial by jury takes this form. Originally the jurors are called in, not in order that they may hear, but in order that they may give, evidence. They are witnesses. They are

neighbours of the parties; they are presumed to know before they come into court the facts about which they are to testify. They are chosen by the sheriff to represent the neighbourhood—indeed, they are spoken of as being "the neighbourhood," "the country"—and the neighbourhood, the country, will know the facts. In the twelfth century population was sparse, and men really knew far more of the doings of their neighbours than we know nowadays. It was expected that all legal transactions would take place in public; the conveyance of land was made in open court, the wife was endowed at the church-door, the man who bought cattle in secret ran a great but just risk of being treated as a thief; every three weeks a court was held in the village, and all the affairs of every villager were discussed. The verdict, then, was the sworn testimony of the countryside; and if the twelve jurors perjured themselves, the verdict of another jury of twenty-four might send them to prison and render them infamous for ever. In course of time, and by slow degrees—degrees so slow that we can hardly detect them—the jury put off its old and acquired a new character. Sometimes, when the jurors knew nothing of the facts, witnesses who did know the facts would be called in to supply the requisite information. As human affairs grew more complex, the neighbours whom the sheriff summoned became less and less able to perform their original duty, more and more dependent upon the evidence given in their presence by those witnesses who were summoned by the parties. In the fifteenth century the change had taken place, though in yet later days a man who had been summoned as a juror,

and who sought to escape on the ground that he already knew something of the facts in question, would be told that he had given a very good reason for his being placed in the jury-box. We may well say, therefore, that trial by jury, though it has its roots in the Frankish inquest, grew up on English soil; and until recent times it was distinctive of England and Scotland, for on the continent of Europe all other forms of legal procedure had been gradually supplanted by that which canonists and civilians had constructed out of ancient Roman elements.

We have yet to speak of the employment of the inquest in criminal cases. The Frankish kings had employed it for the purpose of detecting crime. Do you suspect any of murder, robbery, larceny, or the like? This question was addressed by royal officers to selected representatives of every neighbourhood, and answered upon oath, and the suspected persons were sent to "the judgment of God." The Church borrowed this procedure; the bishop could detect ecclesiastical offences as the king detected crimes. It is not impossible that this particular form of the inquest had made its way into England some half-century before the Norman Conquest; but we hear very little about it until the days of Henry II. He ordained that it should be used upon a very large scale and as a matter of ordinary practice, both by the justices whom he sent to visit the counties and by the sheriffs. From his time onward a statement made upon oath by a set of jurors representing a hundred, to the effect that such an one is suspected of such a crime, is sufficient to put a man upon his trial. It is

known as an indictment. It takes its place beside the old accusation, or "appeal," urged by the person who has been wronged, by the man whose goods have been stolen or the nearest kinsman of the murdered man. It is but an accusation, however, and in Henry's days the indicted person takes his chance at the hot iron or the cold water; God may be for him, though man be against him. But already some suspicion is shown of the so-called judgment of God; for though he comes clean from the ordeal, he has to leave the country, swearing never to return. At last, in 1215, the Fourth Lateran Council forbade the clergy to take part in this superstitious rite. After this we hear no more in England of the ordeal as a legal process, though in much later days the popular belief that witches will swim died hard, and many an old woman was put in the pond. The judges of the thirteenth century had no substitute ready to take the place of that supernatural test of which an enlightened Pope had deprived them. Of course, if the indicted person will agree to accept the verdict of his neighbours, will "put himself upon his country"—that is, upon the neighbourhood—for good and ill, all is easy. Those who have indicted him as a suspicious character can now be asked whether he is guilty or no; and if they say that he is guilty, there will be no harm in hanging him, for he consented to the trial, and he must abide the consequences. To make the trial yet fairer, one may call in a second jury different from that which indicted him. Here is the origin of those two juries which we see employed in our own days—the grand jury that indicts, and the petty jury that tries. But suppose

that he will not give his consent; it is by no means obvious that the testimony of his neighbours ought to be treated as conclusive. Hitherto he has been able to invoke the judgment of God, and can we now deprive him of this ancient, this natural right? No, no one can be tried by jury who does not consent to be so tried. But what we can do is this—we can compel him to give his consent, we can starve him into giving his consent, and, again, we can quicken the slow action of starvation by laying him out naked on the floor of the dungeon and heaping weights upon his chest until he says that he will abide by the verdict of his fellows. And so we are brought to the pedantic cruelty of the "peine forte et dure." Even in the seventeenth century there were men who would endure the agony of being pressed to death rather than utter the few words which would have subjected them to a trial by jury. They had a reason for their fortitude. Had they been hanged as felons their property would have been confiscated, their children would have been penniless; while, as it was, they left the world obstinate, indeed, but unconvicted. All this—and until 1772 men might still be pressed to death—takes us back to a time when the ordeal seems the fair and natural mode of ascertaining guilt and innocence, when the jury is still a new-fangled institution.

The indictment, we have said, took its place beside the "appeal"—the old private accusation. The owner of the stolen goods, the kinsman of the murdered man, might still prosecute his suit in the old manner, and offer to prove his assertion by his body. The Church had not abolished, and could not abolish, the judicial

Outlines of English Legal History 457

combat, for though in truth it was an ordeal, no priestly benediction of the instruments that were to be used was necessary. By slow degrees in the thirteenth century the accused acquired the right of refusing his accuser's challenge and of putting himself upon a jury. What is more, the judges began to favour the "indictment" and to discourage the "appeal" by all possible means. They required of the accuser a punctilious observance of ancient formalities, and would quash his accusation if he were guilty of the smallest blunder. Still, throughout the Middle Ages we occasionally hear of battles being fought over criminal cases. In particular a convicted felon would sometimes turn "approver"—that is to say, he would obtain a pardon conditional on his ridding the world, by means of his appeals, of some three or four other felons. If he failed in his endeavour, he was forthwith hanged. But those who were not antiquarians must have long ago ceased to believe that such a barbarism as trial by battle was possible, when in 1818 a case arose which showed them that they had inadequately gauged the dense conservatism of the laws of their country. One Mary Ashford was found drowned; one Abraham Thornton was indicted for murdering her; a jury acquitted him. But the verdict did not satisfy the public mind, and the brother of the dead girl had recourse to an "appeal": to this accusation the previous acquittal was no answer. Thornton declared himself ready to defend his innocence by his body, and threw down, in Westminster Hall, as his gage of battle, an antique gauntlet, "without either fingers or thumb, made of white tanned skin, orna-

mented with sewn tracery and silk fringes, crossed by a narrow band of red leather, with leathern tags and thongs for fastening." The judges did their best to discover some slip in his procedure; but he had been careful and well advised; even his glove was of the true mediaeval pattern. So there was nothing for it but to declare that he was within his rights, and could not be compelled to submit to a jury if he preferred to fight. His adversary had no mind to fight, and so let the glove alone. After this crowning scandal Parliament at last bestirred itself, and in the year of grace 1819 completed the work of Pope Innocent III by abolishing the last of the ordeals.

If we regard it as an engine for the discovery of truth and for the punishment of malefactors, the mediaeval jury was a clumsy thing. Too often its verdicts must have represented guess-work and the tittle-tattle of the countryside. Sometimes a man must have gone to the gallows, not because anyone had seen him commit a crime, not because guilt had been brought home to him by a carefully tested chain of proved facts, but because it was notorious that he was just the man from whom a murder or a robbery might be expected. Only by slow degrees did the judges insist that the jurors ought to listen to evidence given by witnesses in open court, and rely only upon the evidence that was there given. Even when this step had been taken, it was long before our modern law of evidence took shape, long before the judges laid down such rules as that "hearsay is not evidence," and that testimony which might show that the prisoner had committed other crimes was not relevant to the

question whether he had perpetrated the particular offence of which he stood indicted.

But whatever may have been the case in the days of the ordeal—and about this we know very little— we may be fairly certain that in the later Middle Ages the escape of the guilty was far commoner than the punishment of the guiltless. After some hesitation our law had adopted its well-known rule that a jury can give no verdict unless the twelve men are all of one mind. To obtain a condemnatory unanimity was not easy if the accused was a man of good family; one out of every twelve of his neighbours that might be taken at random would stand out loyally for his innocence. Bribery could do much; seignorial influence could do more; the sheriff, who was not incorruptible, and had his own likes and dislikes, could do all, since it was for him to find the jury. It is easy for us to denounce as unconstitutional the practice which prevailed under Tudors and Stuarts of making jurors answer for their verdicts before the King's Council; it is not so easy for us to make certain that the jury system would have lived through the sixteenth century had it not been for the action of this somewhat irregular check. For the rest, we may notice that the jury of the Middle Ages, if it is to be called a democratic institution, can be called so only in a mediaeval sense. The jurors were freeholders. The great mass of Englishmen were not freeholders. The peasant who was charged with a crime was acquitted or convicted by the word of his neighbours, but by the word of neighbours who considered themselves very much his superiors.

If, however, we look back to those old days, we shall find ourselves deploring not so much that some men of whose guilt we are by no means satisfied are sent to the gallows, as that many men whose guilt is but too obvious escape scot-free. We take up a roll upon which the presentments of the jurors are recorded. Everywhere the same tale meets our eye. "Malefactors came by night to the house of such an one at such a place; they slew him and his wife and his sons and his daughters, and robbed his house; we do not know who they were; we suspect no one." Such organisation as there was for the pursuit of these marauders was utterly inefficient. Every good and lawful man is bound to follow the hue and cry when it is raised, and the village reeve, or in later days the village constable, ought to put himself at the head of this improvised and unprofessional police force. But it was improvised and unprofessional. Outside the walls of the boroughs there was no regular plan of watch and ward, no one whose business it was to keep an eye on men of suspicious habits, or to weave the stray threads of evidence into a halter. The neighbours who had followed the trail of the stolen cattle to the county boundary were apt to turn back, every man to his plough. "Let Gloucestershire folk mind Gloucestershire rogues." They would be fined, when the justices came round, for neglect of their duties—for the sheriff, or the coroner, or someone else, would tell tales of them—but meanwhile their hay was about, and the weather was rainy. Even when the jurors know the criminal's name, the chances seem to be quite ten to one that he has not been captured.

Nothing could then be done but outlaw him. At four successive county courts—the county court was held month by month—a proclamation calling upon him to present himself, "to come in to the king's peace," would be made, and at the fifth court he would be declared an outlaw. If after this he were caught, then, unless he could obtain some favour from the king, he would be condemned to death without any investigation being made of his guilt or innocence; the mere fact of his outlawry being proved, sentence followed as a matter of course. But the old law had been severer than this: to slay the outlaw wherever he may be found was not only the right but the duty of every true man, and even in the middle of the thirteenth century this was still the customary law of the Welsh marches. The outlaw of real life was not the picturesque figure that we have seen upon the stage; if he and his men were really "merry" in the greenwood, they were merry in creditable circumstances. Still, it is not to be denied that he attracted at times a good deal of romantic sympathy, even in the ages which really knew him. This probably had its origin in the brutal stringency of the forest laws, which must be charged with the stupid blunder of punishing small offences with a rigour which should have been reserved for the worst crimes.

The worst crimes were common enough. Every now and then the king and the nation would be alarmed, nor needlessly alarmed, by the prevalence of murder and highway robbery. A new ordinance would be issued, new instructions would be given to the judges, sheriffs would be active, and jurors would

be eager to convict; a good deal of hanging would be done, perhaps too indiscriminately. But so soon as the panic was over, Justice would settle down into her old sluggish habits. Throughout the Middle Ages life was very insecure; there was a great deal of nocturnal marauding, and the knife that every Englishman wore was apt to stab upon slight provocation.

The Church had not mended matters by sanctifying places and persons. In very old days when the blood-feud raged, when punishment and vengeance were very much one, it was a good thing that there should be holy places to which a man might flee when the avenger of blood was behind—places where no drop of blood might be spilt without sacrilege. They afforded an opportunity for the peacemaker. The bishop or priest would not yield up the fugitive who lay panting at the foot of the altar until terms had been made between him and his pursuers. But at a later time when the State was endeavouring to punish criminals, and there would be no punishment until after trial, the sanctuary was a public nuisance. The law was this:—If a criminal entered a church he was safe from pursuit; the neighbours who were pursuing him were bound to beset the church, prevent his escape, and send for the coroner. Sometimes they would remain encamped round the church for many days. At last the coroner would come, and parley with the fugitive. If he confessed his crime, then he might "abjure the realm"—that is, swear to leave England within a certain number of days (he was allowed days enough to enable him to reach the nearest seaport), and never to return. If he strayed

from the straight road which led to the haven, or if he came back to the realm, then he could at once be sentenced to death. For a man to take sanctuary, confess his crime and abjure the realm, was an everyday event, and we must have thus shipped off many a malefactor to plunder our neighbours in France and Flanders. If the man who had taken sanctuary would neither confess to a crime, nor submit to a trial, the State could do no more against him. It tried to teach the clergy that their duty was to starve him into submission; but the clergy resented this interference with holy things. A bad element of caprice was introduced into the administration of justice. The strong, the swift, the premeditating murderer cheated the gallows. Especially in the towns he might fairly complain of bad luck if he could not slip into one of the numerous churches before he was caught. On the other hand, the man who had not plotted his crime would get hanged.

And then the clergy stood outside the criminal law. If a clerk in holy orders committed a crime—this was the law of the thirteenth century—he could not be tried for it in a lay court. He could be accused there, and the judges might ask a jury whether he was guilty or no; but even though they found him guilty, this was no trial. At the request of his bishop—and the bishops made such requests as a matter of course—he was handed over for trial in an ecclesiastical court. Such a court had power to inflict very heavy punishments. It might draw no drop of blood, but it could imprison for life, besides being able to degrade the clerk from his orders. As a matter of fact, however, we hear

very little of any punishment save that of degradation. What is more, the criminal procedure of the ecclesiastical courts in England was of an absurdly old-fashioned and clumsy kind. They held by compurgation. If the accused clerk could but get some eleven or twelve friends of his own profession to swear that they believed him innocent, he was acquitted; he might resume his criminal career. Church and State are both to blame for this sad story. The Church would yield no jot of the claims that were sanctified by the blood of St Thomas; the lay courts would not suffer the bishops to do criminal justice in a really serious fashion. There can be no doubt that many of the worst criminals—men who had been found guilty by a jury of brutal murders and rapes—escaped scot-free, because they had about them some slight savour of professional holiness. It should be understood that this immunity was shared with the bishops, priests, and deacons by a vast multitude of men who were in "minor orders." They might have no ecclesiastical duties to perform; they might be married; they might be living the same life which laymen lived; but they stood outside the ordinary criminal law. One of the worst evils of the later Middle Ages was this "benefit of clergy." The king's justices, who never loved it, at length reduced it to an illogical absurdity. They would not be at pains to require any real proof of a prisoner's sacred character. If he could read a line in a book, this would do; indeed, it is even said that the same verse of the Psalms was set before the eyes of every prisoner, so that even the illiterate might escape if he could repeat by heart those saving words.

Criminal law had been rough and rude, and sometimes cruel; it had used the gallows too readily; it had punished with death thefts which, owing to a great fall in the value of money, were becoming petty thefts. Still, cruelty in such matters is better than caprice, and the "benefit of clergy" had made the law capricious without making it less cruel.

THE GROWTH OF JURISPRUDENCE. 1154-1273.

During the period which divides the coronation of Henry II (1154) from the coronation of Edward I (1272) definite legislation was still an uncommon thing. Great as were the changes due to Henry's watchful and restless activity, they were changes that were effected without the pomp of solemn law-making. A few written or even spoken words communicated to his justices, those justices whom he was constantly sending to perambulate the country, might do great things, might institute new methods of procedure, might bring new classes of men and of things within the cognisance of the royal court. Some of his ordinances—or "assizes," as they were called—have come down to us; others we have lost. No one was at any great pains to preserve their text, because they were regarded, not as new laws, but as mere temporary instructions which might be easily altered. They soon sink into the mass of unenacted "common law." Even in the next, the thirteenth, century some of Henry's rules were regarded as traditional rules which had come down from a remote time, and which might

be ascribed to the Conqueror, the Confessor, or any other king around whom a mist of fable had gathered.

Thus it came about that the lawyers of Edward I's day—and that was the day in which a professional class of temporal lawyers first became prominent in England — thought of Magna Carta as the oldest statute of the realm, the first chapter in the written law of the land, the earliest of those texts the very words of which are law. And what they did their successors do at the present day. The Great Charter stands in the forefront of our statute book, though of late years a great deal of it has been repealed. And certainly it is worthy of its place. It is worthy of its place just because it is no philosophical or oratorical declaration of the rights of man, nor even of the rights of Englishmen, but an intensely practical document, the fit prologue for those intensely practical statutes which English Parliaments will publish in age after age. What is more, it is a grand compromise, and a fit prologue for all those thousands of compromises in which the practical wisdom of the English race will always be expressing itself. Its very form is a compromise—in part that of a free grant of liberties made by the king, in part that of a treaty between him and his subjects, which is to be enforced against him if he breaks it. And then in its detailed clauses it must do something for all those sorts and conditions of men who have united to resist John's tyranny—for the bishop, the clerk, the baron, the knight, the burgess, the merchant—and there must be some give and take between these classes, for not all their interests are harmonious.

But even in the Great Charter there is not much new law; indeed, its own theory of itself (if we may use such a phrase) is that the old law, which a lawless king has set at naught, is to be restored, defined, covenanted, and written.

The Magna Carta of our statute book is not exactly the charter that John sealed at Runnymede; it is a charter granted by his son and successor, Henry III, the text of the original document having been modified on more than one occasion. Only two other acts of Henry's long reign attained the rank of statute law. The Provisions of Merton, enacted by a great assembly of prelates and nobles, introduced several novelties, and contain those famous words, "We will not have the laws of England changed," which were the reply of the barons to a request made by the bishops, who were desirous that our insular rule, "Once a bastard always a bastard," might yield to the law of the universal Church, and that marriage might have a retroactive effect. Among Englishmen there was no wish to change the laws of England. If only the king and his foreign favourites would observe those laws, then—such was the common opinion—all would be well. A change came; vague discontent crystallised in the form of definite grievances. After the Barons' War the king, though he had triumphed over his foes, and was enjoying his own again, was compelled to redress many of those grievances by the Provisions of Marlborough, or, as they have been commonly called, the Statute of Marlbridge. When, a few years afterwards, Henry died, the written, the enacted law of England consisted in the main of but

four documents, which we can easily read through in half an hour—there was the Great Charter, there was the sister-charter which defined the forest law, there were the Statutes of Merton and of Marlbridge. To these we might add a few minor ordinances; but the old Anglo-Saxon dooms were by this time utterly forgotten, the law-books of the Norman age were already unintelligible, and even the assizes of Henry II, though but a century old, had become part and parcel of "the common law," not to be distinguished from the unenacted rules which had gathered round them. Englishmen might protest that they would not change the law of England, but as a matter of fact the law of England was being changed very rapidly by the incessant decisions of the powerful central court.

Legal Reform under Edward I.

On the death of Henry III there followed some eighteen years which even at this day may seem to us the most brilliant eighteen years in the whole history of English legislation. At all events, if we are to find a comparable period we must look forward, for five hundred years and more, to the age of the first Reform Bill. Year by year King Edward I in his Parliaments made laws on a grand scale. His statutes will not be in our eyes very lengthy documents; but they are drastic, and they are permanent. They deal with all sorts of matters, public and private, but in particular with those elementary parts of the law of property and the law of civil procedure which English legislators

Outlines of English Legal History 469

have, as a general rule, been well content to leave alone. Just for this reason they are exceedingly permanent; they become fundamental; elaborate edifices of gloss and comment are reared upon them. To this day, despite all the reforms of the present century, we have to look to them, and the interpretation which has been set upon them, for some of the most elementary principles of our land law. When all has been said that can be said for the explanation of this unique outburst of legislation, it still remains a marvellous thing.

A professional class of English temporal lawyers was just beginning to form itself. We say "of English temporal lawyers," because for more than a century past there had been " legists " and " decretists " in the land. These legists and decretists constituted a professional class; they held themselves out as willing to plead the causes of those who would pay their fees. They did a large business, for the clergy of the time were extremely litigious. The bishop who was not perennially engaged in interminable disputes with two or three wealthy religious houses was either a very fortunate or a very careless guardian of the rights of his see. And all the roads of ecclesiastical litigation led to Rome. Appeals to the Pope were made at every stage of every cause, and the most famous Italian lawyers were retained as advocates. The King of England, who was often involved in contests about the election of bishops—contests which would sooner or later come before the Roman Curia—kept Italian canonists in his pay. Young Englishmen were sent to Bologna in order that they might learn the law of

the Church. The University of Oxford was granting degrees in civil and canon law, the University of Cambridge followed her example. There was no lack of ecclesiastical lawyers; indeed, the wisest and most spiritual of the clergy thought that there were but too many of them, and deplored that theology was neglected in favour of a more lucrative science. And what we might call an ecclesiastical "Bar" had been formed. The canonist who wished to practise in a bishop's court had to satisfy the bishop of his competence, and to take an oath obliging him to practise honestly. The tribunals of the Church knew both the "advocate" (who pleads on behalf of a client), and the "procurator" or "proctor" (who represents his client's person and attends to his cause).

In course of time two groups similar to these grew up round the king's court. We see the "attorney" (who answers to the ecclesiastical proctor) and the "pleader," "narrator," or "countor" (who answers to the ecclesiastical advocate). But the formation of these classes of professional lawyers has not been easy. Ancient law does not readily admit that one man can represent another; in particular, it does not readily admit that one man can represent another in litigation. So long as procedure is extremely formal, so long as all depends on the due utterance of sacramental words, it does not seem fair that you should put an expert in your place to say those words for you. My adversary has, as it were, a legal interest in my ignorance or stupidity. If I cannot bring my charge against him in due form, that charge ought to fail; at all events, he cannot justly be called upon to answer another person,

some subtle and circumspect pleader, whom I have hired. Thus the right to appoint an attorney who will represent my person in court, and win or lose my cause for me, appears late in the day. It spreads outwards from the king. From of old the king must be represented by others in his numerous suits. This right of his he can confer upon his subjects—at first as an exceptional favour, and afterwards by a general rule. In Henry III's reign this process has gone thus far:— A litigant in the king's court may appoint an attorney to represent him in the particular action in which he is for the time being engaged: he requires no special licence for this; but if a man wishes to appoint prospectively a general attorney, who will represent him in all actions, the right to do this he must buy from the king, and he will not get it except for some good cause. The attorneys of this age are by no means always professional men of business. Probably every free and lawful man may act as the attorney of another; indeed, shocking as this may seem to us, we may, not very unfrequently, find a wife appearing in court as her husband's attorney.

The other "branch of the profession" grows from a different stock. In very old days a litigant is allowed to bring his friends into court, and to take "counsel" with them before he speaks. Early in the twelfth century it is already the peculiar mark of a capital accusation that the accused must answer without "counsel." Then sometimes one of my friends will be allowed, not merely to prompt me, but even to speak for me. It is already seen that the old requirement of extreme verbal accuracy is working injustice.

A man ought to have some opportunity of amending a mere slip of the tongue; and yet old legal principles will not suffer that he should amend the slips of his own tongue. Let another tongue slip for him. Such is the odd compromise between ancient law and modern equity. One great advantage that I gain by putting forward "one of my counsel" to speak for me is that if he blunders—if, for example, he speaks of Roger when he should have spoken of Richard—I shall be able to correct the mistake, for his words will not bind me until I have adopted them. Naturally, however, I choose for this purpose my acutest and most experienced friends. Naturally, also, acute and experienced men are to be found who will gladly be for this purpose my friends or anybody else's friends, if they be paid for their friendliness. As a class of expert pleaders forms itself, the relation between the litigant and those who are "of counsel for him" will be very much changed, but it will not lose all traces of its friendly character. Theoretically one cannot hire another person to plead for one; in other words, counsel cannot sue for his fees.

Seemingly it was in the reign of Henry III that pleaders seeking for employment began to cluster round the king's court. Some of them the king, the busiest of all litigants, kept in his pay; they were his "serjeants"—that is, servants—at law. Under Edward I a process, the details of which are still very obscure, was initiated by the king, which brought these professional pleaders and the professional attorneys under the control of the judges, and began to secure a monopoly of practice to those who had been formally

ordained to the ministry of the law. About the same time it is that we begin to read of men climbing from the Bar to the Bench, and about the same time it is that the judges are ceasing to be ecclesiastics. If we look back to Richard I's reign we may see, as the highest temporal court of the realm, a court chiefly composed of ecclesiastics, presided over by an archbishop, who is also Chief Justiciar; he will have at his side two or three bishops, two or three archdeacons, and but two or three laymen. The greatest judges even of Henry III's reign are ecclesiastics, though by this time it has become scandalous for a bishop to do much secular justice. These judges have deserved their appointments, not by pleading for litigants, but by serving as clerks in the Court, the Exchequer, the Chancery. They are professionally learned in the law of the land, but they have acquired their skill rather as the civil servants of the Crown than as the advocates or advisers of private persons; and if they serve the king well on the Bench, they may hope to retire upon bishoprics, or at all events deaneries. But the Church has been trying to withdraw the clergy from this work in the civil courts. Very curious had been the shifts to which ecclesiastics had been put in order to keep themselves technically free of blood-guiltiness. The accused criminal knew what was going to happen when the ecclesiastical president of the court rose but left his lay associates behind him. Hands that dared not write "and the jurors say that he is guilty, and therefore let him be hanged," would go so far as "and therefore, etc." Lips that dared not say any worse would venture a sufficiently intelligible " Take him away, and let him

have a priest." However, the Church has her way. The clerks of the court, the Exchequer, the Chancery, will for a very long time be clerks in holy orders; but before the end of Edward I's reign the appointment of an ecclesiastic to be one of the king's justices will be becoming rare. On the whole, we may say that from that time to the present, one remarkable characteristic of our legal system is fixed—all the most important work of the law is done by a very small number of royal justices who have been selected from the body of pleaders practising in the king's courts.

Slowly the "curia" of the Norman reigns had been giving birth to various distinct offices and tribunals. In Edward's day there was a "King's Bench" (a court for criminal causes and other "pleas of the Crown"); a "Common Bench" (a court for actions brought by one subject against another); an Exchequer, which both in a judicial and an administrative way collected the king's revenue and enforced his fiscal rights; a Chancery, which was a universal secretarial bureau, doing all the writing that was done in the king's name. These various departments had many adventures to live through before the day would come when they would once more be absorbed into a High Court of Justice. Of some few of those adventures we shall speak in another place, but must here say two or three words about a matter which gave a distinctive shape to the whole body of our law—a shape that it is even now but slowly losing. Our common law during the later Middle Ages and far on into modern times is in the main a commentary on writs issued out of the king's Chancery. To understand this, we must go

back to the twelfth century, to a time when it would have seemed by no means natural that ordinary litigation between ordinary men should come into the king's court. It does not come there without an order from the king. Your adversary could not summon you to meet him in that court; the summons must come from the king. Thus much of the old procedure we still retain in our own time; it will be the king, not your creditor, who will bid you appear in his High Court. But whereas at the present day the formal part of the writ will merely bid you appear in court, and all the information that you will get about the nature of the claim against you will be conveyed to you in the plaintiff's own words or those of his legal advisers, this was not so until very lately. In old times the writ that was drawn up in the king's Chancery and sealed with his great seal told the defendant a good many particulars about the plaintiff's demand. Gradually, as the king began to open the doors of his court to litigants of all kinds, blank forms of the various writs that could be issued were accumulated in the Chancery. We may think of the king as keeping a shop in which writs were sold. Some of them were to be had at fixed prices, or, as we should say nowadays, they could be had as matters of course on the payment of fixed court-fees; for others special bargains had to be made. Then, in course of time, as our Parliamentary constitution took shape, the invention of new writs became rarer and rarer. Men began to see that if the king in his Chancery could devise new remedies by granting new writs, he had in effect a power of creating new rights and making new laws without the concur-

rence of the estates of the realm. And so it came to be a settled doctrine that though the old formulas might be modified in immaterial particulars to suit new cases as they arose, no new formula could be introduced except by statute. This change had already taken place in Edward I's day. Thenceforward the cycle of writs must be regarded as a closed cycle; no one can bring his cause before the king's courts unless he can bring it within the scope of one of those formulas which the Chancery has in stock and ready for sale. We may argue that if there is no writ there is no remedy, and if there is no remedy there is no wrong; and thus the register of writs in the Chancery becomes the test of rights and the measure of law. Then round each writ a great mass of learning collects itself. He who knows what cases can be brought within each formula knows the law of England. The body of law has a skeleton, and that skeleton is the system of writs. Thus our jurisprudence took an exceedingly rigid and permanent shape; it became a commentary on formulas. It could still grow and assimilate new matter, but it could only do this by a process of interpretation which gradually found new, and not very natural, meanings for old phrases. As we shall see hereafter, this process of interpretation was too slow to keep up with the course of social and economic change, and the Chancery had to come to the relief of the courts of law by making itself a court of equity.

ENGLISH LAW, 1307–1600.

The desire for continuous legislation is modern. We have come to think that, year by year, Parliament must meet and pour out statutes; that every statesman must have in his mind some programme of new laws; that if his programme once become exhausted he would cease to be a statesman. It was otherwise in the Middle Ages. As a matter of fact a Parliament might always find that some new statute was necessary. The need for legislation, however, was occasioned (so men thought) not by any fated progress of the human race, but by the perversity of mankind. Ideally there exists a perfect body of law, immutable, eternal, the work of God, not of man. Just a few more improvements in our legal procedure will have made it for ever harmonious with this ideal; and, indeed, if men would but obey the law of the land as it stands, there would be little for a legislator to do.

During the fourteenth century a good deal is written upon the statute roll, and a good deal can still be said in very few words. "Also it is agreed that a Parliament shall be holden once a year or more often if need be." This is a characteristic specimen of the brief sentences in which great principles are formulated and which by their ambiguity will provide the lawyers and politicians of later ages with plenty of matter for debate. Many of these short clauses are directed against what are regarded as abuses, as evasions of the law, and the king's officers are looked upon as the

principal offenders. They must be repeated with but little variation from time to time, for it is difficult to bind the king by law. Happily the kings were needy; in return for "supply" they sold the words on the statute roll, and those words, of some importance when first conceded, became of far greater importance in after times. When we read them nowadays they turn our thoughts to James and Charles, rather than to Edward and Richard. The New Monarchy was not new. This, from its own point of view, was its great misfortune. It had inherited ancient parchment rolls which had uncomfortable words upon them.

But Parliament by its statutes was beginning to interfere with many affairs, small as well as great. Indeed, what we may consider small affairs seem to have troubled and interested it more even than those large constitutional questions which it was always hoping to settle but never settling. If we see a long statute, one guarded with careful provisos, one that tells us of debate and compromise, this will probably be a statute which deals with one particular trade; for instance, a statute concerning the sale of herring at Yarmouth fair. The thorniest of themes for discussion is the treatment of foreign merchants. Naturally enough our lords, knights, and burgesses cannot easily agree about it. One opinion prevails in the seaports, another in the upland towns, and the tortuous course of legislation, swaying now towards Free Trade and now towards Protection, is the resultant of many forces. The "omnicompetence," as Bentham called it, of statute law was recognised by all, the impotence of statute law was seen by none. It can determine the rate of wages,

the price of goods, the value of money; it can decide that no man shall dress himself above his station.

On the other hand, the great outlines of criminal law and private law seem to have been regarded as fixed for all time. In the twentieth century students of law will still for practical purposes be compelled to know a good deal about some of the statutes of Edward I. They will seldom have occasion to know anything of any laws that were enacted during the fourteenth or the first three-quarters of the fifteenth century. Parliament seems to have abandoned the idea of controlling the development of the common law. Occasionally and spasmodically it would interfere, devise some new remedy, fill a gap in the register of writs, or circumvent the circumventors of a statute. But in general it left the ordinary law of the land to the judges and the lawyers. In its eyes the common law was complete, or very nearly complete.

And then as we read the statute-roll of the fifteenth century we seem for a while to be watching the decline and fall of a mighty institution. Parliament seems to have nothing better to do than to regulate the manufacture of cloth. Now and then it strives to cope with the growing evils of the time, the renascent feudalism, the private wars of great and small; but without looking outside our roll we can see that these efforts are half-hearted and ineffectual. We are expected to show a profound interest in "the making of worsteds," while we gather from a few casual hints that the Wars of the Roses are flagrant. If for a moment the Parliament of Edward IV can raise its soul above defective barrels of fish and fraudulent gutter tiles, this will

be in order to prohibit "cloish, kayles, half-bowl, hand-in-hand and hand-out, quekeboard," and such other games as interfere with the practice of archery.

In the end it was better that Parliament should for a while register the acts of a despot than that it should sink into the contempt that seemed to be prepared for it. The part which the assembled Estates of the Realm have to play in the great acts of Henry VIII may in truth be a subservient and ignoble part; but the acts are great and they are all done "by the authority of Parliament." By the authority of Parliament the Bishop of Rome could be deprived of all jurisdiction, the monasteries could be dissolved, the king could be made (so far as the law of God would permit) supreme head of the English Church, the succession to the Crown could be settled first in this way, then in that, the force of statute might be given to the king's proclamations. There was nothing that could not be done by the authority of Parliament. And apart from the constitutional and ecclesiastical changes which everyone has heard about, very many things of importance were done by statute. We owe to Henry VIII—much rather to him than to his Parliament—not a few innovations in the law of property and the law of crime, and the Parliaments of Elizabeth performed some considerable legal exploits. The statutes of the Tudor period are lengthy documents. In many a grandiose preamble we seem to hear the voice of Henry himself; but their length is not solely due to the pomp of imperial phrases. They condescend to details; they teem with exceptions and saving clauses. One cannot establish a new ecclesiastical

polity by half-a-dozen lines. We see that the judges are by this time expected to attend very closely to the words that Parliament utters, to weigh and obey every letter of the written law.

Just now and then in the last of the Middle Ages and thence onwards into the eighteenth century, we hear the judges claiming some vague right of disregarding statutes which are directly at variance with the common law, or the law of God, or the royal prerogative. Had much come of this claim, our constitution must have taken a very different shape from that which we see at the present day. Little came of it. In the troublous days of Richard II a chief justice got himself hanged as a traitor for advising the king that a statute curtailing the royal power was void. For the rest, the theory is but a speculative dogma. We can (its upholders seem to say) conceive that a statute might be so irrational, so wicked, that we would not enforce it; but, as a matter of fact, we have never known such a statute made. From the Norman Conquest onwards, England seems marked out as the country in which men, so soon as they begin to philosophise, will endeavour to prove that all law is the command of a "sovereign one," or a "sovereign many." They may be somewhat shocked when in the seventeenth century Hobbes states this theory in trenchant terms and combines it with many unpopular doctrines. But the way for Hobbes had been prepared of old. In the days of Edward I the text-writer whom we call Britton had put the common law into the king's mouth: all legal rules might be stated as royal commands.

Still, even in the age of the Tudors, only a small

part of the law was in the statute-book. Detached pieces of superstructure were there; for the foundation men had to look elsewhere. After the brilliant thirteenth century a long, dull period had set in. The custody of the common law was now committed to a small group of judges and lawyers. They knew their own business very thoroughly, and they knew nothing else. Law was now divorced from literature; no one attempted to write a book about it. The decisions of the courts at Westminster were diligently reported and diligently studied, but no one thought of comparing English law with anything else. Roman law was by this time an unintelligible, outlandish thing, perhaps a good enough law for half-starved Frenchmen. Legal education was no longer academic—the universities had nothing to do with it, they could only make canonists and civilians—it was scholastic. By stages that are exceedingly obscure, the inns of court and inns of chancery were growing. They were associations of lawyers which had about them a good deal of the club, something of the college, something of the trade-union. They acquired the "inns" or "hospices" —that is, the town houses—which had belonged to great noblemen: for example, the Earl of Lincoln's inn. The house and church of the Knights of the Temple came to their hands. The smaller societies, "inns of chancery," became dependent on the larger societies, "inns of court." The serjeants and apprentices who composed them enjoyed an exclusive right of pleading in court; some things might be done by an apprentice or barrister, others required a serjeant; in the Court of Common Pleas only a serjeant could be

heard. It would take time to investigate the origin of that power of granting degrees which these societies wielded. To all seeming the historian must regard it as emanating from the king, though in this case, as in many other cases, the control of a royal prerogative slowly passed out of the king's hand. But here our point must be, that the inns developed a laborious system of legal education. Many years a student had to spend in hearing and giving lectures and in pleading fictitious causes before he could be admitted to practice.

It is no wonder that under the fostering care of these societies English jurisprudence became an occult science and its professors "the most unlearned kind of most learned men." They were rigorous logicians, afraid of no conclusion that was implicit in their premises. The sky might fall, the Wars of the Roses might rage, but they would pursue the even course of their argumentation. They were not altogether unmindful of the social changes that were going on around them. In the fifteenth century there were great judges who performed what may seem to us some daring feats in the accommodation of old law to new times. Out of unpromising elements they developed a comprehensive law of contract; they loosened the bonds of those family settlements by which land had been tied up; they converted the precarious villein tenure of the Middle Ages into the secure copyhold tenure of modern times. But all this had to be done evasively and by means of circumventive fictions. Novel principles could not be admitted until they were disguised in some antique garb.

A new and a more literary period seems to be beginning in the latter half of the fifteenth century, when Sir John Fortescue, the Lancastrian Chief Justice, writing for the world at large, contrasts the constitutional kingship of England with the absolute monarchy of France, and Sir Thomas Littleton, a Justice in the Court of Common Pleas, writing for students of English law, publishes his lucid and classical book on the tenure of land. But the hopes of a renascence are hardly fulfilled. In the sixteenth century many famous lawyers added to their fame by publishing reports of decided cases and by making "abridgments" of the old reports, and a few little treatises were compiled; but in general the lawyer seems to think that he has done all for jurisprudence that can be done when he has collected his materials under a number of rubrics alphabetically arranged. The alphabet is the one clue to the maze. Even in the days of Elizabeth and James I Sir Edward Coke, the incarnate common law, shovels out his enormous learning in vast disorderly heaps. Carlyle's felicity has for ever stamped upon Coke the adjective "tough"—"tough old Coke upon Littleton, one of the toughest men ever made." We may well transfer the word from the man to the law that was personified in him. The English common law was tough, one of the toughest things ever made. And well for England was it in the days of Tudors and Stuarts that this was so. A simpler, a more rational, a more elegant system would have been an apt instrument of despotic rule. At times the judges were subservient enough: the king could dismiss them from their offices at a moment's notice; but the clumsy, cumbrous system, though it might

bend, would never break. It was ever awkwardly rebounding and confounding the statecraft which had tried to control it. The strongest king, the ablest minister, the rudest Lord-Protector could make little of this "ungodly jumble."

To this we must add that professional jealousies had been aroused by the evolution of new courts, which did not proceed according to the course of the common law. Once more we must carry our thoughts back to the days of Edward I. The three courts—King's Bench, Common Bench, and Exchequer—had been established. There were two groups of "Justices," and one group of "Barons" engaged in administering the law. But behind these courts there was a tribunal of a less determinate nature. Looking at it in the last years of the thirteenth century we may doubt as to what it is going to be. Will it be a house of magnates, an assembly of the Lords Spiritual and Temporal, or will it be a council composed of the king's ministers and judges and those others whom he pleases for one reason or another to call to the council board? As a matter of fact, in Edward I's day, this highest tribunal seems to be rather the council than the assembly of prelates and barons. This council is a large body; it comprises the great officers of state—Chancellor, Treasurer, and so forth; it comprises the judges of the three courts; it comprises also the Masters or chief clerks of the Chancery, whom we may liken to the "permanent under-secretaries" of our own time; it comprises also those prelates and barons whom the king thinks fit to have about him. But the definition of this body seems somewhat vague. The sessions or

"parliaments" in which it does justice often coincide in time with those assemblies of the Estates of the Realm by which, in later days, the term "parliaments" is specifically appropriated, and at any moment it may take the form of a meeting to which not only the ordinary councillors, but all the prelates and barons, have been summoned. In the light which later days throw back upon the thirteenth century we seem to see in the justiciary "parliaments" of Edward I two principles, one of which we may call aristocratic, while the other is official; and we think that, sooner or later, there must be a conflict between them—that one must grow at the expense of the other. And then again we cannot see very plainly how the power of this tribunal will be defined, for it is doing work of a miscellaneous kind. Not only is it a court of last resort in which the errors of all lower courts can be corrected, but as a court of first instance it can entertain whatever causes, civil or criminal, the king may evoke before it. Then lastly, acting in a manner which to us seems half judicial and half administrative, it hears the numerous petitions of those who will urge any claim against the king, or complain of any wrong which cannot be redressed in the formal course of ordinary justice.

In the course of the fourteenth century some of these questions were settled. It became clear that the Lords' House of Parliament, the assembly of prelates and barons, was to be the tribunal which could correct the mistakes in law committed by the lower courts. The right of a peer of the realm to be tried for capital crimes by a court composed of his peers was established.

Precedents were set for those processes which we know as impeachments, in which the House of Lords hears accusations brought by the House of Commons. In all these matters, therefore, a tribunal technically styled "the King in Parliament," but which was in reality the House of Lords, appeared as the highest tribunal of the realm. But, beside it, we see another tribunal with indefinitely wide claims to jurisdiction— we see "the King in Council." And the two are not so distinct as an historian, for his own sake and his readers', might wish them to be. On the one hand, those of the King's Council who are not peers of the realm, in particular the judges and the Masters of the Chancery, are summoned to the Lords' House of Parliament, and only by slow degrees is it made plain to them that, when they are in that House, they are mere "assistants" of the peers, and are only to speak when they are spoken to. On the other hand, there is a widespread, if not very practical, belief that all the peers are by rights the king's councillors, and that any one of them may sit at the council board if he pleases. Questions enough are left open for subsequent centuries.

Meanwhile the Council, its actual constitution varying much from reign to reign, does a great deal of justice, for the more part criminal justice, and this it does in a summary, administrative way. Plainly there is great need for such justice, for though the representative commoners and the lawyers dislike it, they always stop short of demanding its utter abolition. The commoners protest against this or that abuse. Sometimes they seem to be upon the point of denouncing

the whole institution as illegal; but then there comes some rebellion or some scandalous acquittal of a notorious criminal by bribed or partial jurors, which convinces them that, after all, there is a place for a masterful court which does not stand upon ceremony, which can strike rapidly and have no need to strike twice. They cannot be brought to admit openly that one main cause of the evils that they deplore is the capricious clumsiness of that trial by jury which has already become the theme of many a national boast. They will not legislate about the matter, rather they will look the other way while the Council is punishing rich and powerful offenders, against whom no verdict could have been obtained. A hard line is drawn between the felonies, for which death is the punishment, and the minor offences. No one is to suffer loss of life or limb unless twelve of his neighbours have sworn to his guilt after a solemn trial; but the Council must be suffered to deal out fines and imprisonments against rioters, conspirators, bribers, perjured jurors; otherwise there will be anarchy. The Council evolves a procedure for such cases, or rather it uses the procedure of the canon law. It sends for the accused; it compels him to answer upon oath written interrogatories. Affidavits, as we should call them, are sworn upon both sides. With written depositions before them, the Lords of the Council, without any jury, acquit or convict. The extraction of confessions by torture is no unheard-of thing.

It was in a room known as the Star Chamber that the Council sat when there was justice to be done, and there, as "the Court of Star Chamber," it earned its

infamy. That infamy it fairly earned under the first two Stuart kings, and no one will dispute that the Long Parliament did well in abolishing it. It had become a political court and a cruel court, a court in which divines sought to impose their dogmas and their ritual upon a recalcitrant nation by heavy sentences; in which a king, endeavouring to rule without a Parliament, tried to give the force of statutes to his proclamations, to exact compulsory loans, to gather taxes that the Commons had denied him ; a whipping, nose-slitting, ear-cropping court ; a court with a grim, unseemly humour of its own, which would condemn to an exclusive diet of pork the miserable Puritan who took too seriously the Mosaic prohibition of swine's flesh. And then, happily, there were doubts about its legality. The theory got about that it derived all its lawful powers from a statute passed in 1487, at the beginning of Henry VII's reign, while manifestly it was exceeding those powers in all directions. We cannot now accept that theory, unless we are prepared to say that for a century and a half all the great judges, including Coke himself, had taken an active part in what they knew to be the unlawful doings of the Council—the two Chief Justices had habitually sat in the Star Chamber. Still we may be glad that this theory was accepted. The court was abolished in the name of the common law.

It had not added much to our national jurisprudence. It had held itself aloof from jurisprudence; it had been a law unto itself, with hands free to invent new remedies for every new disease of the body politic. It had little regard for precedents, and, therefore, men

were not at pains to collect its decisions. It had, however, a settled course of procedure which, in its last days, was described by William Hudson in a very readable book. Its procedure, the main feature of which was the examination of the accused, perished with it. After the Civil War and the Restoration no attempt was made to revive it, but that it had been doing useful things then became evident. The old criminal law had been exceedingly defective, especially in relation to those offences which did not attain the rank of felonies. The King's Bench had, for the future, to do what the Star Chamber had done, but to do it in a more regular fashion, and not without the interposition of a jury.

Far other were the fortunes of the Star Chamber's twin sister, the Court of Chancery. Twin sisters they were; indeed, in the fourteenth century it is hard to tell one from the other, and even in the Stuart time we sometimes find the Star Chamber doing things which we should have expected to be done by the Chancery. But, to go back to the fourteenth century, the Chancellor was the king's first minister, the head of the one great secretarial department that there was, the President of the Council, and the most learned member of the Council. Usually he was a bishop; often he had earned his see by diligent labours as a clerk in the Chancery. It was natural that the Lords of the Council should put off upon him, or that he should take to himself, a great deal of the judicial work that in one way or another the Council had to do. Criminal cases might come before the whole body, or some committee of it. Throughout the Middle Ages

criminal cases were treated as simple affairs; for example, justices of the peace who were not trained lawyers could be trusted to do a great deal of penal justice, and inflict the punishment of death. But cases involving civil rights, involving the complex land law, might come before the Council. Generally, in such cases, there was some violence or some fraud to be complained of, some violence or fraud for which, so the complainant alleged, he could get no redress elsewhere. Such cases came specially under the eye of the Chancellor. He was a learned man with learned subordinates, the Masters of the Chancery. Very gradually it became the practice for complainants who were seeking the reparation of wrongs rather than the punishment of offences, to address their petitions, not to the King and Council, but to the Chancellor. Slowly men began to think of the Chancellor, or the Chancery of which he was president, as having a jurisdiction distinct from, though it might overlap, that of the Council.

What was to be the sphere of this jurisdiction? For a long time this question remained doubtful. The wrongs of which men usually complained to the Chancellor were wrongs well enough known to the common law—deeds of violence, assaults, land-grabbing, and so forth. As an excuse for going to him, they urged that they were poor while their adversaries were mighty, too mighty for the common law, with its long delays and its purchasable jurors Odd though this may seem to us, that court which was to become a byword for costly delay started business as an expeditious and a poor man's court. It met with much opposition: the

House of Commons did not like it, and the common lawyers did not like it; but still there was a certain half-heartedness in the opposition. No one was prepared to say that there was no place for such a tribunal; no one was prepared to define by legislation what its place should be.

From the field of the common law the Chancellor was slowly compelled to retreat. It could not be suffered that, merely because there was helplessness on the one side and corruptive wealth on the other, he should be suffered to deal with cases which belonged to the old courts. It seems possible that this nascent civil jurisdiction of the Chancellor would have come to naught but for a curious episode in the history of our land law. In the second half of the fourteenth century many causes were conspiring to induce the landholders of England to convey their lands to friends, who, while becoming the legal owners of those lands, would, nevertheless, be bound by an honourable understanding as to the uses to which their ownership should be put. There were feudal burdens that could thus be evaded, ancient restrictions which could thus be loosened. The Chancellor began to hold himself out as willing to enforce these honourable understandings, these "uses, trusts or confidences" as they were called, to send to prison the trustee who would not keep faith. It is an exceedingly curious episode. The whole nation seems to enter into one large conspiracy to evade its own laws, to evade laws which it has not the courage to reform. The Chancellor, the judges, and the Parliament seem all to be in the conspiracy. And yet there is really no conspiracy: men are but living from hand

to mouth, arguing from one case to the next case, and they do not see what is going to happen. Too late the king, the one person who had steadily been losing by the process, saw what had happened. Henry VIII put into the mouth of a reluctant Parliament a statute which did its best—a clumsy best it was—to undo the work. But past history was too strong even for that high and mighty prince. The statute was a miserable failure. A little trickery with words would circumvent it. The Chancellor, with the active connivance of the judges, was enabled to do what he had been doing in the past, to enforce the obligations known as trusts. This elaborate story we can only mention by the way; the main thing that we have to notice is that, long before the Tudor days—indeed, before the fourteenth century was out—the Chancellor had acquired for himself a province of jurisdiction which was, in the opinion of all men, including the common lawyers, legitimately his own. From time to time he would extend its boundaries, and from time to time there would be a brisk quarrel between the Chancery and the law courts over the annexation of some field fertile of fees. In particular, when the Chancellor forbade a man to sue in a court of law, or to take advantage of a judgment that he had obtained in a court of law, the judges resented this, and a bitter dispute about this matter between Coke and Ellesmere gave King James I a wished-for opportunity of posing as the supreme lord of all the justice that was done in his name and awarding a decisive victory to his Chancellor. But such disputes were rare. The Chancellors had found useful work to do, and they had been suffered to do it without

much opposition. In the name of equity and good conscience they had, as it were, been adding an appendix to the common law. Every jot and tittle of the law was to be fulfilled, and yet, when a man had done this, more might be required of him in the name of equity and good conscience.

Where were the rules of equity and good conscience to be found? Some have supposed that the clerical Chancellors of the last Middle Ages found them in the Roman or the Canon Law, and certain it is that they borrowed the main principles of their procedure from the canonists. Indeed, until some reforms that are still very recent, the procedure of the Court of Chancery was the procedure of an Ecclesiastical Court. In flagrant contrast to the common law, it forced the defendant to answer on oath the charges that were brought against him; it made no use of the jury; the evidence consisted of written affidavits. On the other hand, it is by no means certain that more than this was borrowed. So far as we can now see, the Chancellors seem to get most of their dominant ideas from the common law. They imitate the common law whenever they can, and depart from it reluctantly at the call of natural justice and common honesty. Common honesty requires that a man shall observe the trust that has been committed to him. If the common law will not enforce this obligation it is failing to do its duty. The Chancellor intervenes, but in enforcing trusts he seizes hold of and adopts every analogy that the common law presents. For a long time English equity seems to live from hand to mouth. Sufficient for the day are the cases in that day's cause-list. Even in the seven-

teenth century men said that the real measure of equity was the length of the Chancellor's foot. Under the Tudors the volume of litigation that flowed into the Chancery was already enormous; the Chancellor was often sadly in arrear of his work, and yet very rarely were his decisions reported, though the decisions of the judges had been reported ever since the days of Edward I. This shows us that he did not conceive himself to be straitly bound by precedents: he could still listen to the voice of conscience. The rapid increase in the number of causes that he had to decide began to make his conscience a technical conscience. More and more of his time was spent upon the judgment-seat. Slowly he ceased to be, save in ceremonial rank, the king's first minister. Wolsey was the last Chancellor who ruled England. Secretaries of State were now intervening between the king and his Great Seal. Its holder was destined to become year by year more of a judge, less of a statesman. Still we must look forward to the Restoration for the age in which the rules of equity begin to take a very definite shape, comparable in rigour to the rules of the common law.

Somehow or another, England, after a fashion all her own, had stumbled into a scheme for the reconciliation of permanence with progress. The old mediaeval criminal law could be preserved because a Court of Star Chamber would supply its deficiencies; the old private law could be preserved because the Court of Chancery was composing an appendix to it; trial by jury could be preserved, developed, transfigured because other modes of trial were limiting it to an appropriate sphere. And so our old law maintained its continuity.

As we have said above, it passed scathless through the critical sixteenth century, and was ready to stand up against tyranny in the seventeenth. The Star Chamber and the Chancery were dangerous to our political liberties. Bacon could tell King James that the Chancery was the court of his absolute power. But if we look abroad we shall find good reason for thinking that but for these institutions our old-fashioned national law, unable out of its own resources to meet the requirements of a new age, would have utterly broken down, and the "ungodly jumble" would have made way for Roman jurisprudence and for despotism. Were we to say that that equity saved the common law, and that the Court of Star Chamber saved the constitution, even in this paradox there would be some truth.

Printed in January 2023
by Rotomail Italia S.p.A., Vignate (MI) - Italy